Recording
State Rites
in Words
and Images

遮陽扇

頭目

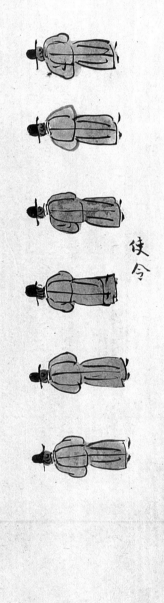

侍令

捧炬軍

Recording
State Rites
in Words
and Images

Uigwe of
Joseon Korea

YI SONG-MI

P. Y. and Kinmay W. Tang
Center for East Asian Art
Department of Art
and Archaeology,
Princeton University

in association with
Princeton University Press

Contents

Uigwe
of the
Five Rites
of State

—

PART ONE

Foreword

Nearly ten years ago, in 2014, as featured speaker for the Tang Center Lecture Series, Yi Song-mi, professor emerita at the Academy of Korean Studies, presented three lectures and two graduate seminars on Korean art at Princeton University. The seminar on *uigwe*, royal court documents of Joseon Korea, in particular, captivated students and scholars alike, as few at the time were aware of their visual richness or of the relationship of *uigwe* to other genres of Korean art. With encouragement from then-Tang Center Director Jerome Silbergeld and others, Professor Yi thus made *uigwe* the focus of a Tang Center publication.

It is our great privilege and pleasure to publish this volume of Professor Yi's pioneering scholarship on *uigwe* and Korean art, and to enhance it with abundant illustrations and substantial reference material. We thank Professor Yi for her remarkable patience, tenacity, and erudition, and for sharing her expertise and crafting a manuscript that will serve as the foundation for future studies not just on *uigwe* but also on many other topics in Korean art, history, and culture.

Many people participated in a variety of ways at different stages of this project. We are particularly indebted to three researchers who provided invaluable assistance. Sunkyung Sohn Kim (PhD, Duke University) and Kwi Jeong Lee (PhD, Princeton University) carefully reviewed the manuscript and provided insights into how to navigate the Revised Romanization rules for Korean. Gina J. Choi, PhD candidate at Princeton University, not only helped with romanization but also researched *uigwe* editions, obtained images, and photographed sites in Korea. John Blazejewski contributed beautiful copy-stand photographs, as he often does for Tang Center projects. We are also grateful to Mary Gladue, who edited the early rounds of the manuscript, and Vanessa Davies, who joined the editorial team to finalize the text. Christopher Moss was, as always, ready to provide editorial advice as well as edit and proofread the text with remarkable precision. Special thanks go to Rose E. Lee, who, during the final stages, copyedited and proofread the

entire text with laser-sharp focus and good cheer despite the compressed schedule. We also thank Hyunjee Nicole Kim for additional proofreading and Susan Stone for indexing the book.

For design and production, we owe a debt of gratitude to Joseph Cho and Stefanie Lew of Binocular Design. We have worked with them for over two decades, and they never fail to create an innovative book design that harmonizes with the theme of the volume. Their boundless energy and high standards are admirable, particularly for this publication, which required enormous attention to detail. We wish also to acknowledge Trifolio, an exceptional printing company that honors the artistry of ink, paper, and binding — a fitting resonance for this volume on the hand-written, painted, and printed *uigwe* books.

To our partners at Princeton University Press, especially Michelle Komie and Christie Henry, we express our thanks for their enthusiasm for our publications and for their continued support. Finally, we are always grateful to Oscar L. Tang and Constance Tang Fong for their generous support of the Tang Center and their belief in all our endeavors.

Andrew M. Watsky *Director*
Dora C. Y. Ching *Deputy Director*
Princeton, New Jersey
August 2023

Preface and Acknowledgments

My interest in the study of the *uigwe* royal documents of the Joseon dynasty goes back to the early 1990s, soon after I moved my teaching position from Deoksung Women's University to the Academy of Korean Studies in 1989. The responsibilities of the Academy professorship combined research with graduate teaching, perhaps with more emphasis on the former. This move also gave me privileged access to the vast amount of mostly handwritten and hand-illustrated *uigwe* material in the Jangseogak Library of the Academy at a time when this material could only be studied in person and personally photographed behind the library's heavy metal protective doors. *Uigwe* books recorded state rites that were held during the Joseon dynasty (1392–1910). Previously, only a few scholars had recognized the potential value of *uigwe* books for the study of the culture and history of Korea and had utilized them in their various fields of research. Ever since I joined this small band over a quarter of a century ago, I have been a devotee of *uigwe* studies. This devotion has been sustained by the belief that concerted *uigwe* research could contribute much to our knowledge of Joseon art history. This book is the fruit of intensive study of selected examples of these exceptional texts and images from an art-historical perspective.

When I was given the honor of serving as the 2014 lecturer for the Tang Center Lecture Series at Princeton University, my public lectures and seminar/workshops for graduate students naturally included themes culled from my past publications and continuing research on *uigwe*. The last lecture, "Symbolism and Functions of Palace Screens of the Joseon Dynasty," and the second graduate workshop, "The *Uigwe* Royal Documents of the Joseon Dynasty as Primary Sources for the Study of Korean Cultural History," both addressed subjects treated in more detail in this book. Jerome Silbergeld, then director of the Tang Center, kindly asked me if I might produce a monograph on Joseon dynasty *uigwe* based on my Tang Center presentations, and I was happy to accept the assignment as there was no such work available in English on this

almost unknown subject. This book includes discussions and analyses of many more categories of *uigwe* than I had time to present in my lecture and seminar. These categories are set out in the table of contents, and my reasons for choosing them and selecting certain specimens to represent them are explained in the introduction. I hope I have written a book that will serve as a substantial and accessible introduction to royal *uigwe* documents of the Joseon dynasty for English-speaking audiences around the world.

Needless to say, this book owes much to recent research by the younger generation of scholars in Seoul National University's Kyujanggak Institute for Korean Studies under the leadership of Dr. Han Young-woo, a long-time director of that prestigious institution and now professor emeritus of Korean history. He is the acknowledged pioneer in the field of *uigwe* research. The researchers in the Jangseogak Archives of the Academy of Korean Studies must be similarly recognized for their work in the same vein as that of their Kyujanggak colleagues. The contributions of all of these scholars to the study of royal *uigwe* documents are invaluable, as will be evident from the many citations of their works in my notes and bibliography.

I must also take this opportunity to thank several other individuals. Professor Park Jeong-hye of the Academy of Korean Studies, herself an expert on Joseon court documents and documentary paintings, gave much of her precious time to discuss the overall plan of this book with me and to read several long chapters. My long-time friend and colleague Marsha Haufler, professor emerita in the Department of Art History of the University of Kansas, kindly went over the glossary and also gave me valuable suggestions on the summary and conclusions section. Dr. Yi Su-mi, chief of the curatorial department of the National Museum of Korea, located and secured many of the illustrations for this book. Dr. Yun Jin-yeong of the Academy of Korean Studies worked hard to produce better images from *uigwe* and other documents in the Jangseogak Archives and National Central Library in Seoul. Professor Hwang Jeong-yeon, also of the Academy of Korean Studies, but formerly of the National Cultural Properties Administration, helped me secure images from that institution. Yi Yun-heui, my research associate and former student at the Academy of Korean Studies, helped in all stages of my research and manuscript preparation. Park Hye-young and Kim Du-eun are two other assistants in the past who helped me so efficiently with their excellent computer skills. At this point, I would like to acknowledge the anonymous reviewers' valuable suggestions, most of which I accepted in the revision.

At Princeton, Dr. Dora C. Y. Ching, deputy director of the Tang Center, made every possible effort to ensure the publication of this book the way that it has materialized. No words are adequate to express my gratitude for her devotion to this book. She also made my two weeks' residence in Princeton in May of 2014 comfortable and fruitful, including hosting a gracious dinner gathering at her home. Dora also kindly lined up two able copyeditors, Mary Gladue and Vanessa Davies, who patiently went through the whole manuscript of a very arcane subject matter and turned it into a text readable to English-speaking audiences. By happy coincidence, Dora also engaged my longtime friend and trusted editor, Rose E. Lee, who brought years of experience and expertise to review, copyedit, and proofread the manuscript during the final stages of production.

With deep appreciation, I wish to acknowledge my respected teachers, James F. Cahill (1926–2014) and Wen C. Fong (1930–2018), who launched me into a life of scholarly pursuits and inspired me throughout my career.

Finally, I express my heartfelt gratitude to my husband, Dr. Han Sung-joo, whose constant and caring support for my work has been so important to the realization of this book.

Yi Song-mi
Professor Emerita of Art History
The Academy of Korean Studies
Seongnam, Korea

Note to the Reader

Romanization

This book uses the Revised Romanization of Korean for transliteration, with the exceptions of familiar or conventional spellings common in English-language sources and personal names with a preferred alternate romanization. When permissible according to the Revised Romanization, the author's preferred pronunciation has been incorporated into the spelling. Older systems of romanization also appear in publication titles in the notes and bibliography. To conform to the publisher's house style, the author graciously switched from using a version of the McCune-Reischauer romanization to the Revised Romanization of Korean.

Names

Korean and Asian names are given in traditional order, surname first, with the exception of scholars who live or publish primarily in the West. Names are also romanized according to the personal preferences of the scholars, but the standard spelling according to the Revised Romanization of Korean is included in parentheses in the bibliography.

In accordance with Korean conventions, romanized names of buildings such as palaces or halls include the Korean suffixes that indicate the type of building, such as "gung" for "palace" or "jeon" for "hall." For the convenience of the reader, building names are followed by the English descriptor, as in "Gyeongungung palace," at the first occurrence. Well-known sites, however, may appear without the Korean suffix in English, as in "Changdeok Palace," which is more typically rendered as "Changdeokgung" or "Changdeokgung palace."

Uigwe and Archival Collections

Multiple copies of *uigwe*, the manuscripts and books that recorded state rites held during the Joseon dynasty, were produced and housed at various palaces and history archives in Korea. In this volume, collection numbers are given for those copies of *uigwe* being discussed. In figure

two facing pages of a bound *uigwe*

uigwe page 128b
banchado page 19

uigwe page 128a
banchado page 20

uigwe page 127b
banchado page 21

uigwe page 127a
banchado page 22

original sheets of paper prior to folding and binding

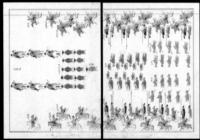

banchado pages 19, 20

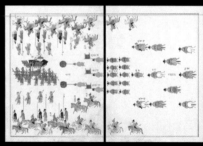

banchado pages 21, 22

illustrated scenes as cropped and presented in this publication

OPPOSITE Explanation of how *uigwe* pages appear in bound form in comparison to how they are presented in this publication. Illustrated pages from the *banchado* in the *Uigwe of the Wedding of King Yeongjo and Queen Jeongsun* (see fig. 45).

BELOW Diagram of the three ways *uigwe* pages are presented in this publication.

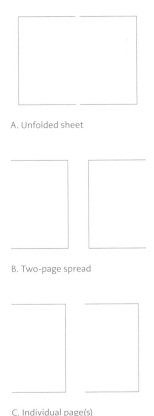

A. Unfolded sheet

B. Two-page spread

C. Individual page(s)

captions, the collection number of the *uigwe* corresponds to the copy reproduced. In Part 1 of the References, the collection number is given only for the primary *uigwe* cited.

Bookbinding in Korea

Many different types of traditional bookbinding existed in Korea, ranging from concertina or sutra binding to whirlwind, butterfly, wrapped-back, and side-stitched binding. By the Joseon period (1392–1910), side-stitched binding predominated. Such books consisted of sheets of paper that were either hand-painted or woodblock-printed on one side, then folded in half with the painted or printed side facing out to form a leaf, and finally stacked and stitched along the cut edge to form the spine, typically with five sewing holes.

Illustrations would typically be painted on the larger sheet prior to folding, and scenes are often defined within a rectangular frame. When viewing the bound form, the reader sees half of one scene on one page and half of another scene on the opposite page. For woodblock printed illustrations, each sheet would similarly have a fixed border framing the text or image. In addition, a column at the center of the sheet, known as the "heart," would have a pattern resembling a fishtail that served as a guide for folding, as well as information such as the name of the book, section, or title and page number. Once folded, this information would be located on the outer edge of the pages along the fold, and the printed border would wrap around from recto to verso pages.

Reproductions of Pages of *Uigwe*

As with all traditional East Asian books, *uigwe* volumes read *right to left*. While conventions vary, *uigwe* leaves can be numbered 1 a/b, 2 a/b, 3 a/b, and so forth, with "a" being a recto (the *left* page in right-to-left books) and "b" being a verso (the *right* page). Alternatively, *uigwe* pages can be numbered 1, 2, 3, and so on, with odd numbers representing the recto and even numbers representing the verso.

Sections containing the multi-page, illustrated processions (*banchado*) most often appear at the end of a *uigwe* volume. Unless noted otherwise, these processions are meant to be read from *left to right*, akin to Western books, and, as a general practice, painted processions begin on the last page at the end of a *uigwe* volume, reading *rightward* toward the front of the book. For the purposes of simplification in this publication, *banchado* pages are numbered 1, 2, 3, etc., to correspond to their sequence as they would be read (left to right), not according to their physical location within a *uigwe* volume. In this numbering system,

odd numbers therefore correspond to right-hand *banchado* pages, even numbers to left-hand pages.

In this publication, *uigwe* pages are presented in one of three ways:

A. Unfolded sheet *Uigwe* pages are most often presented as the "unfolded" sheet (see diagram on page 14). A reproduction of an entire sheet will consist of two photographs arranged to approximate the painted or printed sheet. A 1-mm gap between the two reproduced pages indicates the position of the fold. On these two leaves, border lines will appear on the top, bottom, and outer margins.

B. Two-page spread If an illustration in a *uigwe* was originally composed to be seen as a spread, the two pages are presented either as a single photograph of an open *uigwe* volume (see, for example, fig. 122) or as two photographs arranged side by side with a 1-mm gap (see, for example, fig. 128). On these two leaves, border lines will appear on the top, bottom, and inner margins.

C. Individual page(s) A recto page (the left page in a *uigwe*) will have border lines on the top, right, and bottom. A verso page (the right page in a *uigwe*) will have border lines on the top, left, and bottom. A larger, 5-mm gap between two *uigwe* pages indicates that they are not contiguous in their original binding or are from different volumes (see, for example, figs. 23, 24).

Scale and Cropping

A typical *uigwe* measures approximately 45–50 centimeters in height and 30–35 centimeters in width. For the purposes of focusing on the illustrated areas of the page, blank margins of the original *uigwe* page have been cropped out in this publication (see diagram on page 14).

Illustrations of *Uigwe* and Related Texts

Uigwe and related texts reproduced in this volume are listed here chronologically; figure numbers are given in gray.

Abbreviations:

BNF/NMK Bibliothèque nationale de France, on loan to the National Museum of Korea
Jangseogak Jangseogak Archives, The Academy of Korean Studies
Kyujanggak Kyujanggak Institute for Korean Studies, Seoul National University

1454 *Sejong sillok*
Veritable Records of King Sejong, vols. 128–35
Kyujanggak (Kyu 12722)
figs. 2–4

1474 *Gukjo oryeui*
Five Rites of State
Jangseogak (K2-4761)
fig. 1

1608 *Yeongjeop dogam sajecheong uigwe* (cited as *Sajecheong uigwe*)
Uigwe of the Office in Charge of the Envoys' Bestowal of the Imperial
Memorial Rite for King Seonjo
Kyujanggak (Kyu 14556)
figs. 54–61 (two different *banchado*)

1610 *Uiin wanghu jonho daebijeon sang jonho junggungjeon chaengnye*
wangseja chaengnye gwallyesi chaengnye dogam uigwe
Uigwe of the Investiture of the [Crown Princess Yu as] Queen
(see bibliography for full translated title)
Kyujanggak (Kyu 13196)
figs. 30, 31 (*banchado*)

1627 *[Sohyeon seja] garye dogam uigwe*
Uigwe of the Wedding of Crown Prince Sohyeon
Jangseogak (K2-2592)
figs. 37–40 (*banchado*)

Tables

Tables in this volume are listed here by chapter and table number; page numbers are given in gray.

Joseon Dynastic Lineage (1392–1910)

	MONARCH	REIGN DATES
太祖	Taejo	1392–1398
定宗	Jeongjong	1398–1400
太宗	Taejong	1400–1418
世宗	Sejong	1418–1450
文宗	Munjong	1450–1452
端宗	Danjong	1452–1455
世祖	Sejo	1455–1468
睿宗	Yejong	1468–1469
成宗	Seongjong	1469–1494
燕山君	Yeonsangun	1494–1506
中宗	Jungjong	1506–1544
仁宗	Injong	1544–1545
明宗	Myeongjong	1545–1567
宣祖	Seonjo	1567–1608
光海君	Gwanghaegun	1608–1623
仁祖	Injo	1623–1649
孝宗	Hyojong	1649–1659
顯宗	Hyeonjong	1659–1674
肅宗	Sukjong	1674–1720
景宗	Gyeongjong	1720–1724
英祖	Yeongjo	1724–1776
正祖	Jeongjo	1776–1800
純祖	Sunjo	1800–1834
憲宗	Heonjong	1834–1849
哲宗	Cheoljong	1849–1863
高宗	Gojong	1863–1907
純宗	Sunjong	1907–1910

Daehan Empire
大韓帝國
1897–1910

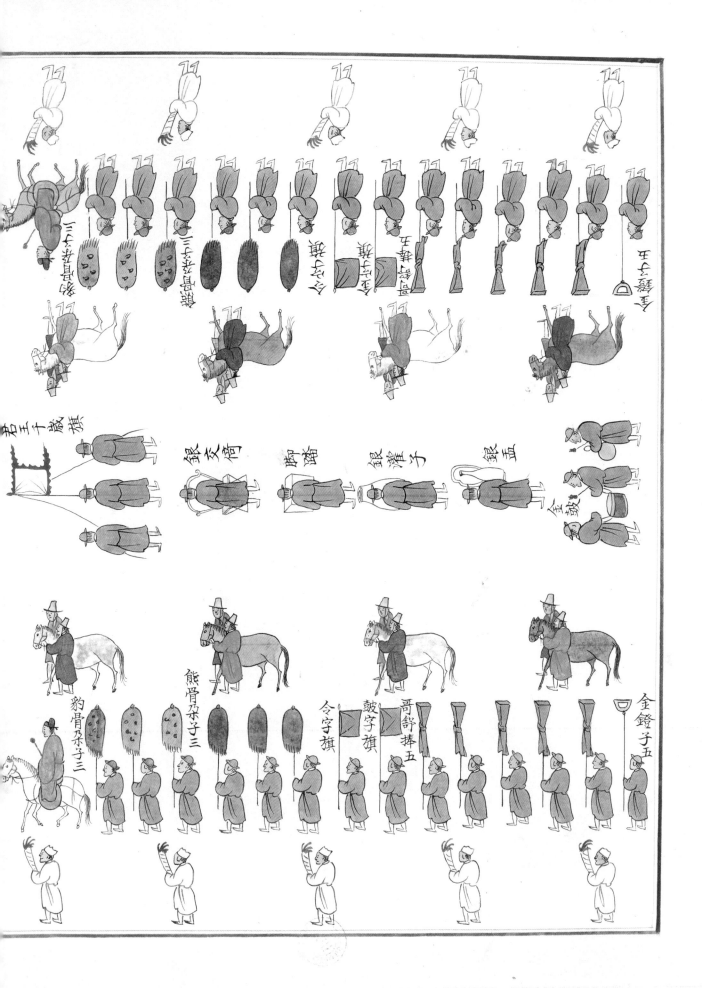

Introduction

The royal house of the Joseon dynasty (1392–1897) documented its conduct of important state rites in words and images in volumes known as *uigwe* 儀軌.[1] *Uigwe* were compiled both to document particular events and to serve as guides for subsequent similar ritual performances. In this book, *uigwe* are introduced with an emphasis on the court culture they document and the pictorial art they contain.

Currently, we find several different translations of the term *uigwe* in English publications. The first character, *ui* 儀, means "rites," and the second, *gwe* 軌, means "tracks to be followed" or "models to be emulated." Translations offered by English publications on *uigwe* are as follows: "book of court rites";[2] "manual of the state event" or "rubric for a state ceremony";[3] "ceremonial rules"; "manual for organizing a state event"; "a state ceremony record";[4] "book of state rites";[5] "ceremonial regulations"; and "records for royal ceremonies."[6] Two English catalogues published in the United States, *In Grand Styles* (2013) and *Treasures from Korea* (2014), both offer the translation "royal protocol."[7] However, this is only a partial reference to one section of *uigwe* documents, namely, the *uiju* section, in which are spelled out all the step-by-step protocols to be followed by the king and other participants of the particular rite.

Having noted the above presentations of various English translations and explanations of the term *uigwe*, throughout this book I will simply use the Korean term *uigwe* for both singular and plural forms.

The earliest record of *uigwe* appears in the *Veritable Records of King Taejong* (r. 1400–1418),[8] and more references are readily found in the *Veritable Records* of later kings.[9] Unfortunately, all of the *uigwe* created before the Japanese invasions of 1592–1598, along with many other invaluable parts of Korea's cultural heritage, were destroyed during the warfare. Consequently, the earliest *uigwe*, [*Jungjong daewang*] *Jeongneung gaejang uigwe*, which documents the rebuilding of the royal tomb of King Jungjong (r. 1506–1544), dates to 1562 and survived at least until 1601.[10] The latest *uigwe*, *Heungwang chaekbong uigwe*, records the investiture of the

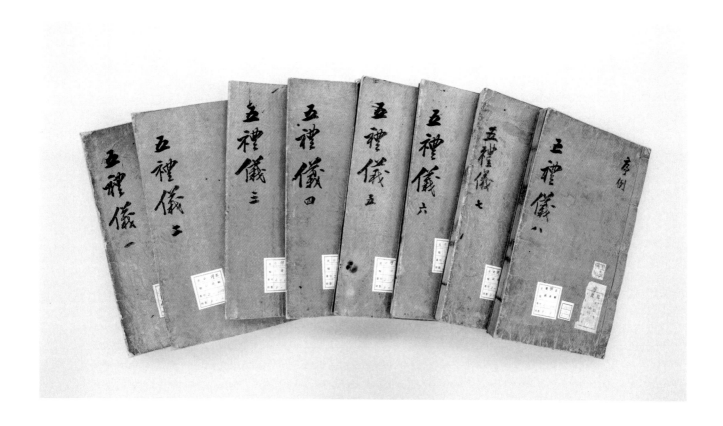

FIG. 1 Eight volumes
of the *Five Rites of State*
(*Gukjo oryeui*), 1474.
Book; ink on paper,
33.5 × 22 cm. Jangseogak
Archives, The Academy
of Korean Studies
(K2-4761).

eldest son of Regent Daewongun in 1910. During the Japanese occupation period (1910–1945), twenty-one more specimens of *uigwe* were compiled, including the *Uigwe of the Funeral of the Emperor [Gojong]* in 1919.[11]

In form and content, the Joseon *uigwe* are unique in East Asian history. About a quarter of the surviving examples are illustrated, and those illustrations have become famous for their depictions of court processions. However, the texts of the *uigwe* are even more important for the information they contain about the royal culture of the Joseon dynasty. When carefully examined, the texts and images yield detailed, multi-dimensional descriptions of Joseon court life from the seventeenth through the early twentieth century. Together with the *Veritable Records of the Joseon Dynasty* and the *Diaries of the Royal Secretariat*, *uigwe* are critical sources of information, offering insights into Joseon society, politics, and economics, as well as into court rituals, literature, art, entertainment, culinary history, and more. By meticulously recording court costumes, musical instruments, ceremonial utensils, and interior decoration (notably, screen paintings), *uigwe* provide unequalled access to the material culture of the Joseon court.

Historical Setting

The Joseon dynasty (1392–1910), founded by Yi Seong-gye (r. 1392–1398) — posthumously known as King Taejo — was the longest in Korean history. Its twenty-seven monarchs maintained rule by the Yi family of Jeonju, in North Jeolla province, for 518 years, through the founding of the Great Han Empire (*Daehan jeguk*) in 1897, until the nation was forcibly annexed by Japan in 1910. The dynasty took Neo-Confucian principles as its state creed, and its monarchs and officials upheld the Confucian tradition of "rule by rites" (*yechi*) as the cardinal doctrine for conducting state affairs and governing society.[12]

The roots of the Joseon Neo-Confucianism are to be found in the late Goryo dynasty, with scholars such as An Hyang (1243–1306), Jeong Mong-ju (1337–1392), Yi Saek (1328–1396), and others who followed Zhu Xi's (1130–1200) Neo-Confucianism (*Daoxue* or *Lixue*)[13] while criticizing the dominance of Buddhism at the late Goryeo court. Neo-Confucianism is a philosophy that explains the origin of man and the universe in metaphysical terms. Neo-Confucian scholars, among them Jeong Do-jeon (1342–1398), Gwon Geun (1352–1409), and Gil Jae (1353–1419), went on to serve at the court of Yi Seong-gye. The study of the Chinese Classics as codified by Zhu Xi[14] began during the late Goryo period and continued into early Joseon society.[15] Important tenets of Confucianism, that is, the five human relationships (*oryun*),[16] continued to be upheld. The early Joseon Neo-Confucianists laid particular emphasis on the three bonds (*samgang*), the first three of

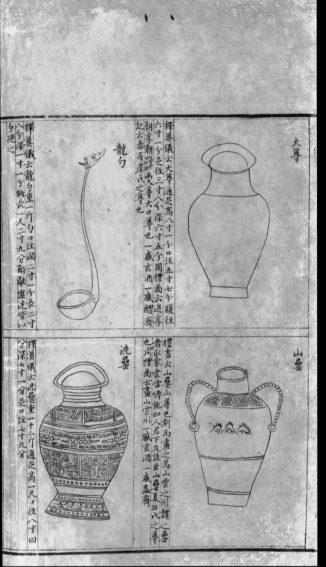

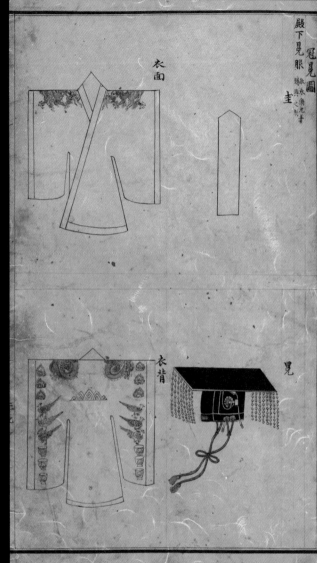

FIG. 2 Ritual vessels and utensils, from the "Five Rites" section of the *Veritable Records of King Sejong (Sejong sillok)*, vol. 128, 1454. Book; ink on paper, 55 × 30.2 cm. Kyujanggak Institute for Korean Studies, Seoul National University (Kyu 12722).

FIG. 3 The king's attire, from the "Five Rites" section of the *Veritable Records of King Sejong (Sejong sillok)*, vol. 128, 1454. Book; ink on paper, 55 × 30.2 cm. Kyujanggak Institute for Korean Studies, Seoul National University (Kyu 12722).

the five human relationships: loyalty to the monarch, filial piety to the father, and chastity to the husband. King Sejong the Great (r. 1418–1450) commissioned the *Illustrated Conduct of the Three Bonds* to educate people in the basic Confucian code of ethics.[17] Neo-Confucian officials also shunned Buddhist family funeral rituals and instead adopted the Neo-Confucian *Family Rites of Zhu Xi (Zhuzi jiali)*,[18] which encouraged the establishment of family shrines to house ancestral tablets and portraits.[19]

On the state level, all of the important state rites were to be conducted according to rituals prescribed by the *Five Rites of State (Gukjo oryeui)* compiled and published in 1474 (fig. 1). The term "five rites" refers to five categories of ritual performance: auspicious (*gillye*); celebratory (*garye*); the reception of foreign envoys (*billye*); military (*gullye*); and funereal (*hyungnye*). These rites were first set down with instructions on how they were to be conducted in the "Five Rites" section of the *Veritable Records of King Sejong (Sejong sillok)* (figs. 2–4).[20] In 1474, during the reign of King Seongjong (r. 1469–1494), a refined version appeared in the *Five Rites of State (Gukjo oryeui)* by Sin Suk-ju (1417–1475) and Jeong Cheok (1390–1475).[21] Ten years later, in 1484, the Joseon court finally published its *Gyeongguk daejeon*, or *Grand Law Code for Managing the Nation* (hereafter cited as *Joseon Law Code*), which was based largely on the *Joseon Law Code for Managing the Nation (Joseon gyeongguk jeon)* by Jeong Do-jeon.

With these publications, the Joseon court firmly established the rules and regulations for the management of state rites according to the Neo-Confucian principles of government, and from then on all state rites had to be performed as prescribed. However, in 1744, during the reign of King Yeongjo (r. 1724–1776), the Joseon court amended certain parts of the 1474 *Five Rites of State* to reflect and accommodate changes that had taken place in the intervening 270 years. King Yeongjo ordered Sin Man (1703–1765) to compile the *Sequel to the Five Rites of State (Gukjo sok oryeui)*, with a volume of illustrations (*seorye*), and the *Sequel to the Law Code (Sok daejeon)* published around the same time. In 1751 King Yeongjo further ordered Sin Man to add two short books to the *Sequel*, resulting in the *Addendum to the Sequel to the Five Rites of State (Gukjo sok oryeui bo)*. Finally, in 1758, King Yeongjo had Hong Gye-hui (1703–1771) and other scholar-officials compile a separate book on funeral rites, called *Addendum to the Funeral Rites of State (Gukjo sangnye bopyeon)*.[22] The dynasty abided by the books on the Five Rites of King Yeongjo's reign until the founding of the Great Han Empire in 1897. At that time, a new code called the *Code of the Daehan Imperial Rites (Daehan yejeon)* (fig. 5) was compiled to accord with the change in the nation's status from a vassal state of China to an ostensibly independent empire. Titles such as king and queen became emperor and

[1]

[2]
[3]
[4]

[5]

FIG. 4 Cover of the
*Veritable Records of King
Sejong (Sejong sillok)*,
1454. Book; ink on
paper, 55 × 30.2 cm.
Kyujanggak Institute for
Korean Studies, Seoul
National University
(Kyu 12722).

FIG. 5 Cover of the
*Code of the Daehan
Imperial Rites (Daehan
yejeon)*, 1898. Book; ink
on paper, 28.4 × 20 cm.
Jangseogak Archives,
The Academy of Korean
Studies (K2-2123).

empress, changes in official costume were spelled out, and the rites of the state were amended to reflect the new political situation.[23]

Uigwe: Content, Production, Use, and Transmission

When the court decided to hold an important event, such as a royal wedding or royal funeral, a temporary office called *dogam*, or superintendency, was set up to plan and carry out the entire event.[24] When it was over, the top-ranking officials of the superintendency oversaw the creation of *uigwe* based on the careful records kept during the ritual production process, called *deungnok*. The *uigwe* records were written in Chinese characters but often combined both literary Chinese and the unique Korean writing system called *idu*,[25] a writing system devised during the seventh century in which Chinese characters were borrowed to record the sound or meaning of Korean words. Occasionally, inscriptions in the phonetic system of Korean writing known as *hangeul* can be found in illustrations of court banquets because a majority of the banquets were held in honor of the dowager queens in the late Joseon period. As is well known, Joseon women, with a few exceptions, were taught to read and write *hangeul* script only.[26] The pictorial records included were *banchado*, pictures of processions in which the participants were organized by rank.

Ritual objects are carried by participants who are responsible for that particular part of the rite. The presence of women such as maids, wet-nurses, or professional wailers in *banchado* is a revelation, as Joseon women were normally not shown in public. The royals were never depicted, but their presence is suggested through their palanquins or empty thrones. In a sense, *banchado* can serve to reveal aspects of Joseon society. Made first in the form of a horizontal scroll for the king to review before the event, *banchado* were subsequently painted onto the pages of the *uigwe* itself, usually toward the end.[27]

It may be helpful to mention some characteristic aspects of *banchado* here. Those who look at the procession paintings may wonder why they show figures, horses, and palanquins from several different viewpoints within a single picture frame (see fig. 45 in chapter 2). For example, at the top of the page, soldiers are depicted standing upside down, whereas the figures on the bottom are standing right-side up; officials on horseback are shown proceeding toward the left, but we see only their back view and the rear end of the horses, placed sideways on the page. All the palanquins are shown from the same point of view as that of the viewers of the book, proceeding to the left. Other standing figures in the back view are shown sideways, as if lying on the ground. Employing multiple viewpoints can also be seen on Joseon-period maps, such as

[45]

the nineteenth-century *Suseon jeondo*, a woodblock map of Hanyang (present-day Seoul) in which mountains all point outward toward the four directions from the center of the city (see fig. 10 in chapter 1).

It seems that by standing the way they do, the soldiers and honor guards at the top and bottom of the pages are creating an enclosed space for the important persons or objects in the center, such as all the important palanquins and officials. Also, by utilizing multiple viewpoints rather than just one, all of the figures, horses, and objects can be seen in their most satisfactory aspects with the least amount of overlapping of one another. Presumably this was considered the best solution for a documentary painting in which all participants and objects were to be depicted.

All the *uigwe* made before 1797 were handwritten and hand-painted, with some use of woodblock stamping for outlines of figures that appear repeatedly in a procession. (The technical change from completely hand-painted to partially printed *uigwe* books is discussed in chapter 7.) However, King Jeongjo decided to print the text part of the *uigwe* of his trip to his father's tomb in 1795 using movable bronze type and illustrated with woodblock-printed images.[28] From this time on, a number of *uigwe* books were printed with movable metal type and woodblocks, although most continued to be handwritten and hand-painted. Since the technical change of *uigwe* production from handwritten to movable metal type took place with the *Jeongni uigwe*, discussed in chapter 7, a brief history of Korean movable metal type printing will be presented there.

Depending on the nature of the particular event, usually six or more copies of a *uigwe* were made: one for the royal viewing (fig. 6), one for the Ministry of Rites, one for the Court History Office (Chunchugwan), and one each for the four history archives (*sago*)[29] located in different places around the country (fig. 7).[30] The royal viewing copies are of the highest quality in both material used (paper, silk for the cover, and binding hardware) and workmanship (calligraphy, illustration, and woodblock printing).[31] In the late Joseon period, when an event was primarily for the crown prince, a copy was also made for the Office of Education of the Crown Prince (Seja sigangwon). In recent times, the *uigwe* books remaining in Korea have been kept primarily in the Kyujanggak Institute for Korean Studies of Seoul National University — which has the largest number of specimens and copies, some 2,700 volumes representing 540 specimens — and in the Jangseogak Archives of the Academy of Korean Studies, which has 356 volumes representing 293 specimens.

In 1866, at the time of the incident called Byeongin yangyo (the Western turmoil in the cyclical year *byeongin*), the invading French navy sacked Ganghwa Island, located off Korea's west coast at the mouth of the

[10]

[6]

[7]

FIG. 6 Cover and text page of the royal viewing copy of the *Uigwe of the Gyeongmo Palace* (*Gyeongmogung uigwe*), 1784. Book; ink on paper, 49 × 33 cm. Jangseogak Archives, The Academy of Korean Studies (K2-2410).

FIG. 7 Cover and text page of the history archive copy of the *Uigwe of the Gyeongmo Palace* (*Gyeongmogung uigwe*), 1784. Book; ink on paper, 46 × 31 cm. Jangseogak Archives, The Academy of Korean Studies (K2-2411).

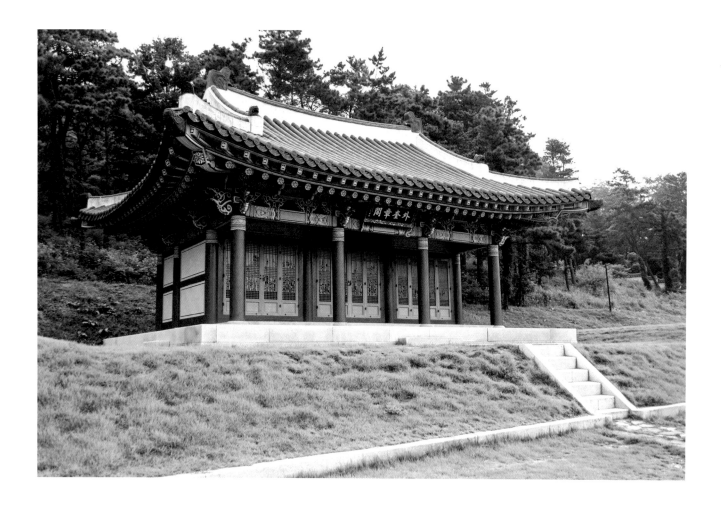

FIG. 8 Oegyujanggak
Library, 1782 (rebuilt
2003). Ganghwa Island,
Incheon. Photograph,
ca. 2005.

Han River, not far from Seoul. Situated on Ganghwa Island was Oegyu-
[8] janggak (the Outer Kyujanggak Library; fig. 8). Called Gangdo oegak, for
short, this annex had been built to accommodate the overflow of books
from the main Kyujanggak [royal] library in Changdeok Palace's Secret
Garden in Seoul, as seen in the eighteenth-century painting attributed
[9] to Kim Hong-do (fig. 9), and therefore contained most of the royal viewing
copies of the *uigwe*. The French navy confiscated *uigwe* books and other
valuable items from the Oegyujanggak, and deposited them with the
Bibliothèque nationale de France (BNF) in Paris.[32]

In 1977 Dr. Park Byeong-seon (1923–2011), a bibliographer and
Korean librarian at the BNF, called attention to the *uigwe* books, which
by that time had been in the BNF for more than a century. She subse-
quently published two important works to further call attention to the
importance of the BNF *uigwe*, first a comparative bibliographical study of
the *uigwe* in the BNF with those in Korea,[33] and later a French translation
of the table of contents of the 297 volumes of the BNF *uigwe*.[34] Prompted
by these works, Korean scholars began to conduct in-depth research on
the BNF's *uigwe* as well as called for their return to Korea.

Finally, as a result of negotiations between the Korean and French
governments that began in 1994, the 297 BNF *uigwe* volumes, mostly pre-
1866 books intended for royal viewing, were returned to Korea in May
2011 and are now housed at the National Museum of Korea in Seoul.[35] In
December 2011, the Japanese government also returned 167 volumes of
uigwe books, mostly works of the Daehan Empire period (1897–1910), that
were taken during the Japanese occupation period and kept in the Office
of the Imperial Household Affairs in Tokyo; those volumes, which repre-
sent 81 specimens of *uigwe*, are now also housed in the National Palace
Museum of Korea in Seoul.

With the return of *uigwe* from Paris and Tokyo, all but one of the
extant examples now reside in Korea. The exception is the well-illustrated
*Uigwe of the Presentation Ceremony and Banquet [for Hyegyeonggung Hongssi]
in the Gisa Year* ([Hyegyeonggung Hongssi] *gisa jinpyori jinchan uigwe*, 1809)
that celebrated the sixtieth anniversary of Lady Hyegyeong's (1735–1815)
coming-of-age ceremony (*gwallye*). She was the grandmother of King
Sunjo. Although this volume was among the *uigwe* books taken to France
in 1866, somehow it passed into private hands and was eventually sold to
the British Museum; it is now housed in the British Library.[36]

Overview of This Book

Part I of this book consists of five chapters, which examine outstanding
examples of *uigwe* of the Five Rites of State in their designated order.

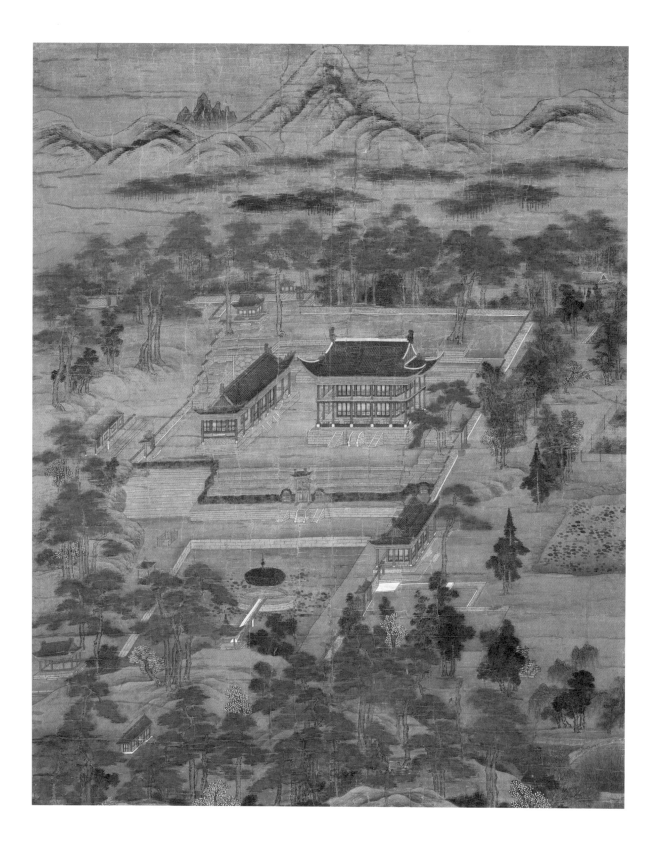

Chapter 1 examines *uigwe* created for auspicious rites, specifically those addressed to the spirits of earth and grain and to the gods of agriculture and sericulture at their respective altars, and to the royal ancestors at Jongmyo, the royal ancestral shrine. Given their centrality to the ritual culture of the court, the royal ancestral rites receive the lion's share of attention. Chapter 2 examines *uigwe* for two types of celebratory rites. In the *Five Rites*, this section begins with rites that have to do with paying respects to China,[37] but since they were not of equal importance in terms of Joseon state rites, no *uigwe* were made for them. The most important ones were those of the investiture rite of a crown prince (*wangseja chaek-bongui*) and of royal weddings, both labeled *garye*. Therefore, two of the investiture rites and two of the royal weddings — one of the crown prince, another of the king — that are representative of each of the categories are discussed in chapter 2.

In chapter 3, rites for receiving foreign envoys are discussed through two *uigwe* of 1609. It was not until the reign of Gwanghaegun (r. 1608–1623) that the Joseon court compiled its first *uigwe* of receiving envoys from China. I examine the earliest extant *billye uigwe* produced after the two visits of Chinese envoys in 1609. The first Ming envoys came in the fourth month to carry out a memorial rite for the late King Seonjo and to bestow on him a posthumous title. In the sixth month of the same year, another group of envoys came to approve the investiture of Gwanghaegun. These *uigwe* are considered valuable because of their early dates as well as their contents, which include *banchado*.

Chapter 4, military rites (*gullye*), presents the only *uigwe* of this category that comes under the title of *Daesarye uigwe* (*Uigwe of the Royal Archery Rites*). This *uigwe*, with a unique set of *banchado*, records the archery rites that King Yeongjo and his officials held in 1743 in the compound of the royal Seonggyungwan college in Hanyang. This represents King Yeongjo's desire to revive the ancient rites of royal archery in the hope of strengthening the country's military power through formal ritual. The state funeral rite, examined in chapter 5, is the most complicated one of the Five Rites. Table 5.1 shows a summary of the step-by-step procedure of the state funeral events as spelled out in the *hyungnye* section of the *Five Rites*. I will examine two funeral-related *uigwe*: the first is that of the royal funeral for King Injo (1649), and the second is that of the funeral for Crown Grandson Uiso (1752). Both include *banchado* illustrations.

Part II is devoted to *uigwe* books of important state events other than those belonging to the Five Rites. Chapter 6 deals with *uigwe* that concern the painting or copying of royal portraits. The entire process — from the selection of royal portrait painters to the final enshrinement

of the finished portraits in the proper royal portrait hall — was to be conducted with as much ritual formality and dignity as other state rites. The chapter also examines how the royal portrait painters are selected, what criteria are applied when selecting the best test copy, and why the Joseon court laid so much emphasis on King Taejo's portraits. Since the first appearance of *banchado* for transporting the king's portrait in 1748, all other *uigwe* of royal portraits included long and colorful *banchado* with the exception of the 1872 *uigwe*.

Chapters 7 and 8 focus on two printed *uigwe* from the reign of King Jeongjo (r. 1776–1800), the *Wonhaeng eulmyo jeongni uigwe*, or *Jeongni uigwe* for short, which records King Jeongjo's visit to his father's tomb with his mother in 1795, and the *Hwaseong seongyeok uigwe*, or *Hwaseong uigwe* for short, of 1801, which documents the construction of the Hwaseong fortress and the detached palace within it.[38] The former technically covers two categories of *uigwe*: royal outings (*haenghaeng*) and palace banquets (*jinchan*).[39] The latter belongs to the category called *yeonggeon*, referring to records of the construction and repair of palace buildings and the royal ancestral shrine. The *Jeongni uigwe* of 1797 is the first *uigwe* printed with the movable metal type called *jeongnija*, developed under the order of King Jeongjo, and illustrated with woodblock prints. Both *uigwe* had much to do with Jeongjo's display of filial piety toward his father, Crown Prince Sado, as well as his political and military ambition to strengthen royal power over the bureaucracy. Both *uigwe* also represent the interests of Jeongjo and the contemporary scholarship of the School of Northern Learning in the new science and technology emerging from Qing China, which were applied in the construction of the fortress.

In part III, *Uigwe* and Art History, I demonstrate how we can use the information handed down in *uigwe* to broaden our knowledge and understanding of Korean court art. Chapter 9 discusses *uigwe* records of polychrome screen paintings[40] that were produced and used in specific venues within the palace for specific rites. Depending on the theme of the screen paintings, they were designated to be used only for kings, queens, crown princesses, or royal brides-to-be. The most royal among all screens, the Five Peaks, was to be used only for the kings. The iconography of such screens is discussed in the context of Joseon culture. Chapter 10 uses information gathered from various categories of *uigwe* to examine the roles and social status of Joseon court painters, artisans, and other workers employed in state rites. This sheds light on the division of labor as well as cooperation among workers to produce elaborately made ritual items. Through the "Award Regulations" section of *uigwe*, the relative pay schedules among painters and artisans can be computed, including the

unusual raise of certain royal portrait painters' official rank. We can also glimpse the possibility for change in social status for some individuals, mostly those who served in royal banquets of the late Joseon period.

The Summary and Conclusions section of this book highlights and sums up the social, historical, art-historical, and cultural significance of Joseon royal *uigwe* documents. The unique form of the *uigwe* documents, which often combine texts and illustrations, provides not only factual written information, but also vivid pictorial descriptions. Without the findings gathered through these seemingly endless primary source materials, our understanding of Joseon dynasty history and culture would be incomplete. The Joseon monarchs from King Sejong, who laid the foundations of the Five Rites of State, to kings Seongjong, Gwanghaegun, Sukjong, Yeongjo, and Jeongjo, all made contributions to the refinement of the forms and contents of *uigwe*. Their contributions have been highlighted in this book. It is my hope that this book will increase the understanding and appreciation of what *uigwe* documents can offer to our study of the history and culture of the Joseon dynasty. ◆

Uigwe
of the
Five Rites
of State

—

PART ONE

Uigwe of Auspicious Rites, *Gillye*

The auspicious rites (*gillye*), which make up the first category of the Five Rites of State, were arguably the most important of all the rites conducted by Joseon kings. Members of the royal family performed them for the benefit of the state and the people. This chapter examines *uigwe* for auspicious rites of the three categories dedicated to (1) the spirits of earth and grain, (2) royal ancestors, and (3) the gods of agriculture and sericulture. Their order corresponds to that in the *Five Rites of State*. As shown in TABLE 1.1 table 1.1, each of the three categories, through its primary, secondary, and miscellaneous sacrifices, encompasses a great variety of spirits found in nature, in the universe, and in history.

In this chapter, I briefly discuss the sacrifices to the spirit of heaven (*cheonsin*) for which there is no *uigwe*. I then move on to the *uigwe* of the sacrificial rites to the spirits of earth and grain (*sajik*), followed by the most important *uigwe* of the royal ancestral shrine (Jongmyo), and, finally, the *uigwe* of royal agriculture and sericulture. The contents of specific *uigwe* are described and placed within their ritual and historical contexts, with attention paid to the light they shed on various aspects of court life, from court painting to the ceremonial roles of court women.

Sacrifices to the Spirit of Heaven

In order to continue the tradition of sacrificing to heaven (*cheonje*) from the preceding Goryeo dynasty (918–1392), King Taejo had the Hwangudan, or "circular mound altar," built at the southern edge of his recently founded Joseon capital of Hanyang (present-day Seoul).[1] However, his officials pointed out that it would be inappropriate for Joseon, as a vassal state of Ming China, to conduct this ritual because it was solely the prerogative of the emperor of China, the Son of Heaven (*cheonja*, Ch. *Tianzi*). Their opinion prevailed, and Joseon kings ceased performing the sacrifice to heaven. (The practice was revived only after King Gojong, in 1897, proclaimed himself the first emperor of the Great Han Empire, and had a new Hwangudan built slightly north of the Sungnyemun, popularly

TABLE 1.1 Categories of Auspicious Rites, from the *Five Rites of State*

	SPIRIT OF HEAVEN (*CHEONSIN*)	SPIRIT OF EARTH (*JIGI*)	ANCESTRAL SPIRITS (*INGWI*)
Primary sacrifices (*Daesa*)	Performed at Hwangudan altar	To the spirits of earth (*sa*) and grain (*jik*) performed at the Sajikdan altar	To the royal ancestors, performed at the royal ancestral shrine (Jongmyo) and the Hall of Eternal Peace (Yeongnyeongjeon)
Secondary sacrifices (*Jungsa*)	To the spirits of wind (*pung*), clouds (*un*), thunder (*roe*), rain (*u*), and snowstorms (*bangsa*)	To the spirits of hell (*ok*), the sea (*hae*), and streams (*dok*)	To the spirits governing agriculture (*seonnong*) and sericulture (*seonjam*), to Confucius (Munseonwang), and to the founders of the dynasties prior to the Joseon
Miscellaneous sacrifices (*Sosa*)	To the spirits governing farming (*yeongseong*), longevity (*noinseong*), of horses (*majo*), and of ice (*sahan*); to the spirits of the first horse rider (*masa*) and the horse harmer (*mabo*)	To the spirits governing mountains and rivers (*myeongsan daecheon*) and the clearing of rain (*yeongje*); to the seven minor spirits (*chilsa*)[1]	To the spirits governing horse domestication (*seonmok*), the military (*maje*), the protection of crops and fields from insects (*poje*), the royal commander's flag (*dukje*), and protecting the country from epidemics (*yeoje*)

1 The seven minor spirits are those that govern human destiny (*samyeong*), interiors (*jungnyu*), households (*ho*), kitchen and hearth (*jo*), gates of the capital's inner walls (*gungmun*), awards and punishments (*taeryeo*), and travel and roads (*gukhaeng*). They are collectively known as the "Seven Deities" because some have been anthropomorphized into popular gods.

called Namdaemun or South Gate.)[2] Thus, starting from the reign of King Taejo, Joseon kings performed only the sacrifices to the spirits of earth and grain at the Sajikdan (Sajik Altar) and the royal ancestral rites at Jongmyo (*Jongmyo jerye*). The secondary and miscellaneous sacrifices were taken care of by local officials, with the exception of those to the first progenitor teachers of agriculture and sericulture, which were occasionally performed by kings and female members of the royal family.

Rites at the Sajikdan

Following ancient Chinese practice, the Sajikdan was built on the right side of the Gyeongbok Palace (Gyeongbokgung, the main royal palace in Hanyang), and the royal ancestral shrine (Jongmyo) was built on the left side.[3] This arrangement can be seen on an early nineteenth-century woodblock-printed map of Hanyang called *Complete View of the Beautiful*
[10] *Capital (Suseon jeondo)* (fig. 10).[4] The individual Sajik altars, one for the spirit of earth and one for the spirit of grain, were built in 1395. They were destroyed by fire during the Japanese invasion of 1592 but rebuilt in the seventeenth century. The main gate was rebuilt again in 1720, after it was destroyed by a windstorm. The sacrifices at the Sajikdan were abolished during the Japanese occupation, and the entire precinct was made into
[11] a park called Sajik Park.[5] Figure 11 shows the plan of the Sajikdan as illus-
[12] trated in the *Sajikseo uigwe* of 1783, and figure 12 shows the overall view of the Sajikdan today.

Despite the importance of the sacrificial rites to the spirits of earth and grain, Joseon kings did not perform this rite in person every year. From the opening century of the dynasty through the reign of King Seongjong (r. 1469–1494), the kings performed only three *sajik* sacrifices, whereas in that same period the rites at Jongmyo, the royal ancestral shrine, were performed at least forty-one times.[6]

Sajikseo Uigwe

The earliest extant *Sajikseo uigwe* was compiled in three volumes by the office in charge of the *sajik* sacrifices at the behest of King Jeongjo in 1783.[7] The next *Sajikseo uigwe*, a five-volume set, was compiled in 1842, during the reign of King Heonjong.[8] The last, a one-volume *uigwe*, was compiled during the Great Han Empire period to reflect the change of rites from those of a kingdom to those of an empire.[9] The Jeongjo-period *Sajikseo uigwe* begins with a series of illustrations showing the overall view of the Sajikdan with its surrounding walls, spirit tablets (*sinju*; see
[11] fig. 11), sacrificial dishes arranged according to the rites to be performed, sacrificial utensils, musical instruments in front of the platforms, rows

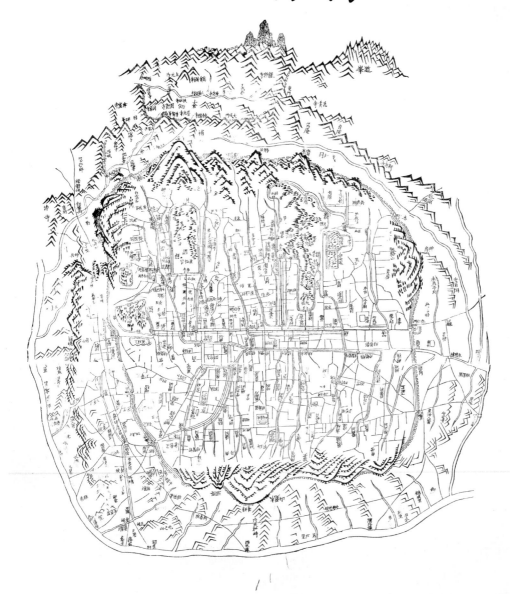

of line dancers (*ilmu*) in performance and their accoutrements, and the ritual costumes of the king and the crown prince.[10]

The Rites at Jongmyo

Of the Joseon dynasty's Five Rites of State, only the royal ancestral rites at Jongmyo, the royal ancestral shrine, were regularly performed. Today it is held once a year on the first Sunday of May. Even after the Japanese annexation of Korea in 1910, the sacrifices at Jongmyo continued, although on a reduced scale. They were suspended between 1945 and 1969 due to the greatly damaged condition of the shrine buildings and compound. The rites were resumed after the buildings were repaired and the compound refurbished. In 1971, representatives of the royal Yi clan of Joseon began performing sacrificial rites at the royal ancestral shrine, as prescribed by the *Jongmyo uigwe*.[11]

To understand the *Jongmyo uigwe*, it is helpful to know something of the physical character of the ritual site.[12] The plan of the compound, including all of the buildings, is illustrated in the *Jongmyo uigwe* (fig. 13). [13] Jongmyo occupies approximately 190,000 square meters of ground divided into two unequal sections: a larger area to the east occupied by the Main Shrine (fig. 16), and a smaller area to the northwest for the Hall of Eternal Peace (fig. 15). The Main Shrine, which is 101 meters long, is the largest single wooden structure in the world.[13] It contains nineteen spirit tablet chambers of equal size in one row, and three on each of the side wings. These chambers hold the spirit tablets of nineteen kings and thirty of their spouses. Under the front portico (fig. 17) are twenty round columns with a slight entasis, behind which the doors of the spirit tablet chambers are visible. The space between the columns and the chambers is used to offer sacrifices to the royal ancestors enshrined in the chambers. Jongmyo was placed on the UNESCO World Heritage List in 1997 for its age, its authenticity as a Confucian royal ancestral shrine, and its unique and well-preserved spatial layout.

The Main Shrine (see fig. 16) stands on a two-tier stone platform called a "moon terrace" and is approached from the Spirit Gate (fig. 14). Gates on the east and west are for the use of the service staff. The large, flat, stone walkway from the Spirit Gate to the Main Shrine has three paths: the center path, reserved for the spirits and the carrying of sacrificial paraphernalia such as incense and gifts of white silk cloth; the right path, reserved for the king; and the left path, reserved for the crown prince. The Spirit Gate and the Main Shrine mark the southern and northern limits of the courtyard (which is otherwise enclosed by stone walls covered with gray clay tiles). Other buildings within this

[13]

[16]

[15]

[17]

[16]

[14]

FIG. 10 *Complete View of the Beautiful Capital* (*Suseon jeondo*), 1840s. Woodblock print; 106.4 × 72.4 cm. Korea University Museum.

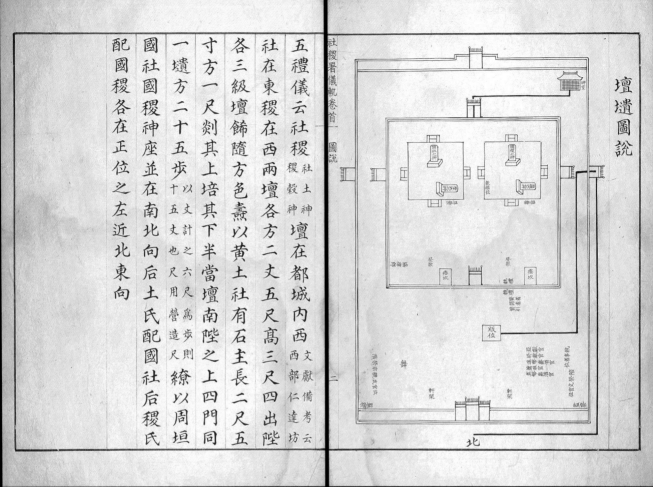

壇壝圖說

北

五禮儀云社稷 社土神

稷穀神 壇在都城內西 西部仁達坊 文獻備考云

社在東稷在西兩壇各方二丈五尺高三尺四出陛

各三級壇飾隨方色燾以黄土社有石主長二尺五

寸方一尺剡其上培其下半當壇南陛之上四門同

一壇方二十五步 以文計之六尺爲步則十五丈也尺用營造尺 繚以周垣

國社國稷神座並在南北向后土氏配國社后稷氏

配國稷各在正位之左近北東向

二

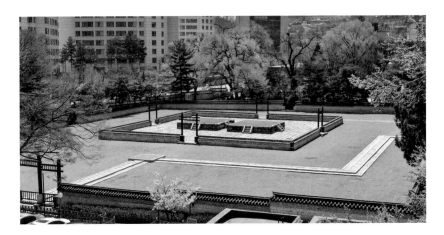

FIG. 12 Two views of
Sajikdan (platforms or
altars for the spirits of
earth and grain), 1395
(most recent restoration
began in 2015; projected
completion in 2027).
Seoul. Photographs,
ca. 2013–2014.

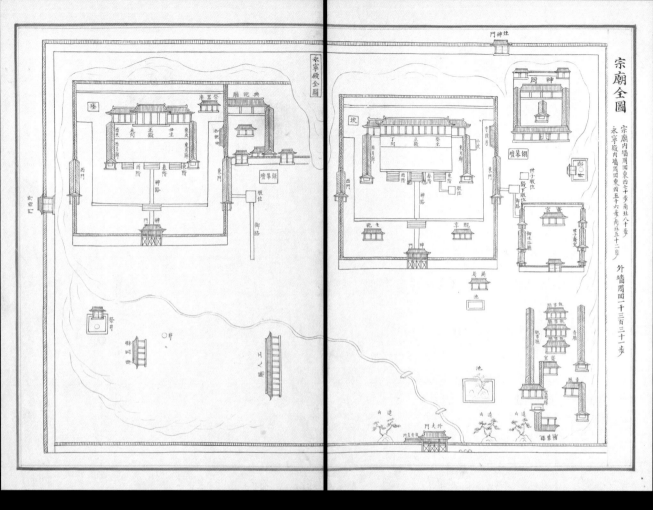

宗廟全圖

宗廟內墻周回東西七十步南北八十步
永寧殿內墻周回東西五十六步南北五十二步

外墻周回二千三百三十一步

FIG. 13 Plan of the Main
Shrine (right) and the
Hall of Eternal Peace
(left) of the Jongmyo
royal ancestral shrine,
from the *Jongmyo uigwe*,
1706. Book; ink on paper,
49 × 36 cm. Kyujanggak

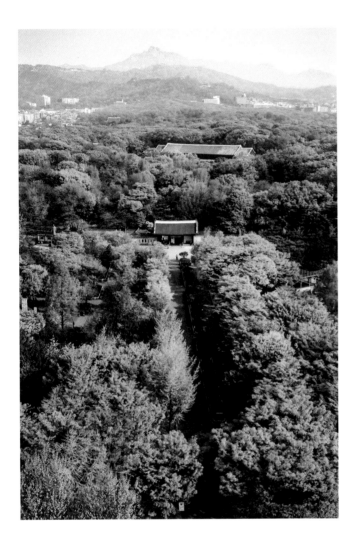
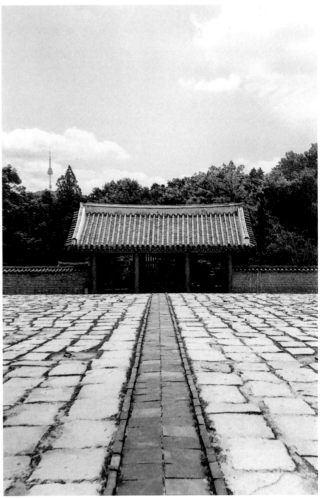

FIG. 14 The Spirit Gate
to the Main Shrine
of the Jongmyo Royal
Ancestral Shrine, 1394
(rebuilt 1608). Seoul.
View of the complex
from above (left) and
of the gate from within
(right). Photographs: left,
2008; right, ca. 2010s.

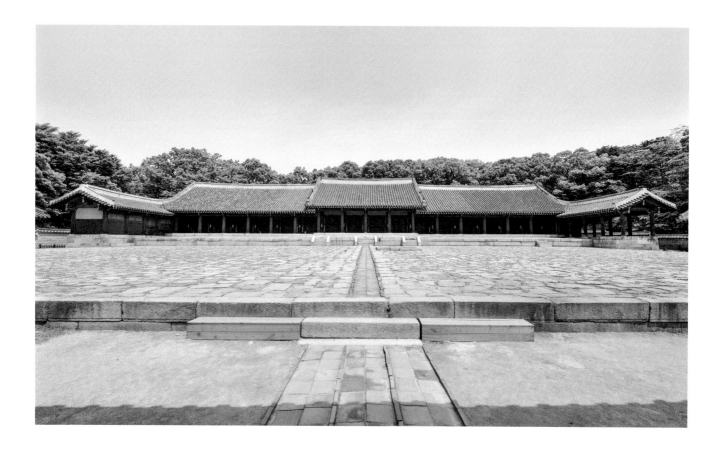

FIG. 15 Hall of Eternal
Peace (Yeongnyeong-
jeon) at the Jongmyo
Royal Ancestral Shrine,
1421 (rebuilt 1608).
Seoul. Photograph,
ca. 2010s.

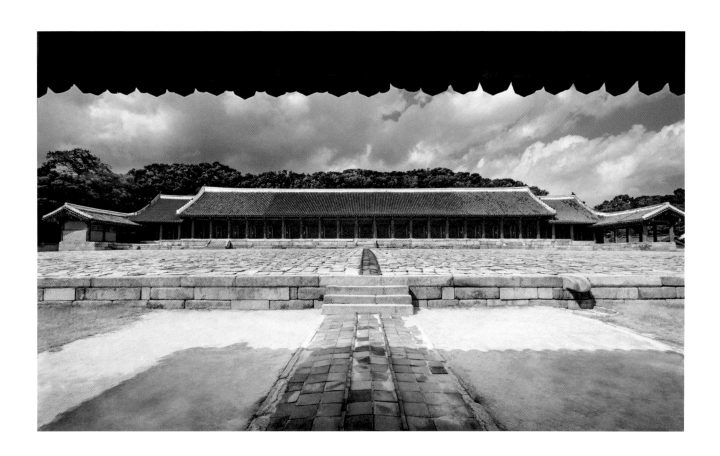

FIG. 16 Main Shrine
(Jeongjeon) at the
Jongmyo Royal
Ancestral Shrine, 1394
(rebuilt 1608). Seoul.
Photograph, 2013.

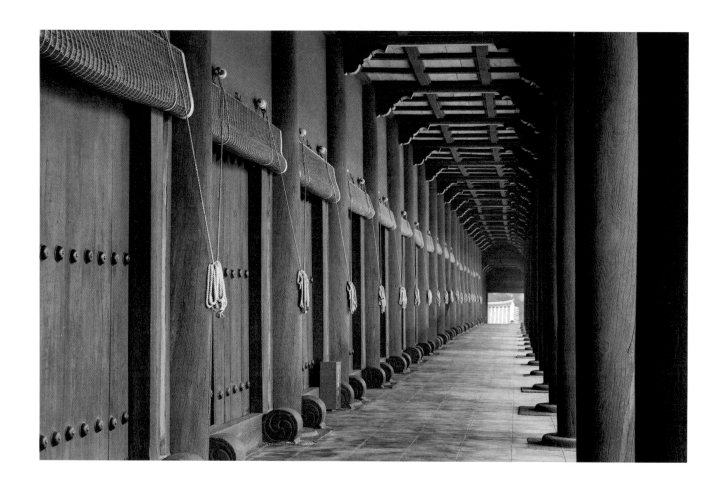

FIG. 17 Portico of the
Main Shrine, Jongmyo
Royal Ancestral Shrine,
1394 (rebuilt 1608). Seoul.
Photograph, 2013.

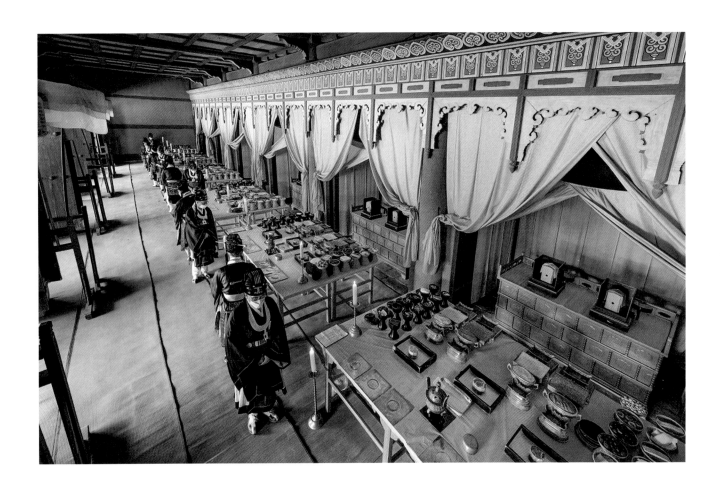

FIG. 18 Spirit tablets
of Joseon kings and
queens in the spirit
chamber of the Main
Shrine, Jongmyo Royal
Ancestral Shrine, 1394
(rebuilt 1608). Seoul.
Photograph, ca. 2020.

第三
世宗室

英文睿武仁聖明孝大王上諡玉冊一部
函裹粉紅綃單袱一 紫紬單袱一
景泰元年 文宗朝庚午五月 日 上 ○今無
英文睿武仁聖明孝大王之寶一 實裹東紅段子袱一 鍍金黃銅寶筒一
袱一 紫泰皮裹實筒一 鍍金朱筒裹東紅段子褓袱一
朱筒盞一 實畫朱筒盞覆匣全 紫泰皮裹多紅
盞護匣全 ○乙酉 肅宗三十一年六月十七日 新備奉 安

永樂二十二年 世宗朝甲辰七月 日 ○加上諡 ○諸具無
印綬多紅紬 印綬多紅紬 ○印筒裹多紅潞州紬褓袱一
外裹紅紬單袱一 鍍金印筒一盞具
紅漆泰皮裹印盞一 外裹紅紬單袱一 鍍金朱筒一盞具
潞州紬褓袱一 紅漆泰皮裹朱盞一 朱筒裹多紅
○乙酉 肅宗三十一年六月十七日 新備奉 安
外裹紅紬單袱一

永樂十八年 世宗朝庚子九月 日 上 ○今無
彰德昭烈元敬王太后加上諡玉冊一部
袱一 朱漆抹金函一
永樂二十二年 世宗朝甲辰七月 日 上 冊裹粉紅綃鎖金袱一 紫紬單袱一
元敬王后之印一 印裹紅段子袱一 鍍金印筒一盞具 西裹粉紅綃
鍍金朱筒一盞具 朱筒裹紅段子袱一 紫泰皮裹朱筒盞一
紫泰皮裹印
印盞朱筒

宗廟謄錄序

FIG. 19 Cover and
two facing pages
of the *Records of the
Jongmyo Shrine* (*Jongmyo
deungnok*), 1789. Book;
ink on paper, 85.8 ×
41.8 cm. Jangseogak
Archives, The Academy
of Korean Studies
(K2-2174).

courtyard are the Hall of Meritorious Officials (located across from the Main Shrine to the southeast), which houses eighty-nine tablets of Joseon-dynasty officials recognized for their loyal and distinguished service to the nation; and the Hall of Seven Rites (to the left of the Spirit Gate), for the seven minor deities.[14] Scattered around outside the Main Shrine are smaller service buildings, including the Hall of Ritual Cleansing (Jaesil) for the king and crown prince, the Hall for the Preparation of Incense (Hyangdaecheong), residential quarters (*jeonsacheong*) of the shrine keepers and ritual attendants, and the musicians' building (*akgongcheong*).[15]

[15] The Hall of Eternal Peace was first built in 1421 (see fig. 15).[16] It now enshrines thirty-four spirit tablets representing four generations of King Taejo's ancestors and their queens as well as twelve other kings and their queens.[17]

In addition to spirit tablets, the spirit chambers in both the Main Shrine and the Hall of Eternal Peace contain gold, silver, or jade seals

[18] and gold, jade, or bamboo books (fig. 18). Each spirit chamber for a king contains a book called *Gukjo bogam* (*Precious Mirror of the Nation*), which lists his illustrious achievements. Included for each queen is an order of royal appointment (*gyomyeong*) written on five-colored silk. These treasured items are kept in cabinets built against the back walls of the chambers. A record of all of the treasured items contained in each hall of the Jongmyo shrine is found in four handwritten volumes called

[19] *Jongmyo deungnok* (*Records of the Jongmyo Shrine*; fig. 19). They were edited during five hundred years of the dynasty, including the period of the Daehan Empire (1897–1910). Now in the Jangseogak Archives of the Academy of Korean Studies, they are the largest of all Joseon dynasty books, measuring 83.6–85.8 × 39.6–41.8 centimeters.[18]

Jongmyo Uigwe

The handwritten and hand-illustrated *Jongmyo uigwe* is composed of nine volumes: the first four, called the *wonjip* (original compilation), were compiled in 1706 during the reign of King Sukjong (r. 1674–1720); five more, the *songnok* (continued record), were added between 1741 and 1842. Two of the original five copies survive, one in the Kyujanggak Institute for Korean Studies and one in the Jangseogak Archives.[19]

The historical backdrop of King Sukjong's decision to have the *Jongmyo uigwe* compiled traces back to the mid-seventeenth century. After the Manchu invasions of 1627 and 1636, the Joseon court in 1637 had its Jongmyo shrine repaired and compiled the *Uigwe of the Repair of the Jongmyo Shrine*. In 1667, the court also had the second building in

TABLE 1.2 Summary of the Contents of Volume 1 of the *Jongmyo Uigwe*

Sec. 1	Plans of Jongmyo and Yeongnyeongjeon	Site plan showing a complete view of Jongmyo shrine and the Hall of Eternal Peace on the right and left side, respectively, of two facing pages (see fig. 13)
Sec. 2	Interior of the spirit tablet chamber	Interior of the spirit tablet chamber, complete with furniture, and a list of the official positions of all the participants in the rites lined up in the portico space in front of the room (see fig. 18 for present-day photograph of interior)
Sec. 3–5	Arrangement of food and wine for the Five Annual Sacrifices, twice-a-month sacrifices, and for the Seven Deities	Diagrams of the arrangement of elaborate food and wine sacrifices for three different rites: (1) the Five Annual Sacrifices and other designated large sacrifices, which were performed at the beginning of each season and on the eve of the Lunar New Year (fig. 21)[1]; (2) the sacrificial ritual performed on the first and fifteenth days of each month; and (3) the sacrifices to the Seven [minor] Deities (*chilsa*)
Sec. 6	*Siyong*[2] positions of musical instruments (*deungga* and *heonga*)	Ritual arrangement of the musical instruments on the higher stone platform for *deungga* and the lower platform for *heonga* performances in front of the Main Shrine and the Hall of Eternal Peace at the court of King Seongjong (r. 1469–1494) (fig. 22)
Sec. 7	*Siyong* positions of *botaepyeong* and *jeongdaeeop* dancers	Ritual positions of *botaepyeong* (preserving the peace) dancers and *jeongdaeeop* (establishing the great task, i.e., the founding and strengthening of the kingdom by early Joseon kings and their subjects) dancers at the court of King Seongjong (r. 1469–1494)
Sec. 8	Arrangement of instruments used for *deungga* and *heonga* at the Main Shrine and the Hall of Eternal Peace	Ritual arrangement of contemporaneous musical instruments on the higher stone platform and on the lower platform in front of the Main Shrine and the Hall of Eternal Peace
Sec. 9	Placement of dancers	Ritual positions of military and civilian line dancers with their accoutrements with textual descriptions
Sec. 10	Ritual vessels and utensils of Jongmyo	Forty-eight ritual vessels and multiple utensils are illustrated and described by medium and dimensions.[3] Many of these can be matched with those currently used for rites and sacrifices at Jongmyo.[4] A page showing a jar called *sannoe* (fig. 23) is an almost exact version of the blue-and-white jar in the Leeum collection (see fig. 25).
Sec. 11–12	Arrangement of musical instruments for *deungga* and *heonga*	Thirty-seven musical instruments arranged on the two levels illustrated, along with seventeen pieces of paraphernalia used in the *jeongdaeeop* dance.[5] See sec. 7 above.
Sec. 13–15	Ritual costumes of kings, crown princes, and participating officials, along with those of the musicians and dancers	Ritual costumes of the participants shown, notably the highly formal ensemble of the king.[6] We see the blue jade tablet he held, his headgear with nine strands of beads hanging from the front and back, and his robe and his skirt embroidered with the Nine Emblems (fig. 24).[7] Even small items, such as socks, are specified. The costume of the crown prince differs from that of the king only in details, notably lacking dragons on the shoulders and the mountains on the back.

1 Five Annual Sacrifices: *Ohyangje*; large sacrifices: *daeje* or *daesa*.
2 The term *siyong* ("used at certain times") refers to rites and ritual utensils used during the time of King Seongjong (r. 1469–1494) when the *Five Rites of State* was first published (1474).
3 Following *Seokjonui* (Ch. *Shizunyi*) and *Zhouli* (*Rites of Zhou*).

4 The ritual vessel *bogaegu* has exactly the same shape as the one in use at Jongmyo today.
5 In this section, several new books have been quoted: *Munheon tonggo* (Ch. *Wenxian tongkao*), *Jinssi akseo* (Ch. *Chenshi yueshu*), and *Samguksa*. The full title of the latter is *Samguk sagi*, and it was compiled in 1145 by Kim Bu-sik under the order

of King Myeongjong (r. 1170–1197) of the Goryeo dynasty.
6 These include the most formal costume called *gujang myeonbok* designated as the most formal attire to be worn by the Joseon ruler during the reign of Yongle (r. 1402–1424), third emperor of Ming China.
7 The term *gujang*, or Nine Emblems, refers to the five symbols embroidered on the king's outer robe — dragon on

the shoulders, mountains on the back, and fire, pheasant (*hwachung*), and *jongi* (two vessels) along the end of the sleeves — plus the four symbols embroidered on the front of the skirt: seaweed (*jo*), grains (*bunmi*), axe (*bo*), and the *bul* motif created by placing two characters for bow (*gung*) back-to-back. The imperial attire worn by Ming emperors on the most formal

of occasions was similar, but would have had three additional symbols — the sun, the moon, and stars — to make it the twelve-emblem robe, or *sibijangbok* in Korean.

the Jongmyo compound, the Hall of Eternal Peace, repaired and had the *Uigwe of the Repair of the Yeongnyeongjeon* compiled. In 1694, as a result of the political victory of the Western Faction (Seoin) through the "Reversal of the Political Situation in the Cyclical Year *gapsul*" (*Gapsul hwanguk*), high officials such as Nam Gu-man (1629–1711) and Bak Se-chae (1631–1695) were given more power by King Sukjong, thereby promoting the Neo-Confucian principle of *yechi* (rule by rite) more than ever before. By doing so, the officials of the Western Faction hoped to reestablish the legitimacy of the Joseon royal lineage after the Manchu invasions. In 1705, while having the royal books and seals that had been kept in the spirit tablet halls of Jongmyo surveyed, King Sukjong realized that the *Yejo deungnok* (*Documents of the Ministry of Rites*) and the *Jongmyo daedeungnok* (*Great Records of the Jongmyo Shrine*) were quite incomplete. Therefore, he had a new *Jongmyo daedeungnok* compiled, complete with up-to-date information on Jongmyo's royal books and seals. However, he believed that compiling the *Jongmyo uigwe* would be a more permanent solution to this situation. It is with this historical and ideological background that, in 1706, the first four volumes of *Jongmyo uigwe* were compiled.[20]

The *Jongmyo uigwe* stands apart from other *uigwe* in that it is not a record of one particular event, but rather a compilation of the institutional rules and regulations pertaining to the Jongmyo shrine, the procedures of the rites being performed regularly, and the records of sacrificial rites performed in the past. First compiled under the order of King Sukjong, the work was carried out by high officials of the Jongmyo Office (Jongmyoseo).[21] In compiling the original four volumes, they consulted the *Five Rites of State*, the *Veritable Records of the Joseon Dynasty*, the *Diaries of the Royal Secretariat*, and other records of relevant government offices; they also drew on the collected writings (*munjip*) of illustrious individuals.

The original four volumes of *Jongmyo uigwe* provide a complete history of the Jongmyo and the Hall of Eternal Peace with detailed descriptions of the sacrifices conducted at both shrines. The illustrations show how the architectural structures changed between the founding of the Jongmyo in 1394 and the time of the completion of its *uigwe* in 1706 to accommodate the ever-increasing number of spirit tablets, and how the "rules" for enshrining spirit tablets in the Main Shrine changed. The protocols for all the sacrificial rites are set out in detail, complete with specifications for costumes and other paraphernalia. Food and libation offerings are enumerated, and their order of offering is spelled out. *Illustrations of Ritual Procedures at the Royal Ancestral Shrine* (*Jongmyo chinje gyuje doseol byeongpung*) shows important rites and ritual utensils with textual explanations (fig. 20). This eight-panel folding screen, painted after 1866,

[20]

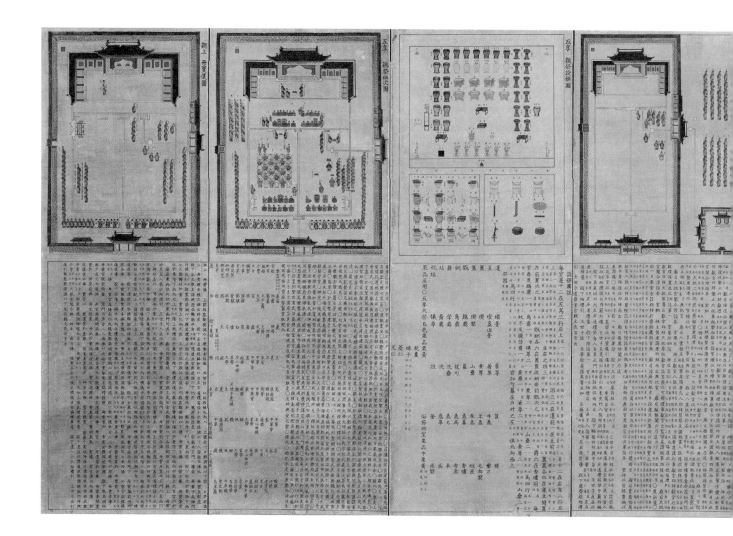

FIG. 20 *Illustrations of Ritual Procedures at the Royal Ancestral Shrine* (*Jongmyo chinje gyuje doseol byeongpung*), after 1866. Eight-panel folding screen; ink and color on silk, each panel 180.8 × 54.3 cm. National Palace Museum of Korea (Jongmyo 6414).

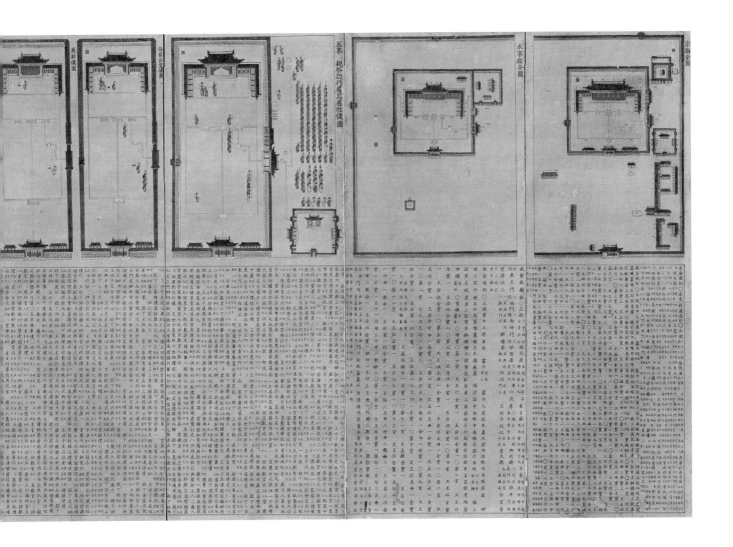

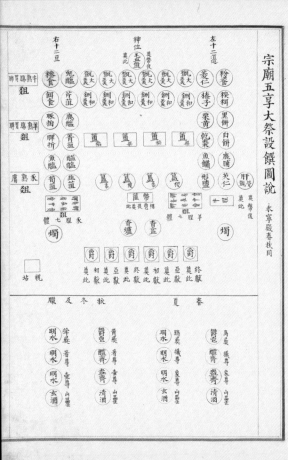

FIG. 21 Arrangement of food vessels identified by name for the Five Annual Sacrifices (*Ohyangje*), from the *Jongmyo uigwe*, 1706.

FIG. 22 Arrangement of musical instruments identified by name, from the *Jongmyo uigwe*, 1706. Book; ink on paper, 49 × 36 cm Kyujanggak

the date of the final enshrinement of King Cheoljong's spirit tablet in the Jongmyo, was presumably made as a visual guide to the actual performance of the sacrificial rites.[22] Lyrics for the ritual music, which along with the dances make the rites a composite of the performing arts, are given. Treasured items, such as the royal books and seals that affirmed the lawful positions held by the enshrined kings and queens at Jongmyo, are carefully catalogued. These treasures and the physical structures of the shrine itself were safeguarded to ensure perpetuation of the royal lineage. The *Jongmyo uigwe* is testimony to this solemn will.

Volume 1 of the *Jongmyo uigwe*, subtitled *Doseol (Illustration)*, provides an overview of the ritual with pictures, diagrams, and descriptions covering everything from the layout of the site to the costumes of the participants (see figs. 21–24).[23] For example, the illustration in the *Jongmyo uigwe* of a jar called *sannoe* matches a fifteenth-century blue-and-white jar, demonstrating the close correspondence between *uigwe* illustrations and actual objects (fig. 25). Table 1.2 shows the order in which each section appears in volume 1 and provides a summary of its contents.

Volume 2 of the *Jongmyo uigwe* consists of eleven sections that explain the physical evolution of the shrines and the protocols related to the spirit tablets housed in them (table 1.3). The Jongmyo shrine underwent many changes over the centuries after it was established in 1394 under King Taejo. At that time there was only one building in which the spirit tablets of the four generations of that founding king's ancestors were enshrined.[24] The first addition to the building took place in 1410, when the side wings were attached at right angles to the original structure. The east wing, which was meant to be used for performing rites in inclement weather, took the form of a porch, with three open sides at the east, west, and south. The Hall of Eternal Peace originally had four spirit tablet rooms and two side rooms on either end of the building. As time went on and more spirit tablets had to be housed, rooms were added to both the Main Shrine and the Hall of Eternal Peace. The Main Shrine was renovated in 1547 with four more spirit tablet rooms to the east of the original structure, bringing the total number of spirit tablet rooms to eleven. The whole complex burned to the ground during the Japanese invasions of 1592–1598. Plans for reconstruction began after the end of the invasions, but could not be carried out until 1604.[25] Reconstruction of the Hall of Eternal Peace began four years later, and in 1667 it was reconstructed with twelve spirit tablet rooms, the original four plus four more on each side. This is the structure illustrated in volume 1 of the *Jongmyo uigwe*. In 1837 two more rooms were added to each end of the building, bringing the total to sixteen, the current size of the hall. The Main Shrine was expanded again

[21]
[22]
[23]
[24]
[25]
TABLE 1.2

TABLE 1.3

山罍

禮書云山罍山尊也刻而畫之爲
山雲之形謂之罍者取象雲雷博
施如人君下及諸臣山罍夏后氏
之尊也〇周禮圖云畫山雲形一皆以勺挹之

龍勺

釋奠儀云龍勺重一斤勺口徑闊
二寸一分長二寸八分深一寸一
分柄長一尺二寸九分酌獻盥洗
盛玄酒一盛盎齊

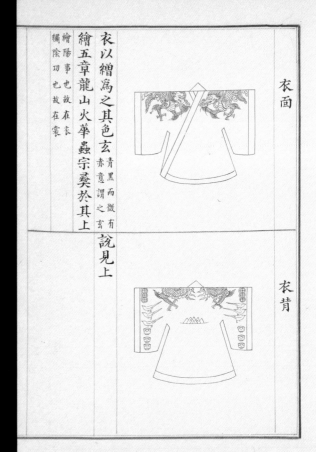

衣面

衣以繒爲之其色玄 青黑而微有
赤意謂之玄
繪五章龍山火華蟲宗彝於其上 說見上

繪陽事也故在衣
繡陰功也故在裳

衣背

FIG. 23 A jar called
a *sannoe* and a ritual
utensil called a *yongjak*,
from the *Jongmyo uigwe*,
1706. Book; ink on paper,
49 × 36 cm. Kyujanggak
Institute for Korean

FIG. 24 The king's
most formal costume
embroidered with
nine symbols (*gujang
myonbok*), from the
Jongmyo uigwe, 1706.
Book; ink on paper,

in 1726 and 1836.[26] A chronological listing of kings and queens enshrined in these Spirit Halls is found in section eight of the volume.

Beyond the structural history of the site, volume 2 deals extensively with all matters pertaining to the tablets housed in the Spirit Halls. Of great concern was the proper form of the inscriptions on the tablets, particularly the titles of the individuals represented. One of the articles in the section on the presentation of posthumous titles, for instance, records the Joseon court's decision not to include the posthumous title for King Injo (d. 1649) bestowed by the Qing emperor, a gesture indicative of the court's contempt for the Jurchen founders of the Qing dynasty (1644–1911), whom they regarded as "barbarian" conquerors of China but whose imperial reign dates Joseon was forced to adopt.[27] Further addressed are the making of spirit tablets (a process called *joju*), their placement in a special container (*dokju*), and rules governing their transfer and ritual enshrinement. Immediately after the royal funeral, the king's temporary spirit tablet was brought back to the palace; after twenty-seven months of the mourning period, it was enshrined in the Jongmyo shrine.

Additionally, there was the rule that, after four generations, a king's spirit tablet would be moved from the Main Shrine (main chamber of the shrine building) to the Hall of Eternal Peace. However, some spirit tablets were exempt from this rule. Known as the "immovable spirit tablets for hundreds of generations" (*baekse bulcheonjiwi*), they belong to kings of special importance to the establishment and development of the dynasty, politically and culturally. They include the dynastic founder Taejo (r. 1392–1398); Sejong (r. 1418–1450), who brought about the invention of the Korean writing system *hangeul* in 1446 and was the first codifier of the Five Rites of State; Sejo (r. 1455–1468), who strengthened the position of the king and the central government, and laid the foundation for Seongjong's legal publications; Seongjong (r. 1469–1494), who was responsible for the publication of the *Five Rites of State* (1474) and the *Joseon Law Code* (1484); and Seonjo (r. 1567–1608), who restored the kingdom after the devastating Japanese invasions of 1592–1598.[28] As a result of the permanent installation of *baekse bulcheonjiwi* (immovable spirit tablets for hundreds of generations), not all of the kings in the Main Shrine are enshrined in the order of their reign.

The topics covered in the ten sections of volume 3 of the *Jongmyo uigwe* range from historical anomalies in the awarding of posthumous titles and enshrinements to protocols of sacrificial offerings, reports to the ancestors, and ritual music (table 1.4).

Particularly helpful for understanding the conduct of the sacrificial rituals as prescribed in the *Five Rites of State* are the step-by-step procedures of the king's personal participation in the sacrificial offerings

FIG. 25 Korean blue-and-white ware jar, 15th century. Ceramic; height: 27.8 cm. Leeum Museum of Art.

TABLE 1.4

TABLE 1.3 Summary of the Contents of Volume 2 of the *Jongmyo Uigwe*

Sec. 1	*Myoje*	shrine systems	Structure of the shrine as prescribed by the *Five Rites of State* and the additions or enlargements to the shrine through the reign of King Seonjo (d. 1608)[1]
Sec. 2	*Changgeon*	establishment	King Taejo's involvement in the building of the shrine in 1394
Sec. 3	*Junggeon*	rebuilding	The rebuilding and repair process after the Japanese invasions of 1592–1598, when the shrine buildings were burned to the ground
Sec. 4	*Gaksil wipan jesik*	protocols for inscribing and enshrining spirit tablets for each spirit chamber	Contains rules and regulations pertaining to royal titles on spirit tablets. Titles all begin with the phrase *yumyeong jeungsi* (posthumous title bestowed by a Ming emperor), followed by the title, in the case of King Taejo, Gangheon (comfortable and benevolent), also given by the Chinese emperor. Then comes the king's shrine title (or *myoho*), or Taejo. Finally, an additional ten characters, including *daewang* (great king), complete the sixteen-character title of King Taejo.[2] At the end of this section, detailed procedures for writing the characters on a spirit tablet and placing it in a wooden spirit-tablet container (*wipan gwe*) are explained. These lists are followed by the step-by-step protocols, or *uiju*, for ritual enshrinement of the spirit tablet from the Spirit Tablet Hall of the palace to Jongmyo.
Sec. 5	*Juje*	spirit-tablet systems	Covers the proper manner of inscribing the titles onto kings' and queens' spirit tablets. Articles from the *Veritable Records*, *Diaries of the Royal Secretariat*, *Documents of the Ministry of Rites*, and the *Collected Writings of Kim Sang-heon* (1570–1652)[3] were consulted to compile this section. This section also explains methods of making the spirit tablet (*joju*), inscribing the titles on the tablet (*jeju*), remaking the tablet (*gaeju*), changing the titles on the tablet (*gaeje*), and making the container for the tablet (*dokju*).
Sec. 6	*Sangsi*	presentation of posthumous titles	Collection of articles from the *Diaries of the Royal Secretariat* concerning posthumous titles conferred on kings by the Joseon court, excluding those bestowed by the Ming court[4]
Sec. 7	*Myoho*	king's shrine title	Conferring shrine titles on a king after his death, that is, the title of a king by which he is referred to in history, for example, Taejo, Sejong, etc.
Sec. 8	*Gaksil wiho*	information on kings and queens in each Spirit [Tablet] Hall	Chronological listing of Joseon kings and queens in their respective Spirit Halls along with the dates of their accession to the throne, their death, their funeral, and the names and orientation of their tombs[5]
Sec. 9	*Bumyo*	final enshrinement of the spirit tablets from the palace to Jongmyo	Covers ritual protocol for moving temporary spirit tablets from the Spirit Tablet Hall (*Honjeon*) of the Gyeongbok Palace to Jongmyo.[6] The temporary spirit tablet of mulberry wood (*uju*) was brought back from the royal tomb after the royal funeral and was kept for twenty-seven months in the palace before its final enshrinement at Jongmyo. The section ends with a detailed *uiju* protocol for the enshrinement rite.
Sec. 10	*Sesil*	immovable spirit tablet chamber	Articles culled from the *Veritable Records*, *Diaries of the Royal Secretariat*, and *Documents of the Ministry of Rites* on the creation of *bulcheonjiwi* (immovable spirit tablets), or tablets of great kings that cannot be removed from the main chamber (Main Shrine) of Jongmyo.
Sec. 11	*Jocheon*	transferring spirit tablets within the Jongmyo	Covers protocols for moving spirit tablets from the Main Shrine to the Hall of Eternal Peace after four generations. Added to this section is the detailed *uiju* protocol for the last rite of the final enshrinement at Jongmyo. This section helps one understand the operational logistics of the Hall of Eternal Peace.

1 *Jongmyo uigwe*, 1:121–54. Information here was culled from the *Veritable Records* and other documents.
2 Kings Taejo (I), Taejong (III), Sejong (IV), Sejo (VII) Seongjong (IX), Jungjong (XI), Seonjo (XIV), Wonjong (posthumously elevated to kingship), Injo (XVI), Hyojong (XVII), and Hyeonjong (XVIII), along with their respective queens, are in the Main Shrine. The four generations of Taejo's ancestors posthumously elevated to kingship, the kings Jeongjong (II), Munjong (V), Danjong (VI), Deokjong (posthumously elevated to kingship), Yejong (VIII), Injong (XII), and Myeongjong (XIII), with their respective queens, are in the Hall of Eternal Peace. *Jongmyo uigwe*, 1:177–86. The title for King Taejo is Yumyeong jeungsi Gangheon Taejo Jiin Gyeun Seongmun sinmu daewang.
3 Kim Sang-heon was a high official under the kings Injo and Hyojong. His collected writings are published as *Cheongeum jip*, titled after his sobriquet, Cheongeum. This *munjip* was first published in 1671 in woodblock edition; a revised edition, also in woodblock, was published in 1861. A facsimile edition based on the revised edition was published in 1977.
4 *Jongmyo uigwe*, 1:250–57.
5 Ibid., 1:259–67.
6 Ibid., 1:299–318.

TABLE 1.4 Summary of the Contents of Volume 3 of the *Jongmyo Uigwe*

Sec. 1	Bokgwi	restoration of a royal title	From the *Veritable Records*, the *Diaries of the Royal Secretariat*, and the *Documents of the Ministry of Rites* concerning the restoration in 1698 of King Danjong's (r. 1452–1455) title, and the Soreung tomb, the final resting place of his mother, Queen Hyeondeok[1]
Sec. 2	Chusung	posthumous elevation of titles	Conferring the title of kingship to King Seongjong's biological father as Deokjong and King Injo's biological father as Wonjong[2]
Sec. 3	Chubu	posthumous re-enshrinement of a spirit tablet	Covers reversing the removal of the spirit tablet of Queen Sindeok (d. 1396), the second queen of King Taejo, from the Main Shrine by King Taejong in 1412.[3] More than two hundred years later, Confucian scholars tried to correct the situation, and finally in 1669, her spirit tablet was re-enshrined in the Main Shrine next to that of King Taejo.
Sec. 4	Chusang jonho	posthumous conferring of a shrine title	Covers conferring a shrine title on the second monarch, King Jeongjong (r. 1398–1400), who had been known as Gongjeong daewang until 1681. Due to a disrupted succession process at the beginning of the dynasty, his legitimacy had not been previously recognized.
Sec. 5	Gasang jonsi	conferring of additional posthumous title(s)	In 1683 (Sukjong 7), the court decided to confer an additional posthumous title of four characters on the dynastic founders King Taejo and King Taejong,[4] making the titles (*hwiho*) on each of their spirit tablets twelve characters long.
Sec. 6	Jehyang	program for offering sacrificial libation	Details the libation ritual (*jakheollye*) at Jongmyo,[5] such as how many times the king or other participants in the sacrificial rite should bow or where in front of the spirit chamber they should be positioned when offering libation cups.
Sec. 7	Chinje; Ohyang daejeui	sacrifices the kings presided over; rituals of the Five Annual Sacrifices	Summarizes the instances when kings personally presided over the great sacrificial rites at Jongmyo. Under a separate heading, details descriptions of the protocols for the Five Annual Sacrifices offered yearly, at the beginning of each of the four seasons and on the third *mi*-day after the winter solstice.[6] See table 1.5.
Sec. 8	Myohyeon	reporting court events to Jongmyo	Articles drawn from the *Veritable Records* on visits by the king and queen to Jongmyo to report on important events, such as royal weddings and paying their respect to their ancestors[7]
Sec. 9	Sangmang sokjeol	sacrifices offered on the first and the fifteenth day of each month, and other important folk holidays	Offerings are made on a reduced scale on these days.
Sec. 10	Akjang	musical instruments and lyrics	Detailed accounting of instruments and lyrics for songs[8]

1 Danjong, who ascended the throne at the age of eleven, was usurped by his ambitious uncle, Prince Suyang (Suyang daegun, later King Sejo), who demoted Danjong to Prince Nosan (Nosangun) and later put him to death. For the bloody incidents at that time, see Lee Ki-baik, *A New History of Korea*, 173. King Sejo also had his younger brother, the great Prince

Anpyeong (Anpyeong daegun 1418–1453), the third son of King Sejong and famous calligrapher of the early Joseon period, assassinated. Prince Anpyeong was also known for his painting collection, which included many works of the Northern Song period. His collection was catalogued by Sin Suk-ju (1417–1475) with comments under the title "Hwagi"

(Records of Paintings) section of his collected writings, the *Bohanjaejip*. For the complete list of the prince's collected paintings in Joseon painting styles, see Ahn Hwi-joon, *Hanguk hoehwasa* (1980; repr., Seoul: Ilchi-sa, 1986), 93–96 and 126. For an English translation of the "Records," see also Burglind Jungmann, "Sin Sukju's Record on the Painting Collection of Prince

Anpyeong and Early Joseon Antiquarianism," *Archives of Asian Art* 61 (2011): 118–21.
2 *Jongmyo uigwe*, 2:47–102.
3 King Taejong was the son of Taejo's first queen, Queen Sinui (d. 1397); Queen Sindeok, Taejo's second queen, was Taejong's stepmother.
4 *Jongmyo uigwe*, 2:139–55.
5 Ibid., 2:157–63.
6 Ibid., 2:165–79. For a detailed explanation of

the entire process of the sacrificial rites, see Yi Uk, "Jongmyo jehyang ui jeolcha wa teukjing," in *Jongmyo* (Seoul: National Palace Museum of Korea, 2014), 142–47.
7 *Jongmyo uigwe*, 2:181–91.
8 Ibid., 2:199–244.

TABLE 1.5 The King's Participation in the Rituals of the Five Annual Sacrifices, from Volume 3 of the *Jongmyo Uigwe*

Jaegye	purification and ablution	Prior to the ritual, the king and all the participants underwent a seven-day period of purification and ablution to cleanse themselves mentally and physically in preparation for receiving the ancestral spirits. During this time, they abstained from eating meat, consuming alcoholic beverages, having sex, listening to music, and visiting the sick or the dead.
Chwiwi	ritual positions	Officials take their designated ritual positions.
Singwallye	early-morning reception of the spirits by the king	The king burns incense and pours a cup of fragrant *ulchangju*, liquor made from the plant called *ulgeumcho*, onto the ground to summon the spirits of the ancestors, which take two forms: the *yang* form known as *hon*, and the *yin* form known as *baek*. He then inspects sacrificial preparations, burns incense, and receives the ancestral spirits.
Jeonpye	presenting gifts	The king places a gift of white silk cloth inside a bamboo basket and, aided by the offering official, places the basket in front of the spirit tablet in each of the spirit chambers.
Jin mohyeolban, gallyodeung	purification ritual	The official in charge of communicating with the ancestral spirits (*chuksa*) places a small tray of fur and blood of the sacrificial animal (*mohyeolban*) in front of the spirit tablet, and a ceramic jar containing the liver and intestinal fat of the sacrificial animals (*gallyodeung*) on the right edge of the first row of dishes. After a short while, he removes the liver from the jar and takes it outside to burn it. The fur and blood tray is also removed before the start of food offerings. These constitute the purifying sacrifices of the ritual.
Gwesik	presenting sacrificial meat and other foods	The sacrificial offerings of food and libations are presented using sixty-three utensils as illustrated in volume 1 of *Jongmyo uigwe*. The food and wine are as follows: three kinds of ritually slaughtered meats (*samsaeng*), braised beef, lamb, and pork, served in covered dishes (*saenggap*); two kinds of soup (*igaeng*); four kinds of raw grains (*seo jik do ryang*); two kinds of *ije* wine;[1] three kinds of *samju* wine, namely, wine freshly brewed, wine brewed two seasons earlier, and wine brewed three seasons earlier; six kinds of fruit (*yukgwa*); six kinds of rice cake (*yukbyeong*); two kinds of dried meat (*ipo*); and four kinds of salted food (*sahae*). The presiding officiant announces that the *jinchan* (presentation of food) will begin when the sacrificial meats are brought out from the kitchen. The music played at this time is called *punganak*.
Choheollye	the first offering of libation	After the meat offering comes the first offering of libation of sweet wine (*yeje*). The king offers the first cup of wine to the ancestral spirits while the officiant bows and recites the memorial address. *Botaepyeong* (Preserving the Peace) music and dance are performed at this time.

TABLE 1.5 (continued)

Aheollye	second offering of libation	The crown prince or the prime minister offers the second cup of wine (*angje*, brewed two seasons earlier). The music and dance performed at this time is *jeongdaeeop* (establishing the Great Task).
Jongheollye	third and final offering of libation	The minister of the left, or the right, if he is absent, presents the libation offering of *cheongju* or freshly brewed wine. After the sacrifices at the Main Shrine and the Hall of Eternal Peace are over, the offering officials move to the tent pitched within the court-yard of the Main Shrine, where the spirit tablets of the meritorious officials and the Seven Spirits are displayed, to partake in the offerings.
Eumbongnye	partaking and extending the blessings	After the above sacrifices are over, all the participants share the libation wines and some of the sacrificial foods that had been placed in front of the spirit tablets in order to receive the blessings bestowed by the royal ancestors. In this process, some food items are packed and distributed to people outside the royal family. This royal gesture symbolizes the benevolent rule of the king over his people.
Cheolbyeondu	removing the utensils	All dishes with leftover food are cleared from the offering table while *onganak* (pleasant and comforting music) plays.[2] The dishes are not removed completely but moved slightly to one side by the officials.
Yepil	ending the ritual	The official tells all the participants to bow four times to the ancestral spirits, and then announces that the sacrificial ritual is over.
Heunganak[3]	sending the ancestral spirits off with music	"Merry and peaceful" *heunganak* music is played to send off the ancestral spirits. The king then moves to a staging chamber of Jongmyo to change out of his ritual costume.
Mangye[4]	burying the offerings	Burying of the offered food (*seojikban* in the form of cooked millet), the memorial address, and the white silk cloth that had been presented to the ancestral spirits concludes the enactment of an *ohyang* ritual at Jongmyo.

1 Wine brewed with carefully measured amounts of water and fire, recorded in *Zhouli*. See Morohashi Tetsuji, *Dai Kanwa Jiten*, 13 vols. (Tokyo: Toyo Gakshu Kenkyusho, 1990), 12:1080.
2 A *byeon* is a plate made of bamboo; a *du* is a plate made of wood.
3 See Song, *Confucian Ritual Music*, 80 for the lyrics that accompany this music.
4 However, this practice of burying was changed to "burning" (*mangye*) during the reign of King Yeongjo, who had the second sequel volume of *Jongmyo uigwe* compiled in 1770 (Yeongjo 46). *Jongmyo uigwe songnok* (1770; repr., The Academy of Korean Studies, 2012), 2:154–55. King Yeongjo and his officials, having surveyed the practices of previous reigns as well as the Chinese practices through the Tang to Song dynasties, decided to follow those of *Daming jili* (*Rites of the Great Ming*), which was compiled between 1369 and 1370, because they considered it ritually purer to burn the food that had been offered during the rite, so as to not leave any trace.

TABLE 1.6 Summary of the Contents of Volume 4 of the *Jongmyo Uigwe*

Sec. 1	Rites of removing and returning spirit tablets from Jongmyo for various reasons (*ihwanan*)
Sec. 2	Sacrifices conducted by the king's deputy rather than the king (*seopsaui*)
Sec. 3	Prayers or reports (*gigo*) at Jongmyo
Sec. 4	Styles of written prayers to be read at ritual sacrifices and the offering of white silk cloth to the spirits (*chukpye*)
Sec. 5	Meat, libation liquor, candles, and other foodstuffs to be presented at the sacrifices (*huisaeng chanpum*). Utmost care is emphasized in preparing all items.
Sec. 6	Misconduct during the removal of the food dishes at the end of the sacrifice (*cheolchan*) during the reign of King Injo
Sec. 7	Problems with securing seasonal food items or sacrificial animals (*cheonsin*), i.e., their type and quantity, their place of origin, and their transportation to the capital
Sec. 8	Officials asking for King Sukjong's permission to survey (*bongsim*) the parts of Jongmyo damaged by strong wind
Sec. 9	Records of minor repairs to Jongmyo shrines and walls and the pruning of trees in its precinct (*sugae*) found in the *Diaries of the Royal Secretariat* and the *Documents of the Ministry of Rites*[1]
Sec. 10	The repair of damaged objects (*subo uijang*) in Jongmyo during the 1624 rebellion of Yi Gual (1587–1624),[2] and also on the replacement of thin red silk (*hongcho*) draperies in the spirit chambers with thicker red silk (*hongju*) draperies
Sec. 11	Contains records of royal books and seals (*chaekbo*). Listed are books made of strips of jade or bamboo (*okchaek, jukchaek*) joined together with wire and inscribed with the posthumous and other titles of kings and queens, and seals made of jade or gold (*okbo, geumbo*). These items are kept in the treasure chests (*bogap*) in each of the spirit tablet chambers.
Sec. 12	Contains records of sacrificial rites held at Jongmyo at times of grave national turmoil (*byeollye*). Some rites were missed or improperly performed during the Japanese invasions of the late 1590s and the Manchu invasions of 1627 (*Jeongmyo horan*) and 1636 (*Byeongja horan*). There are also records of repairs made to the shrine and spirit tablets at Jongmyo and to the Sajikdan altar, both structures damaged during the turmoil. The official responsible for safeguarding the tablets was dismissed and exiled.
Sec. 13	Theft at Jongmyo (*dobyeon*) of valuable items such as silver and gold royal seals, offering utensils, musical instruments, and draperies during the reigns of kings Seonjo, Injo, and Sukjong
Sec. 14	The Seven Sacrifices,[3] sacrificial rites to the seven minor spirits (*chilsa*) enshrined in the Hall of Seven Deities.[4]
Sec. 15	Sacrifices performed along with those of the royal ancestors (*baehyang*), list of ninety-two meritorious officials whose spirit tablets were enshrined in the Gongsindang (Hall of Meritorious Officials) at Jongmyo.
Sec. 16	Contains prohibition against cutting trees (*geumbeol*) near the walls of the Hall of Eternal Peace. King Hyeonjong in 1667 (Hyeonjong 8) ordered the caretakers not to cut down any more trees, but rather to prune them so that the walls remained intact.
Sec. 17	Collection of anecdotes (*gosa*) related to Jongmyo from 1401 through the early eighteenth century
Sec. 18	List of Jongmyo office staff
Sec. 19	List of soldiers (*sujik*) who guard Jongmyo[5]
Sec. 20	List of miscellaneous work staff (*subok*), detailing their working conditions, including the cleanliness of their uniforms.
Sec. 21	List of items that relevant government offices must prepare (*jehyangsi jingong gaksa mulmok*) for the rites at the Main Shrine and at the Hall of Eternal Peace[6]

1 *Jongmyo uigwe*, 2:247–336.
2 The Rebellion of Yi Gwal is the only time in Korean history that a rebel general occupied the capital. This caused King Injo to flee to the southern city of Gongju, which in turn allowed Yi Gwal to install Injo's son Heungangun or Yi Je, on the throne. However, generals loyal to King Injo attacked Yi Gwal, who then was killed by his own subordinates.
3 *Jongmyo uigwe*, 2:337–447.
See Table 1.1 note 1 above for the Seven Deities.
4 Mostly this is a transcription of the rite from the *Five Rites of State* (1474).
5 *Jongmyo uigwe*, 2:449–74.
6 Ibid., 2:475–87.

TABLE 1.5

(*chinje*) found in section 7 under the subheading Rituals of the Five Annual Sacrifices (*Ohyang daejeui*) (see table 1.5).[29]

Jongmyo jeryeak, Jongmyo sacrificial ritual music played at various points in the proceedings, is a combination of instrumental music (*ak*), vocal music (*ga*), and dance (*mu*).[30] The first piece played, *botaepyeong* (preserving the peace), consists of eleven short songs praising former kings for their endeavors in maintaining peace in the nation. The eleven songs of the second piece, *jeongdaeeop* (establishing the great task), praise the founding fathers of the dynasty and later monarchs who solidified the dynastic foundation, protected the nation, and defended it against foreign enemies.[31] The music played when food dishes are being offered is called *punganak* (music of abundance and peace), four-character, eight-line compositions with short and simple lyrics that assure the spirits that the food dishes have been prepared with the utmost care and sincerity and are offered in the spirit of filial piety.[32] The lyrics explain the types of offering utensils and the fragrance of the food so as to move the ancestral spirits. Finally, when all offering procedures are over, the *heunganak* (merry and peaceful music) is played. Those lyrics are even shorter — four-character, six-line compositions stating that the sacrifices were completed according to the rules, and thus the ancestral spirits may feel comfortable. The king and the participants are led to feel as though they are looking back at us as they ascend into the clouds.[33]

Volume 4 of the *Jongmyo uigwe* treats diverse, apparently unrelated matters, from ritual concerns to shrine repairs, theft, and staffing.[34]

TABLE 1.6

While the contents are most easily captured in a simple list (table 1.6), one item — the entry for the collection of anecdotes (*gosa*) relating to Jongmyo — deserves particular notice for its relevance to the creation of this *uigwe*.[35] It was during the process of compiling this section that King Sukjong realized that documents on Jongmyo were less than complete, and suggested the compilation of this *uigwe* as a remedy.

As seen in the above summary of the contents, the *Jongmyo uigwe* informs us in detail not only about the history of the Jongmyo shrine but also about the most complicated procedures of sacrificial rites, including purification rites, the offering of foods and libations, instrumental and vocal music with lyrics, and the *ilmu* dances. The *Jongmyo uigwe* also includes illustrations of many categories of Joseon material culture, ranging from the architectural arrangement of the buildings in the entire Jongmyo compound to sacrificial utensils, ritual costumes of important participants, and much more. The book makes it clear that the Joseon kings were determined to safeguard the traditions of the most important rites in their ancestral worship.

FIG. 26 Weaving scene from the *Peiwen Studio Pictures of Tilling and Weaving* (*Peiwenzhai gengzhi tu*), 1696. Woodblock printed album, 36.4 × 23.8 cm. Jangseogak Archives, The Academy of Korean Studies (C3-75).

FIG. 27 Tilling scene from the *Peiwen Studio Pictures of Tilling and Weaving* (*Peiwenzhai gengzhi tu*), 1696. Woodblock printed album, 36.4 × 23.8 cm. Jangseogak Archives, The Academy of Korean Studies (C3-75).

The Rites of Agriculture and Sericulture

The rites of agriculture and sericulture, which originated in ancient China, were performed in Korea as early as the Three Kingdoms period[36] and also in the Goryeo dynasty.[37] As the most basic industries of Joseon and earlier kingdoms, farming and silk making were supported by ritual performances (*chingyeongui* and *chinjamui*, respectively) conducted by the royal family.[38]

The traditional view of farming as men's work and silk making as women's work is rooted in the legendary love story of the herd boy (Gyeonu or Hegu) and his bride, the weaving maiden (Jingnyeo). Both are personifications of the two heavenly bodies Dabih (herd boy) and Vega (weaving maiden), which are seen coming closer together on the seventh day of the seventh lunar month across the galaxy.[39] Although this story seems to have originated in the later Han period in China, Korean children even today grow up with the story. The images of the herd boy and the weaving maiden appeared in Korean art as early as the Goguryeo tomb painting, datable to 408 CE, in Deokheungni, near Pyongyang.

Although the royal farming rite was included in the auspicious rites section of the *Five Rites of State*, it was not performed until 1475, during the reign of King Seongjong. King Seongjong performed it two more times, in 1488 and 1493, but did not have any *uigwe* compiled to record it. However, he did have compiled detailed protocols for conducting the ritual, with frequent references to such works as the Chinese *Zhouli* (*Rites of Zhou*), *Munheon tonggo* (*Comprehensive Examination of Literature*; Ch. *Wenxian tong-kao*; 1317), and the *Goryeosa* (*History of the Goryeo Dynasty*).[40] Performances were irregular thereafter. During the reign of Gwanghaegun (r. 1608–1623), the rite was performed on the sixteenth day of the third month of 1620, although high officials opposed it on the grounds that it was a busy time for spring farming. King Sukjong also tried to revive this venerable tradition in 1720, but inclement weather kept the ritual from being carried out.

Uigwe of Royal Agriculture, 1739, 1767

King Yeongjo, who was intent on following revered Chinese precedents, performed the farming rite four times, in 1739, 1753, 1764, and 1767, and had *uigwe* compiled for the first and last occasions.[41] For the 1739 royal farming rite,[42] the king, along with his officials and royal relatives, would go to a state-designated field (*jeokjeon*) to perform cultivation. Before the actual farming, they made sacrifices to Sinnong (Ch. Shennong), also called Seonnong, the legendary ancient Chinese emperor who taught farming to mankind, and Hujik (Ch. Houji), the god of grains, at the Altar of the First Farmer situated at the northern end of a ritual field.[43] Then the king shoveled five times, high officials each seven times, and royal

FIG. 28 Kim Du-ryang
(1696–1763) and Kim
Deok-ha (1722–1772),
*Landscapes of the Four
Seasons*, 1744. Detail
showing winnowing.
Handscroll; ink and
color on silk, 8.4 × 184
cm. National Museum
of Korea (Deoksu 2146).

relatives, nine times.[44] The rest of the plowing would be finished by farmers. During the ritual plowings, court ceremonial music (*a'ak*) was played. However, King Yeongjo had the more popular music of the people (*yeominrak*) played during the celebration that followed the rite, when food and wine were served to all the participants, especially those over seventy years of age, and to commoners who came out to watch.[45]

In the 1739 *uigwe* we find an official request for three good court artists to paint the farming scene, and an additional request for materials to make a hanging scroll and an eight-panel folding-screen painting of silk, each panel measuring 3.6 × 1.6 *cheok* (approx. 108 × 48 cm) for the crown prince's residence.[46] In this connection, it is useful to mention the illustrated Chinese woodblock-printed album *Peiwenzhai gengzhi tu* (*Peiwen Studio Pictures of Tilling and Weaving*, 1696) that Choe Seok-jeong (1646–1715), the Joseon envoy to the Qing court, brought back to the Joseon court in 1697 (figs. 26, 27). Printed by order of the Kangxi emperor and based on the drawings by the court artist Jiao Bingzhen (active 1689–1726), the books contain forty-six scenes equally divided between farming and silk making. These scenes had a great impact on eighteenth-century Korean genre painting.[47] A set of two handscrolls depicting the activities of the four seasons, painted by Yeongjo's favorite court painter Kim Du-ryang (1696–1763) and his son Kim Deok-ha (1722–1772), for instance, contain many "quotations" from the Chinese album (fig. 28). Perhaps the popularity of these illustrations, coupled with King Yeongjo's intention to follow revered Chinese precedents, played some role in King Yeongjo's enactment of the royal farming and silk-making rites.

On the whole, the 1767 royal farming ritual did not differ much from that of the 1739 enactment except that the crown grandson (future King Jeongjo) participated in it.[48] This required altering the program of plowing to accommodate him. King Yeongjo did this simply by having the high officials and the royal relatives plow nine times each.

Uigwe of Royal Sericulture, 1767

On the tenth day of the third month of the same year, King Yeongjo, together with his second queen, Queen Jeongsun (1745–1805), performed a royal sericulture rite and had the *Uigwe of Royal Sericulture* compiled.[49] Although the same rites had been performed in earlier reigns, this was the first and the only such *uigwe* produced during the Joseon dynasty.[50]

Notably, this rite was performed in Gyeongbok Palace, which had lain in ruins since its destruction during the Japanese invasions at the end of the sixteenth century. Key parts of the ritual were performed on platforms built on the east side of the Gangnyeong Hall site, where the queen's

quarters had been located. Prior to the sericulture rites, Queen Jeongsun did not perform the rite at the Seonjamdan, or the altar where the first teacher of sericulture to mankind, Seonjam or Chinjam, was worshipped, because it was located outside the Gyeongbok Palace. The court's decision not to let her go there was in accordance with the Joseon custom of upper-class women not being seen in public.[51] Instead, Yeongjo had a separate platform built next to the Altar of Picking Mulberry Branches, or *chaesangdan*, and had the opening libation rite to Chinjam performed there. Then the queen proceeded to pick leafy mulberry (*chaesang*) to feed the silkworms (the heart of this rite), and performed the last of the ritual activity for the women, paying respect to the elderly royal ladies (*johyeollye*). Yeongjo also wanted to have the congratulatory ceremony (*jinha*) at the site of the throne hall, Geunjeungjeon. Having the royal sericulture rite performed in the Gyeongbok Palace was in truth a symbolic gesture, as Yeongjo had always felt that not rebuilding the main palace of the dynasty was a great loss.

The picking and gathering of mulberry leaves takes place at the Altar of Picking Mulberry Branches (*chaesangdan*), where mulberry trees were set up to be harvested. The queen picks five branches, the wife of the crown grandson (*sesonbin*) then picks seven branches, and each of the court ladies and the ladies of royal relatives pick nine branches. The number of branches to be picked by the three categories of royal ladies is much like that of rows plowed at the royal farming rite. All of the partici-pating ladies were to dress according to their rank.[52]

King Yeongjo was quite moved by the successful performance of the sericulture rite with his second queen (whom he had reluctantly married eight years earlier, in 1759, when he was sixty-six years old and she was only fifteen).[53] On this occasion, not only his young queen, but also his newly married granddaughter-in-law, the wife of his heir apparent, participated. King Yeongjo wanted to celebrate this memo-rable occasion by bestowing a special opportunity for civil and military state examinations; on the eleventh day of the third month, it was held on the grounds of the Gyeongbok Palace.[54] To further celebrate the occa-sion, King Yeongjo had many convicts released from the capital prison, and gave pardons to convicts with sentences of less than a year jailed outside the capital. King Yeongjo had this celebration painted on an eight-panel screen, *Examination in the Presence of the King at Geunjeong Hall inside Gwanghwa Gate* (*Chinim Gwanghwamun nae Geunjeongjeon jeongsido*) (fig. 29).

In contrast to most other *uigwe*, which have sections for award regulations (*sangjeon*) given to all participants from prime minister down to female servants, the *Uigwe of Royal Sericulture* has no such section. King Yeongjo made a provision instead for recording the awards in a section

FIG. 29 *Examination in Geunjeong Hall inside Gwanghwa Gate in the Presence of the King* (*Chinim Gwanghwamun nae Geunjeongjeon jeong-sido*), 1747. Panel 1 of an eight-panel folding screen; ink and color on silk, each panel 208.8 × 71 cm. Seoul Museum of History (Seo 3072).

[29]

named *bimanggi* (special memorandum).[55] The awards come in many different forms depending on the importance of the role one played in the event. Notable for that time is that, instead of material awards, a change in social status from the *cheonmin* (lowborn class) to the *yangmin* (free-born, good people) class was granted to those who so wished.[56] This is the earliest instance in Joseon history in which a change of social status was granted after a state rite. From the late eighteenth century through the nineteenth, there are many instances of such awards, especially following state banquets in the nineteenth century. Thus, King Yeongjo's granting of this form of award opened a way for upward social mobility not only for members of the lowborn class in his era, but also for many more lowborn people in later times.[57]

Uigwe of Royal Gathering of Seeds and Silk Cocoons, 1767

On the twenty-sixth day of the fifth month of the same year, King Yeongjo had the rite of royal gathering of seeds and silk cocoons (*jang-jong sugyeonui*) enacted, the only one of its kind held during the Joseon dynasty. Originally, only one copy of this *uigwe* was made, which is the one now extant. It is titled *Uigwe of Queen Jeongsun's* [second wife of Yeongjo] *Gathering and Storing of Seeds and Silk Cocoons* (*Yeongjo bi Jeongsun hu sugyeon uigwe*) and is a royal viewing copy with a brocade cover.[58] It consists of only fifty-eight pages and has a simple table of contents listing only three items: (1) king's order; (2) report to the king; and (3) protocol. On the next page is a program of two rites: the gathering of seeds and silk cocoons on the twenty-sixth day of the fifth month held at the Deogyu Hall of the Gyeonghui Palace and the congratulatory event on the twenty-ninth day of the fifth month held at Sungjeongjeon, the main throne hall of the Gyeongheui Palace. Written on the cover, albeit at a later date, is the title "Queen Jeongsun," identifying her as the main celebrator of the event. This is the only *uigwe* to have a queen's title specified on the cover. Together with the 1767 *Uigwe of Royal Sericulture*, this *uigwe* is significant as a record of a state rite where women — the queen, the granddaughter-in-law, and other court ladies — played major roles. To be sure, many court banquets were held for dowager queens in the nineteenth century, but those royal women did not play leading roles like those played by women in the rites of sericulture. In the sphere of royal rituals, the year 1767 marks an important point in the history of Joseon court women. ◆

CHAPTER TWO
Uigwe of Celebratory Rites, *Garye*

The second category of the Five Rites of State is called *garye*. The word *ga* has a range of related meanings, including good, beautiful, happy, propitious, and joyful; thus, *garye* are ceremonies of celebration; fifty are listed in this category.

The first one, *manggwol haengnye* (rite of paying respect to the palace), was conducted by kings, crown princes, and high officials of the court who paid respect to the Chinese emperor by bowing in the direction of the imperial palace in Beijing on the morning of the first day of the New Year, on the winter solstice, and on the emperor's birthday. Many other rites having to do with paying respect to China are also recorded, reflecting Joseon's status as a tributary state of China[1] — although from the point of view of the Joseon court, they were not of the same level of importance as the Joseon's own state rites. Among them, the most important were royal weddings, also called *garye*, and the rite for the investiture of a crown prince, called *wangseja chaekbongui*. This chapter discusses *uigwe* produced for such occasions.

The 1610 Investiture *Uigwe*: A Record of Five Separate Events
This *uigwe* records the investiture of the first son of Gwanghaegun (r. 1608–1623), Crown Prince Ji (1598–1623), who did not live to take the throne,[2] as well as four other ritual events of Gwanghaegun's reign. The year 1610 was only the second full year of his reign, but Gwanghaegun ambitiously undertook to perform five different rites within a month and six days (from the fifth day of the fourth month to the eleventh day of the fifth month).[3] They were: the elevation of the titles of two dowager queens, the first to the late dowager queen Uiin (Virtuous and Humane) and the second to the dowager queen Inmok (Humane and Revered); the investiture of his own consort, Crown Princess Yu, to the rank of queen; and the prince's *gwallye* (coming-of-age or capping ceremony), which was a prerequisite to his investiture as crown prince.[4] Compiled in the Office of the Investiture of Crown Prince, it is the earliest of the five extant

uigwe made for the investitures of crown princes.[5] Minister of the Left Yi
Hang-bok (1556–1618), one of the most respected scholar-officials of the
time, headed the superintendency responsible for these rites.[6]

Since this was the period just after the Japanese invasions of 1592–
1598, when earlier *uigwe* documents were all but lost, there was a great
deal of discussion about the procedures to be followed for each of the
events, and Gwanghaegun and his officials frequently looked to the *Veritable Records* of earlier kings for precedents. The resulting 1610 investiture
uigwe was produced in multiple copies and deposited with the relevant
offices in the palace and in four history archives across the country. Only
one copy survives, the one formerly kept in the Taebaeksan History
Archive, and now in the Kyujanggak Institute for Korean Studies, Seoul
National University.[7] However, this *uigwe* contains the records of only
the first event, that of the *Uigwe of Elevating the Title of Queen Uiin* plus the
banchado of all five events at the end.

The schedule of the five events that took place at this time is as
follows. There are thirty-eight pages of *banchado* attached at the end of
the *uigwe*. The breakdown in the number of pages each event took up in
the *banchado* is indicated in parentheses at the end of each item.

1. The fifth day of the fourth month: the rite of elevation of the
 title of the late Dowager Queen Uiin (9 pages)
2. The nineteenth day of the fourth month: the rite of elevation
 of the title of the Dowager Queen Inmok (8 pages)
3. The twenty-second day of the fourth month: the investiture
 of Gwanghaegun's consort, Crown Princess Yu, to the rank of
 queen (11 pages)
4. The sixth day of the fifth month: the prince's *gwallye* (coming-
 of-age or capping ceremony) (4 pages)[8]
5. The eleventh day of the fifth month: the Crown Prince Ji's
 investiture rite (6 pages)

For all these events, the court conducted three rehearsals. After the
crown prince's capping ceremony, he had to pay respects in person to the
king, the Dowager Queen Inmok, and the newly installed queen.[9]

The third event, that of the investiture of Gwanghaegun's consort,
Crown Princess Yu, to the rank of queen, is the first of its kind of the
Joseon dynasty and comes with eleven pages of colorful *banchado* illustrations. There survive nine specimens of *uigwe* of queens' investiture rites
from 1610 to 1901, but only this first and the last one include *banchado*.[10]
Since there is no textual record of the investiture rite itself in this *uigwe*

of multiple events, except for the program of the event and the *banchado*, we will rely on the *Daily Records of Gwanghaegun* for textual information on the actual rite. On the twenty-second day of the fourth month, 1610, the king (Gwanghaegun) donned his *myeonbok*, the most formal attire of a king, and ordered Yi Hang-bok and Yi Jeong-gwi (minister of rites) to send the jade book and the gold seal, emblems of the queen, to the quarters of Crown Princess Yu and promoted her to the position of a queen. On the same day, the king proclaimed a congratulatory edict for the nation celebrating the newly installed queen.[11] Below, we will examine the *banchado* illustrating the investiture of Gwanghaegun's queen.

The *Banchado* of the Investiture of Crown Princess Yu as Queen This *banchado* shows the superintendency officials and the queen's honor guards transporting the important ritual items to be used for the rite. The queen-to-be's palanquin does not appear. The ritual items were produced in the subdivision offices of the superintendency located outside the palace and were transported to Changdeok Palace, where the ceremony was to take place. On the first page, we see five ushers (*illoin*), so identified as such by three Chinese characters on top and bottom of the page, with long sticks to be used to clear the way. In the center of the second page, we see two grooms with a white horse identified by inscription as the *boma* (royal horse), followed by the queen's colorful honor guards

[30] with flags and ritual weapons (fig. 30). A red parasol bearer at the end of the scene announces the coming of a series of five red palanquins marked with the characters identifying the ritual items they carry: the first, *gyomyeong*, carries the royal order of the appointment to queen; the

[31] second carries the jade book (*okchaek*) (fig. 31). Three more palanquins, not shown here, appear: the third bears the queen's own seal; the fourth holds the pheasant robe (*jeogui*), the queen's most formal outfit, a blue silk gown embroidered with pheasants; and the fifth carries the queen's dress shoes and socks (*seongmal*). The final scenes of this *banchado* show the superintendency officials and their "errand men."

The *banchado* illustrations in this *uigwe* were all hand-painted, and the labels identifying the figures and other items were also handwritten. Four painters' names are given at the end of the records concerning the superintendency's first subdivision.[12] Today we know more about only one of them, Yi Sin-heum (1570–1631), a painter of landscapes and figures. These artists took care of all the painting needs of the superintendency, including the *banchado* productions, although the specific division of labor is not known. Because this particular *uigwe* was not the royal viewing copy, we can assume it does not represent the highest-quality painting

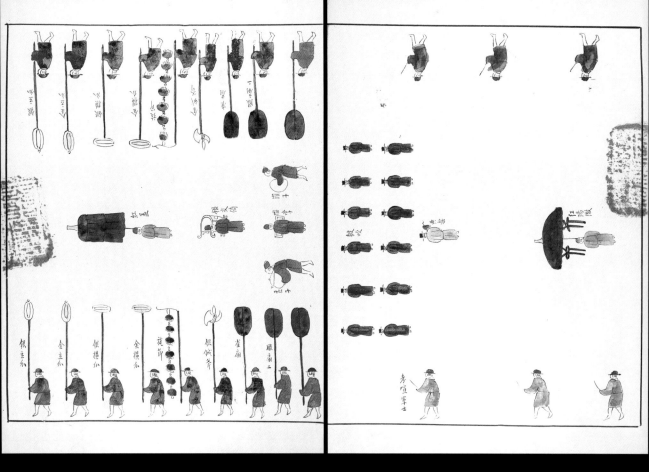

page 13

page 14

FIG. 30 The queen's honor guards, from the *banchado* in the *Uigwe of the Investiture of the [Crown Princess Yu as] Queen (Uiin wanghu jonho* *wangseja chaengnye gwallyesi chaengnye dogam uigwe)*, 1610. Book; ink and color on paper, 44 × 33.3 cm. Kyujanggak Institute for Korean

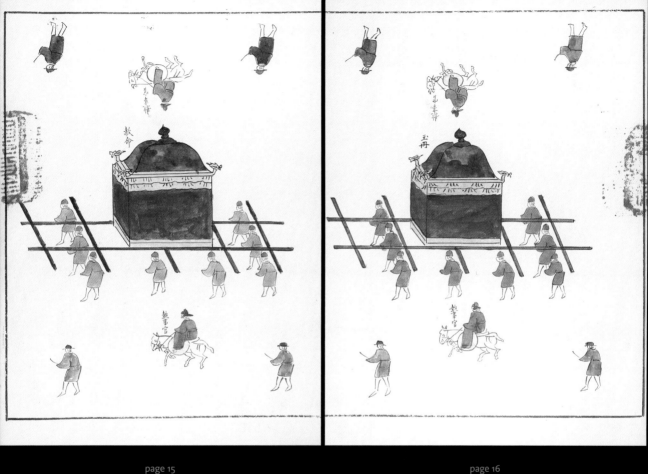

page 15

page 16

FIG. 31 Small red palanquins carrying the royal order (page 15) and jade book (page 16), from the *banchado* in the *Uigwe of the Investiture of the [Crown Princess Yu as] Queen (Uiin wanghu jonho daebijeon sang jonho junggungjeon chaengnye wangseja chaengnye gwallyesi chaengnye dogam uigwe)*, 1610. Book; ink and color on paper, 44 × 33.3 cm. Kyujanggak Institute for Korean Studies, Seoul National University (Kyu 13196).

and calligraphy. Nevertheless, its importance lies in the fact that it is the earliest of its kind showing five separate palanquins carrying ritual items necessary for a queen's investiture.

The 1690 *Uigwe* of the Investiture of Crown Prince Yun (Later King Gyeongjong)
Although the investiture rite of Crown Prince Ji included in the 1610 *uigwe* of multiple events is the earliest of its kind, we will introduce the better documented 1690 *Uigwe of the Investiture of the Crown Prince*, who became King Gyeongjong.

The circumstances surrounding the 1690 investiture of the crown prince who became King Gyeongjong (r. 1720–1724) were quite unusual. First of all, he was installed as crown prince when he was only three years old by Korean count. Also, he was not the natural son of King Sukjong's queen, Queen Inhyeon, but rather of his controversial consort Jang, whose title was Huibin (auspicious concubine). King Sukjong's reign (1674–1720) is generally acclaimed for bringing about the recovery of the country after the devastating Japanese invasions of the late sixteenth century and the Manchu invasions of 1627 and 1636, stabilizing the economy through land tax systems and currency reforms, and laying the foundation for the cultural efflorescence of the eighteenth century. However, it was also a time of intense factional strife with frequent shifts in political power.

One such shift involved royal women: Huibin Jang initially prevailed in a power struggle with Queen Inhyeon, and, as a result, she became Sukjong's legal queen in 1689, and her son became the crown prince. Queen Inhyeon was forced to forfeit her title, and demoted to a commoner. But in 1694 Jang was demoted to the status of concubine again, and Queen Inhyeon was reinstalled. Jang was put to death in 1701, and around that time the crown prince fell ill. Nevertheless, in 1717 he was given an opportunity to take charge of court affairs in place of King Sukjong. However, his poor health continued, and his reign as King Gyeongjong lasted only four years. He died, suddenly, in 1724.[13]

According to the 1690 investiture *uigwe*,[14] the whole series of events leading up to the investiture was put in motion on the thirteenth day of the fourth month, when King Sukjong met with his high officials. Prime Minister Gwon Dae-un (1612–1699) brought up the need to appoint a crown prince soon, other officials concurred, and the king accepted their recommendation. The event was set to occur sometime in the sixth month in Injeong Hall at Changdeok Palace. The next day, the superintendency in charge of the ritual was established, with Prime Minister Gwon as the superintendent (*dojejo*). The first page of the *uigwe* gives

the program of events, a list of superintendency officials, the rehearsal schedule, and the date of the rite, the sixteenth day of the sixth month. Because of the crown prince's tender age and the hot weather that month, the prime minister suggested changing the venue to the Huijeongdang hall, located closer to the queen's quarters.[15]

A few days before the designated date of the actual investiture, on an auspicious day, the sacrificial rites of announcement to the ancestral spirits (goyuje) at the royal ancestral shrine (Jongmyo) and to the spirits of earth and grain were performed.

According to the "Protocol" section (uiju), important parts of the procedure of the investiture rites include: (1) investiture rite proper of crown prince (chaek wangsejaui); (2) the rite of the crown prince's acceptance (wangseja janae suchaegui); and (3) one day prior to the event, the rite of bringing the letter of appointment, the bamboo book, and the seal of the crown prince into the palace.[16] Although the order of events in the protocol section is given as above, it seems appropriate for us here to discuss the third one, that is, the event one day before the investiture rite proper.

The third protocol spells out how the ritual items should be properly brought into the Injeongjeon hall, where the investiture rite was to be held, from the subdivision offices of the superintendency outside the palace where they were made. In preparation, a banchado depicting the procession to bring the royal order of appointment, bamboo book, and the jade seal to the palace was presented to the king for his approval.[17] The procession, which will be discussed in detail shortly, was made up of honor guards and the officers of the superintendency, who followed three small palanquins carrying the aforementioned ceremonial objects. The Hanseong Administrative Office made sure that the streets along the way were cleaned and newly covered with fresh yellow dust. Once the procession arrived at the palace, the ceremony of stamping the royal seal on the royal order of appointment (anborye) was performed, with one or two court painters and a scribe from the Bureau of Royal/Diplomatic Documents (Seungmunwon) to ensure the stamping was done properly. Then all of the ceremonial objects were presented to the king for his viewing and approval.

On the day of the investiture (the first rite), all of the high officials and the royal relatives donned their appropriate official costumes and took their places at the ceremonial venue, the Injeongjeon hall, to await the arrival of the king. When the king was finally seated on his throne, the rite began with the proclamation of the royal order of appointment, in which it is said "the first-born royal son is installed as crown prince" (chaengnip wonja wi wangseja). Because the crown prince was too young at that time, the first rite was conducted without his participation.

列朝故兹教示想宜知悉

之訓庭欽體柞

勉小學柞治齊之功寔爰

用柞前日擴大猷柞精一

立以教宣合德器之益修

奚俚咸儀之必慈濟以弘

惟懷遠圖貌思恭色思温

蓋蒙養當慎厥始而豫建

言動視聽毋好狎柞近習

詩書禮樂須資沃柞賢僚

收心接物事而必先制義

懋聞宏謨處宴間而必先

為王世孫爾其誕膺遐福

祧禽謀允諧予意丕決命爾

德漸将就今宜加冊而重

復長元日既定諦而崇嫡

而實類常謂當興我家位

輝固知克昌厥後儼英表

員荷之必能異重輪而增

其初姿質之允美洎乎長

FIG. 32 Bamboo Book (*jukchaek*) of the Investiture of the Crown Grandson, 1759. Bamboo strips; 25.2 × 107.2 cm. National Palace Museum of Korea (Jongmyo 13506-1).

The rite of the crown prince's acceptance (the second rite) was conducted in the Huijeongdang hall with the letter of appointment, the bamboo investiture book (*jukchaek*), and the seal of the crown prince brought to the hall by two messengers, and accepted by the prince, who was being held in the arms of his nurse. She bowed to the messengers to accept the ritual items on behalf of the prince. Afterward, a series of congratulatory memorials addressed to the king and the crown prince were ceremoniously enacted by court officials and royal relatives. The crown prince, in turn, paid formal visits to the king and the dowager queens.

Besides the main office (*docheong*) of the superintendency, three subdivisions were set up to take charge of the production of documents and objects necessary for all stages of the rites.[18] The first subdivision was responsible for the most important items, such as the royal order of appointment and the bamboo book, which takes the form of ancient books made of bamboo strips as exemplified by the *Investiture Book of the Crown Grandson* (later King Jeongjo), 1759 (fig. 32).[19] All the paraphernalia to go with those two items, such as a wooden box, two tables, and two small palanquins to carry them separately in the procession, are also prepared by this unit, as are the crown prince's costume (*myeongbok*) for the occasion, the written instructions of the protocols, and the *banchado* to be presented to the king and the crown prince prior to the event.[20]

The second subdivision was responsible for preparing the crown prince's jade seal (*ogin*), the inner and the outer boxes for the seal, the red seal ink and seal-ink box, and a table upon which to place the seal and ink boxes.[21] The third subdivision is responsible for all of the ritual weapons and the flags of the honor guards, the sedan chair (*gyoja*), and two large palanquins (*yeon* and *yeo*).[22] A unit for special work (*byeolgongjak*) was also created to repair old items and perform whatever additional work was needed for the event.[23]

The *Banchado* Appearing at the end pages of the *uigwe*, this *banchado* is titled *Gyomyeong chaegin yegwol banchado*, meaning *Banchado of Bringing in the Royal Letter of Appointment, Bamboo Book, and the Seal of the Crown Prince to the Palace*, and spans twelve pages (figs. 33–35).[24] Unlike other *banchado* illustrations, in which the procession is shown proceeding from right to left, this *banchado* shows it proceeding from left to right. The opening pages (fig. 33) show the crown prince's honor guards on the move, each with his assigned ritual flag or weapon. They are followed, on pages five and six (fig. 34), by the small palanquin carrying the royal order of appointment borne by eight men, followed by four equestrian figures, two officiants or masters of ceremony (*jipsa*), and two holders of the black table to spread

[32]

[33]
[34]
[35]

[33]

[34]

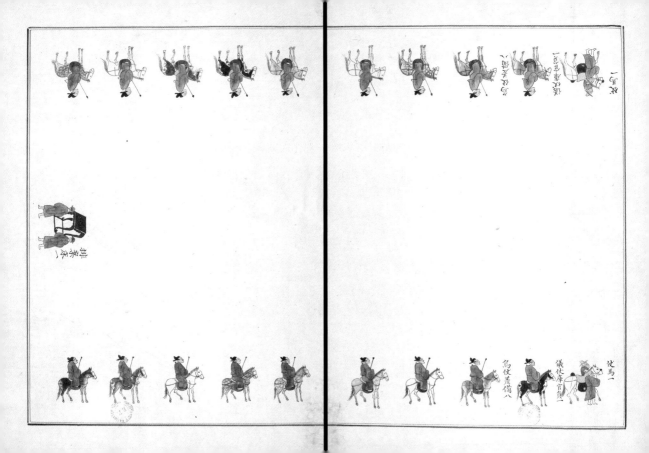

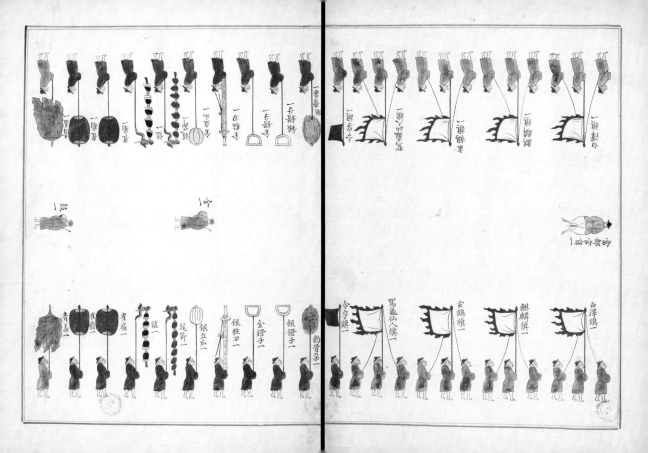

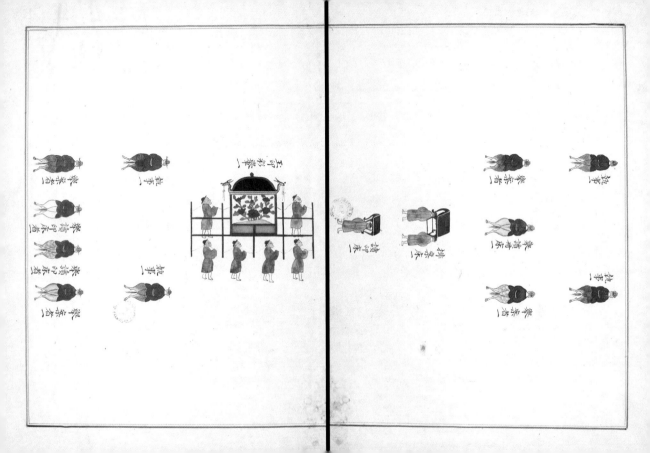

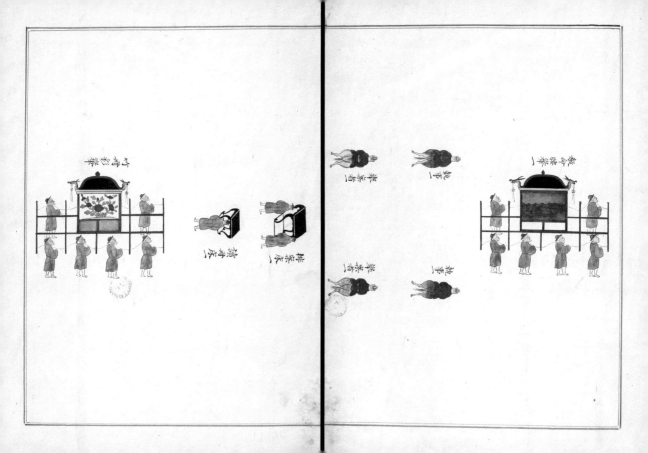

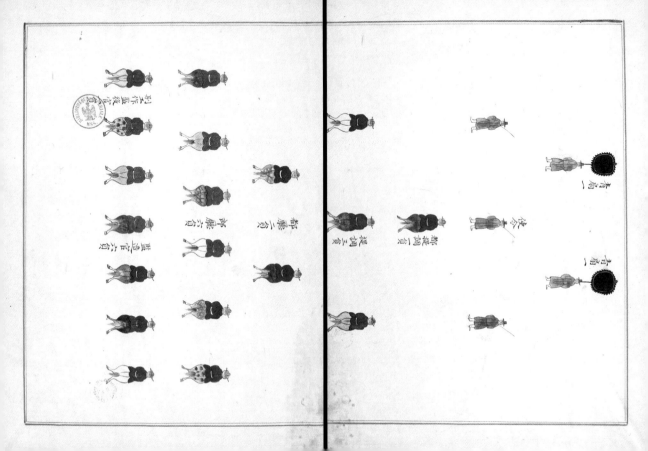

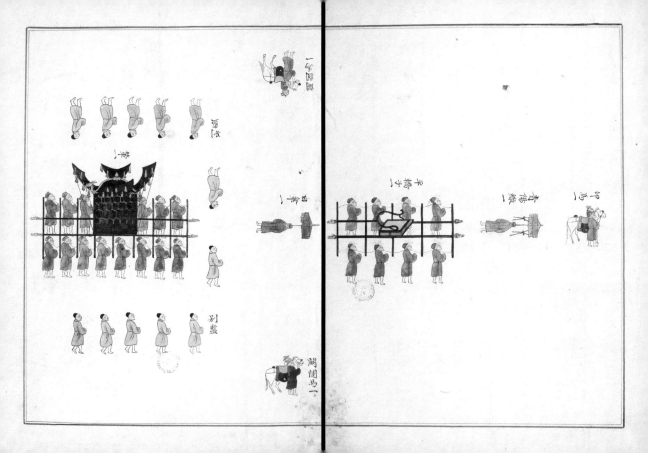

一鞭圄過

羅察

一雀扇

小轝子

一鞭

別監

一大鐙爐

一香亭子

一爐

閭閭馬一

out the ceremonial items (*geoanja*), all wearing the most formal court robes and gold crowns. On page six, two black lacquered tables (*baeansang* and *dokchaeksang*), one upon which the ceremonial items are laid out and one for reading the bamboo book, precede the small painted palanquin carrying the bamboo book (*jukchaek chaeyeo*), which is also borne by eight men. The shape and the colors of these small palanquins, which are carried at waist level (*yoyeo*, or waist palanquin), are the standard for palanquins carrying small ritual items in the processions recorded in *uigwe*. As shown in this *banchado*, when they are decorated with peony flowers on the side, they are called painted palanquins (*chaeyeo*). On page [34] eight (see fig. 34) is another colorful palanquin carried by eight men, which holds the jade seal of the crown prince. It is followed by six equestrian figures, two in charge of the ceremony in the front and four in the next row.

[35] On page nine (fig. 35) the seal horse (*inma*), a white horse with two grooms, immediately follows the seal palanquin's retinue. This horse does not actually carry the seal, but for symbolic protection goes ahead of the blue parasol (*cheongyangsan*), which in turn is followed by the crown [35] prince's sedan chair carried by eight men. Page ten (see fig. 35), the highlight of this *banchado*, shows the crown prince's formal palanquin borne by sixteen men surrounded by ten special guards preceded by a parasol bearer in the center and a pair of horses on either side identified by inscription as *gwoldalma*, horses used by the crown prince inside the palace. The [35] two last pages (see fig. 35) begin with the two bearers of large blue fans, who follow the crown prince's palanquin, shielding it from behind. Then three subordinates holding long sticks lead the officials of the superintendency on horseback in the following order: the superintendent, two second-ranking officers in charge, six third-ranking officers, six inspectors of work in the last row, and another inspector for the subdivision responsible for "special work" brings the procession to a close.[25]

The roles of painters and artisans in the superintendency are not spelled out in this *uigwe*. However, the names of court painters appear in the list of artisans for each subdivision in the "Award Regulations" section, where all of the high officials depicted in the *banchado* and most of the artisans and other workers are listed along with whatever awards they received for their roles in this undertaking. Examples of such service include decorating the borders of the royal order of appointment scroll, copying the Chinese-character calligraphy for the bamboo books and jade seals, engraving the characters, and filling in the grooves of the engraved characters with gold dust. Painters and artisans were also needed to decorate all the palanquins, as well as the flags and other ritual paraphernalia of the honor guards. They also produced the *banchado* used to

guide the procession rehearsals and, later, bound to the *uigwe* book. The names of painters listed in the first subdivision are Han Hu-bang, Jang Ja-uk, Yi Man-eok, and Jo Seong-myeong; the ones in the second subdivision are Yun Sang-ik and Yi Gwi-heung. Except for Yun Sang-ik, whose portrait painting was recently discovered,[26] none of these painters are otherwise known today.[27]

Uigwe of Royal Weddings

Among the celebratory rites, royal weddings were of great importance as ritual validations of royal unions and the selection of women suitable to be a queen, or "mother of the nation" (*gungmo*),[28] thus ensuring the continuation of the dynasty.[29] Therefore, many *uigwe* related to royal weddings were made. Twenty survive, dating from the early seventeenth century to the early twentieth.[30] Ten of those represent weddings of crown princes, nine document weddings of reigning kings, and one records the wedding of the crown grandson who later became King Jeongjo (r. 1776–1800). The earliest is the *Uigwe of the Wedding of Crown Prince Sohyeon* (1612–1645) in 1627. The latest is the 1906 *Uigwe of the Wedding of Crown Prince Cheok* who became Emperor Sunjong (r. 1907–1910) of the Daehan Empire.[31]

When the court decides to hold a royal wedding, the first step is to select the bride-to-be through the three-stage selection process called *gantaek*, for which the Ministry of Rites issues an order of marriage prohibition (*yejo geumhollyeong*) on all maidens between the ages of nine and thirteen.[32] Exceptions to this prohibition were also spelled out: maidens of Jeonju Yi surname (royal family); maidens of Yi surname other than Jeonju Yi; maidens of the same surname as the dowager queen within a five-*chon* radius of her, a *chon* being the degree of kinship, or the number of times removed from a relative;[33] maidens of the same surname as the queen within a seven-*chon* radius of her, or different surname within six *chon*; and maidens of a surname other than Yi who are within eight *chon* from the crown prince.

The names of eligible maidens between the ages of nine and thirteen from scholar-official families are submitted, including the names and official titles of their fathers, grandfathers, and great-grandfathers, plus the names and official titles of their maternal lineage up to their grandfather. An example of such a list (*gantaek danja*) survives from the first wedding of the crown prince (later Emperor Sunjong) in 1882 (fig. 36).

A maiden who enters the palace for marriage into the royal family is considered royal from the moment of her third (final) selection to be the queen or the crown princess, and she does not return to her parents' home. Instead, she is taken to a detached palace (*byeolgung*), where she stays until

[36]

the wedding day and is instructed on the etiquette, manners, and lifestyle of the royal palace. The detached-palace system was necessary because a private home would have been inadequate to accommodate the very complicated series of ceremonial events leading up to the royal wedding.[34] The wedding proper takes place in the royal palace, but other preparatory ceremonies are performed at the detached palace.

The royal wedding requires six rites: (1) the royal proposal (*napchae*); (2) the acceptance of the royal proposal (*napjing*); (3) the announcement of the date of the wedding (*gogi*); (4) the royal appointment of the queen or crown princess (*chaekbi* or *chaekbin*); (5) the royal groom's visit to the detached palace to meet the bride and escort her to the palace (*chinyeong*); and (6) the formal wedding ceremony in which the royal couple exchange bows and share a cup of wine (*dongnoeyeon*).[35]

In the course of the six rites of the royal wedding, the royal family twice sends the gift of a live wedding goose to the detached palace, once at the time of the proposal and again at the time of the royal groom's visit to the detached palace to meet the bride in person. Koreans believed that a goose is faithful to its mate all through its life, so the goose became a symbol of marital fidelity. Since it was a live bird, its neck had to be tied and its wings and body kept in a wrapping cloth specially made for it. The presentation of the goose is a vow to be faithful to the bride.[36] At the time of the second presentation, the bearer of the goose (*jangchukja*) goes on horseback ahead of the groom's palanquin, and hands the bird to the groom upon his arrival. The groom then places the bird on a table[37] for the rite of presenting the goose [to the bride]. The royal couple then proceed to the formal marriage rite, *dongnoeyeon*, or exchange of bows and wine.

With this basic outline of royal wedding rites in mind, I shall examine two royal wedding *uigwe*: the earliest existing wedding *uigwe*, which documents the 1627 wedding of the Crown Prince Sohyeon (1612–1645) and Crown Princess Kang (1611–1646),[38] and the 1759 *uigwe* of the wedding of King Yeongjo (1694–1776) and Queen Jeongsun (1745–1805).[39] These two examples not only shed light on specific features of these rites, but also show how the royal wedding rites changed from the early seventeenth century to the second half of the eighteenth century.

Uigwe of the Wedding of Crown Prince Sohyeon, 1627

Prince Sohyeon, who is remembered especially for the nine years he spent as a hostage in the Manchu Qing court and the sad fate of his wife and sons,[40] was appointed crown prince in 1625 and two years later married the daughter of Gang Seok-gi (1580–1643), then minister of the right. The wedding *uigwe* consists of a single volume, with eight

pages at the end illustrating the wedding procession.[41] As in other early seventeenth-century *uigwe*, the format of the book was not formally established, and there is no table of contents at the beginning. Minister of the Left Sin Heum (1566–1658) was appointed to lead the superintendency in charge of the ceremonial proceedings.

Since this was the wedding of a crown prince, an additional ceremony called *imheon chogye* (king's admonishing of the crown prince at the stone platform to the east of the throne hall) was required. The crown prince had to appear before his father (the king) and court officials in front of the throne hall of the main palace to receive his father's order: "Go and meet the bride and order her to inherit the affairs of the royal ancestral shrine and manage subordinates with authority." The crown prince receives the order, saying, "Your subject will follow the order with utmost respect." He then bows to the king four times.[42] This ceremony was performed on the same day as the royal groom's visit to the detached palace, just before he set out to meet his bride.

The *uigwe* records that the first round of the selection process took place on the twenty-fifth day of the sixth month, the proposal on the twenty-eighth day of the tenth month, the acceptance on the twentieth day of the eleventh month, and the announcement on the twenty-first day of the eleventh month. The subsequent appointment of the crown princess took place on the fourth day of the twelfth month and the groom's visit to the detached palace on the twenty-seventh day of the twelfth month. The Bongung palace in the precinct Hyanggyo-dong,[43] the birthplace of Sohyeon's younger brother, served as the detached palace for the bride-to-be. The first four stages of the wedding rites were performed in this location. However, the fifth stage, going to meet the bride, took place in Taepyeonggwan hall, ordinarily the guesthouse for Chinese envoys.[44] According to the *uigwe*, instead of visiting the detached palace to meet the bride, the crown prince went directly to Taepyeonggwan and waited for her there. The bride, therefore, had to go there in her own palanquin with her own honor guards. The wedding rite proper (*dongnoeyeon*), took place in the Sungjeongjeon (Throne Hall) of the Gyeonghui Palace.[45]

The preparations for all the above stages of the wedding were recorded from the sixth month of 1627 to the first month of 1628. These include the preparation of the goods and materials for all stages, the regulations on costumes for all participants, and a list of gifts to be sent to the bride's parents. The first subdivision of the superintendency prepared the document of appointment of the princess and her special wedding costume. The second subdivision was responsible for the flags and ceremonial weapons to be used for the procession of the honor guards,

父通政大夫行成川都護府使兼成川鎮兵馬僉節制使慶母城右嘗軒　李弘

福國崇祿大夫議政府領議政兼事曹判書世孫禁府事經筵義禁嘗事侍講院蔡善衛都總府都總管　贈謚孝憲書學　贈謚孝

曾祖　贈右議政行資憲大夫書判書兼知義禁府事五衛都總府都總管　贈謚孝貞公　東獻

外祖嘉善大夫行龍驤衛護軍閔致序本驪興

處子徐氏年十六壬申正月二十四日時生本大邱　西部嘉華坊大貞洞

父折衝將軍行龍驤衛副護軍　葵淳

祖通訓大夫行富平都護府使兼南陽鎮管兵馬同僉節制使鎮撫前營將　鳳輔

曾祖　贈領議政行正憲大夫禮曹判書兼知經筵春秋館義禁府事五衛都總府都總管　有寧

外祖　贈吏曹判書行成均進士金在謙本光山

處子閔氏年十一辛未正月初五日寅時生本驪興　南部會賢坊美洞契

父折衝將軍行龍驤衛副護軍　侍講院兼輔德　昌植

祖　贈吏曹叅判　泳瓚

曾祖　贈吏曹叅議　俊鏞

外祖啓功郎繕工監假監役李徽黑本延安

FIG. 36 List of marriage-able maidens (*gantaek danja*) from the first wedding of the crown prince (later Emperor Sunjong), 1882. Ink on paper, 118.5 × 25.8 cm; title on silk. Jangseogak Archives, The Academy of Korean Studies (RD 01756).

處子洪氏年九癸酉七月初三日丑時生本南陽　北部嘉會坊齋洞契

父折衝將軍行龍驤衛副護軍　萬植

祖朝奉大夫行童蒙教官　淳敬

曾祖　贈領議政行通政大夫吏曹參議　鍾遠

外祖通訓大夫前行禮山縣監兼洪州鎮管兵馬節制都尉金延根本安東

處子閔氏年十壬申十月二十日戌時生本驪興　中部慶寧坊磚石洞契

父崇政大夫判敦寧府事兼知中樞府事經理統務衙門事　世子左副賓客　台鎬

曾祖　贈吏曹判書行嘉善大夫吏曹參判兼知　經筵義禁府事五衛都摠府副摠管　弘燮

祖　贈左贊成　玫三

處子趙氏年八甲戌三月十六日丑時生本豐壤　北部陽德坊桂生洞契

外祖通訓大夫行刑曹正郎宋在華本礪山

父將仕郎前行童蒙教官　秉黙

祖正憲大夫禮曹判書兼知　經筵春秋館事弘文館大提學藝文館大提學知經筵義禁府事知成均館事同知成均館事五衛都摠府都摠管　龜夏

曾祖崇政大夫判敦寧府事兼判義禁府事知經筵春秋館事五衛都摠府都摠管　奎章閣提學　秉鉉

preparation of the interior and exterior of the event halls, boxes for ritual items, and all the screen paintings, including those for the detached palace. The third subdivision was responsible for the preparation of the bamboo book and all the utensils to be used for the event. Listed by their trade are the artisans who served each subdivision.[46] It should be noted that not all *uigwe* show the same division of labor. A special memorandum (*bimanggi*) lists awards given to officials, workers, and artisans.[47]

The *Banchado* The eight-page *banchado* is the shortest of all known surviving wedding *uigwe* (figs. 37–40). This is in part because the wedding was that of a crown prince rather than a king. More fundamentally, however, it is because the wedding custom of the time did not require the groom to go to the detached palace in person and escort his bride to the palace. The groom first met the bride at Taepyeonggwan, but the couple went separately to the palace. Therefore, the procession featured only the bride's palanquin and other smaller ones carrying ritual objects. (The *banchado* of King Yeongjo's second wedding in 1759, discussed below, was the first one to show both the king's and the queen's palanquins.)

 The *banchado*'s title, *Banchado of the Occasion of the Crown Princess Going from the Detached Palace to Daepyeonggwan* (*Sejabin ja byeolgung ye daepyeonggwan si banchado*), is written at the end of the page adjoining the end of the *banchado*. The *banchado* opens with various kinds of palace guards who clear the way for the procession (fig. 37). Most of them are labeled, and important persons are on horseback. On the second page, a small palanquin holding the royal order of appointment is carried by twelve men. Flanking the palanquin are palace guards on white horses, with two stewards closer to the palanquin. The third through the fifth pages feature three more small palanquins, those carrying the bamboo book, the seal of the crown princess (fig. 38), and the crown princess's formal costumes (fig. 39). The seal palanquin is flanked by flag bearers and honor guards with ritual weapons as prescribed in the *Five Rites of State*. These four palanquins always precede the larger palanquin of the royal bride, which here appears on page six. On either side of the crown princess's palanquin are female palace attendants, including two wet nurses (*yumo*) on horseback who wear veils under their hats to cover their faces, in accordance with the Joseon period custom of covering women's faces in public. It is unusual to see female palace attendants in public street processions of the Joseon period. Although the social status of wet nurses and palace servants (*sinyeo*) is low, that of *sanggung* (palace lady, rank 5a) is higher.[48] Following the female riders on page seven (fig. 40) are palace eunuchs and officials of the superintendency, including Superintendent

[37]
[38]
[39]
[40]

[37]

[38]
[39]

[40]

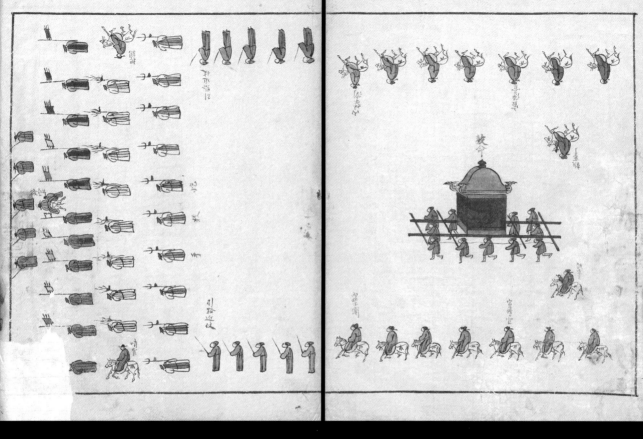

page 1

page 2

FIG. 37 The crown princess's honor guards and the small palanquin carrying the royal order, from the *Prince Sohyeon ([Sohyeon seja] garye dogam uigwe)*, 1627. Book; ink and color on paper, 43.4 × 35 cm. Jangseogak Archives,

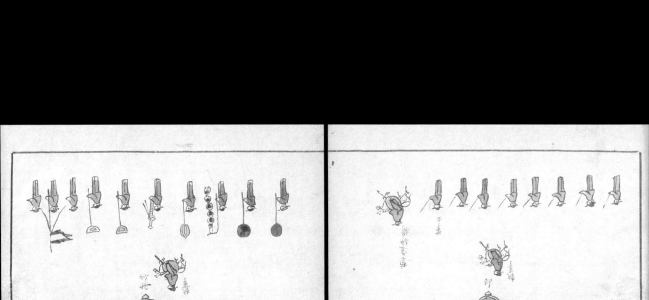

page 3 page 4

FIG. 38 Two small palanquins carrying the bamboo book (page 3) and the seal (page 4) of the princess, from the *banchado* in the *Uigwe of the Wedding of Crown Prince Sohyeon* (*[Sohyeon seja] garye dogam uigwe*), 1627. Book; ink and color on paper, 43.4 × 35 cm. Jangseogak Archives, The Academy of Korean Studies (K2-2592).

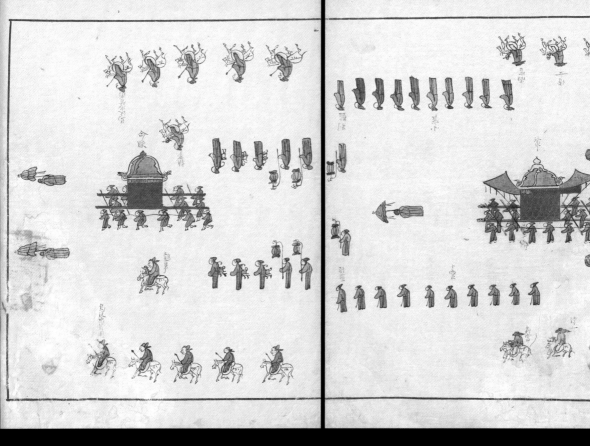

page 5 page 6

FIG. 39 Small palanquin carrying the crown princess's formal costume (page 5) and the palanquin of the crown princess (page 6), from the *banchado* in the *Uigwe of the* *Wedding of Crown Prince Sohyeon ([Sohyeon seja]* *garye dogam uigwe)*, 1627. Book; ink and color on paper, 43.4 × 35 cm. Jangseogak Archives, The Academy of Korean Studies (K2-2592).

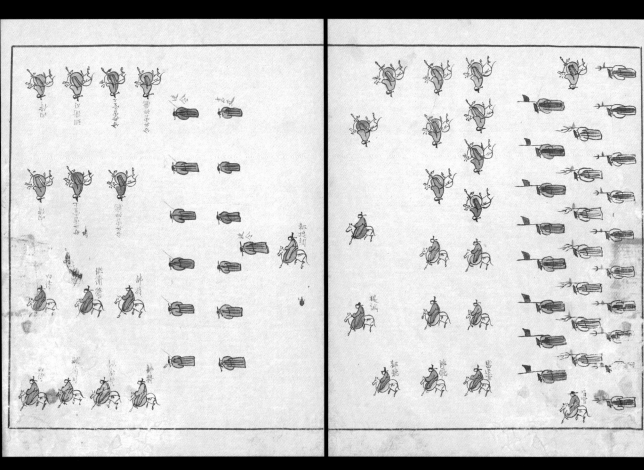

page 7 page 8

FIG. 40 Officials of the
superintendency and
rear honor guards, from
the *banchado* in the
Uigwe of the Wedding

dogam uigwe), 1627.
Book; ink and color on
paper, 43.4 × 35 cm.
Jangseogak Archives,
The Academy of Korean

Minister of the Left Sin Heum. The last page is filled with various guards and soldiers who are protecting the rear of the procession.

Although short, this wedding *banchado* contains the basic components of a wedding *banchado*: the four small palanquins carrying ritual items for the royal wedding, and the full-size palanquin of the royal bride with appropriate attendants, flags, and honor guards with their ritual weapons. More than 430 figures can be counted in this procession painting, but in reality there were more. All other wedding *uigwe banchado* before the 1759 wedding of King Yeongjo and Queen Jeongsun follow this basic composition with small variations depending on whether it is a *banchado* for the wedding of a king or a crown prince.

Uigwe of the Wedding of King Yeongjo and Queen Jeongsun, 1759[49]
King Yeongjo's first queen, Jeongseong (1692–1757), passed away without producing a male heir to the throne. The court then selected the daughter of a young scholar with no official position, Kim Han-gu, as the new queen. She became Queen Jeongsun. At that time, Yeongjo was already sixty-six years old, while his new bride was only fifteen.[50]

The 1759 *uigwe* of this royal wedding was the first one produced after the 1744 publication of the *Sequel to the Five Rites of State*, the 1751 publication of the *Addendum to the Sequel to the Five Rites of State* (*Gukjo sok oryeui bo*) with illustrations, and the 1749 *Established Protocol for a Royal Wedding* (*Gukon jeongnye*), which limited the quantity of the wedding costumes and gifts in keeping with King Yeongjo's adherence to the Confucian spirit of frugality.

Another important change was in the procession from the detached palace to the palace: after meeting his bride at the detached palace, the king brought her back to the palace, traveling in the same procession but in separate palanquins. The rite of *chinyeong* (whereby the groom meets the bride in person) was not completely new as there are records of its performance by King Jungjong in 1517 and King Injo in 1602, although no *uigwe* were compiled for their wedding rites. In fact, from the beginning of the Joseon dynasty, there were debates about the *chinyeong* system based on the Confucian model, but scholar-officials who preferred the age-old Joseon customs of sending a messenger to the detached palace prevailed most of the time.[51] Although King Sukjong's second wedding, in 1681, did not follow the precedents of King Injo, he decided to perform the *chinyeong* rite for his third wedding, in 1702.[52] This decision and practice was reflected in the compilation of the *Sequel to the Five Rites of State* of 1744 along with the note, "Sukjong made this decision in the *imo* year (1702)."[53] However, the eighteen-page *banchado* of the 1702 wedding *uigwe* shows only the queen's procession.[54]

The 1759 wedding *banchado* is, therefore, the first one to reflect the updated *chinyeong* rite showing the palanquins of both the queen and the king, each with their own honor guards. All later subsequent wedding *banchado* followed this model.

This 1759 *Uigwe of the Wedding of King Yeongjo and Queen Jeongsun* is also the first wedding *uigwe* to have a well-organized table of contents for the two-volume set, which is as follows:

- List of personnel of the superintendency (*jwamok*)
- Letters to the king (*gyesa*)[55]
- Documents sent to other offices from the Ministry of Rites (*yegwan*)
- Documents to and from offices of the same level (*imun*)
- Documents received from higher- or equal-level offices (*naegwan*)
- List of documents to superior offices mostly asking for supplies (*pummok*)
- Documents from higher- to lower-level offices (*gamgyeol*)
- Written report to the superintendent (*seogye*)
- Discussion of awards from the court to all participants in the event (*nonsang*)
- Supplement, *uigwe* of the subdivisions of the superintendency ([Bu] *uigwe*, *Ilbang uigwe*, *Ibang uigwe*, *Sambang uigwe*, *Suriso uigwe*)
- *Banchado* (illustration of the procession showing placement of participants by rank)

Volume 1 contains everything up to the first subdivision of the superintendency, and the second volume contains the rest, including the *banchado* at the end. An important difference from the 1627 royal wedding *uigwe* is a long section (at the end of the section on the first subdivision) that provides a step-by-step protocol for all stages of the wedding rites based on the *Five Rites of State* and its sequel.[56] Notably, the personnel section lists as superintendent Prime Minister Sin Man (1703–1765), who was responsible for editing the *Sequel to the Five Rites of State*.

Many of the ritual items recorded were either newly made or repaired for the event, and the list of items under each of the five subdivisions indicates the division of labor. For example, the first subdivision produced the royal order of appointment in a handscroll of five-colored silk, formal costumes for the bride and the groom (*uidae*), and step-by-step procedures and protocols for the ceremony (*uiju*), not to mention floor coverings (*pojin*), tables of all sizes and heights (*sangtak*), and covered

boxes and containers (*gweham*). The second subdivision prepared the palanquins, flags, and other ritual weapons.

The names of all the artisans, painters, scribes, and seamstresses who contributed to the event are entered under their specialties or trades at the end of each subdivision record, shedding light on the division of labor among Joseon artisans.[57] Court painters are listed for all three subdivisions, seven names each under the first and second subdivisions and four under the third.[58] Yi Pil-seong, whose name appears twice, under the second and third subdivisions, probably painted the well-known album *Simyanggwando* (*Scenes of Shenyang Hall*), which depicts scenes from the 1760–1761 Joseon embassy to China.[59] Of all the painters cited, however, Kim Eung-hwan (1742–1789), who was attached to the second subdivision, is perhaps the best known. His remaining works are mostly landscapes.[60]

Most wedding *uigwe* list several screen paintings to be newly made, identifying their subjects and the locations where they were to be used in the ceremony.[61] In this *uigwe*, however, there is no mention of new screen paintings. We find names of artisans designated screen craftsmen (*byeongpungjang*), but they were artisans who specialized in making or constructing screens, not painting them. Apparently, in the spirit of frugality, King Yeongjo had existing screens repaired for his wedding. This is suggested by remarks he made three years later, in 1762, at the time of his grandson's wedding:

> [The king said] the sayings of scholars of old are worth keeping in mind as maxims. They said that talking about wealth in a marriage is only what the barbarians do. Furthermore, the Joseon court has considered it a virtue to be frugal.... Lately, as extravagance is becoming a fad among the general population, the royal family should set a model [of frugality].[62]

On the same occasion, the king ordered the reuse of an existing pair of jade figurines to be placed on red lacquered tables for the formal wedding ceremony[63] and the use of gold-plated metal rather than pure gold for accessories, except for the pair of wine cups used by the bride and groom.[64]

The *Banchado* Of the fifty pages of this *banchado*, the first twenty-eight pages show the procession centered on the king's palanquin, while the remaining twenty-two pages illustrate the procession with the queen's palanquin.[65] The order of the king's procession reflects the regulations governing the king's grand procession (*daega*) complete with accompanying honor guards (*nobu*) in the celebratory rites section of the *Illustration of*

the Five Rites of State.[66] The procession is led (pages 1–3) by palace guards
[41] (figs. 41, 42), followed by the mayor of Hanseong, the minister of rites (*yejo*
[42] *dangsang*), the minister of revenue (*hojo dangsang*), the inspector general
(*saheonbu dangsang*), and the minister of defense (*byeongjo dangsang*), all on
horseback.[67]

The symbols specific to the presence of the king in the grand proces-
sion (pages 9, 10) are the distinctive military flag, called *duk*, made of thick
red fur mounted on a metal tripod held by a single equestrian figure, and
a large yellow flag of intertwined dragons with red borders (*gyoryonggi*)
[43] carried by five men, one mounted and four on foot (fig. 43). These two
royal symbols, in turn, are led by a chief palace guard (*geumgun byeoljang*)
and three subordinates (*gyoryeongwan*), all on horseback with quivers
on their backs. Next come flags of the red phoenix of the south and the
yellow dragon of the center, two of the deities of the four directions, then
[44] several pages filled with flags, ritual weapons, and horses (fig. 44). Next
comes a procession of fan bearers, six phoenix fans, five peacock fans, and
one dragon fan, flanking people carrying necessary items, such as a chair
and a footrest, protected by horses and grooms. Behind this procession is
an open sedan chair borne by ten men preceding the secondary palanquin
(labeled *buyeon*), which is smaller than the king's palanquin, and guarded
on either side by ten soldiers who bear either a sword or a spear; it is
customary to have a backup palanquin for the king's procession.

The heart of this *banchado* is the section featuring the king's large
[45] palanquin (fig. 45), which is preceded by special forces on horseback, each
soldier equipped with a quiver and arrows. The soldiers tightly guard
either side of the front musical band (*jeonbu gochwi*); the band, wearing red
uniforms (conductor wears green), marches in front of lantern bearers.
More soldiers guard the front of the king's palanquin, which is carried
by eighteen men. The palanquin is open on all four sides, presumably to
allow a view of the king, although his image is not depicted. On the right
side of the palanquin is a parasol bearer carrying the red parasol of the
king. Following the palanquin are attendants holding a pair of large blue
fans and more flags. The rear musical band (*hubu gochwi*) and its conductor
bring up the rear of the royal palanquin unit. Arranged along the top and
bottom edges of the composition are equestrian officials, whose duty is to
closely guard the palanquin, as well as the royal physician and a eunuch,
[46] who need to be close to the king. The subsequent pages (fig. 46) depict the
staff of the Royal Secretariat (Seungjeongwon), the chief royal secretary
(*doseungji*), four secretaries, and four court historiographers (*sagwan*),
followed by the staff of the royal pharmacy. High officials of the civil
(*dongban*) and military (*seoban*) classes are dressed in gold-crown court

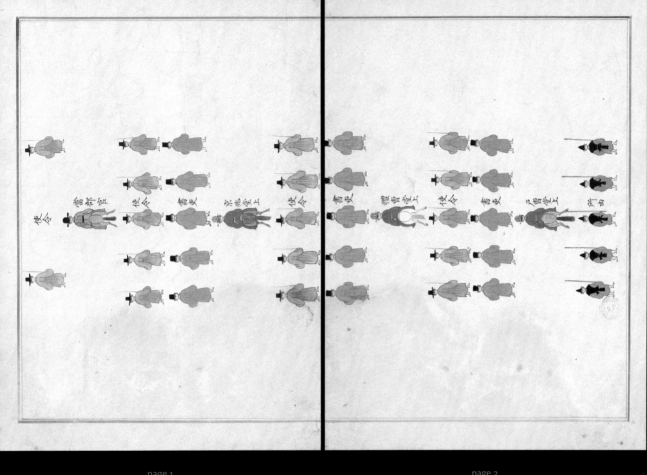

使令　書吏知印　使令　書吏　京兆堂上　使令　書吏　禮曹堂上　使令　書吏　戶曹堂上　所由

page 1 page 2

FIG. 41 The beginning of the king's procession showing palace guards, the mayor of Hanseong (page 1), the minister of rites, and the minister of revenue (page 2), from the *banchado* in

Queen Jeongsun ([Yeongjo Jeongsun wanghu] garye dogam uigwe), 1759. Book; ink and color on paper, 47.2 × 33.8 cm. Bibliothèque nationale de France (2535), on loan to the National

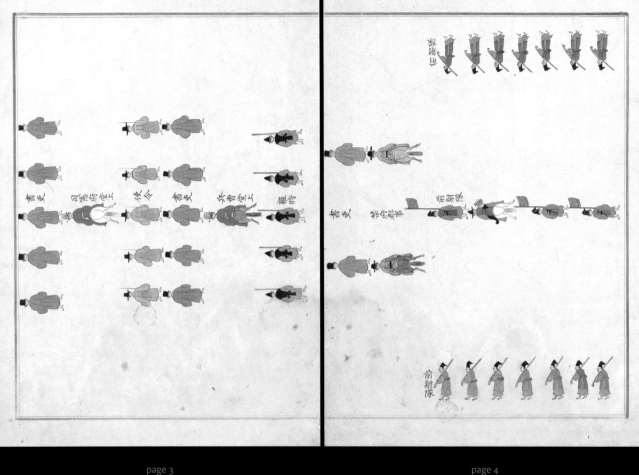

page 3

page 4

FIG. 42 The inspector general and the minister of defense (page 3), archers (page 4), and the king's grand procession flags and honor guards (pages 5, 6), from the *banchado* in

Queen Jeongsun ([Yeongjo Jeongsun wanghu] garye dogam uigwe), 1759. Book; ink and color on paper, 47.2 × 33.8 cm. Bibliothèque nationale de France (2535), on loan to the National

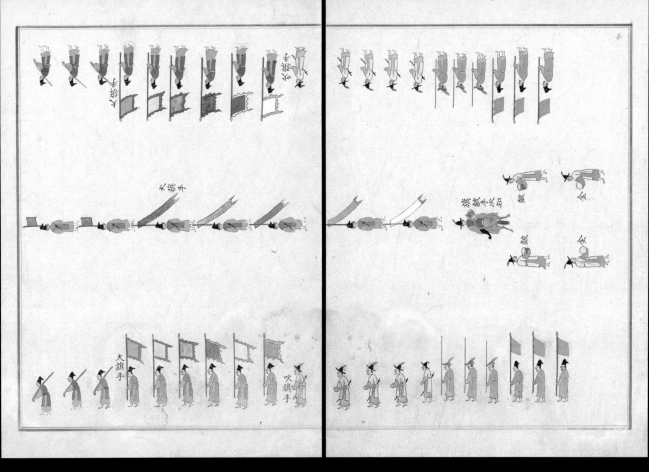

大纛纛

大旗手

大旗手 吹旗手

旗鼓手次執纛 鼓 金

鐵 金

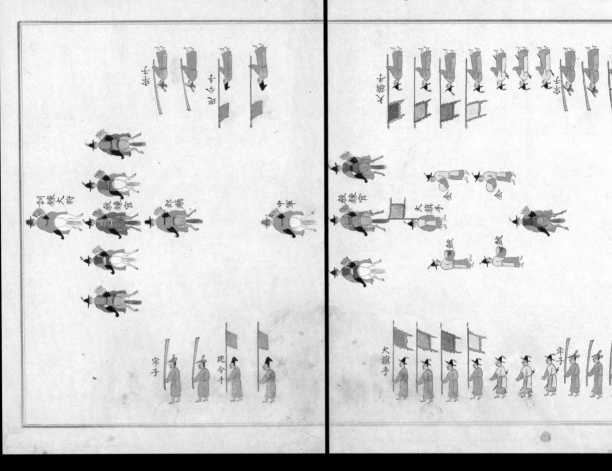

士旗 守內 士旗 大旗手 士旗

訓練大將 敎鍊官 部將 中軍

敎鍊官 大旗手 金 金

軍 敎 敎

守子 廵令手 大旗手 守子 守子

page 7　　　　　page 8

FIG. 43 The king's grand procession flags and honor guards (page 8) and the chief palace guard leading the "duk" military flag (pages 9, 10), from the *banchado* in the *Uigwe of the* ([*Yeongjo Jeongsun wanghu*] *garye dogam uigwe*), 1759. Book; ink and color on paper, 47.2 × 33.8 cm. Bibliothèque nationale de France (2535), on loan to the National Museum

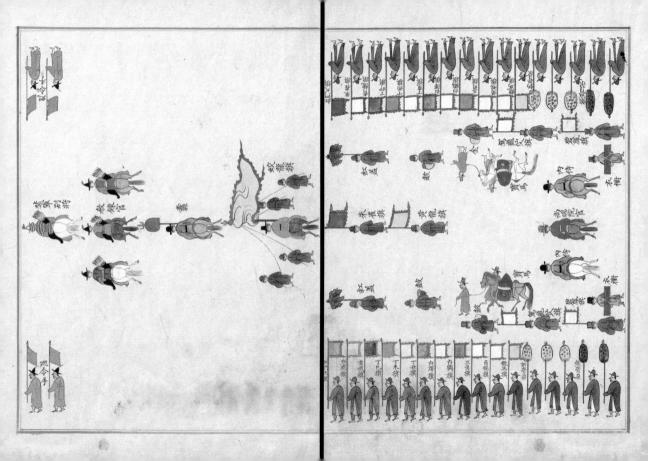

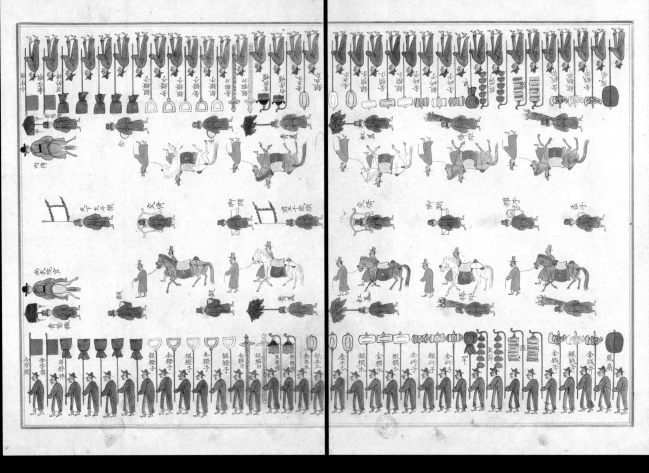

page 11

page 12

FIG. 44 Ceremonial flags, ritual weapons, horses, and participants in the procession, from the *banchado* in the *Uigwe of the Wedding of King Yeongjo and Queen Jeongsun ([Yeongjo Jeongsun wanghu] garye dogam uigwe)*, 1759. Book; ink and color on paper, 47.2 × 33.8 cm. Bibliothèque nationale de France (2535), on loan to the National Museum of Korea (Ogu 204).

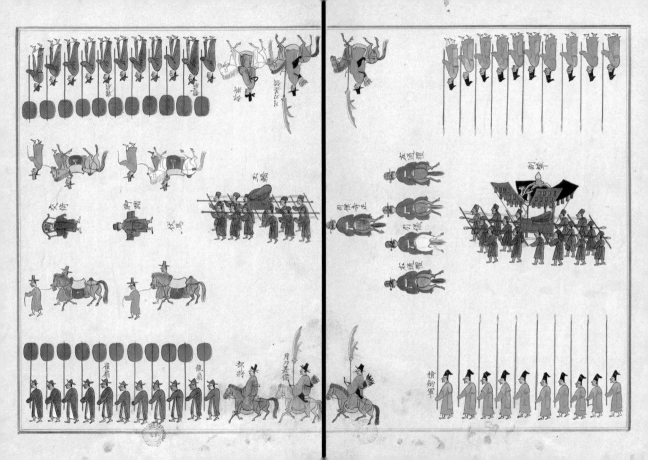

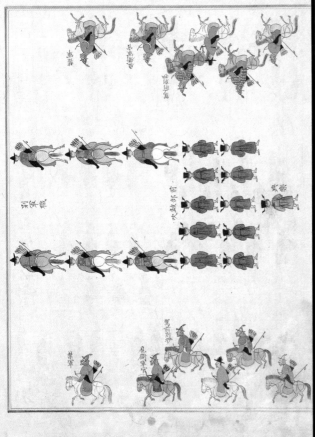

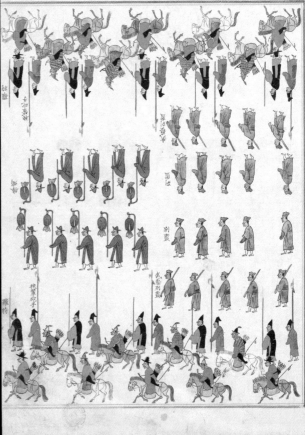

page 19

page 20

FIG. 45 King Yeongjo's palanquin (page 21) flanked by candle bearers, guards, a musical band, and officials, from the *banchado* in the *Uigwe* Jeongsun ([*Yeongjo Jeongsun wanghu*] *garye dogam uigwe*), 1759. Book; ink and color on paper, 47.2 × 33.8 cm. Bibliothèque nationale de France (2535), on loan

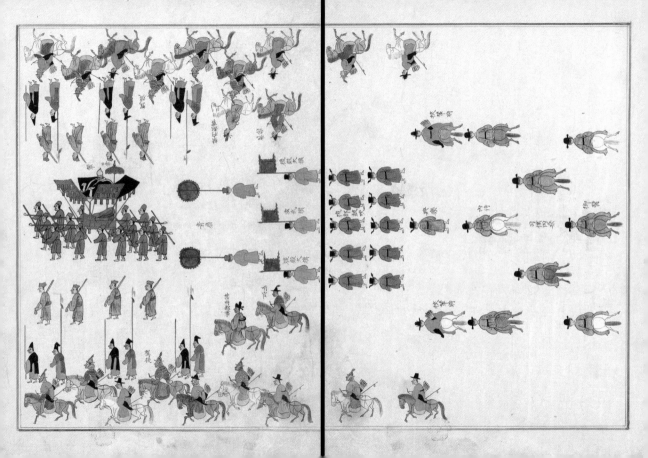

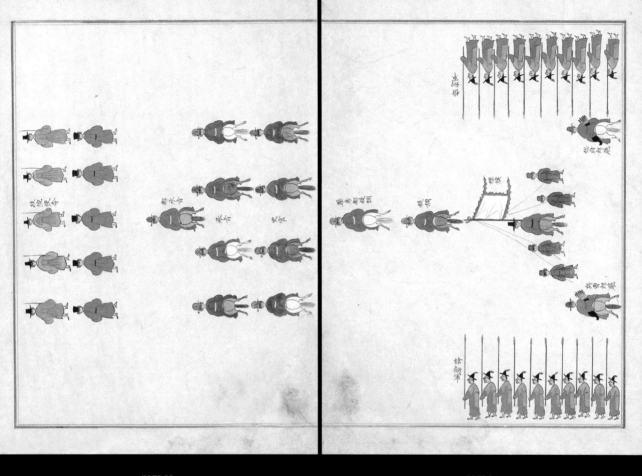

page 23

page 24

FIG. 46 The chief of the
Royal Secretariat, his
four secretaries and
four court historiog-
raphers (page 23), the
Royal Pharmacy and
armed guards (page
24), and high-ranking

the *Uigwe of the Wedding
of King Yeongjo and
Queen Jeongsun ([Yeongjo
Jeongsun wanghu] garye
dogam uigwe)*, 1759.
Book; ink and color on
paper, 47.2 × 33.8 cm.
Bibliothèque nationale

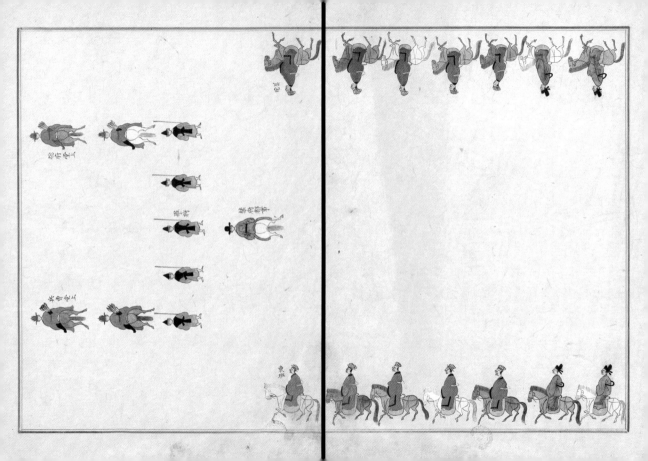

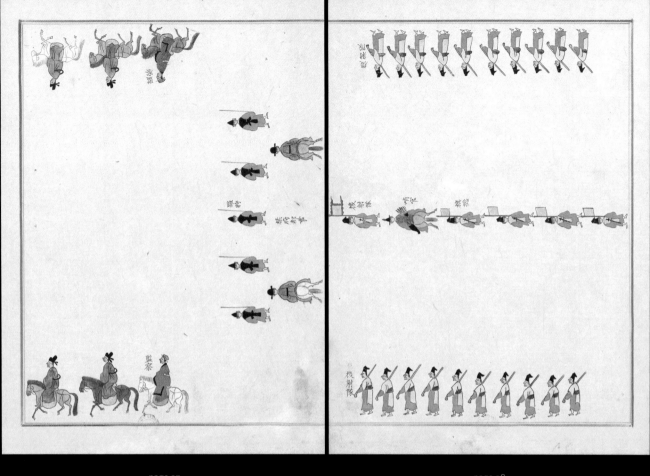

page 27

page 28

FIG. 47 King Yeongjo's
rear guards (pages
27, 28) and Queen
Jeongsun's front guards
(pages 29, 30), from
the banchado in the
Uigwe of the Wedding
Jeongsun wanghu] garye
dogam uigwe), 1759.
Book; ink and color on
paper, 47.2 × 33.8 cm.
Bibliothèque nationale
de France (2535), on
loan to the National

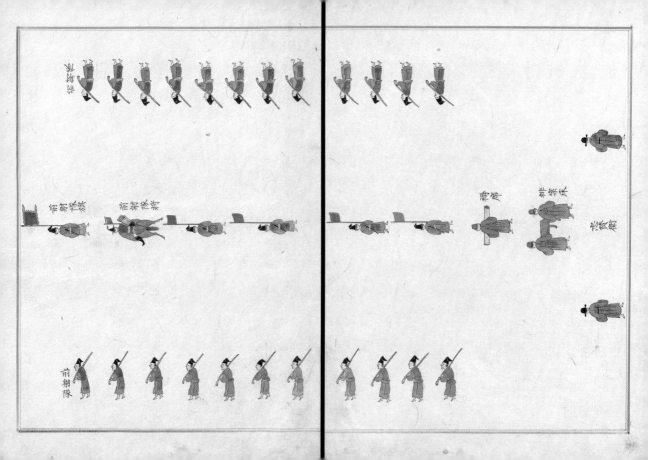

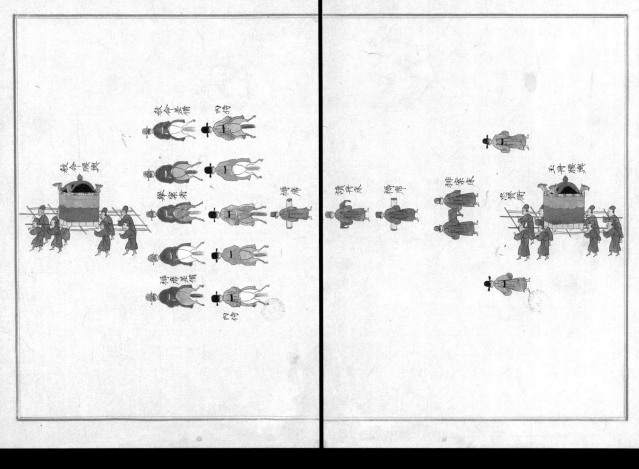

敎令差備　內待
敎令腰輿
捧彩者
捧席差備　內待

捧席
捧彩者

讀冊差備　捧冊
排彩差備
彩冊差備
玉冊腰輿

page 31 page 32

FIG. 48 Queen Jeong-
sun's small palanquins,
including those carry-
ing the jade book (page
32) and the queen's
gold seal (page 34),
from the *banchado* in

*Queen Jeongsun ([Yeongjo
Jeongsun wanghu] garye
dogam uigwe)*, 1759.
Book; ink and color on
paper, 47.2 × 33.8 cm.
Bibliothèque nationale
de France (2535), on loan

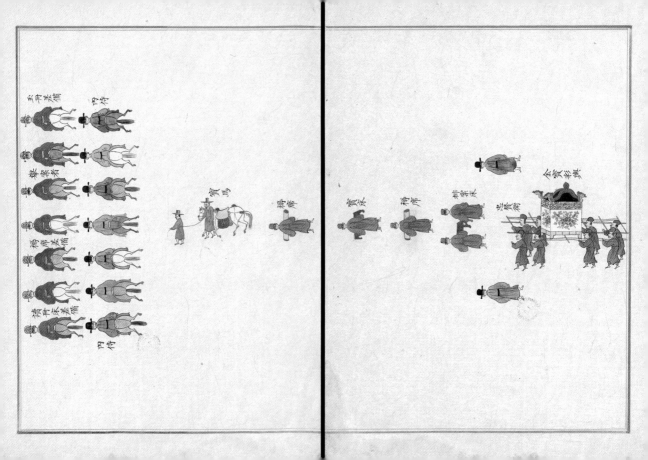

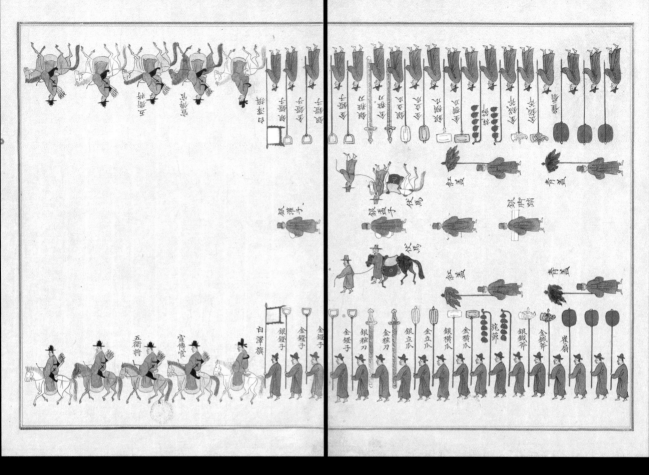

page 37

page 38

FIG. 49 The queen's honor guards, bearers of ritual weapons and fans (pages 37, 38), officials and musicians (pages 39–50), from the *banchado* in the *Uigwe of the Wedding*

Queen Jeongsun ([Yeongjo Jeongsun wanghu] garye dogam uigwe), 1759. Book; ink and color on paper, 47.2 × 33.8 cm. Bibliothèque nationale de France (2535), on loan to the National Museum

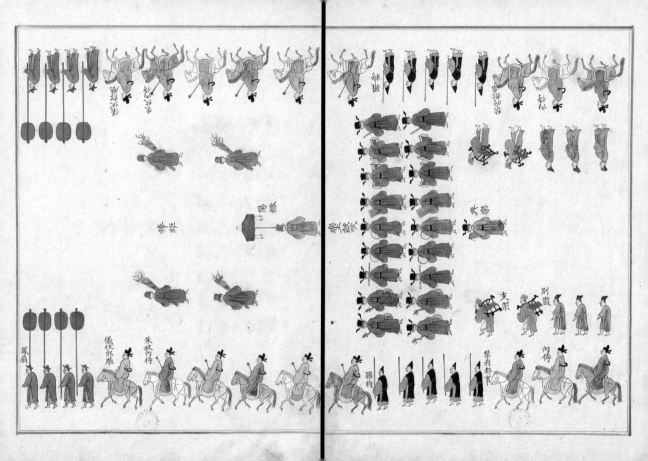

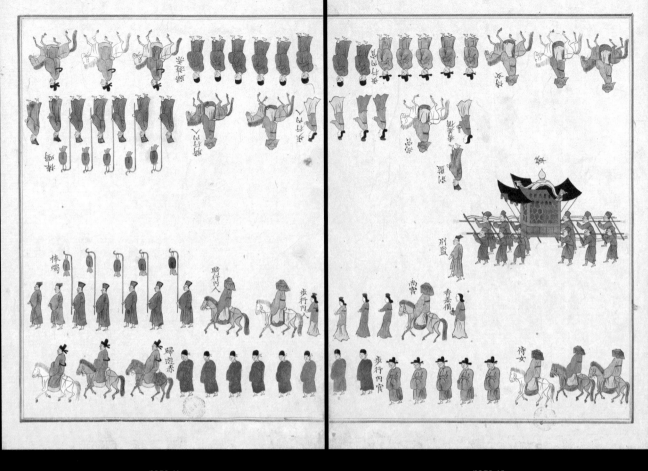

page 41

page 42

FIG. 50 The queen's palanquin preceded by female palace staff and followed by officials from the superintendency as well as civil and military officials,

Queen Jeongsun ([Yeongjo Jeongsun wanghu] garye dogam uigwe), 1759. Book; ink and color on paper, 47.2 × 33.8 cm. Bibliothèque nationale de France (2535), on

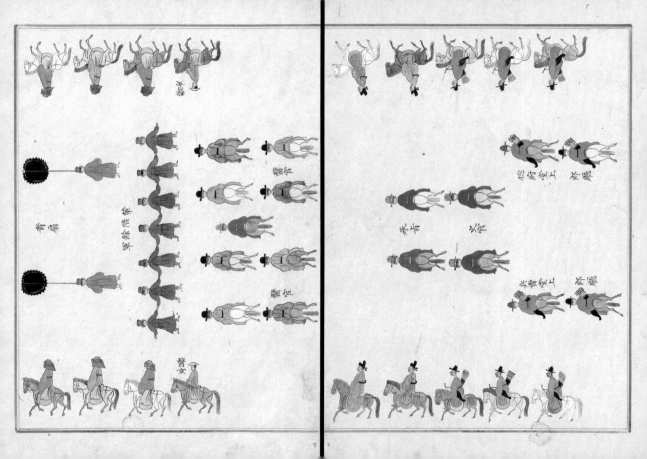

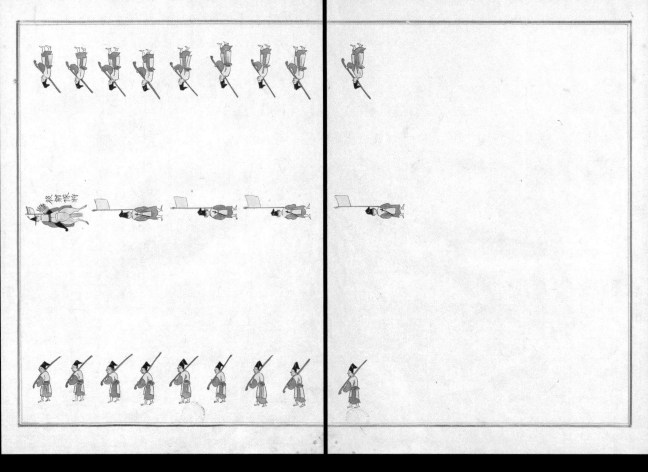

page 49

page 50

FIG. 51 Rear guards, from the *banchado* in the *Uigwe of the Wedding of King Yeongjo and Queen Jeongsun ([Yeongjo Jeongsun wanghu] garye dogam uigwe)*, 1759.

Book; ink and color on paper, 47.2 × 33.8 cm. Bibliothèque nationale de France (2535), on loan to the National Museum of Korea (Ogu 204).

costume (*geumgwan jobok*), the most formal court attire for officials, and follow the procession on either side.

The queen's procession is introduced (pages 29, 30) by guards and figures carrying objects for the final wedding ceremony, such as a quilt

[47] and a small, red-lacquered table for displaying ritual items (fig. 47). Four small palanquins carrying the necessary ritual items to be given to the queen appear one by one: (1) the king's letter of appointment; (2) the jade book; (3) the queen's gold seal; and (4) the queen's official costumes. The first two palanquins are in green and red colors below the black roofs, but the third and the fourth show side panels decorated with a large peony flower amidst abundant leaves against the white background. For

[48] this reason, they are referred to as painted palanquins (*chaeyeo*) (fig. 48). Pages 31–34 of the banchado show the second palanquin, which carries the queen's jade book, and the first painted palanquin, which carries the queen's gold seal. As in the king's procession, palace staff such as eunuchs and others charged with setting up the wedding banquet are seen in between the palanquins.

The procession of the queen's honor guards begins with the special palace guards. People are transporting silver items to be used for the queen, among them a ewer, a wine cup, a chair, and a footrest, flanked by men carrying other honor-guard items such as silver knives (*eunjangdo*),[68] flags, parasols, and fans. The honor guards for the queen's palanquin are shown next, each with their proper attributes such as ritual weapons

[49] and fans (fig. 49). Figure 50 shows three pages centering on the queen's
[50] palanquin and a fourth page of officials of the superintendency as well as additional civil and military high officials. On page 41, female palace staff with their heads properly veiled, some on foot and others on horse-back, go before the queen's palanquin in the center. Just ahead of it stand two equestrian chiefs of the female palace staff (*sanggung*), followed by servants who prepare incense and incense burners on page 42. The procession continues with more female staff, including female physicians. The queen's palanquin is carried by twelve men, followed by seven standbys (labeled as *yeonbae yeogun*) in case something happens to any of the designated bearers. Unlike the king's open-sided palanquin, the queen's palanquin is closed from view all around with red drapes decorated with hexagonal patterns outlined in green. The *banchado* ends with

[51] the rear guards (fig. 51).

This grand wedding procession went along the broad street from Eoui Palace on the northwestern side of Gyeongbok Palace (in today's Sajik-dong), where King Yeongjo met his bride to escort her to the Tong-myeongjeon hall of Changgyeong Palace, a distance of approximately

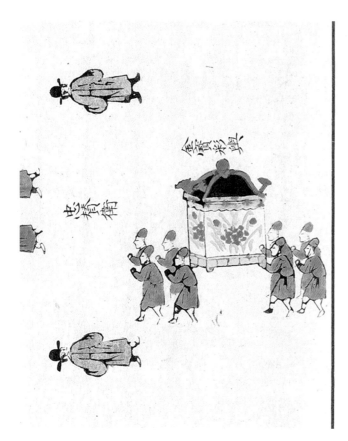

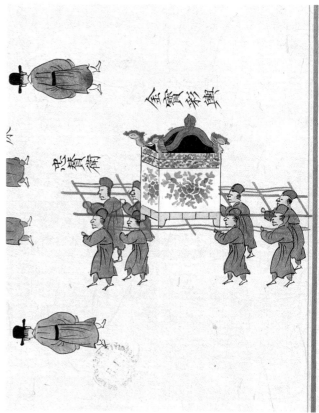

FIG. 52 Gold seal palanquin from a history archive copy. Detail of the *banchado* in the *Uigwe of the Wedding of King Yeongjo and Queen Jeongsun* ([Yeongjo *Jeongsun wanghu] garye dogam uigwe*), 1759. Book; ink and color on paper, 45 × 32.3 cm. Jangseogak Archives, The Academy of Korean Studies (K2-2591).

FIG. 53 Gold seal palanquin from the royal viewing copy. Detail of *banchado* (page 34) in the *Uigwe of the Wedding of King Yeongjo and Queen Jeongsun* (fig. 48).

3.6 kilometers. The distance was not great, but the pace of the procession was very slow in order to give the king's retinue maximum exposure to the people along the way. Beginning with King Yeongjo, late Joseon kings used such grand processions to demonstrate their concern with maintaining close contact with the people.[69] In 1759, King Yeongjo became the first king to leave a pictorial record of his participation in his own wedding procession.[70]

As for the quality of the procession paintings, we are fortunate to have the royal viewing copy and the history archive copies for comparison. The *banchado* of the royal viewing copy was entirely hand-painted and hand-colored, whereas the *banchado* of the history archive copies show occasional use of stamping for the outline of figures that were similar and thus repeatable. As a result, the figures in the royal viewing copy display individual characteristics, with lively movements and expressions, while those in the distribution copies do not. Also, some of the pages of the distribution copies lack certain fine details, such as the arrows in the equestrian archers' quivers, seen in the royal viewing copy. Furthermore, the rendering of the gold seal palanquin in the distribution [52] copies (fig. 52) lacks the two parallel bars, short transverse bars, and braided cotton ropes (*damjul*) used to carry it that are visible in the royal [53] viewing copy (fig. 53). As a result, the bearers and the palanquin are separate, and the palanquin seems to be hovering in the air.

The two *uigwe* for royal wedding ceremonies discussed above, created some 150 years apart, give a sense of how this ritual tradition was sustained and developed in the mid-Joseon period. In both cases, the order of the six rites for royal weddings remained mostly unchanged. However, the 1759 performance of the fifth rite, wherein the royal groom visits the detached palace to meet the bride and escort her to the palace, differed from that of the 1627 wedding. On the earlier occasion, the groom, Crown Prince Sohyeon, did not go to the detached palace in person but instead waited for his bride to come to him at the palace, in her own palanquin, and with her own entourage. For the 1759 wedding rite, the royal groom, King Yeongjo, called on the bride in person at the detached palace and escorted her to the royal palace in a grand joint royal entourage, featuring both of their palanquins, for the wedding ceremony. Given King Yeongjo's personal proclivities and imposing personality, we can assume that he took it upon himself to decide how the wedding rites were to be performed. These two wedding *uigwe* document the enduring continuities as well as the changes possible in court rituals. ◆

CHAPTER THREE

Uigwe of Rites for Receiving Envoys, *Billye*

In Joseon Korea, the reception of any Chinese envoys for state funerals, investitures of kings or crown princes, and other important state occasions had to be performed with utmost formality and care. Also, there were occasions when Japan and Ryukyu sent emissaries to the Joseon court, and those too had to be received by Joseon kings with formalized courtesy. According to the *Five Rites of State* (1474), the third of the five rites is *billye*, or receiving envoys from China, Japan, and Ryukyu.[1] *Billye* is performed for the following occasions:

1. The royal banquet for Chinese envoys at the Taepyeonggwan guesthouse upon their arrival in Hanyang
2. The banquet for the envoys hosted by the crown prince at the Taepyeonggwan guesthouse
3. The banquet for the envoys hosted by the royal relatives at the Taepyeonggwan guesthouse
4. The reception of letters and gifts from emissaries of Japan and Ryukyu at Geunjeongjeon, the throne hall of the Gyeongbok Palace
5. The banquet for emissaries of Japan and Ryukyu, held at Sajeongjeon, the royal residential hall in Gyeongbok Palace

Although there was an article in the entry dated 1420 (Sejong 4) of the *Veritable Records of King Sejong* in which the superintendency for the reception of a Ming envoy (*Yeongjeop dogam*) presents a poppy to the envoy, it is not clear whether a *uigwe* was compiled at that time. The record of the reception of Chinese envoys who came to announce Emperor Shenzong's (r. 1573–1620) ascension to the throne in 1572 (Seonjo 5) remains in the form of an album painting titled *Uisungwan yeongjodo*, which depicts the Uisungwan Guesthouse in Uiju, just across the Amnok/Yalu River, where the envoys were greeted by Joseon officials.[2]

But it was not until the reign of Gwanghaegun (r. 1608–1623) that the Joseon court compiled its first *uigwe* of receiving envoys from China. Compared to *uigwe* of other state events, which consist of the *uigwe* of the main superintendency and three or more subdivision *uigwe* that are all attached to the main *uigwe*, *uigwe* for *billye* rites were in quite a different format. In addition to the main superintendency for the supervision of the entire event, six subdivisions were established for the following tasks:

1. Military (*gunsaek*) to help with the roadwork of receiving envoys
2. Provisions (*eungpansaek*) to help prepare gifts for the envoys as well as other items they requested
3. Banquet preparation (*yeonhyangsaek*)
4. Main meal preparation (*mimyeonsaek*)
5. Side dishes preparation (*banseonsaek*)
6. Snack preparation (*jammulsaek*)

It was also customary to compile a separate *uigwe* to record the work of each of the subdivisions. During his reign, Gwanghaegun had three *billye uigwe* compiled after the Chinese envoys visited: the first in 1609, the second in 1610,[3] and the third in 1622. Today, only the first two survive.[4] During the reign of King Injo (1623–1649), *billye*-related *uigwe* were produced five times, one each in 1626 and 1634 for Ming envoys, one in 1637, and two in 1643 for the envoys from the newly established Qing empire.

At this time, due to the dynastic change from Ming to Qing in China, the proper performance of *billye* rites became a more complicated and serious task for the Joseon court. Ming envoys were received on three occasions.[5] In June 1634 (Injo 12), the Joseon court received Qing envoys who brought the letter of approval of the Manchu court for the investiture of Crown Prince Sohyeon.[6]

In 1637 (Injo 15), the Joseon court had to receive the Manchu envoys immediately after the humiliating surrender to the Chinese at the time of *Byeongja horan* (the Manchu invasion in the cyclical year *byeongja*).[7] The Joseon court did not produce any more *billye uigwe* after the reign of King Injo, which historians largely attribute to the pejorative attitude of the Joseon court toward the Qing as a barbarian empire. Records of the reception of envoys after King Injo's reign survive in the form of preliminary records called *deungnok*.[8]

While *uigwe* of the visits of Qing envoys were not produced by the Joseon court, there is a Chinese album of painting and calligraphy that

recorded the visits of the Qing envoy to Joseon, Akedun (1685–1765), who
made four visits between 1717 and 1725 (ninth month, 1717; twelfth
month, 1717; fourth month, 1722; and first month, 1725). The album, titled
Fengshi tu (*Diplomatic Paintings*), is now preserved in the Ethnic Library
of China in Beijing[9] and has been the topic of studies by two scholars in
Korea and in the United States.[10] In her pioneering study of 2007, Jeong
Eun-ju identified the painter of the twenty-leaf painting album as Zheng
Yu of Qing through the inscriptions and seals on the painting, the date of
which was determined to be between the first month of 1725, just after
the envoy's last trip to Hanseong, and the sixth month of the same year.[11]
Additionally, she compared the painting style of the album leaves with
that of *Akedun guoting tu* (*Akedun Strolling in the Garden*), a hanging scroll
now in the National Palace Museum, Beijing. She demonstrated how the
paintings reflect painting styles and customs of contemporary Korea.[12]
An important point of Jeong's analysis of the album is her treatment of
leaves 14 through 18, which depict, for the first time in documentary
paintings, a record of Chinese envoys' trips to Korea, the actual scenes of
the specific court rites along with images of Joseon kings and the crown
prince.[13] In Joseon documentary paintings, members of the royal family
were never depicted.

Lihong Liu's article concentrates on Akedun's diplomatic role in
ameliorating the relations between Qing and Joseon in the eighteenth
century, which had become less cordial. Akedun's last trip to Hanseong
was in the first month of 1725, to confer the imperial recognition of the
investiture of King Yeongjo, whereas his third trip was in the fourth
month of 1722, to confirm the appointment of Prince Yeoning (Gyeong-
jong's half-brother)[14] as the heir apparent to succeed King Gyeongjong.
According to Liu, the dramatic improvements in the diplomatic relations
between the two countries were due not only to King Yeongjo's efforts,
such as insisting on the participation of the king in person at the farewell
banquet,[15] but also to Akedun's personal effort in emphasizing the impor-
tance of cultural and diplomatic engagements.[16]

Earliest *Uigwe* of the *Billye* Rite for Two Visits of Chinese Envoys, 1609

In this section we will examine the earliest extant *billye uigwe* produced
after the two visits of envoys in 1609. Although the date of the completion
of the *uigwe* is 1610,[17] the main superintendency was set up nearly two
years earlier, in the fourth month of 1608.[18] This reflects the Joseon court's
respectful attitude toward the Ming, who loomed as the savior of the
dynasty from the Japanese invasions at the end of the previous century.
The first Ming envoys (from the eighth day of the fourth month to the

TABLE 3.1 Schedule of Chief Envoy Xiong Hua's Visit, 1609

1	On the eighth day of the fourth month, Chief Envoy Xiong Hua and his retinue cross the Amnok/Yalu River, arriving in Joseon at Uiju.[1]
2	On the twenty-fifth day of the fourth month, the envoys arrive at Hongjewon, just west of Hanyang (present-day Seoul), to change their robes before proceeding to the Mohwagwan (Hall of Revering China) where they will be formally received.[2]
3	At Mohwagwan, the chief envoy Xiong Hua and his retinue are greeted by the king, Gwanghaegun.
4	Gwanghaegun moves into Taepyeonggwan guesthouse to receive the Ming emperor's letter of mourning and decision to confer the posthumous rank of imperial nobility (*gomyeong* [Ch. *gaoming*]) on King Seonjo, the late father of Gwanghaegun, to be read in a memorial rite.
5	On the twenty-ninth day of the same month, the envoys are treated by Gwanghaegun to a welcome dinner, or *hamayeon* ("banquet for safely getting off the horse") at the Seonjeongjeon (living quarters of the king), Changdeok Palace.
6	On the first day of the fifth month, the envoys enjoy a pleasure-boat ride along the capital's scenic Han River.
7	On the third day of the fifth month, Xiong Hua performs the memorial rite (see Table 3.2) for King Seonjo at Injeongjeon, the throne hall of Changdeok Palace.
8	On the sixth day of the fifth month, in preparation for departure, the envoys are treated to a *sangmayeon* ("banquet for getting back on the horse"), at Taepyeonggwan where they had been staying.
9	On the eighteenth day of the fifth month, the chief envoy and his retinue cross the Amnok/Yalu River back to China.

1 From Uiju to the capital Hanyang, the envoys were guarded by Joseon soldiers. They were treated to banquets upon arrival and on overnight stops along the route.
2 Located outside the west gate of the capital in present-day Hyeonjeo-dong.

sixth day of the fifth month) came to conduct a memorial rite for the late King Seonjo and to bestow upon him a posthumous title. In the same year, another group of envoys arrived, on the second day of the sixth month, to approve the investiture of Gwanghaegun; they stayed until the nineteenth day of the sixth month. Detailed records of the two events were compiled in three parts: (1) *Yeongjeop dogam docheong uigwe*, the *Uigwe of the Main Office of the Superintendency for the Reception of the Envoys;*[19] (2) *Yeongjeop dogam mimyeonsaek uigwe*, the *Uigwe of the Meal-Preparation Subdivision for the Reception of the Envoys;*[20] and (3) *Yeongjeop dogam sajecheong uigwe* (henceforth, *Sajecheong uigwe*), the *Uigwe of the Office in Charge of the Envoys' Bestowal of the Imperial Memorial Rite for King Seonjo.*[21] The third is the only *uigwe* with monochrome illustrations and the procession paintings in color.

The protocol for the reception of envoys begins when the official notice of the envoys' arrival, written on a wooden board called *paemun*, is received at the Ministry of Personnel. The Ministry, with the king's approval, then appoints officials, such as the one who was to meet the envoys at the national border (*wonjeopsa*), and other section chiefs of the subdivisions of the superintendency. Then all other low-ranking personnel were lined up, the equipment and utensils necessary for receiving envoys were prepared, and the stages of the reception were rehearsed before the envoys arrived. The responsibility of the military subdivision was to safeguard the envoys on their way from the point of arrival in Joseon to the capital, pitching tents for the overnight stay, and taking good care of the envoys during their visit.

As in other *uigwe* books of the early seventeenth century, these *uigwe* books are not well organized, and sometimes the same documents appear twice. The copies now kept in the Kyujanggak Institute for Korean Studies all show poor handwriting of the texts and poor draftsmanship in painting the procession. However, they are considered valuable because of their early dates and their contents, which include the *banchado*. Furthermore, it is recorded in the first *uigwe* that the subdivisions for military, provisions, banquet preparation, side-dish preparation, and snack preparation were all established, and each subdivision left many records that were put together only in preliminary *deungnok* form.

Chief Envoy Xiong Hua's Visit, 1609

Of the aforementioned tripartite *uigwe* of the two events for receiving Ming envoys known as *tianshi* (the envoy of the Son of Heaven, *Tianzi*), the *Uigwe of the Main Office of the Superintendency for the Reception of the Envoys* records the entire process of their reception, from the moment they

TABLE 3.2 Protocol of the Memorial Rites, Third Day of the Fifth Month, 1609

1	The king (Gwanghaegun) and other participants stand wailing facing west (toward China) under the eastern steps of Injeongjeon hall, the throne hall at Changdeok Palace.
2	The presiding officiant brings in food on low tables[1] and displays the dishes in front of the door of the Throne Hall.
3	The chief envoy (Xiong Hua) is led to the Throne Hall, and stands facing north in front of the spirit-tablet chair (*yeongjwa*).
4	The wailing stops momentarily; food dishes are brought in and displayed in front of the spirit-tablet chair (*yeongjwa*).
5	The chief envoy burns incense and offers libation three times in a row.
6	The imperial memorial (*chuk*) from the Ming emperor is read aloud by the designated memorial reader,[2] after which the king bows eight times.
7	The *chuk* reader then takes the imperial memorial outside the Throne Hall and burns it on a bronze dish.
8	The king and the participants come out of the Throne Hall, stand once again under the eastern steps, and resume wailing.
9	The envoy is escorted out of the Throne Hall to his tent (pitched on the lawn for the duration of the rite), and the ritual food is removed.
10	The king sends off the chief envoy and resumes wailing under the steps of the Throne Hall.

[1] The table is called a *jang* and has slightly taller legs than an ordinary tray table. See Yeongjeop *dogam sajecheong uigwe*, 189–98.

[2] The text of the memorial letter can be found in ibid., 104–5.

crossed the border in Uiju along the Amnok/Yalu River until they returned to China. The dates of the chief envoy Xiong Hua's arrival and departure are recorded at the beginning: the retinue crossed the Amnok/Yalu River on the eighth day of the fourth month, arrived in Hanyang on the twenty-fifth day, departed Hanyang on the sixth day of the fifth month, and crossed the river back to China on the eighteenth day of the same month.

TABLE 3.1 That schedule (see table 3.1) is followed by a list of all the high officials and other personnel (e.g., the guards, painters, and scribes) who worked for the events, including the dates of their appointment and dismissal. The head official (*gwanban*) responsible for taking care of the chief envoy was the Minister of Defense Yi Jeong-gwi (1564–1635); the official who was to greet the envoys at the river crossing was Yu Geun (1549–1627), a scholar-official who held many prestigious titles, including minister of rites.[22] Those two appointments reflect Gwanghaegun's strong desire to please the envoys.

The *uigwe* contains a detailed protocol for the king and the officials when they greeted the envoys, including the formal attire they were to wear. Material provisions such as good-quality paper, brushes, and ink sticks to make the envoys' stay comfortable, are all listed in detail. Gwanghaegun's strict instructions not to waste material goods and his order to return all unused materials and other goods were recorded. Additionally, the king instructed that women be kept away from the envoys' lodges and travel paths.[23] The signboards along the way or at their lodges were all to bear the Ming envoys' handwriting, so they would feel respected.

There also is a detailed list of the presents to be given to the envoys. At the river's crossing, the chief and deputy envoys were given a leopard-fur coat; five *geun* of ginseng (1 *geun* equals 600 grams); five sheets of *hwamunseok* (a high-quality floor mat of woven straw with floral patterns); two pieces of six-fold oiled paper; five bolts of cotton and silk cloth; inkstones; ten scrolls of white paper; twenty yellow fur brushes; ten good-quality ink sticks; three shields or covers from rain made of bamboo (*urong*); and ten white folding fans. Moreover, certain food items were to be prepared for the envoys before their arrival — abalones, sea cucumbers, tangerines, fresh citrons, and dried persimmons — as long as they were seasonal.[24]

The Imperial Memorial Rite in the *Sajecheong Uigwe*

This rite is the most important part of the envoys' activity in Hanyang. It is also the most difficult task for Joseon officials in terms of preparing the proper settings for the envoys in order to perform the rite of imperially bestowed memorial service for King Seonjo, Gwanghaegun's father. For

this event, the court had to hold two rehearsals. The protocol for this particular rite is not included in the *billye* section of the *Five Rites of State*, and since this is the first *uigwe* to record the performance of an imperial memorial rite (*saje*), we learn of many debates between Gwanghaegun and his officials. They discussed, among other things: the details of the arrangement of ritual objects such as the spirit tablet of King Seonjo; where to place the incense pavilion (*hyangjeong*), a small pavilion-like structure that houses the incense burner; and toward which direction the chief envoy should face.

In the *Sajecheong uigwe* we find the protocol for the memorial rite (*sajeui*) itself in the section titled "Protocol of the Ministry of Rites" (*yejo uiju*).[25] It contains very detailed instructions for all the participants of the memorial service.[26] The conduct of the chief envoy and the king according to this text is listed in table 3.2.

TABLE 3.2

As noted earlier, the last duty of the king toward chief envoy Xiong Hua was to give the "farewell" banquet at the Taepyeonggwan guesthouse before the departure of the envoy and his retinue from Hanyang on the sixth day of the fifth month.

The Two *Banchado* of the *Sajecheong Uigwe*

Two sets of *banchado* illustrating the two separate visits by Chinese envoys to the Joseon court in 1608 are attached to the *Sajecheong uigwe*: the *Cheonsa bancha* (Bancha[do] of Chinese Imperial Envoys) and the *Gwak wigwan jemul baejin bancha* (Bancha[do] of Eunuch Guo Presenting Memorial Gifts [from the Ming emperor]), or *Gwak wigwan bancha* for short.[27]

Cheonsa Bancha

The *Cheonsa bancha* consists of nine pages of procession paintings showing the chief envoy coming to Hanyang led by Joseon officials and all the appropriate honor guards, including musicians.[28] Most of the important figures, palanquins, ritual weapons, and parasols are labeled next to them. As in the case of all procession paintings attached to the end of a *uigwe* book, the beginning of the procession starts after the last page of the text. The important elements at the beginning of the procession are the eighteen torch bearers (*bonggeogun*) on either side, and the sixteen Joseon court officials on horseback (*baekgwan*), wearing the most formal [54] court attire and followed by honor guards (fig. 54). On the next three pages are musicians and two small pavilion-shaped carriers for both an incense burner (*hyangjeong*) and the imperial letter of memorial (*jemun yongjeong*) [55] (fig. 55). They are followed by a black-roofed palanquin, the side of which is covered with plain silk cloth, carrying the imperial gifts for the memorial

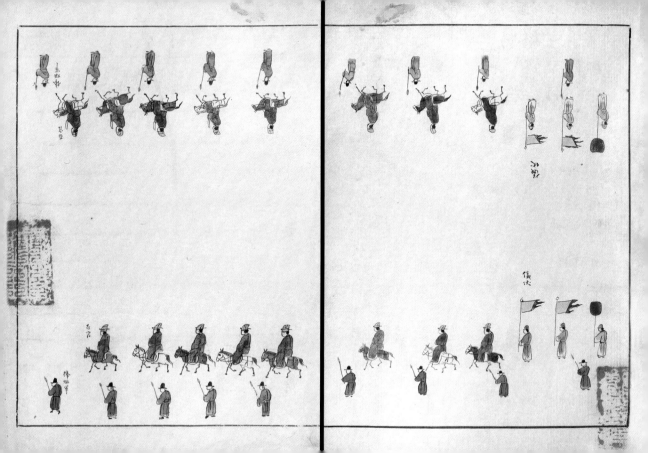

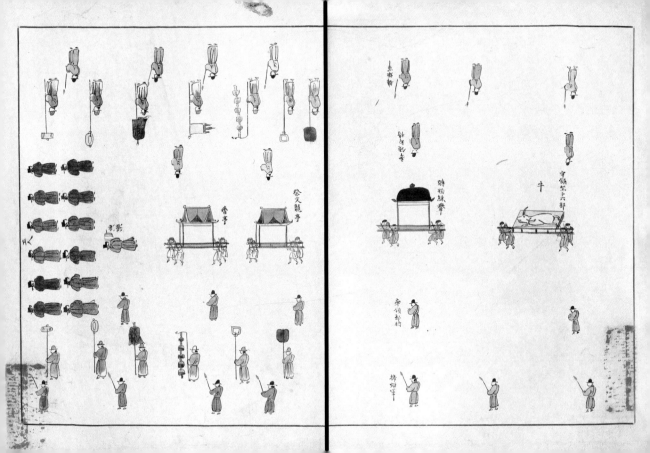

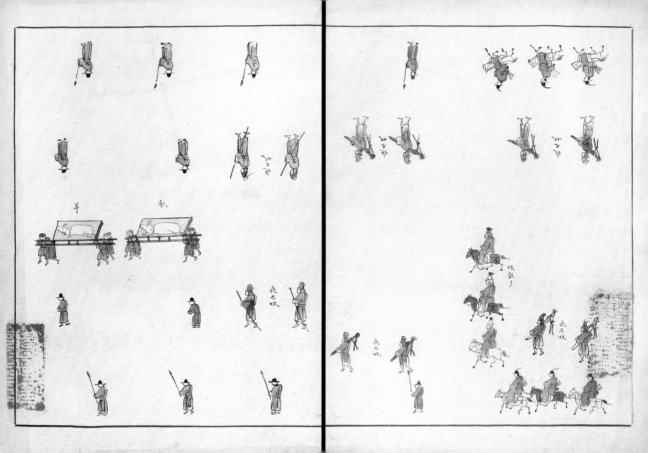

羊

豕

夜不收

夜不收

吹鼓手

夜不收

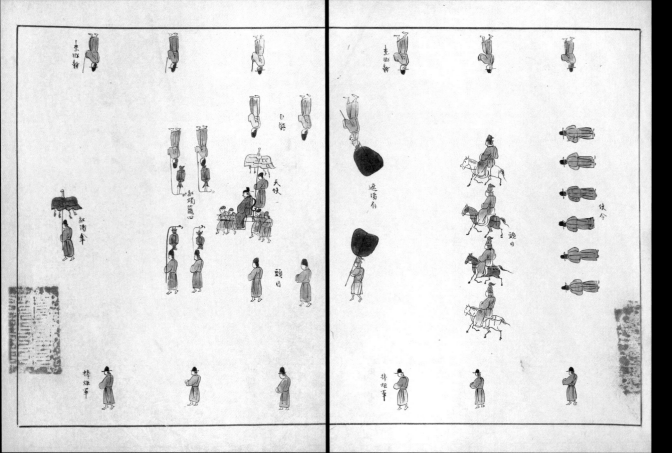

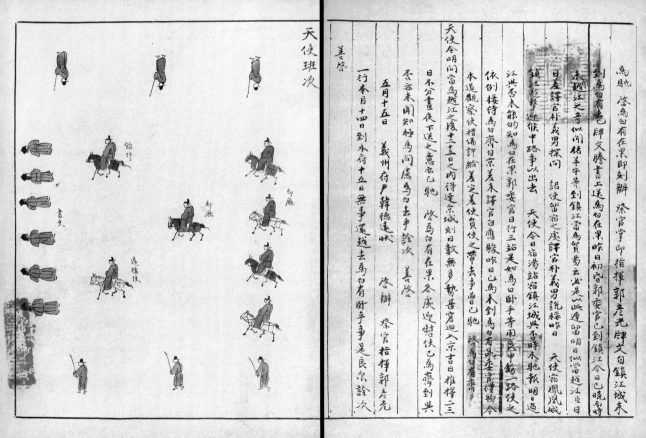

天使班次

館伴
印廬
都廬
遠接使

差啓

為馳啓為白有亦卽刻辦察官掌印指揮郭彦光牌文自鎮江城末

到為白有亦牌文謄書工送為白在果曉日初昏郭委官已到鎮江今日已晚南時

未時渡江之奇似聞猪羊牛等到鎮江當為貿易云此遷留明日似當渡江

日差譯官朴義男探問詔使留宿之慮譯官朴義男詭辭昨日天使宿鳳凰城

鎮江遊擊迎候中路事以出去天使今日宿湯站宿鎮江城興否時未馳明日過

江興否未能的知為白在果郭委官行三站是如為白臥乎用民申筭一路之

依例接待為白齊日京差未譯官已應駿眼日已到卽未到為白有亦勢무事酉日已馳以遷入京吉日推擇二三

本道觀察使措備許給差定差使負侠之帶去事酉日已馳以遷為白齊差遣為白齊

天使令明間當為越江之意十二三日之內得達京城則目數無乎勢역무日窄選迎對侠已為齊到興

日不分晝夜下送之意亦已馳啓為白有在果各處迎對侠已為齊到興

不가未聞知極為悶慮亦去事以詮次差啓

五月十五日義州府尹韓德遠狀啓辦察官指揮郭彦光

一行本月十四日到本府十五日無事還越去為白有臥乎事是良厼詮次

rite labeled *bumul chaeyeo.* Then there are men carrying wooden stretchers, each loaded with sacrificial animals — a cow, a lamb, and a pig. Although the label next to the first stretcher (*noechan gaja yukbu* [six food-carrying stretchers]) specifies six, only three appear in the actual scene.

[56] Eight "twenty-four-hour" messengers (identified as *yabulsu*) carrying long swords (pages 5, 6) precede the retinue of the chief envoy, which begins with a red-parasol bearer (fig. 56). The chief envoy, in red costume and a black hat, is shown in a sedan chair being carried by four bearers and followed by four equestrian foremen identified as *dumok,* Chinese traders who accompanied Chinese imperial envoys to the Joseon court. The procession closes with a series of Joseon men: six servants (*saryeong*) of the government office, six scribes (*seori*), and the chief officials Yu Geun and Yi Jeong-gwi, both on horseback. The end of the procession is marked by the third-highest officials in the superintendency, called *nangcheong,* who are also on horseback. The title, *Cheonsa bancha* (position in procession for Ming envoys based on rank and affiliation) appears on the top right of the last page (page 9).

Gwak Wigwan Bancha[do]

The *Gwak wigwan bancha[do]* (figs. 57–61) is ten pages in all.[29] At the begin-
[57] ning (fig. 57) are ushers (*jirochi*) followed by a series of black-roofed, plain
[58] silk palanquins (fig. 58) labeled as "seventy-five plain silk palanquins carrying offerings to the memorial rite" (*jemul chaeyeo chilsibobu*), although for compositional reasons only nineteen of them are visible. Altogether, eighty small pavilion-shaped silk palanquins (*chaejeong*) and regular-sized silk palanquins (*chaeyeo*) had to be made to carry the necessary items for the memorial rite.[30]

[59] Two groups of four men carrying wooden boards for food offerings follow the palanquins (fig. 59). They are identified by a label "six stretchers to carry food offerings" (*jemul ipseong gaja yukbu*) but only two of them are depicted. On the penultimate page, Chief Eunuch Guo [Gwak] appears on horseback preceded by a yellow-parasol bearer and two twenty-four-hour
[60] messengers (fig. 60). Eight foremen on foot and two imperial messengers (*chagwan*) surround Guo [Gwak]. At the end of the procession, four Joseon office servants identified as *saryeong* precede the equestrian officials of the superintendency (*docheong* and *nangcheong*). This is followed by a diagrammatic arrangement of food tables (*sangbae dosik*) on two pages in which 123 small food and libation tables are arranged in front of the spirit-tablet
[61] chair (*sineojwa*) of King Seonjo (fig. 61).[31] Tables for an incense burner and candles on either side of it are placed in the front row, preceded by a table to place the letter of imperial memorial.

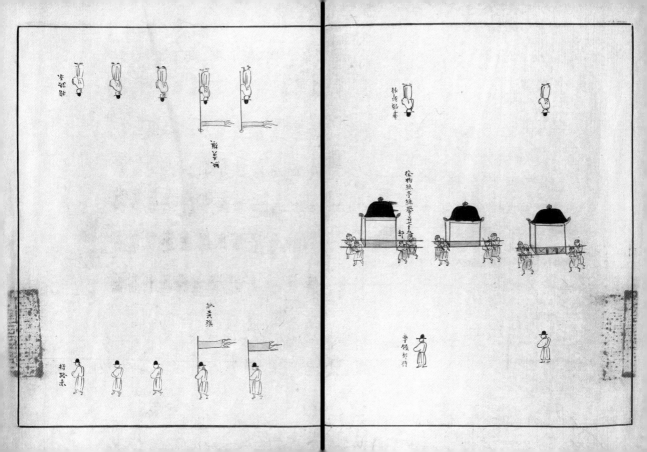

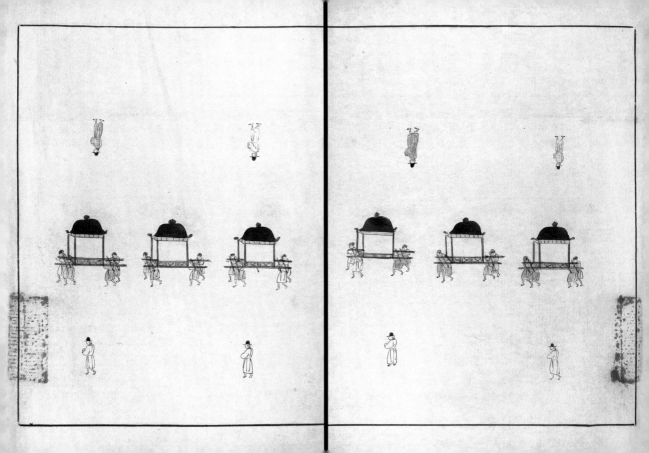

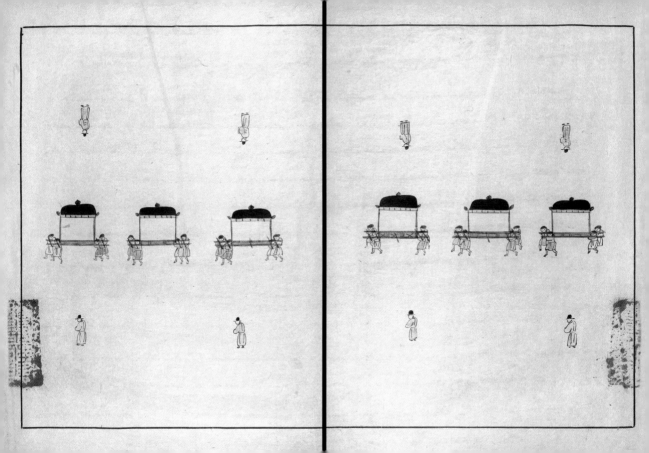

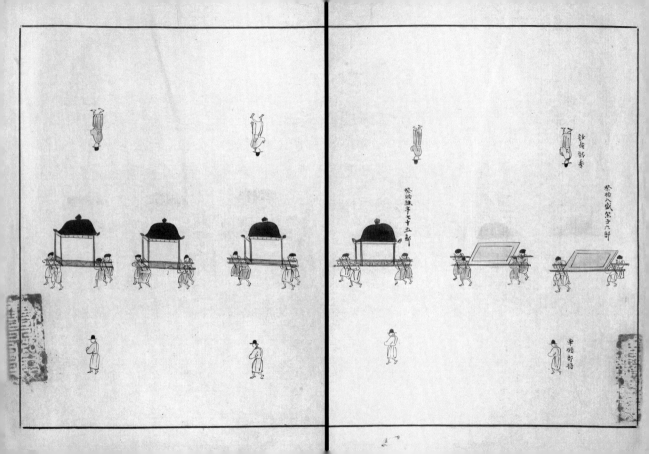

即應

別應

從令

郭委官

差官

差官

京橋傘

衣不攻

白解

TABLE 3.3 Schedule of Envoy Liu Yong's Visit, 1609

1	On the twenty-fifth day of the fourth month, Envoy Liu and his retinue cross the Amnok/Yalu River.
2	On the second day of the sixth month, the Chinese mission arrives at the capital city of Hanyang (present-day Seoul).
3	On the day of their arrival, King Gwanghaegun receives the Letter of Approval for Investiture (*chaekbong gomyeong*) from the Ming emperor at Injeongjeon, the throne hall of Changdeok Palace.
4	After the investiture ceremony, Gwanghaegun hosts a welcoming banquet at the Taepyeonggwan, a dedicated guesthouse for Chinese envoys.[1]
5	On the fifth day of the sixth month, another banquet for Envoy Liu and his retinue is given.
6	On the tenth day of the same month, more banquets take place at the Taepyeonggwan to honor the envoys.
7	On the twelfth day another banquet is held at the Seonjeongjeon, or king's quarters in Changdeok Palace to honor the envoys.
8	On the eighteenth day a departure banquet is held in the Taepyeonggwan guesthouse.
9	On the nineteenth day another farewell banquet (*jeonyeon*) is held for the envoys at the Mohwagwan (Hall of Revering China).
10	On the ninth day of the seventh month, Envoy Liu and his retinue once again cross the Amnok/Yalu River back to China.

1 In the *Yeongjeop dogam mimyeonsaek uigwe*, this particular ceremony was not recorded on that day, but the *Daily Records of Gwanghaegun* has a detailed entry.

The names of the four painters who were supposed to have taken care of all the painting and decorating needs for the event (including the *banchado*) are listed at the beginning of the *Sajecheong uigwe*.[32] Of the four, only Kim Eop-su appears in another source, namely, the *Daily Records of Gwanghaegun* (1613) in which he was questioned for getting into a dispute and is mentioned as being seventy years of age. The other three painters are not known through any other documentary sources or surviving paintings.[33] This might account for the poor quality of the procession paintings. Listed among the names of painters is Yi Sin-heum (1570–1631), a better-known court painter with surviving works, although it is not known whether he had any part in the procession paintings. The poor quality of the *banchado* can also be attributed to the fact that this is not a royal viewing copy. No matter how poor the quality of this *banchado*, historically it is very important because no other *billye*-related *banchado* shows the unique and informative components of the Chinese emperor's memorial gifts to a deceased Joseon king in such vivid pictorial images, including whole sacrificial animals on stretchers.

Envoy Liu Yong's Visit, 1609

On the second day of the sixth month of the same year, the second envoy Liu Yong,[34] and his retinue arrived to approve the investiture of Gwanghaegun. Since it was after the Ming court's fifth denial of Gwanghaegun's investiture as crown prince by Seonjo on the grounds that he was the second, not the first, son of King Seonjo,[35] the Joseon court particularly welcomed Liu Yong because it was important for Gwanghaegun to secure his political position. Table 3.3 shows the schedule of Liu's visit.

TABLE 3.3

At the investiture ceremony, the Ming emperor's letter of admonition (*joseo*) was read by Jeong Yeop (1563–1625), vice minister of the Ministry of Rites. Gwanghaegun, kneeling, listened to it and bowed accordingly. Then the letter of approval was read by the royal secretary Yu Gong-ryang (1560–1624). Gwanghaegun paid the same respect. The Ming emperor bestowed the formal royal outfit and additional silk cloth on Gwanghaegun.[36] The Joseon court had to prepare a total of six royal banquets within the seventeen-day period of the envoy's stay. In addition, Liu Yong and his retinue's demand for silver in lieu of their daily food supply[37] was such that the Joseon court suffered a great shortage of revenue. At the envoy's departure, the court was said to be left with only enough provisions for four months.

Even though the Ming court's enactment of the memorial rite and bestowment of posthumous imperial titles for King Seonjo took place one year and three months after the death of King Seonjo (first day of

床排圖式

神御座

郎廳通訓大夫禮賓寺正 李軿

館伴正憲大夫禮曹判書兼弘文館大提學藝文館大提學知春秋館成均館事芽耆賓客同知經筵事李恒福

萬曆三十六年五月

日

the second month, 1608), and the investiture rite for Gwanghaegun was delayed even further (a year and four months after King Seonjo's death), from that point on, Gwanghaegun was able to establish himself firmly as the ruler of Joseon. To celebrate these two events, he ordered the super-intendencies to produce enough copies of the preliminary records of the events for the respective government offices as well as for all of the history archives where the copies of the *Veritable Records* were sent.

The completion in 1610 of the earliest *uigwe* in Joseon history for the conduct of the rite of *billye* for the receiving of envoys based on the above records is a testament to Gwanghaegun's strong desire to document state rites for future generations. Altogether thirty-seven copies were made at that time, including a royal viewing copy, which does not seem to have survived.[38] No matter how poor the quality of the calligraphy of the text and the *banchado* paintings are, we owe the existence of these tripartite *billye*-related *uigwe* to Gwanghaegun, a shrewd diplomat who as ruler had to deal with delicate situations during the transitional period of Ming, Later Jin, and Qing dynastic changes in China.[39] ◆

CHAPTER FOUR

Uigwe of Military Rites, *Gullye*

The fourth of the five rites as represented in the *Five Rites of State* (1474) are military rites (*gullye*), which are listed below:[1]

1. Archery rite on the shooting platform (*sau sadanui*) including the rite of watching (*gwan sau sadanui*)
2. Military exercise on the occasions of royal hunting (*daeyeorui*)
3. Observation of the solar eclipse (*guilsigui*)
4. Exorcising ritual in the twelfth lunar month (*gyedong daenaui*)
5. Archery rite in local administrative centers (*hyangsaui*)

[62]

However, the only extant *uigwe* of military rites is *Daesarye uigwe* (*Uigwe of the Royal Archery Rites*) (fig. 62), which records the royal archery rites of King Yeongjo and his officials. Those rites were held in 1743 in the compound of the Seonggyungwan National College in Hanyang, the highest national Confucian educational institution in Joseon.[2] King Yeongjo wanted to revive the ancient rites of archery in the hope of strengthening his regime's military power both in appearance and in reality. In the *Sequel to the Five Rites of State*, compiled and published under the order of King Yeongjo in 1744, the royal *daesaryeui* rite appears as the first military rite listed.[3] Furthermore, the *Gukjo sok oryeui seorye* (*Sequel to the Five Rites of State with Illustrations*) contains illustrations of the king's archery target represented by the head of a bear (*unghu*) and that of the officials represented by the head of a deer (*mihu*). In addition, there is a *munbanchado*, or "written *banchado*," diagramming the positions of all civil participants by rank for the archery event.[4] In 1764 (Yeongjo 40), King Yeongjo performed the rite once again, although no *uigwe* was commissioned or produced.[5]

The *daesaryeui* rite is mentioned as early as 1417 in the *Veritable Records of King Taejong*: "When Minister of the Ministry of Rites Maeng Sa-seong (1360–1438) submitted to the king the literature and diagram/painting concerning the royal archery rites, the king said, 'I will not be bound by the old records, but perform the archery rites by taking into consideration the

ancient rules, and also what is appropriate for the current situation.'"[6] No royal archery rite was performed at this time, but the reference to past literature and diagram/painting by Maeng Sa-seong seems to point to earlier incidents of it. The three *daesaryeui* rites performed before King Yeongjo's reign occurred in 1477 (Seongjong 8), 1502 (Yeonsangun 8), and 1534 (Jungjong 29). However, apparently none were recorded in any *uigwe* books.

Daesarye Uigwe, 1743

The *Daesarye uigwe* of 1743[7] begins with a table of contents followed by twelve pages of color illustrations depicting four scenes each of the royal archery rite (*eosaryedo*), the attending officials' archery rite (*sisaryedo*), and the awards and punishments for the attending officials (*sisagwan sangbeoldo*). They are followed by an "explanation of the illustrations" in which the stages of the event from the moment of the king's arrival until his return to the palace are detailed. Next is a list of the names of the thirty "attending archers" (*sisagwan*) who participated in the preparation and the archery event itself: eight royal relatives, two royal in-laws, and ten civil and ten military officials. In the special state examinations at the event, six civil and sixty military applicants received passing grades. The protocol of the royal archery rites are listed below:

1. Royal offering of libation (*jakheollye*) to Confucius at the Munmyo shrine (Shrine for Confucius) within the compound of the Seonggyungwan National College.
2. Royal bestowing of both civil and military examinations (*Munmugwa sichwiui*) to commemorate this historic occasion at the Myeongnyundang (Hall of Bright Ethics), also in the Seonggyungwan compound.
3. The royal archery rites begin with King Yeongjo shooting first.
4. Archery rite of attending officials (ministerial level first).
5. Archery rite of the royal relatives (eight princes).
6. Archery rite of civil and military officials (ten each).
7. Archery rite of the two royal sons-in-law (*uibin* with the title *wi*).
8. Awards and punishments ceremony for the good archers and the poor archers.
9. Announcement of the successful candidates before the king returns to the palace.
10. Music is played on and off all through the rites.

The king shoots a set of four arrows, called *seungsi*, which has been presented to him by a subject. All of the accompanying officials, royal

FIG. 62 Cover of the *Uigwe of the Royal Archery Rites (Daesarye uigwe)*, 1743. Book; ink and color on paper, 46 × 33 cm. Kyujanggak Institute for Korean Studies, Seoul National University (Kyu 14941).

relatives, and the royal sons-in-law stand on the shooting platform in pairs and also shoot a set of four arrows. The minister of the Ministry of War, Seo Jong-ok (1688–1745), reviews the results of the shootings and reports them to the king. A lower-ranking officer of the Ministry of War calls the names of the individuals to be awarded and those to be punished. The awards for the "outer and inner materials" of clothing included the lining for one's robes (*pyori*) as well as bow and arrows for the good archers; the poor archers were made to consume "punishment wine" in a cup made of ox horn painted in black lacquer (*chi*).

Many of the items mentioned above were illustrated in color with specifications such as material, size, and color.[8] The objects include, among others, a royal bow and arrow, flags, targets, the small screen that blocks stray arrows, tables on which to lay out the items to be awarded, the punishment wine cup, and so forth. For example, to make the royal target, it was necessary to prepare a square piece of red hemp cloth measuring 506 square centimeters and a piece of white leather measuring 168 square centimeters on which a bear's head was painted and then set onto the middle of the large red square.[9] The details are too numerous to list them here. I now turn to the most important illustrations, the *banchado*.

The *Banchado* Illustrations

The twelve pages of *banchado* illustrations in the *Daesarye uigwe* each measure 46 × 33 centimeters, but they deviate from those of other *uigwe* in several ways. First, this *banchado* is not a procession but rather depicts the three archery rites: the royal archery rite, the attending officials' archery rite, and the rites of awards and punishments for the attending officials. Second, instead of putting the *banchado* pages together at the end of the book, these pages were placed at the beginning, just after the table of contents. Third, because each of the three illustrated scenes takes up four book pages, to comprehend each scene, we have to "read" those contiguous pages vertically rather than horizontally (see fig. 66). Fourth, in all other *banchado*, each page has its own margin defined by black lines (or red in the royal viewing copy), but in this *banchado* there is no such definition at the margins. Finally, the paintings maintain a single viewpoint, as opposed to the multiple viewpoints in other *banchado*.[10] Therefore, no figures are placed sideways or depicted upside down except for one, which I will explain shortly.

The King's Archery Rite
The first four contiguous *banchado* pages offer a complete view of the king's archery rite, which is the first event in the royal archery rites. In

[66]

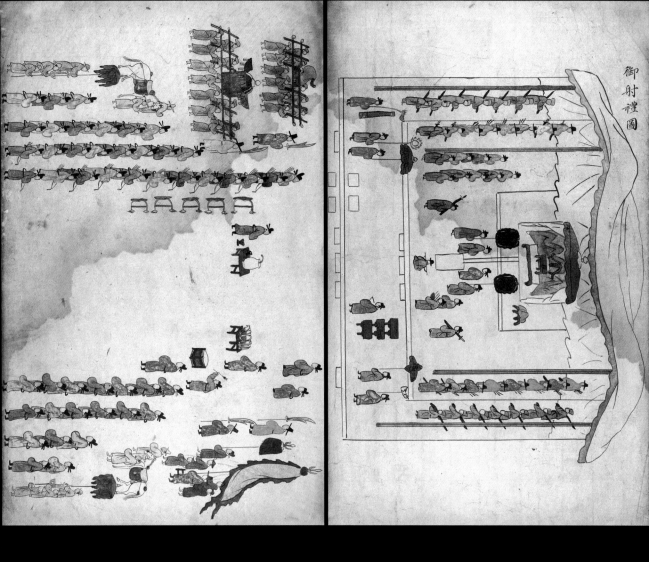

御射禮圖

FIG. 63 The king's portable throne under a tent (right) and the king's palanquin and the yellow dragon flag with participants (left), from the *banchado* in the *Uigwe of the Royal* Archery Rites (*Daesarye uigwe*), 1743. Book; ink and color on paper, 46 × 33 cm. Kyujanggak Institute for Korean Studies, Seoul National University (Kyu 14941).

the scene, the position of the king and other figures follow that of the hierarchical arrangement by rank shown in the *munbanchado* in the *Sequel to the Five Rites of State with Illustrations* (1744).[11] The first page (fig. 63, right) shows the white canopy for the king under which a portable throne protected by a Five Peaks screen, symbolizing the presence of a king, is situated.[12] Just outside of the tent, the king's shooting platform is marked by a rectangle surrounded by nine guards. A man seated in front of the platform is holding a bow, and the figure to the right of the seated one is seen holding four arrows for the king. From the king's shooting platform to the target, the distance is ninety steps, about thirty meters.[13]

[63]

[63] The second page (fig. 63, left) contains the king's palanquin parked on the left, opposite the *gyoryonggi*, the large yellow flag with the red trimmings that shows a pair of intertwining dragons. This flag comes at the head of a king's procession. Officials and a pair of white horses of the royal honor guards are also visible on either side. In front of these men, five colorful arrow stands (*bok*)[14] are seen laid out on the ground. The

[64] royal honor guards continue on either side of the third page (fig. 64, right); in the center, two groups of musicians stand on the right and left behind bell and chime stands, as well as the stand for a percussion instrument called *gyeong*. Immediately behind these musical instruments is a set of small "red arrow gates" (*hongjeonmun*) to announce that the area is "holy."[15]

[64] The fourth page (fig. 64, left) shows the royal target and two small, three-fold screens on either side behind which several people are shown standing. The screens, called *pip* (to throw away, or be poor), act as shields to catch arrows that miss the target. The royal target, a concentric square of red, gray, white, and red, shows in the white center a gray-colored upside down bear's head. The man in front of the target, who also stands upside down, facing north toward the direction of the king's canopy, is the arrow catcher (*hoekja*). The rest of the figures and horses are shown standing in profile, facing each other, on either end of the page.

One might wonder why the bear's head on the royal target and the man in front of it are depicted upside down. The answer to this question can be found if we put the four pages together vertically to create a complete scene of the royal archery rite. The result will be

[66] a vertical scroll measuring 132 × 46 centimeters (see fig. 66). The only change incorporated here is that the fourth scene is slightly trimmed at its top to bring the group of people closer together. A complete pictorial scene of the king's archery rite is created with the king's canopy on top and the bear-head target on the bottom, guarded on either side by other figures and elements in the scene. The four-page scene reads as both visible and imaginary space. It is "visible" because it only exists in the

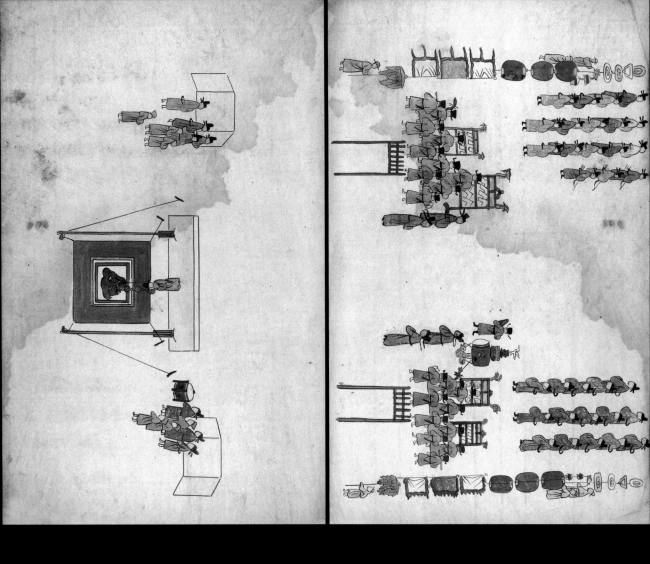

FIG. 64 Two groups of musicians (right) and the royal target of a bear's head and two three-fold screens (left), from the *banchado* in the *Uigwe of the Royal* *Archery Rites (Daesarye* *uigwe)*, 1743. Book; ink and color on paper, 46 × 33 cm. Kyujanggak Institute for Korean Studies, Seoul National University (Kyu 14941).

two dimensions of the flat picture plane. It is "imagined" in that one can imagine a three-dimensional space created by the upside-down target and the figure in front of it facing toward the royal canopy. This is a novel and ingenious device to construct a three-dimensional space out of a two-dimensional medium in the picture.

It is interesting as well as instructive to compare this depiction with that in the handscroll version of the royal archery rite in the collection of the Korea University Museum (fig. 65).[16] There, the same three scenes (royal archery rite, attending officials' archery rite, and awards and punishments for the attending officials) appear side by side reading from right to left. Each scene is somewhat squat: the width for each scene is nearly the same as that of our *Daesarye banchado*, but by putting together the four pages of our *banchado* vertically, we newly create a scene that is much longer. The scene of the royal archery rite in the handscroll measures 60.4 × 46.9 centimeters (fig. 67), whereas our *uigwe* version measures 132 × 46 centimeters.

While the compositional elements are arranged close together in the handscroll version, with more figures overlapping, all are there — including landscape and architectural elements — so one can identify the setting as the Seonggyungwan National College in Hanyang. Behind the royal tent can be seen the walls of the Seonggyungwan compound with trees and thin layers of clouds above them; at the lower right corner is the royal stele pavilion, in front of which can be seen a white drapery and a flag presumably put there to prevent any arrows from reaching the pavilion. Another important identifying feature is the narrow moat-like trench called Seonggyungwan *bansu*,[17] over which are two stone bridges along the right edge of the scene.

The most important difference between the *uigwe* version and the handscroll version is that the bear's head is upside down in the *uigwe* version but right side up in the handscroll. This is also true of the other targets in the handscroll versions. Presumably, the artists who painted the handscroll version at a later date could not understand the "imagined three-dimensional spatial enclosure" explained above.[18]

In our search for additional differences between the two versions, we shall compare details from the "Awards and Punishments for Attending Officials" section of the *uigwe* to that of the handscroll. In the center of the uigwe version (fig. 68), there are twenty-seven seated figures in four rows of five, nine, six, and seven from the top, apparently the "attending officials" who are to be called upon to be either awarded or punished. The right figure in the first row seems to be responding to a call from the standing figure to his right, who is holding a white piece of

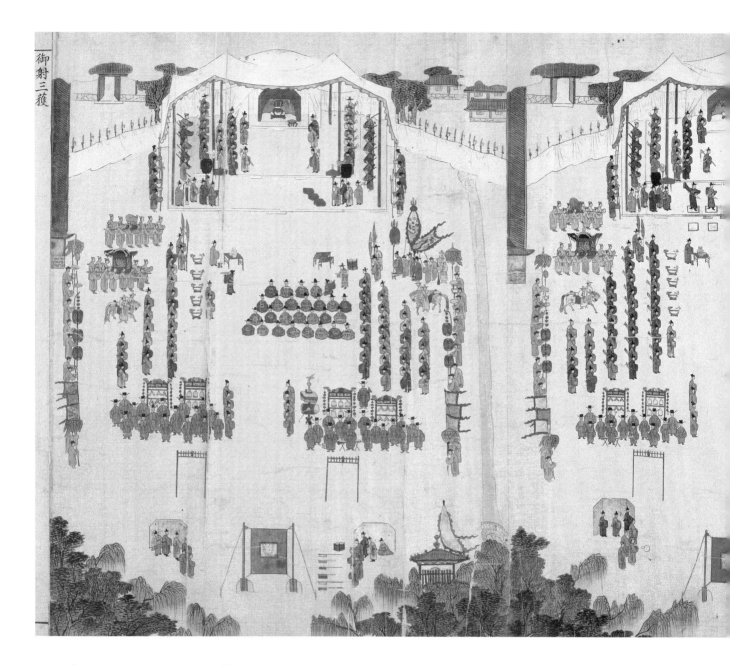

御射三獲

FIG. 65 *The Royal Archery Rites*, 1743. Handscroll; ink and color on silk. "King's Archery Rite," right section: 60.4 × 46.9 cm; "Attending Officials' Archery Rite," center section: 60.4 × 46.9 cm; "Rites of Awards and Punishments for the Attending Officials," left section: 60.4 × 47.4 cm. Korea University Museum (2201).

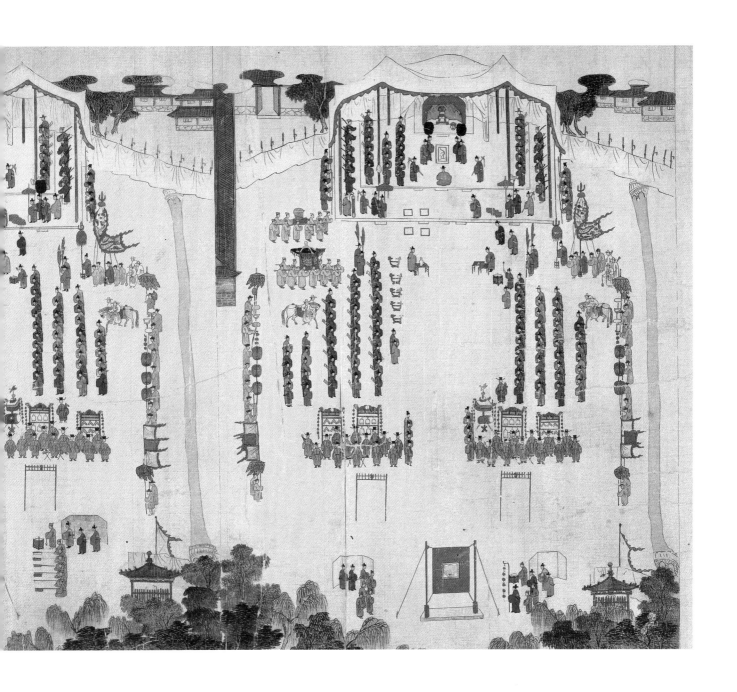

FIG. 66 Diagram of the four pages from the *banchado* in the *Uigwe of the Royal Archery Rites* (figs. 63, 64) assembled vertically to create a complete "imagined" scene.

FIG. 67 Right section of *The Royal Archery Rites* (fig. 65).

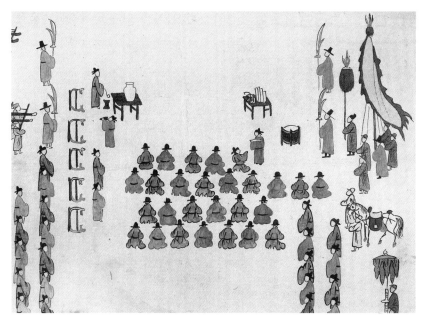

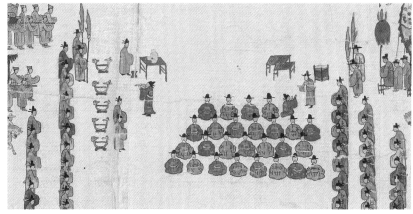

FIG. 68 Awards and punishments for attending officials, detail from the *banchado* in the *Uigwe of the Royal Archery Rites* (*Daesarye uigwe*), 1743. Book; ink and color on paper, 46 × 33 cm. Kyujanggak Institute for Korean Studies, Seoul National University (Kyu 14941).

FIG. 69 Awards and punishments for attending officials. Detail of left section of *The Royal Archery Rites* (fig. 65).

paper. Above this figure group are two red-lacquered tables placed wide apart from each other: the table on the right is for items to be awarded, and the one on the left is for a white porcelain jar of punishment wine. A man standing next to the table with the wine jar is holding a brass ladle above a wooden, red-lacquered cup stand called a *pung*. Just below him and slightly to the left is a standing figure who is drinking the punishment wine from a black-lacquered ox-horn cup as specified in the *uigwe* text.[19]

[69] The man next to the wine jar in the Korea University's scroll version (fig. 69), however, does not hold a ladle in his hand. In fact, his hands are not depicted at all. The poor archer is drinking the punishment wine out of a light-brown horn cup instead of a black lacquered one. These minor differences between the two versions seem to be in line with the difference in the placement of the targets, as pointed out earlier. The painter of the Korea University scroll did not fully understand the intent or nuances of *uigwe* illustration, and therefore the handscroll version could not be of the same date as those in the *uigwe* book.

The fact that King Yeongjo revived the ancient royal archery rite after more than two hundred years by performing it twice (in 1743 and 1764) — and in 1743 had the first and only *uigwe* of a military rite of the Joseon dynasty compiled, complete with illustrations — is in line with his general policy of reestablishing the regulations on state rites. The auspicious rites section discussed in chapter 1 relates that King Yeongjo also performed the ancient rites of royal farming and sericulture four times and had the *uigwe* compiled twice, in 1739 and 1767. The royal archery rite, which was absent in the *Five Rites of State* of 1474, was newly included in the *Sequel to the Five Rites of State* compiled and published in 1744 under the order of King Yeongjo.[20] The revival of the royal archery rite is also symbolic of King Yeongjo's effort to strengthen the military power of the nation.[21] At the same time, it represents his strong desire to reestablish the ways of ancient Chinese sage kings. Some historians attribute Yeogjo's interest in his "policy of impartiality" (*tangpyeong chaek*) to his wish to strengthen national defense. However, his policy of impartiality was not as successful as he had wished.[22] Nevertheless, his reign of fifty-two years, the longest in Joseon history, is considered to be the most successful reign both politically and culturally. ◆

CHAPTER FIVE
State Funeral and Related Rites, *Hyungnye*

Among the Five Rites of State, the funeral and related rites called *hyungnye* are the most complicated, involving more than sixty different rites and spanning nearly three years. These rites strictly follow the Confucian tradition of filial piety and ancestral worship. The death of a king is called *hungseo*, meaning it causes an enormous shock to the nation and the people. Not just the royal family members, but also the entire nation mourns the death of a king.[1]

The detailed procedure of the royal funeral rites of the Joseon dynasty takes up the largest portion of the *Five Rites of State* (1474), volumes 7 and 8. The Joseon royal family adhered to the precise, complicated procedures for almost three centuries, until the reign of King Yeongjo (1725–1776). Yeongjo had to conduct four full-scale state funerals: those of his father, King Sukjong (1722); his biological mother, Sukbin (1670–1718); his first queen, Queen Jeongseong (1692–1757); and Queen Inwon (1687–1757), the second queen of his father, plus four funerals of members of the royal family other than kings and queens, called *yejang*.[2] Considering the amount of work all those funerals necessitated, it is understandable that Yeongjo finally had his officials compile the *Addendum to the Funeral Rites of State* (*Gukjo sangnye bopyeon*) in 1758, which provided a simplified version of the state funeral rites. At the end of the nineteenth century, the Joseon kingdom decided to elevate itself to the status of empire and established the Daehan Empire (1897–1910). All state rites had to be changed accordingly, so the ten-volume *Code of the Daehan Imperial Rites* (*Daehan yejeon*) was compiled.[3] The eighteen-section part on funeral rites is in the last volume.

When a king's death is confirmed, the Ministry of Personnel informs the State Council and immediately establishes three (sometimes more) superintendencies: that of the Coffin Hall (*binjeon dogam*); that of the State Funeral (*gukjang dogam*); and that of the Construction of the Royal Tomb (*salleung dogam*). After the royal funeral, the first superintendency also assumes the task of managing the Spirit Tablet Hall (*honjeon*), at which point the name of the superintendency is changed to *honjeon dogam*.

FIG. 70 Cover and first page of a history archive copy of the *Uigwe of the Royal Funeral of King Injo ([Injo] gukjang dogam uigwe)*, 1649. Book; ink and color on paper, 43.4 × 33.8 cm. Kyujanggak Institute for Korean Studies, Seoul National University (Kyu 13521).

About twenty-seven months after the state funeral, another superintendency, called *bumyo dogam*, is established to take charge of the final rite of the state funeral (*bumyo*). The deceased king's spirit tablet, which had been kept in the Spirit Tablet Hall of the palace, finally leaves the palace to be enshrined in Jongmyo, the royal ancestral shrine.

It is customary to label the entire mourning period of approximately thirty months "a three-year mourning period." In the case of royal funerals, the four or five months of time required for construction of the royal tomb plus a period of twenty-seven months after the funeral before the final enshrinement of the spirit tablet in Jongmyo add up to thirty-one or -two months, that is, four or five months short of the full thirty-six months or three years. Therefore, "three-year mourning period" actually refers to the "third year" after the death of a king. The same method of counting months for the period of mourning applies to the rest of society, except that the duration of tomb construction is much shorter.[4]

TABLE 5.1 Table 5.1 shows a summary of the step-by-step protocol of royal funeral events as spelled out in the *hyungnye* section of the *Five Rites of State*.[5] There would be small variations to the protocol as described, depending on which member of the royal family had died, but the basic format stayed the same over the years.

TABLE 5.1 Considering the above outline (with special attention to Table 5.1) of the official events following the death of a king, we now examine two funeral-related *uigwe*: that of the royal funeral of King Injo (1649) and that of the *yejang* funeral of Crown Grandson Uiso (1752), which will further help us understand Joseon royal family's funeral rites.

The earliest *uigwe* of a royal funeral is that of King Seonjo in 1608, but unfortunately it is incomplete. Instead of the *uigwe* of the main superintendency surviving, only those of the three subdivisions (1, 2, and 3 *bang*) remain today, in three separate volumes that are kept in the library of the Kyujanggak Institute for Korean Studies.[6] Therefore, the more complete records of King Injo's funeral in 1649 are more helpful in understanding the entire process of royal funerals, from the death of a king to the final enshrinement of his spirit tablet in the Jongmyo shrine.

Uigwe of the Royal Funeral of King Injo, 1649

[70] The *Uigwe of the Royal Funeral of King Injo* (*[Injo] gukjang dogam uigwe*)[7] (fig. 70) survives with the companion *Uigwe of King Injo's Coffin Hall* (*Injo binjeon dogam uigwe*), which also includes the *Uigwe of King Injo's Spirit Tablet Hall* (*Injo honjeon dogam uigwe*) and a separate *Uigwe of the Construction of King Injo's Tomb* (*[Injo Jangneung] salleung dogam uigwe*). These provide us with a complete picture of mid-seventeenth-century royal funeral rites.

TABLE 5.1 Protocol for a Royal Funeral, from the *Five Rites of State*

SUPERINTENDENCY (DOGAM) IN CHARGE	SCHEDULE OF RITES OR PROCEDURES	PROGRAM CONTENT
	Confirmation of the death of a king (*chojong*)	A medical eunuch puts soft cotton into the nostrils and mouth of the ailing king. If there is no movement of breath on the cotton, his death is confirmed.
Coffin Hall (*binjeon dogam*)	**DAY 1**	
	Calling the spirit back (*bok*)	A eunuch stands on the roof of the palace and shakes the deceased king's robe three times while calling for his spirit to return.
	Changing into funerary robes (*yeokbok*)	The members of the royal family don white robes and shoes, removing all headgear and hair ornaments.
	Fasting (*bulsik*)	The crown prince and his brothers fast for three days.
	Announcing the rules to be followed during the time of national mourning and funeral (*gyeryeong*)	Military forces stand on high alert. All sacrificial rituals are suspended until the Coffin Hall is set up, after which only sacrifices to the spirits of earth and grain are performed. Music can be played during the three-year mourning period, but only after the primary sacrifices have been made.
	Washing the king's corpse (*mogyok* or *yeom*)	The royal corpse is washed and bathed inside a draped compartment of a palace hall that has been designated as the "Coffin Hall" before burial at the royal tombs.
	Shrouding the body (*seup*)	The royal corpse is dressed in his everyday garment, then blanketed with nine layers of white silk.
	Setting up the offering table (*jeon*)	The offering table for holding a box of incense and a candle is placed on the east side of the royal corpse.
	Assigning wailing places for the crown prince and immediate royal family members (*wiwigok*)	Only the crown prince prostrates and wails inside the Coffin Hall; the rest of the royal family members do so outside the hall.
	Assigning wailing places for royal relatives and officials (*georim*)	Royal relatives and government officials are assigned places in the outer courtyard of the palace.
	Filling the deceased king's mouth with rice and pearls (*ham*)	Rice that has been washed in clear water is scooped to fill the right, then the left, and finally the center of the deceased king's mouth. Into each cheek, a pearl is added to the rice.
	Constructing the wooden structure for ice (*seolbing*)	To keep the coffin cool, a large wooden platform to be filled with ice (*bingban*) is built, and the coffin placed upon it. There it will remain for four or five months until the day of the funeral.
	Setting up the spirit-tablet seat (*yeongjwa*)	To the south of the king's corpse, an enclosure is created using a screen and drapery. Within, a wooden spirit-tablet seat in the form of a high chair is set up to house the cloth-wrapped royal spirit tablet (*honbaek*).
	Making the funerary banner (*myeongjeong*)	A vertical, red silk flag with a length of nine *yegi cheok* units (about 252 cm) is made. It bears the deceased king's royal title written in seal script using gold dust.
	DAY 3	
	A high official performs the announcement rite (*gosamyo*) at the royal ancestral shrine.	This rite takes place at the Sajikdan altar for performing sacrificial rites to the spirits of earth and grain and the Main Hall of Jongmyo or the royal ancestral shrine.
	Preliminary wrapping of the corpse (*soryeom*)	The royal corpse is wrapped with additional everyday as well as ceremonial robes, nineteen layers in all.
	Setting up the offering table (*jeon*) once more	After the preliminary wrapping of the royal corpse, offerings are made. (This rite will be repeated after the final shrouding on Day 5 [see below].)

TABLE 5.1 (continued)

SUPERINTENDENCY (DOGAM) IN CHARGE	SCHEDULE OF RITES OR PROCEDURES	PROGRAM CONTENT
Coffin Hall (*binjeon dogam*) (continued)	**DAY 3** (continued)	
	Constructing the inner coffin (*chibi* [*chibyeok*])	The inner coffin is constructed of wood. Its interior is lined with thick red silk embellished with green silk at the corners. The royal corpse should fit snugly, touching the coffin's walls.
	DAY 5	
	Final shrouding of the royal corpse (*daeryeom*)	The royal corpse undergoes its final wrapping with ninety more layers of clothing, complete with jade ornaments. The body is then placed into the inner coffin and the lid is closed.
	Setting up the Coffin Hall (*seongbin*)	Within the main hall of the palace is constructed a small, house-shaped structure (*changung*) in which the royal coffin is placed until the day of the funeral.
	DAY 6	
	Donning the mourning garments (*seongbok*)	The crown prince and all other royal family members don the mourning garments, which are made of very coarse hemp cloth.
	Succession (*sawi*) of the Crown Prince	For the ascension ceremony, the crown prince is dressed in full regalia. After being crowned, he changes back into mourning garments.
	Proclamation of the first royal message (*gyoseo banpo*)	The new king sends out his first proclamation to the whole country, and all the local officials send congratulatory messages in return.
	Presentation of the posthumous title and the seal (*sangsi chaekboui*)	The rites of bestowing a posthumous title and the seal on the deceased king are performed.
State Funeral (*gukjang dogam*) and Construction of the Royal Tomb (*salleung dogam*)	**4–5 MONTHS AFTER THE KING'S DEATH**	
	Departure of the king's coffin (*barin*)	Four or five months after the king's death, the main funeral rites and burial begin with a royal procession to escort the royal coffin from the palace to the royal tomb.
	On-the-road offerings (*noje*)	Most of the time, offerings are made once at the Mohwagwan (Hall of Revering China), where the Joseon king greets the Chinese envoys upon arrival.
	Deposition (*hahyeongung*)	The king's coffin is lowered into the burial chamber of the tomb.
	Inscribing the royal name on the spirit tablet (*jeju*)	The temporary spirit tablet (*uju*) of mulberry wood is made immediately after the king's death for use during the first twenty-seven months of mourning. The *jeju* rite is performed for the inscription of the king's royal title on the *uju* spirit tablet. Later, a permanent spirit tablet (*wipan*) is made for the king's final enshrinement at Jongmyo.
	Bringing the temporary spirit tablet back to the palace (*banu*)	The temporary spirit tablet (*uju*) is returned to the palace after the state funeral.
Spirit Tablet Hall (*honjeon dogam*)	Setting up the late king's *uju* in the Spirit Tablet Hall	The new king performs daily offerings of morning and evening meals, tea at midday, and special ceremonial offerings at the beginning of the four seasons and at the end of the year in front of the late king's *uju* spirit tablet.
	27 MONTHS AFTER THE FUNERAL	
	Ceremonial offerings (*damje*) to mark the end of the mourning period	A ceremonial offering occurs twenty-seven months after the state funeral, marking the end of the country's ritual mourning for the king.
Enshrinement in Jongmyo (*bumyo dogam*)	Final enshrinement of the king's permanent spirit tablet in Jongmyo (*bumyo*)	On an auspicious day after the *damje* ceremony, the permanent spirit tablet (*wipan*) of the king is enshrined in Jongmyo.

TABLE 5.2 Schedule of Funerary Procedures, from the *Uigwe of the Royal Funeral of King Injo*, 1649

TIME/DATE	EVENTS
Between 1 and 3 p.m. (*misi*) on the eighth day of the fifth month (day 1)	The king passes away at Daejojeon, the queen's living quarters and royal bed chamber at Changdeok Palace.
On the twelfth day of the fifth month (day 5)	The king's body is moved to the Coffin Hall that has been temporarily set up to house it at Seonjeongjeon, the king's living quarters at Changdeok Palace.
Between 11 p.m. and 1 a.m. (*jasi*) on the eleventh day of the ninth month, or approximately four months later	The royal coffin leaves the palace (*barin*) for burial at the royal tombs.
Between 11 a.m. and 1 p.m. (*osi*) on the twentieth day of the ninth month	The royal coffin is lowered into the burial chamber, followed by the inscription of the late king's royal titles on the temporary spirit tablet (*uju*).
Between 3 and 5 a.m. (*insi*) on the twenty-first day of the ninth month	The first and the second food and libation offerings are presented at the royal tomb. The late king's temporary spirit tablet is brought to the Spirit Tablet Hall (*honjeon*) of Munjeongjeon, the crown prince's living quarters at Changgyeong Palace.

TABLE 5.3 Schedule of Funerary Preparations for the Coffin Hall, from the *Uigwe of King Injo's Coffin Hall*, 1649

DATE	EVENT
On the eighth day of the fifth month (day 1)	Calling for the king's departed spirit to return (*bok*)
On the same day	Washing the king's corpse (*yeom*)
On the same day	Dressing the king's corpse (*seup*) in complete sets of all the official costumes he wore as a rule
On the tenth day of the fifth month (day 3)	Preliminary wrapping of the royal corpse (*soryeom*) with nineteen layers of white silk
On the twelfth day of the fifth month (day 5)	Final wrapping of the royal corpse (*daeryeom*). More layers of white silk wrapping plus the late king's ceremonial costumes and jade accessories are put on the royal body before it is laid to rest in the coffin. In total, ninety layers of either white silk wrappings or costumes are put on the deceased king. The coffin is then placed on the *bingban*, a wooden platform-like receptacle filled with ice to keep the royal corpse cool.
On the same day	The Coffin Hall (*seongbin*) is finally set up to house the royal coffin.
On the thirteenth day of the fifth month (day 6)	The crown prince dons the mourning garments and begins making daily and special-day offerings to the late king.

Often the Spirit Tablet Hall *uigwe* is included in the Coffin Hall *uigwe*, as was the case for King Injo's funeral. Usually, the same palace hall can be used as the Coffin Hall at the beginning of the funeral and as the receiving hall, which is set up to receive the temporary spirit tablet when it is brought back from the royal tomb after the royal funeral. The spirit tablet (*uju*), which is made of mulberry wood,[8] is to stay in the hall for twenty-seven months, during which time it is to receive daily offerings of food, plus special offerings on special days, until the three-year mourning period is over. At that time, another *dogam* superintendency is set up, called a *bumyo dogam*, to oversee the entire procedure of transporting the king's permanent spirit tablet to Jongmyo. The first task is to have a permanent spirit tablet made of chestnut wood, the *wipan*. In an elaborate procession, this new spirit tablet is transferred from the palace to Jongmyo for final enshrinment there.[9]

[70]

TABLE 5.2

TABLE 5.3

On the first page of King Injo's funeral *uigwe*, his full shrine title (*myoho*) of twelve characters, "Injo heonmun yeolmu myeongsuk sunhyo daewang," is written (see fig. 70).[10] Only the first two characters, Injo, represent how he is to be referred to in history; the rest are his honorific titles. On the same page, the schedule of the important events is spelled out (table 5.2).[11] The schedule of events for the Coffin Hall is listed in the Coffin Hall *uigwe* (table 5.3).[12]

Next we will examine the funeral procession that took place about four months after the death of the king, on the eleventh day of the ninth month. The painting is called *barin banchado*, a depiction of the procession, by rank, of participants who took part in the departure of the royal coffin.

Banchado of King Injo's Funeral There are twenty-nine pages of illustration devoted to the funeral procession at the end of the *uigwe* for Injo's royal funeral. Naturally it would contain different elements from either a procession painting of a royal wedding or of a transport of the ritual items to the palace for the investiture rite of a crown prince. A review of the important elements of Injo's funeral procession follows.[13]

[71]

[72]

The first page shows the officials on horseback (the mayor of Hanseong, ministers of rites, of the interior, of defense, the inspector general, etc.), led by a rank-6 official (*jubu*) in front (fig. 71). Three torchbearers are depicted on either side of this central group, although the text of the *uigwe* mentions that there were five hundred torchbearers in the actual procession at that time. On page 3 (fig. 72) of the *banchado* is depicted the beginning of the honor guards of the reigning king's procession, called *giruijang* (auspicious honor guards), with generals of the Left and Right Guard leading the parade of some 160 flags and ritual

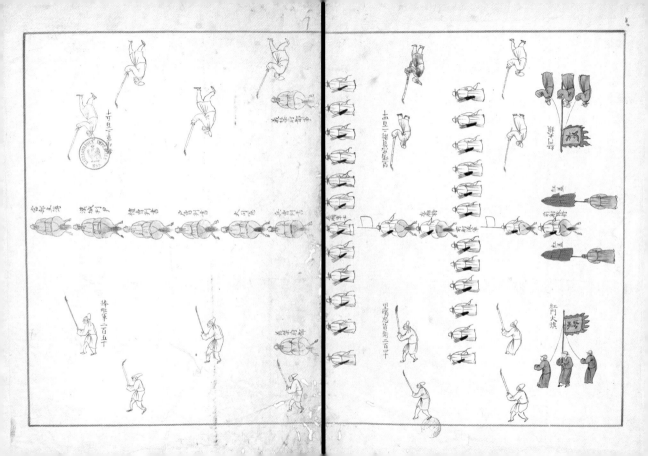

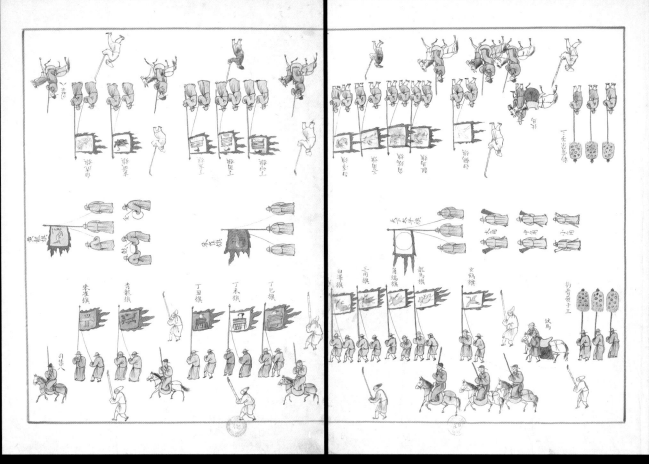

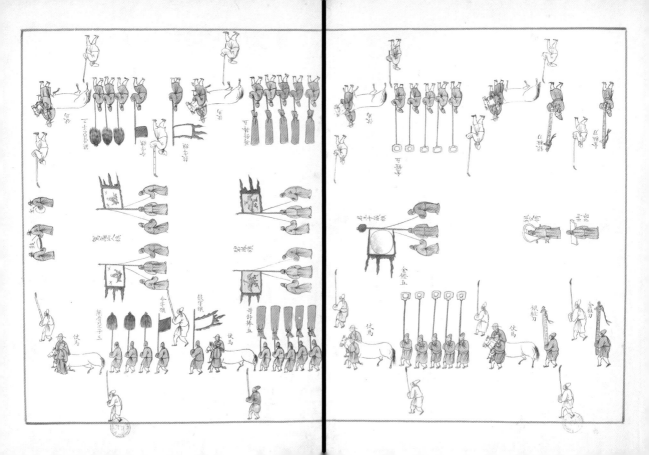

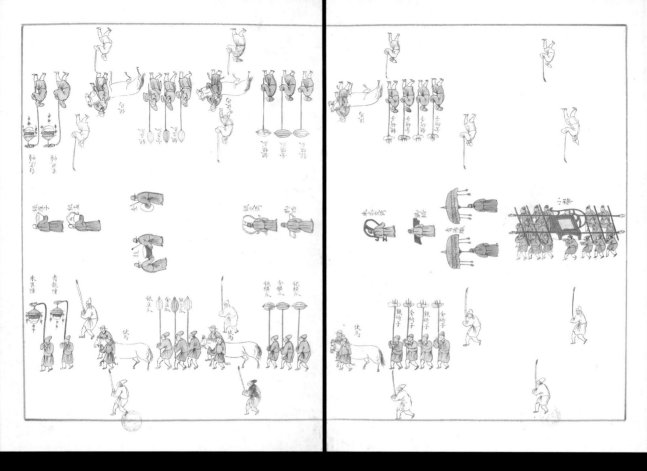

page 7 page 8

FIG. 73 Small palanquin for the deceased king (page 9) follows porters holding lanterns, ritual weapons, vessels, parasols, and a sedan chair (pages 7, 8) while a musical band plays

the *Uigwe of the Royal Funeral of King Injo* (*[Injo] gukjang dogam uigwe*), 1649. Book; ink and color on paper, 46.4 × 34.8 cm. Bibliothèque nationale de France (2552), on loan to the

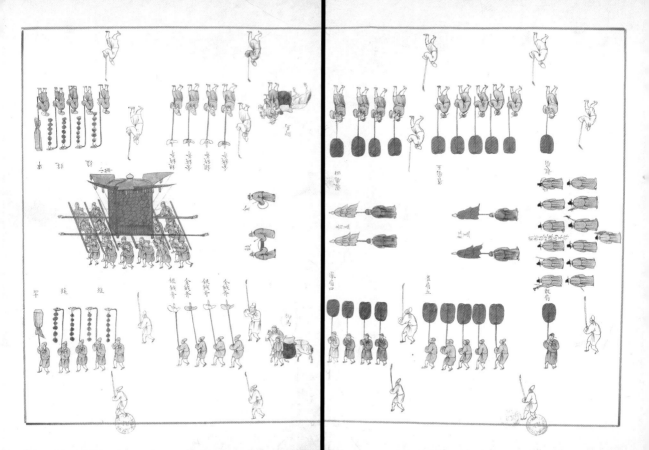

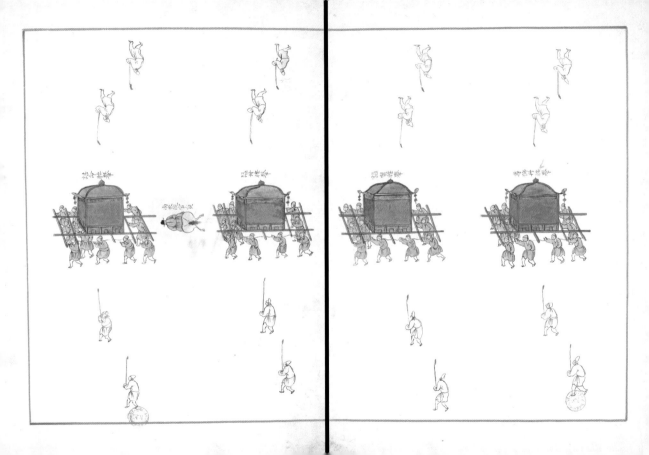

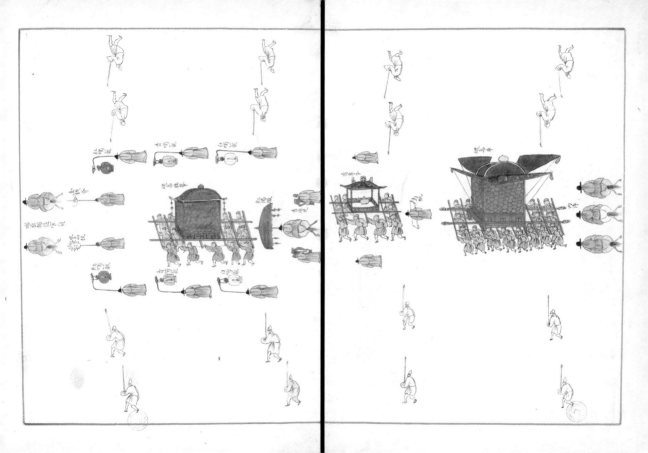

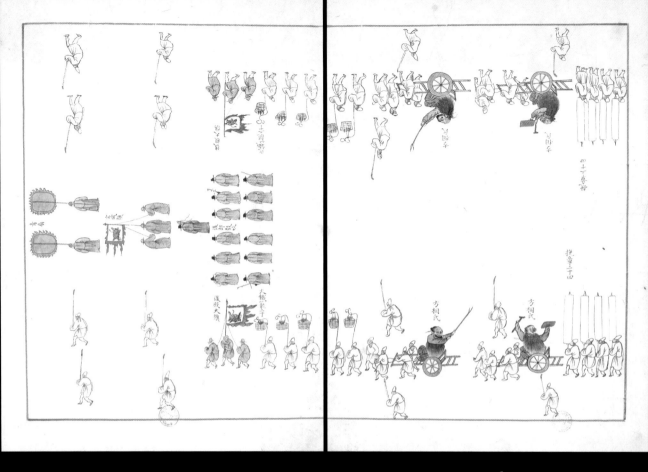

page 15

page 16

FIG. 75 Musical band marking the end of the auspicious honor guard procession (page 15) and the beginning of the funeral procession with four demon quel-

from the *banchado* in the *Uigwe of the Royal Funeral of King Injo* (*[Injo] gukjang dogam uigwe*), 1649. Book; ink and color on paper, 46.4 × 34.8 cm. Bibliothèque

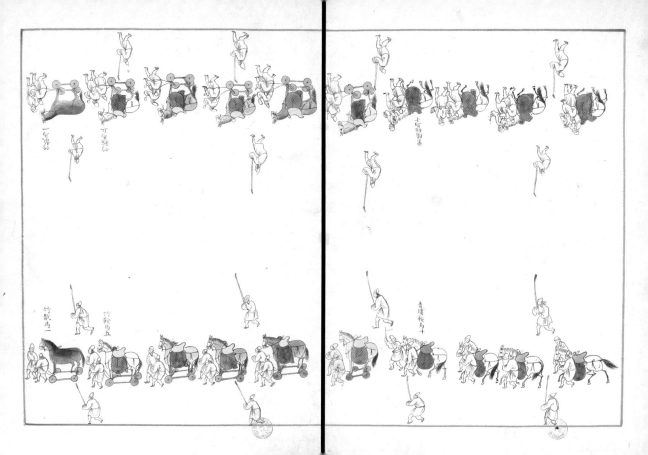

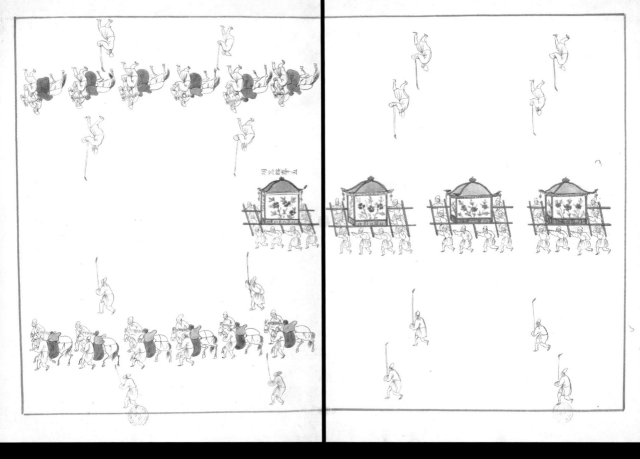

FIG. 76 Five painted
palanquins decorated
with peony flowers
carrying burial goods,
a flat palanquin
containing the king's
costumes (pages 19–21),
and a smaller funeral

banchado in the *Uigwe*
of the Royal Funeral of
King Injo ([Injo] gukjang
dogam uigwe), 1649.
Book; ink and color on
paper, 46.4 × 34.8 cm.
Bibliothèque nationale
de France (2552), on

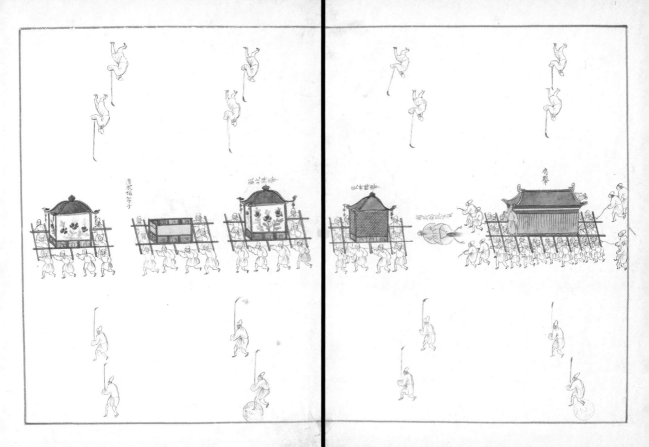

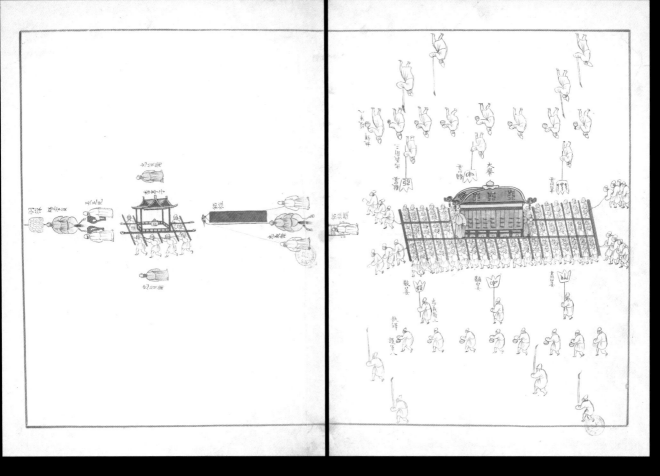

page 23

page 24

FIG. 77 Royal coffin palanquin preceded by the bearer of the *ubo*, the incense pavilion, and the red funeral banner (pages 23, 24), ([*Injo*] *gukjang dogam uigwe*), 1649. Book; ink and color on paper, 46.4 × 34.8 cm. Bibliothèque nationale de France (2552), on loan to

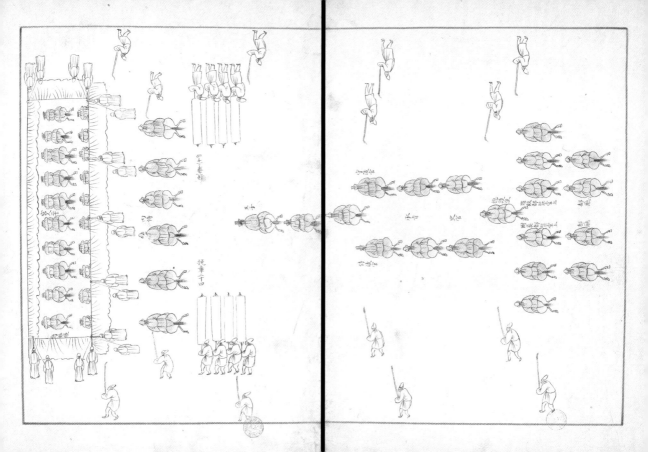

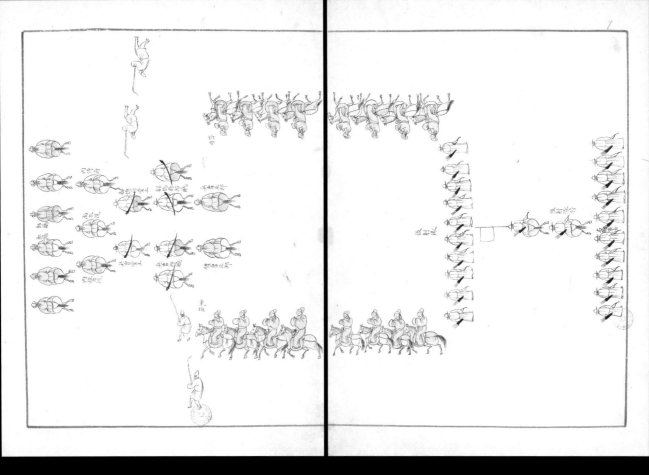

page 27

page 28

FIG. 79 The rear honor guard, from the *banchado* in the *Uigwe of the Royal Funeral of King Injo ([Injo] gukjang dogam uigwe)*, 1649. Book; ink and color on paper, 46.4 × 34.8 cm. Bibliothèque

weapons that are the standard accompaniment in the formal procession

[72] of a king (fig. 72). Although this is a funeral procession, it is customary to show the elements of the reigning king's procession first.[14] Leading the multitude of flags is the large flag called *gyoryonggi*, which is held up by three standard bearers. This flag symbolizes the authority of the king, and positioning it at the head of the king's retinue indicates the king is in command of the entire procession.[15]

On page 9 of the *banchado*, a small palanquin (*soyeon*) that used to
[73] serve the deceased king, is seen flanked by sets of ritual weapons (fig. 73). A pair of white royal horses (*eoma*), each tended by two grooms, follows the palanquin. This section ends (page 10) with more honor guards and a group of twelve musicians in pink costumes whose conductor wears a green costume.

[74] In the next section (fig. 74) are the four small red palanquins called *yoyeo* (pages 11 and 12 of the *banchado*) that carry: the Chinese emperor's letter of approval for posthumously elevating the late king to higher rank (*gomyeong*); the jade book on which the late king's posthumous titles are engraved (*sichaek*); the king's posthumous seal (*sibo*); and the jade book in which his elevated titles are inscribed (*jonhochaek*). On page 13 is the *yoyeo* carrying the bundle of silk cloth called *honbaek*, the folded silk or ramie cloth in which the deceased king's spirit is housed. Then, on page 14, appears a small pavilion-shaped palanquin carrying an incense burner, followed by another, much larger palanquin called *honbaekgeo*. The *honbaekgeo* actually carries the *honbaek* and the temporary mulberry-wood spirit tablet (*uju*). The *honbaekgeo* is supposed to be borne by fifty men, but in this picture only twenty-three are visible. Although on pages 10 and 15 of the *banchado* there are two bands of musicians, twelve men each, with various instruments and a conductor in green costume, they are not playing music, in accordance with the regulation not to play music during the twenty-seven months of the state mourning period.

The next section marks the beginning of the "funeral proper" or
[75] main elements of a [king's] funeral (*hyunguijang*) (fig. 75). We see four unusually dressed figures seated on a two-wheeled cart pulled by several men. They are the demon quellers, *bangsangsi*, who chase out any evil spirit that might hide in the king's burial chamber. Of course they must look scary: they wear golden masks with four eyes, drape themselves with bear pelts, wear red skirts (although blue in this section), and wield long weapons. They are the only lively figures in this otherwise solemn funeral procession. Starting from the right side of page 16 are men clad in white carrying long white streamers on which funeral eulogies for the deceased are written (*manjang*). Supposedly there are twenty-four on each

side, although only eight of them are shown. In the funeral processions of kings and queens, this group is followed by ceremonial horses made of bamboo set on four wheels and pulled by two men in white costume (pages 17, 18). Two more bamboo horses lead the procession (*cheong-suanma*), followed by white horses with either blue or purple embroidered saddles (*jasuanma*) that continue onto page 19.

[76] Starting from the end of page 19 (fig. 76), we see a succession of five small *yoyeo* palanquins decorated with peony flowers, carrying burial goods (*myeonggi*) such as small-scale sets of porcelain tablewares and bamboo or wooden utensils. On page 21, a small, boxlike, flat palanquin carrying the king's costumes that had been used at the "calling for spirit ritual" (*yuuiching gaja*) by a eunuch on the roof of the palace, follows the last *yoyeo* of the previous page. It is followed by another *yoyeo* that contains more clothing and other personal items of the deceased (*bogwan yoyeo*).

On page 22 of the *banchado*, another *yoyeo*, completely covered with green cloth carrying eulogies for the deceased written on a jade book (*aechaek*), and a spare coffin palanquin called *gyeonyeo* (a palanquin carried on shoulders, to be used in narrow and steep mountain roads to the royal tomb) occupies the center of the page. This coffin palanquin is supposed to be borne by sixty to seventy men, but it was not possible to depict all

[77] in this small illustration. On page 23 (fig. 77), a small pavilion-shaped palanquin carrying an incense burner follows close behind the bearers of the *ubo*, a pole covered with abundant white feathers on top, the function of which is to announce the coming of the king's large funeral palanquin. Next comes the tall red funeral banner (*myeongjeong*) that bears the identification of King Injo's coffin written in twelve gold characters (憲文烈武明肅 純孝大王梓宮 [*Heonmun yeolmu myeongsuk sunhyo daewang jaegung*]): the first ten characters are the honorific posthumous title given by his subjects based on his rule and the last two refer to the royal coffin. The banner will be placed on the coffin when it is lowered into the burial chamber.

The larger royal coffin palanquin (*daeyeo*) occupies the center of page 24, immediately after the stand for the red funeral banner (*myeong-jeonggi*). The *uigwe* informs us that for the funeral of King Injo, as many as 6,438 men were mobilized, not to mention the construction of the royal tomb, which required 2,848 men, including 1,000 Buddhist monks drafted by the state for the task. Two hundred and eighteen soldiers carried the large royal coffin palanquin, but six shifts were necessary to cover the distance of about 40 kilometers (90 *li*) between Hanyang and Paju, which means 1,308 soldiers were needed just for the royal coffin palanquin. Eight hundred and seventy-two soldiers were grouped in four shifts for the task, indicating that two groups of bearers worked twice.

Behind the royal coffin palanquin on page 25 are twenty palace women who perform as wailers (*gokgungin*), hidden discretely inside the white-draped compartment[16] lest they be shown in public. Three of King Injo's princes on horseback in a straight line, together with dozens of mounted court officials, follow the draped compartment (figs. 78, 79).

[78]
[79]

Although the *banchado* does not identify them by name — it simply bears a label *wangja* (prince) next to the first prince in the line on page 25 — we know that they are Prince Inpyeong (Inpyeong daegun, 1622–1658), Prince Sungseon (Sungseongun, d. 1690), and Prince Nakseon (Nakseongun, 1641–1695), the third, fourth, and fifth sons of King Injo, respectively.

[80]

King Injo's current tomb, Jangneung, in Paju, Gyeonggi province (fig. 80), is not the original one constructed in 1649, but a replacement constructed in 1731 after snakes and insects had swarmed in the first tomb, not too far away from the present one.

The *uigwe* offers many more fascinating details about who and what was included in Injo's royal funeral procession, enough to fill a whole other book. We will end here by listing the names of three of the painters who worked for the events: Kim Myeong-guk (b. 1600), a court painter famous for landscapes and figures; Yi Yu-seok; and Yi Yu-tan. We know the last two painters only by name through their participation in various other state rites in the second half of the seventeenth century.[17]

In addition to the procession painting, screens of the Five Peaks and of peony flowers had to be painted for royal funerals. In the funeral-related *uigwe* texts, we learn that plain screens — that is, those without any painting — were to be used to shield the area in the funeral hall while the corpse was being washed and shrouded. Screens of the Five Peaks were to be placed behind the royal coffin. Whenever the royal coffin was moved or rested, even for a short while, the Five Peaks screens always had to protect it. The sites where Five Peaks screens were used to shield the royal coffin include: the Mohwagwan (Hall of Revering China),[18] where an on-to-[the royal tombs] offering was performed; the royal tomb chamber during excavation (*neungsanggak*); and the T-shaped pavilion that fronts the royal tomb (*jeongjagak*). In the Spirit Tablet Hall, screens of peony flowers formed another layer of protection behind the screen of the Five Peaks.[19]

Uigwe of the Construction of King Injo's Tomb

The basic detail of the construction of a royal tomb is spelled out in the tomb construction (*chijang*) section of the *Five Rites of State*.[20] According to its description there, at the beginning of the Joseon dynasty the walls of royal tomb coffin chambers were made of stone. The ceiling of the

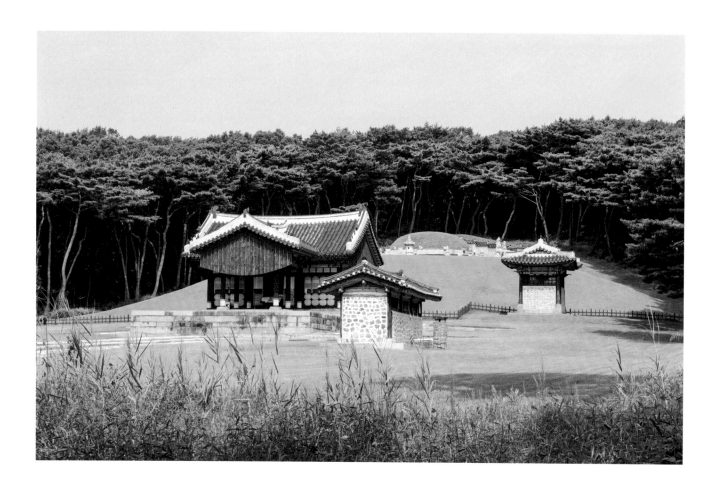

FIG. 80 Jangneung,
King Injo's Tomb, 1649
(rebuilt 1731). Paju,
Gyeonggi province.
Photograph, ca. 1998.

chamber's interior was decorated with the sun, moon, constellations, and the galaxy. On the walls were painted four directional animals (*sasudo*): blue dragon of the east, white tiger of the west, red phoenix of the south, and black warrior of the north. These four animals are the same as those called *sasindo* (Four Deities) that decorated the walls of Goguryeo tombs. There has been no study yet that clarifies this term change. *Sasu* first appeared in the special "Five Rites" section of the *Veritable Record of King Sejong* (1446),[21] which became the basis of the *Five Rites of State* of 1474. Since then the term *sasu* has been consistently used in all *uigwe* documents. Perhaps Neo-Confucian scholar-officials of the early Joseon preferred the down-to-earth appellation *sasu* to *sasin*, which has Daoist religious connotations.

However, beginning in the late fifteenth century, coffin chambers were constructed no longer of stone but instead a combination of lime, yellow dirt, and fine sand, and wall and ceiling decorations were eliminated. The *Uigwe of the Construction of King Injo's Tomb* records this change. According to the document, which is dated to the nineteenth day of the seventh month, King Taejong (1367–1422) ordered the *salleung dogam* superintendency not to use the usual large stone slabs for the walls of his queen, Wongyeong (1306–1420), but instead to use smaller ones for easy transport. This order was not adhered to when King Sejong's mother passed away, however. According to an anecdote, Sejong, out of his filial piety, went back to the use of larger stone slabs for her coffin chamber, and had the ceilings and the walls decorated.[22] However, King Sejo ordered his subjects not to use stone slabs in his own tomb chambers, and his successor, King Yejong, adhered to this order when constructing King Sejo's tomb upon his death in 1468.[23] To date, no Joseon dynasty royal tombs have been excavated to reveal the actual interior decoration of their walls and ceilings.

In the *Addendum to the Funeral Rites of State* of 1758, we find that the walls of the coffin chamber and the burial-goods chamber next to it are to be covered with *sammul*, a mixture (3:1:1 proportion) of lime powder, yellow soil, and fine sand. There is no mention of ceiling paintings of the sun, moon, and stars, nor is there any mention of the animals of the four directions.[24] A section on *sammul* workshops for tomb-chamber construction appears not only in this Injo royal tomb construction *uigwe*, but also in other royal tomb *uigwe* before 1758.

The Four Animals that used to be painted on the walls of the tomb chamber were instead painted on the interior of a house-shaped structure [81] called a *changung* (fig. 81). This was a structure built to house the royal coffin within the Coffin Hall before its departure to the royal tomb. This

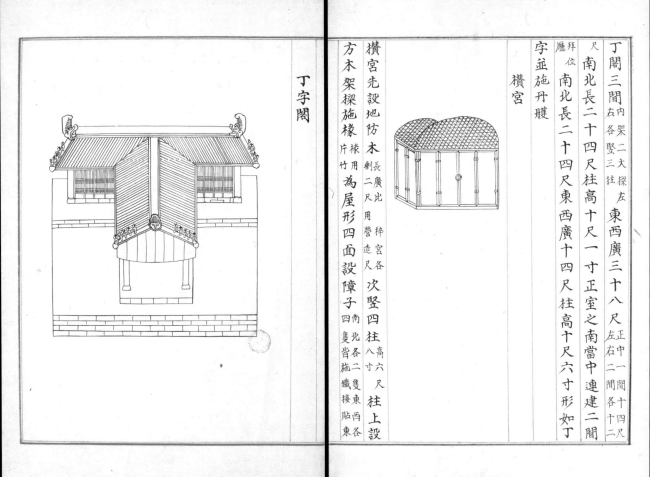

FIG. 81 Drawing of a *jeongjagak* (left) and depiction of a *changung* (right), from the *Uigwe of the Construction of Crown Prince Sado's Tomb (Hyeollyungwon wonso dogam uigwe)*, 1789. Book; ink on paper, 45.8 × 33 cm. Kyujanggak Institute for Korean Studies, Seoul National University (Kyu 13627).

temporary housing for the royal coffin was to be burned on the day of the funeral, and its ashes buried in the ground behind the Coffin Hall. A second *changung* was constructed at the T-shaped building (*jeongjagak*) to temporarily house the royal coffin on the funeral day, and it, too, was burned after the entombment.

The paintings of the Four [directional] Animals (*sasudo*) on the inner walls of *changung* are familiar to us through the wall paintings of the Goguryeo tombs. The best example of painting of the Four [directional] Deities (*sasindo*) can be found in the early seventh-century Great Tomb at Gangseo (Gangseo daemyo), near Pyongyang (fig. 82). In this tomb, each of the Four Deities occupies one wall of the tomb chamber. However, this tradition did not seem to have continued into the Goryeo dynasty (918–1392), where, for example, the wall decoration of the Hyeolleung tomb (943) — the resting place of the Goryeo founder, Wang Geon (r. 918–943) — shows a small blue dragon under bamboo and a blossoming plum tree.[25] Therefore, the Four Animals on the walls of the *changung* can be considered directly related to the Four Deities painting tradition on the walls of Goguryeo tombs.

At the time of King Jeongjo's funeral in 1800, the second *changung* decorated with the Four Animals was carried to the Hwaseong Detached Palace near his tomb, Geolleung, and burned there.[26] Therefore, the illustrations in *uigwe* books serve as the only visual evidence of the Four Animals subject in the Joseon dynasty.[27] In a comparison of the Four Animals illustrations in the 1649 Injo royal tomb construction *uigwe* (fig. 83) and those in the 1800 Jeongjo royal tomb construction *uigwe* (fig. 84), the most visible difference is in the depiction of the red phoenix of the south. The 1649 bird maintains certain traits of the imaginary bird — three legs, three heads, and widespread wings — but the 1800 red phoenix takes the form of a small bird, more like a large sparrow. In fact, the compound character for red phoenix is 朱雀 (*jujak*) and the second element alone means "sparrow." This change took place with the 1753 royal tomb construction *uigwe* of Queen Jeongseong, and remained that way until Emperor Sunjong's funeral of 1926, which was the last occasion to construct a *changung*.[28]

A less noticeable difference is in the posture of the white tiger of the west: the 1649 tiger is seated quietly with its forelegs upright, whereas the 1800 tiger takes on a dynamic posture with all four legs upright, and even its tail twisted upward adds to the sense of movement. This posture can also be found in the 1753 *uigwe*, although it is not as dramatic as that of the 1800 tiger. The twisting movements of the blue dragon of the east in the two *uigwe* also differ: while the 1649 blue dragon assumes a reverse C curve, the 1800 dragon twists its tail in the opposite direction

[82]

[83]
[84]

A

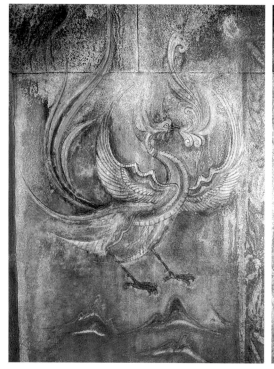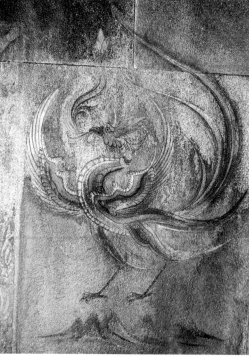

FIG. 82 Four [directional] Deities from the Great Tomb at Gangseo, Nampo, early 7th century. A, Blue dragon of the east. B, White tiger of the west. C, Pair of red phoenixes of the south, flanking the doorway. D, Black warrior of the north.

C

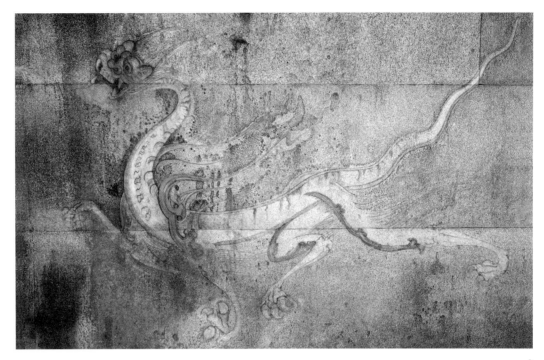

B

D

FIG. 83 Blue dragon, white tiger, red phoenix, and black warrior, from the *Uigwe of the Construction of King Injo's Tomb ([Injo Jangneung]* *salleung dogam uigwe),* 1649. Book; ink and color on paper, 44 × 33.7 cm. Jangseogak Archives, The Academy of Korean Studies (K2-2367).

FIG. 84 Blue dragon, white tiger, red sparrow, and black warrior, from the *Uigwe of the Construction of King Jeongjo's Tomb* ([Jeongjo] Geolleung salleung dogam uigwe), 1800. Book, ink and color on paper, 46.7 × 33.5 cm. Kyujanggak Institute for Korean Studies, Seoul National University (Kyu 13640).

and creates an S curve, although the upper part of the "S" is considerably smaller than the lower part.

The differences or changes mentioned above are reflections of the painting styles from the mid-seventeenth century through the late eighteenth century, when Joseon painting was being influenced by Western realism through China in almost all areas, animal paintings included.[29] The posture of the white tiger of the west in King Jeongjo's royal tomb *uigwe* is very similar to that of *Ferocious Tiger* painted by Kim Hong-do (1745–1806) in the Leeum Museum of Art (fig. 85).[30]

[85]

Painters in the superintendency of the royal tomb *uigwe* also took care of all the drawing and painting needs. They produced the necessary drawings for the stone sculptures to be placed in front of the royal tomb and decorated the T-shaped building in front of the tomb. Therefore, more names of the painters are listed in this *uigwe*.[31]

Uigwe of the Funeral of Crown Grandson Uiso, 1752

This examination of funeral-related *uigwe* ends by introducing the only Joseon dynasty *uigwe* of the funeral of a grandson who was to be the heir apparent — the *Uiso seson yejang dogam uigwe*. This *uigwe* is a record of the funeral of King Yeongjo's first grandson, Uiso (1750–1752), who was appointed crown grandson (*seson*) in the fifth month of 1751, even before his first birthday. He was the first son of Crown Prince Sado (1735–1762), and the eldest brother of King Jeongjo. King Yeongjo expressed his love for his first grandson and told his subjects to make swift arrangements for appointing the baby as the heir apparent.[32] Uiso died in the third month of the following year, however, when he was about nineteen months old.

One might wonder why Uiso was appointed crown grandson when King Yeongjo's crown prince was still alive. We find the answer in the Joseon kings' wishes to secure the legitimate line of succession by appointing the first son as the heir apparent down two generations. This practice began as early as the fifteenth century, when King Sejong appointed his grandson heir (later King Danjong) in 1448 while the crown prince (later King Munjong) was alive.[33]

As the Korean title of the *uigwe* shows, the royal grandson's funeral is called *yejang*, not *gukjang*, which means that it relates to the funeral of members of the royal family *other* than kings and queens.

Since this funeral was the first one of a crown grandson, and happened while King Yeongjo was having the *Addendum to the Funeral Rites of State* compiled, the king wanted to have all the details carefully recorded. In fact, we find his remarks and orders during the funeral recorded and attached as volume 6 of the *Addendum*.[34] In it, we find Yeongjo trying to

FIG. 85 Kim Hong-do (1745–1806), *Ferocious Tiger*, 18th century. Hanging scroll; ink and pale color on silk, 90.3× 43.8 cm. Leeum Museum of Art.

TABLE 5.4 Outline of Events of Crown Grandson Uiso's Funeral, 1752

DATE	EVENT
On the fourth day of the third month (day 1)	Death of the crown grandson in Tongmyeongjeon, the queen's quarters in Changgyeong Palace
On the sixth day of the third month (day 3)	The Coffin Hall (*bingung*)[1] is set up in Sungmundang, a banqueting hall in Changgyeong Palace.
On the seventh day of the third month (day 4)	Royal family members don the mourning garments made of very coarse hemp cloth.
On the eleventh day of the fifth month (day 8)	The royal coffin leaves the Coffin Hall for the funeral (*barin*).
On the twelfth day of the fifth month (day 9)	The royal coffin is placed in the T-shaped pavilion before its final entombment.
On the same day	The royal coffin is kept in the *giryugung*, a temporary structure made of bamboo and drapery, while the identity (royal title) of the deceased is written on the temporary spirit tablet (*uju*).
On the same day	The *uju* is brought back and placed in the Spirit Tablet Hall (*hongung*) set up in the Gangseowon, the office in charge of Uiso's education in Changgyeong Palace.

1 If it were the funeral of a king or queen, it would be called *binjeon*.

simplify the procedure of the funeral as much as possible. For example, he issued an order to set up just one instead of three separate superintendencies for the ritual program at the Coffin Hall, the funeral, and the tomb construction. Also, he issued orders not to make new offering utensils, to reduce the amount of food offered at every stage of the funeral, and to reduce the size of flags of the honor guards in the procession.

TABLE 5.4 Table 5.4 shows the program of ritual events for the funeral. After the schedule of events in the 1752 *uigwe* are written the deceased prince's posthumous title, Uiso, the Uiso Spirit Tablet Hall (Uiso *hongung*), and the title of the tomb, Uisomyo. The head of the superintendency at this time was Kim Yak-ro (1694–1753), who served as both the minister of the left and the minister of the privy council. As seen in the schedule, the funerary program — from the death of the crown grandson until his funeral — took only two months and one week. This is a drastically short-ened schedule when compared with that of the royal funeral of King Injo in 1649, which took four months and three days to complete (see table

TABLE 5.1 5.1 above).

We are fortunate that the sole surviving copy of this *uigwe* is the royal viewing copy, which came back to Korea from the Bibliothèque nationale de France and is now kept in the National Museum of Korea. Below, we will examine the *uigwe*'s funeral *banchado*, which illustrates the funeral procession that took place on the eleventh day of the fifth month of 1752.[35] It consists of twenty-eight pages and is attached to the end of the first volume of the *uigwe*.[36] However, here we will examine only a

[86] small portion of it (figs. 86–88), as we already examined the basic compo-
[87] nents of a royal funeral procession through the *banchado* of King Injo's
[88] funeral. In terms of quality of workmanship, it is the best funeral-related *banchado* that survives today; the *uigwe* text records that the best paper and the best pigments available were used for this *banchado*. We can see more than 500 figures and 152 heads of horses, although it would not have been possible to include in this painting all of the figures and horses that were in the actual procession.[37]

Pages 11 and 12 of the *banchado* show the small palanquin carrying the cotton-wrapped spirit tablet (*honbaengnyeon*), and the four demon

[86] quellers on wheeled carts (fig. 86) that together signal the coming of the
[88] main coffin palanquin (fig. 88). The main palanquin (page 21) is preceded by the small incense pavilion and the funeral banner of the crown grandson (pages 19, 20), followed by the wailing palace women (page 22). Both sections demonstrate the high quality of the workmanship: all of the characters identifying the figures and objects are neatly and flaw-lessly written in regular script. The postures and gestures of figures of

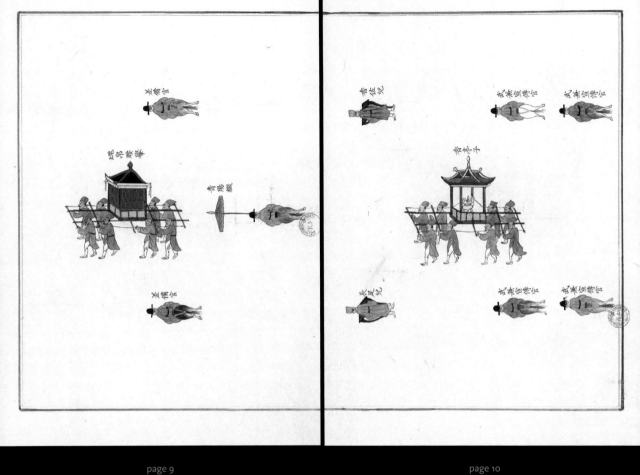

page 9

page 10

FIG. 86 Small palanquin carrying the cotton-wrapped spirit tablet and the four demon quellers of the crown grandson (pages 11, 12), from the *banchado* in (*Uiso seson yejang dogam uigwe*), 1752. Book; ink and color on paper, 48.6 × 36 cm. Bibliothèque nationale de France (2511), on loan to the National Museum

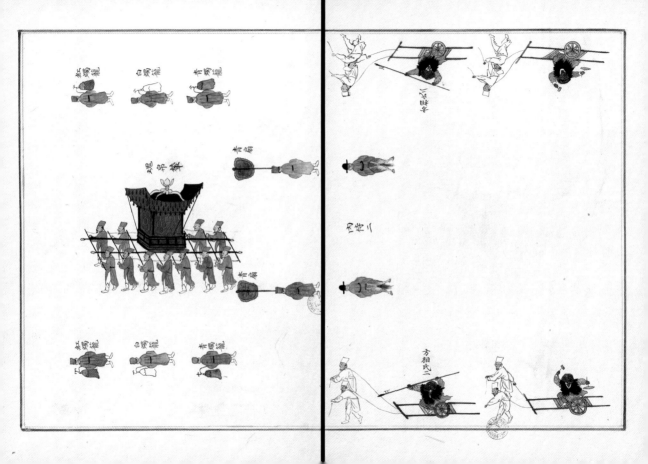

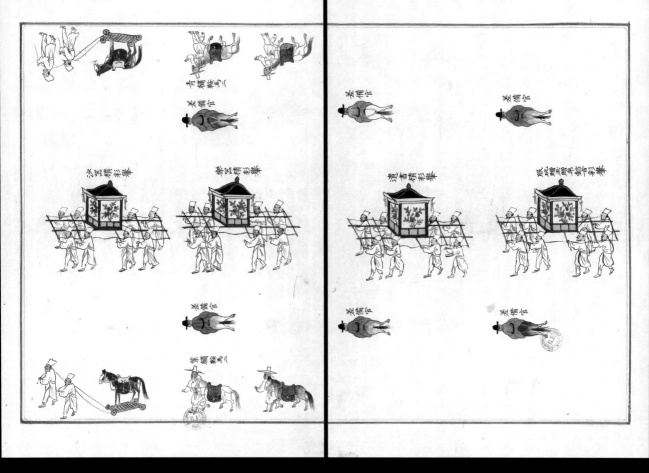

page 15

page 16

FIG. 87 Four painted palanquins decorated with peony flowers carrying burial goods such as musical instruments, leftover clothing, and playthings of the crown grandson (pages 15, 16), a small palanquin containing the book of eulogy (page 17), and a coffin palanquin called *gyeonyeo* for use over narrow or steep terrain (page 18), from the *banchado* in the *Uigwe of the Funeral of Crown Grandson Uiso* (*Uiso seson yejang dogam uigwe*), 1752. Book; ink and color on paper, 48.6 × 36 cm. Bibliothèque nationale de France (2511), on loan to the National Museum of Korea (Ogu 181).

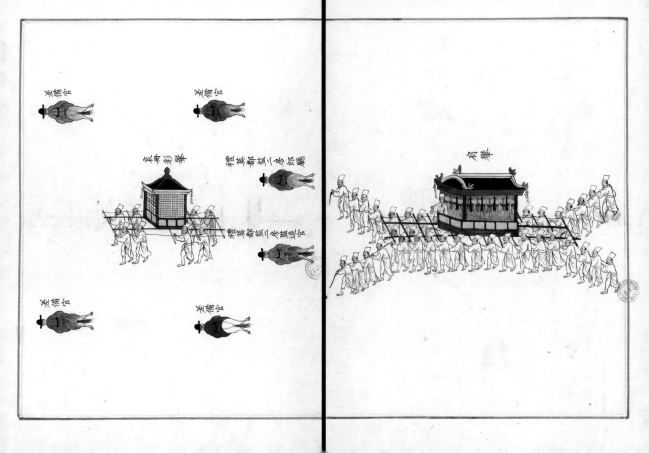

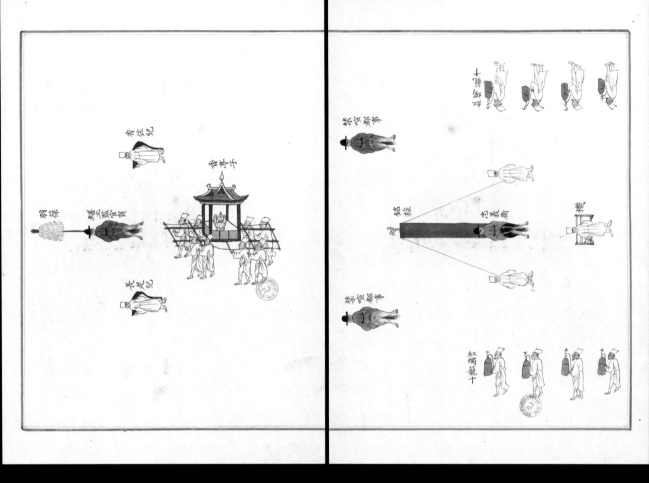

page 19

page 20

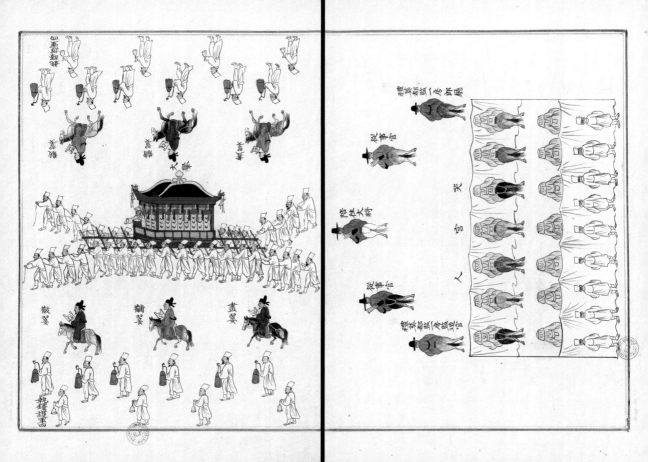

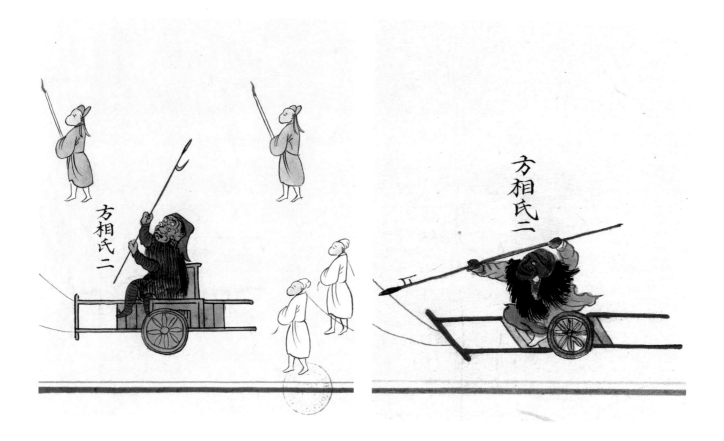

FIG. 89 Demon queller. Detail from the *bancha-do* in the *Uigwe of the Funeral of Queen Jang-nyeol* (*Jangnyeol wanghu gukjang dogam uigwe*), 1688. Book; ink and color on paper, 48.6 × 38 cm. Bibliothèque nationale de France (2561), on loan to the National Museum of Korea (Ogu 070).

FIG. 90 Demon queller. Detail from the *banchado* (page 12) in the *Uigwe of the Funeral of Crown Grandson Uiso* (fig. 86).

the same group holding the same attributes are subtly differentiated to express the liveliness and individuality of the figures; their stance and the drapery lines suggesting slight movements of the body contribute to this dynamic effect.

Rather than using primary colors as in most other procession paintings, here, mostly secondary or tertiary colors that are deeper in tonality and more subdued in expression were chosen. The deep wine color of the eaves, four columns, and the lower parts of the coffin palanquin, including the bars used to lift the palanquin, are juxtaposed with subdued blues, greens, and yellows. The color combinations of the costumes of the equestrian figures follow the similarly subtle color scheme.

Finally, the liveliness of the figures in this *banchado* can be demonstrated by a comparison between an earlier image of a demon queller (*bangsangsi*) from Queen Jangnyeol's (Injo's queen) royal tomb construction tion *uigwe* of 1688 (fig. 89). The image from the Uiso seson *banchado* (fig. 90) shows the demon queller making a dashing movement from the left to the right, wielding his long spear diagonally. His blue drapery and the black bear's fur being ruffled by the fast movement reflect the violent gesture of the demon. The demon figure in the Injo-period image, by contrast, holds his spear nearly upright and appears to be almost stationary. Accordingly, no movement of his drapery or the bear's fur is indicated. The only scary part is his four large eyes, which perhaps would be enough to expel uninvited spirits from the royal tomb chamber.

It was not specified in the *uigwe* who the painter of the Uiso *uigwe banchado* was, but among the artisans (including the painters) listed under the main superintendency, appears the name Kim Deok-seong (1727–1797). He was the nephew of the famous landscape and genre painter Kim Du-Ryang of King Yeongjo's Painting Academy. Kim Deok-seong is a well-known painter of Buddhist deities, and his *Wind and Rain God* bears the critic Gang Se-hwang's colophon saying that Kim's painting shows the artist's mastery of the subtleties of Western painting in the use of brush and color. Gang seems to be referring to the Western realism in the depiction of figures and the use of light and shade. For this first (and only) *uigwe* of the funeral of a crown grandson, King Yeongjo wished to record all the details for future reference, to create a *uigwe* book with a funeral procession that reflected contemporary artistic trends of the period by employing the best painters of the period. The liveliness of the figures in the procession is akin to Western realism that is seen in the Four [directional] Animals paintings for King Jeongjo's *changung* discussed above.

This survey of two funeral rites–related *uigwe* helps us understand how the Joseon people wished to express their last farewell to the departed

[89]
[90]

king. No matter how complicated the protocols were, royal descendants performed the rites with Confucian filial piety. During the three-year mourning period, no music was allowed to play, and no celebratory events such as royal weddings or royal banquets could take place. Austerity and solemnity governed the mood of the entire country until the deceased royal was enshrined at Jongmyo in the form of the permanent wooden spirit tablet twenty-seven months after the funeral.

About three months after the final enshrinement of Uiso's spirit tablet in Jongmyo, King Yeongjo ordered to have the Uiso Shrine (Uisomyo) built in Changuigung. Therefore, the Office of the Construction for the Uiso Shrine (Uisomyo yeonggeon cheong) was set up to carry out the king's order. The work began on the second day of the eighth month, and it was finished less than two months later, on the twenty-eighth day of the ninth month. Upon completion of the shrine, the *Uigwe of the Construction of the Uiso Shrine* (*Uisomyo yeonggeon cheong uigwe*, 1752) was compiled.[38] On the second day of the tenth month, Yeongjo came to see the completed shrine and rewarded the officials and workers who built it. This seems to be the king's final expression of affection toward his deceased grandson and heir apparent, as well as a consolation for himself.

As mentioned earlier, heavy stone tomb chambers gave way to ones constructed with a mixture of mud, sand, and plaster sometime in the fifteenth century. This change of material for tomb construction naturally brought about modifications in the interior decoration of tomb chambers. Presumably, the softer walls of the later tomb chambers were not suitable for wall paintings, and the Four Animals motif that once decorated the walls of royal tombs are now only in the form of the *uigwe* illustrations showing the interiors of the *changung*, the temporary structure for housing a royal coffin before ritual burial

In order to simplify the complicated state funeral procedure, King Yeongjo had the *Addendum to the Funeral Rites of State* compiled in 1752. While this work was in progress, the court had to conduct the funeral of Uiso seson. Therefore, Yeongjo wanted to have all the details of the first funeral of a crown grandson carefully recorded, and attached as volume 6 of the *Addendum to the Funeral Rites of State*. Though simplified in many respects, the painting of the funeral procession of Crown Grandson Uiso is one of the best of its kind and reflects the highest standards of mid-eighteenth-century Joseon painting.

Throughout the 518 years of the dynasty, the Joseon people maintained their royal tombs and its precinct with utmost respect and care, which is why today there remain forty-two magnificent royal tombs set in the most natural and beautiful surroundings as exemplified by King

[80] Injo's tomb (see fig. 80).[39] Most of these royal tombs are located within an 80 *li* (about 42 kilometers) radius of the capital so that the royal visits and maintenance of the tombs would be relatively convenient.[40] No other country in the world has preserved and maintained its royal tombs as well and for such a long time. The many *uigwe* of royal tomb construction, together with the *Veritable Records of the Joseon Dynasty*, serve as the most detailed documentary evidence for these tombs. The historical, documentary, and cultural values of Joseon royal tombs have been recognized worldwide, leading to their registration in 2009 as a UNESCO World Heritage Site.[41] These well-maintained, park-like precincts are open to the public most of the time and also can be visited online.[42] ◆

Uigwe of
Important
State
Events
Other than
the Five
Rites
—
PART TWO

Many state rites were conducted with equal formality and dignity as those of the Five Rites. Accordingly, *uigwe* were compiled after those events and categorized as follows:

- The painting of a reigning king's portrait or the copying of damaged royal portraits
- Royal banquets[1]
- Compilation of the *Veritable Records of the Joseon Dynasty*
- Construction and repair of royal palaces and royal ancestral shrines
- Construction and repair of the placenta burial of kings and crown princes
- Posthumous elevation of titles of kings and queens
- Posthumous elevation to kingship[2]
- Awarding the status of special merit subject
- Compilation or revision of the *Book of Royal Lineage* (*Seonwon boryak*)
- King's move of residence (*ieo*) and outings (*haenghaeng*)
- Production of vessels and utensils for royal ancestral worship
- Production of musical instruments for state rites

Of these twelve categories, the three that contain the most information on art and art history will be discussed in this section, which consists of three chapters: chapter 6 (*uigwe* related to royal portraits); chapter 7 (*uigwe* of King Jeongjo's visit to his father's tomb in 1795, which includes the royal banquet that celebrated the sixtieth birthday of King Jeongjo's parents held at the Hwaseong Detached Palace); and chapter 8 (*Uigwe of the Construction of the Hwaseong Fortress*, which includes the construction records of the detached palace within). Chapters 7 and 8 also address King Jeongjo's contribution to the production of printed *uigwe* of the Joseon dynasty.

CHAPTER SIX

Uigwe Related to Royal Portraits

The painting of a reigning king's portrait or the copying of damaged portraits of past kings was itself considered a state rite to be conducted with as much formality and dignity as other state rites.[1] According to the *Applications of the Six Codes* of 1867, "royal portraits were to be painted once every ten years during a king's reign,"[2] although this rule was not always observed. In 1901, Emperor Gojong wanted to have his and the crown prince's portrait painted and asked his officials to establish a *dogam* superintendency for the task. He said, "since the reigns of the 'two sage kings' (*yangseongjo*), royal portraits were supposed to have been painted once every ten years, but due to more urgent affairs, this could not be observed."[3] In the above passage, it is not certain whose reigns he meant by "two sage kings."[4] Most likely it refers to the reigns of Kings Sukjong and Yeongjo, or Yeongjo and Jeongjo, when the royal portrait tradition revived and flourished after two foreign invasions, the Japanese and Manchu.[5] But it is interesting to find that *uigwe* were compiled after only a handful of occasions. Setting up a special office and compiling a *uigwe* is a costly endeavor, and Joseon kings, in keeping with the Confucian ethical standards of frugality, avoided large state spending. King Jeongjo, for example, called his cabinet ministers and asked for their approval *not* to set up the *dogam* each time his portraits were painted.[6] As a result, there remain only nine specimens of *uigwe*, ranging in date from 1688 to 1902, that detail the state rites for the painting or copying of royal portraits:

1688 *Uigwe of the Copying of King Taejo's Portrait*[7]
1713 *Uigwe of the Painting of King Sukjong's Portrait*[8]
1735 *Uigwe of the Copying of King Sejo's Portrait*[9]
1748 *Uigwe of the Copying of King Sukjong's Portrait*[10]
1837 *Uigwe of the Copying of King Taejo's Portrait*[11]
1872 *Uigwe of the Copying of King Taejo's Portrait*[12]
1900 *Uigwe of the Copying of King Taejo's Portrait*[13] plus the
 Uigwe of the Copying of King Sunjo's and King Munjo's Portraits[14]

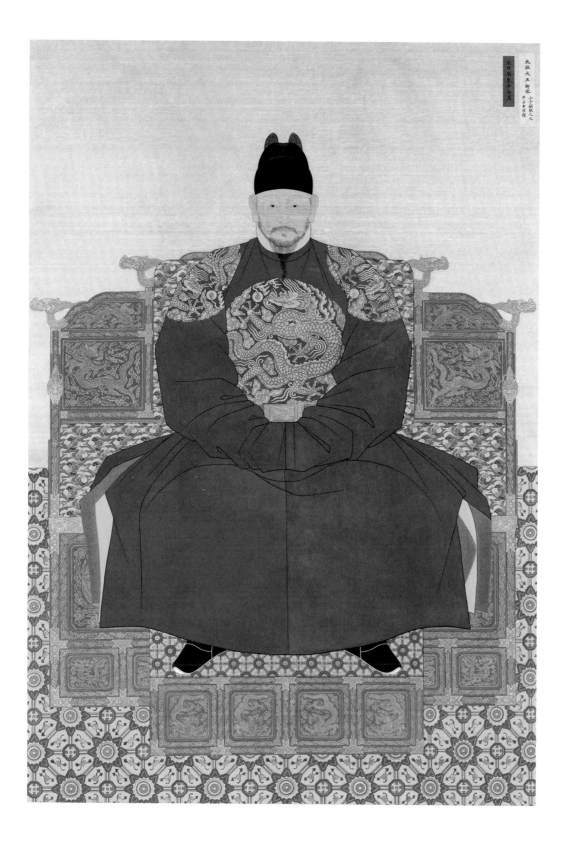

1901 *Uigwe of the Copying of Seven Kings' Portraits (Taejo, Sukjong, Yeonjo, Jeongjo, Sunjo, Munjo, and Heonjong)*[15]
1902 *Uigwe of the Painting of Emperor Gojong's and the Crown Prince's [later Emperor Sunjong] Portraits*[16]

In addition to the above *uigwe*, there survives what is called the *Uigwe of Repairing the Portrait of King Sejo* (1670), which in fact predates the nine listed above but is only a preliminary record of five pages.[17] Therefore, for this chapter we will examine the nine listed *uigwe*.

Among the existing nine *uigwe*, two involve the painting of a living king's portrait — that of King Sukjong, done in 1713, and that of Emperor Gojong and the crown prince (later Emperor Sunjong), made in 1901–2. There are five *uigwe* involving the copying of portraits of past kings, four of these on the copying of King Taejo's portrait (1688, 1837–1838, 1872, and 1900), and one *uigwe* on the copying of portraits of seven past kings, including King Taejo. Two of the nine are of the copying of King Sejo's portrait (1735) and the copying of King Sukjong's portrait (1748). These numbers reveal that the Joseon court paid the utmost attention and respect to the portraits of the country's founder, Taejo. Today two portraits of King Taejo are extant: the best-known is the 1872 copy desig-
[91] nated as National Treasure no. 317 (fig. 91), installed in the Royal Portrait
[92] Museum (within the Gyeonggijeon shrine compound) in Jeonju (fig. 92); the other is the copy produced in 1837 and installed in the Junwonjeon hall in Yeongheung, North Hamgyeong province, in today's North Korea. We know of the 1837 portrait of King Taejo only through a 1911 black-and-white photograph kept in the National Museum of Korea.[18] In addition, there remain two more royal portraits, both of which are undamaged: the
[93] portraits of King Yeongjo (fig. 93) and Emperor Gojong (fig. 94).[19] There are
[94] three more versions of Gojong's portraits, one of which, the version in the Wongwang University Museum, includes a Five Peaks screen as the back-
[95] ground (fig. 95). Several more severely damaged royal portraits are in the National Palace Museum of Korea, notably the portrait of Crown Prince Yeoning (later King Yeongjo) painted under the order of King Sukjong in 1714.[20] Although portraits of crown princes had to be painted soon after they were appointed, this is the only extant example.[21]

Royal Portrait Halls of the Joseon Dynasty
From the beginning of the Joseon dynasty, royal portraits were kept in special halls built for that particular purpose. At the beginning of the dynasty, six royal portrait halls were built at different locations to house King Taejo's portraits.[22] Important portrait halls for all royal portraits of

FIG. 91 Portrait of King Taejo, copy made in 1872. National Treasure no. 317. Hanging scroll; ink and color on silk, 220 × 151 cm. Royal Portrait Museum, Jeonju, North Jeolla province.

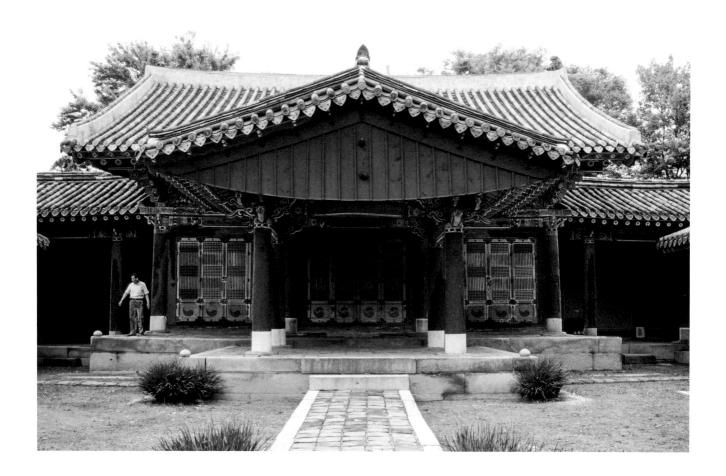

FIG. 92 Gyeonggijeon
royal portrait hall, 1410
(rebuilt 1614). Jeonju,
North Jeolla province.
Photograph, ca. 2010.

the Joseon kings are listed below. Halls that are for King Taejo's portrait only are indicated by an asterisk. The suffix "jeon" at the end of each building's name listed below means "hall."

[92]
- Gyeonggijeon in Jeonju (see fig. 92), the birthplace of the Jeonju Yi royal family*
- Munsojeon in Gyeongbok Palace*
- Junwonjeon in Yeongheung, the birthplace of King Taejo*
- Mokcheongjeon in Gaeseong, the capital of the Goryeo dynasty*[23]
- Jipgyeongjeon in Gyeongju, the capital of the Silla dynasty*
- Yeongsungjeon in Pyongyang, the capital of the Goguryeo Kingdom*
- Seonwonjeon in Gyeongbok Palace soon replaced Munsojeon, and was used for displaying portraits of kings and queens of subsequent reigns[24]

The Origin of the Term *Eojin*

In all the existing *uigwe* of royal portraits, the term *eojin* or *yeongjeong* designates a royal portrait. Before King Sukjong's reign (1674–1720), different words had been used to refer to royal portraits, as, for example, these from the *Veritable Records of the Joseon Dynasty*: *jinyong* [lifelike image] (second month, 1398); *yeongja* [painted image] (ninth month, 1398; second month, 1409); *seongjin* [lifelike image of a ruler] (eighth month, 1419); *shwi-yong* [sage visage] (sixth month, 1423); *eoyong* [royal face] (seventh month, 1442); and *yeongjeong* [portrait in hanging scroll format] (sixteenth–early seventeenth century). However, Sukjong wanted to reexamine these terms on the occasion of "labeling" his newly painted portrait in 1713.[25]

As recorded in the 1713 *uigwe*, it was during the reign of King Sukjong that the Korean word *eojin* — now used for "royal portrait" — was coined. The first syllable (*eo*) means "royal" and is taken from the term *eoyong* or "royal face"; the second syllable (*jin*) means "image" as in *sajin* (Ch. *xiezhen*). A portrait hall is called a *jinjeon* or "image hall." Although the compound word *eojin* consists of two Chinese characters, it is not a Chinese word and is not found in two of the most comprehensive encyclopedic dictionaries of the Chinese language.[26]

The subject arose when Sukjong and his officials were debating how to refer to the newly painted portrait of him in the cartouche to be attached to the painting. During the discussions among King Sukjong and the officials of the superintendency, Yi I-myeong (1628–1722), then minister of the left, who was serving as the superintendent of the *dogam*, brought up the term by saying that *eoyong* refers to the king's face and *sajin* to portraits. Therefore, taking one character each from the two

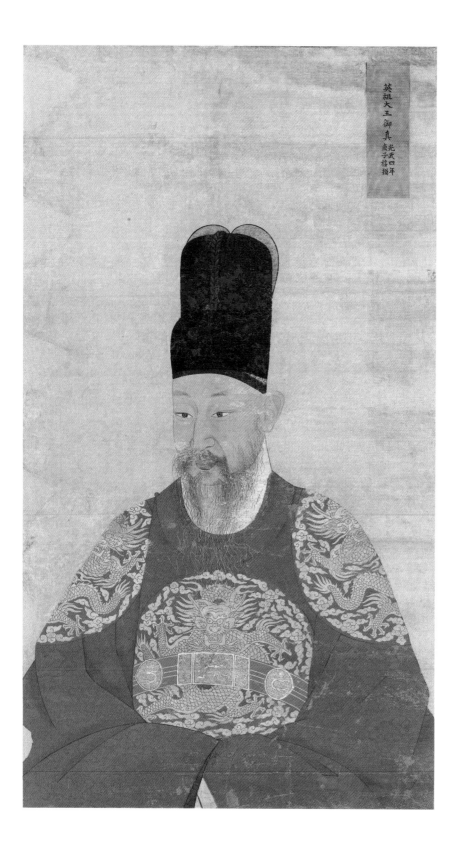

compound words, the new term *eojin* was coined to refer to a king's portrait. King Sukjong and Kim Jin-gyu (1658–1716), the vice superintendent in charge of the *dogam*, agreed with Yi I-myeong's suggestion[27] and decided to use the new term in the character phrase on the cartouche of King Sukjong's portrait: "Portrait of His Royal Highness, Displaying Righteousness, Brightening Ethics" (*Hyeonui gwangnyun yeseong yeongnyeol wang eojin*). Written below this line, in smaller characters, was the date: "Painted in the fifth month of the cyclical year *gyesa*, the eighty-sixth year after the beginning of the Chongzhen reign [1713]."[28]

Interestingly, the newly coined term *eojin* was not used exclusively to refer to royal portraits after its adoption in 1713. In most of the surviving *uigwe* on the production of the portraits, the term *yeongjeong* continued to be used. Only two of the *uigwe* listed above (1872 and 1902) employ the term *eojin*. Today, *eojin* refers to royal portraits only, whereas *yeongjeong* is used for any type of portrait, whether a painting or a photograph.

The Procedures for Painting or Copying Royal Portraits

We learn from the *uigwe* that there were strict protocols or procedures for painting or copying royal portraits, as outlined below.

Selection of Auspicious Dates

Once the *dogam* superintendency was established and the officers appointed, the location of the office within the palace was decided upon, after which the auspicious dates for carrying out the various stages of the work were selected.

Rite of Transporting a Royal Portrait

When a damaged portrait of a past king was to be replaced, a model for copying had to be brought to the capital from one of the royal portrait halls outside the capital. The superintendency appointed officials and guardsmen to travel to that location and transport the portrait in a spirit palanquin (*sinyeon*) in a stately procession. We have two cases of such travel itineraries, one from Seoul to Jeonju, in 1688, and another from Seoul to Yeongheung, in 1837.[29] When the portrait arrived at the palace gate, the king and the high officials, dressed in formal attire, waited outside the palace to respectfully receive it. A libation rite (*jakheollye*) was performed for the arrival of the portrait before the copying work began.

Selection of the Painters

The superintendency, in consultation with the king, was also in charge of selecting the portrait painters, which included a test of skills for court

FIG. 93 Portrait of King Yeongjo, copy made in 1901. Hanging scroll; ink and color on silk, 110.5 × 61.8 cm. National Palace Museum of Korea (Changdeok 6363).

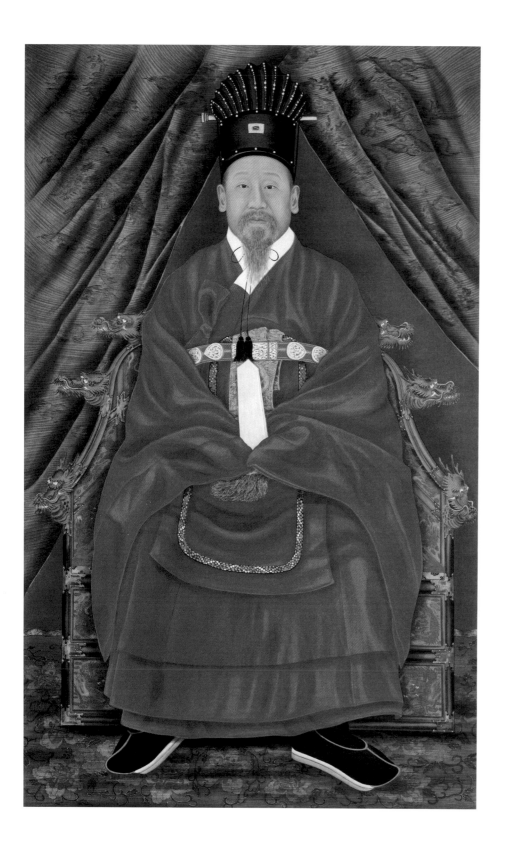

painters and other professional painters outside the court who had been recommended by court officials. Scholar-painters were exempted from the test, probably because of their high reputation as both men and artists. Not just painting skill but also moral fitness was considered important. Typically, one master painter (*jugwan hwasa*), two or more participating painters (*dongcham hwasa*), and several more assistant painters (*sujong hwasa*) were selected. This stage will be further elaborated below.

Draft Versions and the Review Committee
Once the painters were selected, several draft versions (*chobon*) of the portrait to be made were produced on oiled paper and submitted to the king and a committee of officials for review. When King Sukjong's portrait was painted in 1713, the review committee also included a court physician, who presumably judged whether the subject's bone structure was well rendered and whether the skin color, facial features, and especially the eyes reflected those of a healthy and spirited person. The king and the same group of officials reviewed the final draft version of the portrait.

The Final Version
After a draft version was approved, the final version of the portrait, complete with color, was made. This was done in two stages: *sangcho*, tracing the outline of the image onto a silk picture surface from the oiled paper draft, and *seolchae*, applying the color. The king apparently sat for the artists when the color was applied. Of the nine surviving *uigwe*, two record this stage of production: King Sukjong in 1713, and Emperor Gojong and the crown prince (later Emperor Sunjong) in 1902. The vice superintendent (*jejo*) under King Sukjong, Kim Jin-gyu (1658–1716), insisted that the king sit for the artists when his face was painted. He also specified that the sessions take place in the morning, as the light was not sufficient after three o'clock in the afternoon, when artists could instead execute the costume parts of the portrait.[30] The 1902 *uigwe* records that Emperor Gojong and the crown prince sat for the artists more than fifty times, yielding a total of nine portrait versions.[31] This process should be viewed as placing emphasis on realism after the introduction of Western painting techniques in the eighteenth century.[32]

Burning Draft Versions and Unsatisfactory Finished Versions
After the completion of the final version of the portrait, it was customary to "wash away traces of the brush" (*secho*) or destroy unsatisfactory versions. The silk they were painted on was burned, the ashes put in a jar, and buried either in the rear garden of Jongmyo or near the portrait halls

FIG. 94 Portrait of Emperor Gojong, early 20th century. Hanging scroll; ink and color on silk, 210 × 116 cm. National Palace Museum of Korea (Changdeok 6590).

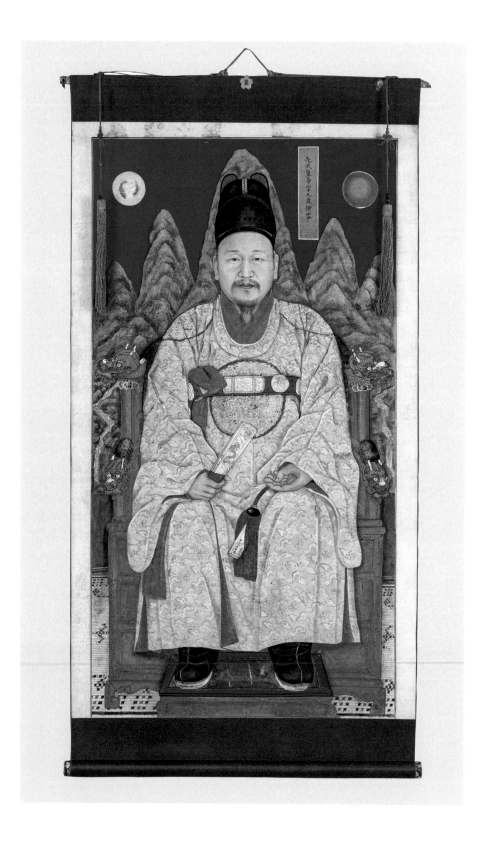

or other palace buildings. However, when King Sukjong's portrait was painted in 1713, the superintendent Yi I-myeong, then the minister of the left, suggested that rather than burning and destroying the version by Jo Se-geol (1636–after 1705), which was not chosen as the final copy, it would be better to keep it with the cartouche written by the king identifying the portrait. With Sukjong's consent, the portrait was saved.[33] This is perhaps the only recorded case of a decision being made to preserve the secondary version of a royal portrait, although it has not survived. It is a loss to art historians that the practice of saving unsatisfactory versions was not continued.

The Mounting and the Cartouche
The final version, mounted on extra layers of paper and silk, was sprayed with fragrance for three days (*swae hyangsu*), after which it was readied for making into a hanging scroll by attaching a jade roller to its lower end. Judging from the 1872 copy of King Taejo's portrait (see fig. 91), the cartouche identifying the portrait was placed in the upper right corner. As we have seen in King Sukjong's case, the cartouche included the king's full title, along with the imperial reign year and the cyclical date of the painting's production. The king himself sometimes inscribed the cartouche, but most of the time, especially when a number of portraits of past kings were copied, the cartouche was written by a well-known calligrapher chosen from among high officials.

Final Rite
When the newly painted or copied portrait was ready to leave the palace and travel to its final destination, the king performed a libation rite and also made offerings of incense as a way of "reporting" the completion of the new portrait to the royal ancestors. The portrait was then wrapped three times with a specially-made silk wrapping cloth and placed in a black wooden box. The box was filled with a soft yet firm padding to stabilize the scroll during transport. The box was then wrapped with a silk wrapping cloth. The portrait box was transported on a small spirit palanquin (*sinyeon*) from the workshop within the palace to the palace gate, where it was transferred to a specially-built formal spirit palanquin that would carry the painting to its final destination.[34] The king and the officials, dressed in their most formal attire, attended the departure rite.

Procession for Transporting the Royal Portrait
The newly painted royal portrait had to be transported to its place of installation in a stately procession. It was not until 1748 that the

[91]

FIG. 95 Portrait of Emperor Gojong, early 20th century. Attributed to Chae Yong-sin (1850–1941). Hanging scroll; ink and color on silk, 137 × 70 cm. Wongwang University Museum.

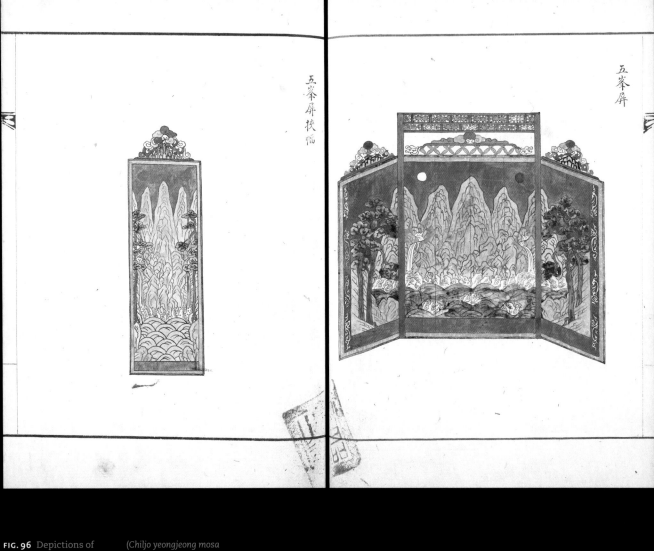

五峯屏挾幅　　　五峯屏

FIG. 96 Depictions of
an eight-panel folding
screen (right) and a
narrow one-panel
screen (left), from the
*Uigwe of the Copying of
Seven Kings' Portraits*
(*Chiljo yeongjeong mosa
dogam uigwe*), 1901.
Book; ink and color on
paper, 44.7 × 32.8 cm.
Jangseogak Archives,
The Academy of Korean
Studies (K2-2768).

procession was illustrated in color, eighteen pages in all, and included in the *uigwe* text. From this time on, with the exception of the 1872 *uigwe*, *uigwe* on royal portraits included illustrations of their transportation.

Installation of the Royal Portrait in the Portrait Hall
When the newly painted portrait arrived at the designated portrait hall, a ceremony (known as *goyuje*) announcing its arrival to the royal ancestors was performed accompanied by an offering of incense and tea. The portrait was then hung in front of a Five Peaks screen, the same type of painted screen that stood behind the royal throne in Joseon palaces.[35] The reasoning is that the royal image of the deceased king was to be accorded the same respect and protection as the living monarch. The only royal portrait now displayed in front of a Five Peaks screen is that of King Taejo in the Royal Portrait Museum. There is only a four-fold Five Peaks screen behind that portrait, however, which does not seem to be the right way of installing a royal portrait of the founding king, given the prescriptions in the *uigwe* of 1713 through 1901 for installing Five Peaks screens behind the royal portrait. According to the 1713, 1735, and 1901 *uigwe*, the royal portrait is supposed to be placed in front of a large one-panel Five Peaks screen or a four-fold, six-fold, or eight-fold one, while a narrow one-panel screen called *hyeoppok* (supporting side panel) is to be placed on either side of the larger main screen to provide the extra depth and symbolic protection of the Five Peaks for the portrait.[36]

[96]

[97]
[98]
[99]

However, it is only in the *Uigwe of the Copying of Seven Kings' Portraits*, 1901, that we find the illustrations of an eight-panel folding screen (fig. 96, right), one of a pair of narrow panel screens (fig. 96, left) to be placed on either end of the eight-panel screen, and a one-panel screen on a stand (*sapbyeong*) (fig. 97). An example of a *sapbyeong* can be found in the National Palace Museum collection (fig. 98). Today, in each of the twelve niches of the new Seonwonjeon (fig. 99), a portrait hall built in 1921 in Changdeok Palace that originally displayed royal portraits, is an eight-panel Five Peaks screen bordered on either side with a band of dragons painted in gold, symbolizing the emperor, and two small *hyeoppok*-type Five Peaks screens on either side of the eight-panel screen.[37] The iconographical development of the Five Peaks screens will be discussed in chapter 9.

Criteria for Selecting the Portrait Painters
The above ten stages of production and final installation of new portraits as recorded in the *uigwe* show us how much care, respect, and formality were to be accorded when producing and handling royal portraits. Since

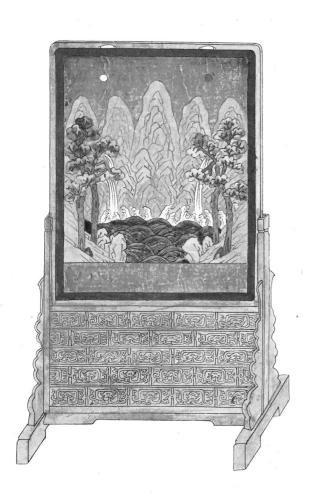

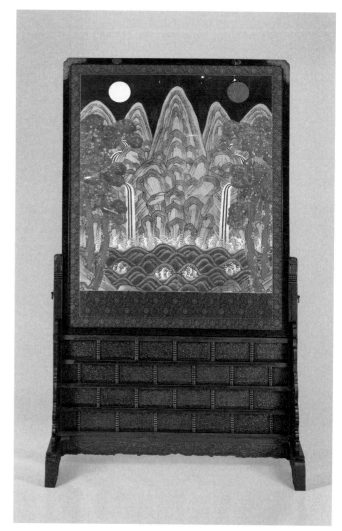

FIG. 97 Depiction of a one-panel screen on a stand, from the *Uigwe of the Copying of Seven Kings' Portraits* (*Chiljo yeongjeong mosa dogam uigwe*), 1901. Book; ink and color on paper, 44.7 × 32.8 cm. Jangseogak Archives, The Academy of Korean Studies (K2-2768).

FIG. 98 Screen on stand (*sapbyeong*). One-panel screen; ink and color on silk, 149 × 126.7 cm, total height with stand 278 cm. National Palace Museum of Korea (Changdeok 6423).

the task of painting a royal portrait is of paramount importance to court painters as well as non-court painters, the royal portrait-related *uigwe* provide a fair amount of specific information on them. Below, we will examine how royal portrait painters were selected for the task.

Painting Skills

Royal portrait artists were initially recruited by an examination of their painting skills. According to the 1688 *uigwe*, which documents the copying of King Taejo's portrait, King Sukjong and high officials of the superintendency recommended eight artists for the examination. Superintendent Kim Su-heung (1626–1690) suggested that it was disrespectful to the late king for artists to copy his royal portrait as a test of their skills. Therefore, it was decided that the painters would instead copy portraits of meritorious officials for submission to the superintendency. This account reveals that the king and officials of the superintendency were knowledgeable about the abilities of a wide range of artists, both in the capital and in the provinces, the latter of whom were chiefly known for portraits of scholar-officials.[38]

Criteria for an Excellent Portrait

In their review of the copies of portraits produced by the artists, the king and officials looked for four qualities: (1) successful "transmission of the subject's spirit"; (2) "life likeness"; (3) "faithfulness/likeness to the model"; and (4) "grasp of fine details." When it was unanimously agreed that a certain artist's test copy excelled in these criteria, that artist would be named as the master painter. The task of the master painter was to paint the face, while other lesser painters executed the royal robe or crown.

Confucian Virtues

This section will touch upon relevant Confucian-related issues pertaining to the selection of royal portrait painters.[39] Even if an artist was found to have excelled on the test, he was excluded from serving the court if he happened to be in the period of mourning (*jeongu*) for his parents. This was the case with Kim Jin-gyu, who was excused from participating in the production of the copy of Taejo's portrait in 1688. Prime Minister Nam Gu-man (1629–1711), quoting from the *Book of Rites*, stated:

> "The Princely Man does not forfeit one's mourning period for parents. It is not possible to do so unless it is in time of war."[40]
> Although the copying of the royal portrait is gravely important,

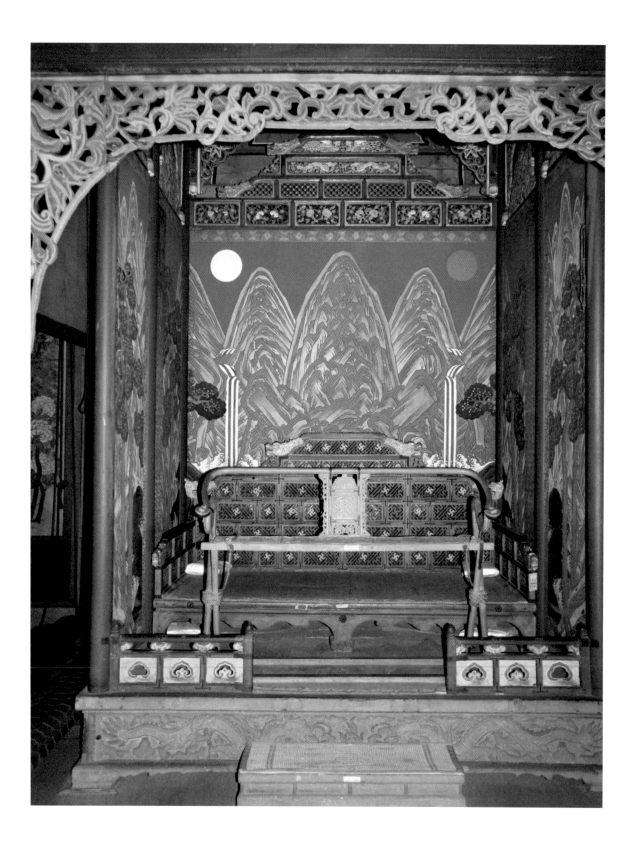

it is not comparable to the urgency of a war. If the king orders the artist in mourning to do the work of copying, he would be forfeiting one's mourning duty; if the artist obeys the king, he would not be filial to his parents. This should never happen in time of peace.[41]

Kim was thus exempted on this occasion as a royal portrait painter, but in 1713 he served as high official of the upper third rank (3a) in the superintendency (*dogam dangsang*) for the painting of King Sukjong's portrait. This incident demonstrates the adherence of Joseon society to the virtue of filial piety, one of the eight cardinal Confucian virtues. In 1900, however, we find that a court painter, Jo Seok-jin (1853–1920), was selected to participate in copying King Taejo's portrait despite being in mourning. It would seem that the strictness of Confucian standards in the last days of the Joseon dynasty did not match that of earlier periods.

In 1748 Sim Sa-jeong (1707–1769), a professional painter of elite *yangban* origin, was recommended to the superintendency but was denied the job on the grounds that his grandfather Sim Ik-chang (1652–1725) had been dishonored shortly before his death for participating in the attempted coup against the crown prince, later King Yeongjo.[42] Even a grandson of a disloyal subject carried a stigma and was not allowed to participate in the "exalted" rites of copying royal portraits.

Painters' Ages

In the 1688 *uigwe*, we find that King Sukjong and his officials also considered the relative ages of painters. The king said that Jo Se-geol might, on the whole, be a better painter than Yun Sang-ik (act. 1669–1690), but Yun was younger and therefore would have clearer vision. The king's preference for a younger artist for the final version of King Taejo's portrait won Yun Sang-ik the celebrated position of master painter. Jo Se-geol apparently produced a colored version, but later it was washed of "traces of the brush" and burned along with other drafts.

Scholar-Painters

Scholar-painters (called *yuhwa* in *uigwe* documents rather than *munin hwaga* [literati painter] or *sain hwaga* [scholar painter]) were exempt from the test of skills given to court painters or non-*yangban* painters. In 1748 the well-known scholar-painter Jo Yeong-seok (1686–1761), then serving as district magistrate of Uiryeong County, was recommended to participate in the copying of King Sukjong's portrait. Jo's portrait of his elder brother Jo Yeong-bok (1672–1728) (fig. 100), who had served as a high official at

FIG. 99 Royal portrait niche in the new Seonwonjeon, Changdeok Palace, 1921. Seoul. Photograph, ca. 2010.

[100]

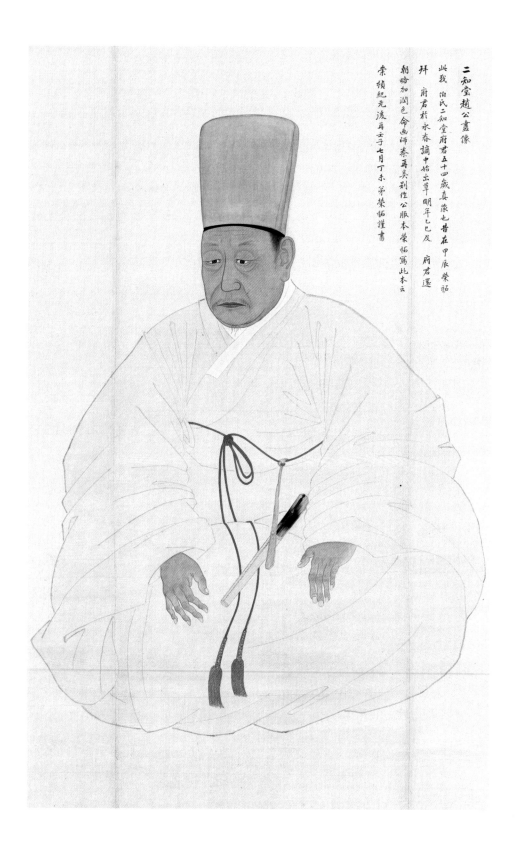

二知堂趙公畫像

此我 伯氏二知堂府君五十四歲真像也昔在甲辰榮祏

拜 府君於永春謫中始出草 翌年乙巳及 府君還

朝略加潤色命畫師秦再吳別作公服本榮祏寫此本云

崇禎紀元後再壬子七月丁未弟榮祏謹書

the court of King Sukjong, testifies to his skill in portraiture.[43] Word of the wondrous quality of the portrait's "transmission of spirit" spread quickly among the *yangban* scholar-officials in court circles. Even King Yeongjo knew about it. Jo apparently did not report to the court when called upon several times. The 1748 *uigwe* mentions that he was solicited by the court but refused to serve at that time. It also lists him as having served in the position of supervisor (*nangcheong*) for four days (twentieth–twenty-third of the first month), but the *uigwe* documents did not record what happened to him afterward. From his own collected writings, the *Gwanajae go*, we learn that Jo was jailed in 1735 for not serving the court in whatever capacity he would have been assigned (though his name is not mentioned in the 1735 *uigwe*) and that he refused to serve in 1748 on the pretext of old age (he was then sixty-two). The main reason for his refusal, however, was that he thought it inappropriate for a *yangban* scholar-painter to perform as a lowly professional painter at the court's demand.[44] His behavior exemplifies the pride of a late Joseon literati painter at its most extreme.[45]

Another scholar-painter whose name appears in the 1748 *uigwe* is Yun Deok-hui (1685–1776), son of Yun Du-seo (1688–1715), who was a well-known scholar-painter who painted an unusually realistic self-portrait.[46] The painting is still preserved in the Yun family collection in Haenam, South Jeolla province, which is the artist's hometown.[47] Yang Hui-maeng is mentioned in the same document as a "young scholar" (*yuhak*). It seems that no scholar-painters were called to paint or copy royal portraits after the Jo Yeong-seok incident in 1748.

Master Painters of Royal Portraits

The *uigwe* list not only the master painters but the "participating" and "assistant" painters, as well as all painters who did screen paintings, procession paintings, or other decorative chores, such as decorating palanquins and painting the banners of honor guards.[48] The master painters recorded in the nine royal portrait-related *uigwe* are:

1688 *uigwe*	Yun Sang-ik (active 1669–1690)
1713 *uigwe*	Jin Jae-hae (1691–1769)
1735 *uigwe*	Yi Tae (dates unknown)
1748 *uigwe*	Jang Gyeong-ju (b. 1710)
1837 *uigwe*	Yi Jae-gwan (1783–1837)
1872 *uigwe*	Jo Jung-muk (dates unknown)
1900 *uigwe*	Jo Seok-jin (1853–1920) and Chae Yong-sin (1850–1941)

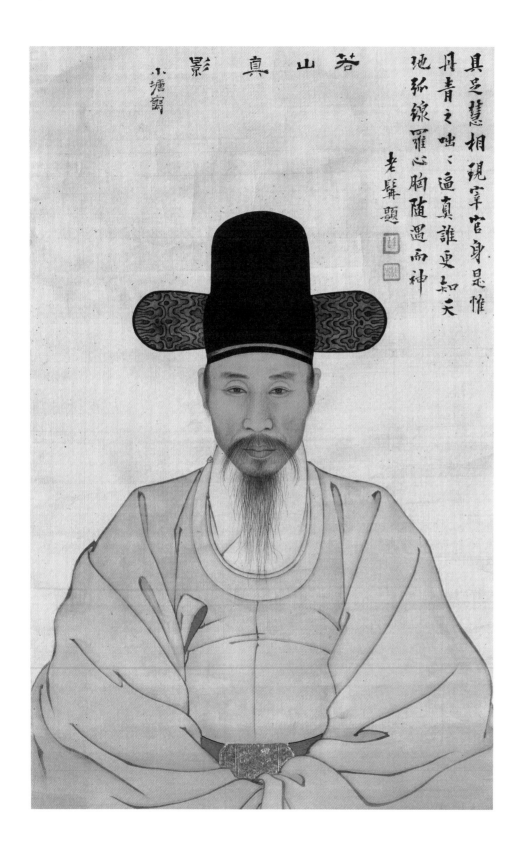

具足慧相現宰官身是惟
丹青之咄咄逼真誰更知天
地孤線羅心胸隨遇而神

若　山　苕
影　真

小塘窩

老彝題

1901 *uigwe* Jo Seok-jin and Chae Yong-sin

1902 *uigwe* Jo Seok-jin and An Jung-sik (1861–1919)

Although Yun Sang-ik, the 1688 master painter, is recorded as having served in various state rites between 1669 and 1690,[49] his other activities are virtually unknown to art history. Recent research, however, revealed that King Sukjong awarded him a rank 3a official position (*gaja*), generally known as *dangsanggwan* (an official who merits a chair placed on the upper level of the palace hall at the morning council).[50] The honorific title of officials of this rank is *tongjeong daebu* ("arrived thoroughly at the executive ranks"). A *dangsanggwan* enjoyed a great deal of privilege in Joseon society, including the right to don official costumes complete with gold crown (*geumgwan jobok*), the right to appoint lower-level officers, and even, after retirement, the right to remain in government as an advisor at full salary.

There is no surviving royal portrait painting by Yun Sang-ik. However, a bust portrait of a meritorious official, Yu Sun-jeong (1459–1512), is attributed to Yun and was discovered without its authenticity and attribution clearly established.[51] Better known is the 1713 *uigwe* master painter, Jin Jae-hae, who left a number of portraits, among them one of Yu Su (b. 1678), in the collection of the Gyeonggi Provincial Museum, and a single landscape painting in the Seoul National University Museum. The 1735 *uigwe* master painter Yi Tae is known only through that work. His name does not appear in any other books of state rites of the mid-eighteenth century, nor have any works by him or attributed to him survived.

The 1748 *uigwe* master painter, Jang Gyeong-ju, the son of another court painter, Jang Deuk-man (1684–1764), collaborated with several court painters on the album titled *Gisa gyeonghoecheop* (*Celebratory Gathering at the Club of Elders*), which was created in 1744 to commemorate King Yeongjo's entry into the club. The state-funded Club of Elders was made up of retired high-ranking officials, usually over the age of seventy. The album, now in the National Museum of Korea, contains eight portraits of the elder statesmen who participated in the event.

The 1837 *uigwe* master painter, Yi Jae-gwan, was a well-known court painter. Among his surviving works are a portrait of the scholar-official and painter Gang I-o (b. 1788) (fig. 101), now in the National Museum of Korea, and a number of true-view landscape paintings that depict Korean scenery, now in the collection of Seoul National University Museum. The 1872 *uigwe* master painter, Jo Jung-muk, participated in three other royal-portrait painting events: the painting of King Heonjong's portrait in 1846 and King Cheoljong's portraits in 1852 and 1861. No *uigwe* were produced for those events.[52]

[101]

FIG. 101 Yi Jae-gwan (1783–1837), *Portrait of Gang I-o (b. 1788)*, 1837. Hanging scroll; ink and pale color on silk, 63.9 × 40.3 cm. The National Museum of Korea (Deoksu 3070).

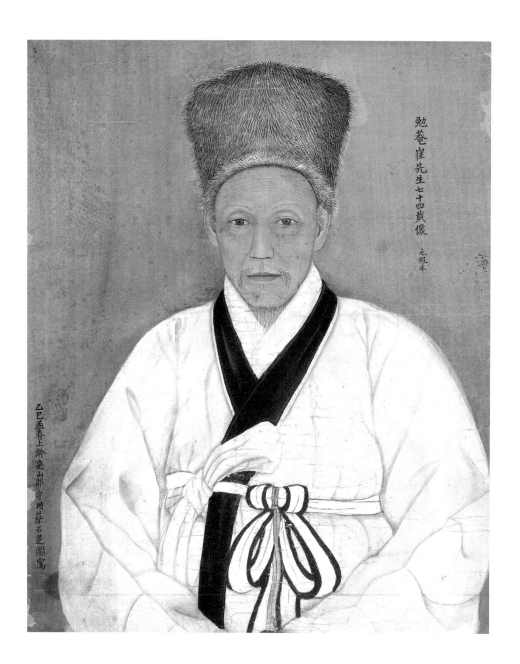

The master painters in 1900, 1901, and 1902 — Jo Seok-jin, Chae Yong-sin, and An Jung-sik — were all top-ranking painters. Jo was famous for figures and landscapes, narrative paintings, and paintings of fish and crabs. Chae was known mainly for portraits, of which some sixty have survived.[53] A good example is his 1905 bust portrait of Choe Ik-hyeon (1833–1906) (fig. 102), a hero of the turn-of-the-century Independence Movement. An Jung-sik was famous for paintings of landscapes, antique vases with cut flowers (a genre known as *gimyeong jeolji*), and geese.[54]

[102]

In addition to a nominal monthly salary for serving in the superintendency, the painters received other awards. All the *uigwe* contain a section called "Award Regulations" (*sangjeon*), which lists the awards given to each participant of the superintendency. Usually, the superintendent was given a full-grown horse, while the master painters were promoted three ranks, from the sixth to the third. According to the *Joseon Law Code* published in 1484, the highest rank attainable by a court painter was lower sixth (6b); a promotion to upper third (3a) was an unusually generous reward for services rendered. It is an indication that to serve as the master painter for a royal portrait was truly an honor. An in-depth analysis of this issue appears in chapter 10.

Processions for Transporting Royal Portraits

The royal portrait–related *uigwe* of the seventeenth and early eighteenth centuries did not contain any procession paintings. Although there were processions for transporting a good copy to the palace from its remote royal portrait hall, such as the 1688 removal and reinstallation of King Taejo's portrait, no *banchado* of that event was included in the *uigwe*. However, the text of the 1688 *uigwe* records the route the procession took from Jeonju to Seoul (about 197 km), the distance it traveled each day, and day stops and overnight stays. The total travel time was seven nights and eight days. At that time, King Sukjong did not travel with the newly copied portrait of King Taejo.

It was King Yeongjo who in 1748 initiated the king's personal participation in the procession of transporting the newly copied royal portrait to its portrait hall. For the newly copied portrait of King Sukjong, he had his own palanquin follow the larger spirit palanquin (*sinyeon*) to Yeonghuijeon, a royal portrait hall outside the palace, and had the procession painting included in the *uigwe*.

The eighteen-page *banchado* starts with the usual palace guards leading the procession. The smaller royal portrait palanquin that carries the portrait within the palace walls can be seen on page 4 of the *banchado* (fig. 103), followed by a small pavilion-shaped palanquin called the "incense

[103]

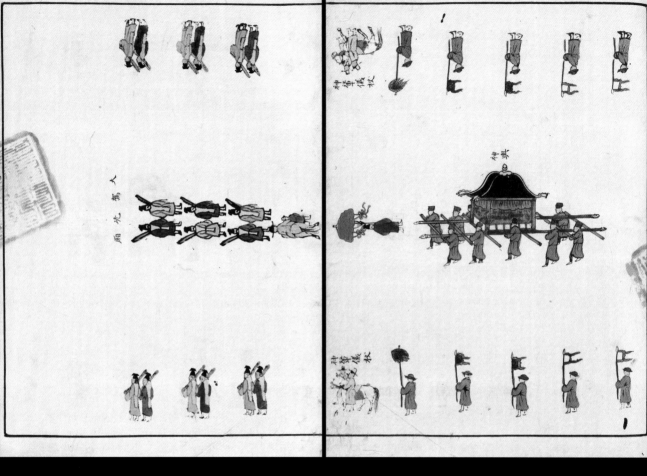

page 3

page 4

FIG. 103 Royal portrait palanquin (page 4) and pavilion-shaped palanquin carrying an incense burner (page 5) followed by the front

of King Sukjong's Portrait ([Sukjong] yeongjeong mosa dogam uigwe), 1748. Book; ink and color on paper, 36.6 × 32.7 cm. Kyujanggak Institute for

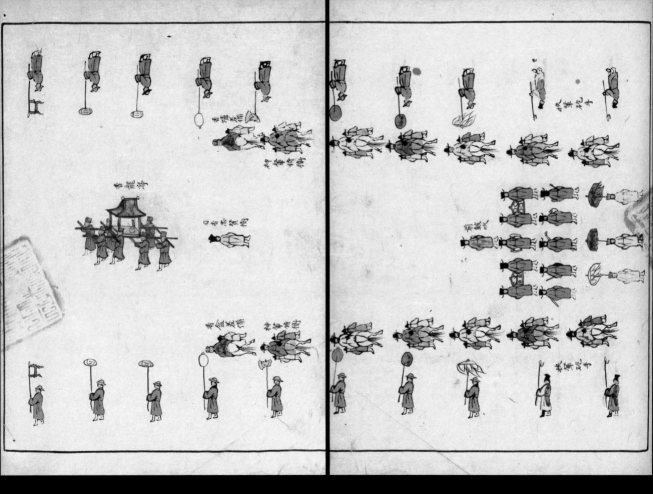

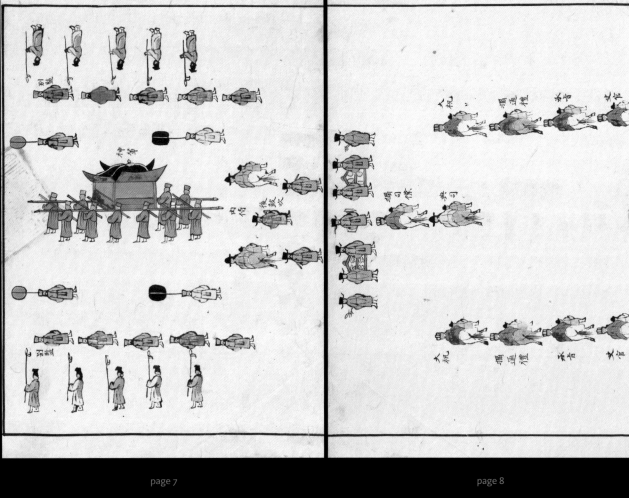

page 7

page 8

FIG. 104 Main spirit palanquin, followed by the rear musical band (pages 7, 8) and members of the superintendency, with porters holding flags and ritual weapons (pages 11, 12), from the *banchado* in the

Uigwe of the Copying of King Sukjong's Portrait ([Sukjong] yeongjeong mosa dogam uigwe), 1748. Book; ink and color on paper, 36.6 × 32.7 cm. Kyujanggak Institute for Korean Studies, Seoul National University (Kyu 13997).

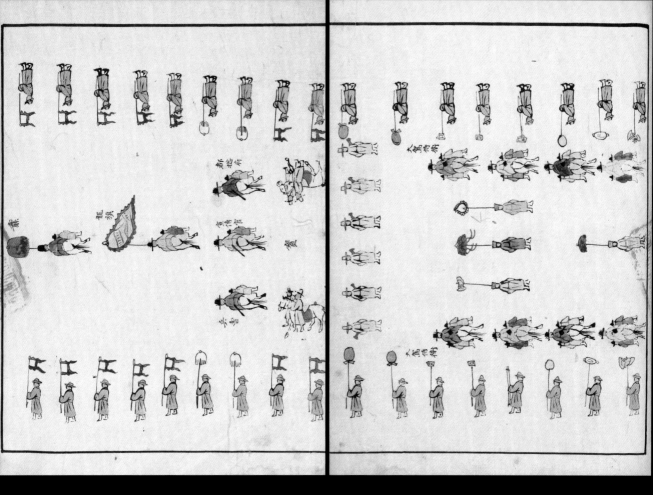

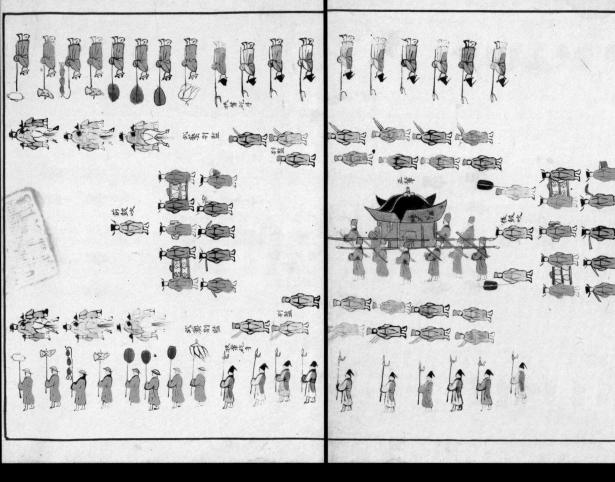

page 13

page 14

FIG. 105 King Yeongjo's palanquin, flanked by front and rear musical bands (pages 13, 14), and the white flag with black borders called *pyogi* (page 16) amid the procession of officials from the Ministry of Military Affairs and palace guards, from the *banchado* in the *Uigwe of the Copying of King Sukjong's Portrait* (*[Sukjong] yeongjeong mosa dogam uigwe*), 1748. Book; ink and color on paper, 36.6 × 32.7 cm. Kyujanggak Institute for Korean Studies, Seoul National University (Kyu 13997).

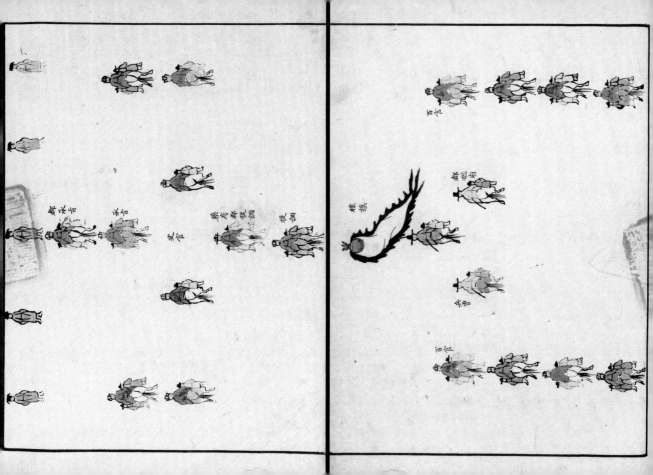

and royal words pavilion" (*hyangnyongjeong*), which contains an incense burner and the king's eulogy on page 5. The front musical band (*jeongochwi*) on page 6 announces the coming of the main spirit palanquin [104] carrying the newly copied portrait. On pages 7 and 8 (fig. 104), the main spirit palanquin, borne by twelve men (six on each side) and flanked by honor guards with ritual weapons and fans, leads the way. The group of musicians in the rear behind the palanquin, together with the front musical band, encloses the space for the main spirit palanquin.

The honor guards of the king's most formal procession, complete with the ritual weapons and flags symbolizing the king's presence (*daega uijang*), begins at the end of page 10 and is preceded by the equestrian procession of the high officials of the superintendency. On page 11, the procession is led by a flag bearer on horseback holding an object called [104] a *duk* that looks like a lampshade with irregular edges (fig. 104). It originally was an oxtail held by a spear but later became a "flag" with red fur. This, together with the *gyoryonggi*, the large yellow flag with red borders showing two intertwining dragons, heralds the coming of a king. On page 13, the honor guards with fans and ritual weapons flank the front musical band for the royal palanquin, which appears on page 14 marked as *jeongyeon*. The rear musical band follows the king's palanquin. On page 16, the white flag with black borders (*pyogi*) of the Ministry of Mili- [105] tary Affairs can be seen prominently (fig. 105). The procession ends with the same kind of palace guards we saw at the beginning, a symmetrical arrangement of the guards for the entire procession.[55]

The 1837 *uigwe* of the copying of King Taejo's portrait had an eighteen-page *banchado*, and the 1900 *uigwe* had a twenty-seven-page *banchado*, but neither King Heonjong in 1837 nor Emperor Gojong in 1900 participated in the procession themselves. By far the most grandiose [106] *banchado* is the eighty-six-page one in the 1901 *uigwe* of the copying [107] of the portraits of King Taejo and six other kings (figs. 106–108).[56] This [108] was necessitated by the previous year's fire at Seonwonjeon, the royal portrait hall in Changdeok Palace, which damaged all the royal portraits there. The procession can be divided into seven parts, centering on the spirit palanquin for each of the seven portraits. The basic components of the procession are more or less the same for each part. However, the content of this *banchado* reflects the new imperial protocols of the nation's polity change in 1897 from a kingdom to an empire. The procession started at Heungdeokjeon hall in Gyeongungung (present-day Deoksugung palace), where the actual copying took place, and proceeded to the newly refurbished Seonwonjeon in Changdeok Palace, a distance of approximately 3.4 kilometers.

page 1

page 2

FIG. 106 Pages 1 and 2 from the *banchado* in the *Uigwe of the Copying of Seven Kings' Portraits* (Chiljo yeongjeong mosa dogam uigwe), 1901. Book; ink and color on

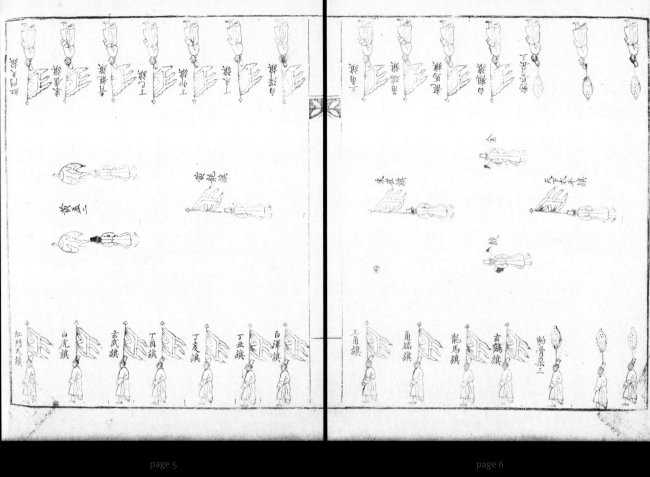

page 5

page 6

FIG. 107 Flag bearers marching in yellow costumes (pages 5, 6), from the *banchado* in the *Uigwe of the Copying of Seven Kings' Portraits* (*Chiljo yeongjeong mosa dogam uigwe*), 1901. Book; ink and color on paper, 44.7 × 32.8 cm. Jangseogak Archives, The Academy of Korean Studies (K2-2768)

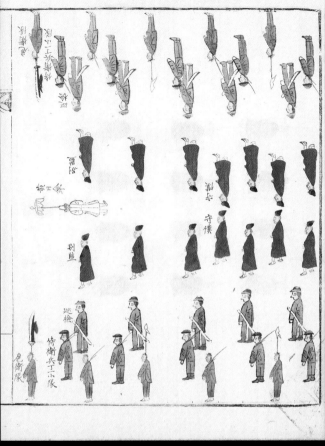
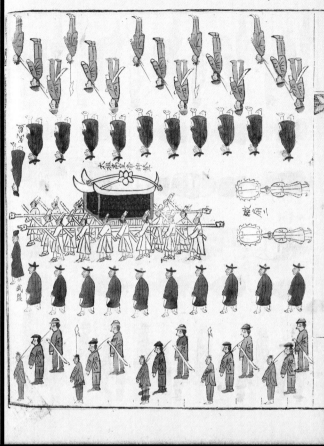

page 14

page 15

FIG. 108 Emperor [King] Taejo's spirit palanquin (page 15), from the *banchado* in the *Uigwe of the Copying of Seven Kings' Portraits (Chiljo yeongjeong mosa dogam uigwe)*, 1901. Book; ink and color on paper, 44.7 × 32.8 cm. Jangseogak Archives, The Academy of Korean Studies (K2-2768).

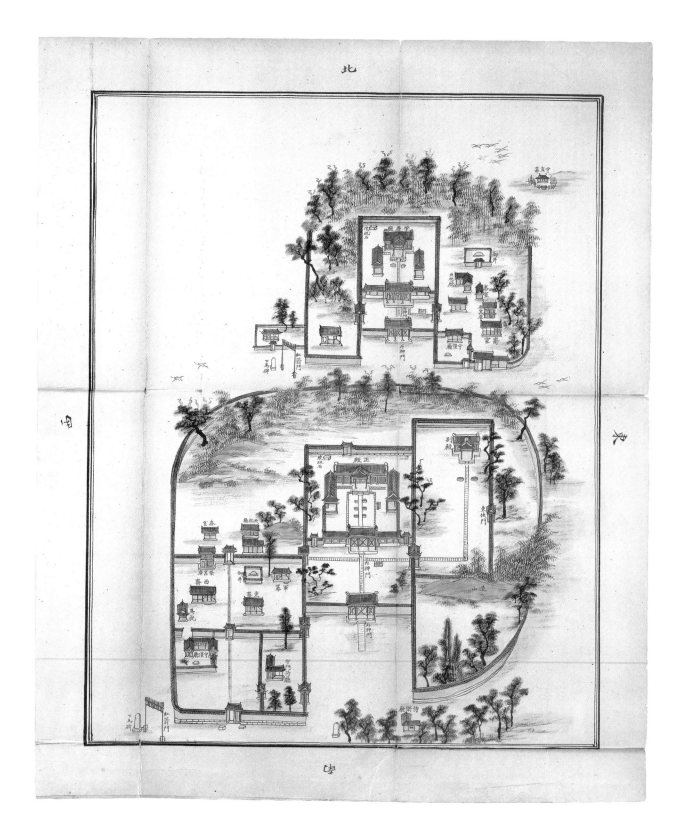

[106]

The title of the procession is written along the left edge of the first page (fig. 106): "*Banchado* on the occasion of transporting seven past kings' — Taejo, Sukjong, Yeongjo, Jeongjo, Sunjo, Munjo, and Heonjong — portraits [from Gyeongungung to Changdeok Palace]" (*Taejo gohwangje Sukjong daewang Yeongjo daewang Jeongjo seonhwangje Sunjo sukhwangje Munjo ikhwangje Heonjong daewang yeongjeong ibong gyosisi banchado*). As can be seen, the title of Kings Taejo, Jeongjo, Sunjo, and Munjo was changed to "emperor" (*hwangje*), whereas that of Sukjong, Yeongjo, and Heonjong remained "king" (*wang*). Since 1897, most of the previous kings were referred to as emperors in documents, although historically they were referred to as "King so-and-so" — King Sukjong, King Yeongjo, etc. Instead of the palace guards seen in earlier *banchado*, here we see police guards in Western-style uniforms, and all their titles are modernized. Occupying the center of the second page is the mayor of Hanseong (Hanseong *panyun*) in full court attire and on horseback, followed by two pages filled with police guards. Beginning on page 5, all the flag bearers and the various symbolic and auspicious flags of the rulers are headed by the *hongmun daegi* (large flag of the red gate)[57] in a golden yellow color

[107]

reflecting the protocol of the Daehan Empire (fig. 107). Other flags on pages 5 and 6 are those of the Five Deities of the five directions (yellow dragon in the center, blue dragon of the east, white tiger of the west, red phoenix of the south, and black warrior/tortoise of the north). On pages 7–10, there are more flag bearers and the "army band," followed by bearers of ritual weapons, all of whom march in yellow costumes. Taejo's spirit palanquin, marked as "the Spirit Palanquin of Emperor Taejo" (*Taejo gohwangje sinyeon*), appears on page 15 (fig. 108), protected on either side by

[108]

four rows of guards in both modern and traditional costumes. The roof of the palanquin and the costumes of the palanquin bearers are all in gold color, in keeping with imperial protocol.

The international political situation at the end of the nineteenth century, especially with regard to Japan's threat to Korea, might have given the ruling class of the Daehan Empire a sense of urgency to safeguard the nation. In 1899 Emperor Gojong, in an effort to bring the empire together after so many crises,[58] ordered the construction of the Jogyeongdan altar on Mount Geonji in Jeonju, and Jogyeongmyo, a shrine just behind the Gyeonggijeon royal portrait hall, also in Jeonju,[59] for the performance of ancestral rites for the Jeonju Yi clan from which the founder of the Joseon dynasty came. An illustration of the area of Gyeonggijeon and Jogyeongmyo is found in an album presumably done

[109]

about 1899 (fig. 109). Emperor Gojong also ordered the construction of a stele named Daehan Jogyeongdan bi. The two final rites of copying

FIG. 109 The environs of Gyeonggijeon royal portrait hall and Jogyeongmyo shrine, ca. 1899. Album leaf; ink and color on paper, 56.4 × 46.1 cm. National Museum of Korea.

King Taejo's portraits (1900 and 1901) took place just after the construction of those projects in Jeonju, North Jeolla province. The *uigwe* of 1900 and 1901 devote twenty-seven and eighty-six pages, respectively, to the illustration of the processions, as if to display the grandeur of the whole "imperial event."

* * *

We have seen how the Joseon rulers upheld Confucian principles in every stage of the painting and copying of royal portraits. The selection of the painters was based not only on the excellence of their skill, but also on their fitness to do the exalted job according to the Confucian ethical standards. The procedure of installing royal portraits with appropriate rites was carefully documented in *uigwe*. It was, however, not until 1748 that *uigwe* included the *banchado* illustrating the ritual procession of transporting royal portraits for enshrinement, at which time King Yeongjo personally participated in the procession, representing the court's highest respect to royal portraits. Kings and officials regularly paid respect to royal portraits throughout the year, as they did to royal ancestors in Jongmyo. Although many of the royal portraits were damaged during the Korean War, these *uigwe*, along with the articles in the *Veritable Records of the Joseon Dynasty*, serve as the proof and guardian of the dynasty's 518-year history of royal portrait making. ◆

CHAPTER SEVEN
Uigwe of King Jeongjo's Visit to the Tomb of Crown Prince Sado

Wonhaeng eulmyo jeongni uigwe (hereafter *Jeongni uigwe*), the *Uigwe of King Jeongjo's Visit to the Tomb of Crown Prince Sado*, published in 1797, documents the visit in 1795 of King Jeongjo (r. 1777–1800) to Hyeollyungwon, the tomb of his father, Crown Prince Sado, in Hwaseong.[1] He had traveled with his mother, Lady Hyegyeong, in the second leap month of 1795, the year when both the king's parents reached the age of sixty (*jugap*).[2] The year 1795 also marked the twentieth anniversary of King Jeongjo's ascension to the throne and the fifty-first birthday of Queen Jeongsun, the second queen of King Yeongjo, so it was a triple celebratory year.

If we look for the proper categories of court events recorded in this *uigwe*, the first is that of a royal outing (*haenghaeng*), and the second is that of a court banquet, called *jinchan*, the most common of court banquets. During King Jeongjo and his mother's visits to Hwaseong in 1795, two banquets were held in the detached palace in Hwaseong: one was the banquet that celebrated the sixtieth birthday of Jeongjo's parents in the Bongsudang (Hall of Revering Longevity), and the other was the Banquet for Elder Officials held at Nangnamheon (Southern House). Although there were sixteen banquet-related *uigwe* documents produced during the second half of the Joseon, this *uigwe* is the only one that documented a royal outing.[3]

Historical Background of King Jeongjo's Trip to Hwaseong
Although the *Hwaseong seongyeok uigwe* (*Uigwe of the Construction of the Hwaseong Fortress*), hereafter cited as *Hwaseong uigwe*, was published after the *Jeongni uigwe*, in 1801, the process of the construction of the Hwaseong Fortress began in the spring of 1794 and ended in the fall of 1796. Both had much to do with Jeongjo's display of filial piety toward his biological father, Crown Prince Sado (1735–1762), the second son of King Yeongjo. Sado was put to death by his own father (Jeongjo's grandfather), who considered him deranged and unfit to assume the throne. Yeongjo had Sado put into a wooden rice chest of four cubic feet and left him to slowly

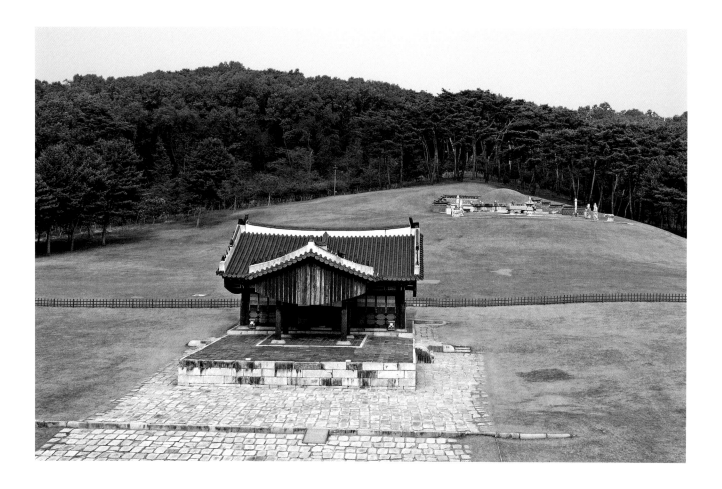

FIG. 110 Crown Prince
Sado's tomb, 1789.
Yungneung, Hwaseong,
Gyeonggi province.
Photograph, ca. 2010.

waste away for eight days under sweltering summer heat. He died on the twenty-first day of the fifth leap month (12 July of the solar calendar), 1762.[4]

In 1764 Yeongjo made his grandson (future King Jeongjo) heir apparent. The heir apparent grandson was an "adopted" son of Prince Hyojang (1719–1728), the deceased elder brother of Prince Sado. By doing so, Yeongjo wanted to assure trouble-free succession of the Joseon royal lineage (i.e., the first son or spare). But this incident became a life-long source of sadness for Jeongjo, who, as a ten-year-old child, had to witness his birth father's tragic end and could not even claim to be Sado's son. Yeongjo's first heir apparent, Prince Hyojang, died in 1728. Yeongjo put to death his second heir apparent, Prince Sado (b. 1735) in 1762, when his third heir apparent (b. 1752) was but a child. The events surrounding the death of Sado is a stain on Yeongjo's otherwise long and glorious reign (1724–1776) with its many political, social, and cultural achievements.[5]

Although Yeongjo had his second heir apparent killed, about two months later, on the twenty-third day of the seventh month, out of sympathy, Yeongjo gave him a funeral fit for a royal son, and bestowed upon him the title Sado seja or "Crown Prince of Mournful Thought." Yeongjo himself participated in the funeral with his civil and military officials. Yeongjo had Sado buried in Baebongsan in Yangju, Gyeonggi province, naming the tomb Sueunmyo (Tomb of Bestowing Grace).

As soon as Jeongjo, Yeongjo's grandson, assumed the throne in 1776, he elevated his late birth father's title to Jangheon seja (Crown Prince of Solemn Dedication). Jeongjo also changed the name of the tomb to Yeonguwon (Tomb Forever Protected by Heaven). In 1789 he moved the tomb from Yangju to Hwaseong in Suwon, about thirty-nine kilometers south of Seoul, changed its name once more, to Hyeollyungwon (Brightly Rising Tomb),[6] and in 1790, had a Buddhist temple, Yongjusa (see fig. 149 in chapter 8), built nearby as the tomb's patron temple for spiritual protection (wonchal).[7]

[149]

After that, Jeongjo visited his father's tomb at Hwaseong every year, but his trip in 1795 was a very special one as his mother and two sisters accompanied him for the first time. His mother, Lady Hyegyeong (1735–1816), was given the title of Hyebin (Gracious Princess) after the death of her husband, Sado, and, spent years in the palace looking after her young son (Jeongjo). She outlived his father by fifty years. She left a memoir of her life of profound agony modestly titled *Hanjungnok* (*Records Written in Silence*).[8] 1795 marked the sixtieth birthday of the late Crown Prince Sado and Lady Hyegyeong, and Jeongjo had planned to celebrate the occasion near his father's tomb in Hwaseong, a new city with defensive walls, in the vicinity of the tomb to safeguard it. His trips to Hwaseong itself are closely related

傳敎

甲寅十二月初十日

以賓廳請上　慈殿　慈宮尊號進宴啓辭　傳曰連日
力請之餘幸得勉循而進宴與上號之難以並舉不但輓
念民事事屬張大不得許之爲敎到今順志之道莫若先
舉上號之禮待明年秋成更請宴禮允合情禮　殿宮上
號令該曹以來月擇吉舉行大臣以下應叅諸臣待其承
牌卽爲議號昨筵已有詳諭者來月二十一日展謁　景
慕宮日　慈殿　慈宮亦當詣宮令該曹問其合行儀節
於大臣仍禮官意見草記中宮殿行禮一依續五禮儀
廟見儀磨鍊明年何年惟予一分寓慕伸誠之方在此叅

整理儀軌　卷一　傳敎　一

以國朝典禮亦有可據之例來春　園幸陪　慈宮行展
省之禮每歲　園幸雖除整理使名以壯勇外使例兼而
明年則別差整理堂上然後可以爲之戶判自是主人而
司僕提調及　園幸定例堂上畿伯壯勇內使並差整理
堂上分掌勾管勿論經費與民力皆有預先措置者令整
理堂上知予此意可也

上之御極二十年乙卯卽　慈殿寶齡望六　景慕宮
誕彌舊甲　慈宮寶齡周甲之歲也前二年癸丑因賓
廳啓議上　景慕宮進宴上號凡四啓以　慈志謙抑只許上
慈殿　慈宮進宴上號以　慈志謙抑只許上
號陳賀又請上　大殿尊號再啓未蒙允只命行御極
二十年賀儀仍議定　慈殿加上尊號曰綏敬　景慕

FIG. 111 Pages printed with movable *jeongnija* metal type, from the *Jeongni uigwe* (*Wonhaeng eulmyo jeongni uigwe*), 1797. Printed book, 34.3 × 17.2 cm. Jangseogak Archives, The Academy of Korean Studies

[110]

to the construction of the fortress. Later, Jeongjo had his own tomb built next to his father's tomb, and the two-tomb complex is now known as Geolleung Yungneung (fig. 110). In fact, an examination of the two *uigwe* books under discussion shows that they are closely related to each other.[9]

The Title of the *Jeongni Uigwe*

The title, *Wonhaeng eulmyo jeongni uigwe*, needs some explanation. Tombs of the members of the royal family other than kings and queens are called "*won*." The second character, "*haeng*," refers to kings' outings. *Eulmyo* is the cyclical date of 1795. Finally, *jeongni* or *jeongnija* refers to the movable bronze type developed under the order of King Jeongjo in the Jeongniso, the office that makes necessary preparations for a king's outings. This *uigwe* was the first to be printed with *jeongnija* metal type and woodblock illustrations. The *jeongnija* metal type was fashioned after the Qing dynasty's metal type used for printing the *Kangxi Dictionary*. The first page of volume 1

[111]

(fig. 111) shows the title of this *uigwe* in the rightmost vertical column, followed by the title of the section, "Royal Order" (*jeongyo*), on the second line. The third line is the date of the order, "the tenth day of the twelfth month of the *gabin* year" (1794). Then follows the contents of the order that concern the elevation of the titles for his mother, Lady Hyegyeong, and Queen Jeongsun, his grandmother, the second queen of King Yeongjo. The characters have a classic look, with every stroke well ordered.

As mentioned above, the *Jeongni uigwe* marks a turning point in the history of *uigwe* production of the Joseon dynasty in that it is the earliest *uigwe* printed with movable metal type and woodblock illustration. Soon after the printing of *Jeongni uigwe*, in 1801, the *Uigwe of the Construction of the Hwaseong Fortress* (*Hwaseong seongyeok uigwe*) was also printed with *jeongni* type and woodblock illustration. As mentioned in the introduction, all *uigwe* books prior to the *Jeongni uigwe* of 1797 were handwritten and hand-illustrated with occasional stamping of outlines of figures that appear repeatedly. My study of twenty royal wedding *uigwe* revealed that until the mid-seventeenth century, all wedding procession paintings (1627, 1638, and 1651) were hand painted. However, those of the second half of the seventeenth century (1671, 1681, and 1696) employed both brush painting and stamping.[10] Procession paintings of the eighteenth century show heavier reliance on stamping for many of the figures due to the increased length of procession paintings.[11] Even after the use of the metal type and woodblock illustration in 1797, however, many *uigwe* books remained handwritten and hand illustrated. Therefore, before going into an examination of the *Jeongni uigwe*, it is useful to briefly introduce the history of printing with movable metal type in Korea.

FIG. 112 Large *jeongnija* movable metal type, ca. 1796. Each *hanja* (character) 1.1 × 1.1 × 0.8 cm. National Museum of Korea (Bongwan 3364).

The History of Printing with Movable Metal Type in Korea

The history of Korean printing goes back to 1377 (Uwang 3, Goryeo), when the Buddhist monk Baegun's compilation of *Jikji simche yojeol* (*Jikji* for short)[12] was first printed at the Heungdeoksa temple in Cheongju, North Chungcheong province.[13] This is considered the earliest book printed by movable metal type in the world, predating the Gutenberg Bible of 1455 by some seventy-eight years.[14]

Koreans further developed the technique and have employed it since the mid-fifteenth century in printing the most detailed recordkeeping of the dynasty, the *Veritable Records of the Joseon Dynasty* (1413–1865). Beginning with the *Veritable Records of King Sejong* published in 1473,[15] although a handwritten copy was always made, three copies of the metal-type printed versions were also published with the metal type called *eulhaeja* (font developed in the *eulhae* cyclical year, 1455). This font took the calligraphy of the noted scholar-official, painter, and calligrapher Gang Hui-an (1417–1464) as its model. However, by the early seventeenth century, many of the characters were either damaged or worn out so that in order to print three copies of the *Veritable Records*, the printing office had to make wooden font pieces to replace the lost or damaged metal ones.

King Jeongjo's interest in creating the metal printing font was no doubt stimulated by the earlier Joseon achievement, but, more importantly, by Chinese achievements in metal-type printing. Even before his reign, during the reigns of kings Sukjong and Yeongjo, important printed books of the Kangxi era were purchased through emissaries to Yanjing: *Peiwen yunfu* (*Rhyme Dictionary of Literary Allusions and Poetic Dictions*, 1713), *Xingli jingyi* (*Essential Meanings of Works on Nature and Principles*, 1715), and *Kangxi zidian* (*Kangxi Dictionary*, 1729), to name a few. In 1792, King Jeongjo had the so-called *saengsaengja* wooden printing font developed that was modeled after the Qing dynasty's metal type used for printing the *Kangxi zidian*. However, only two books were printed using this *saengsaeng* wooden type.[16] Three years later, in 1795, Jeongjo had the *jeongnija* bronze type developed, fashioning it after the *saengsaengja*. The wooden type became defunct and was mostly destroyed by a fire in 1857.[17] The *jeongnija* bronze type was used to print the *Jeongni uigwe* (1797) as well as the *Hwaseong uigwe* (1801). In the National Museum of Korea is a wooden chest of drawers that once stored the *jeongnija* metal type and a "page" of movable type (fig. 112).

[112]

Jeongjo's interest in metal type was to have the *jeongnija* developed for printing the *Jeongni uigwe*, but, more importantly, it was directly linked to his interest in Qing dynasty printed books such as the *Gujin tushu jicheng* (*Complete Collection of Illustrations and Writings from the Earliest to Current Times*), which began under the Kangxi emperor (r. 1661–1721) and

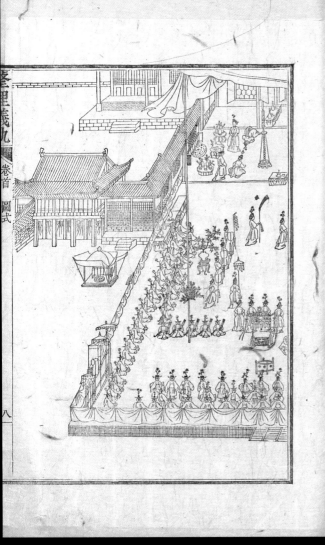
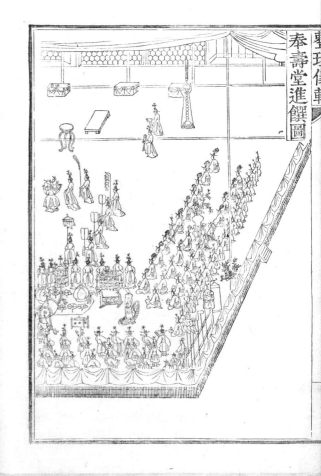

FIG. 113 Royal banquet at Bongsudang, from the *Jeongni uigwe* (*Wonhaeng eulmyo jeongni uigwe*), 1797. Printed book, 34.3 × 17.2 cm. Jangseogak Archives, The Academy of Korean Studies (K2-2897).

was completed under the Yongzheng emperor (r. 1722–1735) in 1726, and the *Siku quanshu* (*Comprehensive Library of the Four Treasuries*),[18] completed in 1783. In 1777 Jeongjo was able to purchase a set of *Gujin tushu jicheng* through the emissaries Yi Eun (1722–1781) and Seo Ho-su (1736–1799),[19] who brought back 5,020 volumes of the *Gujin tushu jicheng* with 6,484 illustrations.[20] Jeongjo also wanted to purchase a set of the *Siku quanshu*, but that publication was still in progress.

It is interesting to note that the official who was the vice superintendent in the special office in charge of the production of the Qing collectanea *Siku quanshu* was Kim Gan (Jin Jian; b. 1794), a man of Korean origin whose ancestors were taken to China during the two Manchu invasions (1627, 1636).[21] He was instrumental in improving the wooden printing font that he undoubtedly learned from Joseon Korea.[22] Lothar Ledderose acknowledges the indebtedness of the Qing wooden printing font for the *Siku quanshu* to Kim Gan (Kan), who was well informed about the Joseon technique of wooden printing font, and was in charge of the imperial printing office in 1777.[23]

The volumes of *Gujin tushu jicheng* and their illustrations provided the royal Kyujanggak library scholars, who had the privilege to study the books, with new knowledge and techniques not only of Qing China but also of the West through China. Much of the newly acquired knowledge was applied in the construction of Hwaseong.[24] This aspect will be explored in chapter 8.

Contents of the *Jeongni Uigwe*

The *Jeongni uigwe* consists of ten volumes. The preface of the lead volume (*gwon su*) and volumes 1 through 5 constitute the main text. In addition, there are four volumes of appendices which record events that took place before and after the grand trip to the Hwaseong Fortress.[25] The structure of this *uigwe* deviates from previous *uigwe* in that there is no subdivision of the work units called *bang*. In this chapter, we will only examine the important points within the main text of the *Jeongni uigwe*.

The Preface

The lead volume begins with the "selection of auspicious dates" and the "list of officials in charge." Chae Je-gong (1720–1799), minister of the right, was appointed superintendent. Also listed are the important illustrations:

[113]

1. Detached Palace of Hwaseong (*Hwaseong haenggungdo*)
2. Royal Banquet at Bongsudang (*Bongsudang jinchando*) (fig. 113)
3. Banquet of Elder Officials at the Nangnamheon (*Nangnamheon yangnoyeondo*)

4. King Jeongjo's Visit to the Shrine of Confucius (*Alseongdo*)
5. Announcement of the Successful Candidates for the Special State Examination Held on the Occasion of Jeongjo's Visit to Hwaseong (*Bangbangdo*)
6. Military Exercise at Seojangdae (*Seojangdae seongjodo*)
7. Royal Bestowal of Rice at Sinpungnu (*Sinpungnu samido*)
8. Drawings of Lady Hyegeong's Palanquin, including ten pages of details (*Gagyodo*)
9. Smaller Palanquin Built for King Jeongjo's Two Sisters (*Yuokgyo*)
10. The Pontoon Bridge over the Han River (*Jugyodo*) Built for the Trip, on two facing pages
11. Drawings of silk flowers of all types that were used for the event, as well as vessels and utensils, costumes of performers, etc.
12. Sixty-three pages of *banchado* that show the procession of the royal retinue returning to Hanyang
13. Royal Banquet at Yeonhuidang, Lady Hyegyeong's residence at Changgyeong Palace (*Yeonhuidang jinchando*)[26]
14. Royal Bestowal of Rice at Honghwamun, the main gate of Changgyeong Palace (*Honghwamun samido*)

These *banchado* illustrations will be discussed below in their relevant contexts. Scenes 13 and 14 are illustrations of events that took place on the eighteenth day of the sixth month, about four months after their trip to Hwaseong, and go with the contents of the first appendix.[27]

Volume 1

Volume 1 begins with King Jeongjo's series of orders for the preparations of the grand trip.[28] The trip to Hwaseong and back to Hanyang took eight days. The royal retinue left Hanyang on the ninth day of the second leap month and returned to Hanyang on the sixteenth day of the second leap month.[29] The itinerary of important stops and activities of the royal family on the way to Hwaseong are summarized below.

Day 1 Departed from Changdeok Palace early in the morning and traveled to Siheung Detached Palace (Siheung haenggung) where the royal retinue stayed overnight

Day 2 Departure before seven o'clock in the morning from Siheung
 • Stopped at Sageunpyeong Detached Palace for lunch
 • On to Hwaseong Detached Palace to stay until departure back to Hanyang

Day 3 Visit to the County Shrine of Confucius of Hwaseong

- Special civil and military examinations for local applicants at the Nangnamheon of Hwaseong Detached Palace[30]
- Rehearsal for the banquet at Bongsudang

Day 4 Visit to Hyeollyungwon tomb, afternoon through the night
- Military exercise at Hwaseong

Day 5 Morning banquet at Bongsudang for the sixtieth birthday of King Jeongjo's parents, the late Crown Prince Sado and Lady Hyegyeong

Day 6 Early morning royal bestowal of rice at Sinpungnu, the main gate of Hwaseong Detached Palace
- Breakfast banquet at Nangnamheon for elder officials
- Survey of Hwaseong Fortress, from afternoon through the night
- Arrow shooting and the setting off of a cascade of paper "plum blossom" firecrackers (maehwa po), the fiery flares of which resemble falling plum blossoms

Day 7 Departure from Hwaseong and travel to Siheung Detached Palace

Day 8 Departure from Siheung Detached Palace
- Stop at Yongyang bongjeojeong,[31] the "Pavilion of Leaping Dragon and Flying Phoenix" at Noryangjin
- Back to Changdeok Palace

Since the relocation in 1789 of his father's tomb from Baebongsan in Yangju to Hwaseong in Suwon and renaming it the Hyeollyungwon, King Jeongjo made yearly trips alone to the tomb (1789, 1790, 1791, 1792, 1793, and 1794) before inviting along his mother and his two sisters in 1795. The previous trips lasted either three or four days, but the special trip of 1795 took eight days. After that grand trip, he continued to visit the tomb every year until his death in 1800.[32] However, *Jeongni uigwe* is the only *uigwe* that documents Jeongjo's yearly visits to his beloved father's tomb site at Hwaseong. In fact, it is the only *uigwe* with *banchado* that documents a king's outing in all of Joseon history.

Volume 2

In volume 2, under the royal orders of the twenty-eighth day of the second leap month, we find Jeongjo in the office *dogam*, along with military personnel with appropriate costume, giving an order to hire the court painter and former magistrate Kim Hong-do and to have him stand by (to supervise the illustrations that were already in the *Jeongni uigwe*).[33] Therefore, it is not clear exactly what kind of contribution Kim Hong-do actually made for the publication of the *Jeongni uigwe*. Consequently, his name does not appear in the *uigwe*'s "Award Regulations" section.[34]

御製舟橋指南

舟橋之制載於詩見於史昉之久矣我國僻陋至今未之
行于於是決意欲行之諮于廟堂詢及父老者非不勤且
懇矣對揚之地未嘗以分數明三字畱心着手故其料量
排布只出於蠡拳闊籌以水則摠爲之船則
摠爲之八九十隻以材木則摠爲之四五千株以船則
摠爲之五六百名行且謀之遂不復更事綜核及其措置
也結爲一船而較其高低不合則退之一船之聯結
殆費半日造橋則繫百艘而待其排比有餘則退之百艘
之廢業殆爲數月矼材則催督諸路民邑受困役丁則吩
咐軍校任渠董督惟知有虛聲咮喝豈能無暗地姦僞鋪
莎則誘以細節都不置意船槍則名雖按例一遇水上之

添波始乃棼棼貼貼若是而其可曰善料事平舟橋之設
爲每歲行幸之須則一副金石之式趙今合有講定究其
要不過曰分數明三字燕閒之暇漫錄如左以待有司者
稟旨舟橋之制定則上以補經用下以除民斃豈直師古
云爾乎哉一舉而有兩得舟橋之謂也庚成孟秋書
一日形便舟橋形便自東湖而下鷺梁爲最何者東湖流
緩岸立爲可取然水闊而路迂爲不便矣冰湖水狹爲可
取然南岸勢緩而延遠水縱添尺岸退十丈添尺之淺水
不能引餘船以補則勢將增廣船槍而船槍爲新水所嚙
原築者猶不能支況可以新增乎渡涉之期日已屆水勢
之增減度則半日江次變路之停畱往年事可鑑也且
水性異於灘洑其趨迅甚新波衝濤及於聯舟冰湖尤不

FIG. 114 King Jeongjo's instructions on how to build a pontoon bridge, from the *Jeongni uigwe* (*Wonhaeng eulmyo jeongni uigwe*), 1797. Printed book, 34.3 × 17.2 cm. Jangseogak Archives, The Academy

Perhaps the most noteworthy aspect of this trip is Jeongjo's construction of the pontoon bridge over the Han River, a feat that had not been attempted before in Korean history. This achievement demonstrates Jeongjo's scientific mind, which was also revealed in the construction of the Hwaseong Fortress (as will be shown in the next chapter). The following section summarizes King Jeongjo's fifteen points of instruction on how to build the pontoon bridge consisting of sixty boats.

Instructions on How to Build a Pontoon Bridge (*Eoje jugyo jinam*)

[114] At the end of the volume 4 (fig. 114), Jeongjo states that although the pontoon bridge system appears in China as early as in the *Book of Poetry* and other history books, Korea, being a remote country, had not previously constructed one.[35] He deplored the repeated unsatisfactory efforts to build a pontoon bridge for his earlier trips and created a fifteen-point list of instructions for constructing one successfully:

1. *On the suitable geographic conditions and the flow of water*
 The Noryang area is deemed to be the most suitable place.
2. *On the width of the river*
 It is about 300 *pa* [about 540 meters: 1 *pa* = 6 *cheok*; 1 *cheok* = about 30 centimeters] at the Noryang ford, which is suitable for building a pontoon bridge.
3. *On the selection of boats*
 Boats in the best condition from the Five Rivers (Han, Nakdong, Geum, Seomjin, and Yeongsan) should be mobilized, and their height should be measured.
4. *On the number of boats to cover the width of the river*
 If the width of the river is 300-*pa* units, then 60 boats, each 5 *pa* wide, would be needed.
5. *On the height of the boats*
 The highest boat should be placed in the middle of the river to create the highest elevation point (*jungnyung*), and the elevation should diminish gradually on either side to create a pontoon bridge with gradual incline toward the center and decline at either end to form a rainbow-shaped pontoon bridge.
6. *On the horizontal wooden crossbars to be used across the boats*
 Since the width of a boat is 5 *pa*, if a bar 7 *pa* long is put across the boat, one *pa* on either side will overlap with that of the adjacent boat, making it easier to stabilize the boats. Each boat will need 5 crossbars, and the total number of crossbars for the 60 boats would be 300 crossbars.

7. *On the planks to be placed lengthwise on the boats*
 The boardwalk across the pontoon bridge should be of the same width as the royal path, which is 4 *pa* wide. The boardwalk of the bridge will require 1,800 planks. [The state lumber farm in] Jang-sangot in Hwanghae province can provide enough pine trees for the 300 horizontal crossbars, and pine trees from Anmyeondo island or any other place near Hanyang can be used for the wooden planks.

8. *On laying turf on the royal path (posa)*
 All boat owners should prepare the patches of turf before they come to Noryang Ford and line their boats up to form the pontoon bridge. Since it takes five years to grow turf of suitable thickness, small patches should be taken out from each place.

9. *On railings along the royal path*
 Seven hundred posts will be enough to build railings on either side of the royal boardwalk. The railing should be draped with fine bamboo curtains. If one bamboo curtain is 5 *pa* wide, 150 or 160 of them will do.

10. *On lowering the anchor cables*
 When laying anchor, each boat should be careful when lowering its anchor at the head of the boat. That way, anchor cables will not be entangled with one another.

11. *On storing parts such as the railing posts for all the boats*
 The parts necessary for the construction of the pontoon bridge should all be marked according to the position of the boats so that there would be no confusion when the bridge is dismantled and stored for rebuilding.

12. *On forming units and ranks*
 From the highest boat in the center, boats on either side should form work units and an appointed leader of each unit should be responsible for ordering other boatmen to quickly group their boats to form the rainbow-shaped pontoon bridge when the drums announce the king's procession.

13. *On awards and punishments*
 The owners of the boats participating in forming the pontoon bridge should be given awards when they worked hard and punished when they did not. Also, the owners of the participating boats should be given privileges, such as transporting the tax grains of Jeolla, Chungcheong, and Gyeongsang areas, and the sea salt from the west coast to the capital. Anyone who abuses these privileges should be removed from the royal service list of pontoon-bridge boats (*jugyoan*).

14. *On gathering the boats on time (gihoe)*
 Usually the royal outing that requires the crossing over the pontoon bridge occurs once in late January or early February, and again in the fall, around mid-August. Therefore, all the boats can freely go around but must quickly gather together for the two royal occasions.

15. *On connecting the [pontoon] bridge [dock] (changgyo) between the shore and the pontoon bridge*
 This multi-boat pontoon bridge–dock should be securely fastened to the side of the first boat, but be able to float with the pontoon bridge as the height of the tide changes.

The above instructions are so clear that one can easily understand not only the structure of the bridge, but also the management system of rebuilding the bridge for future occasions. Although not all the points spelled out in the royal instructions are illustrated, the illustrations and royal instructions combined help us comprehend the scientific, administrative, and artistic achievements of King Jeongjo and his subjects.

Royal Banquets at Hwaseong Detached Palace

There were two banquets held at the detached palace.[36] The banquets were represented in the eight-panel screen painting that documented the important highlights of the Hwaseong trip. In addition, after coming back to Hanyang, another royal banquet was held at Yeonhuidang, Lady Hyegyeong's residence at Changgyeong Palace. This banquet was not included in the screen painting, but, as seen above, the woodblock illustration of the scene is included in the lead volume.[37]

The *Jeongni uigwe* documents all details of the banquets from the interior decoration of the banquet hall down to the number of flowers used to decorate the hall and guests' food trays. All types of flowers are illustrated in the lead volume. We learn from the *uigwe* that two sets of screens of the Ten Symbols of Longevity and one other painted screen, most probably that of Peonies or Birds-and-Flowers, decorated the Bongsudang banquet hall. Screens of the Ten Symbols of Longevity are particularly suitable for the hall because Bongsudang means the "Hall of Revering Longevity."[38] The inventory list is too expansive to completely itemize here.[39] Among the more important decorative pieces are floor coverings (*jiui*) with horseshoe and flower patterns; a wide bench decorated with lotus flowers (*yeon pyeongsang*); several floor cushions, some of which have lotus flower design; and a cushion of leopard pelt, a novelty for the period. Other, smaller items complete the furnishings. In addition to the woodblock

illustrations in the *uigwe*, this trip was also well documented in the form of scrolls as well as screens that were produced just after the trip.[40]

Of the two banquets at the detached palace, the morning banquet at Bongsudang was a major one that celebrated the sixtieth birthday of Crown Prince Sado and Lady Hyegyeong. As in other court banquets, a rehearsal of this event was also held. Birthday banquets were traditionally held in the morning, complete with music and dance entertainment, and wine offerings with congratulatory eulogies in the form of a libretto (*akjang*). In this case, King Jeongjo presented the libation toast to his mother and deceased father, and composed the librettos. The first portion of Jeongjo's libretto is presented below.[41] It consists of five lines that correspond to the five notes of traditional Korean music that are, from bottom to top, *gung*, *sang*, *gak*, *chi*, and *u*.[42]

> As the banquet is taking place in the era of great peace,
>> An [auspicious] image appears in the middle of the sky,
>> In the form of the Star of Longevity (Canopus). (*gung*)
> On a happy spring day,
>> The person who brought longevity is Hwabongin.[43] (*sang*)
> On a long, long spring day,
>> In the Jangnakgung,[44] a great banquet is given.
>> The Hwabongin wished my mother the Three Blessings. (*gak*)
> Her high accomplishments in helping her son
>> And her grandchild is such that,
>> Brightly shining happiness and wealth appear overflowing. (*chi*)
> The music of Emperor Yao's period,
>> The tune composed by the Yellow Emperor,
>> Good food and wine[45] will be prepared every year. (*u*)

嘉會屬昇平昇平今有象厥象問如何老人中天郎(宮)
含飴駐我長樂春祝聖徠女華封人(商)
春長長樂酌斗華祝至三壽母(角)
翼子詒孫功何巍穰穰福祿光輝(徵)
咸池鼓雲門琴玉漿璃液年年斟(羽)

The libretto is imbued with Jeongjo's earnest and loving respect for his mother, who endured long and difficult years of solitude after the tragic death of his father. His trip to his father's tomb with his mother in 1795 was his way of expressing his gratitude to her.

The names of all the guests invited to the two banquets (at Bongsudang and Nangnamheon) are recorded in volume 5, along with the

names of all the female dancers and musicians.[46] Their contribution to the banquets was amply compensated, as recorded in the "Award Regulations" section at the end of the volume 5.[47] On two occasions (the Hyeollyungwon sacrificial rite and the royal banquet at Bongsudang), Buddhist monks — led by the head of the Yongjusa temple, Sa-il, and the monk Cheorak — were given a special royal award in the form of a raise of their clerical rank.[48]

Screens Depicting the Royal Trip to Hwaseong

The *Hwaseong wonhaeng dobyeong* used to be called *Suwon neunghaengdo* or *Hwaseong neunghaeong dobyeong*. The recent change of title is based on the fact that in 1795 the tomb was not a royal one (*neung*) but a tomb of a prince (*won*), and the location of the tomb was not Suwon but more specifically Hwaseong.[49] Therefore, the title of the screen in English should be *Screen of [King Jeongjo's] Visit to Hyeollyungwon in Hwaseong*. For clarity, it is best to use the Korean title, *Hwaseong wonhaeng dobyeong*, instead of a made-up English title such as "Events from King Jeongjo's Visit to Hwaseong in 1795."[50] As this screen has been studied recently by several scholars,[51] I will examine it only briefly here.

In the *uigwe*, it was recorded that, under the direction of the Ministry of the Interior, three sets of large eight-fold screens and three sets of medium-size eight-fold screens were produced and presented to the palace.[52] In addition to those sets, smaller-scale screens were produced as communal *gyebyeong* paintings to be shared among the participating officials of the superintendency regardless of their rank.[53] The first character, *gye*, means a gathering of like-minded people, and the second, *byeong*, refers to screen paintings. *Gyebyeong* were produced to commemorate the participation of a group of people in certain events, and to be shared among them. In this case, the expenses for the screens were paid by the individuals. However, for the *gyebyeong* produced after the 1795 event, all of the expenses were paid by the court.[54]

Four complete sets of the eight-panel screens are in existence today: in the National Museum of Korea, National Palace Museum of Korea, the Leeum Museum of Art, and the Uhak Culture Foundation of Yong In University (Uhak Munhwa Jaedan). I will discuss the one in the Leeum Museum of Art (fig. 115), as it is the best preserved. The subjects of its eight panels are:

[115]

1. King Jeongjo Paying His Respects at the Hwaseong Shrine of Confucius (*Hwaseong seongmyo jeonbaedo*)
2. Announcement of the Successful Candidates of the Special State Examination at Nangnamheon (*Nangnamheon bangbangdo*)

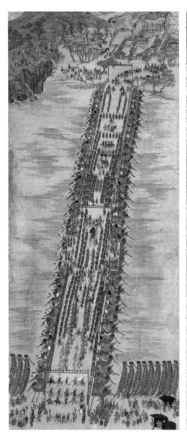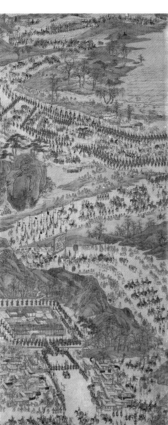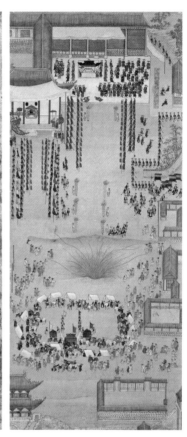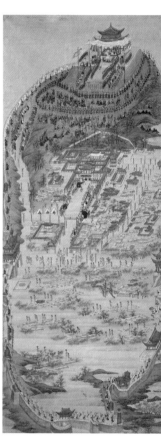

FIG. 115 *Hwaseong wonhaeng dobyeong*, after 1795. Eight-panel screen; ink and color on silk, each panel 147 × 62.3 cm. Leeum Museum of Art.

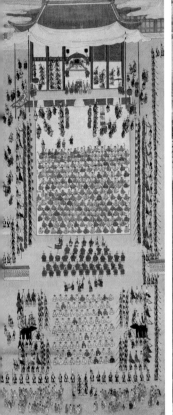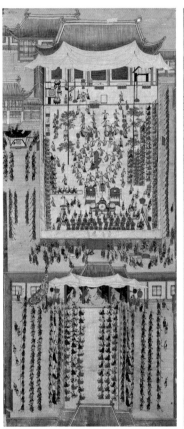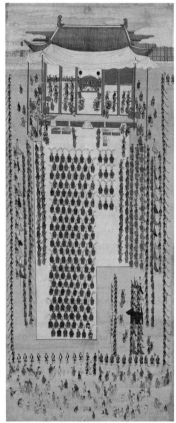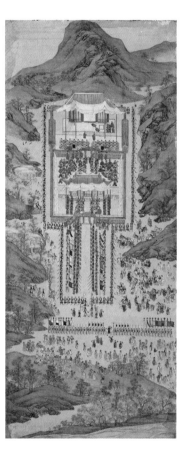

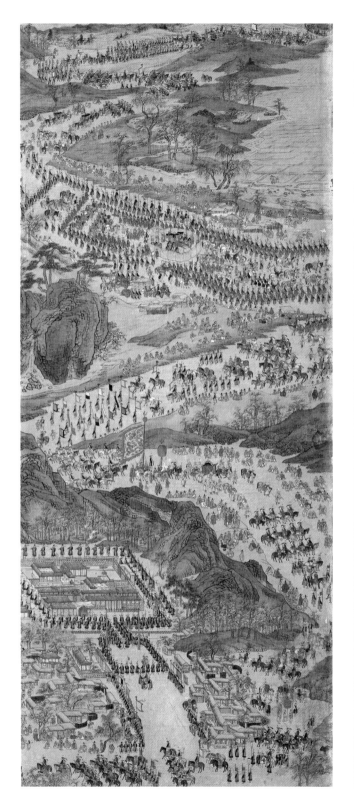

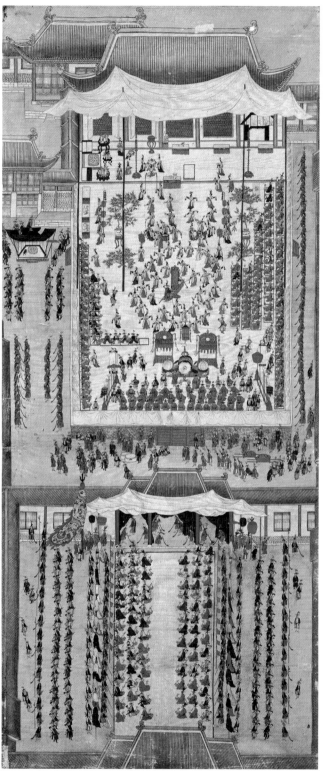

3. Sixtieth Birthday Banquet at Bongsudang (*Bongsudang jinchando*)
4. Banquet for the Elder Officials at Nangnamheon (*Nangnam-heon yangnoyeondo*)
5. Evening Military Exercise at Seojangdae (*Seojangdae yajodo*)
6. Royal Archery at Deukjungjeong (*Deukjungjeong eosado*)
7. Royal Procession Back to Hanyang (*Hwaneo haengnyeoldo*)
8. Royal Return Procession at the Pontoon Bridge over the Han River (*Hangang jugyo hwaneodo*)

[116] The first six panels depict events in Hwaseong and adhere to the traditional perspective system. The last two panels represent the royal retinue's trip back to Hanyang and show elements of novel Western perspective that was recently introduced into Korean painting (fig. 116). I examine the third, seventh, and eighth panels below.

[117] The third panel, the "Sixtieth Birthday Banquet at Bongsudang" (fig. 117), depicts a large area in front of the hall under the white tent pitched from the hall's eaves. Several court entertainments are taking place in the middle section, the most prominent being the "pleasure of [118] a boat ride" (*seonyurak*) (fig. 118). In the scene, several court dancers in colorful costumes are dancing around a representation of a boat with a tall sail. This particular theme appears in all court banquets of the late Joseon period. A drawing of the dance is illustrated in the *Jeongni uigwe* [119] (fig. 119), although it appears sketchy compared with the screen painting. Depicted below the dancers are musicians with a large colorful drum and other court music instruments.

[118] Just under the tent to the left (see fig. 118), we see the empty platform seat of Lady Hyegyeong surrounded by a painted screen and marked by a cushion made of leopard pelt. Her image is not shown, as it is customary in Joseon paintings not to represent kings, queens, or other royals of high standing. In describing this Joseon practice, Burglind Jungmann applied the term "aniconic image,"[55] a phrase used mostly for religious art.[56] In Chinese documentary paintings, emperors are represented in human forms, but it is a convention in Korea not to do so. There are three tray tables in front of the seat: the one in the center is a small black-lacquered table on which are placed wine cups and some food; the two larger ones on either side are red-lacquered with many dishes of food stacked up high and topped with decorative flowers. In Joseon Korea, food was served individually on a small tray table such as the one we see in this panel for Lady Hyegyeong. Likewise, in the lower part of this panel all the invited guests have a small tray table of food in front of them.

FIG. 116 Royal procession back to Hanyang. Panel 7 of *Hwaseong wonhaeng dobyeong* (fig. 115).

FIG. 117 Sixtieth birthday banquet at Bongsudang. Panel 3 of *Hwaseong wonhaeng dobyeong* (fig. 115).

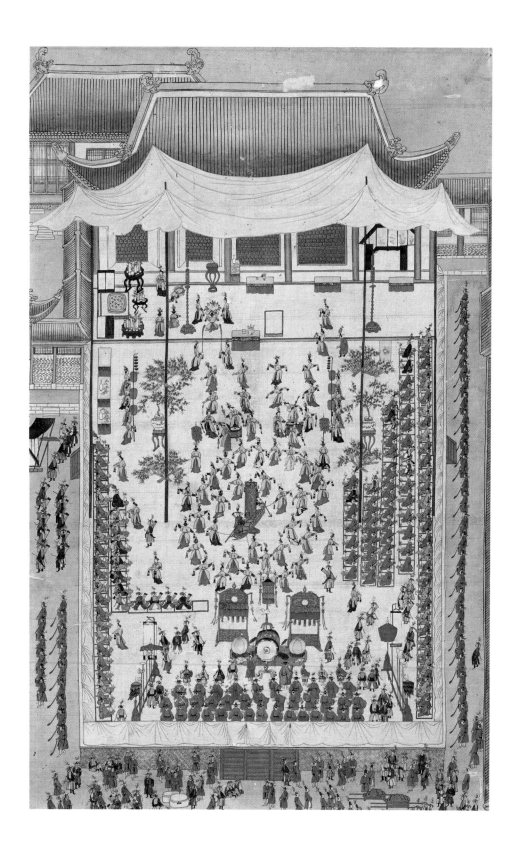

FIG. 118 Sixtieth
birthday banquet at
Bongsudang. Detail
of panel 3 of *Hwaseong
wonhaeng dobyeong*
(figs. 115, 117).

FIG. 119 Dance evoking the "pleasure of a boat ride" (right) and a sword dance (left), from the *Jeongni uigwe* (*Wonhaeng eulmyo jeongni uigwe*), 1797. Printed book, 34.3 × 17.2 cm. Jangseogak Archives, The Academy of Korean Studies

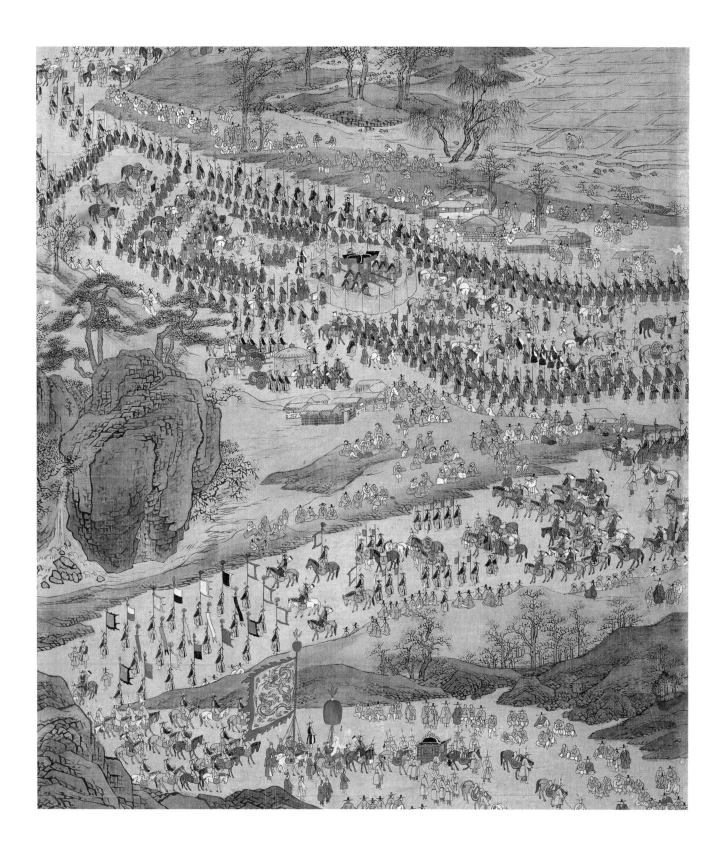

Panel seven, "Royal Procession Back to Hanyang," displays knowledge of the Western perspective system, newly introduced to Korea beginning in the early eighteenth century, in its depiction of the long procession of the royal retinue.[57] From the top to the bottom of the panel (see fig. 116), the procession moves in a meandering fashion, zigzagging as many as seven times before it finally goes into the heavily guarded Siheung Detached Palace through the red gateway called *hongjeonmun*.[58] The palace, seen prominently in the foreground under the mountain, is depicted in traditional blue-and-green landscape style. It is where the royal family will stay overnight before the last day of the journey. The figures grow larger as the procession moves toward the foreground. One third from the top, King Jeongjo's white royal horse is seen just behind his mother's palanquin, hidden from view on all sides behind a curtain of white drapes, and the royal presence is guarded heavily with soldiers in red uniforms (fig. 120). Along the entire length of the procession, we find many spectators of all ages and in all attires, either walking along with the procession or sitting on the patches of grass in open fields. These figures are familiar to us through contemporary genre paintings popularized by such artists as Kim Hong-do and Kim Deuk-sin. A royal procession such as this was a rare sight, and people assembled along its path to watch. King Yeongjo deliberately made as many public appearances as possible among the people through his "move outside the palace" (*geodung*) initiative,[59] and it was during his reign (1724–1776) that the term "public sightseer" (*gwangwang minin*) first appeared in documents.[60]

Panel eight, "Return Royal Procession at the Pontoon Bridge over the Han River" (fig. 121), also displays knowledge of the Western perspective system in that the pontoon bridge is narrower at the top of the panel and gradually widens at the Noryang Ford in the foreground, where the front red arrow gate greets the royal retinue. The "pontoon bridge" in the *Jeongni uigwe* illustration (fig. 122) is spread on two contiguous pages of the *uigwe* book, and therefore the effect of the perspective going into the background is represented more naturally than in the screen painting. We cannot see all of the fifteen points of royal instruction in the depiction on this long, narrow panel, but upon closer examination, the bridge indeed looks higher at the midpoint where the middle red arrow gate stands. Lady Hyegyeong's palanquin can be found just below the middle red gateway, while Jeongjo's white horse is between the front and the middle red gateway. Although Jeongjo's instructions included the laying of turf over the royal path on the bridge, the surface of the bridge covered with turf is not visible. Perhaps this is due to the season of the

[116]

[120]

[121]

[122]

FIG. 120 "Royal Procession back to Hanyang." Detail of panel 7 of *Hwaseong wonhaeng dobyeong* (figs. 115, 116).

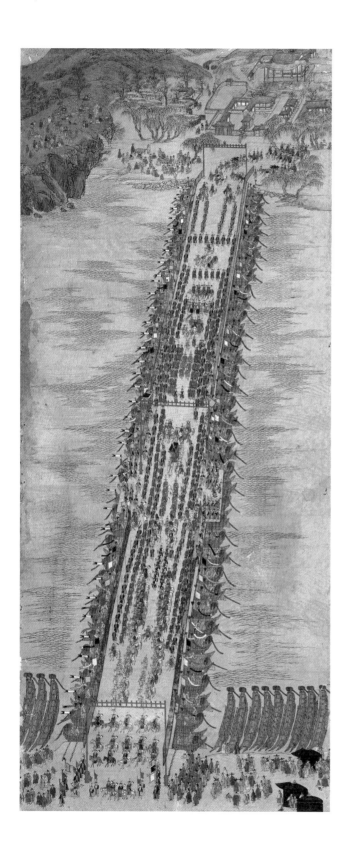

FIG. 121 "Return Royal
Procession at the
Pontoon Bridge over
the Han River." Panel 8
of *Hwaseong wonhaeng
dobyeong* (fig. 115).

整理儀軌
舟橋圖

整理儀軌
卷首 圖式

三十

FIG. 122 Pontoon bridge,
from the *Jeongni uigwe*
(*Wonhaeng eulmyo
jeongni uigwe*), 1797.
Printed book, 34.3 ×
17.2 cm. Jangseogak
Archives, The Academy
of Korean Studies

trip (second leap month). Since no *uigwe* was produced on occasions of Jeongjo's repeated trips to Hwaseong, this is the only depiction of this elaborate pontoon bridge.

Handscroll of the *Banchado* of the Royal Trip to Hwaseong

There are other works related to this trip, for example, the album of paintings in the National Museum of Korea that obviously is a later work judging from the quality of the paintings.[61] All known forms of illustrations of the event were accounted for in the 2015 exhibition catalogue and illustrated with many details.[62] I will briefly examine the handscroll of the *banchado* (*Hwaseong wonhaeng banchado*) in the National Museum

[123] (fig. 123).[63]

As mentioned earlier, the *Jeongni uigwe* contains sixty-three pages of woodblock illustrations of the procession. Each page measures 34.3 × 17.2 centimeters, and if the sixty-three pages were connected, the total length would be about 1,084 centimeters.[64] According to the "Retinue" (*baejong*) section in volume 5 of the *Jeongni uigwe*, more than 7,200 persons were listed as participants of the procession.[65] But the actual number depicted in the *Jeongni uigwe* procession is about 1,490 figures and 520 horses, which represents only 18 to 20 percent of the entire retinue.[66] Needless to say, a procession painting, no matter how elaborate, cannot possibly include all participants.

There are two important differences between this procession painting and all other earlier *banchado*. First, in all previous Joseon-period ones, we find a combination of several different viewpoints throughout the painting, the most notable being figures standing upside down along the upper edge of the painting. But, for the first time, this *banchado* maintains a single viewpoint so that all the figures and horses are seen standing on the same ground level. In the section showing

[124] Lady Hyegyeong's palanquin in the *Jeongni uigwe* (fig. 124)[67] and the corresponding part of the procession in the handscroll in the National

[125] Museum of Korea (fig. 125), we see a great deal of overlapping of figures and horses, as they occupy a narrow space.[68] This is in line with Western influence, as we have seen in the last two panels of the screen painting.

The second new feature of this *banchado* procession is that not only Lady Hyegyeong's palanquin (which is the largest in this procession), but also those of King Jeongjo's two sisters, which are smaller, are being conveyed by two horses, one in the front and one in the back, aided by several grooms. A groom is holding the reins of the horse in the front, and the long parallel poles (*janggang*) on either side of the palanquin are tied to the sides of the horses, although the bars are also held by ten

bearers. In earlier procession paintings, all of the palanquins, regardless of their size, were borne by men. Yet here, in the "Letters to the King" (gyesa) section of volume 2 of Jeongni uigwe, we find on this occasion the mention of the use of horses.[69] This letter asks King Jeongjo for permission to employ horses not only for Lady Hyegyeong's palanquin, but also for the two smaller palanquins carrying Jeongjo's two sisters. Jeongjo gave his approval and, as a result, in this banchado we see all the palanquins conveyed by horses along with the bearers.

Given that there are so many versions of the Jeongni uigwe–related screen paintings and banchado, we expect to find many names of painters in the service of this event. Their names are found in the "Award" section in volume 5, under "Awards after Presenting the Palace Banquet Screens." They are Choe Deuk-hyeon,[70] Kim Deuk-sin (1754–1822), Yi Myeong-gyu, Jang Han-jong (1768–1815), Yun Seok-geun, Heo Sik (b. 1762), and Yi In-mun (1745–1821).[71] Also listed is the name of Im U-chun, an artisan who specialized in constructing painted screens (byeongpungjang).[72] These painters are well-known artists who repeatedly served in contemporary court events. All seven are found in a list of a special group of painters, called "painters-in-waiting at Kyujanggak" (Gyujanggak jabidaeryeong hwawon),[73] who were selected from among court painters through special testing of skills for higher emoluments, and who served King Jeongjo's painting needs whenever possible.[74]

It is rare in a uigwe document to specify the role of individual painters, as they collaborated in creating screen paintings presented to the palace. The onlookers along the royal procession in the seventh panel of the screen, mentioned earlier (see figs. 116, 120), could have been painted by Kim Deuk-sin, who, along with Kim Hong-do, was known as one of the foremost genre painters of the period. The detailed landscape depiction of the same panel reminds us of the works by Yi In-mun, a versatile landscape painter who was the exact contemporary of Kim Hong-do, and more often than not overshadowed by the latter. We also notice the liveliness in the postures and gestures of the figures in the banchado even in depictions of similar figures such as the guards who surround Lady Hyegyeong's palanquin. Their stances with slight turning motion of the torso distinguish the gait of each one of the uniformed figures. The groom and the palanquin bearers also show equally lively gestures that are rarely seen in other banchado.

The eight-volume Wonhaeng eulmyo jeongni uigwe is the second largest uigwe compiled under the order of King Jeongjo, with a total of 1,270 pages of text and illustrations.[75] It is the only uigwe of the Joseon dynasty in which the categories "king's outing" and "palace banquets"

[116]
[120]

FIG. 123 *Hwaseong won-haeng banchado*, 1795. Detail depicting King Jeongjo's 1795 trip to Hwaseong. Handscroll; ink and color on paper; entire scroll, 46.5 × 4,483 cm. National Museum of Korea (Deoksu 2507).

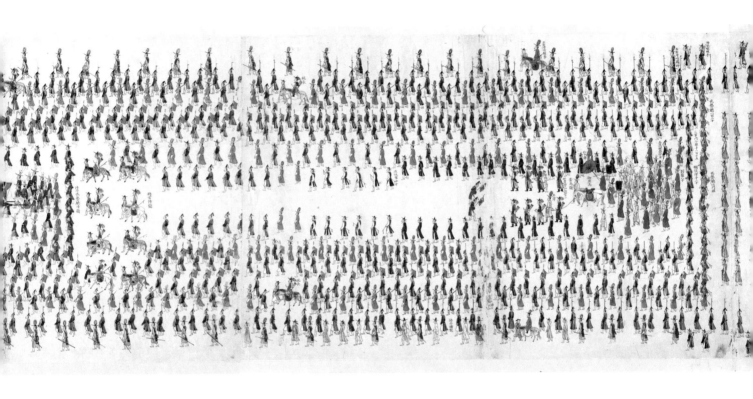

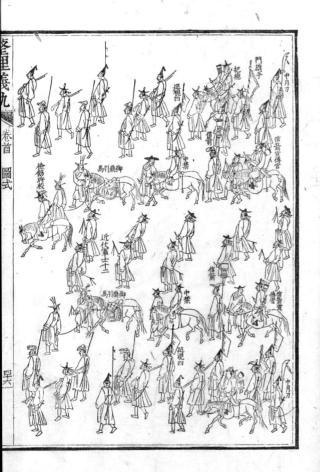
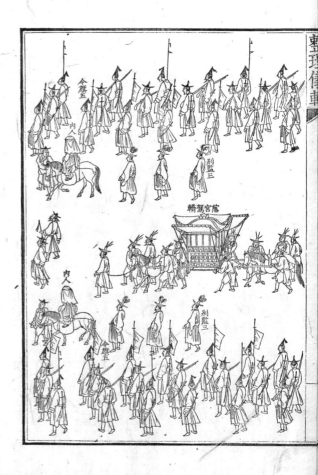

FIG. 124 Lady Hye-gyeong's palanquin, from the *Jeongni uigwe* (*Wonhaeng eulmyo jeongni uigwe*), 1797. Printed book, 34.3 × 17.2 cm. Jangseogak Archives, The Academy of Korean Studies (K2-2897).

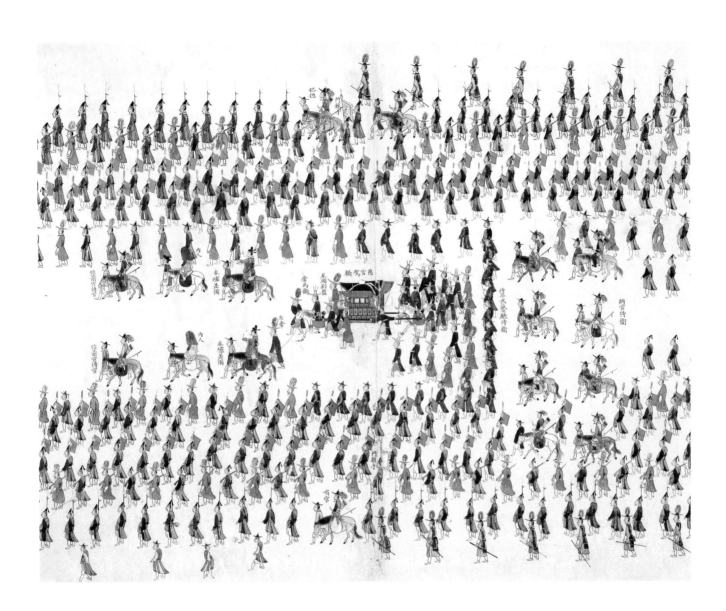

FIG. 125 Lady Hye-
gyeong's palanquin.
Detail of *Hwaseong
wonhaeng banchado*
(fig. 123).

are combined.[76] The king's outing in this case was an unusually elaborate one, as he was accompanied by his mother and two sisters. All the plans for and execution of this trip to his father's tomb near Hwaseong Fortress, which was built at nearly the same time (1794–1796) as the trip, are carefully documented with illustrations. Handscrolls and eight-panel screen paintings that depict the trip and the banquets bear witness to King Jeongjo's devotion to his parents, on the one hand, and his wish to project himself as a true Confucian monarch to the people through his display of filial piety on the other. To be sure, the construction of the Hwaseong Fortress near the tomb of his father can be construed as exemplifying Jeongjo's military and political ambition[77] along with his strong filial piety. The buildings of the Hwaseong Fortress will be discussed in more detail in chapter 8.

This is also the first *uigwe* to be printed with the movable metal type developed under the order of King Jeongjo. Altogether, 102 copies were published at this time and distributed not only among relevant government offices (Ministry of Rites, Ministry of War, Office of Education of the Crown Prince) and the five history archives, but also, for the first time in Joseon history, to high officials of the superintendency in charge of the royal event, such as Chae Je-gong.[78] One copy was also presented to Lady Hyegyeong, and thirty copies were kept in the main palace in Hanyang, and in palace offices such as the Jeongniso and the Hwaseong Detached Palace. As a result, today more than twenty copies of complete sets survive in major university or museum libraries.[79] Additionally, some incomplete sets are found in private collections.[80]

The production of so many copies of this *uigwe* is a triumph of the Joseon dynasty's printing technology, spearheaded by King Jeongjo, better known in Korean history as the powerful Joseon monarch who overcame the destabilizing factional struggles that he inherited from his grandfather, King Yeongjo. By producing more than one hundred copies of the first printed *uigwe* of his special visit to his father's tomb, accompanied by his mother and two sisters, Jeongjo wanted to memorialize this event as the most important state rite of his reign. ◆

CHAPTER EIGHT
Uigwe of the Construction of the Hwaseong Fortress

Hwaseong seongyeok uigwe (hereafter cited as *Hwaseong uigwe*), the *Uigwe of the Construction of the Hwaseong Fortress* of 1801, is categorized as a *yeonggeon dogam uigwe*, which can be roughly translated as "construction-related *uigwe*" or "*uigwe* of the reconstruction and repair superintendency" ("*dogam*" has the meaning of "superintendent" or "executive oversight"). Joseon palace buildings were wooden structures that were easily damaged by fire and required reconstruction, and the *Changdeokgung yeonggeon dogam uigwe* (*Uigwe of the Construction of Changdeok Palace*) of 1834 is a record of such a rebuilding. Two other *uigwe* that deal with rebuilding are the *Jongmyo suri dogam uigwe* (*Uigwe of the Repair of the Jongmyo Shrine*) of 1726 and the *Injeongjeon jungsu uigwe* (*Uigwe of the Repair of the Injeong-jeon*) of 1854–1857. The *Hwaseong uigwe*, however, seems to be unique among construction-related *uigwe* in that it is the only one that records building a new fortress complete with defensive walls and a detached palace within.

[126] Among the notable achievements during the reign of King Jeongjo, the building of the new city of Hwaseong with its defensive walls can be ranked as one of the highest.[1] Figure 126 illustrates a page in the *uigwe* showing the complete view of Hwaseong. Jeongjo's desire to present himself as an ideal Confucian monarch through his display of filial piety toward his parents found a perfect outlet in the dual task of constructing the tomb near Hwaseong to honor his late father and escorting his mother there in 1795 to celebrate the sixtieth birthday of both his parents, who were born in the same year. At that time, the newly constructed walled city of Hwaseong was a showcase of his political and military ambitions, as the city was to be one of the *yusubu*, local administrative units responsible for the defense of the capital, and located at one of the four cardinal directions ringing the capital.[2] The Hwaseong *yusubu* was self-sufficient economically because it was equipped with irrigation systems and all other facilities necessary for farming and raising of cattle for food.[3] Moreover, the construction of the fortress was the first attempt

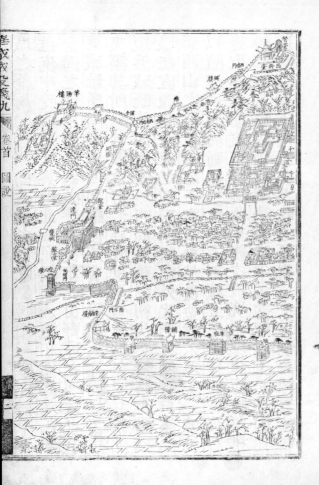
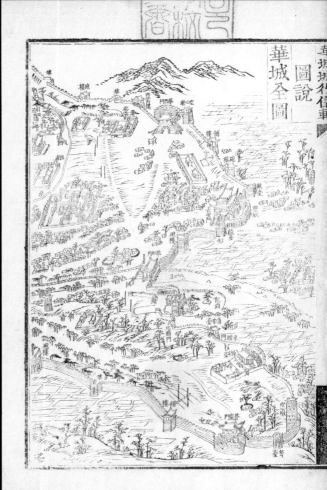

FIG. 126 "Complete View of Hwaseong," from the *Uigwe of the Construction of the Hwaseong Fortress* (*Hwaseong seongyeok uigwe*), 1801. Printed book, 34 × 21.7 cm.

in Joseon history to combine stone blocks, bricks, and mud for its walls. The new construction also demonstrates the use of load-bearing and transportation devices for moving heavy stone blocks. Those innovations were made possible by scholars who belonged to a branch of the School of Practical Learning called the School of Northern Learning, which advocated the importation of advanced Qing science and technologies.

In the first part of volume 1, we find King Jeongjo's "Imperially Composed Comprehensive Plan of Hwaseong" (*Eoje seonghwa juryak*), which is based largely on the "Fortress Construction Plan" (*Seongseol*) submitted by Jeong Yak-yong (1762–1836).[4] Jeong also devised the load-bearing machines (*geojunggi* and *nongno*). He learned of these from the *Yuanxi qiqi tushuo luzui* (*Illustrated Book of Far Western Wondrous Mechanical Instruments: The Most Important Items*) — henceforth, *Qiqi tushuo*, for short — compiled by the Jesuit priest Johannes Terrenz (Deng Yuhan, 1576–1630) and the Chinese scientist-engineer Wang Zheng (b. 1544). This book, imported in 1777,[5] was in the Qing encyclopedic *Gujin tushu jicheng* and at the disposal of the royal Kyujanggak library scholars, Jeong Yak-yong among them. Without these and many of the other devices illustrated and explained in the lead volume (*gwon su*), the construction of the fortress might not have been possible in such a short time.

It should be noted that combining stone blocks and bricks for the construction of the walls was advocated by scholars such as Bak Ji-won (1737–1805), who visited Yanjing in 1780 as a member of the retinue of the emissary sent to honor the Qianlong emperor's seventieth birthday. Bak's travel diary, *Yeolha ilgi* (*Jehol Diary*), is full of his observations on Qing material culture and is considered one of the best literary pieces of the late Joseon period. In it, Bak advocates the practicalities of brick-and-stone wall construction and the use of a pulley to draw water from a well. He also points out the presence of an additional semicircular wall in front of the major city gates of Yanjing.[6] This defensive structure, called *ongseong* ("jar wall"), can be seen in the major gates of Hwaseong (figs. 127–131). Thus, the construction project of the fortress is a tangible result of King Jeongjo's interest in, and knowledge of, science and technology imported from Qing China through emissaries to the Qing court.

The *Hwaseong uigwe*, published in 1801, was the second *uigwe* printed with *jeongnija* movable metal type. Together with the *Uigwe of King Jeongjo's Visit to the Tomb of Crown Prince Sado in the Eulmyo Year* (*Jeongni uigwe*, 1797)[7] (see fig. 111), the first to be printed with the same metal type, the *Hwaseong uigwe* marks a turning point in the history of printed *uigwe* of the Joseon dynasty. A concise history of movable metal type printing in Korea was given earlier in chapter 7.

[127]
[128]
[129]
[130]
[131]

[111]

The Construction and Naming of the City of Hwaseong

The 1,100-character text of the *Hwaseong gijeokbi* (*Stele Memorializing the Construction of Hwaseong*) composed by Kim Jong-su (1728–1799), chief academician and minister of the right, is a concise summary of the reasons for building the Hwaseong Fortress.[8] To quote in part: "The name of the city, Hwaseong 華城, is taken from the name Hwasan 花山 [the town where Crown Prince Sado's tomb, the Hyeollyungwon, is located] since the two characters 'hwa' 華 and 'hwa' 花 can be used interchangeably. [The characters 華 and 花 are pronounced *hua* in Chinese and *hwa* in Korean.] It also alludes to the phrase 'the dweller of the Hua area congratulated the legendary Emperor Yao' (*Hwain chukseong*, Ch. *huaren zhusheng*). Everything was conducted under the order of our respected king."[9] Kim makes it clear that all the ideas about the construction of Hwaseong are from King Jeongjo. The phrase is directly from the *Zhuangzi*. The gist of the story is that Emperor Yao declined the offer of the three worldly desires, "longevity, wealth, and many sons," on account of their hindrance to nourishing virtue.[10] Kim's allusion to the story from the *Zhuangzi* is interpreted as referring to King Jeongjo, a sage king who does not pursue "worldly happiness" for himself, but only positions himself as a virtuous ruler of the people.[11]

This passage is followed by a concise summary of the major structures of the fortress, along with enumerations of the total cost of construction (approximately 800,000 gold *geum*) and the number of workers employed (some 700,000 men), paid for from the royal family's private fund (*satang*), not from state revenue. King Jeongjo's filial piety toward his father, who lies buried in the Hyeollyungwon nearby, was greatly extolled at the end of Kim's text.

In conjunction with Jeongjo's reorganization of the capital's defense system, he initiated military reform in 1788 by establishing the Jangyong-yeong, a military unit of "strong and brave soldiers" that grew out of Jangyongwi, a unit of soldiers established in 1784 to closely guard the king.[12]

As soon as he ascended the throne in 1776, King Jeongjo established Kyujanggak within Changdeok Palace as a place for policy studies by young scholar-officials, and as a royal library to store the writings and calligraphy of successive kings. Gradually, it also came to function as the royal library for storing massive collections of Chinese books, *uigwe*, and other documents. The scholars he enlisted for Kyujanggak included Jeong Yak-yong, Bak Je-ga (1750–1805), Yi Deok-mu (1741–1793), and Yu Deuk-gong (1748–1807), all of whom belonged to the School of Northern Learning.[13] King Jeongjo thus equipped himself with the manpower and scholarly talent to launch the construction of the new city, Hwaseong.

Despite his enormous contribution to the Hwaseong project, Jeong Yak-yong, one of the young scholars most favored by King Jeongjo, is not mentioned in the *Hwaseong uigwe*. The reason for this oversight might have been that just after Jeongjo's death in 1800, Jeong was implicated with Catholicism, which had been banned by the court. In 1801, he was exiled first to Janggi in North Gyeongsang province, and later to Gangjin in South Jeolla province.

A Brief Introduction to the *Hwaseong Uigwe*

The *Hwaseong uigwe* consists of ten volumes, including three addenda, all bound into nine books that record the entire construction project of the Hwaseong Fortress, from January 1794 (Jeongjo 18) to September 1796 (Jeongjo 20).[14] The work on the final version of the *uigwe* began in 1800 under the direction of Jo Sim-tae (1740–1799), who was the head of the Suwon *yusubu*. The work was suspended due to King Jeongjo's untimely death in June 1800, but was resumed in 1801, and in September was published using the *jeongnija* metal type and woodblock illustrations.

According to Ok Young Jung, 154 final copies were printed.[15] Of those, fourteen complete sets survive, eleven in Korea and three abroad.[16] Records show that in 1797 Jeongjo initially ordered that fifteen copies be printed.[17] However, after printing began in early 1800, he asked Yi Man-su (1752–1820) how many copies of the *Jeongni uigwe* were printed, and Yi told him that 130 copies had been printed. Following the precedent of the *Jeongni uigwe*, Jeongjo then ordered that the same number be printed of the *Hwaseong uigwe*.[18]

The eight instruction points of Jeongjo's "Comprehensive Construction Plan" refer to:

1. *Dimensions*: Circumference: 3,600 steps. Height: 2 *jang* 5 *cheok* [Assuming this refers to measurements for construction, where 2 *jang* 5 *cheok* is 25 *yeongjocheok* and a *yeongjocheok* is about 30 centimeters, then the total height is about 750 centimeters.]
2. *Construction material* [Despite considerations of earthen rampart or brick walls, Jeongjo decides that the walls should be made of stone.]
3. *Digging a moat around the walls*: It should be about 3 or 4 *jang* away from the walls with a depth of about 1 *jang* 5 *cheok*.
4. *Preparing the ground*: Creating support for the walls and all the buildings within
5. *Quarrying* [Jeongjo orders the construction stones to be in three or four different sizes for convenience of transport.]

6. *Paving the road*: From the stone quarries to the actual construction site
7. *Making the vehicles for transporting construction materials* [drawings of wooden wheels, axles, vehicle floor, and a complete vehicle built by combining these parts]
8. *Wall profiles*:[19] In order for the fortress wall to be stable, the profile of the length of the entire finished wall should have an inward curve similar to that of a *hol* [or *gyu*] scepter.

The instructions are very concrete and detailed, but we know that not all of them were adhered to in the end since the final composition of the fortress walls is a mixture of brick and stone. Jeongjo must have accepted the suggestions of the scholars of the School of Northern Learning who saw the advantage of the brick-and-stone combinations they had seen in Qing China. There is no moat around the fortress, although floodgates were built inside its walls. The dimensions of the wall also differ from that of the "Comprehensive Plan": the current length is 5.7 kilometers, and the height ranges from 4.9 to 6.2 meters.

The lead volume (*gwon su*) of the *Hwaseong uigwe* begins with a section that lists twelve explanatory notes. Normally a section of explanatory notes is unnecessary, as all *uigwe* follow a set format, but in this case, King Jeongjo wanted to change the format to match that of the *Jeongni uigwe* of 1797.[20] After the explanatory notes is the daily schedule of the construction work, followed by a list of names of officials in charge of each division of construction work, the *uigwe* compilation task, and finally the printing of the *uigwe*. Chae Je-gong (1720–1799), then the prime minister, was appointed superintendent of the *dogam*, and Jo Sim-tae was appointed the Hwaseong *yusu* (head of Hwaseong). The rest of the lead volume, ninety-nine pages, is devoted to woodblock illustrations showing all the structures of the Hwaseong and the mechanical devices employed in its construction. The major illustrations listed below are grouped together by category. What is novel about this *uigwe* is not only its realistic rendering of architectural and mechanical structures, but also its detailed explanation of the construction materials used, as well as the measurements for the structures.

The fortress was nearly destroyed during the Korean War of 1950–1953.[21] Without the *Hwaseong uigwe* and its detailed illustrations, measurements, and records, the formidable task of reconstructing the fortress would have been impossible to accomplish. I will present illustrations from the *Hwaseong uigwe*, juxtaposing some of them with photographs of Hwaseong as it exists today.

The "Complete View of Hwaseong" is shown on two facing pages (see fig. 126) followed by twelve pages of text on its geographical setting and the distance from one structure to another. The total length of the wall is computed as 27,600 *jucheok* (a Zhou dynasty unit of measure), or 4,600 steps. The note further gives us the length of a step being either 6 *jucheok* or 3.8 *yeongjocheok* (a unit of measure for construction). If these figures are computed by metrics on the scale of 1 *jucheok* of about 20 centimeters, or 1 *yeongjocheok* of about 30 centimeters, one step would be about 114–120 centimeters, which is a very wide step. So the total length of the wall would be close to 5 kilometers. The actual length of the reconstructed fortress wall is currently 5.7 kilometers. The text further lists Hwaseong's major gates, hidden gates, floodgates, command posts, and so forth, but the number of structures is not always correct, as in the case of beacon towers; initially the text mentions only one, but later in the book two additional beacon towers are mentioned.

The last page gives us important information on the six quarries that supplied stones for the construction of most of the lower parts of the wall. They were identified as two each at the Sukjisan mountain and Yeogisan mountain, and a fifth in the Gwondong valley. Additionally, Paldalsan mountain also was found to have a stone vein that could be exploited. Apparently, at the beginning it was thought that there were no quarries nearby, and the possibility of all brick walls or mud ramparts were talked about, but then they found the first two quarries within 5 *li* of each other (one *li* equals about 0.4 km). Stone veins hidden under the earth were discovered in those mountains, and they supplied enough stone blocks for the construction — the total from the six quarries was 187,600.[22] As a result, it was possible to construct the walls of stone, brick, and mud, a unique method for that time.

The twelve groups of major structures of Hwaseong Fortress are presented below with illustrations and photographs.

1. The Four Gates: North, South, East, and West

Janganmun, the north gate of the fortress, is the first gate one encounters coming from Hanyang, the capital (fig. 127). It is the largest, most majestic and elaborate structure, as illustrated in "View of Janganmun [the north gate] from Outside" on two facing pages (fig. 128). This view shows the gate's semicircular dual-protection wall in front of the gate, called *ongseong* because of its semicircular shape that resembles half of a large jar.[23] There is also "View of Janganmun [the north gate], from Inside"

on two facing pages (fig. 129). The two Janganmun images are followed by four pages of detailed explanations and measurements of all the parts

FIG. 127 Janganmun,
the north gate of
Hwaseong, 1794
(rebuilt 1975). Suwon,
Gyeonggi province.
Photograph ca. 2022.

that together create the north gate with a two-story gatehouse above the arched gateway.

The three other gates are Paldalmun in the south (which has a structure similar to the north gate), Changnyongmun in the east, and [131] Hwaseomun in the west (fig. 131). A frontal view of the Hwaseomun from [130] outside the fortress is illustrated in *Hwaseong uigwe* (fig. 130).[24]

2. Five Secret Gates

Along the walls are five heavily guarded *ammun* (secret gates), one at each of the four cardinal directions and an additional one on the southwest side, to be used for transporting people and military supplies in and out of the fortress. The most elaborate one is on the southwest side, shown on two pages, with a *posa*, a house-shaped watchtower/guardhouse above the hidden gate where soldiers can watch for enemies or simply relax.

3. Two Floodgates

The water flows down from north to south and out of the fortress through two floodgates that are situated on the north and south of the wall. The north floodgate is called Hwahongmun (Gate of Beautiful Arches) because [134] of the seven arched sluices under the single-story gate house (fig. 134). Two views, one from outside and another from within the fortress, are illustrated on two pages, "View of the North Floodgate from Outside" [132] (fig. 132) and "View of the North Floodgate from Inside."[25] The south floodgate (Namsumun), on the opposite side of the fortress, does not have a fancy name, and was in complete ruin even before the Korean War. Its rebuilding took much longer than other structures and was finally completed in 2002 with all nine floodgates restored along with the guardhouse structure (*posa*) above.[26]

4. Two Hidden Underground Sewers

"View of [South] Hidden Underground Sewers" (*Eungudo*) shows a bridge-like structure under the wall through which the sewage from inside the fortress flows into two well-landscaped ponds below.[27]

5. Two Military Command Posts and Arrow-Shooting Platforms

The West Military Command Post (Seojangdae): From this post, situated on top of Paldalsan mountain, one can see everything in eight directions, that is, 360 degrees. The most prominent structure is the pavilion with a [135] two-story roof (fig. 135). Behind it (in this view, to the left of the post) is a high, arrow-shooting tower platform called a *nodae*. The *uigwe* illustration

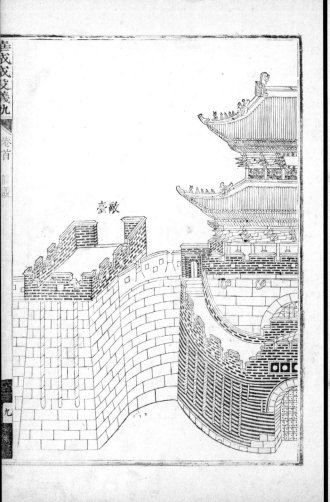

華城城役儀軌

卷首
圖說

十

FIG. 129 "View of Jangan-mun [the north gate], from Inside," from the *Uigwe of the Construction of the Hwaseong Fortress (Hwaseong seongnyeok*

華城城役儀軌

華西門內圖

華西門外圖

卷首 圖說

十七

FIG. 130 "View of
Hwaseomun [the west
gate]," from inside
(left) and from outside
(right), from the *Uigwe*
of the Construction of
the Hwaseong Fortress
*(Hwaseong seongyeok
uigwe)*, 1801. Printed
book, 34 × 21.7 cm.
Kyujanggak Institute for
Korean Studies, Seoul
National University
(Garam go 951.2-H992).

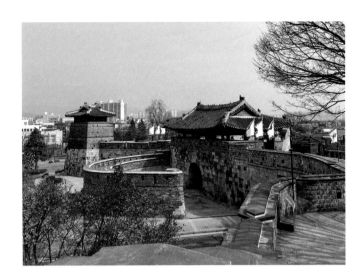

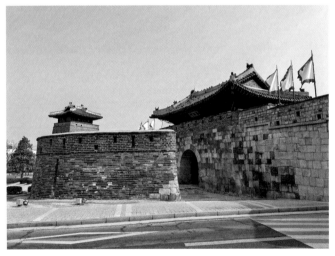

FIG. 131 Hwaseomun, the west gate of Hwaseong, 1796 (repaired 1848 and 1975). Suwon, Gyeonggi province. Photographs, 2023.

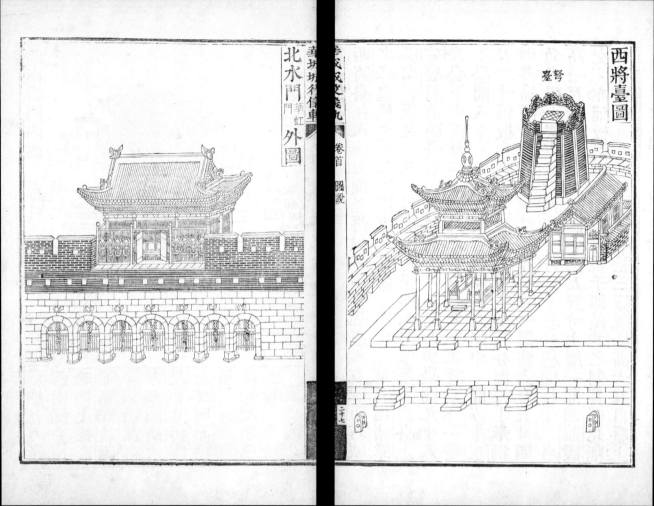

華城城役信車　華虹門　外圖
北水門

華城城役之卷九

卷首　圖說

西將臺圖
臺弩

二十七

FIG. 132 "View of the
North Floodgate from
Outside," from the
*Uigwe of the Construction
of the Hwaseong Fortress
(Hwaseong seongyeok
uigwe)*, 1801. Printed
book, 34 × 21.7 cm.

FIG. 133 "The West Mili-
tary Command Post,
Including the Arrow-
Shooting Terrace," from
the *Uigwe of the Construc-
tion of the Hwaseong For-
tress (Hwaseong seong-
yeok uigwe)*, 1801. Printed

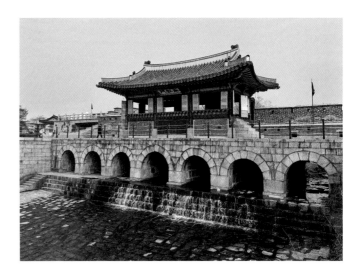

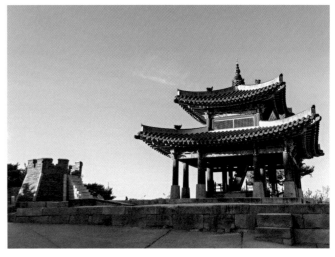

FIG. 134 Hwahongmun, the north floodgate of Hwaseong, 1795 (rebuilt 1848 and 1932). Suwon, Gyeonggi province. Photograph, 2023.

FIG. 135 Seojangdae, the West Military Command Post, including the arrow-shooting terrace, 1794 (rebuilt 1971, repaired 2006). Suwon, Gyeonggi province. Photograph, ca. 1996.

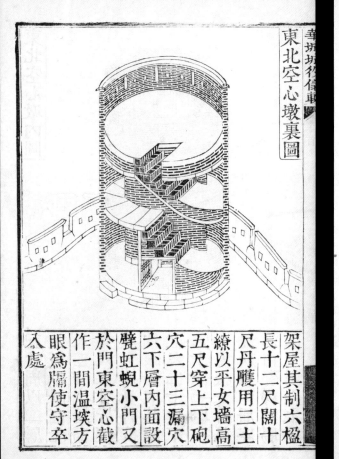

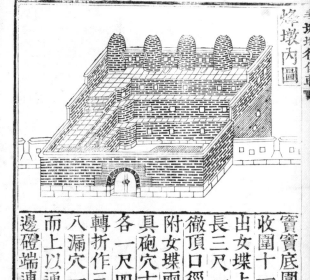

東北空心墩裏圖

架屋其制六楹
長十二尺闊十
尺丹雘用三土
繚以平女墻高
五尺穿上下砲
穴二十三漏穴
六下層內面設
壁虹蜺小門又
於門東空心截
作一間溫堗方
眼爲牖使守卒
入處

烽墩內圖

寶寶底圍各十七尺二寸上
收圍十一尺五寸高十一尺
出女堞上六尺炬口在腰各
長三尺一寸闊一尺五寸上
徹頂口徑一尺五寶之間列
附女堞兩端轉曲向內三面
其砲穴十八下二層甓砲闊
各一尺四寸高三尺三寸亦
轉折作三面甓城穿銃眼十
八漏穴一各方一尺 由左右曲甓
而上以通炬路甓各十層兩
邊甓端連以甓築之屋覆以

FIG. 136 "Interior of the Northeast [Hollow] Observation Tower," from the *Uigwe of the Construction of the Hwaseong Fortress (Hwaseong seongyeok uigwe*

FIG. 137 "View of the Beacon Towers from Inside," from the *Uigwe of the Construction of the Hwaseong Fortress (Hwaseong seongyeok uigwe)*, 1801. Printed

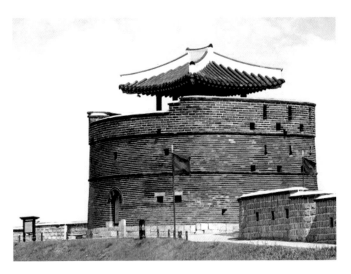

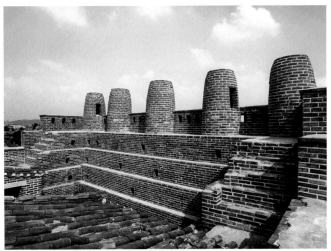

FIG. 138 Northeast [Hollow] Observation Tower of Hwaseong, 1796 (rebuilt 1976). Suwon, Gyeonggi province. Photograph, ca. 2023.

FIG. 139 Beacon towers of Hwaseong, 1796 (repaired 1971). Suwon, Gyeonggi province. Photograph, ca. 2017.

東北角樓內圖

華城城役儀軌

卷首 圖說

東北角樓外圖二

龍淵

三十七

FIG. 140 "View of the
Pavilion of Following
Willows and Searching
for Flowers (Banghwa
suryujeong)," from
inside (left) and from
outside (right), from the

of the Hwaseong Fortress
(Hwaseong seongyeok
uigwe), 1801. Printed
book, 34 × 21.7 cm.
Kyujanggak Institute for
Korean Studies, Seoul
National University

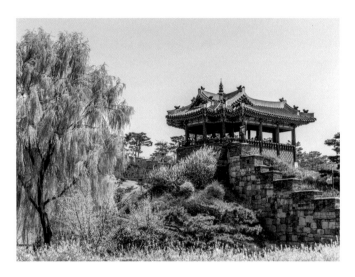

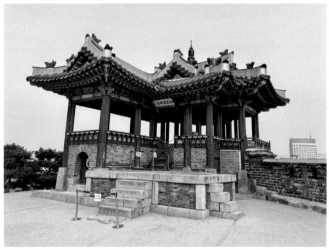

FIG. 141 Pavilion of Following Willows and Searching for Flowers (Banghwa suryujeong), 1794 (repaired 1934). Suwon, Gyeonggi province. Photographs, ca. 2022–2023.

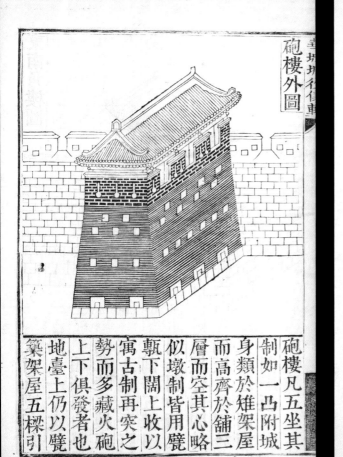
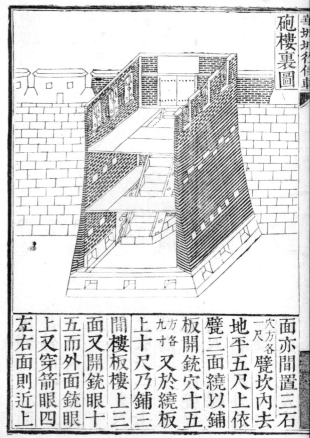

砲樓凡五坐其
制如一凸附城
身類於雉架屋
而高齊於鋪三
層而空其心略
似墩制皆用甓
甕下闊上收以
寓古制再突之
勢而多藏火砲
上下俱發者也
地臺上仍以甓
築架屋五樑引

面亦間置三石
壁坎內去
地平五尺上依
甓三面繞以鋪
板開銃穴十五
又於繞板
上十尺乃鋪三
間樓板樓上三
面又開銃眼十
五而外面銃眼
上又穿箭眼四
左右面則近上

FIG. 142 "Views of the Gun-Firing Tower," from outside (left) and from inside (right), from the *Uigwe of the Construction of the Hwaseong Fortress* (*Hwaseong seongyeok uigwe*), 1801. Printed book, 34 × 21.7 cm. Kyujanggak Institute for Korean Studies, Seoul National University (Garam go 951.2-H992).

(fig. 133) shows the two in an aerial view in which the tower of the arrow-shooting platform is more prominent.

The East Military Command Post (Dongjangdae): This post, situated on top of Seonamsan mountain at the northeast end of Hwaseong, is a strategic command post from which to fire guns. As seen in the *uigwe* illustration, the spacious pavilion for the commander is situated on the high terrace in an enclosed area.[28]

6. *Three [Hollow] Observation/Arrow-Shooting Towers*

The Northwest [Hollow] Observation Tower (Seobuk gongsimdon) and the South [Hollow] Observation Tower (Nam gongsimdon) have a square plan and a pavilion on top. The Northeast [Hollow] Observation Tower (Dongbuk gongsimdon) is built on a circular plan, with two levels of

brick walls topped with a low pavilion (fig. 138). The "hollow" interior is not completely hollow, but partly filled with two tiers of mud floors and spiral staircases for soldiers to move up and down. The interior view of this observation tower is illustrated in the *uigwe* with the title "Dongbuk gongsimdon ido" (Interior of the Northeast [Hollow] Observation Tower)

(fig. 136).[29] These observation towers protected the gates nearby and were built to rise higher than the fortress walls.

7. *Two Beacon Towers*

Of the two beacon towers (*bongdon*), the one illustrated in two views is situated prominently, directly opposite the Seojangdae. Built of bricks on top of a three-tiered terrace, the five large, jar-shaped smoke chimneys have a smoke-spewing spout on top and, on the side, an opening through

which to supply firewood (fig. 139). The *uigwe* illustration of the "Bongdon

naedo" (Beacon Towers from Inside) (fig. 137)[30] approximates the photographic view taken from a similar viewpoint.

8. *Four Corner Sentry Towers*

These pavilion-like sentry towers are situated on the northeast, northwest, southeast, and southwest corners along the wall, hence the name "corner pavilions." The northeast corner sentry is known as the Pavilion of Following Willows and Searching for Flowers (Banghwa suryujeong) after a poem by the Song Neo-Confucian scholar-poet Cheng Hao (1032–1085).[31] The one and only type of this pavilion has its origin in China.[32] At Hwaseong, it is perched on top of Dragon Head Cliff overlooking Dragon Pond. The pavilion has a peculiar plan approximately resembling the character *man* "卍," a motif that has been repeated in the patterns on the doors and balustrades outside. This pavilion is illustrated in three

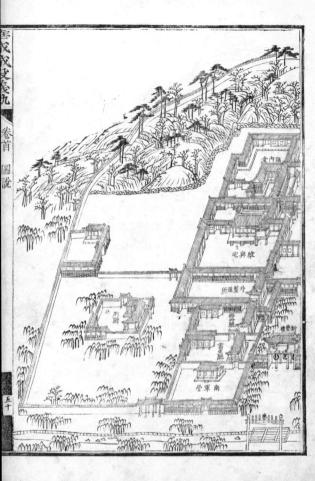
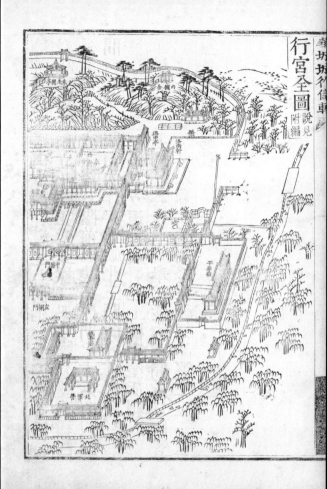

FIG. 143 "Complete View of the Hwaseong Detached Palace," from the *Uigwe of the Construction of the*

separate views: two views from outside the fortress (one close-up view, not illustrated here, the other, a view that includes the Dragon Pond [fig. 140, left])[33] and a third, from within the pavilion which shows a platform and stairs to approach the pavilion (fig. 140, right).[34] For comparison with a similar photographic image of the pavilion see figure 141, top. The very imposing third illustration of the pavilion from within is also compared with a photographic image of it (fig. 141, bottom).

[140]

[141]

9. Five Gun-Firing Towers

These pavilion-like towers (*poru*) are situated along the wall of the fortress at the northeast, northwest, west, south, and east sides, and their shapes and structures are all alike. Three views of these towers are illustrated to show a clear picture of the structures from outside and inside the fortress, as well as one showing the interior of the tower that resembles the interior of the observation towers with hollow interiors. The first and third illustrations are shown here in one figure (fig. 142).[35] The tower was built of brick on a stone foundation and roofed with tiles, just like an upper-class Joseon-period house. Entry was from inside the wall, the elevation of which matches that of the battlement of the fortress. Along the wall on three levels are fifteen rectangular "portholes" from which to fire guns.

[142]

10. Eight Turrets

Turrets open to the sky can be seen all along the wall from the outside. They are rectangular in plan and protrude a short distance from the fortress wall. Soldiers used them as lookouts to watch for approaching enemies. The Korean term for turret is *chiseong*, "pheasant wall," a reference to pheasants who can hide themselves well.

11. Shrine of the Fortress God

The walled Shrine of the Fortress God (Spirit) (Seongsinsa) was built below the protective screenlike rocky surface and protrudes a short distance from Paldalsan mountain. The front entrance to the walled compound consists of a three-door structure with two additional wings that are used as service spaces for sacrificial offerings. The main shrine inside the compound is a three-*gan* structure with the spirit chamber in the middle part; a *gan* is equivalent to 1.88 square meters.[36]

12. The Detached Palace

An overall view of the Detached Palace (*haenggung jeondo*)[37] within the Hwaseong Fortress is illustrated on two facing pages (fig. 143).[38] The major

[143]

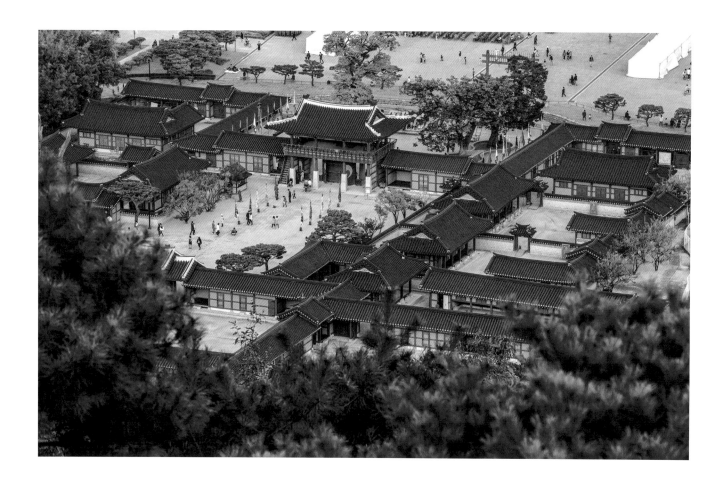

FIG. 144 Hwaseong Detached Palace, 1796 (rebuilt 2003). Suwon, Gyeonggi province. Photograph, 2017.

buildings featured prominently in King Jeongjo's visit to Hwaseong are:

- Bongsudang (Hall of Revering Longevity)
- Jangnakdang (Hall of Lasting Pleasure)
- Gyeongnyonggwan (House of the Great Dragon [i.e., the king])
- Bongnaedang (Hall of Incoming Happiness)
- Yuyeotaek (House of Togetherness)
- Nangnamheon (Southern House — from Hanyang)
- Noraedang (Hall of Approaching Old Age)
- Deukjungjeong (Pavilion of Moderation)
- Sinpungnu (Gate of New Abundance)

[144] A photograph of the detached palace (fig. 144) shows the view from the opposite side as the illustration. Outside the fortress's walls are:

- Sajikdan (altar to perform sacrificial rites to the spirits of earth and grain)
- Munseonwangmyo (Shrine of Confucius)
- Yeonghwajeong (Pavilion of Welcoming Beautiful Scenery), built over the reservoir
- Manseokgeo (reservoir for watering a rice field producing at least 10,000 *seok* of rice [1 *seok* equals 144 kg])
- Yeonghwayeok (Yeonghwa Horse Station), which is situated not far from the Janganmun gate. Also called Yeokgwan (Horse Station House) because it houses the families of grooms and soldiers.

The Illustrated Parts of the Fortress's Structure

There are thirteen pages of drawings that show several parts of the fortress walls.[39] The first one shows a outward curve of the profile of the entire fortress wall and notes, "the mass of the fortress wall is similar to [145] that of a *gyu*" 圭 (fig. 145).[40] A *gyu* is a long piece of jade or ivory which is oblong at the bottom but gradually tapers to a flat end at the top; it is held [146] by kings and queens (fig. 146).

Because the construction of the fortress required so many bricks, it was imperative to build brick-firing kilns (*byeogyo*) nearby. Three such kilns were built, one each in Gwangju, Wangnyun, and Seobongdong.[41] The *uigwe* has two pages of drawings showing the shape and structure of the interior of the kiln, as well as the methods of loading bricks into it.[42] These drawings are followed by detailed explanations of the

FIG. 145 "Profiles of the Fortress Wall," showing the inward curve of the wall profile resembling the character *gyu* (right), from the *Uigwe of the Construction of* (*Hwaseong seongyeok uigwe*), 1801. Printed book, 34 × 21.7 cm. Kyujanggak Institute for Korean Studies, Seoul National University (Garam go 951.2-H992).

shape, structure, dimensions, and loading and firing methods learned from the Chinese text *Tiangong kaiwu* (Compendium of Science and Technology).[43]

[147] In figure 147 we see, on the right, an overall view of the load-bearing machine (*geojunggi jeondo*) and, on the left, its individual parts (*bundo*). This machine utilized pulleys of three different sizes and was capable of lifting stone blocks of enormous weight. Approximately 4.5 meters high, it was operated by thirty men and enabled each man to lift a total load of 400 *geun* (1 *geun* = 0.6 kg), or approximately 240 kilograms.

[148] Similarly, figure 148 shows, on the right, an overall view of another load-bearing device (*nongno jeondo*) and, on the left, its individual parts (*bundo*). This simpler device, which is operated by four men on either side, also lifts heavy blocks by means of pulleys, but by allowing the rope tied to the load to be pulled from two sides, it has the advantage of controlling the direction of the final position of the load.

Eight large vehicles (*daegeo*) were employed to transport the heaviest stones to the construction site, each pulled by forty bulls. Seventeen smaller vehicles (*pyeonggeo*) were used to transport lumber with a team of no more than ten bulls. Though smaller than *daegeo*, *pyeonggeo* were similar in shape. To transport lighter loads like small boulders or stones, vehicles or carts called *balcha* were used. The *balcha* usually served as the lead vehicle in a transport line of construction materials. Constructed with two wheels cut from a whole tree trunk, each *balcha* was pulled by a bull. Additionally, 192 children's carts (*dongcha*) were used as transport vehicles. *Dongcha* had four wheels but were much smaller than the lead vehicle and could be either pulled or pushed by men. Horses were also used in transport, and eight pony boards (*gupan*) are illustrated. They were composed of two wood planks tied together at one end, to be pulled on two round logs placed on the ground parallel to each other. Finally, nine boat-shaped wooden sleds (*seolma*) were pulled from one end. Nineteen drawings of various other smaller parts, tools, and devices complete the section on machinery used for the construction of the fortress.

The sheer volume of the visual and textual information on the construction of Hwaseong cannot be compared with any *uigwe* before or after. One might expect to find at least some of these machines, devices, and vehicles in other *uigwe* of the construction of palace buildings or royal tombs, but after the time of King Jeongjo we find only two drawings of pulleys, included in the *Uigwe of the Construction of King Jeongjo's Tomb*, that are similar to the one found in the *Hwaseong uigwe*.[44]

FIG. 146 Jade *gyu*, ca. 19th century. Jade, 14.4 × 6 cm. National Palace Museum of Korea (Uisang 424).

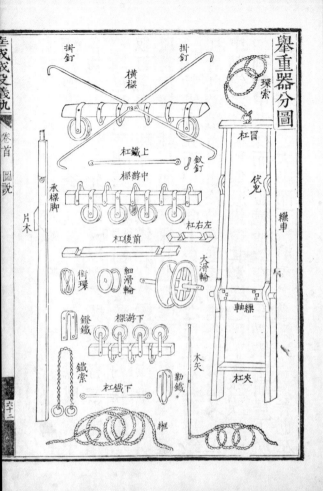

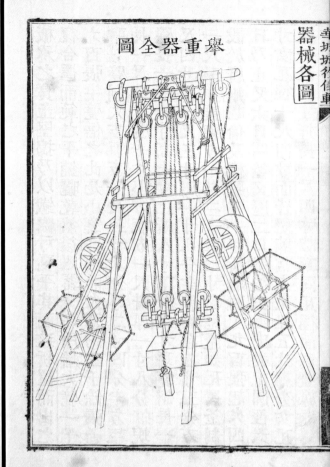

FIG. 147 Complex load–
lifting machine (right)
and its components
(left), from the *Uigwe
of the Construction of
the Hwaseong Fortress
(Hwaseong seongyeok
uigwe)*, 1801. Printed

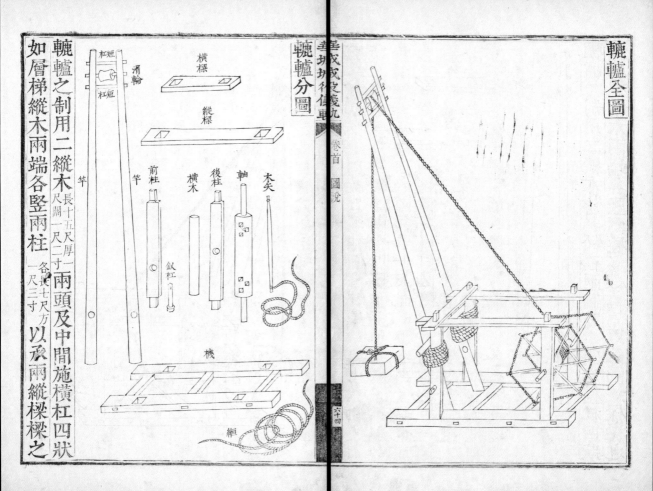

轆轤分圖

華城城役儀軌九

卷首 圖說

六十四

轆轤之制用二縱木 長十五尺厚一寸 關一尺二寸 兩頭及中間施橫杠四狀

如層梯縱木兩端各竪兩柱 各長七尺方 一尺三寸 以承兩縱樑樑之

橫樑
縱樑
竿
竿
前柱
後柱
軸
木矢
横木
釱杠
杠短
滑輪
杠短
械
緪

FIG. 148 Simple load–lifting machine (right) and its components (left), from the *Uigwe of the Construction of the Hwaseong Fortress (Hwaseong seongyeok uigwe)*, 1801. Printed

Other Important Items Recorded in the *Hwaseong Uigwe*

Volume 2

In volume 2 are recorded eight of King Jeongjo's own literary composi-
tions (*eoje*), such as memorial texts and poems. Altogether, twenty-three
occasions of the royal bestowal of food (*bansa*) and wine (*hogwe*) for all
levels of workers were recorded in detail. Some cash was also given out.
As outlined in the "Award Regulations" (*sangjeon*) section, the amount
and kind of award varies depending on the contribution one made to the
project.[45] For example, Chae Je-gong, the superintendent of the *dogam*,
was awarded the pelt of a large tiger; Jo Sim-tae received an elevation
of official rank; and another official received one horse. Artisans mostly
received bushels of rice or bolts of cotton, and court scribes, among them
Bak Jae-in and Yi Suk-cheol, were elevated in social status, from lowborn
(*cheonmin*) to freeborn (good people [*yangmin*]), in accordance with their
wishes. That topic will be discussed more thoroughly in chapter 10.

The "Protocol" (*uiju*) section details the step-by-step procedures of
the six rites performed during the construction of Hwaseong:[46]

- Announcement to the spirits of breaking ground for the
 construction (*gaegi goyujeui*)
- Placement of the largest crossbeam of wooden buildings with
 a written prayer of dedication (*sangnyangmun bongan jeui*)
- Announcement of the king's bestowal of food and wine one day
 before the actual distribution of food and wine (*daehogweui*)
- The first sacrificial rite at the Shrine of the Fortress God (Spirit)
 at Hwaseong (*Seongsinsa bongan jeui*)
- Military exercises presided over by the king at the Seojangdae
 command post of Hwaseong (*chinim Seojangdae seongjosik*)
- Nighttime military exercise (*yajo sik*)

New Tasks Required for the Defense of Hwaseong[47] Once Hwaseong was
built, the following aspects were to be emphasized in its defense:

- Reconnaissance and vigils in all directions
- Hourly communications by signal exchange among the guards
 along the fortress wall
- Elevated degree of alert at the time of the king's visit by signal
 exchange among the guards inside and outside the fortress wall
- Constant drills to maintain the military skills of soldiers
 and guards

- List of arms and insignia needed (two large guns, two power-ful canons, two small guns, and flags of white, blue, red, and black, etc.)
- Report by signaling with guns and beacons
- Number of generals and soldiers needed for day and night watch
- Regulations on the defense at the gun posts

By citing ancient Chinese precedents of the Han and Tang dynasties about guarding imperial tombs, it is suggested that Hwaseong should be designated as a city "second to the capital" (*yusubu*).[48]

Setting Up the Fortress Repair Fund and Method of Payment This section begins with a preamble by Jeongjo in which he expounds on the importance of Hwaseong for guarding his father's nearby tomb as well as the detached palace. Therefore, it was imperative that the fortress and its buildings be maintained in top condition. The instructions for collecting revenue for this task are spelled out in a list of twenty-one points.[49]

Three Categories of Literary Writing Volume 2 ends with literary pieces by King Jeongjo and other men of letters that can be classified into three categories:[50]

1. *Goyumun* (thirteen texts of announcement [to spirits]): On occasions of groundbreaking rites and one prayer text for spring and autumn sacrificial rites at the Shrine of the [Hwaseong] Fortress God (Spirit) (Seongsinsa).
2. *Sangnyangmun* (eleven texts written for the occasion of placing the most important crossbeam of a building):[51] In addition to the date of the beam's placement, *sangnyangmun* also include descriptions of the surrounding scenery, activities around the building, and, most importantly, wishes for an auspicious future and the prosperity of the building.

 The list begins with the four principal gates of Hwaseong (Janganmun, Paldalmun, Changnyongmun, Hwaseomun), followed by Hwahongmun, Seojangdae, and other pavilions and lesser wooden buildings. Each piece is rather long, and at the end of each piece is recorded the name and the official position of the composer and calligrapher. For example, the first one for Janganmun was composed and written by Hong Yang-ho (1724–1802), then the chief academician (*daejehak*). The *sangnyangmun* for Paldalmun was composed by Yi Myeong-sik

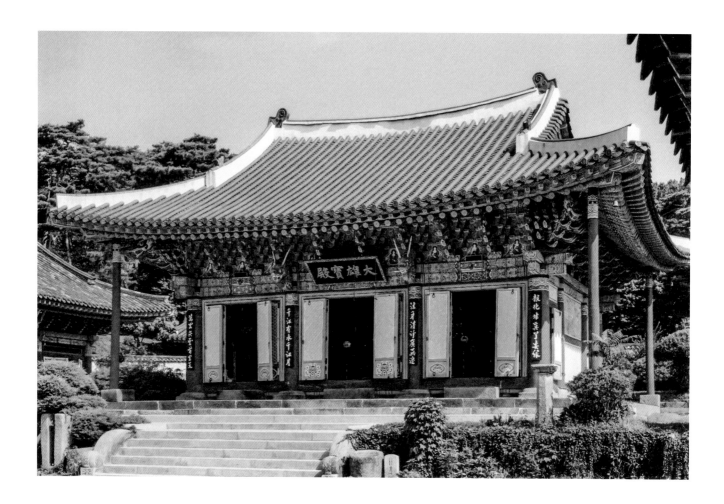

FIG. 149 Yongjusa
temple, 1790. Hwaseong,
Gyeonggi province.
Photograph, ca. 1990s.

(1720–1800), then minister of defense and head of the Privy Council, and written by Yi Myeon-eung (1746–1812), the then-governor of Gaeseong.

3. *Bimun* (text for stele): Hwaseong gijeokbi, the stele memorializing the construction of Hwaseong, is the only item listed under this heading. The text (discussed earlier in this chapter) was composed by Kim Jong-su (1728–1799), the chief academician and minister of the right.

The whole of volume 2 is not only a succinct history of the Hwaseong construction, but is also a rare and valuable collection of literary pieces by men of letters of the period, beginning with King Jeongjo's own writings.

Volumes 3 and 4

Volumes 3 and 4 contain all the written reports to the king, documents that were exchanged from one office to another concerning the logistics of supplying materials for construction, new recruiting of necessary manpower, and the regulations for payments. The format and styles of these documents are the same as those found in other *uigwe*, but here they tend to be more detailed.

Special attention should be given to the "List of All Artisans" (*gong-jang*), in which were recorded the names of 1,807 artisans, listed by their trade along with their hometown and the number of days of their service.[52] For example, included are 646 stonemasons, 335 carpenters, 295 plasterers, 150 brickmakers, 83 blacksmiths, 62 sawyers, 48 lacquer workers, 46 painters, and 36 sculptors, to mention the most important crafts and trades listed. In terms of information provided on each artisan, this is by far the most detailed record of all Joseon dynasty *uigwe* documents. Within the same trade, listed first are the artisans from the capital who worked the most number of days. Among the masons, Han Si-ung, who was from the capital and worked for 782 days at various locations within Hwaseong, is named first. Of the 46 painters, Eom Chi-uk is named first, having served for 342 days. He is the only one whose landscape paintings are known today.

It is worth noting that forty of the painters named are Buddhist monks. Among Joseon monarchs, King Jeongjo is well known for his patronage of Buddhism and Buddhist art.[53] (The construction in 1790 of Yongjusa temple [fig. 149] as the patron temple for his father's tomb was mentioned in chapter 7.) The role of these monk-painters in the construction of Hwaseong is not spelled out in the *uigwe*. However, in the section "List of New Tasks for Defense of Hwaseong" in volume 2, it is noted that

[149]

TABLE 8.1 Screen Paintings and Scrolls of Hwaseong Fortress, from the *Hwaseong Uigwe*, 1801

FUNCTION/LOCATION	TITLE/SUBJECT	MEDIUM	QUANTITY/SIZE	COST (IN CASH)
For use in the main palace (*naeip*) at Hanyang	Complete View of Hwaseong (screen)	silk	2 large	150
For use in the detached palace	Eight Spring and Autumn Scenes of Hwaseong (screen)	silk	2 medium	50
For distribution among high officials (*bansa*)[1]	Complete View of Hwaseong (screen)	silk	6 large	100
For distribution to local defense officials (*yusubu*)	Complete View of Hwaseong (screen)	paper and silk	2 large	30
For distribution to lower-level superintendency (*dogam*) officers	Complete View of Hwaseong (scroll)	paper	30 medium	5
TOTAL NUMBERS			12 screens, 30 scrolls	1,210

1 Specifically, Chae Je-gong and five others who are chiefs of various sections in the *dogam*.

the monks are sometimes more skilled in the defense of the fortress than the soldiers; therefore, monks from Yongjusa could have been assigned to the defense of areas outside the fortress.[54] We may recall that Buddhist monks were also mobilized at the time of King Injo's funeral in 1649 to carry Injo's large funeral palanquin to the royal tomb site at Paju.[55]

Volumes 5 and 6
Included under the heading "Finance and Expenditure" (*jaeyong*) in volume 5 is the section "Plan and Preparation" (*jobi*), which lists the quantity and price of grains (rice, bean, millet, barley, etc.), and the quantity, size, and price of each type of construction material (lumber, metal goods, clay tiles, and bricks), as well as charcoal, lime powder, and *danhwak* (pigments for the colorful decoration of wooden architecture). Also listed for the construction are other items, such as paper (and brush and ink sticks), miscellaneous materials, such as hemp, straw mats, straws, glues (from fish or cereal), animal skins and fur (horse, dog, pig), utensils, and machinery such as load-bearing devices (illustrated in volume 1).

The first two sections in both volumes 5 and 6 disclose amazing details about finance and expenditure (*jaeyong*). In the first section, budget sources (*guhoek*) and additional unforeseen costs disclose the many different places where funds were found, such as administrative centers from all over the country, that King Jeongjo used for the construction of Hwaseong. In the second section, actual expenditures (*sirip*) are recorded under four separate headings: (1) cost of the twenty-four construction sites; (2) cost of twenty-one items hard to assign to a particular construction site; (3) cost of ten items that were not considered normal for fortress construction; and (4) the price of the volume of grain exchanged among local administrative offices.

TABLE 8.1

Important information on the production of screen and scroll paintings can also be found in volumes 5 and 6, which is summarized in table 8.1.[56] With the contents of this table, let us examine two screen paintings, now in the National Museum of Korea, that depict the overall view of Hwaseong and its surrounding areas.

[150]

The first one is the *Complete View of Hwaseong* on six panels (fig. 150), each measuring 178.4 × 62.4 centimeters, which was displayed in public only in 2016, at a special exhibition mounted by the National Museum of Korea called *Misul sok dosi, dosi sok misul* (The City in Art, Art in the City).[57] According to the catalogue entry written by Yi Su-mi, this screen was likely produced just after the completion of the fortress, since King Jeongjo's shrine Hwanyeongjeon, which was built in 1801 after his death in 1800, is not shown.[58] Also, the fact that this screen is on silk makes

FIG. 150 *Complete View of Hwaseong*, ca. 1796. Six-panel screen; ink and color on silk, each panel 178.4 × 62.4 cm. National Museum of Korea (Bongwan 8937).

FIG. 151 *Complete View of Hwaseong,* ca. early 1800s. Twelve-panel screen; ink and color on paper, each panel 165.3 × 37 cm. National Museum of Korea (Bongwan 10969).

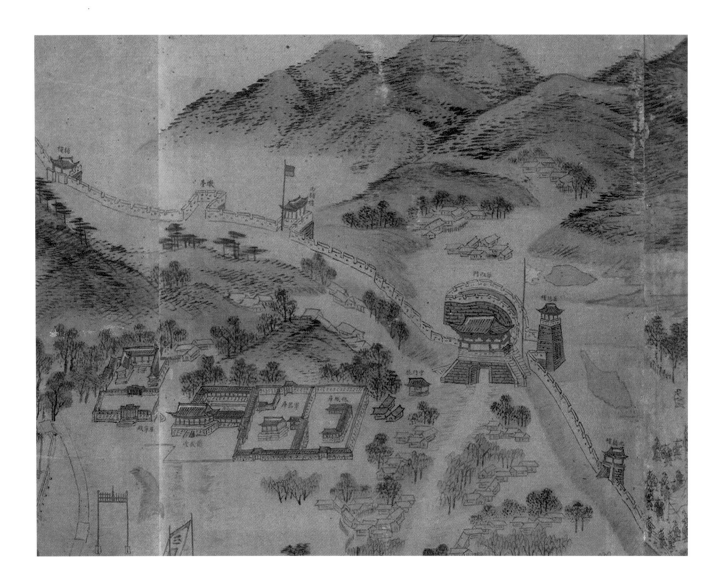

FIG. 152 Detail of panels
4–6 of *Complete View of
Hwaseong* (fig. 151) with
King Jeongjo's shrine
(Hwanyeongjeon), built
in 1801, and showing
the Agyangnu tower
adjacent to the Hwaseo-
mun gate.

it a plausible candidate for the palace screen recorded in the *Hwaseong uigwe*. Therefore, its date could be just after the completion of the fortress in 1796.

[151] The second screen is the *Complete View of Hwaseong*[59] on twelve panels, each measuring 165.3 × 37 centimeters (fig. 151). Here, all the important buildings in the fortress are identified by names inscribed with *hanja* characters.[60] Again, if we look for clues to dating, Jeongjo's shrine Hwanyeongjeon, built in 1801 and identified by inscription, can be spotted just outside the detached palace on the right side. We see the shrine preceded by the tall red Hongsalmun gate, indicating that this is [152] a spiritual realm (fig. 152).

Some of the identifying inscriptions, however, make one wonder when the buildings began to be called by their names. The northwest [152] observation tower (Seobuk gongsimdon; fig. 152), which guards the Hwaseomun gate, is identified as Agyangnu (Ch. Yueyang lou), which is a famous Chinese pavilion in Yueyang, Hubei province. The pavilion is known for its beautiful view over Lake Dongting, and literary works composed by famous poets since the Tang dynasty — Li Bo (701–762) and Du Fu (712–777), among others — have memorialized the beauty of the pavilion and the lake. Another observation tower, Dongbuk gongsimdon, famous for its hollow cylindrical interior with spiral staircases, is identified as Soraru (Pavilion of Conch Shell), referring to both its interior and exterior structures. Normally the word *sora* is not written in Chinese characters, but here the characters were borrowed for their pronunciation regardless of their meanings.[61]

On panels 7 and 8, just outside the Janganmun gate, we see a royal retinue, identified by the yellow flag with red flaming borders (*gyoryonggi*) that presumably represents the 1795 trip to Hwaseong undertaken by King Jeongjo and his mother, Lady Hyegyeong, though it is unclear in what direction the procession is heading. Certain motifs were borrowed from the screen painting of that famous 1795 trip, such as the tent that is partly hidden by drapes, presumably for Lady Hyegyeong's privacy. It bears only a faint resemblance, however, as the 1795 screen shows the scene of her midday snack in greater detail. Judging from these incorrect depictions and identifying inscriptions, it seems certain that the screen painting was made after 1801, if not later.

The last section of volume 6 contains a detailed list of articles in stock that total 12,926.2 *ryang* in cash value. These articles include masonry, lumber, metal goods, charcoal, roof tiles and bricks, pigments, construction machinery, and so forth. This formidable list of expenditure concludes the main part of the *Hwaseong uigwe*.

Addenda Volumes

Volume 6 of the *Hwaseong uigwe* is followed by three addenda volumes (*bupyeon*) that record the construction of the various buildings of the detached palace (*haenggung*) within the Hwaseong Fortress, King Jeongjo's "home away from home."

At the beginning of the first addendum volume, it is stated that many of the buildings of the Hwaseong Detached Palace were built in 1789 (Jeongjo 13) and used as the administrative office of Suwon city. However, in 1794 covered walks (*haenggak*) were added to Bongsudang hall and other buildings. Also, the hall, formerly called Jangnamheon, was renamed as Bongsudang.[62] Many more details about the additions to existing structures were enumerated. This volume has no illustrations, as all the illustrations were included in the so-called lead volume.[63]

The second addendum volume is a collection of documents beginning with King Jeongjo's orders, discussions, letters to the king, poems by the king followed by rhyming poems by officials, five occasions of King Jeongjo's archery events, and many other documents related to the building of the Detached Palace. The last three documents are orders from the higher office to the lower offices, and two of them are about the postponement of the celebration party for the completion of the Detached Palace.

The third addendum volume is the record of the actual expenditures for all of the work recorded in the first and second addenda volumes, ending with a section showing the total expenses recorded in the main part and the addenda:

- 860,698.02 *ryang* (in cash)
- 1,495.114 *seok* (in rice)
- 13,170.6818 *seok* (in other cereals collected at the provincial level)
- 12,926.2 *ryang* (in goods in stock)[64]

Conclusions

The *Hwaseong uigwe* has the most detailed records — not only of construction, but also of all other categories — of any *uigwe* published during the Joseon dynasty. No other *uigwe*, before or since, matches it in terms of concreteness of information, the number of illustrations and literary compositions by the king and his subjects, information on workers and the pay they received, and the cost of the materials that were used to build the fortress, the detached palace, and other buildings associated with it. King Jeongjo's personal filial piety, his humane attitude toward

his people, his political will in solidifying military control, and his authority as ruler, as seen through the *Hwaseong uigwe* and the *Jeongni uigwe*, have been the subject of many books and articles by historians.[65] The *Hwaseong uigwe* has made an unparalleled contribution to our understanding of the Joseon dynasty's record-keeping practice.

Recognized as an architectural monument with "outstanding universal value," the Hwaseong Fortress was named a UNESCO World Heritage Site in 1997. The *Hwaseong uigwe*, with its incredibly detailed illustrations and records, made possible the restoration of the fortress to its original state after its total destruction in the Korean War. The documentary evidence commissioned by King Jeongjo was also instrumental in bringing back to life the tangible cultural heritage of one of the most important architectural structures of the late Joseon, a remarkable legacy.[66] ◆

Uigwe
and Art
History
—
PART THREE

CHAPTER NINE

Polychrome Screen Paintings for Joseon Palaces

This chapter is devoted to a large number of polychrome screen paintings that were made in connection with various state events of the late Joseon period. The term *polychrome* is adopted here to designate multicolored paintings as opposed to ink monochrome paintings. They will be examined in the context of *uigwe* documents of several categories, such as royal weddings, funerals, state banquets, and others, as the *uigwe* specifies how the screen paintings were produced and used.

Until recently, art historians classified the Joseon-period polychrome screen paintings as either *minhwa*, meaning "folk painting,"[1] or "palace decorative painting."[2] However, recent research on *uigwe* has revealed that they were not simply decorative but had a more solemn role as they adorned the surroundings of the members of the royal family in events of the utmost formality.[3] Therefore, when we characterize the function or role of painted screens in the palace, it is preferable to use the term *jangeom*, meaning to solemnly adorn in a sacred sense, rather than *jangsik*, meaning simply to decorate. In Buddhist art, the term *jangeom* is used to denote *sarira* containers and utensils collectively as *sari jangeomgu* because they not only protect the *sarira*, but also solemnly adorn what is inside the containers.[4] Therefore we will set aside recent lively discussions on the issue of "court style" versus "folk style" screen paintings, mostly devoted to the theme of *munbangdo* (scholar's paraphernalia), also called *chaekgado* (bookcase painting),[5] and instead concentrate on the palace screen paintings produced in the context of state rites.

In this chapter, the Joseon-period palace screens are grouped together according to the person for whom they were used in various state rites. Additional information on palace screens can be found in the *Veritable Records of the Joseon Dynasty, Diaries of the Royal Secretariat.* Information on the period after King Jeongjo's reign (1776–1800) can be found in *Naegak illyeok* (*Daily Calendar of the Kyujanggak*). The collected writings of Goryeo and Joseon literati as well as the Chinese Classics also shed light onto our understanding of the subject matters of royal

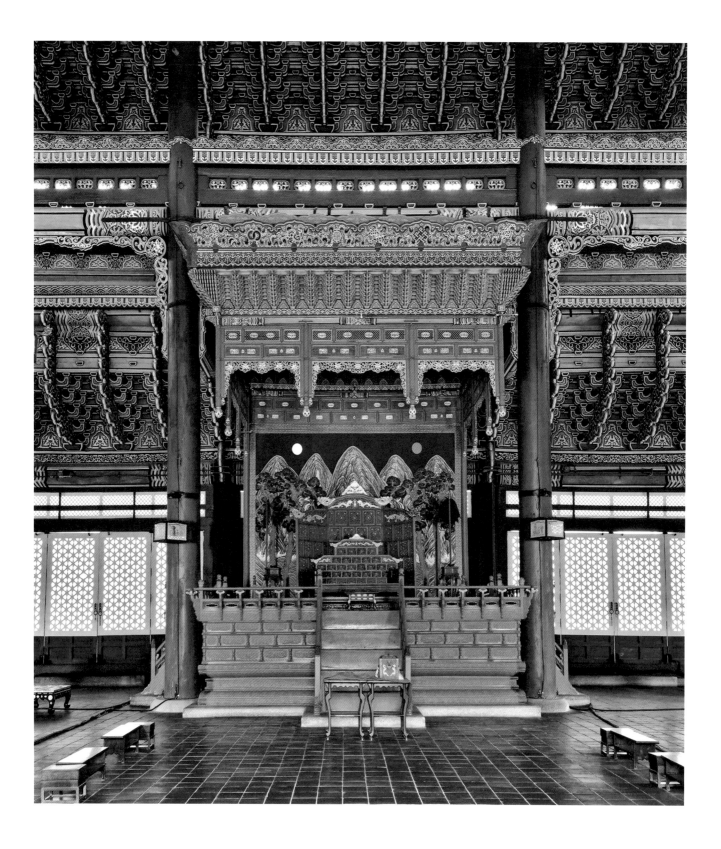

screen paintings. Therefore, whenever necessary we will consult those primary sources.

Screen Paintings for the King

One of the most important findings of *uigwe* research was that a painted screen's designated placement in a state rite is strictly defined by its subject. The Five Peaks screen (*obongbyeong*) and the Peacock screen (*gongjakbyeong*) were used only as a backdrop behind the king's throne or seat. The Peonies screen (*moranbyeong*), on the other hand, was mostly used for the presence of female members of the royal family, but also a king in a coffin room and in portrait halls. The screen of Sea and Peaches of Immortality (*haebando dobyeong*) is also found among those used for

TABLE 9.1 royal portraits. Table 9.1 shows screens used as the backdrops behind the throne and other royal seats, behind royal portraits, and behind coffins at royal funeral rites. Each will be examined in more detail.

Five Peaks Screens
This screen is always placed behind the throne, behind royal portraits, or in the coffin hall, as well as in the spirit tablet hall of the palace.[6] Shown here is the view of the decorative canopy or *dangga* with a Five Peaks screen in the Geunjeongjeon (main throne hall) of Gyeongbok Palace

[153] (fig. 153). Although the coffin hall and spirit tablet hall in the palace have not been preserved, we have learned about the use of this screen with royal portraits from the nine royal portrait-related *uigwe* in existence.[7] In essence, the Five Peaks screen protects the king, living or dead, while also symbolizing the king's presence in paintings that show his place in banquets or other scenes without actually depicting his image.[8]

An early Joseon-period use of the Five Peaks screen placed behind a portable throne can be seen in "Martial Arts Performance at Seochongdae

[154] Terrace" ("Myeongmyojo Seochongdae siyedo"), an album leaf (fig. 154) that depicts an archery event at Changdeok Palace in 1560 under King Myeongjong (r. 1546–1567). The painting is the third leaf of an album called *The Uiryeong Nam Family Heritage Painting Album* (*Uiryeong Namssi gajeon hwacheop*). On the basis of the style of the depiction of the mountain peaks with choppy strokes, which was in vogue in the mid-sixteenth century, Park Jeong-hye considered it to be a work of the mid-sixteenth century.[9] However, in this painting, the screen behind the throne is so faintly visible that the characteristic features of a Five Peaks screen are barely apparent.[10] Another version of the same painting is the seventh leaf of an album with the title *To Be Handled with Respect So As Not to Inflict*

[155] *Damage* (*Gyeong i mulhwe*) (fig. 155), which is now in the National Palace

FIG. 153 Royal throne with Five Peaks screen, Geunjeongjeon throne hall, Gyeongbok Palace, 1395 (rebuilt 1867). Seoul. Photograph ca. 2022.

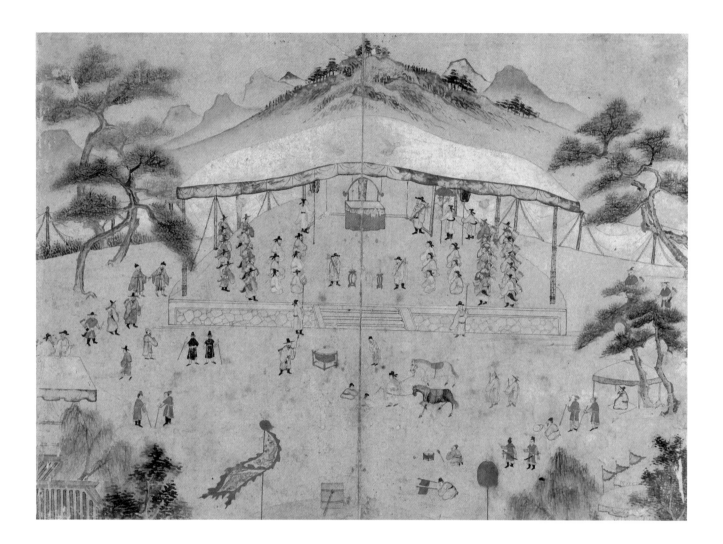

FIG. 154 "Martial Arts
Performance at Seo-
chongdae Terrace."
Third leaf from the
album *The Uiryeong Nam
Family Heritage Painting
(Uiryeong Namssi gajeon
hwacheop)*, 18th century.
Ink and color on paper,
42.6 × 52.3 cm. Hongik
University Museum.

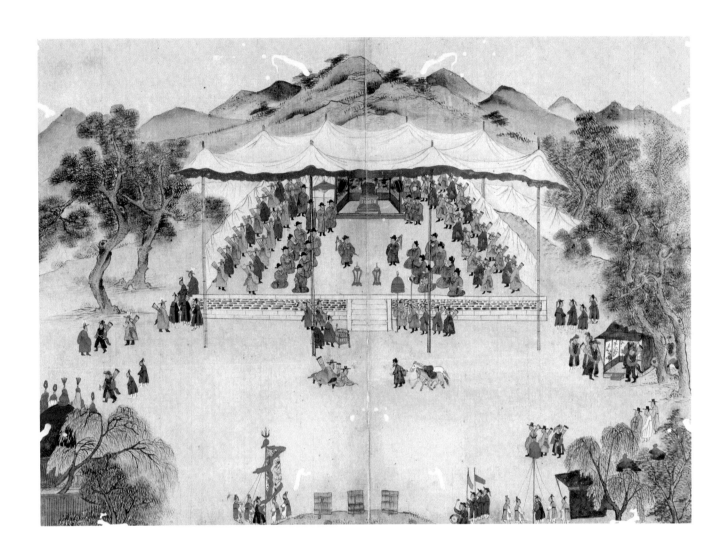

FIG. 155 "Martial Arts Performance at Seo-chongdae Terrace." Seventh leaf from the album *To Be Handled with Respect So As Not to Inflict Damage (Gyeong i mulhwe)*, 19th century. Ink and color on paper, 42.8 × 59.3 cm. National Palace Museum of Korea.

TABLE 9.1 Screen Paintings for the King

SUBJECT	LOCATION/VENUE	FORMAT
Five Peaks (*obongbyeong*)	Behind the throne in the throne hall Behind other royal seats at court events Behind the royal portrait	Large one-panel screen, eight-panel screen, four-panel screen Pair of narrow one-panel screens Screen on stand
Sea and Peaches of Immortality (*haebando dobyeong*)	Perhaps behind the royal portrait niche	Pair of four-panel screens
Peacocks (*gongjakbyeong*)	Behind the royal seat at court events	One-panel screen on stand (originally a hanging scroll?)
Peonies (*moranbyeong*)	Behind the royal coffin before burial Behind the royal portrait	Four-panel screen, eight-panel screen
Plum Blossoms (*maehwabyeong*)	Inside the royal portrait hall	Four-panel screen

Museum of Korea. In this version, one can clearly see the Five Peaks screen under the royal canopy behind the small portable throne. Scholars agree that, on the basis of stylistic grounds, especially the use of a quasi-one-point perspective in depicting the receding space under the canopy, this painting likely dates as late as the nineteenth century,[11] but suggests an early use of a Five Peaks screen behind the throne.[12]

Although the *uigwe* on palace banquets before 1795 did not record any use of the screens, there remain several art works that depict palace banquets of the eighteenth century that used the Five Peaks screen.[13] One can see such a screen in a securely datable album of painting that depicts the banquet celebrating the thirtieth anniversary of King Sukjong's ascension to the throne in 1706, titled *Jinyeon docheop*.[14] This album, now in the National Central Library of Korea, depicts the banquet scene held in the Injeongjeon hall of Changdeok Palace. A detail of the upper part shows the king's presence in the form of an empty royal seat at the center, behind [156] which there is a Five Peaks screen clearly visible (fig. 156). Another mid-eighteenth-century example would be the *Album of Paintings and Calligraphy Celebrating King Yeongjo's Entry into the Club of Elders* (*Gisa gyeonghoecheop*) of 1744–1745. The leaf called "King's Visit to Yeongsugak Pavilion" (*Yeong-sugak chinimdo*)[15] shows a Five Peaks screen behind an empty red chair, [157] which signifies the presence of the king (fig. 157).

In the three examples above, we have seen that the Five Peaks screen is a "must-have" furnishing behind the king's seat in palace banquets and other events prior to 1795. It is no surprise then that in the nine royal banquet-related *uigwe* of the nineteenth century (1827, 1828, 1829, 1848, 1868, 1873, 1877, 1887, and 1892), it was recorded that the Five Peaks screens had to be placed where the king was to be seated.[16] In *uigwe* texts, information on screen paintings appears in the section called "placement of objects in the banquet hall" (*baeseol* or *jeonnae baeseol*). On rare occasions the Five Peaks screen was placed behind the queen or the dowager queen's seat. An example is the palace banquet *uigwe* of 1827 (Sunjo 29) that celebrated the presentation of elevated titles to King Sunjo and Queen Sunwon (1789–1857) by Crown Prince Hyomyeong (1809–1830; he died before ruling but was posthumously elevated to King Ikjong/Munjo). The two facing pages of the *Uigwe of the Royal Banquet of the Offering of Wine Cups at Jagyeongjeon* (*Jagyeongjeon jinjak jeongnye uigwe*) show the places of the king and the queen in front of [158] the Five Peaks screens in Jagyeongjeon hall at Changgyeong Palace (fig. 158).[17]

The Iconography of the Five Peaks Screen With the above information on the use of the Five Peaks screens from *uigwe*, I now turn to the iconography of the screen. Although it is most frequently called the *obongbyeong*

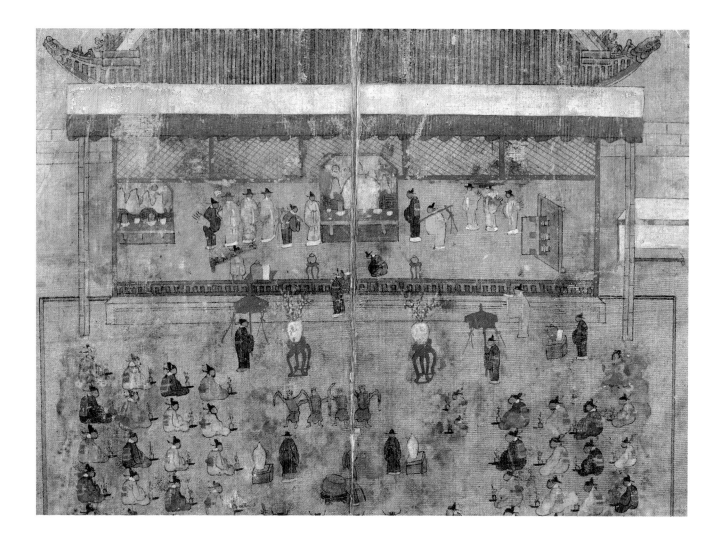

FIG. 156 "Banquet Celebrating the 30th Anniversary of King Sukjong's Ascension to the Throne." Detail from the album *Jinyeon docheop*, 1706. Album leaf; ink and color on silk, 29 × 41 cm. National Library of Korea (Hangwigojo 51-Na 237).

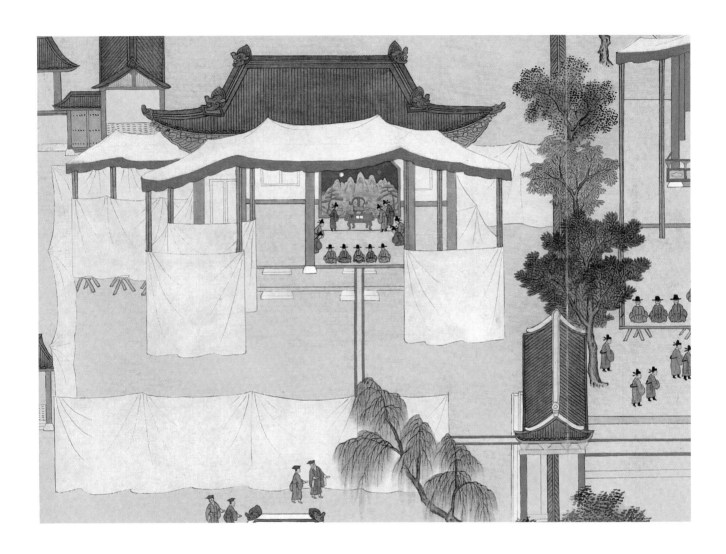

FIG. 157 Jang Deuk-man
(1684–1764) et al., "King's
Visit to Yeongsugak
Pavilion." Detail from
the album *Celebrating
King Yeongjo's Entry
into the Club of Elders*,
1744–1745. Ink and color
on silk, 44 × 64.9 cm.
National Museum of
Korea (Deoksu 6181).

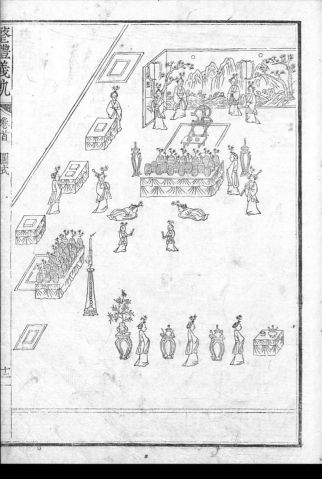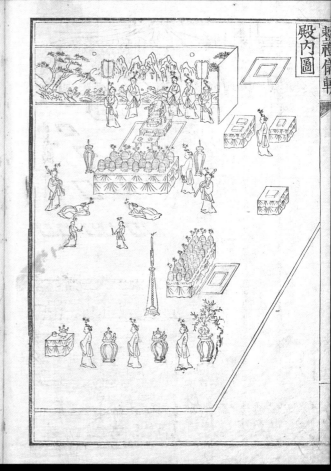

(Five Peaks screen) in Joseon-period documents, it is also called the *irwol obongbyeong* (Sun, Moon, and Five Peaks screen) since the sun, moon, and the five mountain peaks feature prominently in the composition. Other constant elements in the painting are pine and cypress trees and a body of water in the foreground, formed by two waterfalls gushing down into the watery valley below mountain peaks. The iconography of this screen can best be explained by the contents of *Tianbao* (Heaven Protects)[18] in the "Xiaoya" (Minor Odes of the Kingdom) chapter of the *Book of Poetry* (*Shijing*).[19] A few relevant parts of the poem are quoted below:

天保定爾	Heaven protects and establishes thee
亦孔之固	With the greatest security
俾爾單厚	Makes thee entirely virtuous
何福不除	So that in everything thou dost prosper
…	…
如山如阜	Like the high hills (*shan*), and the mountain masses (*fu*)
如岡如陵	Like the topmost ridges (*gang*), and the greatest mounds (*ling*)
如川之方至	That as the stream (*chuan*) ever coming on
以莫不增	Such is thine increase
…	…
群黎百姓	All the black-haired race, in all their surnames,
徧爲爾德	Universally practice your virtue
如月之恒	Like the moon (*yue*) advancing to the full
如日之升	Like the sun (*ri*) ascending the heavens
如南山之壽	Like the longevity of the southern hills (*nanshan*)
不騫不崩	Never waning, never falling
如松栢之茂	Like the luxuriance of the fir and the cypress (*songbai*)
無不爾或承	May such be thy succeeding Line!

In this poem, the king's subjects and the honored guests praise the ruler's virtue and wish him a continuous line of succession and the protection of heaven and the ancestors. Nine items in nature are cited. Five are protective gifts from heaven: high hills, mountain masses, topmost ridges, greatest mounds, and streams. Four show how the ruler practices his virtue: the moon advancing to the full phase, the sun ascending the heavens, the longevity of the southern mountain, and the luxuriance of fir and cypress.

In China, the *Tianbao* theme was illustrated as early as the Southern Song by Ma Hezhi in his illustration of the *Shijing*.[20] In Ma's illustration, the scene is more like a naturalistic depiction of mountains, trees, and the sun on the left side, with the moon being barely visible on the right.

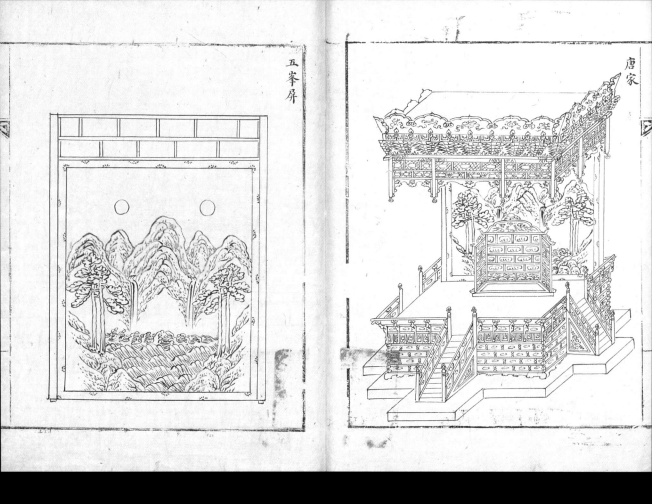

五峯屛

唐家

FIG. 159 Five Peaks
screen (left) and Five
Peaks screen under a
canopy (right), from the
*Uigwe of the Repair of the
Injeongjeon (Injeongjeon
jungsu uigwe)*, 1857.
Printed book; ink on

Under the sun is a pool of water represented by thin wavy lines. Therefore, it looks more like a landscape painting in ink and light colors, and the compositional elements are not formalized as in Korean Five Peaks screens. In terms of the composition, what looks like a source of the Joseon dynasty's Five Peaks screens can be found in the 1605 Ming-period *Master Cheng's Ink Garden* (*Chengshi moyuan*); a book of illustrations of pictorial designs used for relief decoration on ink cakes.[21] The title of the illustration is given as *Tianbao jiuru*. There are mountain peaks large and small, plus the sun on the right and a half-moon on the left. The rest of the composition consists of pine trees and a body of water in the foreground. The half-moon is a rather faithful representation of the text, "Like the moon advancing to the full." Most other Chinese illustrations take the form of a hanging scroll, painted in ink, or ink and light colors.[22] Although Hongnam Kim proposed that the Five Peaks screen was placed behind the throne of the Gyeongbok Palace from the beginning of the dynasty,[23] no documentary or visual evidence can be found to support this view.

The Format of the Five Peaks Screen We learn from several categories of *uigwe* books that there are different formats of Five Peaks screens. The *Uigwe of the Repair of the Injeongjeon* (*Injeongjeon jungsu uigwe*) of 1854–1857 has a black-and-white illustration of a Five Peaks screen (fig. 159) under a *dangga* canopy that resembles the ornate eaves under the roof of wooden architecture.[24] To the right side of the *dangga* (left-hand page) a screen of the Five Peaks is shown independently, to be placed behind the throne in Injeongjeon throne hall when the repair is completed. As we have seen in chapter 6, the 1901 *Uigwe of the Copying of Seven Kings' Portraits* (*Chiljo yeongjeong mosa dogam uigwe*) contains illustrations of three screen formats with their respective dimensions.[25] They are: the eight-fold screen; the narrow one-panel screens placed on either side of the portrait; and the wider, one-panel screen called *sapbyeong*, which is kept upright by a heavy ornamental stand. All surviving Five Peaks screens are represented in one of the three formats.

In this 1901 *uigwe* we find the greatest volume of information concerning screen paintings made in connection with royal portraits. Screens newly made or repaired at that time are:

- One standing screen (subject matter not specified)
- Two four-fold screens of Plum Blossoms
- Seven four-fold screens of the Five Peaks
- Seven screens of the Five Peaks repaired

[159]

FIG. 160 Five Peaks screen, early 17th century. Four-panel folding screen; ink and color on paper; overall dimensions 247 × 328 cm. Gyeonggijeon royal portrait hall, Jeonju, North Jeolla province.

- Twenty-eight one-panel screens of Peonies for the opposite wall
- Two one-panel screens of Plum Blossoms for the eastern and western walls
- Two four-fold screens of Peonies
- Two four-fold screens of the Sea and Peaches of Immortality

From the above list we learn that not only the Five Peaks screens but other screens of such subjects as Plum Blossoms, Peonies, and the Sea and Peaches of Immortality were also used to adorn the royal portrait hall.

The Painting Style of the Five Peaks Screen Having examined the iconography of the Five Peaks screen and its precedents in China, one wonders how such formalization of the compositional elements rendered in strong colors came about in Joseon Korea. In order to figure out the stylistic changes over the centuries, we need to examine the dated examples, whether they are actual screens or screens within paintings. Unfortunately, none of the existing Five Peaks screens is dated.

[160]

The only screen that can be circumstantially dated to the early seventeenth century is the large one (247 × 328 cm) that used to be behind the 1872 copy of the portrait of King Taejo (r. 1392–1398) in the Gyeonggi-jeon royal portrait hall in Jeonju, North Jeolla province (fig. 160). We need to rely on the documentary evidence for the use of this screen. We know that Gyeonggijeon was completely destroyed in 1592 at the time of Hideyoshi's invasion, and that it was rebuilt in 1614.[26] In his collected essays titled *Ijae yugo* (first published in 1829 by the author's grandson Hwang Su-gyeong), Hwang Yun-seok (sobriquet, Ijae 1729–1791) recorded that in order to save the portrait of King Taejo from destruction, it had been removed in 1592 to Myohyangsan mountain in Pyeongan province, along with the copy of the *Veritable Records* kept in the Jeonju History Archive. It was brought back to Gyeonggijeon in late 1614.[27] Although it is not known whether there was a Five Peaks screen behind King Taejo's portrait at that time, we presume that the installer of the portrait did follow the tradition. If so, the screen must have been there since the early seventeenth century and could, therefore, be the earliest Five Peaks screen surviving today.

In this painting, the body of water with scale patterns and white-caps occupies slightly more than half of the entire height of the screen, an unusually large proportion compared with other Five Peaks screens. It looks as if the five peaks here, along with the sun and the moon, are rising above the sea. Finally, the two waterfalls that can be found in other Five Peaks screens are missing from the composition. In this regard, the screen echoes the Chinese *Chengshi moyuan* composition, although the

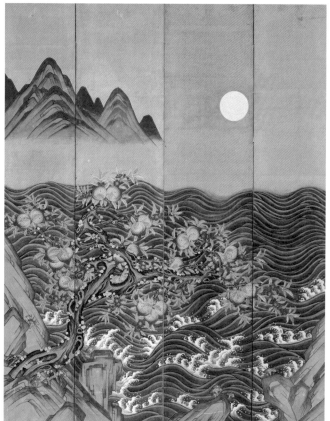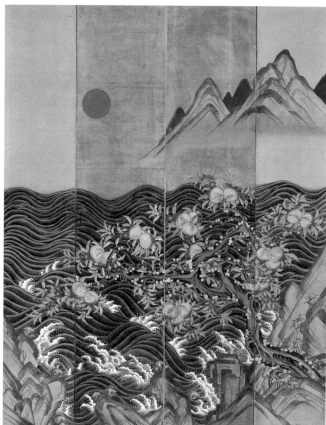

FIG. 161 *Sea and Peaches of Immortality*, 19th–20th century. Pair of four-panel folding screens; ink and color on silk, 317 × 220 cm (left section) and 317.5 × 220.8 cm (right section). National Palace Museum of Korea (Changdeok 6443, Changdeok 6444).

[157]

motifs are much more rigidly rendered. The large proportion of the water in this Five Peaks screen in the Royal Portrait Museum (Gyeonggijeon), Jeonju, can also be found in the screen within a painting that we have seen in a leaf titled "King's Visit to Yeongsugak Pavilion" (see fig. 157), datable to 1744–1745. Also, both show the body of water under the mountain peaks in tones of brown, and the water reaches nearly halfway to the mountain. Later screens have a much lower horizon, marked by upright whitecaps. The Five Peaks screens illustrated in the 1901 *Uigwe of the Copying of Seven Kings' Portraits* show blues and reds of stronger tonality than the earlier screens, due to the use of aniline dyes imported from Europe in the second half of the nineteenth century that were called *yangcheong* (Western blue) and *yanghong* (Western red).[28]

In terms of its iconography, the Five Peaks screen, which is the most important screen in Joseon palaces, originated in China. However, Joseon painters, while appropriating all of its compositional elements from Chinese painting, transformed it almost completely and created a uniquely Korean painting. No Chinese painting of the same subject even comes close to the Korean screen in the rendering of forms and the use of bright colors. The imposing forms of the Five Peaks, the sun and the moon against the blue sky (an unusual phenomenon),[29] the waterfalls, the powerful pine and cypress trees on either sides of the foreground, and the sea with stylized waves topped with whitecaps all contribute to creating a timeless and surreal atmosphere, one that is fit for the absolute authority of the king.

Sea and Peaches of Immortality Screens
Although this subject is related to that of the Ten Symbols of Longevity, the screen itself was recorded in the 1901 *Uigwe of the Copying of Seven Kings' Portraits*. Therefore, we have to consider the screen in the context of royal portraits. In the National Palace Museum of Korea, Seoul, is a

[161]

large eight-panel screen divided into two four-panel sections (fig. 161). The screen shows the sun on the right half and the moon on the left half of the composition, blue-and-green mountain peaks above the sea, and a large tree of peaches of immortality growing from rocky boulders, again in each half of the composition. The screen is quite tall, measuring 317 × 220 centimeters (the half with the moon), and 317.5 × 220.8 centimeters (the half with the sun). Opinions differ on how the two halves were put together to form a meaningful screen of the Sea and Peaches of Immortality.

It seems reasonable to put the section with the sun on the right and the one with the moon on the left, so the peach trees appear to be leaning

香爐

孔雀挿屏

豹皮方席

座椅子

進爵儀軌〉戊子卷首圖式

香盒

床烟爐

寶案

龍平床

泥金

欄干隔板刻
牧丹蝙蝠並
朱漆物形施
左右後三層設
鍍金後四層
寸四閭籠頭
四寸前高六
寸換高一尺
後高二尺一
廣二尺九寸
長七尺二寸

二十

FIG. 162 Peacock screen and other objects, from the *Uigwe of the Royal Banquet of the Offering of Wine Cups (Jinjak uigwe)*, 1828. Printed book; ink on paper, 37.2 × 24.2 cm. Kyujanggak Institute for Korean Studies, Seoul

toward the left in the sun panel, and to the right in the moon panel. It would then form a screen similar to a Five Peaks screen, with the sun on the right, and the moon on the left. The peach trees would then take the place of the pine and cypress trees on either end of the composition. The only problem is that the mountain peaks would not come together to form the so-called five peaks. Due to the screen's large size and, more importantly, its inclusion among the screens for royal portraits, it has been suggested that the screen might have been placed behind one of the seven royal portraits copied in 1901.[30]

If this screen were to be placed behind a royal portrait, it is hard to believe that the royal portrait would be placed directly in front of it because no such cases of using a screen other than the Five Peaks screen behind the royal portrait are known. Therefore, it is reasonable to assume that the screen was placed outside and behind a portrait niche containing the Five Peaks screen, just as we shall see later, the way Peony screens were placed.

Peacock Screens

A peacock, considered the most handsome and majestic of all birds, can also be a fitting adornment for a king's place in a banquet hall. So far, only in the *Uigwe of the Royal Banquet of the Offering of Wine Cups* (*Jinjak uigwe*) of 1828 was it recorded that a "Peacock screen on stand" adorned the place of the king. This modest-scale banquet celebrated Queen Sunwon's thirty-ninth birthday (*sasun*). The *uigwe* has a woodblock illustration of the Peacock screen on a stand (fig. 162) along with other paraphernalia that should accompany the king, such as a small table for the royal seal, an incense burner, and an incense case.[31]

[162]

The stand for the Peacock screen looks elaborately carved out of fairly thick wood. In the painting, a large piece of *taehoseok* (porous rocks from the Taihu lake in China) juts out from the right toward the left, behind which several trees are seen leaning toward the left. Under the rock, a peahen and a peacock are walking around, and in the air, a pair of small birds is flying toward the tree. There is no concrete remark in the *uigwe* text as to the specific location of the Peacock screen except that it is listed as the first screen to be placed near the royal seat. Earlier, we have seen that in the scene of the banquet in the Jagyeongjeon, illustrated in the *Uigwe of the Royal Banquet of the Offering of Wine Cups at Jagyeongjeon* (*Jagyeongjeon jinjak jeongnye uigwe*), 1827, a pair of Five Peaks screens is placed behind the royal seat, one for the king, the other for the queen (see fig. 158). Therefore, it looks like the Peacock screen is placed behind the royal seat, which in turn was placed in front of a large Five Peaks screen.

[158]

In extant birds-and-flowers paintings of the Joseon dynasty, no such independent painting of peacocks can be found, although a peacock with fully spread wings may appear on one of the panels in a multipanel screen of birds and flowers. However, recently a pair of hanging scrolls, each showing a pair of phoenixes with the sun and a peacock and peahen pair with the moon, was discovered in the collection of the Philadelphia Museum of Art; the documentary evidence about this combination of themes led to the conclusion that they were used as decorations in a Joseon palace.[32] However, evidence also shows that Koreans had these exotic birds as early as the Three Kingdoms period.[33] Peacocks can be spotted in the garden courtyard of the Tang dynasty general Guo Ziyi's sprawling estate as depicted in the screen *The Happy Life of Guo Fenyang* (Ziyi) (see fig. 170), the iconography of which is Chinese in origin. In this connection, we may bring in a large hanging scroll, *Qianlong Watching Peacocks in Their Pride* (1761),[34] originally fixed onto the wall of the Ziguangge (Purple Light Hall) in the Zhongnanhai imperial park just west of the Forbidden City.[35] A group of artists that included many foreign Jesuit artists in the service of the Qing court produced this magnificent "scenic illusion."

[170]

Unlike the phoenix, which is an auspicious bird of an imaginary realm, the peacock is the king of birds in the natural world. It is not certain whether peacocks were known in late Joseon Korea, but given the frequent interaction with China through emissaries and traders, Joseon artists must have known about them. In his *Damheon seo*, Hong Dae-yong (sobriquet, Damheon, 1731–1783) recorded that he had heard about peacocks being in Yuanmingyuan garden, another imperial park in Beijing, but did not see them in person.[36] If any bird theme has a place in a screen near the king, it would be that of a peacock.

Peony Screens

Peonies, whose beauty and luxuriance are symbols of wealth and nobility, were also closely associated with the royal presence. As we have seen, the list of screens made at the time of the copying of the portraits of the seven past kings in 1901 included twenty-eight panels of Peony screens and two four-fold Peony screens. The Peony screens used in connection with the royal portraits can be seen in the royal portrait niches of the new Seonwonjeon royal portrait hall (see fig. 99 in chapter 6); on the left side behind and outside of the portrait niche we can see a Peony screen that was discreetly placed yet remains clearly visible. Through the royal funeral-related *uigwe*, we also learn that the Peony screens solemnly adorn the royal coffin halls and the spirit tablet halls of the palace. The

[99]

same screens are used inside the temporary pavilion (*neungsanggak*) erected on top of the mound for the royal tomb-to-be while the underground coffin chamber is being excavated, and in the T-shaped pavilion near the tomb.[37] The above findings from *uigwe* documents on the use of the Peony screen in connection with the royal presence all have to do with the king's afterlife.

The peony, being the king of flora, symbolizes the status of a king. At the same time, however, the flower's secular attributes, i.e., wealth and abundance, may have been in the collective minds of his people who wished him the same blessings even in the afterlife, in a spirit similar to providing abundant grave goods for the king.

Plum Blossoms Screens

As seen above, the Plum Blossoms screens (*maehwabyeong*) are found among the screens produced at the time of the 1901 copying of the seven past kings' portraits. Interestingly, this is the only appearance of the Plum Blossoms screen in connection with royal portraits. Currently, in King Taejo's portrait niche in the new Seonwonjeon royal portrait hall, to the left of and behind the narrow screen of the Five Peaks, we find a portion of a screen of plum blossoms and green bamboo leaves, barely visible from the front.[38] It is useful to mention that in Gyeonggijeon, the hall of King Taejo's portrait in Jeonju, we find a screen of blossoming plums, though not behind his portrait, but on the floor to the left of his high portrait niche. It is a fairly large eight-fold screen, signed with an inscription by Yi Wang-jae (sobriquet, Maecheon, 1928–2001), who identified himself as the twentieth-generation descendant of King Taejo's uncle Yi Ja-heung (b. 1305), also known as Prince Wanchang. Judging from the painter's birthdate, this screen must have been brought in much later, when the screen originally kept there was lost.[39]

Why is there a screen of plum blossoms only in the royal portrait hall of King Taejo, or only in King Taejo's portrait niche in new Seonwonjeon? Perhaps King Taejo was associated with plum blossoms — the first among the "Four Gentlemen" — which bloom early in the spring, braving the cold weather and snow. King Taejo's achievement of having founded the dynasty might have been recognized in this noble and elegant way.

Screen Paintings for Palace Ladies

Screens that played important roles in court rituals involving royal ladies include those of Peonies (*moranbyeong*), the Ten Symbols of Longevity (*sipjangsaengbyeong*), Flowers and Grasses (*hwachobyeong*), Lotus Flowers

TABLE 9.2 Screen Paintings for Royal Weddings

YEAR	WEDDING	SUBJECT	SIZE / NUMBER OF PANELS	VENUE
1627	Crown Prince Sohyeon	Ten Symbols of Longevity	large / 10 panels	wedding ceremony hall
		Flowers and Grasses	large / 10 panels	wedding ceremony hall
		Peonies	medium / 10 panels	bridal dressing room
		Lotus Flowers	medium / 10 panels	bridal detached palace
1638	King Injo	Ten Symbols of Longevity	large^ (on ramie)	main palace
		Peonies	medium^ (on ramie)	main palace
		Flowers and Grasses, with Birds and Animals	medium^ (on silk)	main palace
		Lotus Flowers	medium^ (on ramie)	bridal detached palace
1651	Crown Prince Yeon (later King Hyeonjong)	Flowers and Grasses	large / 10 panels	wedding ceremony hall
		Ten Symbols of Longevity	large / 10 panels	wedding ceremony hall
		Peonies	medium / 10 panels	bridal dressing room
		Lotus Flowers	medium / 10 panels	bridal detached palace
1671	Crown Prince Sun (later King Sukjong)	Flowers and Grasses	large / 10 panels	wedding ceremony hall
		Ten Symbols of Longevity	large / 10 panels	wedding ceremony hall
		Lotus Flowers	medium / 10 panels	bridal dressing room
		Peonies	medium / 10 panels	bridal detached palace
1696	Crown Prince Yun (later King Gyeongjong)	Flowers and Grasses	large / 10 panels	bridal dressing room
		Ten Symbols of Longevity	large / 10 panels	bridal dressing room
		Lotus Flowers	medium / 10 panels	bridal dressing room
		Peonies	medium / 10 panels	bridal dressing room
1718	King Sukjong*	Flowers and Grasses	large / 10 panels	wedding ceremony hall
		Ten Symbols of Longevity	large / 10 panels	wedding ceremony hall
		Lotus Flowers	medium / 10 panels	wedding ceremony hall
		Peonies	medium / 10 panels	bridal detached palace
1727	Crown Prince Hyojang (posthumously elevated to King Jinjong)	Flowers and Grasses	large / 10 panels	wedding ceremony hall
		Ten Symbols of Longevity	large / 10 panels	wedding ceremony hall, crown prince's residence
		Lotus Flowers	medium / 10 panels	bridal dressing room
		Peonies	medium / 10 panels	bridal detached palace

^ Number of panels unspecified
ᴮ Size of panels unspecified
ᶜ Subject unspecified
* The groom's second marriage
† The first appearance of this subject, hereafter referred to as "Happy Life of Guo Fenyang"

TABLE 9.2 (continued)

YEAR	WEDDING	SUBJECT	SIZE / NUMBER OF PANELS	VENUE
1744	Crown Prince Sado	Flowers and Grasses	large / 10 panels	wedding ceremony hall
		Ten Symbols of Longevity	large / 10 panels	wedding ceremony hall, crown prince's residence
		Lotus Flowers	medium / 10 panels	bridal detached palace, wedding ceremony hall
		Peonies	medium / 10 panels	bridal detached palace
1802	King Sunjo	Happy Life of Guo Ziyi (king of Fenyang)[†]	8 panels[B]	[unspecified]
		Birds and Animals	large[A]	[unspecified]
1819	Crown Prince Hyomyeong (posthumously elevated to King Ikjong/Munjo)	Happy Life of Guo Fenyang	large[A]	bridal detached palace
		One Hundred Children	medium[A]	bridal dressing room
1837	King Heonjong	Happy Life of Guo Fenyang	large / 8 panels	bridal detached palace
		Birds and Animals	large / 10 panels	bridal detached palace
		Plain ramie screen[C]	8 panels[B]	wedding ceremony hall
1844	King Heonjong*	Plain ramie screen[C]	8 panels[B]	wedding ceremony hall
		Happy Life of Guo Fenyang	large / 8 panels	bridal detached palace
		Birds and Animals	large / 10 panels	bridal detached palace
		Xiwangmu's Banquet at the Turquoise Pond Garden (yojiyeondo)[†]	[unspecified]	bridal detached palace
1851	King Cheoljong	Happy Life of Guo Fenyang	8 panels[B]	bridal detached palace
		Birds and Animals	large / 10 panels	bridal detached palace
		Peonies	[unspecified]	wedding ceremony hall
1866	King Gojong	Two sets of painted silk screens		
		Happy Life of Guo Fenyang	8 panels[B]	bridal detached palace
		Birds and Animals	large / 10 panels	bridal detached palace
		Peonies	8 panels[B]	wedding ceremony hall
1882	Crown Prince Cheok (later Emperor Sunjong)	Happy Life of Guo Fenyang	10 panels[B]	bridal detached palace
		One Hundred Children	10 panels[B]	bridal detached palace
		Peonies	10 panels[B]	wedding ceremony hall
1906	Crown Prince Cheok (later Emperor Sunjong)*	Two sets of painted silk screens		
		Happy Life of Guo Fenyang	[unspecified]	bridal detached palace
		Birds and Animals	[unspecified]	bridal detached palace
		Peonies	large / 10 panels	wedding ceremony hall
		Plain ramie screen[C]	[unspecified]	[unspecified]

(*yeonhwabyeong*), and the Happy Life of Guo Fenyang (*Gwak Bun-yang haengnak dobyeong*).

TABLE 9.2

All these screens were produced for royal weddings of court ladies to crown princes or reigning kings. Table 9.2 presents information about their use by subject, size/format, and venue in royal weddings as cited in *uigwe* texts ranging from 1627 to 1906.[40]

Peony Screens

Screens that adorned the living quarters of palace ladies were documented mostly in the *uigwe* of royal weddings and royal banquets. The symbolism of the peony at that time was that of wealth and nobility. Peony screens were used in royal weddings to adorn important places within wedding ceremonies, and were also placed behind the seats of royal ladies at palace banquets. Below is a list of royal weddings at which Peony screens were used and the palace interiors where they were deployed.

1627 medium ten-panel screen for the bridal dressing room, within the bridal detached palace
1638 medium screen for the main palace
1651 medium ten-panel screen for the bridal dressing room
1671 medium ten-panel screen for the bridal detached palace
1696 medium ten-panel screen for the bridal dressing room
1718 medium ten-panel screen for the bridal detached palace
1727 medium ten-panel screen for the bridal detached palace
1744 medium ten-panel screen for the bridal detached palace
1851 screen of unspecified size for the wedding ceremony hall
1866 eight-panel screen of unspecified size for the wedding ceremony hall
1882 ten-panel screen of unspecified size for the wedding ceremony hall
1906 large ten-panel screen for the wedding ceremony hall

The above list shows that Peony screens used for royal weddings had either eight or ten panels, and were used mainly in the bridal detached palace up through the wedding of Crown Prince Sado (1744). From King Cheoljong's wedding in 1851, however, Peony screens started to be used in the wedding ceremony hall (*dongroeyeon*). Also, in the 1906 wedding of Crown Prince Cheok, the screen became large, close to two meters high, in accordance with the change of Joseon polity in 1897 from a kingdom to an empire.

The Painting Style of the Peony Screen Stylistically, the existing Peony screens can be divided into two groups. The first, as exemplified by the ten-panel Peony screen of medium size in the National Museum of Korea [163] (fig. 163), shows tree peonies (*paeonia suffruticosa*) rendered naturally, growing from the ground with an occasional mix of rocks near the roots of the shrubs. The flowers also look natural, blooming from the branches among the leaves. It is a medium-size screen, each panel measuring 166.8 × 45.4 centimeters.

Compared with this screen, the larger eight-panel Peony screen [164] in the National Palace Museum of Korea (fig. 164), each panel measuring 201 × 52 centimeters, shows a considerable degree of stylization. The tree peonies stand behind a stylized Taihu rock with a large hole in the center. The flowers are also stylized, and the same flower form in colors of red, white, and variegated pink and white is repeated from top to bottom of the trees. These basic forms of rock and flower on the first panel are repeated in the second panel, except there the rock is painted in blue, and the peony on top is a mix of pink and white instead of red. The first and second panels form one compositional unit that is repeated four times to compose the entire eight-panel screen. This kind of extreme stylization can be seen in many of the surviving Peony screens, and the peonies tend to be tall compared with the more natural depiction of flowering tree peonies. It seems that the latter variety date from the late nineteenth or the early twentieth century.[41]

Flowers and Grasses with Birds and Animals

As seen in the list of screens for royal weddings (table 9.2), this genre played an important role in royal weddings of the Joseon period. However, because of the subject matter in which several different plants or flowers and grasses and/or animals and birds appear mixed in no set formula, and also because of the modern term "painting of flowers and birds" (*hwajo hwa*), rather than Flowers and Grasses screen (*hwachobyeong*) as recorded in *uigwe* documents, this genre did not receive its due attention until recently.[42] The term *hwajo* is found on the list of subject matters given as a test when recruiting court painters.[43] Figure 165 is a late [165] nineteenth-century example of a four-panel screen entitled *Birds and Flowers*, which shows flowering magnolia trees, peonies, Buddha's hand, and lotus flowers, along with a couple of deer and several pairs of colorful birds. Most of these flowers, birds, and animals all appear on other screens, either singly or in combination.[44] Below is a list of royal weddings at which Flowers and Grasses screens are recorded to have been used:

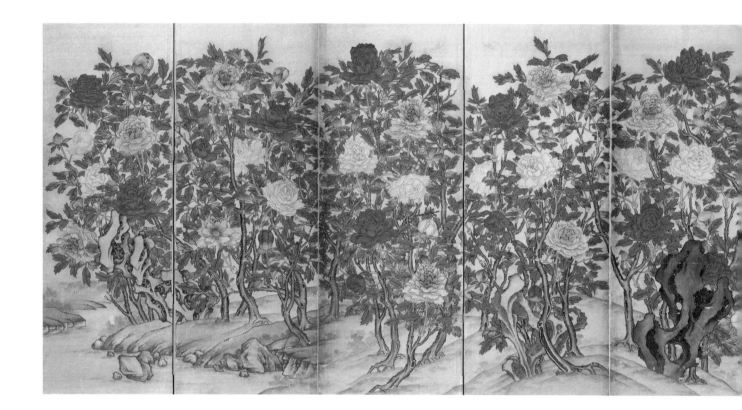

FIG. 163 *Peonies*, late
19th century. Ten-panel
folding screen; ink
and color on silk, each
panel 166.8 × 45.4 cm.
National Museum of
Korea, Seoul (Bongwan
8165).

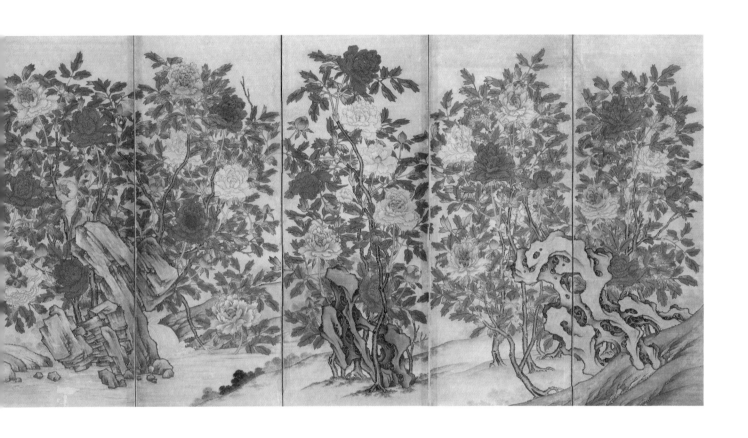

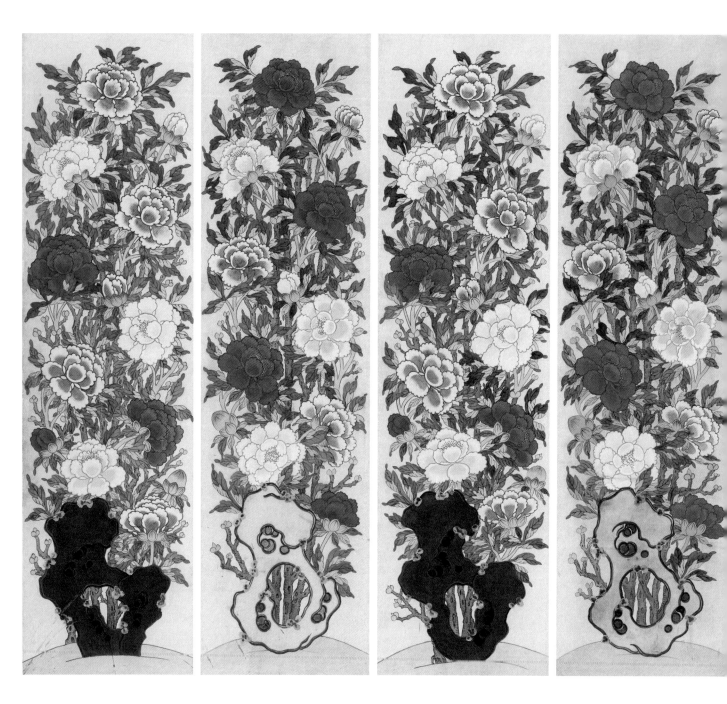

FIG. 164 *Peonies*, datable to the late 19th–early 20th century. Eight-panel folding screen; ink and color on silk, each panel 201 × 52 cm. National Palace Museum of Korea (Changdeok 6433).

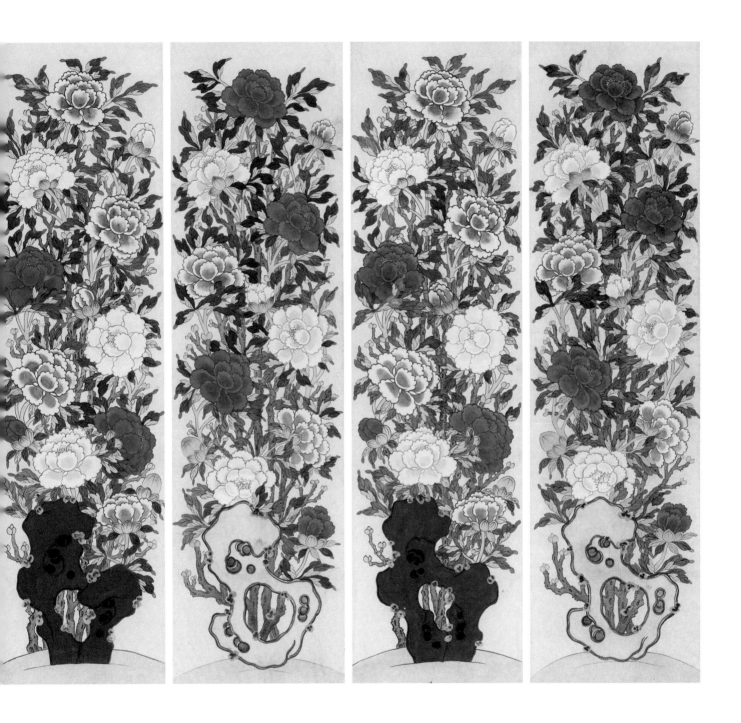

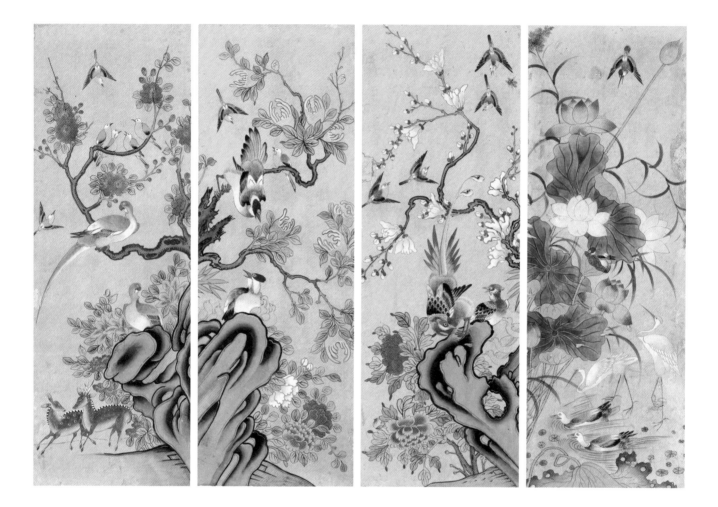

FIG. 165 *Birds and Flowers*, late 19th century. Four-panel folding screen; ink and color on paper, each panel 164.8 × 53.5 cm. National Palace Museum of Korea (no. 6478).

1627 large ten-panel screen for the wedding ceremony hall
1638 medium-sized screen with birds and animals for the main palace
1651 large ten-panel screen for the wedding ceremony hall
1671 large ten-panel screen for the wedding ceremony hall
1696 large ten-panel screen for the bridal dressing room
1718 large ten-panel screen for the wedding ceremony hall
1727 large ten-panel screen for the wedding ceremony hall
1744 large ten-panel screen for the wedding ceremony hall
1802 large screen with birds and animals (venue unspecified)
1837 large ten-panel screen with birds and animals for the bridal detached palace
1844 large ten-panel screen with birds and animals for the bridal detached palace
1851 large ten-panel screen with birds and animals for the bridal detached palace
1866 two large ten-panel painted silk screens with birds and animals for the bridal detached palace
1906 two painted silk screens of unspecified size with birds and animals for the bridal detached palace

TABLE 9.2

In the cases listed above, the Flowers and Grasses screen was used in the wedding ceremony hall except in 1638 and 1696, as was the screen of Ten Symbols of Longevity (table 9.2). Unfortunately, the half-written (*munbanchado*) and half-illustrated *banchado* showing the placement of participants (or rather their platform seats) and the arrangement of food, wine, and objects (incense burners, flowers, etc.) used in the 1837 wedding of King Heonjong does not also show the positions of screen paintings within the wedding ceremony hall (see fig. 199). My guess is that the Ten Symbols of Longevity screen would have been placed behind the food tables at the top of the drawing, and the Flowers and Grasses screen would occupy the opposite side of the hall to enclose the space with large, colorful screen paintings.

[199]

Ten Symbols of Longevity Screens
A uniquely Korean creation, the Ten Symbols of Longevity screen (*sipjang-saengbyeong*) (fig. 166) was the one used most frequently for royal wedding rites and royal banquets, and most were placed in the wedding ceremony hall. The following is a list of the royal weddings from 1627 to 1744 in which the Ten Symbols of Longevity screens were used.[45]

[166]

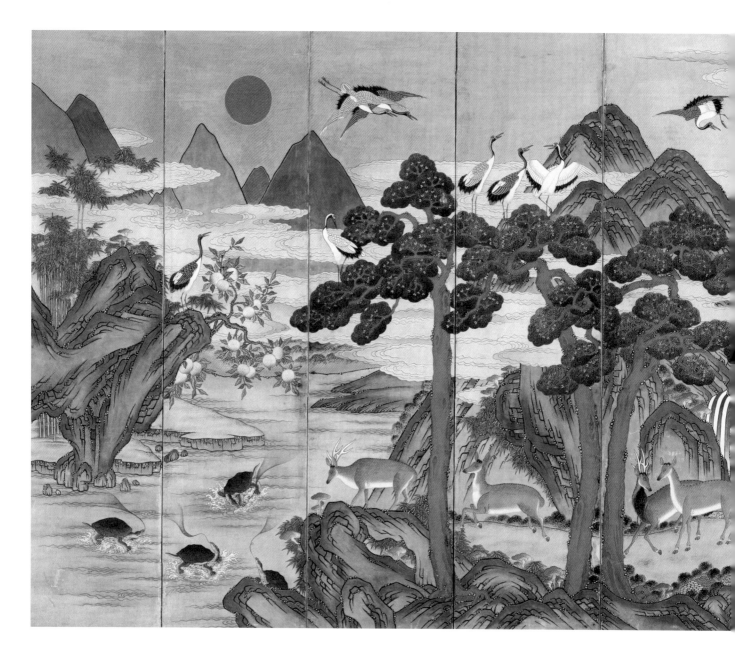

FIG. 166 *Ten Symbols of Longevity*, ca. 1880s. Ten-panel folding screen; ink and color on silk, overall dimensions 187.5 × 350.4 cm. National Palace Museum of Korea (Changdeok 6447).

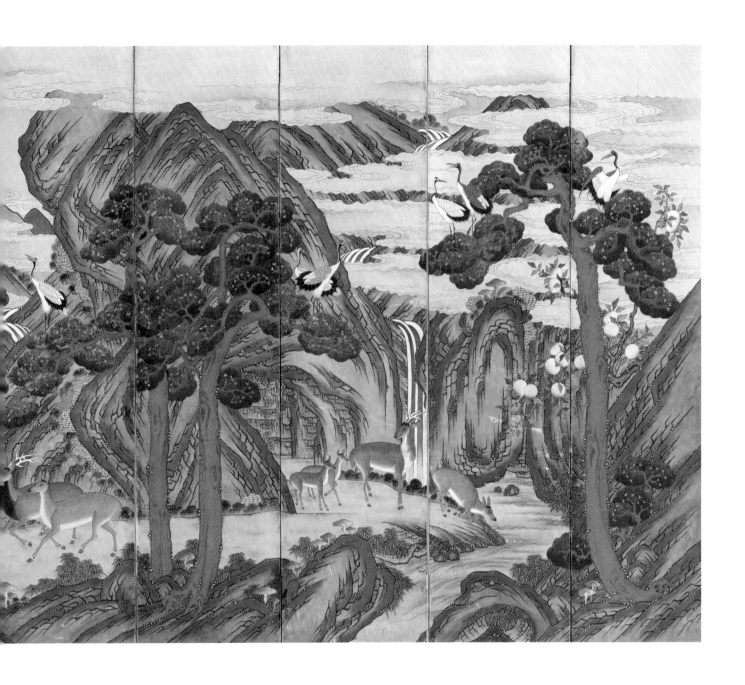

FIG. 167 Six-sided "con-
trasting colors" (*doucai*)
Chinese flowerpot,
Kangxi period (1662–
1722). Porcelain with
polychrome decoration;
42.4 × 60.3 cm. National
Palace Museum, Taipei.

1627 large ten-panel screen for the wedding ceremony hall
1638 large panels on ramie for the main palace
1651 large ten-panel screen for the wedding ceremony hall
1671 large ten-panel screen for the wedding ceremony hall
1696 large ten-panel screen for the bridal dressing room
1718 large ten-panel screen for the wedding ceremony hall
1727 large ten-panel screen for the wedding ceremony hall
 and crown prince's residence
1744 large ten-panel screen for the wedding ceremony hall
 and crown prince's residence

This shows that the Ten Symbols of Longevity screen was always large and was always placed in the wedding ceremony hall. On only two occasions (1727 and 1744) was it also placed in the crown prince's residence. Although late eighteenth-century wedding *uigwe* do not list the use of the Ten Symbols of Longevity screens, no doubt they were used in a similar way as that described in banquet-related *uigwe* of the late eighteenth through the end of the nineteenth century, which frequently mention its placement behind royal ladies.[46]

The Iconography of the Ten Symbols of Longevity Screen The wish for longevity has its roots in the human desire for immortality. It originated in religious Daoism in China, and there are Chinese paintings that depicted the abode of the immortals known collectively as *Samsinsan* (Three Sacred Mountains): Penglai, Yingzhou, and Fangzhang. A good example would be the 1563 painting by Wen Boren (1502–1573), *Fanghu tu*, currently in the National Palace Museum, Taipei. (*Fanghu* is an alternate name for *Fangzhang*.) The painting depicts a lone island in the sea, away from the mundane world. But the Chinese depictions of the Three Sacred Mountains are very different from Korean screens of the Ten Symbols of Longevity.[47]

The Ten (or more) Symbols of Longevity include the deer from the animal kingdom, the turtle from the watery world, and the crane from the feathered world; and from the plant kingdom, the pine tree, bamboo, peach of immortality, and mushroom of immortality (*yeongji*). Other motifs that appear in depictions of the Ten Symbols of Longevity are the sun, clouds, rocks or mountains, and water. Any ten of these items can appear in combination to form the Ten Symbols of Longevity in screen paintings of Korea. In Chinese ceramics, we find that up to seven symbols and motifs might appear as decoration on a pot, but not more. On a polychrome six-sided flowerpot of the Kangxi period, the crane,

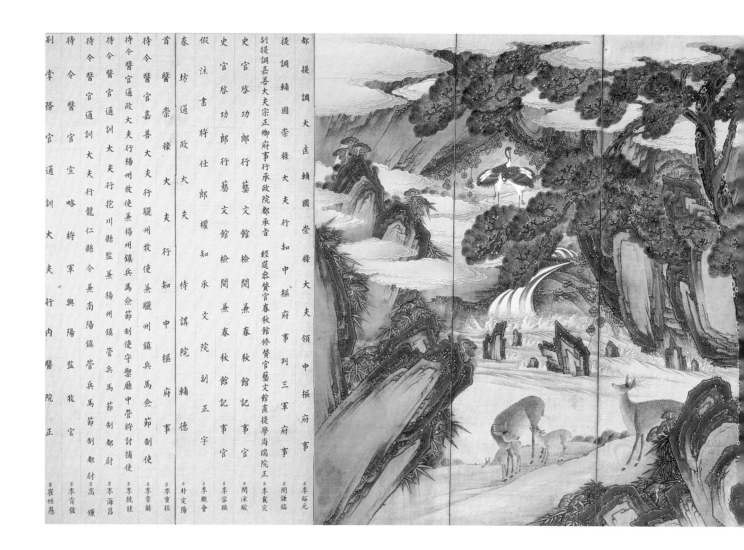

FIG. 168 *Ten Symbols of Longevity*, 1880. Ten-panel folding screen; ink, color, and gold on silk, overall dimensions 200.5 × 516 cm. Jordan Schnitzer Museum of Art, University of Oregon, Murray Warner Collection of Oriental Art (MWK68:3).

[167]

[168]

deer, rock, water, clouds, pine tree, and peaches of immortality are repre-
sented (fig. 167). In Korea, as early as the late Goryeo period, paintings
containing all ten symbols were being created. None have survived, but
we know of their existence through literary evidence.[48] Chinese and Japa-
nese scholars also agree that the Ten Symbols of Longevity screen is a
uniquely Korean creation.[49]

Although a considerable number of late Joseon-period Ten Symbols
of Longevity screens survives, there is only one example that carries
inscriptions, with a date equivalent to 1880, in the collection of the Jordan
Schnitzer Museum of Art of the University of Oregon (fig. 168). According
to Charles Lachman's essay on this screen, it was purchased by the
museum in 1924.[50] Lachman's thorough introduction to the ten longevity
symbols and a stylistic analysis of the screen is the first of its kind in
English.[51] The ten-panel screen, rather imposing in size, each panel
measuring around 200 × 50 centimeters, was painted to commemorate
the recovery of the crown prince (later Emperor Sunjong) from smallpox.
It was produced as a *gyebyeong* to be shared among the staff of the Office
of Court Medicine (Uiyakcheong) who worked together to take care of the
crown prince. On panels 9 and 10 are inscribed the names and titles of
the fourteen officials of the Office of Court Medicine.[52]

In this regard, it is interesting to find a screen of the same subject
matter, and almost exact composition, but a bit smaller in size, each
panel measuring approximately 165 × 40 centimeters, in the Amore-
pacific Museum of Art in Seoul. This screen has been made public only
recently through the exhibition titled *Beyond Folding Screens* accompanied
by a catalogue of the same title.[53] The most obvious difference is that the
Amorepacific Museum screen lacks the last two inscription panels. It
seems that the Oregon screen was made, complete with the inscriptions,
for the royal palace, whereas the Amorepacific Museum screen is one of
the several *gyebyeong* made to be distributed to important members of
the Office of Court Medicine.[54] To celebrate the occasion, the court had
another screen made, titled *Wangseja duhu pyeongbok jinha dobyeong (Screen
Produced to Commemorate the Crown Prince's Recovery from Smallpox).*[55]

The painting section in panels 1–8 shows all Ten Symbols of
Longevity spread through the brilliantly colored blue-and-green style
landscape setting. In the center, two tall pine trees against a backdrop
of blue and green rocky boulders dominate the composition, while prom-
inent in the sky to the right of the clouds is a large red sun. Below and
around the sun amidst clouds, cranes are seen either flying around or
perched on top of trees or rocks. Two cascades of waterfalls reach the
body of water in the foreground in which numerous turtles swim around.

On the shore are several deer in various postures. To complete the Ten Symbols, stalks of bamboo and clusters of bright red mushrooms of immortality are randomly spread all through the scene against the rocks. Besides being the only Ten Symbols of Longevity screen to come with documentation, it reflects the late nineteenth-century palace preference for screens of larger dimensions (more than 200 centimeters in height) and use of bright colors at its best.[56]

Lotus Flower Screens

The Lotus Flower screen (*yeonhwabyeong*) played a function similar to Peony screens in royal weddings and banquets. Lotus flowers emerge from the muddy pond untainted and beautiful, thus symbolizing purity. For this reason, lotus flowers arranged in large vases adorn the altar of Buddhist temples. Lotus pods with many seeds and the fish that inhabit the same pond symbolize fertility. Birds and fish depicted in pairs in the painting also symbolize conjugal felicity, making the screen a fitting furnishing for the royal bride-to-be. The following list shows the use of Lotus Flower screens in royal weddings from 1627 to 1744.

> 1627 medium ten-panel screen for the bridal detached palace
> 1638 medium screen for the bridal detached palace
> 1651 medium ten-panel screen for the bridal detached palace
> 1671 medium ten-panel screen for the bridal dressing room
> 1696 medium ten-panel screen for the bridal dressing room
> 1718 medium ten-panel screen for the wedding ceremony hall
> 1727 medium ten-panel screen for the bridal dressing room
> 1744 medium ten-panel screen for the detached palace and
> wedding ceremony hall

The Lotus Flower screen was used mostly for the bridal detached palace where the bride-to-be stays until the wedding day after the third and the final selection of the bridal candidate. On two occasions (1718 and 1744), the Lotus Flower screen adorned the wedding ceremony hall; in the 1727 wedding, however, it was placed in the dressing room (*gaebokcheong*) of the bride. It is interesting to note that Bird and Animal screens (*yeongmobyeong*) took the place of Lotus Flower screens in the weddings of 1802 and 1837.

The twelve-panel Lotus Flower screen in the Leeum Museum of Art collection (fig. 169) serves as a good example of a palace screen. The iconography of the Lotus Flower screen, from the first panel on the right to the last panel on the left, represents the life cycle of a lotus plant progressively from the flower buds, semi-bloomed stage, fully bloomed

[169]

FIG. 169 *Lotus Flowers*, undated, 19th century. Twelve-panel folding screen; ink and color on paper, each panel 103.3 × 32.5 cm. Leeum Museum of Art.

FIG. 170 *Happy Life
of Guo Ziyi (Fenyang)*,
19th century. Eight-
panel folding screen;
ink and color on silk,
overall dimensions
165.9 × 388 cm. National
Palace Museum of
Korea (Gogung 2591).

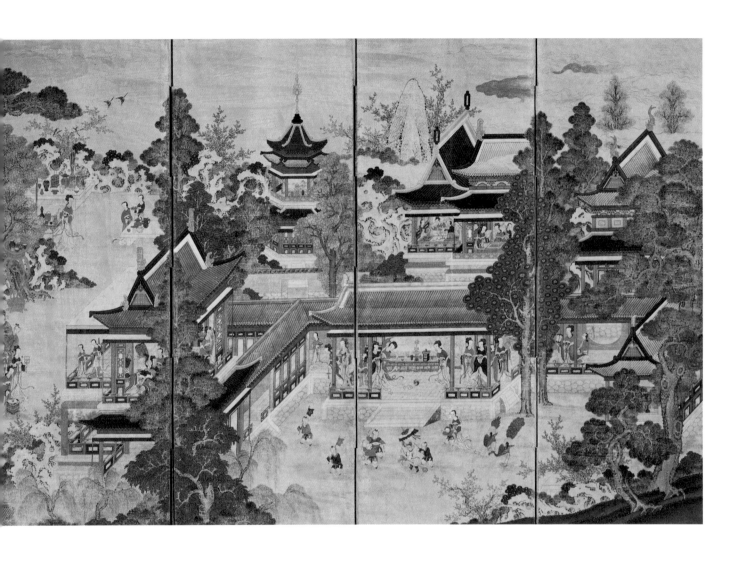

flowers, and finally, to the lotus pods and withered leaves. This representational tradition in Chinese painting can be seen in the handscroll painting by Chen Chun (1483–1544) of the Ming dynasty, currently in the Nelson-Atkins Museum of Art, Kansas City, Missouri. Fish of several different species, many in pairs, are represented swimming close to the surface of the pond, while in the air, birds are seen mostly in pairs, symbolizing conjugal happiness. The lotus pods in the last section of the screen represent wishes for many offspring. With all the symbolism associated with lotus flowers, they are a fitting subject for bridal screens.

Happy Life of Guo Ziyi (Fenyang) Screens
This screen began to appear in royal wedding *uigwe* in 1802. My discovery of its appearance in that royal wedding scene occurred in 1994, when I first conducted research on the royal wedding-related *uigwe* of the Joseon dynasty.[57] A fine example of this screen would be the *Happy Life of Guo Ziyi (Fenyang)* (*Gwak Bun-yang haengnak dobyeong*) (fig. 170) in the National Palace Museum of Korea. It is relatively large in size among surviving examples.[58] This eight-fold screen depicts the successful career and happy life of the Tang dynasty general Guo Ziyi (697–781), who subdued the An Shi Rebellion in 755[59] and received from Emperor Suzong (r. 756–762) the title of King of Fenyang for his military valor. Therefore, he is referred to as Guo Fenyang more frequently than as Guo Ziyi, especially in Korea. For this reason, we will use the title Happy Life of Guo Fenyang when referring to paintings of Guo Ziyi, who led a long and prosperous life until the age of eighty-five. His eight sons and seven sons-in-law were also successful in their careers and had numerous grandchildren and great-grandchildren.[60] It is, then, an ideal subject for a screen to adorn the surroundings of a royal bride-to-be.

[170]

Before its appearance as a screen painting used for royal weddings, some form of the Happy Life of Guo Fenyang apparently existed as early as the beginning of the eighteenth century, as evidenced by King Sukjong's two colophons to a painting of that title, datable to 1701–1704 and now preserved in the *Collections of Successive Kings' Compositions* (*Yeolseong eoje*).[61] The story of Guo Fenyang was introduced to Korea through novels written in *hangeul* in the eighteenth century.[62] The Happy Life of Guo Fenyang stayed on the list of wedding screens until the end of the dynasty, as seen in the following:

 1802 eight-panel screen mounted in *waejang* style (venue unspecified)

1819 large screen for the bridal detached palace

1837 large eight-panel screen mounted in *waejang* style
 for the bridal detached palace

1844 large eight-panel screen mounted in *waejang* style
 for the bridal detached palace

1851 eight-panel screen mounted in *waejang* style for the
 bridal detached palace

1866 two large eight-panel screens mounted in *waejang* style
 for the bridal detached palace

1882 ten-panel screen mounted in *waejang* style for the bridal
 detached palace

1906 two screens of unspecified size for the bridal detached
 palace

In this context, it is useful to cite the appearance of the subject in the list of painting subjects given to a special group of painters called "painters-in-waiting at Kyujanggak" (*Gyujanggak jabidaeryeong hwawon*) for their quarterly test for higher emolument (*nokchwijae*) from 1783 to 1879. These themes are culled from the *Daily Calendar of the Kyujanggak* (*Naegak illyeok*).[64] Happy Life of Guo Ziyi of Tang appears for the first time in 1834 (Sunjo 34), and again in 1873 (Gojong 10) as Guo Fenyang and One Hundred Children. Like Lotus Flower screens, most of the Happy Life of Guo Fenyang screens were designated for use in the special residence (detached palace) of the royal bride-to-be.

Iconography and Compositional Elements The image of Guo Ziyi (posthumously Prince Zhongwu of Fengyang, hence he is also referred to as Guo Fengyang) as a symbol of fortune and happiness is exemplified in a New Year's painting of the Qing period called *A Table Full of Scepters* (Ch. *Wanchuanghu*; Kr. *Mansanghol*). This painting shows Guo and his wife in a palatial setting seated on either side of a table in front of which is a couch full of jade scepters (*hol*) that their eight sons and seven sons-in-law placed as insignias of their official ranks. Jeong Yeong-mi considers this particular image to be the origin of the central portion of the Guo Fenyang screen paintings in Korea.[65] The Guo Fenyang theme existed in Chinese painting under the title The Birthday Celebration of Guo Ziyi (Ch. *Guo Ziyi zhushou tu*, Kr. *Gwak Ja-ui chuksudo*), but not in the same composition and medium as Korean screens.[66] The Chinese versions are mostly lacquered screens with dominant architectural elements in the composition,[67] whereas Korean screens are done in ink and colors on silk.

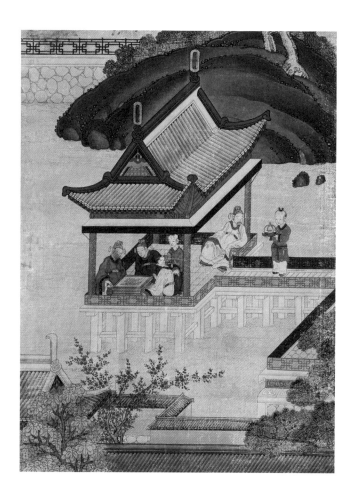

FIG. 171 The "Four Old Men of Shangshan" playing a game of *weiqi*. Detail of panel 7 of *Happy Life of Guo Ziyi (Fenyang)* (fig. 170).

FIG. 172 The "Four Old Men of Shangshan" playing a game of *weiqi*, after the illustration of Li Bai's "Summer Day" from *Tangshi huapu* published by Huang Fengchi, 1621. Woodblock printed album, 35 × 22.8 cm.

Korean screens of the Happy Life of Guo Fenyang generally show three distinct scenes in one. The first is the banquet scene, set in a large mansion against a blue-and-green landscape background. Guo is shown in the center of the composition, prominently positioned under a white tent pitched against the backdrop of pine trees (panels 4–6). He is surrounded by many people, and is entertained by dancers in the foreground. Guo's eight sons on the left and seven sons-in-law on the right are shown standing, prominently wearing official costumes complete with black silk hats.

The second distinct scene is to the right of this one. Guo's wife looks at the center scene from a separate pavilion along with her attendants (panels 2–4). The directions of her posture and gaze toward the center scene serve as the unifier of the two separate scenes in the composition. To the right of her pavilion, the courtyard of the mansion is seen with several ladies and, to be faithful to the story of the couple having numerous grandchildren and great-grandchildren, many children are found engaged in various kinds of play.

[171] The third identifying scene shows four guests playing the game *weiqi* in a small pavilion on the far left (panel 7; fig. 171). They are the "Four Old Men of Shangshan" (Shangshan sihu) — Dongyuan gong, Xiahuang gong, Lu Li xiansheng, and Qi Liji — who led a life of eremitism during the last phase of the Qin dynasty of China but later became teachers of the emperor Han Huidi (r. 195–188 BCE). The iconography was borrowed from the illustration of the renowned Tang poet Li Bai's poem,
[172] "Summer Day" in *Tangshi huapu* (fig. 172).[68] As for the inclusion of this theme in this painting, Jeong Yeong-mi interprets the idle atmosphere of the four hermits metaphorically, as recalling the period of Guo's exile due to the accusation of the eunuch Yu Chaosi just before the Uyghur invasion in 765, which Guo was able to subjugate.[69]

Jeong Yeong-mi also enumerated the plants and birds scattered all over the painting that add to the wishes for longevity and happy life.[70] In addition to the pine trees behind Guo's tent, a pair of deer can be seen at the top of panel 7, a pair of cranes on panel 6, peonies to the left of Guo's tent, a bamboo grove above the tent beyond the pine trees, and a pair of peacocks in the courtyard behind Lady Guo's pavilion where children are at play. To the far left, near the top, a cascade of waterfalls can be seen against the blue-green rocky boulder (panel 8). Bands of auspicious clouds in the sky float above the entire scene.

As for the painting style of the background, it shares the typical blue-and-green landscape style of the Ten Symbols of Longevity paintings or the Xiwangmu's (Seowangmo) Banquet at the Turquoise Pond Garden (*yojiyeondo*) paintings.[71] The architectural drawings of the pavilions show

the precise line drawing of the "ruled-line" painting tradition imported from China in the early Joseon period. In chapter 10, I discuss the tradition of "ruled-line" painting going back to the sixteenth century in Korea (see fig. 203).

[203]

As with all other screens produced in the palace, it is difficult to single out a particular painter, as these screens were produced in the superintendency where a group of artists work together. However, in the 1802 wedding when the Happy Life of Guo Fenyang screen first appeared, among the painters who worked for that occasion we find the name of Kim Deuk-sin (1754–1822), who, along with Kim Hong-do, was one of the best painters of the period.[72] Also, there is a scroll painting titled *Guo Ziyi [Fenyang] with Eight Sons and Seven Sons-in-Law* in ink and light color "signed" by Kim Hong-do (fig. 173), but Jin Jun-hyeon considers it not to be an authentic work of Kim.[73] Nevertheless, the composition of this scroll, from right to left, contains all the major elements seen in screen painting, testifying that in the Bureau of Court Painting, this composition was prevalent.

[173]

It is important to emphasize the fact that Happy Life of Guo Fenyang screens were produced to be placed in the bridal detached palace where the bride-to-be stayed, the better to educate her in the life and decorum of the palace, from the day she was selected to be the queen or crown princess until the wedding day. For the eight occasions I determined from the wedding *uigwe* listed above, the venue specified in all was the bridal detached palace except for two (where the screen's display venue was not specified). As we have seen in our discussion of the Ten Symbols of Longevity screens, the screens placed in the wedding ceremony hall are mostly Ten Symbols of Longevity or Flowers and Grasses, never a Happy Life of Guo Fenyang.

In connection with the screen of the Happy Life of Guo Fenyang, as is listed in table 9.2, under the 1844 wedding of King Heonjong, we find that along with the Guo Fenyang screen, another small screen of Xiwangmu's Banquet at the Turquoise Pond Garden was also sent to the bridal detached palace.[74] The same screen appears in the wedding ceremony of King Heonjong and his concubine, Gyeongbin Gim, in 1847 at which occasion the above two screens were paired and sent to the bridal detached palace. No *uigwe* was produced at this time, but the wedding was recorded in a *hangeul* diary.[75] Seo Yoonjung also discovered that at the weddings of the two princesses, namely, Sukseon Ongju in 1804[76] and Bogon Gongju in 1830, a screen of Xiwangmu's Banquet at the Turquoise Pond Garden was also produced.[77] At both weddings, no *uigwe* were produced, but records were kept in the form of *deungnok*.[78]

TABLE 9.2

Like the Guo Fenyang screen, the screen of Xiwangmu's Banquet at the Turquoise Pond Garden seems to have joined the group of wedding screens in the early nineteenth century. The protagonist, Xiwangmu, the Queen Mother of the West, invited King Mu (r. 976–922 BCE) of China's Zhou dynasty to her abode by the Turquoise Pond on Mount Kunlun for a sumptuous party, at which the eight Daoist immortals as well as Buddhist figures were present. The subject, like the screen of Ten Symbols of Longevity, is a typical Daoist allusion to longevity. Woo Hyunsoo attributes the appearance of Daoist themes in the heavily Neo-Confucian oriented Joseon court to the economic and cultural revitalization after King Jeongjo's reign (1776–1800).[79] But the screen of Xiwangmu's Banquet at the Turquoise Pond Garden was used only at one royal wedding of a queen-to-be, and the rest of the occasions were either the wedding of a royal concubine or princesses, that is, events considered "minor" in the scale of Joseon royal wedding rites.

Seo Yoonjung argues that at the royal weddings of the Joseon period, although musicians with instruments were present, they did not actually play the music, according to the regulation of "presented, but did not play" or *jinibujak*. Therefore, the scenes of playing music in the two screens take the place of an actual musical performance.[80] But what is not certain in this case is that the screens of Guo Fenyang and of Xiwangmu's Banquet at the Turquoise Pond Garden were used only in the bridal detached palace, where there is no banquet that would require musical performances. For this reason, it is safe to conclude that they were there simply for good wishes and colorful interior decoration for the bride.

Guo Ziyi, king of Fenyang, had become a symbol of longevity and happiness in late Joseon Korea. The iconography of the screen painting is a combination of several different elements that originated in China, and the blue-and-green style of landscape painting also has roots in Chinese paintings of the Ming and Qing periods. However, as in the case of the Ten Symbols of Longevity screens, the blue-and-green landscape setting and the subject itself, along with other compositional elements borrowed from China, were appropriated by Joseon court painters who created a uniquely Korean painting for use in the happy occasion of royal weddings.

Screen Paintings for Crown Princes

A group of screen paintings recorded to have been placed in the living quarters of crown princes can also be found in late Joseon banquet-related *uigwe*. The subjects of these screens include:

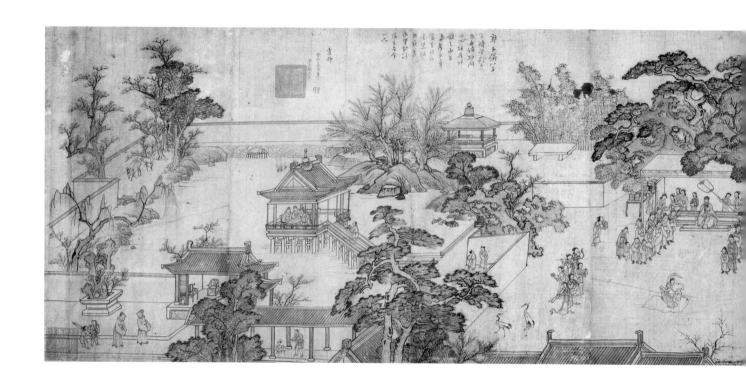

FIG. 173 Attributed to
Kim Hong-do (1745–
1806), *Guo Ziyi [Fenyang]
with Eight Sons and Seven
Sons-in-Law.* Handscroll;
ink and color on paper,
59.9 × 260.2 cm. National
Museum of Korea (Dong-
won 2628).

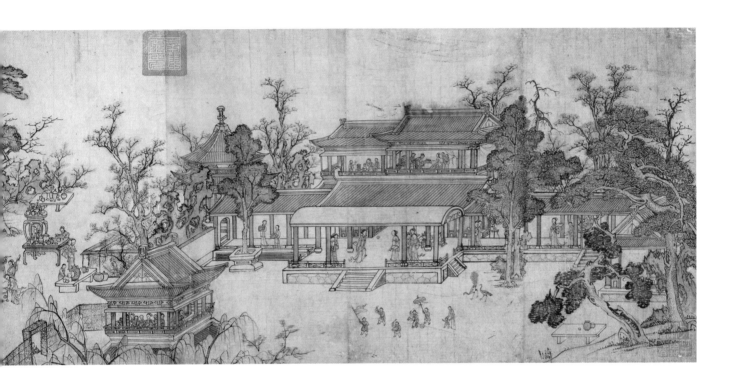

- One Hundred Children (*baekjadongdo*)
- Guo Fenyang and One Hundred Children
 (*Gwak Bun-yang baekjadongdo*)
- Ten Symbols of Longevity (*sipjangsaengbyeong*)
- Scholar's Paraphernalia (*munbangdobyeong*)
- Calligraphy (*seobyeong*)

Two themes related to the Happy Life of Guo Fenyang — namely, One Hundred Children and Guo Fenyang and One Hundred Children — belong to this group for obvious reasons. Only in rather rare cases do we see a Ten Symbols of Longevity screen used in the residence of the crown princes, after their respective weddings in 1727 and 1744. More important screens in this group are Scholar's Paraphernalia and Calligraphy. Calligraphy screens do not have any particular iconography, but could be items that add moral, intellectual, literary, and artistic flavor to the princely interiors through literary contents and calligraphic beauty.

One Hundred Children
The paintings of children playing in garden settings developed in China from the Northern Song period. The titles of such paintings are either *Yeonghuido* (Ch. *Yingxi tu*) or *Huiyeongdo* (Ch. *Xiying tu*) in which fewer than ten children are represented in various playful modes. Good examples of such works are those attributed to Su Hanchen (act. twelfth century).[81] Among the wedding-related *uigwe* of Joseon Korea, only for the 1819 wedding of Crown Prince Hyomyeong is there a record of a screen of One Hundred Children, installed in the bridal dressing room, as a wish for the bride to bear many children. It is not clear when the terms *baekja*, *baekjadong*, and *baekdongja* evolved, but it seems that in the late Joseon period the preferred term was *baekjadongdo*.[82]

Guo Fenyang and One Hundred Children
Since the theme of the Happy Life of Guo Fenyang has already been discussed, the iconography of this screen will not be repeated here. Presumably "one hundred children" was emphasized to describe this screen because it adorned the living quarters of a crown prince. Combining the two themes in one painting naturally happened in the nineteenth century because Guo Fenyang's grandchildren and great-grandchildren appear playing in the garden on the screen *Happy Life of Guo Ziyi (Fenyang)* [170] (see fig. 170, panels 2 and 3). Also, it should be noted that in the painting, the children are all boys, therefore fitting for a crown prince's room.

Ten Symbols of Longevity

This screen was recorded in wedding *uigwe* to have been placed in the wedding ceremony hall and the crown prince's residence on only two occasions: the wedding in 1727 of the Crown Prince Hyojang, posthumously elevated to Jinjong, and the wedding in 1744 of Crown Prince Sado (posthumously elevated to Jangjo).[83] No further explanation is given regarding the furnishing of the screen in the crown princes' residences.

Scholar's Paraphernalia

This subject matter, known in documentary contexts as *munbangdo* (painting of scholar's objects) or *chaekgado* (painting of scholar's book-cases),[84] is also known by its vernacular Korean form, *chaekgeori* (books and things). By the latter part of the nineteenth century, however, the term *munbang dobyeong* (screen painting of scholar's objects) had become more common. *Chaekgado* was also popularly used.[85] Because of the books in the painting, not only crown princes but even the scholarly King Jeongjo himself kept this type of screen in his private quarters, and is said to have found consolation in it for his lack of time to read books. This story, found in volume 162 of *Hongjae jeonseo* (*Collected Writings of Hongjae* [*King Jeongjo*]), and volume 20 of *Geumneung jip* (*Collected Writings of Geumneung*) by Nam Gong-cheol (1760–1840), has been quoted by all the writers on *chaekgado*.[86]

Compositional Elements and Painting Styles There are two basic compositional types: one with bookcases in which books and other items are neatly organized, as exemplified by Yi Hyeong-rok's (1808–after 1863) eight-fold screen, now in the Leeum Museum of Art (fig. 174); the other type, showing items piled up or placed near one another without bookcases, can be seen in the screen also by Yi Hyeong-rok called *Chaekgeori* (fig. 175) in the National Folk Museum of Korea, Seoul. Since both have Yi Hyeong-rok's "hidden seal" in the form of painted seals in the painting (panel eight, and panel one, respectively), it seems that the two different compositional styles existed side by side in court circles.[87] To be sure, the second style, without bookcases, was easily adopted by village artists who did not want to deal with a perspective system for drawing bookcases.

Another type, also with bookcases, takes the illusion of space into another dimension: the eight-panel *chaekgado* of Jang Han-jong (1768–after 1815) in the Gyeonggi Provincial Museum (fig. 176) shows a bookcase filled with books and objets d'art in a beautiful way, through an opened drapery curtain of gold-colored silk embellished with double-happiness

[174]

[175]

[176]

FIG. 171 Yi Hyeong-rok (1808–after 1863), *Scholar's Paraphernalia (Munbangdo)*, 19th century. Eight-panel folding screen; ink and color on paper, 139.5 × 421.2 cm. Leeum Museum of Art.

FIG. 175 Yi Hyeong rok
(1808–after 1863), *Book-
case Painting* [without a
bookcase] (*Chaekgeori*),
before 1864. Six-panel
screen; ink and color
on paper, each panel
154.5 × 38.5 cm. National
Folk Museum of Korea,
Seoul (Minsok 45481).

characters (囍) in roundels. This outer drape is lined with a blue silky material that is exposed on the top and sides when the curtain is lifted.[88] On the last panel, we find a hidden seal reading "Jang han jong in" (fig. 177). Since he is primarily known as a painter of fish, crab, and shrimp, for his signature on this screen he used two small rectangular sections of ink paintings (a shrimp and withering lotus flowers) on panels 4 and 5 (fig. 178). It is a very clever and elegant way of placing his signature, a practice not found in any other artist's painting.

[177]

[178]

Although there is no *munbangdo* attributed to Kim Hong-do, in the *Hwajurok* (*Records of the Painting Cabinet*) by Yi Gyu-sang (1727–1799), it is recorded that Kim Hong-do painted *chaekga hwa* (bookcase paintings) applying Western perspectives, and upper-class families decorated their homes with such paintings.[89]

As the terms *munbangdo*, *chaekgado*, and *chaekgeori* suggest, these are paintings that show books and other items scholars use in their studios, such as brushes, ink, ink-stones, scrolls of paper, and seals. Added to these are scholars' collectibles, such as Chinese ceramic vases or bowls that hold rare plants and fruits (pomegranate, Buddha's hands), ancient Chinese bronzes, a small watch of Western origin hanging from a decorative string, peacock feathers in a vase, pieces of coral arranged in a vase, precious minerals, daffodils, ceramic carp, and more.[90] These items were mostly brought back to Korea by emissaries to the Qing court, many of whom recorded what they had seen in Yanjing and elsewhere in China. The emissaries left a large body of literature collectively known as *Yeonhaengnok* (*Records of Travel to Yanjing*), in which accounts of how the travelers encountered these items abound.

For example, Hong Dae-yong's *Yeongi* (*Record of Travel to Yanjing*) informs us of items he saw in the palace that were introduced to him by a salesman named Chang Geng. He saw paintings, an ancient bronze incense burner and incense container, and, next to it, a vase with numerous peacock feathers. His translator, Yi Deok-seong, a well-known court translator during the reign of King Jeongjo, wanted to buy a clock displayed on a table.[91] All of the items mentioned by the travelers can be found in *munbang dobyeong* (screen paintings of scholar's paraphernalia). Extensive comments on ancient Chinese bronzes can be found in Bak Ji-won's *Godongnok* (*Records of Curios*) contained in his famous *Yeolha ilgi* (*Yehol diary*), a section of which was quoted in chapter 8 in this book. Additionally, in *Yeonhaenggi* (*Travel Diary to Yanjing*, 1790) by Seo Ho-su (1736–1799), we find information on the different grades of peacock feathers — the three-to-one circle design at the tip — worn by the Qing emperor and officials of different levels.[92] Joseon emissaries

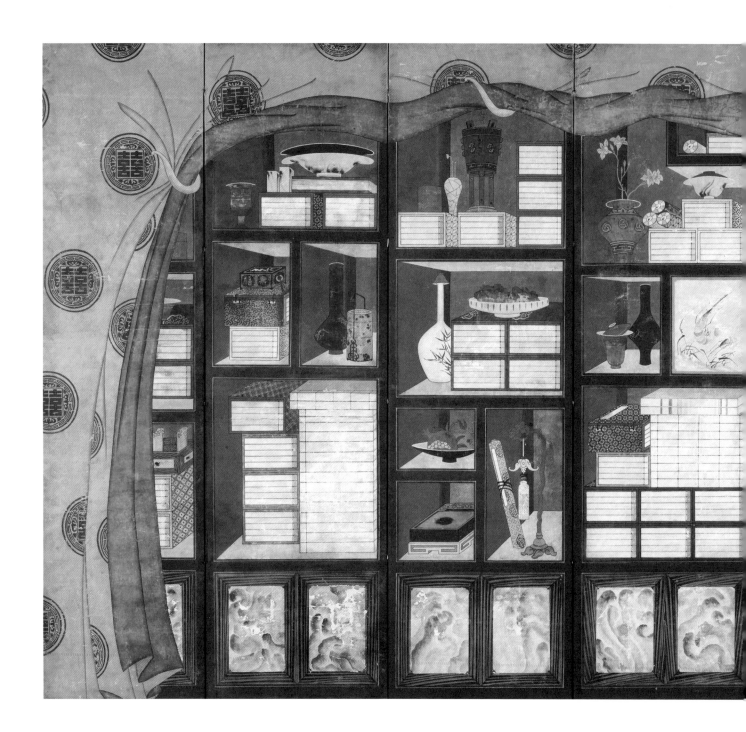

FIG. 176 Jang Han-jong
(1768–1815), *Bookcase
Painting* [with a book-
case] (*Chaekgado*), late
18th–early 19th century.
Eight-panel folding
screen; ink and color on
paper, overall dimen-
sions 195 × 361 cm.
Gyeonggi Provincial
Museum (Sojang 6672).

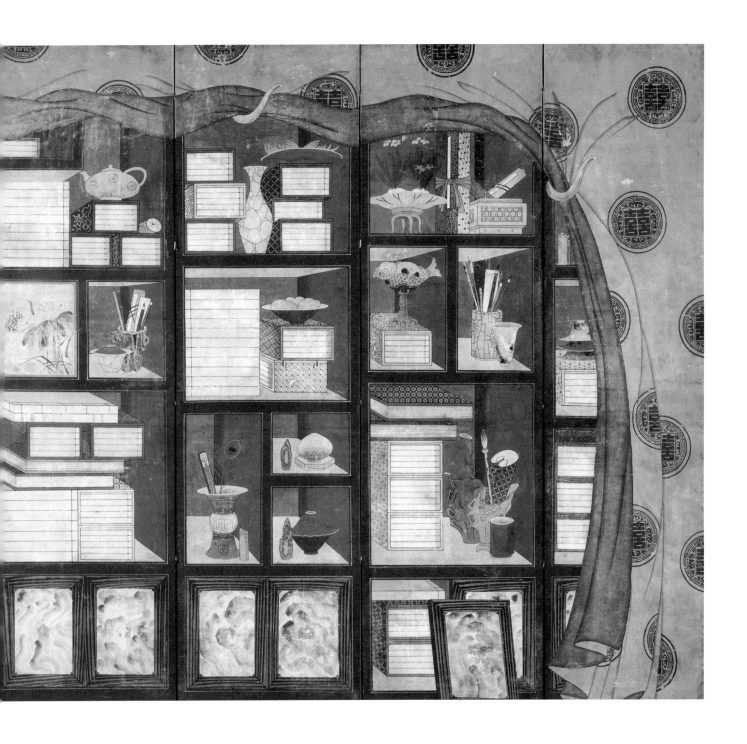

FIG. 177 Detail of panels 8–9 of *Chaekgado* (fig. 176) with the hidden seal "Jang han jong in" on a tray atop books next to the curtain on the left.

FIG. 178 Detail of panels 4–5 of *Chaek-gado* (fig. 176) with ink paintings of a lotus flower (right) and a shrimp (left).

are interested not only in objects themselves, but also in the regulations regarding Qing official costumes.

In recent years, partly due to the revival in Korea of interest in *minhwa* (folk art), exhibitions of *munbang dobyeong* in Korea and the United States have been organized by scholars in both countries. The first one in Korea was held at the Gyeonggi Provincial Museum in 2012,[93] and the second one, with the title *Chaekgeori: The Power and Pleasure of Possessions in Korean Painted Screens*, 2017, traveled to three venues in the United States: Stony Brook University, Stony Brook, New York; Spencer Museum of Art, University of Kansas, Lawrence, Kansas; and the Cleveland Museum of Art, Cleveland, Ohio. The titles of the essays in the 2017 exhibition catalogue reflect the new approaches to studies on the subject of *chaekgeori* and show how the objects of Chinese or Western origin depicted in the screens were interpreted in light of the late Joseon period's social, cultural, and material contexts.[94]

The following is a listing of *munbang dobyeong* as cited in the *Naegak illyeok*:

1784 (Jeongjo 8)	*chaekga* (bookcase)
1864 (Gojong 1)	*munbang* (scholar's studio/paraphernalia)
1865 (Gojong 2)	*munbang*
1867 (Gojong 4)	*munbang*
1868 (Gojong 5)	*munbang*
1870 (Gojong 7)	*munbang*
1872 (Gojong 9)	*munbang*
1873 (Gojong 10)	*munbang*
1875 (Gojong 12)	*munbang*
1876 (Gojong 13)	*munbang*
1878 (Gojong 15)	*munbang*
1879 (Gojong 16)	*munbang*

In the above list, the bookcase theme called *chaekga* in 1784 was changed to *munbang* in 1864, and remained as such until 1879, the last year of the *Naegak illyeok*'s recordings. *Munbang* is the only theme that appeared continuously from 1864 to 1879, indicating its popularity in late Joseon Korea.

The bookcase type seems to have been influenced by the *Duobao kejing tu (Treasure Cabinet)* attributed to Lang Shining (Giuseppe Castiglione, 1688–1766), an Italian Jesuit painter who worked at the Qing court (fig. 179). Korean *munbang dobyeong* also show the considerable influence of the Western perspective system and chiaroscuro seen here in their rendering

[179]

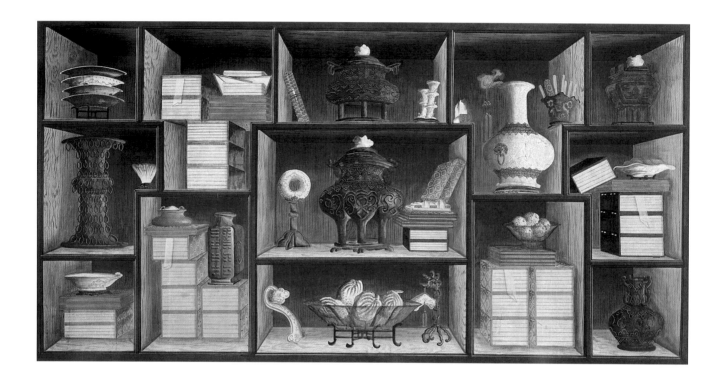

FIG. 179 Attributed to
Lang Shining (Giuseppe
Castiglione, 1688–1766),
*Treasure Cabinet (Duobao
kejing tu)*, 17th century.
Ink and color on paper,
124.5 × 245.4 cm. Private
collection, Florida.

of the depth and spatial arrangement of the bookshelves despite the two-dimensional limitations of the screen. In geometric perfection, however, the bookcase's perspective system is not quite a match to the Western one-point perspective system. The orthogonals do not converge on one vanishing point but rather on at least five vanishing points on the central axis of the screen.[95] Because of the screen's theme of reverence for scholarship, interest in things from advanced Qing culture, and adoption of the progressive Western painting style, it seems fitting to place *munbang dobyeong* in the living space belonging to crown princes, who are the hope of the country's future.

<div align="center">* * *</div>

Summing up, through *uigwe* records and other literary sources we have learned where and what kind of screen paintings were used in Joseon-period state rites. Depending on their subjects, each screen had its designated place and role to play in the respective rites. Moreover, each screen's iconography offers pictorial evidence of late Joseon art and culture. The Five Peaks and the Peony screens, both of which were used for the king (the latter for the palace ladies also), proved to be the only ones used throughout the Joseon dynasty.

Screen Paintings for Palace Banquets

From *uigwe* texts dating to the mid-eighteenth to early twentieth century, we find eight instances where a screen painting (sometimes in multiple copies) was commissioned to record in pictorial form the banquet segment of a court event. Some of these painted screens still survive in museum collections today, and we can match them to their mention in the *uigwe* texts by title, year of event, and format (table 9.3). This chapter ends with an examination of a typical screen showing the scene of a typical royal banquet. It is the screen of the 1887 court banquet that celebrated the seventy-ninth birthday (*palsun*) of Dowager Queen Sinjeong (1808–1890).[96]

TABLE 9.3

[180]

Palace Banquet of the Jeonghae Year, 1887
The event represented on this screen is recorded in the four-volume *Uigwe of the Palace Banquet of the Jeonghae Year (Jeonghae jinchan uigwe)*, 1887.[97] The ten-panel screen painting, *Palace Banquet of the Jeonghae Year (Jeonghae jinchan dobyeong)*, is one of the most grandiose and well-preserved among palace banquet screens (fig. 180). The banquet celebrated the Dowager Queen Sinjeong (also known as Jo Daebi [Queen Mother Jo]), who was the

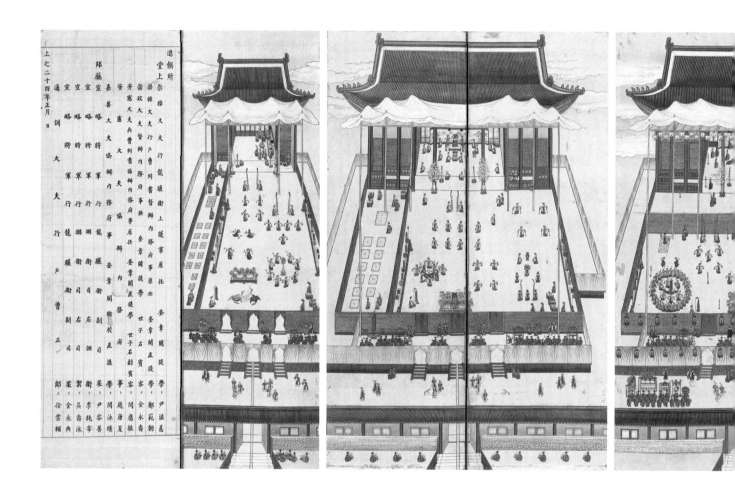

進饌所

堂上崇祿大夫行龍驤衛上護軍原任奎章閣提學尹滋悳

崇祿大夫行戶曹列書皆辦內務府事兼奎章閣直提學鄭範朝

資憲大夫行戶曹列書皆辦內務府事兼奎章閣提學世子右賓客金永壽

資憲大夫兵曹列書協辦內務府事原任奎章閣直提學世子右副賓客閔應植

嘉善大夫協辦內務府事奎章閣直提學事趙康夏

嘉善大夫協辦內務府事奎章閣檢校直提學閔泳緩

郎廳宣略將軍行龍驤衛副司果尹關善

宣略將軍行�衛副司果尹純宰

宣略將軍行朔衛右司禦李壽宰

宣略將軍行朔衛右司禦吳壽泳

通略將軍行龍驤衛副司果金永典

上之二十四年正月日
訓戶曹正 郎廳徐雲輔

大夫行戶曹正

FIG. 180 *Palace Banquet of the Jeonghae Year (Jeong-hae jinchan dobyeong),* 1887. Ten-panel folding screen; ink and color on silk, each panel 147 × 48.5 cm. National Museum of Korea (Deoksu 6184).

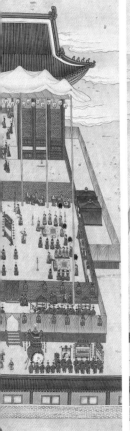

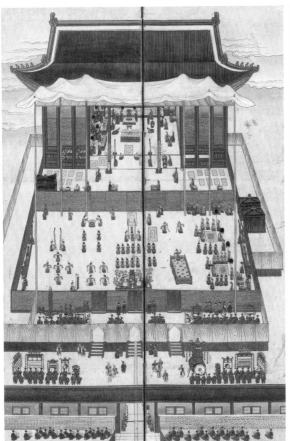

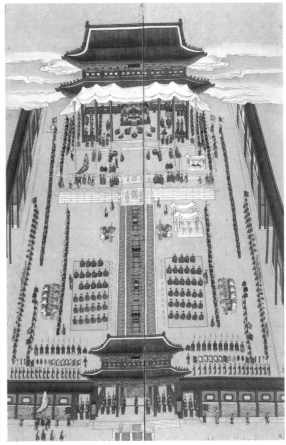

TABLE 9.3 Screen Paintings for Palace Banquets in the Late Joseon Period

YEAR	TITLE OF SCREEN	EVENT	FORMAT	COLLECTION(S)
1765	*Yeongjo euryu giro yeon / Gyeonghyeondang sujagyeon dobyeong*	Palace banquet for the elder officials given by King Yeongjo at Gyeonghyeon Hall in the Euryu year	8 panels	Seoul History Museum[1]
1795	*Hwaseong wonhaeng dobyeong*	Detached palace banquet for King Jeongjo and his mother's trip to Hwaseong Fortress	8 panels	Four copies: National Museum of Korea; National Palace Museum of Korea; Leeum Museum of Art; Uhak Foundation for Culture, Yong In University Museum
1829	*Gichuk jinchan dobyeong*	Palace banquet of the Gichuk year	8 panels	Two copies: National Museum of Korea; Leeum Museum of Art
1848	*Musin jinchan dobyeong*	Palace banquet of the Musin year	8 panels	Jeonju National Museum
1868	*Mujin jinchan dobyeong*	Palace banquet of the Mujin year	8 panels	Los Angeles County Museum of Art[2]
1887	*Jeonghae jinchan dobyeong*	Palace banquet of the Jeonghae year	10 panels	Two copies: National Palace Museum of Korea (first version); whereabouts unknown (second version)
1901	*Sinchuk jinchan dobyeong*	Palace banquet of the Sinchuk year	10 panels; 8 panels	Two copies: National Palace Museum of Korea (10 panels); a copy is in Yonsei University Museum, Seoul (8 panels)
1902	*Imin jinchan dobyeong*	Palace banquet of the Imin year	10 panels	National Center for Korean Traditional Performing Arts, Seoul

1 This was a court banquet of modest scale held in 1765 (Yeongjo 41) and documented in the *Uigwe of Receiving Wine-Cup Offerings in the Euryu Year (Euryu sujak uigwe)*. In 1765 King Yeongjo turned seventy-one, and in Korea this age is called *mangpal* (looking up to the age of eighty). The crown prince (Yeongjo's grandson, later King Jeongjo) and high officials at court repeatedly asked Yeongjo to hold a court banquet to celebrate the occasion, but the king, for reasons of frugality, refused their wishes, ultimately accepting the most modest scale of the court event called *sujagyeon*, "receiving wine-cup offerings," on the eleventh day of the tenth month. In the *uigwe*, there is no mention of a screen painting produced after the event. Documentary evidence concerning this screen points to a possible attribution of the painting to Kim Hong-do (1745–1806), although this is not universally accepted. This screen was first introduced by Kim Yang-gyun, "Yeongjo euryu giro yeon • Gyeonghyeondang sujagyeon dobyeong ui jejak baegyeong gwa jakga," *Munhwajae bojon yeongu* 4 (2007): 44–69. Kim leans toward the authorship of Kim Hong-do, although Park Jeong-hye considers that almost impossible. For Park's essay, see Yi, *Yeongjo dae ui uigwe wa misul munhwa*, 174n116.

2 This screen was introduced for the first time in Yi, "Joseon hugi jinjak jinyeon uigwe reul tonghae bon gungjung ui misul munhwa," 139–141, along with the illustrations of the scenes on the screen juxtaposed with the same illustrations in the *uigwe*. For the first introduction of this screen in English, see Jungmann, "Documentary Record," 95–111.

most powerful lady of the court. She was the mother of King Heonjong and the wife of King Sunjo's first heir apparent (Crown Prince Hyomyeong, 1809–1830), who died before he was enthroned but posthumously was given the title King Ikjong in 1834, when Sunjo's second heir apparent, King Heonjong, was enthroned. In addition to this banquet, two other banquets were held in the dowager queen's honor: the first was in 1848, to celebrate her fortieth birthday;[98] the second was in 1868, for her sixtieth birthday. *Uigwe* were produced for all three occasions, along with large-scale screen paintings.[99]

One might wonder why the Joseon court, so frugal when it came to deciding whether to compile a *uigwe* for a certain event, chose to produce for Dowager Queen Sinjeong not only three *uigwe* (1848, 1868, and 1887) but also large-scale court banquet screens. The position of Dowager Queen Sinjeong in late Joseon history should be explained in the context of the so-called in-law government (*sedo jeongchi*). When King Jeongjo was succeeded by King Sunjo, who was only ten years old, King Sunjo's father-in-law, Kim Jo-sun (1765–1832) of the powerful Andong Kim clan, took advantage of the situation by filling all the influential positions at court with Andong Kim men. This was challenged when King Heonjong (r. 1834–1849) succeeded Sunjo, and the mother of Heonjong, Dowager Queen Sinjeong, came to the fore as the daughter of another powerful official, Jo Man-yeong (1776–1846) of the Pungyang Jo clan. Jo Man-yeong was instrumental in changing the political scene put into place by the Andong Kim clan.

When King Cheoljong (r. 1849–1863), who succeeded Heonjong, died without an heir, Dowager Queen Sinjeong (Heonjong's mother), then the eldest lady in the royal family, had the power to select the next king. She approached Heungseongun, the great-great-grandson (*hyeonson*) of King Yeongjo, an ambitious royal relative famous for his ink orchid paintings. She asked him — and he agreed — to allow his second son to be adopted as son to her and her long-deceased husband, Crown Prince Hyomyeong. The boy of twelve thus ascended the throne as King Gojong (r. 1863–1907), and Dowager Queen Sinjeong was able to exercise her power at court in the form of "regency from behind the bamboo curtain" (*suryeom cheong-jeong*).[100] Heungseongun assumed the title of regent, and was referred to as Heungseon Daewongun. Together with Dowager Queen Sinjeong, he embarked on the rebuilding of the Gyeongbok Palace, which had been destroyed during the Japanese invasion at the end of the sixteenth century. For the dowager queen, this was a fulfillment of her late husband's wish, and the 1868 and 1887 banquets in her honor were held in the newly reconstructed Gyeongbok Palace.

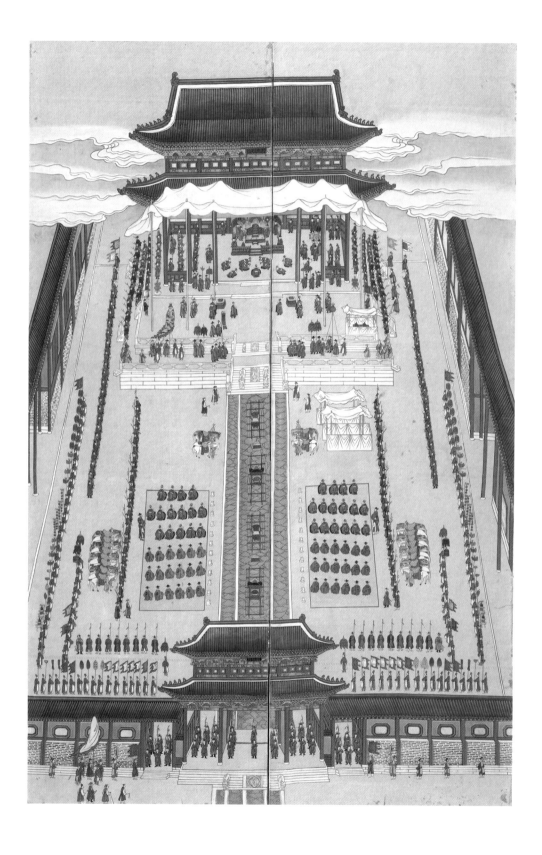

The 1887 banquet lasted for three days, from the twenty-seventh to the twenty-ninth day of the first month, and two banquets were held per day, one during the day and another in the evening. All these banquet scenes were illustrated in the *uigwe* in woodblock prints as well as in the screen painting. The *uigwe* contains eighty-two illustrations, which include the banquet scenes as well as the scenes of performances collectively called *jeongjae* (presented performances). It also includes seven pages showing all the flowers made of silk that were used throughout the banquet to decorate either the halls or the food tables. Because of the detailed record they provide, the *uigwe* illustrations are very important for understanding the scenes of the painted screen.

Although the *uigwe* does not indicate how many sets of the *gyebyeong* screens of this 1887 banquet were produced after the event, two nearly identical versions of this screen survive, one in the National Palace Museum of Korea and the other published in a Sotheby's auction catalogue in 1996.[101] Panels 1 and 2 (fig. 181) depict a scene of the congratulatory ceremony for King Gojong in Geunjeongjeon (the throne hall), "Geunjeongjeon jinchando," held before the banquet began. Under the eaves of the majestic roof of the throne hall, a white tent was pitched in front and the red throne in the center was placed in front of a Five Peaks screen. The king's image is not shown, as is customary in Joseon documentary paintings, but the Five Peaks screen and the throne together signify that he was present at the scene.

On panels 3 and 4, the first of the banquets in the Mangyeongjeon hall, "Mangyeongjeon jinchando," is depicted (fig. 182). The Dowager Queen Sinjeong, Queen Mother Jo's royal seat is visible in front of a large Ten Symbols of Longevity screen. In front of her royal seat is a large table filled with dishes with layers of food stacked up to form a conical shape that is topped with flowers. In panel 4, female entertainers are seen performing the dance called *monggeumcheok*, a celebration of King Taejo's dream (*mong*) in which he received a golden ruler (*geum cheok*) from a divine spirit who told him to rule the country with it.[102] To their left, in panel 3, another performance, called *museonhyang* is in progress in which a dancer performs on a raised, oblong podium covered with leopard pelts. Musicians are seen at the bottom of the scene, where on the right a large drum is shown in perspective. On either side of the drum are two sets of percussion instruments, *pyeonjong* (bronze bells) and *pyeongyeong* (flat chimes of stone or jade), hanging from their respective two-tiered wooden frames.[103]

Panels 5 and 6 represent the scene of the nighttime banquet in the Mangyeongjeon hall called "Mangyeongjeon yajinchando" (fig. 183);

[181]

[182]

[183]

FIG. 181 Congratulatory ceremony in the Geunjeongjeon ("Geunjeongjeon jinchando"). Panels 1 and 2 of *Palace Banquet of the Jeonghae Year* (fig. 180).

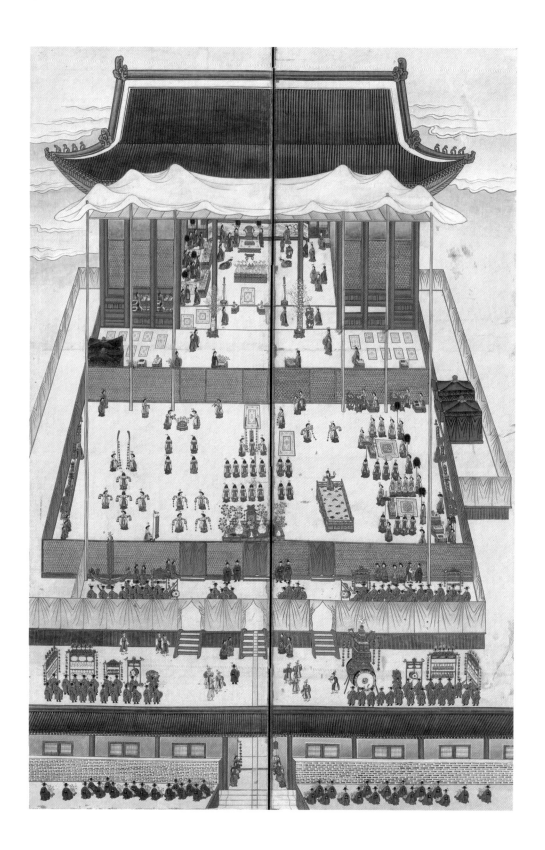

FIG. 182 Banquet in the Mangyeongjeon hall ("Mangyeongjeon jinchando"). Panels 3 and 4 of *Palace Banquet of the Jeonghae Year* (fig. 180).

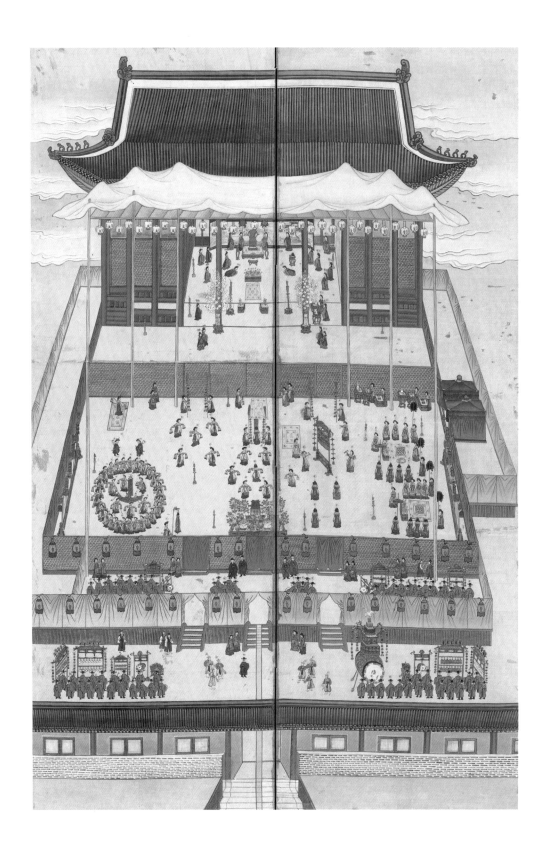

FIG. 183 Nighttime
banquet in the
Mangyeongjeon hall
("Mangyeongjeon
yajinchando"). Panels
5 and 6 of of *Palace
Banquet of the Jeonghae
Year* (fig. 180).

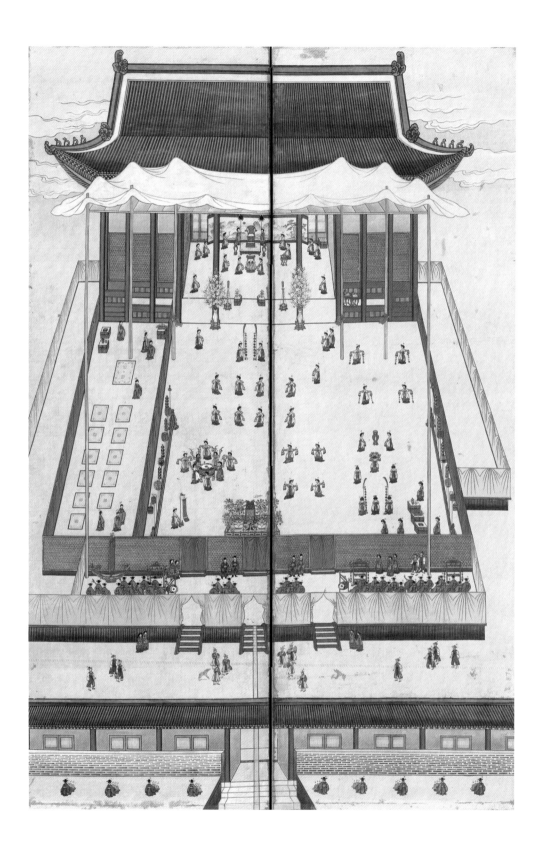

FIG. 184 Offering of wine cups in the Mangyeong jeon hall ("Mangyeong-jeon igil hoejakdo"). Panels 7 and 8 of *Palace Banquet of the Jeonghae Year* (fig. 180).

FIG. 185 Drum dance
(*mugo*), page 24 of the
*Uigwe of the Palace
Banquet of the Jeonghae
Year* (*Jeonghae jinchan
uigwe*), 1887. Printed
book; 37.2 × 24.4 cm.
Kyujanggak Institute for
Korean Studies, Seoul
National University

FIG. 186 Silk-and-wire
flower arrangement in
a blue-and-white vase,
page 31 of the *Uigwe of
the Palace Banquet of the
Jeonghae Year* (*Jeonghae
jinchan uigwe*), 1887.
Printed book; 37.2 ×
24.4 cm. Kyujanggak
Institute for Korean

FIG. 187 Family
members in front
of a banquet screen,
late 19th-century
photograph.

lanterns light the banquet hall, indicating that it is nighttime. The star performance in this section is the "pleasure of a boat ride" (*seonyurak*) in the lower left of the panel 6. An outer circle of twenty-eight female dancers and an inner circle of six dancers surround the boat in the center of which two girls perform as though rowing the boat. The illustration of the same scene in the *uigwe*[104] shows the basic composition for this group as painted on the screen.

[184]

Panels 7 and 8 depict the simpler banquet of offering wine cups in the Mangyeongjeon hall the following day, called "Mangyeongjeon igil hoejakdo" (fig. 184). Prominent in this banquet is the *mugo* (drum dance), in which eight performers circle a large drum and hit it while dancing.

[185]

The matching illustration in the *uigwe* is shown in figure 185. Panel 9, with the title "Mangyeongjeon jaeigil hoejakdo," represents in a narrow format yet another, simpler offering of wine cups on the third and last day

[180]

of the event in Mangyeongjeon. The inscription, on panel 10 (see fig. 180), provides us with the date and the names of nine important officials who were responsible for the planning and execution of the banquet, headed by Yun Ja-deok (1827–1891), a high official in the progressive reorganization of government practices of the 1880s.[105]

The flowers used for adornment of all the palace halls and food tables are called *sagwonhwa*, artificial flowers made of fine hemp or silk held together with fish glue and silver or bronze wires. On large flower arrangements, stuffed real birds were placed for extra decorative effect. Silk flowers also adorn the heads of the dancers. These flowers are all illustrated in the *uigwe*, shown either in bunches or single sprays, or arranged in a large blue-and-white ceramic jar decorated with floral

[186]

motifs, known as a *junhwa* (fig. 186). According to the *uigwe*, a total of 14,090 blossoms were used in the banquets, and the total expense for them was 12,101.5 *ryang*, or about three percent of the entire expense of the banquet, which was 339,393 *ryang*.[106]

Although this particular *uigwe* does not record how many copies of the screen painting for the 1887 banquet were produced, the high officials who participated in the event, and whose names were in the inscription on the last panel of the screen, were most likely the ones who were awarded the *gyebyeong* versions of the banquet to share among themselves. A late nineteenth-century photograph shows the proud family members of one of the awardees of a similar screen posing together

[187]

in front of it (fig. 187).[107] In modern-day Korea, because scenes of royal banquets taken from old paintings were copied and enlarged onto a screen to be placed in the hall for state dinners at the Blue House (presidential mansion), late Joseon palace banquet scenes have become quite

familiar. More specifically, the circular dancing scene of the "pleasure of a boat ride" often serves as a backdrop to the spot where the two heads of state exchange congratulatory toasts, a scene that would be televised on the major evening news. This is a case of a recreated Joseon artwork finding its appropriate place in contemporary Korean culture.

* * *

The above analyses of the specific roles of palace screen paintings in important state rites were based on *uigwe* and other historical writings and documentary evidence, but above all it was through *uigwe* that we were able to distinguish the palace screens from *minhwa*, or folk paintings. Kim Su-jin's PhD dissertation revealed an interesting fact about the palace screens lent by the superintendency or by the palace steward's office (*jeyonggam*) to the upper-class homes for their family events such as weddings and funerals. This practice led to the popularization of the court customs in the late Joseon period.[108] All subject matter of palace screens except for the palace banquet screens was painted in a smaller scale by village painters and were circulated among the general population during the late Joseon period. They show creativity and charm in their own way, and for that very reason, *minhwa* continue to thrive in the modern Korean art scene.

Due to the destruction of all the Joseon palaces, we know little about how the living quarters of Joseon royal families were decorated. A more in-depth study of literature left behind by those who were close to the palace environment would shed light on the general interior decoration of Joseon palaces. Earlier, I quoted the story of King Jeongjo, who recorded in his own diary the depiction of a bookcase screen painting in his living quarters, and the same story appeared in the collected writings of Nam Gong-cheol, a close subject of the king. We await revelations of more such cases in the future. ◆

CHAPTER TEN

Joseon Court Painters, Artisans, Entertainers, and Other Workers

The previous chapters on various categories of *uigwe* have shown us that the amount of information on Joseon art and culture in them is quite overwhelming. This chapter will examine how the information on artists, scribes, artisans, female entertainers (*yeoryeong*), and other workers who served in various capacities in state rites has further expanded and enriched our knowledge and understanding of Joseon arts and crafts, and their status in Joseon society.

Duties of Court Painters, Artisans, and Other Workers

Names of painters and artisans are listed mainly in two sections within *uigwe*. The first is variously called "List of Artisans" (*gongjangjil*), as in a page from the *Uigwe of the Wedding of King Yeongjo and Queen Jeongsun*, 1759 [188] (fig. 188), or "List of Artisans of Various Trades" (*jesaek janginjil*), as in a page from the *Uigwe of the Wedding of the Crown Prince [later King Gyeongjong]* of [189] 1696 (fig. 189). This list includes not only artisans arranged by their trade, but also all painters and scribes who worked with them on a particular court rite. This makes it clear that the court painters were regarded to be on the same level as other artisans, although royal portrait painters were treated somewhat differently. This low regard for court painters stemmed from Confucian literati ideas that considered skills in painting and art in general as lowly crafts (*cheongi*).[1] However, in both theory and practice, the Bureau of Court Painting (Dohwaseo) was an office belonging to the Ministry of Rites with rank 6b (*jong yukpum amun*). Court painters who were recruited through examinations from the fifteenth century on belonged to this office, and two painters out of the twenty recruited were given rank 6b, which is not so low in the total scale of the 9a–b rank system of Joseon bureaucracy.[2]

The lists of artisans appear under separate subdivisions, or *bang*, in the *uigwe*. The second section is the "Award Regulations" (*sangjeon* or [190] *nonsang*) (fig. 190), which lists not only the painters and artisans, but all officials, from the superintendent down to the lowest-ranking persons

一玉匠 李以珎　金三峯　李開川

一笠匠 鄭鳳　俞共仁　崔昌海
　　　 姜黙　金得祥　金繼賢

一權爐匠 姜孝業　李貴里
　　　　 姜善元　張天立　張若大

一小木匠 朴京男　張吉　金承貴
　　　　 朴德建　李戒善　趙五正　李壽正

一雕刻匠 張天命　咸白男　金五龍

一小爐匠 李承善　金命雲　李生必
　　　　 吳仁石　劉萬一　劉起天
　　　　 張莫龍　金貴天

工匠秩

畫　員鄭德弘

小木匠金日柱
金省五　以上圖畫署

金善昌

小爐匠李昌元
廉德山　以上內需司

姜成興
徐大夢
金世中　以上內需司

豆錫匠張後先
金順徵　以上工曹

FIG. 188 "List of Artisans" (*gongjangjil*) from the *Uigwe of the Wedding of King Yeongjo and Queen Jeongsun* ([*Yeongjo Jeongsun wanghu*] *garye dogam uigwe*), 1759. Book; ink and color on paper, 47.2 × 33.8 cm. Bibliothèque nationale de France (2535), on loan to the National Museum of Korea (Ogu 204).

FIG. 189 "List of Artisans of Various Trades" (*jesaek janginjil*) from the *Uigwe of the Wedding of the Crown Prince [later King Gyeongjong]* ([*Gyeongjong*] *wangseja garye dogam uigwe*), 1696. Book; ink and color on paper, 47.4 × 36.8 cm. Bibliothèque nationale de France (2528), on loan to the National Museum of Korea (Ogu 077).

and female entertainers, as well as seamstresses called "needle and thread servants" (*chimseonbi*) who worked the event. Many names of painters and artisans can be retrieved from these lists.

Beginning with the "Award Regulations" section of the *Uigwe of the Wedding of King Sukjong and Queen Inhyeon* (1681), the names of artisans and artists were grouped under the first, second, and third grades. Only one name in each grade category was mentioned, followed by just a numeral indicating how many others belong in the same category but not their names.[3] For example, it records that "court painter Ham Je-geon plus two others," who were workers of the "first grade," was followed by the numeral "15," indicating that fifteen additional artisans of various trades also belonged to the first grade. However, this does not reflect the artistic merits of the artists but rather the number of days they served in the superintendency (*dogam*). Possibly artists in the first grade worked the greatest number of days because they were better painters and artisans than those listed in the second and third grades. In that sense, the grades could indirectly indicate their relative artistic merits.

In many cases, painters recorded in *uigwe* appear in *uigwe* only; that is, their names do not appear in contemporaneous sources, so we do not know anything about their other painting activities. In her article "Court Painters of the Joseon Period Seen through *Uigwe* Books," Park Jeong-hye compiled a long list of all painters whose names appeared in all *uigwe* kept in the Kyujanggak Institute for Korean Studies, along with instances of multiple services of many of the painters in contemporaneous state events.[4] Although the number of actual *uigwe* we have dealt with up through chapter 9 is only a fraction of those that exist, it became apparent that the information on artists and artisans available through traditional biographical and art-related literature was very limited. Even if we compare the cases of Chinese artists who were forgotten in their own country but remembered because of existing works in Korea or Japan,[5] the number of artists' names retrieved through *uigwe* is significantly larger.

Here I would like to mention important findings from my earlier study on the twenty *uigwe* that are related to royal weddings. I found many artists whose names do not appear in traditional biographies and other literature of the Joseon period. From the twenty wedding *uigwe* — from that of Crown Prince Sohyeon in 1627 to that of the last crown prince, who became Emperor Sunjong in 1906 — we have been able to retrieve the names of 234 painters.[6] Of those, 142 are not found in widely known biographies or lists of Joseon painters.[7] This means that only 92 painters are known from contemporaneous art-historical records, and 142, or about 60 percent of them, are known only through *uigwe* documents.[8]

整理儀軌

右頁：

賞典

駕轎造成後施賞

司僕寺提調成有防豹皮一令僉正趙鎮奎壯勇營從事
官洪守榮各大鹿皮一令監官洪樂佐別看役丁遇泰并
相當職除授壯勇營知觳官李完基子鎮鼎守門將加設
調用待窠陞實教鍊官金命淑子昌仁放昌信除本仕牌
將差下書吏柳元榮木二疋庫直李碩禧木布各一疋使
喚旗手三名房子二名役人三名以上各木一疋畫員崔
得賢卜光復尹碩根雕刻出草人李最善李最敏以上各
木二疋布一疋都邊首表德運 小木匠金德才
朴三孫 李喜得 豆錫匠李振福等二名 漆
匠朴世得 以上各木一疋豆錫匠高枝成

左頁：

蔡繼得 金守千 小木匠孫時榮 朴就
根 安尚杓 朴東燁 雕刻匠朴就元等二名 申景
洪萬順等三名 安好文 文有彬 池瑞旭
祿等三名 趙成得 嚴益俊等二名
注匠具春興 張景益 金元瑞 漆匠朴壽福 崔萬大
李振白 崔泰俊 孔益周 安得仁 多繪
匠全必祥 鄭龍才 朴壽康 木手趙大義 針線
轎子匠沈興彬 以上各木一疋豆錫匠張壽明 金益喜
婢五名 入絲匠劉祥瑚等六名
等三名 漆匠洪萬哲 大銀匠朴千得 弓
李昌文 注匠金福興 造家匠吳壽康 文龍哲

FIG. 190 List of artisans and other workers in the "Award regulations" (sangjeon) from the Jeongni uigwe (Wonhaeng eulmyo jeongni uigwe), 1797. Printed book; 34.3 × 17.2 cm. Jangseogak Archives, The Academy of Korean Studies

Likewise, from the nine *uigwe* related to the production of royal portraits examined in chapter 6, I have been able to assemble a list of 154 painters, whose names I have checked against standard biographical source books. Of those, 101 painters, or two-thirds of the artists recorded in the *uigwe*, do not appear in traditional biographical accounts and are unrepresented in modern art-historical studies. On the other hand, Ahn Hwi-jun was able to compile a list of 198 painters who worked on the four construction-related *uigwe* of the period 1804–1832.[9] From that list, I deleted duplicate names and checked the rest against the standard sources. I found as many as 160 new names of artists. It seems that many of these artists were not members of the court painting bureau but rather painters called *bangoe hwasa* (outsider artist) who worked independently or were loosely associated with provincial government offices.

In the wedding *uigwe*, beginning with that of King Heonjong and Queen Hyohyeon (1828–1843) in 1837, we also find painters called *hwasa* (painting masters), as opposed to *hwawon* (court painters). Up until the 1906 wedding of the crown prince, twenty-two *hwasa* were in the service of court weddings. These findings reflect how much information about Joseon dynasty painters has been lost. It seems that as time went on, *hwawon* alone were not enough to meet the demand of various court events. *Hwawon* were responsible for decorating the halls of the events by producing screen paintings of many subject matters, ritual objects, as well as the *banchado*. Below, we will summarize their responsibilities according to the various *uigwe* records.

Responsibilities of Court Painters
The division of labor within a superintendency is clearly marked by the responsibilities of its subsidiary departments or subdivisions called *bang*, and the items handled within each *bang* are listed, occasionally along with the names of painters.[10] There were three *bang* or subunits in the superintendency, and sometimes the responsibilities of each subdivision were not strictly defined. Depending on the situation, the same task could be assigned to either the first or second *bang*. In some cases, no *hwawon* are listed under the third *bang* even when the task included filling in with gold dust the engraved characters of items such as jade or bamboo books, a task normally assigned to such painters, who are listed in the first or second *bang*. Perhaps the amount of work was so little that painters from another *bang* could be mobilized to take care of the artistic task.

In the twenty wedding *uigwe*, there are three such cases (1627, 1696, and 1744). In table 10.1, the responsibilities of each of the three *bang* in the

TABLE 10.1

TABLE 10.1 Duties of the Three *Bang* and Special Units of the Superintendency

	DUTIES (AS CITED IN ROYAL WEDDING *UIGWE*)	DUTIES (AS CITED IN ROYAL FUNERAL *UIGWE*)
First *bang*	Royal letter of appointment for the bride-to-be Costumes of the royal family for the ceremony Wooden containers for ceremonial items Screen paintings *Banchado* illustrations of processions Small tables Floor coverings; the decoration of smaller *yoyeo* palanquins	Large and small funerary palanquins and their accessories Royal coffin and its accessories Spirit palanquins (to carry the spirit tablet), spirit-tablet chair, and their accessories
Second *bang*	Royal palanquins Equipment for palace honor guards (*uijangmul*) such as ritual weapons, flags and banners, fans, umbrellas, etc.	Equipment for palace honor guards, both regular (*giruijang*) and funerary (*hyunguijang*) use Burial goods Floor coverings
Third *bang*	Jade book for the queen; bamboo book for the crown princess Gold seal for the queen; jade seal for the crown princess Boxes to hold these items	Jade book inscribed with eulogies (*aechaek*) Posthumous jade book (*sichaek*) Funerary banner (*manjang*) Ritual vessels Gift of jade and silk for the deceased (*jeungok, jeungbaek*)
Special-task unit	N/A	Funerary structure (*changung*) to house the royal coffin until burial
Object-making unit	N/A	Four [directional] Animals painting for the *changung*[1]
Stone object-making unit (*buseokso*)	N/A	Stone lanterns Images of civil and military officials Guardian animals Stone tables in front of tombs

1 See chapter 5 in this volume.

royal wedding *uigwe* and royal funeral *uigwe* are listed; special *bang* units created for funerals are listed where appropriate.[11]

In *uigwe* texts, the first subdivision took charge of important items such as the weaving of the royal letter of appointment in five-colored silk (representing the five directions — i.e., red, yellow, blue, white, and black), with the embellishment of a white double-dragon motif against a red background at the front and a second white double-dragon against black

[191]

at the back of the handscroll (fig. 191); royal costumes for the occasions; decorated wooden containers for ritual items; screen paintings; and *banchado* illustrations.[12]

The division of labor is such that to make, for example, a wooden container for ritual items that is lacquered and decorated with gold-dust paintings of the "four gentlemen" or phoenix would require the following: a woodworker specializing in making small wooden items called *somokjang*; a hardware worker for the metal fittings called *duseokjang*; a lacquerer; and a court painter to decorate the surface. A recent doctoral dissertation revealed that by matching the existing inner container for a jade book with a *uigwe* record we can precisely date the container if the original contents of the containers remain intact or if the record of the funeral *uigwe* can be precisely matched with the items found in the box.[13] One such item is the inner container of the jade book of Queen Inseon that was crafted in 1661

[196]

for the occasion of elevating her title (see fig. 196).

The small tables, floor coverings, and the decoration of the smaller palanquins called *yoyeo* are also the responsibility of the first *bang*. A royal wedding procession usually has four of these small palanquins, each carrying important items for the bride, such as the royal letter of appointment, jade book, royal seal, and the bride's costumes. The *yoyeo* are covered with a black roof with gold trim at each of the four corners topped with a free-standing phoenix head. The side panels are made of

[38]
[39]
[48]

wine-colored silk fabric (see figs. 38, 39). When decorated on the sides with large peonies on white fabric, these painted palanquins are called *chaeyeo* (see fig. 48). Not only the court painters but also woodworkers, metalsmiths, lacquerers, and weavers of tassels (*maedeupjang*) all worked together in the making of a small palanquin.

The most important task of the second *bang* was to construct the royal palanquins for the procession. Before the 1759 wedding of King Yeongjo and his second queen, Jeongsun, only the palanquin for the queen (or crown princess) had to be made. However, from 1759 on, the royal groom and the bride traveled separately in their own palanquins in a procession from the temporary detached palace of the bride-to-be to the main palace.[14] A royal palanquin of the late Joseon period now in

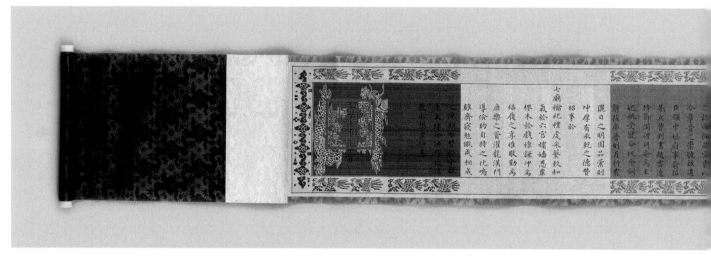

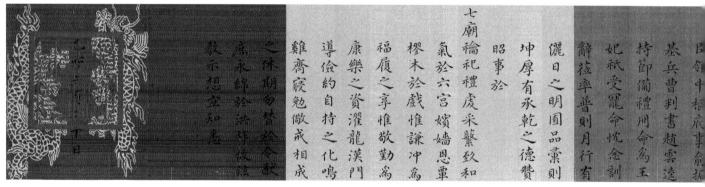

FIG. 191 Royal letter of appointment for Queen Jeongsun, King Yeongjo's second queen, 1759. Handscroll; ink on silk of five colors, 33.7 × 300 cm. National Museum of Korea.

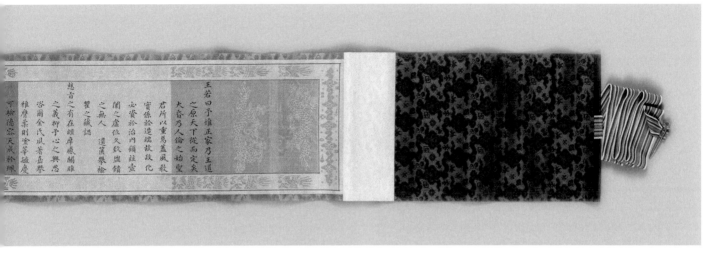

可驗德容天成祎珮
襲徽所貴家範儒素
邇苾之告既協卿士
之謀亦從是妥貴以

雅膺柔則塗莘毓慶
咨爾金氏凤著嘉譽
閩之虚位久致盟饋
之無人　遺篚攀裣
翟之藏認

慈旨之有在經席感關雎
之義抑予心之興思
君所以重焉蓋風敎
實係於造端故政化
必資於治內顧兹壺

王若曰予惟正家乃王道
之原天下從而定矣
大昏乃人倫之始聖

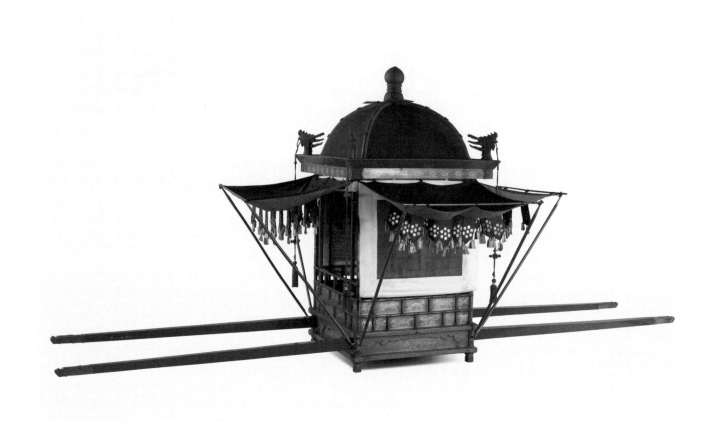

FIG. 192 Royal palanquin, late 19th century. Red-lacquered and gold-painted wood, silk, cotton, and metal; approx. 310 × 165 cm. National Palace Museum of Korea.

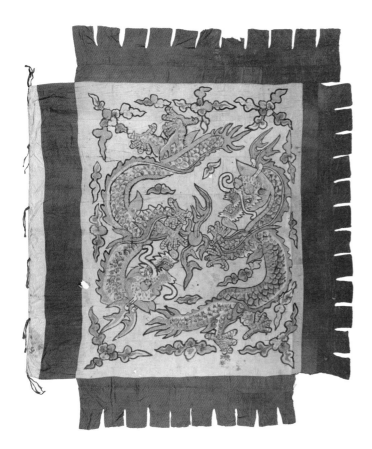

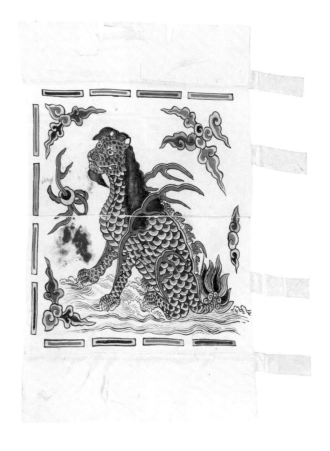

FIG. 193 Blue dragon flag, late 19th century. Silk; 294 × 235 cm. National Palace Museum of Korea.

FIG. 194 White lion flag, late 19th century. Silk; white silk area 139 × 137 cm; yellow flame borders, height 34 cm. National Palace Museum of Korea.

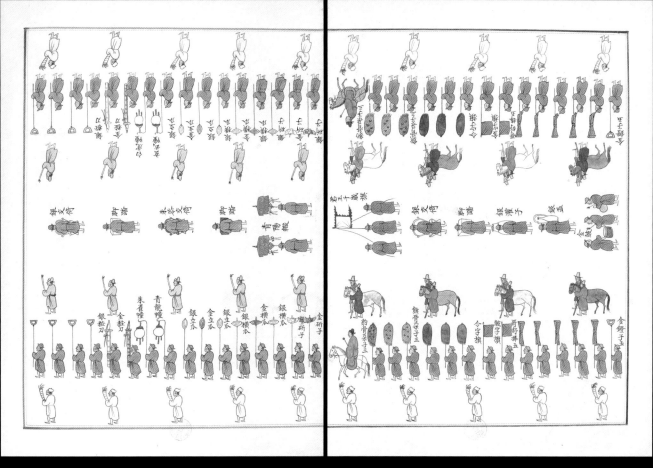

FIG 195 Parasols, lanterns, flags, ritual weapons, *pyogolta* (leopard) and *unggolta* (bear) pelts held upright in royal processions (pages 5, 6), from the *banchado* in the *Uigwe*

King Sukjong ([Sukjong] gukjang dogam uigwe), 1720. Book; ink and color on paper, 47.6 × 35.1 cm. Bibliothèque nationale de France (2565), on loan to the National Museum of

the National Palace Museum of Korea (fig. 192) illustrates the basic house-shaped structure with a black roof. From below the eaves of the roof, four drapery awnings are supported by thin red poles. Inside the drapery of all four sides hang blinds woven with beaded strings called *juryeom*. These

can be fully opened to reveal the interior during a procession (see fig. 45). The red-lacquered railing parts were decorated with images of mythical animals painted in silver dust. Since a procession painting is rather small in scale, all the details of the king's palanquin could not be captured. Such a complicated structure naturally required not only painters but artisans of many different trades. In some cases, the making of smaller palanquins was also the responsibility of the second *bang*.

In addition to constructing the palanquins, the second *bang* took charge of creating items to be held by the honor guards. Collectively, these items are called *uijangmul*, or simply *uijang*. They include flags

and banners of all sizes, shapes, and colors (figs. 193, 194); blue or red

umbrellas and royal red parasols; painted fans with images of a phoenix, peacock, or dragon; plain blue fans; long poles decorated with either leopard or bear skins (*pyogolta* or *unggolta*, respectively) to be held upright,

as seen in King Sukjong's funeral *banchado* (fig. 195); and many small accessories for the making of ritual weapons. They were made according to the specifications and illustrations prescribed in the *Five Rites of State*, and, after 1744, the *Sequel to the Five Rites of State*.[15]

The third *bang* made most of the smaller items, such as the jade book (made of bamboo for the crown princess), gilt-bronze seal (jade for the crown princess), boxes to hold those items, and the wrapping cloth for the boxes. Court painters were responsible for filling with gold dust or red powder the characters that were carved in intaglio by a jade artisan (*okjang*) on the jade pieces. The calligraphy for characters on the jade or bamboo books was written by famous calligraphers among the high officials. One example is the calligrapher Sin Jeong (1628–1687), who wrote the characters for the jade book of King Sukjong's wedding in 1681. Sin later advanced to the position of minister of rites, in 1685.[16]

The gilt-bronze seal of Queen Inwon (1687–1757) (fig. 197), inscribed with her posthumous title (seal of Queen Inwon, [who was] benevolent, righteous, and virtuous[17]), presented by King Yeongjo in 1757, is a good example of a seal with a long inscription using *hanja* characters. In 1776 King Yeongjo bestowed a silver seal, now in the collection of the National Palace Museum of Korea, complete with a wooden box covered with leather and decorated on its front with brass characters (*eo pil eunin*,

meaning "silver seal [engraved] with royal calligraphy") (fig. 198) on his heir-apparent grandson (later King Jeongjo). The making of this set

FIG. 196 Inner container
for the jade book of
Queen Inseon, 1661.
Lacquered wood
painted with gold
dust; 40.5 × 26.9 ×
27.3 cm. National Palace
Museum of Korea
(Jongmyo 13261-2).

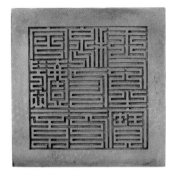
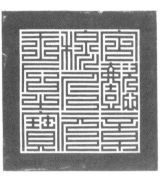

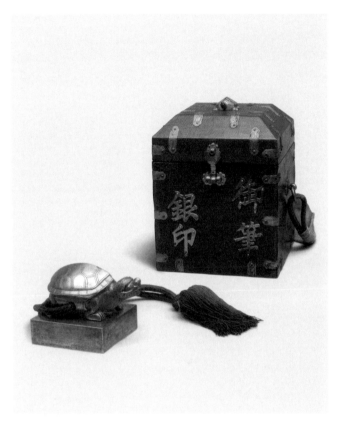

FIG. 197 Impression and engraved face of the gilt-bronze seal of Queen Inwon (1687–1757), 1702. Gilt bronze; height 7.4 cm, base 9.7 × 9.7 × 2.4 cm; tassel 69 cm; weight 3.5 kg. National Palace Museum of Korea.

FIG. 198 Silver-plated bronze seal and wooden box covered with leather bestowed by King Yeongjo on his grandson heir-apparent, 1776. 10.2 × 10.3 × 9.6 cm. National Palace Museum of Korea.

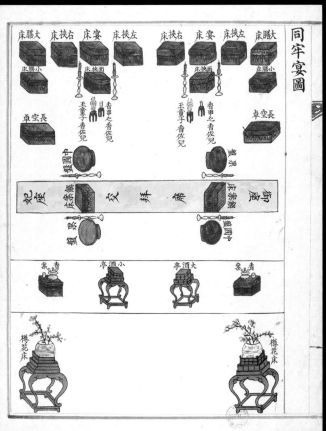

同牢宴圖

床膳大 床挾右 床宴 床挾左 床挾右 床宴 床挾左 床膳大

床膳小 床挾面 床挾面 床膳小

卓空長 玉童子香佐兒 香事之香佐兒 香事之香佐兒 玉童子香佐兒 卓空長

盤圖中 盛果

妃座 床空盞 交拜席 床空盞 界席

界圖中 盤圖中

案香 亭酒小 亭酒大 案香

樽花床 樽花床

教命織造式
五色各一賀每賀各八寸廣一尺二寸七
分各賀外飛鳳上下邊兒各長一寸五分廣
六尺四寸七分飛鳳外玉色賀上下邊兒
各長六分廣六尺七寸五分用禮需尺

第一賀紅色紅賀上一半織�12降龍玉色賀紅鱗�12降龍間

教命二字篆文以黄真絲織造上下邊兒紅飛鳳各
四織造右邊兒紅雲紋織造

第二賀黄色上下邊兒玉色賀黄飛鳳各四織造

第三賀青色上下邊兒玉色賀青飛鳳各四織造

第四賀白色上下邊兒玉色賀白飛鳳各四織造

FIG. 199 Diagram for places of the royal couple and the place-ment of food, wine, incense, and flower tables, page 101 of the *Uigwe of the Wedding of King Heonjong and Queen Hyohyeon ([Heonjong* *Hyohyeon wanghu] garye dogam uigwe)*, 1837. Book; ink and color on paper, 46.8 × 34.1 cm. Bibliothèque nationale de France (2539), on loan to the National Museum of Korea (Ogu 269).

FIG. 200 Illustration of the design for a royal letter of appointment, from the *Uigwe of the Wedding of the Crown Prince [Hyomyeong, posthumously elevated to King Ikjong/Munjo]* *([Ikjong/Munjo] wangseja garye dogam uigwe)*, 1819. Book; ink and color on paper, 45 × 32.2 cm. Jangseogak Archives, The Academy of Korean Studies (K2-2677).

required the collaboration of a silversmith, woodworker, tassel weaver, leather worker, and brazier. Painters also refined the calligraphy carved in relief on gold seals. Not specified in any subdivision is the job of providing illustrations within the *uigwe* books other than the *banchado*, such as illustrating the ceremonial scene where the royal groom and bride perform the "exchange of vows" or *dongnoeyeon [baeseol]do*. The scene shows food and decorated tables and places for guests and the royal couple to exchange bows (fig. 199). Yet another unspecified task was the illustration of the design for a royal letter of appointment with instructions on how to actually weave one (fig. 200).[18]

[199]

[200]

The responsibilities of court painters in various state rites as documented in *uigwe* are:

- To paint or copy royal portraits; to repair damaged royal portraits; to paint portraits of worthy subjects
- To paint screen paintings to be used for various state rites and for decoration of palace halls as well as other documentary paintings
- To draw page margins and vertical lines for each column of characters on the pages of the *uigwe* books in red ink for royal viewing copies; and, for the last one or two panels of a screen painting, to write in the names and positions of officials in that particular *dogam*
- To produce *banchado*, at first in handscroll format to be presented to the royal family before the actual rites and later in multiple copies for inclusion in the *uigwe*
- To draw the design of a royal letter of appointment or other ritual objects to be included in the *uigwe*
- To paint the Four Gentlemen or other motifs on the lacquered surface of wooden containers for ritual items
- To decorate the wooden parts (lacquered wooden eaves) and the base of royal palanquins
- To decorate the sides of smaller palanquins called *chaeyeo* with peonies
- To paint flags, banners, and fans of all kinds for the honor guards of royal processions (*uijangmul* or *uijang*)
- To fill in the intaglio characters of calligraphy of jade books (bamboo instead of jade for the crown princess) and the gold seal (jade instead of gold for the crown princess)

[82]

- To decorate the walls of royal funerary *changung* with the Four [directional] Animals (see figs. 82–84)

[83]

[84]

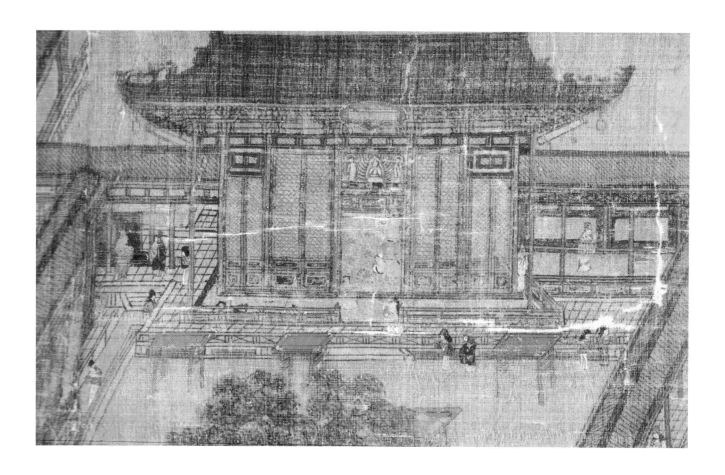

FIG. 201 *Worship of the Buddha in the Palace,* 16th century. Detail. Ink and color on silk, 41.5 × 91.4 cm. Leeum Museum of Art.

- To produce drawings for stone sculptures of figures (civil and military officials) and animals to be placed within the royal tomb precinct
- To produce preliminary drawings for all the woodblock illustrations for *uigwe* printed after 1797

As we have seen, the woodblock illustrations of the two printed *uigwe* of King Jeongjo's reign (1797 and 1801) encompass a wide range of themes: landscapes, figures, and animals. The drawing of architecture and machinery requires a special category of artistic skill in East Asian painting called *gyehwa* (Ch. *jiehua*), or "ruled-line painting."[19] We do not know when the term *gyehwa* began to be used in Korea, but in the mid-sixteenth century, paintings employing the *gyehwa* technique were being

[201] produced, for example, the *Worship of the Buddha in the Palace* (fig. 201) now in the collection of the Leeum Museum of Art. This also applies to numerous drawings of the exteriors and interiors of the palace buildings in palace banquet *uigwe* of the nineteenth century. A typical example of such an illustration would be the "View of Geunjeongjeon, Gyeongbok Palace" in the *Uigwe of the Palace Banquet of the Mujin Year* (*Mujin jinchan uigwe*, 1868) for

[202] the sixtieth birthday of Dowager Queen Sinjeong (fig. 202). This banquet, held in 1868, was the first large-scale court banquet in Gyeongbok Palace, newly rebuilt after its total ruin during the Japanese invasion of 1592. It was important, therefore, to record the majestic view of the Throne Hall and the surroundings from the Geunjeongmun gate of the palace.[20]

In the "Award Regulations" section of the *Uigwe of the Palace Banquet of the Mujin Year*, there are names of ten court painters whose responsibilities are not specified, but who presumably worked on both the preliminary paintings for woodblock illustrations as well as the screen painting of the banquet scene.[21] Of these ten painters, Baek Eun-bae (b. 1820), Yu Suk (1827–1873), and Yi Han-cheol (b. 1808) are well-known court painters with surviving landscape works, genre paintings, and portraits, but they are not particularly known for ruled-line paintings. There are two well-known ruled-line paintings of the late Joseon period,

[203] namely, the *West Palace* and the *East Palace*[22] (fig. 203), both of which are datable to ca. 1828–1830. As we have seen in chapter 9, beginning with the 1795 palace banquet, recorded in the *Jeongni uigwe*, scenes of all the late Joseon palace banquets were illustrated in large-scale screen paintings, sometimes produced in multiple copies. Obviously, the job of painting these screens was the responsibility of the court painters.[23]

It is in early nineteenth-century *uigwe* that the division of labor among court painters was made clear. In the 1819 (Sunjo 19) *Uigwe of the*

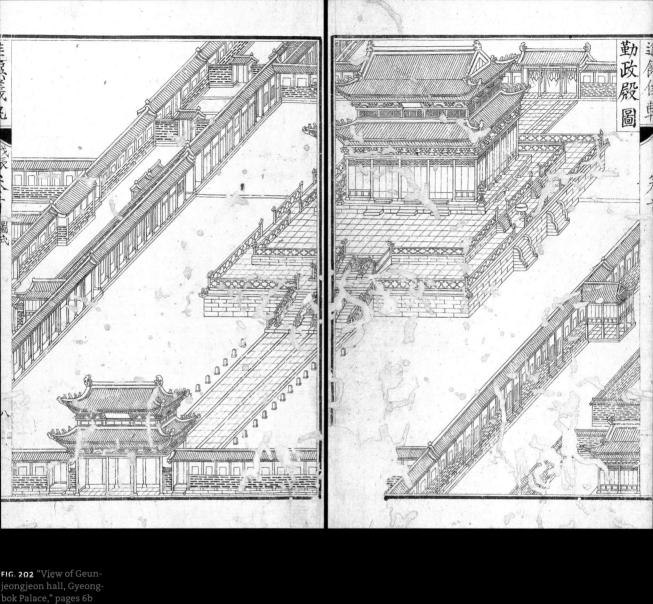

勤政殿圖

FIG. 202 "View of Geun-
jeongjeon hall, Gyeong-
bok Palace," pages 6b
and 7a in the *Uigwe of
the Palace Banquet* (*Mujin
jinchan uigwe*), 1868.
Printed book; ink on
paper, 33.2 × 20.7 cm.
Kyujanggak Institute for
Korean Studies, Seoul
National University

Wedding of the Crown Prince [later King Heonjong] (*[Heonjong] wangseja garye dogam uigwe*), for example, six painters' names — Bak Hui-seo, Choe Won, Heo Un, Heo Sun, Seo Guk-rin, and Yi Hyo-bin — were listed as the ones responsible for screen paintings. For this wedding, four screen paintings (two large sets of the Happy Life of Guo Fenyang, one eight-fold and the other of unspecified number of panels; and two One Hundred Children screens, one large and another medium-sized) were newly made. Also, this was the first time the One Hundred Children screen was made for a royal wedding, presumably because the wedding was for the crown prince, later King Heonjong.[24] There are two other cases, namely, the 1882 (Gojong 19) *Uigwe of the Wedding of the Crown Prince [later Emperor Sunjong]* (*[Sunjong] wangseja garye dogam uigwe*) and the 1906 (Gojong Gwangmu 10) *Uigwe of the Wedding of the Crown Prince [later Emperor Sunjong]* (*[Sunjong] hwangtaeja garye dogam uigwe*) — his second marriage — in which the painters responsible for the screen paintings were separately listed. Seven names were listed for the 1882 royal wedding, and three were listed for the 1906 royal wedding.[25]

The best records of the division of tasks within a superintendency (*dogam*) among painters can be found in three early twentieth-century TABLE 10.2 royal portrait *uigwe*.[26] Table 10.2 lists names of painters other than the royal portrait painters of the three royal portrait-related *uigwe*, namely, those of 1900, 1901, and 1902.

The *dancheong hwasa* (painters of canopies and eaves in bright colors) of the 1900 *uigwe*, Choe Seong-gu and eight others, and the fifteen *dancheong hwasa* in the 1901 *uigwe* were painting masters who decorated the wooden *dangga* (canopy) for royal portrait niches, using colorful paints, primarily *dan* (vermillion red) and *cheong* (cobalt blue). Since they were not court painters (*hwawon*), they were not given official ranks. The first to third grades given to the 1901 *dancheong hwasa* were based on the number of days they served — the first grade being the artists who worked the most number of days. The decoration of the *dangga* canopy is very colorful and ornate, as can be seen in the new Seonwonjeon's niche [99] for King Yeongjo's portrait (see fig. 99).[27] Although we cannot match any of the painters listed in Table 10.2 with existing paintings, the list in the 1901 *uigwe* is nevertheless very impressive.

The duties of the painters and artisans listed, up to the second half of the nineteenth century, were codified in the *Applications of the Six Codes* (*Yukjeon jorye*),[28] compiled in 1867. Among the duties of court painters, as specified in the Code of the Ministry of Rites (*yejeon*), are all things that needed painting (including the royal portraits), filling in the gold or jade seals, and drawing margins and vertical columns for royal viewing

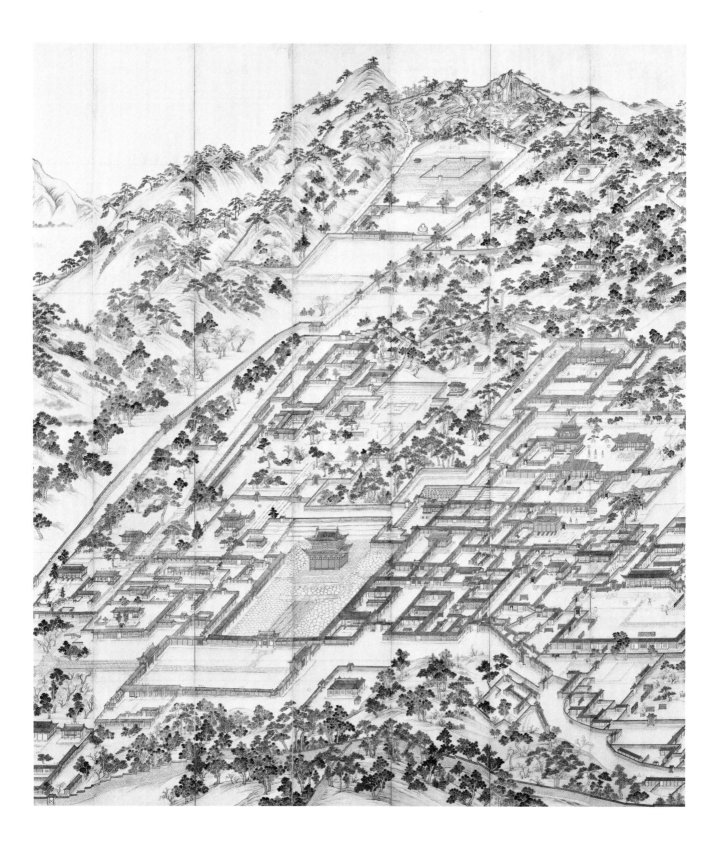

uigwe.[29] Artisans who wove silks for royal letter of appointments and for formal outfits for the royals were under the jurisdiction of the Code of the Ministry of Works (*gongjeon*).[30] The listings closely match those we have seen in various categories of *uigwe*.[31]

Division of Labor among Artisans

The *Hwaseong uigwe* (1801) mentions a total of 1,807 artisans including the painters listed in twenty-two different trades. Since this is the record of building a fortress, stonemasons constitute the single largest group with 633 workers — more than 30 percent of the entire workforce. In my study of the late Joseon palace banquet *uigwe*, I found that the division of labor among late Joseon artisans recorded in *uigwe* was such that the number of their trades far exceeds those recorded in the *Joseon Law Code* (1484) and the *Comprehensive Collection of National Codes* (*Daejeon hoetong*, 1865). In the nine palace banquet *uigwe* from 1797 to 1892, 103 different trades of artisans were mentioned, 67 of which were not recorded in the *Joseon Law Code*, and 68 of which were not found in the 1865 *National Codes*. Trades unrecorded in the 1484 or 1865 *Codes* include, among others, a maker of a belt made of pieces of ox horn (*gakdaejang*); a maker of large silver items (*daeeunjang*); and a polisher of bronze mirrors (*magyeongjang*).[32] However, they are recorded in the palace banquet *uigwe* I examined. This fact, as well as the cooperation of several different trades of artisans needed to produce an item of importance, could be related to the high artistic value and great variety of late Joseon handicrafts.

Salaries and Awards of Painters, Artisans, and Other Workers

We will now turn to the salaries and awards given to the painters and artisans as well as female entertainers from the early seventeenth century to the early twentieth that are recorded within the "Award Regulations" section of various categories of *uigwe*.

It is useful to examine first what kinds of salary were given to the painters appointed to the Bureau of Court Painting in the early Joseon period. There were two managerial positions (*byeolje*) of rank 6b who did not receive any salary for 360 days but after that became eligible for salaried positions. Below them were twenty painters, of whom only one (*seonhwa*) was of rank 6b, one (*seonhoe*) of rank 7b, one (*hwasa*) of rank 8b, and two (*hoesa*) of rank 9b. There were five positions with nominal salary from the bureau called Gwangheungchang in the Ministry of Taxation, which oversaw payments of government workers. Others received occasional compensation or just lunch money. Therefore, their social and economic positions were low and unstable. It was only after the reign

FIG. 203 *East Palace* (*Donggwoldo*), ca. 1828–30. Detail. Sixteen-panel folding screen; ink and color on silk, 273 × 576 cm. National Treasure no. 249. Dong-A University Museum.

TABLE 10.2 Tasks and Ranks of Painters (Other than Royal Portrait Painters), from the 1900, 1901, and 1902 *Uigwe* on Royal Portraits

YEAR	PAINTING TASK	PAINTERS (OTHER THAN ROYAL PORTRAIT PAINTERS)	OFFICIAL RANK
1900	Five Peaks screen	Kim Je-sun and eight others	rank 6
		Hwang Ji-gon	rank 2b
		Baek Nak-seon	former provincial governor
		Kim Jong-guk	rank 4
		Yi Heung-ju	former magistrate
		Yi Deok-ha	rank 9
	Banchado	Bak Chang-su	rank 9
		Ji Tae-won	rank 6
	Dancheong (Bright Color) painting	Choe Seong-gu and eight others	[unspecified]
1901	Five Peaks screen	Kim Bo-yeong	rank 3b
		Hong Byeong-hui and six others	rank 6b
		Kim In-mo	rank 9
	Five Peaks screen on stands	Jo In-hui and seven others	rank 6
	Peonies screen	Kim Gyeong-sik and four others	rank 6
		Choe Hong-seok	rank 9
	Space divider screen of Plum Blossoms	Ju Yun-chang and seven others	rank 6
		Choe Seok-jun	rank 9
	Sea and Peaches of Immortality screen	Bak Man-hyeong and three others	rank 9
		Gang Tae-hyeong and five others	rank 6
	Banchado	Kim Dae-yeong and six others	rank 6
		Kim Hong-guk	rank 9
	Dancheong (Bright Color) painting	Bak Chi-sun and six others	1st grade
		Choe Yeong-su and five others	2nd grade
		Yi Ho-jun and one other	3rd grade
1902	Five Peaks screen on a stand	Yi Gi-yeong	rank 2b
		Four others	[unspecified]

of King Jeongjo, who initiated the system called "painters-in-waiting at Kyujanggak," that painters who passed the quarterly examinations for higher emoluments were given a regular salary equivalent to that of rank 6a and rank 7a.[33]

Forms and Amounts of Emoluments for Workers
Until the mid-nineteenth century, painters and artisans were paid in bushels of rice, bolts of hemp, or cotton cloth, depending on the amount and the kind of services rendered. In the second half of the nineteenth century, a small amount of cash was also awarded as part of the salary.[34] In addition to salaries, extra goods were also given as awards. The *Hwaseong uigwe* (1801) records that the court painter Eom Chi-uk and five others, along with thirty-six monk painters, were given nine bushels of rice in 1795. After the completion of the Hwaseong Fortress in 1796, Eom Chi-uk also received two bolts of cotton and a bolt of hemp cloth, and each of the nine monk painters got nine extra bushels of rice.[35]

The monthly salary of portrait painters engaged in the superintendency (*dogam*) was the highest of all the painters who served in it. In 1688 they were given twelve bushels of rice and one bolt of cotton, whereas in 1748 the *banchado* painters were paid only six bushels of rice and two bolts of cotton. In 1688 sawyers (*ingeogun*) who handled large or small saws and temporary nonprofessional workers were paid three bushels of rice and three bolts of cotton. In 1837 portrait painters and mounters (*janghwangin*), who mounted the portrait painted on silk into an elaborate scroll format ready for hanging, were paid an equal amount — twelve bushels of rice and one bolt of cotton. The scribes were paid nine bushels of rice and one bolt of cotton, while the general inspector was paid nine bushels of rice, two bolts of cotton, and two *ryang* of cash.

One might wonder about the validity of this comparison because I am presenting data from 1688, 1748, and 1837, a wide range of dates spanning about 250 years. This analysis can be done mainly because the payments were made in the same types of goods — rice, cotton cloth, and a very small amount of cash. Therefore, the payments can be evaluated relative to one another.

From the above pay scale we can figure out the relative worth of a bushel of rice and a bolt of cotton during the late Joseon period. For example, a royal portrait painter was paid twelve bushels of rice but only one bolt of cotton, whereas the sawyers were paid three bushels of rice — only one-quarter of the amount paid to painters — but three times more cotton bolts than the painters received. The "Taxation Section" of the *Sequel to the Law Code*, completed in 1746,[36] indicates that

in mountainous regions it was possible to pay taxes in cotton bolts instead of in rice.[37] The equation between rice and cotton cloth varies slightly depending on the regions, but on average ten bushels of rice were worth three bolts of cotton. Therefore, if we compute their salaries all in rice, a royal portrait painter would have received 15.33 bushels of rice and a sawyer 13 bushels. The *banchado* painter's salary, on the other hand, would be 12.66 bushels of rice. By this scale, therefore, a royal portrait painter was the highest-paid worker, although there is only a difference of 2.77 bushels of rice — about 20 percent — between him and a *banchado* painter. The general inspector was the highest-paid person in this scale, receiving 15.66 bushels of rice. These salary computations are presented

TABLE 10.3 in table 10.3.

Bestowing Higher Official Ranks on Painters

In the "Award Regulations" section of the royal portrait *uigwe*, we frequently see somewhat unusual awards that transcend the legal limits prescribed in the *Joseon Law Code* for painters and calligraphers. For example, the highest rank allowed to court painters by the law is rank 6b. However, this limitation was easily circumvented using a form of award called *gaja*, which raised one's rank to rank 3a, the level of the "upper rank," or *dangsanggwan*. The honorific title of officials of this rank is *tongjeong daebu* ("officials who have arrived at the executive ranks"), which was given to retired high officials.[38]

This raise of rank for painters is most apparent in the royal portrait *uigwe* of the late Joseon period. For example, in the 1901 event of copying the seven past kings' portraits, the two master painters, Jo Seok-jin (1853–1920) and Chae Yong-sin (1850–1941), were appointed to the position of magistrate, a position that could go up to rank 2b. Even the painters who collaborated on the various screen paintings were given rank-3 positions.[39] A similarly high award was given to people who served in the 1902 event of the painting of the portraits of Emperor Gojong and the crown prince. The calligrapher who wrote the cartouche on those two portraits, Yun Yong-gu (1853–1959), was awarded a special raise to rank 3a. The master painters Jo Seok-jin and An Jung-sik (1861–1919) were promised the position of magistrate when positions become available. Yi Gi-yeong (dates unknown), who had served in the 1900 and 1901 events, was already a rank 2b, an incredibly high rank for a painter. So when he served as a painter of the Five Peaks screen in the 1902 event, he was awarded a pony instead of a rise in rank.[40]

Not surprisingly, however, the award of high-ranking positions to court painters was met with opposition from high-ranking civil officials,

who basically considered painting to be a lowly craft (*cheongi*). Surely, there were literati painters who excelled in painting and whose works still exist. Nevertheless, the extreme moral rigor of Joseon society looked down on the arts, including painting, as pleasure seeking. Only calligraphy, traditionally considered the highest art form in both China and Korea, was exempt from this censure.[41] That is to say, the scholar-official painters admired and enjoyed all the noble ideals of the traditional theories and practices of literati painting developed in China since the Song dynasty, but shied away from being known to the world by their skills in painting.[42]

Although there is no *uigwe* from King Seongjong's reign that survives, we know from the numerous entries in the *Veritable Records of King Seongjong* that the king's determination to promote Choe Gyeong (act. 2nd half of the fifteenth century) and An Gwi-saeng (d. after 1470) to the rank of *dangsanggwan*, after they had served as royal portrait painters, was met with stiff opposition from officials of the Censorate.[43] They went so far as to admonish the king that such a promotion would set a precedent, leading every other artisan who served the court to request higher rank, thus devaluing the prestige of higher ranks and scholar-officials. In the late Joseon period, when King Yeongjo wanted to promote the famous true-view landscape painter Jeong Seon (1676–1759), he encountered similar arguments from high officials, but was not swayed by them.[44] Yeongjo promoted him to the position of fourth rank in 1754 and to second rank in 1756.[45] Apparently this did open the path for granting higher official positions to painters, for by the late nineteenth century there were many such promotions of painters who had served in important state rites.

Change of Social Status
By far the most unusual form of award was the change of one's social status from lowborn (*cheonmin*), who were often slaves or indentured, to a *yangban*, to freeborn commoner (*yangmin*), an award known as *myeoncheon*, meaning "to be relieved of lowborn status." Instead of material awards, one could elect for a change in social status. Similar changes of status happened occasionally during the Goryeo period, mostly in the military.[46] Examples during the Joseon period can be found in the *Veritable Records of the Joseon Dynasty*, or in the "Punishment" section (*hyeongjeon*) of the 1865 *Comprehensive Collection of National Codes* (*Daejeon hoetong*), where there is a record of a person who caught five Ming thieves and was awarded *yangmin* status.[47] *Uigwe* records show many such instances. As mentioned in chapter 1, the earliest instance in Joseon history of granting a change of social status after a state rite was in 1767 (Yeongjo 43), recorded in

TABLE 10.3 Salaries of Painters and Others in the Royal Portrait Superintendency

UIGWE	TYPE OF WORKER	SALARY (IN BUSHELS OF RICE)	SALARY (IN BOLTS OF COTTON)	COMPUTED SALARY (IN BUSHELS OF RICE)*
1688 *uigwe*	Royal portrait painters	12	1	15.33
1688 *uigwe*	Sawyers (*ingeogun*)	3	3	13
1688 *uigwe*	Nonprofessional workers	3	3	13
1748 *uigwe*	*Banchado* painters	6	2	12.66
1837 *uigwe*	Portrait painters and mounters (*janghwangin*)	12	1	15.33
1837 *uigwe*	Scribes	9	1	12.33
1837 *uigwe*	General inspector	9	2, plus two *ryang* of cash	15.66

* 1 bolt of cotton = approx. 3.33 bushels of rice

the *Uigwe of Royal Sericulture*. The exact phrase is *jongwon myeoncheon* (according to one's wish, to be relieved of lowborn status).

In Joseon society, once born into the *cheonmin* class, one remains as such for life, and his or her descendants will inherit the status. There- fore, the opportunity to change one's class to "freeborn commoner," or *yangmin*, would affect not only that particular individual, but also his or her descendants. In theory, once one becomes a *yangmin*, all social opportunities — including taking the state examination — are available. In reality, the many years of economic support one needed to prepare for the state examinations made upward social mobility difficult if not impossible.[48] At the same time he/she is subject to state tax and statute labor or labor required by law. This meant that the government could now require corvée labor from the newly arrived *yangmin* when needed, such as for a public building project and serving in the military. However, King Yeongjo's decision to grant this form of award did open a path to upward social mobility not only for those who were granted the status change, but also for many formerly lowborn people in the centuries to come.

Beginning in the late eighteenth century and all through the nine- teenth century, there are many instances of such awards, especially after the state banquets of the nineteenth century. For example, in the *Jeongni uigwe*, a female worker and a male scribe were awarded a change of social status, and after the court banquet of 1827, another court scribe and nineteen female *yeoryeong* entertainers were granted a change of status. Except for the court banquet of 1868, the list goes on through the 1892 court banquet, after which a scribe named Jo Myeong-jun, a singer called Myeongju, and more than fifty-five male and female workers were granted a change to a higher social status.[49] At that time, in 1892, a meal servant for the crown prince named Nokju was granted the *yangmin* status for that particular job, and later in the same banquet, she played a musical instrument, and this time, as a *yangmin*, she was awarded one bolt of silk and one bolt of cotton.

No court painters appear on the lists of persons granted changes of status, but there are quite a few low-ranking scribes, called *seori* (rank 7b), who were in charge of recording and taking care of government docu- ments. They were much lower than the court scribes called *sajagwan*, who could go up to rank 4. Traditionally painters and scribes were from the class called *jungin* (middle [social status] people), who rank just below the *yangban* ruling class and above *yangmin* freeborn commoners.[50] Mostly they are professionals, such as translators, meteorologists, geomancers, and medical doctors, who are essential to the running of court affairs. So it is somewhat surprising to find that many low-ranking scribes originally

came from the lowborn class. Besides examples found in the royal banquet *uigwe*, we also find occasional cases in the royal funeral *uigwe* of masons who were awarded change to a higher social status.[51]

Names in Joseon Society

The way male and female workers were recorded in the *uigwe* reveals another interesting aspect of Joseon society. All the male artisans and workers, no matter what their social status was, were listed by their full name, surname followed by their given names. However, all the female workers, mostly entertainers and seamstresses, were listed only by their given names. It is the very reflection of Joseon Neo-Confucian society and its cosmology in which the *yang* force represents male, and the *yin* force represents female. This clear association between gender on the one hand and the cosmic forces of *yin* and *yang* on the other led to the belief in the dominance of male over female.[52] For example, in the list of artisans of the 1759 wedding *uigwe* (see fig. 188), there are four names listed under "seamstress": Chunhyang, Danjeong, Irae, and Chwiyeol. They do not appear to have surnames, unlike male artisans.

It is a telling contrast to the cases of *yangban* ladies. In the royal banquet *uigwe*, we find that the lady invitees to the banquets were listed by their family of origin surnames *only* along with their husband's official titles. For example, fourteen ladies were included in the list of invitees to the banquet of 1848. We find the family names of two royal relatives (*gunbuin*) — Bak ssi (née Bak) and Min ssi (née Min) — and one spouse of the prime minister (*jeonggyeong buin*), Yun ssi (née Yun), as well as two spouses of ministerial-level officials (*jeongbuin*), Jo ssi (née Jo) and O ssi (née O). At the end of the list are three *yuin* (wives of low-ranking officials, rank 9a and 9b), Sin ssi (née Sin), Hong ssi (née Hong), and Nam ssi (née Nam).[53] Likewise, in the Joseon-period family genealogy books known as *jokbo*, a woman's given name would not be recorded, only her surname, her father's name, and the place of origin of her family. Therefore, the females of Joseon Korea, regardless of their social status, lived with only one name: either the given name, in the case of lowborn women, or the family name, in the case of *yangban* ladies.

* * *

Through *uigwe* documents, we gain insights into the various aspects of Joseon society, many of which are revelations for us. They range from factual information on the division of labor among artisans, or relative scale of salaries among artisans and painters, to a more fundamental change of social status from "lowborn" to "freeborn." We also learn that,

on occasion, some royal portrait painters were bestowed extraordinary higher ranks by kings, a practice that was against the normal personnel procedure at court. Gender inequality in Joseon society can be discerned through the way names were recorded, i.e., men complete with surname and given name regardless of social status; lower-class women with only their given names; and finally, upper-class women with only their father's surname. Nevertheless, royal ladies were, on occasion, given the opportunity to rule the country "behind the bamboo curtain," and were treated with the most sumptuous court banquets as if to compensate for the overall discriminatory gender practices of the society. ◆

Summary and Conclusions

The first two parts of this book examine diverse categories of *uigwe* that collectively represent the Joseon kingdom's dedication to "rule by the book" and "rule by rites" in accordance with Neo-Confucian principles. These books testify to the dynasty's determination to document the spirit and substance of its ritual life as a means of perpetuating its rule.

Each chapter in part I introduces *uigwe* for one of the Five Rites of State following the sequence given in the *Five Rites of State* published in 1474. The auspicious rites, or *gillye*, are discussed first, with emphasis on the royal ancestral rites and the royal ancestral shrine (Jongmyo). The *Jongmyo uigwe* published in 1706 gives a complete history of Jongmyo and Yeongnyeongjeon, the two major shrines of the Jongmyo complex, as well as a detailed description of the sacrifices conducted at each one. Covering the three centuries since the founding of Jongmyo in 1394, this *uigwe* shows how the architecture of the two shrines in the compound changed to accommodate the ever-increasing number of royal spirit tablets and how the "rules" for the enshrinement of the spirit tablets were established. All the sacrificial rites are set out with detailed protocols for the king and other participants, complete with illustrations of costumes and other ritual paraphernalia. The food and libation offerings are enumerated along with the order in which they are offered. The instrumental and vocal music and dances that make the entire ritual process a composite of various performing arts are documented. Treasured items, such as the royal books and seals kept inside the cabinets of the spirit chambers, are catalogued. These objects validated the posthumous positions occupied by the kings and queens enshrined in the Jongmyo shrine. Given the importance of the Jongmyo ancestral shrine as a site of dynastic legitimation, it is natural that the original four volumes of the *Jongmyo uigwe* were expanded with sequel records (*songnok*) added seven times between 1741 and 1842 to document special incidents or changes in the rites over successive reigns. By safeguarding the treasures, rituals, and physical structures of the entire shrine, the court attempted to ensure the perpetuation of the royal family. The *Jongmyo uigwe* is testimony to this solemn will.

Since agriculture and sericulture were the fundamental industries of China and Korea, the *gillye* rites included royal rituals of farming and silk production. King Yeongjo performed the farming rites as many as four times (1739, 1753, 1764, and 1767) in accordance with his policy of pursuing the revered ancient Chinese ritual. Although early Joseon kings were recorded to have performed these two rites, we find no *uigwe* that document their performances. King Yeongjo had *uigwe* compiled only for the first and the last occasions upon which the royal sericulture rite and the rite of the royal gathering of seeds and silk cocoons were performed. The latter rite is the only one of its kind in Joseon history, and also the only one in which the main protagonist was the queen, with the participation of the crown princess and other female royal relatives. This contrasts with the role of women in royal banquets as documented by *uigwe* dedicated to these events. Most of the royal banquets of the late Joseon period were held for the dowager queens, who played passive roles as the recipients of congratulations. In the royal sericulture rite and the rite of royal gathering of seeds and silk cocoons, the queen played an active role.

Chapter 2 looks at celebratory rites (*garye*). Many of these had to do with the status of Joseon as a Chinese vassal state and its concurrent obligation to pay respect to the emperor of China, but we examined only *uigwe* for two types of rites important to dynastic succession, that for investitures of a queen or a crown prince and that for royal weddings. The 1610 investiture *uigwe* records not only the investiture of the first son of Gwanghaegun (r. 1608–1623), Crown Prince Ji (1598–1623), the earliest of its kind, but also four other rites including the investiture of his own consort, Crown Princess Yu, to the rank of queen and the prince's *gwallye* (coming-of-age or capping ceremony).[1] We examined the eleven-page *banchado* of the investiture of Gwanghaegun's queen, which is also the earliest of its kind, characterized by five separate palanquins (instead of four as in a wedding procession) carrying ritual items necessary for a queen's investiture.

The 1690 *uigwe* of the investiture of the crown prince was for the three-year-old son of King Sukjong, who later became King Gyeongjong (r. 1720–1724). Sukjong's controversial concubine, Jang Huibin, played a critical role in the realization of the three-year-old's investiture because she was his birth mother. The core of this investiture rite consists of the ritual of bringing in the letter of appointment, the bamboo book, and the seal of the crown prince into the palace; the investiture ritual proper, which was conducted by King Sukjong without the participation of the crown prince; and the crown prince's acceptance in the arms of his nurse. This process is followed by a series of ceremonial congratulations offered to the king and the crown prince by government officials and royal relatives. Finally, the

newly invested crown prince himself pays formal visits to the king and the dowager queens. The twelve pages of *banchado* illustrations show elements unique to the crown prince's procession, including his formal palanquin borne by sixteen men flanked by a pair of horses called *gwoldalma*, used inside the palace only by the crown prince. The royal viewing copy of this *uigwe* is exemplary for its fine calligraphy as well as its *banchado* illustrations.

Twenty royal wedding-related *uigwe* made between the early seventeenth century and the early twentieth century survive. Two of them, the *Uigwe of the Wedding of Crown Prince Sohyeon* of 1627 and the *Uigwe of the Wedding of King Yeongjo and Queen Jeongsun* of 1759, allow for a comparison of wedding rites for individuals of different status. The wedding of a crown prince was distinguished by a rite called *imheon chogye*, which was conducted before the royal groom's meeting with his bride. Specifically, Crown Prince Sohyeon appeared before his father, the king, and officials of the court in front of the throne hall of the main palace to receive solemn admonitions on how to instruct the bride on her future duties. The *Uigwe of the Wedding of King Yeongjo and Queen Jeongsun* is distinctive for showing a limited number of wedding costumes and gifts in keeping with the king's adherence to the Confucian sprits of frugality as set down in the 1749 *Established Protocol for a Royal Wedding*. The fifty-page *banchado* for the *Uigwe of the Wedding of King Yeongjo and Queen Jeongsun* reflects a change in the rite of meeting the bride: the king went to the detached palace in person to meet his bride in the rite of *chinyeong* and bring her to the main palace in a grand procession in which they rode in separate palanquins accompanied by their own honor guards. All later wedding *banchado* followed this protocol in their composition, down to the grandiose wedding procession of King Cheoljong in 1851.

Uigwe documenting rites for receiving Chinese envoys, *billye*, are examined in chapter 3. The reception of Chinese envoys for occasions such as state funerals, royal investitures, and other important state occasions had to be performed with the utmost formality, respect, and care. The *uigwe* documenting such receptions were produced for a fairly short period during the reign of Gwanghaegun and that of King Injo (r. 1623–1649). After the Chinese Ming dynasty fell to the Qing in 1644, the making of such documentary texts became a complicated and delicate task for the Joseon court. Despite the Joseon court's deep loyalty to the defunct Ming, it exchanged envoys with the Qing court, as illustrated in the *Fengshi tu* (*Diplomatic Paintings*), an album of painting and calligraphy recording the four visits of Qing envoy Akedun (1685–1765) to Joseon between 1717 and 1725.

The earliest remaining *billye uigwe* were produced in 1608 after two envoy visits, one to mourn the death of King Seonjo and bestow upon him a posthumous title and the other to approve the investiture

of Gwanghaegun. The *banchado* illustrations contain elements distinctive to these events, such as the chief Chinese envoy riding in an open sedan chair under a red parasol and the sacrificial animals carried on wooden stretchers. Gwanghaegun ordered the production of copies of the preliminary records of these events to be kept in the respective government offices and all the history archives, demonstrating his strong desire to document the state rites for future generations.

Chapter 4 discusses the fourth of the five rites, military ritual or *gullye*, in the *Uigwe of the Royal Archery Rites (Daesarye uigwe)*. The archery rites in question were performed by King Yeongjo and his officials in 1743 in the compound of Seonggyungwan, the National College in Hanyang. By that time performance of the ancient royal archery ritual had lapsed for more than two hundred years. Yeongjo revived it, had it performed twice (1743 and 1764), and had the first and the only military rite *uigwe* compiled to document it. This action was in line with his general policy of reestablishing regulations on state rites, as seen in his publication of the *Sequel to the Five Rites of State* in 1744. His performance of the ancient royal agriculture and sericulture rites four times, with *uigwe* compiled twice (1739, 1767), effected the same goals. All these rites represent his desire to reinstate the ways of the ancient Chinese sage kings. His revival of the royal archery rite was also symbolic of his emphasis on military arts to demonstrate his power to rule.

The last of the five categories of rites, that of state funerals and related rites collectively called *hyungnye*, occupies the largest portion of the *Five Rites of State* due to its complexity. For nearly three centuries, the Joseon royal family adhered to cumbersome procedures until King Yeongjo simplified them in the *Addendum to the Funeral Rites of State (Gukjo sangnye bopyeon)* that he had compiled in 1758. In chapter 5, we examined funerary *uigwe* made before and after this change, *uigwe* for the funeral of King Injo in 1649 and the funeral of Crown Prince Uiso in 1759.

The *Uigwe of the Royal Funeral of King Injo* survives along with the *uigwe* of the Coffin Hall and the construction of the royal tomb. Together the three provide a complete picture of the mid-seventeenth-century royal funeral procedures. In the funeral *uigwe*, we find the schedule of the whole event, from the day of the king's death to the day of the funeral four months and three days later. The Coffin Hall *uigwe* details the preparing of the king's corpse and the disposition of his coffin in the Coffin Hall until its departure for the funeral, in the stately procession depicted in the *barin banchado*. In the twenty-nine pages presenting this procession, we learn a great deal about royal funeral ritual. For instance, we see that the funerary ritual protocol required the palace ladies to immediately follow the royal coffin and perform as wailers. The *uigwe*

on tomb construction (*salleung*) informs us of the construction materials used for the underground burial chambers, specifically the *sammul*, the three combined substances of lime powder, yellow soil, and fine sand that had come to replace the stone-slab construction used for royal tombs up to the time of King Sejo's tomb, built in 1468. This *uigwe* also shows the Joseon dynasty's use of the Four [directional] Animals as a motif to decorate the walls of the *changung* that temporarily housed the royal coffin in the palace until burial in the royal tomb.

The *Uigwe of the Funeral of Crown Grandson Uiso* is the only funeral *uigwe* for a Joseon crown grandson. This funeral was performed while King Yeongjo was having the *Addendum to the Funeral Rites of State* compiled, so this *uigwe* is of special interest as we can see in it the results of Yeongjo's efforts to simplify the rites. This *uigwe* also contains the finest extant funeral-related *banchado* in terms of workmanship.

Overall, funerary *uigwe* document the adherence of the Joseon dynasty to the tenets of Confucian filial piety in the conduct of the final rites for members of the royal family. Court ritual set the tone for the mood of austerity and solemnity that pervaded the entire nation until the eternal spirit of the deceased royal family member finally rested in peace in the Jongmyo ancestral shrine.

The second part of this book examines *uigwe* made for important state events other than those of the Five Rites. Chapter 6 is devoted to *uigwe* concerning the painting of royal portraits and shows the importance of such portraits to Joseon history and art history. Unlike other types of *uigwe*, these books also provide significant information on Joseon painting and painters in general. Nine royal portrait-related *uigwe*, ranging in date from 1688 to 1902, survive, as do two documentary paintings of living rulers, namely, King Sukjong (1713) and Emperor Gojong and his crown prince (later Emperor Sunjong) (1902). Other *uigwe* concern copies of portraits of seven earlier kings. Four record copies of portraits of King Taejo originally made in 1688, 1837–1838, 1872, and 1900, reveal that the Joseon lineage paid the most homage to portraits of its founder. The *uigwe* inform us about the selection of royal portrait artists by examination and about the stages in the production of royal portraits, from the selection of auspicious dates on which to begin painting the portrait to the installation of the finished image in the royal portrait hall.

In 1748 King Yeongjo was the first king to participate in a procession carrying a newly copied royal portrait to the royal portrait hall. Riding in his own palanquin, he followed a larger palanquin containing the newly-copied portrait of King Sukjong to Yeonghuijeon, a royal portrait hall outside the palace. Subsequently, he had a painting of this procession in

eighteen pages included in the *uigwe*. This royal portrait-related *banchado* was the earliest of its kind and became a model for later examples, the most grandiose being the *banchado* of eighty-six pages for inclusion in the 1901 *uigwe* of the copying of the portraits of King Taejo and six other kings after a fire at Seonwonjeon, the royal portrait hall in Changdeok Palace, the previous year damaged all the royal portraits kept therein. This exceptionally long *banchado* reflects the situation of the nation after it declared itself an empire in 1897. The reproduction of the lost royal portraits and the publication of the *uigwe* documenting the 518-year history of continuous production served as symbols of political authority.

Chapter 7 is devoted to the 1797 *Uigwe of King Jeongjo's Visit to the Tomb of Crown Prince Sado* (Wonhaeng eulmyo jeongni uigwe). Documenting King Jeongjo's 1795 visit to the tomb of his father, Crown Prince Sado, in Hwaseong with his mother, Lady Hyegyeong, this *uigwe* combines two categories of court events, the royal outing (*haenghaeng*) and the court banquet (*jinchan*). This *uigwe* also marks a turning point in the history of Joseon *uigwe* production in that it was the first *uigwe* printed with movable metal type and woodblock illustrations. Sixty-three of the latter create an elaborate *banchado* that differs from all earlier *banchado* in two ways. First, in all previous *banchado*, different viewpoints are presented simultaneously with figures shown apparently upside down along the upper edge of the painting as if the viewer were standing on the opposite side of the depicted scene. This *banchado*, however, maintains one viewpoint throughout, so that all the figures and horses are depicted on the same ground level from the viewer's perspective. Second, in the section showing Lady Hyegyeong's palanquin, figures and horses overlap as they would be seen from the viewer's perspective. This method of depicting spatial relationships reflects the Western influence of one-point perspective also seen in other paintings of the time. Along with the handscroll-format *banchado* of nearly 4.5 meters long and screen paintings of the same subject, this technically advanced and stylistically up-to-date *uigwe* promoted the image of King Jeongjo as a true Confucian monarch.

The *Uigwe of the Construction of the Hwaseong Fortress* (Hwaseong uigwe), the subject of chapter 8, describes with great specificity the most notable achievement of King Jeongjo's reign, the building of the new city of Hwaseong, complete with its defense walls. In this *uigwe*, printed in 1801, all the structures of the Hwaseong Fortress and the mechanical devices employed in their construction are depicted in ninety-nine pages of woodblock illustrations. The realistic rendering of the architectural and mechanical structures and the level of detail in the text, which records construction materials, structural measurements, and the roles

of artisans involved in the project, are unparalleled in any other *uigwe*. In addition, the finance and expenditure section of the *uigwe* contains important information on the production of screens, notably, the twelve screens of the *Complete View of Hwaseong* painted on silk now scattered in various collections. This exceptionally detailed account of King Jeong-jo's monumental undertaking in Hwaseong testifies to his efforts to administer a financially transparent government, his filial piety, and his humanistic attitude toward his people, as seen, for example, in having spaces for soldiers to rest inside the fortress observation towers and in recognizing all its workers by name and with rewards given for their service. Jeongjo also sought to achieve peace between warring factions of civil officers at court and to solidify his control over military officials, in sum, to affirm his authority as a strong and righteous Confucian ruler. In modern times, this *uigwe* was essential to the reconstruction of the fortress after its near-complete destruction during the Korean War of 1950–1953. Without the *uigwe*, it would have been impossible to return the fortress to its original state and have it recognized by UNESCO as a World Heritage Site in 1997.

Part III of this book, titled *Uigwe and Art History*, turns from specific examples of *uigwe* to ways in which *uigwe* add to our knowledge about Korean art history more broadly. Chapter 9, "Polychrome Screen Paintings for Joseon Palaces," brings information about screens in *uigwe* records to bear on extant screens made for state events. The *uigwe* indicate who used such screens and where they were placed for a given event. The chapter examined the screens in four categories, three having to do with the identities of the people who used them, beginning with the king. Subjects painted on screens for the king include the Five Peaks, Peacocks, and Peonies. In the second category are screens for palace ladies, such as the screens of Peonies, Flowers and Grasses, the Ten Symbols of Longevity, Lotus Flowers, and the Happy Life of Guo Fenyang, which were used for royal wedding rites and at royal banquets. It is interesting to note that the last painting subject, the Happy Life of Guo Fenyang, appears as late as 1802 and seems to be the top choice for screens placed in the bridal detached palace, presumably to wish for many offspring for the royal bride-to-be.

Among the screens used by kings and crown princes are those depicting books and scholarly paraphernalia, the *munbang dobyeong*, or in its vernacular Korean form, *chaekgeori*. The scholarly King Jeongjo also kept such a screen in his private quarters and reportedly took consolation from it for his lack of time to read books. This theme of *munbang dobyeong*, with books and Chinese antiques as well as Western objects, which Koreans were able to acquire through China is in many ways a mirror

of Joseon upper-class material culture since the time of King Jeongjo if not earlier.

Eight instances when large-scale screens depicting royal banquets were commissioned between 1765 and 1902 are documented in *uigwe*. These screens of royal banquets (some in multiple copies) have survived and can be matched with *uigwe* records. Many of these screens were made for dowager queens. Kings generally shunned the pleas of their subjects or crown princes to hold banquets in their honor. It seems that presenting elaborate banquets and producing large screens for dowager queens was one way for the royal family to express appreciation to dowager queens for their quiet but significant role as the senior female members of the royal household. Through the banquet-related *uigwe*, not only the screen paintings but also other objects used for decorating banquet spaces, we can glimpse the late Joseon royal ladies' taste for foreign goods such as cushions of leopard or orangutan pelt, or glass lamps manufactured from sheet glass which was not produced in Korea until the twentieth century.

The *uigwe* allow us to distinguish the palace screens from *minhwa*, or folk painting, by providing the specific role each of the screens played at a given state rite. This is an issue because all the subjects depicted on the palace screens, except for the palace banquet, were painted in a smaller scale by village painters and were circulated among the general population during the late Joseon period.

The second chapter of part III, "Joseon Court Painters, Artisans, Entertainers, and Other Workers," examines *uigwe* records concerning artists, scribes, artisans, female entertainers, and workers who served in various capacities in state rites. These records appear in two sections, the "List of Artisans" or "List of Artisans of Various Trades" and the "Award Regulations." The names of many more painters are found there than in other sources. Also specified are their duties, official rank, class status, and remuneration. These data reveal a minute division of labor that is reflected in the superb artistic as well as technical quality of their products.

Overall, this book introduces and analyzes key *uigwe* for the light they shed on Joseon state rituals, court culture, and art history. Organized thematically rather than chronologically, it is not written as a history of *uigwe* as a genre of literature or art. Nevertheless, the outline of this history can be discerned in the foregoing pages from names of Joseon rulers mentioned in connection with specific developments. Beginning with King Sejong, who laid the foundation for the Five Rites, successive kings gradually shaped the character of *uigwe* over the centuries. King Seongjong's compilation of the *Five Rites of State* (1474) established the guiding principles of all state rites after which *uigwe* were compiled. Although Gwanghaegun

could not occupy the position of king due to severe factional strife after the death of King Seonjo, he proved to be an able ruler, especially after the period of recovery from the devastating Japanese invasions (1592, 1597). His intention to restore order and legitimacy in government is evident through his compilation of the earliest investiture *uigwe* for his son and for his queen as well as the multiple copies of his other publication projects after the war.[2] Gwanghaegun, a shrewd diplomat, was also responsible for creating the only extant *billye uigwe* documenting the reception of foreign envoys (1610). King Sukjong's achievement in rehabilitating the nation after the two Manchu invasions (1627, 1636) is reflected in the invaluable *Jongmyo uigwe* of 1706, made more than three centuries after the establishment of the Jongmyo ancestral shrine. His determination and will to safeguard the legacy left by his royal ancestors was honored by later kings in the form of compilations of seven sequel volumes of *Jongmyo uigwe*. King Yeongjo had sequels to the original *Five Rites of State* and the *Addendum to the Funeral Rites of State* compiled to codify his simplification and updating of these rituals. Yeongjo was also the first king to perform and have *uigwe* compiled for the rites of royal agriculture and sericulture. Yeongjo's grandson Jeongjo initiated the printing of *uigwe* (1797, 1801) with movable bronze type and woodblock illustrations, a technical triumph over the handwritten and hand-illustrated *uigwe* of the earlier period.

Uigwe compiled under the Daehan Empire inevitably displayed many differences from those of earlier times because of major changes instituted in administration and court protocol.[3] State rites previously conducted in cooperation with the six boards of the state council were now conducted by the Gungnaebu (Office of the Affairs of the Inner [Imperial] Court). Royal titles, ceremonies, music, court dress, and other symbolic features of court life changed. The king became an emperor, the queen an empress, and so on. Gold became the color of their costumes. The number of the ruler's honor guards greatly increased along with their paraphernalia. All of this was duly set down in *uigwe*.

In recent decades, a number of scholars have begun to tap into and benefit from the seemingly endless mine of information contained in *uigwe*, and, fortunately, *uigwe*, which were written using *hanja* characters, are becoming more broadly accessible as they appear in vernacular Korean, such as those produced by the Institute for the Translation of Korean Classics. This book is offered as a contribution to this larger effort, specifically, as further demonstration of the value of *uigwe* to our understanding of Joseon court art and culture. It is the author's hope that the rich Korean documentary tradition embodied in *uigwe* will continue to grow and flourish. ◆

Notes

INTRODUCTION

PAGES 25–39

1 For readings in English on *uigwe*, see Han Young-woo, *A Unique Banchado: The Documentary Painting of King Jeongjo's Royal Procession to Hwaseong in 1795*, trans. Chung Eunsun (Amsterdam: Amsterdam University Press, Renaissance Books, 2017); and Shin Myungho, *Joseon Royal Court Culture: Ceremonial and Daily Life*, trans. Timothy V. Atkinson (Seoul: Dolbegae, 2004). See also the following essays and articles by Yi Song-mi: "The Making of Royal Portraits during the Chosŏn Dynasty: What the *Uigwe* Books Reveal," in *Bridges to Heaven: Essays on East Asian Art in Honor of Professor Wen C. Fong*, ed. Jerome Silbergeld, Dora C. Y. Ching, Judith G. Smith, and Alfreda Murck (Princeton, NJ: P. Y. and Kinmay W. Tang Center for East Asian Art, Princeton University, 2012), vol. 1, 363–86; "The Screen of the Five Peaks of the Joseon Dynasty," *Oriental Art* 42, no. 4 (1996/97): 13–24; "*Uigwe* and the Documentation of Joseon Court Ritual Life," *Archives of Asian Art* 58 (2008): 113–34; and "The *Uigwe* Royal Documents of the Joseon Dynasty: What It Means to the Better Understanding of Korean Culture," in *Baek sasibo nyeon man ui gwihwan: Oegyujanggak uigwe* 145 (Seoul: National Museum of Korea, 2011), 256–91.

2 Yi Song-mi, "The Screen of the Five Peaks of the Joseon Dynasty," *Oriental Art* 42, no. 4 (1996/97): 13–24.

3 *Hanyeong uri munhwa yongeo jip*, comp. Song Ki-joong et al. (Seoul: Jimoon dang, 2001). The term *manual* is somewhat of a misnomer, since *uigwe* are not manuals to be precisely followed.

4 Shin Myungho, *Joseon Royal Court Culture: Ceremonial and Daily Life*, trans. Timothy V. Atkinson (Seoul: Dolbegae, 2004), 280.

5 Han Young-woo, *Joseon wangjo uigwe* (Seoul: Iljisa, 2005); Yi Song-mi, *Garye dogam uigwe wa misulsa* (Seoul: Sowadang, 2008).

6 Burglind Jungmann, "Documentary Record versus Decorative Representation: A Queen's Birthday Celebration at the Korean Court," *Arts Asiatiques* 62 (2007): 97.

7 *Uigwe* contain much more than just the royal protocol.

8 It refers to the *uigwe* of *Jongmyo Ancestral Rites*, in which the new harvest of cherries had been offered at the ancestral rites on the first and fifteenth days of May. *Veritable Records of King Taejong*, vol. 21 (1411) 5/11 (*sinmi* day). See references under *Joseon wangjo sillok* on page 525 of this volume.

9 The appearance of the term *uigwe* in the *Veritable Records* can be searched in Korean at http://sillok.history.go.kr.

10 *Veritable Records of King Seonjo*, vol. 131 (Seonjo 33), first day of the eleventh month. See references under *Joseon wangjo sillok* on page 525 of this volume.

11 See Han, *Joseon wangjo uigwe*, 965–66, for a complete list.

12 Lee Ki-baik, *A New History of Korea*, trans. Edward W. Wagner and Edward J. Shultz (Seoul: Iljo-gak, 1984), 164–66.

13 See the introductory essay by Yu Seung-guk, in *Hanguk ui yuhak sasang: Yi Hwang, Yi I*, trans. and ed. Yi Eun-sang and Yi Byeong-do (Seoul: Samseong chulpansa, 1983), for a comprehensive introduction to the development of Neo-Confucianism in Korea since the late Goryeo period. For a good summary of the Joseon dynasty's Neo-Confucian culture, see Hongkyung Kim, "Joseon: A Dynasty Founded on Confucian Classics," in *Treasures from Korea: Arts and Culture of the Joseon Dynasty, 1392–1910*, ed. Hyunsoo Woo (Philadelphia, PA: Philadelphia Museum of Art, 2014), 13–23.

14 The Four Books of Confucian philosophy are: the *Analects* of Confucius (*Lunyu*), the *Mencius*

(Mengzi), the Great Learning (Daxue), and the Doctrine of the Mean (Zhungyong); see http://en.wikipedia.org/wiki/Four_Books.

15 Lee Ki-baik, A New History of Korea, 165–66.

16 The five human relationships are: (1) between ruler and subject (loyalty to the ruler, chung); (2) between father and son (filial piety, xiao); (3) between husband and wife (respect and difference, bie); (4) among brothers (brotherly love, ti); and (5) among friends (trust, xin).

17 Samgang haengsildo is a collection of stories of loyal ministers, filial sons, and the chaste women of Korea and China, compiled by Seol Sun (d. 1435), and published with woodblock illustration in 1434. See Lee Ki-baik, A New History of Korea, 192–95, for other early Joseon publications through which Joseon Neo-Confucian officials tried to promote moral, ethical values in order to sustain the yangban social order.

18 Lee Ki-baik, A New History of Korea, 166.

19 For a detailed study of social change from late Goryeo to early Joseon period in ancestor worship, funerary rites, succession and inheritance, the position of women and the marriage institution, and the formation of descent groups, see Martina Deuchler, The Confucian Transformation of Korea: A Study of Society and Ideology (Cambridge, MA: Council on East Asian Studies, Harvard University, 1992).

20 Veritable Records of King Sejong, vols. 128–35 (1454). See references under Joseon wangjo sillok on page 525 of this volume.

21 Gukjo oryeui (Five Rites of State) (1474; Hangul translation by the Ministry of Government Legislation, 5 vols., 1982) (hereafter cited as Five Rites of State).

22 King Yeongjo was the longest-ruling monarch of the dynasty, and as such experienced as many as six state funerals (including that of his grandson, the heir-apparent to the throne, in 1752) and naturally reexamined the "Funeral Rites" section in the Five Rites of State of 1474, and felt the need to change and simplify some parts of it. See Gugyeok Gukjo sangnye bopyeon (1758; Hangul translation compiled by National Research Institute of Cultural Heritage. Seoul: Minsogwon, 2008, 21–22).

23 For some reason, this new code was never published in printed form during the Joseon period, and remained as ten handwritten volumes, which are now kept in the Jangseogak Archives of the Academy of Korean Studies. See a Hangul translation of the book by Im Min-hyeok, Seong Yeong-jae, et al., Gugyeok Daehan yejeon, 3 vols. (Seoul: Minsogwon, 2018). See also Yi Uk, Jang Yeong-suk, et al., Daehan jeguk ui jeollye wa Daehan Yejeon (Seongnam: Academy of Korean Studies, 2019).

24 Usually, one of the top government officials, the prime minister or the minister of the left or the right, was appointed as superintendent, or dojejo. Sometimes the dogam was headed by the minister of the Ministry of Rites. Below him, lesser officials took charge of different divisions within the dogam. If the event called for many different kinds of work to be done, three to five subdivisions would be set up, each with its own head and workforce under it. The first three

subdivisions are called bang (meaning "room") numbers one, two, and three, while the fourth subdivision is called byeolgongjak (special work), and the fifth one called suriso (repair place). While the work in each division is being carried out, all the details from discussions among the king and his officials, letters exchanged among various offices of the government, all the necessary goods to be supplied, all the names of persons employed by the dogam, all the expenses spent, and so forth were compiled in a record called a deungnok.

25 Some examples of idu are as follows: 乙良 (that is); 段 (is); 節 (position, now, this time); 上下 (to give out things); 德應 (palanquin); 赤古里 (jeogori jacket). See Jang Ji-yeong and Jang Se-gyeong, Idu sajeon (Seoul: Sanho, 1991).

26 For some exceptional women well versed in Chinese Classics, see Martina Deuchler, "Propagating Female Virtues in Chosŏn Korea," in Women and Confucian Cultures in Pre-modern China, Korea, and Japan, ed. Dorothy Ko (Berkeley, CA: University of California Press, 2003), 142–69 (chap. 6). See also three essays in Creative Women of Korea: The Fifteenth through the Twentieth Centuries, ed. Young-Key Kim-Renaud (Armonk, NY: M. E. Sharpe, 2004); John Duncan, "The Naehun and the Politics of Gender in Fifteenth-Century Korea," 26–57; Song-mi Yi, "Sin Saim-dang: The Foremost Woman Painter of the Chosŏn Dynasty," 58–77; and Kichung Kim, "Hŏ Nansŏrhŏn and 'Shakespeare's Sister,'" 78–95.

27 Surviving today are several scroll-format procession paintings that presumably were used for royal reviewing prior to the day of the event. The

best example is the procession painting, now in the National Museum of Korea, of the trip to Hwaseong taken in 1795 by King Jeongjo and his mother, Lady Hyegyeong. See figs. 123 and 125.

28 Wonhaeng eulmyo jeongni uigwe (1797; repr., Kyujanggak, 1994). The term for the metal type is jeongnija. When this uigwe was finally printed in 1797, 102 copies were published and distributed among the high officials who participated in the royal journey to Hwaseong and worked on the completion of the uigwe. See chap. 7.

29 The late Joseon History Archives were located at Mount Odae in Gangwon province; Mount Jeongjok on Ganghwa Island; Mount Jeoksang in Muju, North Jeolla province; and Mount Taebaek in North Gyeongsang province — all remote mountain areas believed to be safe havens during foreign invasions.

30 In the case of the wedding of King Injo and Queen Jangnyeol in 1638, only five copies were made: one for the royal viewing, and four more for distribution to each of the four History Archives.

31 For a comparative analysis of the book bindings of the royal viewing copy and the distribution copies of the uigwe books, see Jo Gye-yeong, "Bong-an seochaek gwa Oegyujanggak uigwe ui jang-hwang," in Oegyujanggak uigwe ui janghwang (Seoul: National Museum of Korea, 2014), 12–33. For analysis of the binding and paper of the Oegyujanggak royal viewing uigwe books, see Yu Sae-rom, "Oegyujanggak uigwe janghwang ui teukjing," in Oegyujanggak uigwe ui janghwang (Seoul: National Museum of Korea, 2014), 37–63.

32 Yi Tae-jin, *Wangjo ui yusan: Oegyujanggak uigwe reul chajaseo* (Seoul: Jisik saneopsa, 2010).

33 Park Byeong-seon, *Joseon jo ui uigwe: Pari sojang bon gwa gungnae sojang bon ui seojihak jeok bigyo geomto* (Seongnam: Academy of Korean Studies, 1985).

34 Park Byeong-seon, *Règles protocolaires de la cour royale de la Corée des Li (1392–1910)* (Seoul: Kyujanggak Archives, Seoul National University, 1992).

35 Technically the books' ownership still resides with the French government, which has sent them to Korea in the form of a loan renewable every five years.

36 Yi T., *Wangjo ui yusan*, 79–82, and color pls. 8 and 9. In 2018, the National Institute of Traditional Korean Music published the annotated Hangul translation of this *uigwe* (*Yeokju gisa jinpyori jinchan uigwe*).

37 All fifty ceremonies are listed in the tables of contents of volumes 2 and 3 of the *Five Rites of State*, and the procedures for them are spelled out in the main body of the text. *Five Rites*, 2:12–292.

38 Although the construction of the fortress was finished in 1796, the *uigwe* was not printed until 1801.

39 The palace banquets can also be included within the "celebratory rites" category.

40 "Polychrome screen paintings" refer to screen paintings done in many different colors as opposed to ink monochrome paintings.

CHAPTER ONE
PAGES 43–78

1 The Chinese "Hwangudan," which was the model for the Korean one, was the outdoor, circular, stepped platform altar made of marble at the Temple of Heaven in Beijing.

2 The Hwangudan platform is now situated in the center of Seoul, just outside the Westin Choson Hotel.

3 In the introductory essay to the two-volume, reduced-size facsimile edition published by Kyujanggak in 1997 (hereafter cited as *Jongmyo uigwe*), Go Yeong-jin quotes from the *Zhouli* (*Rites of Zhou*), "Ancestral Shrine to the left, Platforms for the Spirits of Earth and Grain to the right."

4 *Suseon jeondo*, attributed to Kim Jeong-ho (d. 1866).

5 Kim Dong-uk, *Jongmyo wa Sajik* (Seoul: Daewonsa, 1990), 97–100. Even after World War II, public buildings such as a library and a primary school were built within the original precinct. In January 2015, the Cultural Heritage Administration announced that by 2027 it would reconstruct the core area of the site by rebuilding thirteen buildings around the two platforms.

6 Han Hyeong-ju, Kim Mun-sik, et al., *Joseon ui gukga jesa* (Seongnam: Academy of Korean Studies, 2009), 22.

7 The three volumes, which total 508 pages, now reside in the Kyujanggak Institute for Korean Studies of Seoul National University; Kyu 14229-1-3.

8 Now in the Jangseogak Archives of the Academy of Korean Studies; K2-2157.

9 This volume of only twelve pages is now kept in the Jangseogak Archives; K2-2159.

10 *Ilmu* is the classical Chinese dance that existed as early as the time of Confucius and was performed only during Sacrifices to Heaven and at the ancestral shrine made by the emperors. In China, the dance consisted of eight rows with eight dancers in each row. During the Joseon, being the vassal state of the Chinese Empire, it consisted of six rows of six dancers until the Daehan Empire period, in 1897, when the dance was modified to eight rows.

11 Kim D., *Jongmyo wa Sajik*, 99. For Jongmyo and sacrificial rites performed during the Joseon dynasty, see also Shin, *Joseon Royal Court Culture*, 246–52.

12 In addition to Kim D., *Jongmyo wa Sajik*, see the chapter on Jongmyo in Lee Kyong-hee, *World Heritage in Korea* (Seoul: Samsung Foundation of Culture, 1997), 48–89.

13 See the volume of black-and-white photographs of Jongmyo by Bae Byeong-u in *Jongmyo: chimmuk gwa eunyu* (*Jongmyo: Silence and Metaphor*), ed. Leeum, Samsung Museum of Art (Seoul: Samsung Foundation of Culture, 2015).

14 The seven minor spirits are those of *samyeong*, human destiny; *jungnyu*, interior; *ho*, household; *jo*, kitchen and hearth; *gungmun*, gates of the capital's inner walls; *taeryeo*, awards and punishments; and *gukhaeng*, travel and roads.

15 This three-by-one bay structure has no walls, only a roof and columns.

16 This is in accordance with the same practice of the Chinese Song dynasty's system of building a Separate Shrine (*byeolmyo*) to the west of the Main Shrine.

17 At the beginning of the dynasty, King Taejo's four ancestors were enshrined in the first building, constructed in 1394 and called the Main Shrine. It is also known as Taemyo, because King Taejo's spirit tablet is enshrined there.

18 In 2010 the four volumes were published by the Academy of Korean Studies in a two-volume, reduced-size facsimile edition with an introductory essay by Shin Myungho, "The Contents and the Significance of *Records of the Jongmyo Royal Ancestral Shrine*," introductory essay in *Jongmyo deungnok* (*Records of the Royal Shrine*), 3–35, 2 vols., reduced-size facsimile edition (Seongnam: Jangseogak Archives of the Academy of Korean Studies, 2010).

19 Five copies of the first four volumes of *Jongmyo uigwe* were produced in 1706. Of those, two copies survive: the royal viewing copy and the one made for the Jongmyo Office. The royal viewing copy is now in the Kyujanggak Institute for Korean Studies of Seoul National University. The other remaining copy is now in the Jangseogak Archives of the Academy of Korean Studies (K2-2905). The four volumes were published in 1997 in a two-volume, reduced-size facsimile edition with an introduction by Go Yeong-jin.

20 See the introductory essay by Go Yeong-jin in volume 1 of *Jongmyo uigwe* (1706; repr., Kyujanggak, 1997).

21 The officials who were the head of the office were Seo Mun-jung (1634–1709) and Kim U-hang (1649–1723), among others.

22 *Jongmyo: The Royal Ancestral Shrine* (Seoul: National Palace Museum of Korea, 2014), 148–53. See also Park Jeong-hye, "Joseon hugi Jongmyo jehyangnye ui sigak jeok dohae: 'Jongmyo chinje gyuje doseol byeongpung' ui naeyong gwa hoehwa jeok teukjing,'" in *Jongmyo chinje gyuje doseol byeongpung eul tonghae bon Jongmyo* (Seoul: National Palace Museum of Korea, 2012), 105–48.

23 The term for "illustration" is *doseol*, or "description in pictures," but many of them have no pictures, only the characters arranged in circles or square grids.

24 They were all given the title of king: Mokjo, Ikjo, Dojo, and Hwanjo.

25 *Jongmyo uigwe*, 2:157–75. The entire process of rebuilding had been recorded in two separate *uigwe* — *Jongmyo suri dogam uigwe* (1633) and *Yeongnyeongjeon sugae dogam uigwe* (1667) — before the compilation of *Jongmyo uigwe* in 1706, *Jongmyo gaesu dogam uigwe* in 1726, and *Jongmyo Yeongnyeongjeon jeungsu dogam uigwe* in 1836.

26 Kim D., *Jongmyo wa Sajik*, 25–26.

27 Officials decided to present an additional two-character title for Injo to make a ten-character spirit tablet title for the monarch.

28 See *Jongmyo uigwe*. See also the introductory article in vol. 1, table 3, for a list of kings who are enshrined in the Main Shrine, and table 4 for those enshrined in Yeongnyeongjeon hall.

29 *Five Rites of State*, 1:67–88.

30 Song H., *Confucian Ritual Music*, for a comprehensive coverage of traditional court music of Korea. The book is accompanied by a CD of important Confucian ritual music titles, and their traditional grid-like music scores translated into Western-style five-line scores. The lyrics of the vocal music are also translated into English.

31 Song Hye-jin, "Joseon sidae garye ui yongak yuhyeong," in *Joseon wangsil ui garye*, ed. Kwon O-yeong, Kim Mun-sik, et al. (Seongnam: Academy of Korean Studies, 2008), 1:71–79.

32 Yi Hye-gu, *Gugyeok Akhak gwebeom* (Seoul: National Institute of Traditional Korean Music, 2000), 159.

33 Ibid., 167.

34 This information was drawn from the *Veritable Records*, *Records of the Ministry of the Rites (Yejo deungnok)*, *Diaries of the Royal Secretariats*, and collected writings of scholar-officials.

35 *Jongmyo uigwe*, 2:465–68.

36 Recorded in the section on *jesa* in Kim Bu-sik, *Samguk sagi* (1145), chap. 32, *japji* (miscellaneous records), 477–87.

37 Recorded in the *Goryeosa* (*History of the Goryeo Dynasty*), compiled by Jeong In-ji et al. (1452). The earliest one was in 983.

38 Shin Myungho, *Joseon Royal Court Culture*, 60–64 and 109–14. His translations — *Chingyeong uigwe* is *Plow In-Person Ceremony Manual*, and *Chinjam uigwe* is *In-Person Sericulture Ceremony Manual* — are less than satisfactory because there is no

sense of the king's or queen's involvement here, and also a *uigwe* is not a manual.

39 The story goes that the weaving maiden was a granddaughter of the Emperor of Heaven, but he became angry with the couple when they got too lazy, and punished them by separating the two, allowing them to meet only once a year. See the story of Gyeonu and Jingnyeo in http://encykorea.aks.ac.kr (in Korean).

40 *Veritable Records of King Seongjong*, vol. 51 (1475) (day 14, 19, and 23 of the first month). See references under *Joseon wangjo sillok* on page 525 of this volume.

41 Originally, five copies of the 1739 *Chingyeong uigwe* were produced, of which three survive: one is now kept in the National Museum of Korea (Ogu 149 / BNF 2662); the other two are in the Kyujanggak Institute for Korean Studies (Kyu 14537 and Kyu 14937). Originally, seven copies of the 1767 *Chingyeong uigwe* were produced, of which six survive: the royal viewing copy (Kyu 14539) and four more copies originally deposited with various history archives are in the Kyujanggak Institute for Korean Studies. They are Odaesan (Kyu 14540), Taebaeksan (Kyu 1452), Jeongjoksan (Kyu 14538), and place unknown (Kyu 14541). The Jeoksangsan History Archive copy is now in the Jangseogak Archives of the Academy of Korean Studies (K2 2905). The two *Chingyeong uigwe* (1739 [Kyu 14937] and 1767 [Kyu 14538]) of King Yeongjo's reign were published in 2001 by the Kyujanggak Institute for Korean Studies in a reduced-size facsimile edition with an introductory essay by Kim Ji-yeong (1–19). That edition also includes the [*Jeonghae*] *Jangjong sugyeon uigwe* (*Uigwe of the*

Gathering and Storing of Seeds and Silk Cocoons [in the Jeonghae Year]). See also Kim Ji-yeong, "Yeongjo dae chingyeong uisik ui geohaeng gwa *chingyeong uigwe*," *Hanguk hakbo* 28, no. 2 (2002): 55–86. King Yeongjo also had his officials considerably revise the section on *chingyeongui* (royal rite of agriculture) of the *Five Rites of State* (1474) in the *Sequel to the Five Rites of State*, which he had published in 1744. The illustrated companion volume called *Gukjo sok oryeui seorye* includes many illustrations of the positioning of the king and his officials at the farming rites, as well as some of the items that were used at the time of the rites — farming vehicles, tools, and bamboo containers for seeds. Also in the *Sequel to the Five Rites of State* is a section on the celebration after the royal farming rite.

42 Yi Song-mi, *Yeongjo dae ui uigwe wa misul munhwa* (Seongnam: Academy of Korean Studies, 2014), 27–47. See also *Gugyeok Chingyeong chinjam uigwe*, trans. Bak So-dong (Seoul: Minjok munhwa chujinhoe, 1999), 1–10, in which the translator presents a history of royal farming and sericulture of the Joseon dynasty.

43 The Joseon-period Seonnong-dan has been preserved in today's Jegi-dong, Dongdaemun-gu, Seoul.

44 The plowing motion is called *twe*, or to push. Normally this character is pronounced as "chu," but in this case it is pronounced as "twe."

45 For music played during and after the royal farming rites, see Song Ji-won, "Joseon sidae ui nongsa wa yangjam eul wihan gukga jeollye wa eumak," in *Hanguk eumak yeongu* 45, no. 6 (2009): 149–75.

46 *Chingyeong uigwe* (1739, 1767; repr., Kyujanggak, 2001), 198 and 206. In the 1767 *uigwe*, there is no mention of the representation of the scene in painting. In the Japanese periodical *Chōsen Nōkai hō* (朝鮮農會報), Kim Ji-yeong found an old photo of a painting that seems to show the royal agricultural rite. From the dim photo, the king's position at the top and those of other participants lined up below can be discerned.

47 See Jeong Byeong-mo, "Paemunjae gyeongjikdo ui suyong gwa jeongae" (MA thesis, Graduate School of the Academy of Korean Studies, 1983).

48 In Korean, the term *seson* indicates that the heir apparent is a grandson, not a son, of the reigning king.

49 Originally seven copies of this *uigwe* were produced, but only two survive. They are the Jeongjoksan History Archive copy (Kyu 14543) and the Jeoksangsan History Archive copy (K2-2906).

50 In composing the detailed protocols of this ancient rite, Yeongjo asked the officials to consult the past examples of royal sericulture rites recorded in the *Veritable Records of Kings Seongjong, Jungjong, and Seonjo*. Records consulted at this time were: 1477 on *chinjam*; 1493 on *chinjam*; 1513 first month on *chinjam*, third month on *chinjam*; and 1572 second month on *chinjam* and third month on *chinjam*. See references under *Joseon wangjo sillok* on page 525 of this volume.

51 Han Hyeong-ju, *Bat ganeun Yeongjo wa nue chineun Jeongsun wanghu* (Seongnam: Academy of Korean Studies, 2013), 121–25.

The Joseon period Seonjamdan was located in today's Seongbuk-dong, Seongbuk-gu.

52 For the proper attire for all participants in the royal sericulture rites, see Yu Song-ok, "Chinjam uigwe e natanan boksik yeongu," *Hanbok munhwa* 14, no. 4 (2011): 150–67.

53 See Sin Byeong-ju, *Yuksibyuk se ui Yeongjo, sibo se ui sinbu reul majihada* (Seoul: Hyohyeong Chulpansa, 2001).

54 The special state examination was named *gyeongjamgwa* (Farming and Sericulture State Examination), *Chinjam uigwe* (K2-2906), 84.

55 *Chinjam uigwe* (1767; repr., Kyujanggak, 2001), 86–89.

56 The exact phrase here is *jongwon myeoncheon* (according to one's wish, be relieved of lowborn status [forever]).

57 Yi Song-mi, "Joseon hugi jinjak jinyeon uigwe reul tonghae bon gungjung ui misul munhwa," in *Joseon hugi gungjung yeonhyang munhwa* (Seoul: Minsogwon, 2005), 2:191–94. On the other hand, in the early Joseon period, some "low-born" people were given the status of "free-born" when married to free-born people. See Han Young-woo, *Joseon sidae shinbunsa yeongu* (Seoul: Jimmundang, 1997), 17.

58 In the collection of the Kyujanggak Institute for Korean Studies, Seoul National University (Kyu 14544). See also *Chingyeong uigwe* (1739, 1767; repr., Kyujanggak, 2001), 305–55.

1 See the table of contents in volumes 2 and 3 of the *Five Rites of State* (1474) in which all fifty ceremonies are listed; their procedures are spelled out in the main body of the text. *Five Rites of State* (1982), 2:12–292.

2 He was put to death in 1623, when his father (Gwanghaegun) was deposed.

3 In the previous year, 1609, he had the Joseon court's first *uigwe* of receiving envoys from China compiled. See chap. 3.

4 Accordingly, the *uigwe* has a long title: *Uiin wanghu sang jonho daebijeon sang jonho junggungjeon chaengnye, seja chaengnye gwallye si chaengnye dogam uigwe* (*Uigwe of Elevating the Title of Queen Uiin, of Elevating the Title of the Queen Dowager, the Investiture of the Queen, and the Investiture and Coming-of-Age Ceremonies of the Crown Prince*). See Han, *Joseon wangjo uigwe*, 74.

5 In addition to the 1610 *uigwe* are those prepared for: the 1651 *Uigwe of the Investiture of the Crown Prince [later King Hyeonjong]* (*[Hyeonjong] wangseja chaengnye dogam uigwe*); the 1667 *Uigwe of the Investiture of the Crown Prince [later King Sukjong]* (*[Sukjong] wangseja chaengnye dogam uigwe*); the 1690 *Uigwe of the Investiture of the Crown Prince [later King Gyeongjong]* (*[Gyeong-jong] wangseja chaengnye dogam uigwe*); and the 1875 *Uigwe of the Investiture of the Crown Prince [later Emperor Sunjong]* (*[Sunjong] wangseja chaengnye dogam uigwe*). See Park Jeong-hye, "Joseon sidae chaengnye dogam uigwe ui hoehwasa jeok yeongu," *Hanguk munhwa* 14 (December 1993): 521–51; Park Eun-sun, "Joseon sidae chaengnye uigwe banchado yeongu," *Hanguk munhwa* 14 (December 1993): 553–612.

6 As in other *uigwe* of the Gwanghaegun period, the contents of this *uigwe* are not well organized. Still, it is clear that the superintendency had the main office (*docheong*) as well as three separate subdivisions called *bang*, in which items necessary for each of the five events were either newly produced or reused old ones, such as the palanquins, ritual weapons, and flags, that were repaired and repainted.

7 *[Gyeongjong] wangseja chaengye dogam uigwe*, 1690, Kyujanggak, 327–38. The 1610 investiture *uigwe* is in the collection of the Kyujanggak (Kyu 13196).

8 Although the coming-of-age rite came before that of the investiture of the crown prince, its *banchado* comes at the end of the book.

9 *Uiin wanghu jonho daebijeon sang jonho junggungjeon chaengnye, wangseja chaengnye gwallyesi chaengnye dogam uigwe*, 1610 (Kyujanggak), 37a. See also *[Gyeongjong] wangseja chaengnye dogam uigwe*, 1690, 37a.

10 They are, in chronological order, *Uigwe of the Investiture of Queen Myeongseong* (Hyeonjong's queen), 1661; *Uigwe of the Investiture of Queen Ingyeong* (first queen of Sukjong), 1676; *Uigwe of the Investiture of Queen Jang* (third queen of Sukjong), 1690; *Uigwe of the Investiture of Queen Inhyeon* (back to the position of queen after Queen Jang was demoted), 1694; *Uigwe of the Investiture of Queen Danui* (Gyeongjong's queen), 1722; *Uigwe of the Investiture of Queen Jeongseong* (Yeongjo's first queen), 1726; *Uigwe of the Investiture of Queen Hyoui* (Jeongjo's queen), 1778; and *Uigwe of the Investiture of Imperial Consort Sun* (consort of Emperor Gojong), 1901. See Yi Song-mi, Choe Jin-ok, Kim Hyeok

et al., eds., *Jangseogak sojang uigwe haeje* (Seongnam: Academy of Korean Studies, 2002), 56–80.

11 *Daily Records of Gwanghaegun* (*Gwanghaegun ilgi*), twenty-second day (*jeongyu*) of the fourth month, 1610, the first and second articles.

12 Ibid., 170. The painters' names are Cha Chung-ik, Yi Hong-gyu, Yi Sin-heum, and Kim Eung-ho.

13 King Gyeongjong and King Sukjong, in *Hanguk minjok munhwa daebaekgwa sajeon*, 28 vols. (Seongnam: Academy of Korean Studies, 1995), 2:85 and 13:338–39, respectively. At this time, Sukjong, who already planned the next successor to Gyeongjong, installed Prince Yeoning (his stepbrother and later King Yeongjo) as heir apparent. The Korean term for this title is *wang seje*, meaning "a king's younger brother made heir apparent."

14 Originally, five copies of the 1690 investiture *uigwe*, handwritten and hand painted, were made, one for royal viewing and one each for the State Council, the Ministry of Rites, the Court History Office, and the Ganghwa History Archive. Now three copies survive. This study was based on the copy in the Kyujanggak Institute for Korean Studies, Seoul National University (Kyu 13091), and BNF (2685). Another copy is in the Jangseogak Archives of the Academy of Korean Studies (K2-2693) under the title *Chaengnye deungnok* or the *Preliminary Records of Investiture Uigwe*.

15 The queen resided in the Daejojeon. For a series of discussions on the venue change for the young crown prince, see [*Gyeongjong*] *wangseja chaengnye dogam uigwe*, 1690, 29–33. Search in Korean at https://kyu.snu.ac.kr.

16 Ibid., 49–53.

17 For a detailed account of the procedure for the event, see *Five Rites of State*, 2:157–68. For a summary, see Park E., "Joseon sidae chaengnye dogam uigwe ui hoehwasa jeok yeongu," 525.

18 Usually three or more separate units called "*bang*," meaning room, were set up.

19 A bamboo book consists of forty or forty-eight flat strips of bamboo fastened together on the top and bottom with a gold band and nails; usually five or six strips form a unit — or "page" — of a book. Royal admonitions to the crown prince are written in gold dust on these so-called pages in an elegant literary style.

20 1690 investiture *uigwe*, 99–151. See note 15 above.

21 Ibid., 173–229.

22 Ibid., 231–319.

23 Ibid., 321–25. These subdivisions were headed by the third-level officers of the superintendency called *nangcheong*.

24 1690 investiture *uigwe*, 327–38. See note 15 above for online database information. The illustrations given on the website are from the BNF royal viewing copy, which we know because the margins are red instead of black. See also [*Gyeongjong*] *wangseja chaengnye dogam uigwe*.

25 The above description is based on the royal viewing copy of this *uigwe* now in the custody of the National Museum of Korea. See the 1690 investiture *uigwe* at https://www.museum.go.kr for images and a brief explanation of the scene by Je Song-heui of the Academy of Korean Studies.

26 Yi Song-mi, "The Making of Royal Portraits during the Chosŏn Dynasty," in *Bridges to Heaven: Essays on East Asian Art in Honor of Professor Wen C. Fong*, ed. Jerome Silbergeld, Dora C. Y. Ching, Judith G. Smith, and Alfreda Murck (Princeton, NJ: P. Y. and Kinmay W. Tang Center for East Asian Art, 2012): 1: 363–86. Yun Sang-ik served as the master painter in the 1688 *Uigwe of the Copying of King Taejo's Portrait*. For a brief discussion, see chap. 6.

27 Park Jeong-hye, "*Uigwe* reul tonghaeseo bon Joseon sidae ui hwawon," *Misulsa yeongu* 9 (1995): 221–90.

28 The term *gungmo* can be found even in the *Goryeosa* (*History of the Goryeo Dynasty*). See chap. 88, "Biography" section 1, the Biography of Gongye taehu (1109–1183): "This maiden is noble beyond comparison, therefore, fit to be the mother of the nation." Search in Korean at http://www.krpia.co.kr.

29 For the adoption of Chinese marriage customs in the late Goryeo and early Joseon periods as part of Korea's Confucianizing process, see Deuchler, *Confucian Transformation of Korea*.

30 See Yi S., *Garye dogam uigwe wa misulsa* (Seoul: Sowadang, 2008), for a monographic treatment of royal wedding *uigwe*. This book was based on the author's earlier work in Yi Song-mi, Gang Sin-hang, and Yu Song-ok, *Jangseogak sojang garye dogam uigwe* (Seongnam: Academy of Korean Studies, 1994), 33–116.

31 For a list of all wedding *uigwe*, see Yi S., *Garye dogam uigwe wa misulsa*, 28–30, tables 2 and 3. In the two listings the total number is twenty-one, but no. 14 of

table 2 is a procession painting in handscroll format, presumably that of the 1906 wedding.

32 Kim Yong-suk, *Joseon jo gungjung pungsok yeongu* (Seoul: Iljisa, 1986), 242–44. It is customary for members of the Joseon royal family to marry at an early age. The average age of the royal groom from King Sejong to King Sunjong was twelve, with the exception of Cheoljong (twenty-one). Accordingly, the age of a royal bride should be between the ages of nine and thirteen.

33 This translation of the term *chon* was taken from Shin, *Joseon Royal Court Culture*, 86n5.

34 For detached palaces and royal weddings of the Joseon period, see Kim Yong-suk, *Joseon jo gungjung pungsok yeongu*, 229–33.

35 For a detailed account of all six rites, see *Five Rites of State*, 2:114–55.

36 A live goose is the proper item for the occasion, but later a wooden goose was used for convenience by the general population. It is customary for an elderly man of the village who has had a lifelong felicitous marriage to carve one and present it to a prospective groom. Many wooden geese from Joseon-dynasty wedding ceremonies are extant today. For an example of a wooden goose wrapped in an embroidered wrapping cloth, see Huh Dong-hwa, *The Wonder Cloth* (Seoul: Museum of Korean Embroidery, 1988), 175.

37 The table on which to place the goose is called *jeonansang*, and the rite of presenting the goose to the bride is called *jeonallye*.

38 [Sohyeon seja] garye dogam uigwe, 1627. Originally eight copies were produced, but only two survive: one in the Kyujanggak Institute for Korean Studies, Seoul National University, and the other in the Jangseogak Archives of the Academy of Korean Studies. Both are distribution copies for the history archives.

39 [Yeongjo Jeongsun wanghu] garye dogam uigwe, 1795.

40 In 1636, after the humiliating surrender of his father, King Injo, to Qing Taizu during the Manchu invasion in the cyclical year byeongja, known in Joseon Korea as Byeongja horan, Crown Prince Sohyeon, his brother Prince Bongnim, and their spouses were taken to Shenyang as hostages. Crown Prince Sohyeon returned to Joseon after nine years of captivity. At the beginning of his captivity in Shenyang, he felt animosity toward the Qing, but gradually he became impressed with Qing culture, especially the adoption of the Western calendric system, astronomy, and Christianity. See Donald L. Baker, "Jesuit Science through Korean Eyes," Journal of Korean Studies 4 (1982–83): 207–39. In 1644 the crown prince spent seventy days in Yanjing, where he happened to meet Adam Schall (Johann Adam Schall von Bell, 1596–1666). Schall gave him a globe and an image of Christ, which the crown prince brought back with him to Joseon in 1645. (For the crown prince's possible role in introducing Western influence into Joseon painting, see Yi Song-mi, Searching for Modernity: Western Influence and True-View Landscape in Korean Painting of the Late Chosŏn Period [Seattle, WA: University of Washington Press, 2015], 17–18.) However, King Injo, as well as other pro-Ming scholar-officials, was unenthusiastic about his son's interest in Qing culture and

did not give him due credit for his diplomatic activities in Shenyang. Crown Prince Sohyeon became ill on the twenty-third day of the fourth month (about two months after his return) and died three days later, on the twenty-sixth day. His wife, Gangbin, was put to death the following year by her father-in-law, King Injo, and the couple's three sons were exiled to Jeju Island, where two of them died of an illness indigenous to the island. It was only in 1718 that she recovered posthumously the status of crown princess and was given a formal title, Gang Hoebin (Crown Princess Gang of Sorrowful Heart). The title Hoebin, or Minhoebin, both refer to her sad and pitiful life. For more on Crown Prince Sohyeon's tragic life and death, see Gyujanggak sojang uigwe haejejip (Seoul: Kyujanggak Institute for Korean Studies, Seoul National University, 2005), 3: 371–82.

41 Originally, eight copies of this uigwe were produced, of which three copies survive: the copies in the Odaesan and Taebaeksan History Archives (Kyu 13198) and (Kyu 13197), respectively, and the Jeoksangsan History Archive copy currently in the Jangseogak Archives (K2-2592).

42 Sohyeon seja garye dogam uigwe, 10a, 15b; Five Rites of State, 2:196–201.

43 Bongung was situated in present-day Nagwon-dong in central Seoul, southeast of the Gyeongbok Palace.

44 The location of Taepyeong-gwan Guesthouse is present-day Seosomun, Taepyeong-ro, in Jung-gu.

45 See Veritable Records of King Injo, 50 vols. (1653), vol. 17, day twenty-seven of the twelfth month. See references under Joseon wangjo sillok on page 525 of this volume.

46 The titles of this part are Jesaek janginjil (artisans of various trades) in the first subdivision, Gongjang (artisans) in the second subdivision, and Gongjangjil (list of artisans) in the third subdivision.

47 Later uigwe have a separate awards section.

48 Park Jeong-hye, "Joseon sidae Uiryeong Namssi gajeon hwacheop," Misulsa yeongu 2 (1988): 23–49. Ladies of higher standing appear in paintings if the event depicted is for them. See the painting album Baekse chaedaebuin gyeongsuyeondo (1605), painted after the celebration of the mother of Yi Geo (1532–1608), Lady Chae, who was 102 years old. The current album in the Seoul History Museum is a nineteenth-century copy.

49 [Yeongjo Jeongsun wanghu] garye dogam uigwe, 1759. After the wedding event, five copies of the uigwe were produced. Three copies survive, two of which are complete. The royal viewing copy, which had been kept at the BNF, is now in the National Museum of Korea.

50 Sin Byeong-ju, Yuksibyuk se ui Yeongjo, sibo se ui sinbu reul majihada (Seoul: Hyohyeong chulpansa, 2001), 133–34. She failed to bear any children. After the untimely death of Yeongjo's successor, King Jeongjo (r. 1776–1800), the eleven-year-old crown prince ascended the throne as King Sunjo (r. 1800–1834). His politically ambitious grandmother, now Dowager Queen Jeongsun, proclaimed that she would act as his "regent behind the bamboo curtain," i.e., hold court while concealed by a

curtain. During her three and a half years as regent, she was deeply involved in politics, mostly undoing the two previous kings' (Yeongjo and Jeongjo) policy of impartiality (tangpyeongchaek), through which they worked hard to remedy the factional strife of the Joseon court. She actively persecuted followers of Catholicism, which had become a social force among southern-faction (naming) intellectuals.

51 For a series of debates among officials on this subject, see Kim Mun-sik, "Joseon wangsil ui chinyeongnye yeongu," in Joseon wangsil ui garye, ed. Kwon O-yeong, Kim Mun-sik, et al. (Seongnam: Academy of Korean Studies, 2008), 1:112–16.

52 See Veritable Records of King Sukjong, 65 vols. (1728), chap. 37 (1702), thirteenth day of the tenth month. See references under Joseon wangjo sillok on page 525 of this volume.

53 For the new chinyeong rite, see Gukjo sok oryeui seorye 1982, 5:156–59.

54 See the eighteen-page banchado in Sukjong Inwon wanghu garye dogam uigwe (1702) (Kyu 13089 and Kyu 13090). The royal viewing copy of the BNF (2529) version is the first volume of the two-volume set and does not have any banchado. The copy in the Jangseogak Archives (Jang-4754) is incomplete.

55 Under the second heading, gyesa, is the schedule for the three-stage selection of the bride-to-be from the second day to the ninth day of the sixth month, and from the thirteenth day to the twenty-second day of the same month. All six rites of the wedding ceremony were performed.

56 Section title: *uiju(jil)*. [*Yeongjo Jeongsun wanghu*] *garye dogam uigwe*, reduced-size facsimile edition, 254–301. The protocol outlined generally follows the procedure detailed in the royal wedding section of the *Five Rites of State* (from *napchae* to *chaekbi*), and for the royal visit (*chinyeong*) in the *Sequel to the Five Rites of State*. The ceremony of the presentation of a live goose appears in the *chinyeong* section. For the rites of *napchae* to *chaekbi*, see *Five Rites of State*, 2:115–55; for the *chinyeong* rite, see *Sequel to the Five Rites of State*, 5:156–59.

57 These names appear in the section called *gongjangjil*. Only one painter's name, Heo Dam, appears in the main office along with the comment "and others for a total of eight persons."

58 Listed under the first subdivision are Hyeon Jae-hang, Yi Choe-in, Yi Bok-gyu, Sin Han-dong, Yi Pil-han, Yi Gwang-pil, and Sin Deok-heup. Listed under the second subdivision are Jang Ja-jing, Han Jong-il, Yi Pil-seong, Kim Eung-hwan, Yi Do-min, Yi Jong-uk, and Heo Jap. Listed under the third subdivision are Jeong Deok-hong, Yi Pil-seong, Han Sa-geun, and Jang Byeok-man.

59 Jeong Eun-ju, "Gyeongjin dongji Yeonhaeng gwa Simyang-gwan docheop," *Myeongcheong sa yeongu* 25 (April 2007): 97–138.

60 For Kim Eung-hwan's landscape paintings, see Yi Song mi, *Korean Landscape Painting: Continuity and Innovation through the Ages* (Seoul: Hollym, 2006), 117, fig. 75.

61 For a list of screen paintings produced for wedding ceremonies during the Joseon dynasty, see Yi S., *Garye dogam uigwe wa misulsa*, 300–303, table 5.

62 [*Jeongjo wangseson*] *garye dogam uigwe* (1762), 1:5.

63 For the places of the jade figurines, see fig. 199 (*dongnoe-yeondo*). Only one jade figurine of the Joseon period survives; it is kept in the National Palace Museum of Korea; see *Joseon ui wangbi wa hugung* (Seoul: National Palace Museum of Korea, 2015), fig. 34. As for the symbolic meaning of the jade figurine in a royal wedding, I was unable to find literature that explains it. My guess is that since the term "jade figurine" (*okdongja*) in Korean also means "a beautiful male child," it is intended at a wedding to signal a wish for a first male child.

64 [*Jeongjo wangseson*] *garye dogam uigwe*) (1762), 1:21.

65 The fifty-page *banchado* is illustrated in its entirety in Yi S., *Garye dogam uigwe wa misulsa*, figs. 4-1–4-28.

66 See *garye nobu doseol* in *Illustration of the Five Rites of State*, vol. 2, in *Five Rites of State*, 4:192–96, showing the flags, ritual weapons, and other paraphernalia for attendants and guards in the royal procession for the celebratory rites. This grand-procession format is also used when the king is receiving a Chinese emperor's orders for the royal ancestral shrine (Jongmyo) rites and for the sacrifice to the spirits of earth and grain.

67 In other *banchado*, the more common term *panseo* is used instead of *dangsang*. The term *dangsang* designates the officials who are of rank 3a and above in the nine-rank system of the Joseon bureaucracy. Ministers are rank 2a.

68 In Joseon Korea, all married women wore a silver knife as part of their dress accessories. The knife was a symbol of a woman's chastity; that is, when attacked by other men, she was to kill herself with the knife to keep her chastity.

69 It was during King Yeongjo's reign that the terms *gwangwang minin* (sightseers) and *gwangwang sanyeo* (sightseeing men and women) first appeared in Korean history in the *Diaries of the Royal Secretariat*. See Kim Ji-yeong, "Joseon hugi gugwang haengcha e daehan yeongu: uigwe banchado wa geodong girok eul jungsim euro" (PhD diss., Seoul National University, 2005), 211–34. Kim found the terms in the *Diaries of the Royal Secretariat*, bk. 850, eighth day, sixth month, 1737 (Yeongjo 13).

70 The king's personal participation in the procession, however, was indicated by the royal palanquin earlier in the *banchado* of the *Uigwe of the Copying of King Sukjong's Portrait* (1748), which depicted the procession that transported King Sukjong's newly copied portrait from the Changdeok Palace to the Yeonghuijeon hall in today's Myeongdong. See chap. 6 for this *banchado*.

1 *Five Rites of State*, 2:293–321.

2 Ahn Hwi-jun, "Gyujanggak sojang hoehwa ui naeyong gwa seonggyeok," *Hanguk munhwa* 10 (1989): 309–92. Originally, this painting was a hanging scroll with the title written across the top, the middle section occupied by the painting, and the lower part filled with the names of officials who participated in the event.

3 The occasion at this time was for the approval of the investiture of the crown prince. Today, only a small portion of the *deungnok* of the meal-preparation subdivision of the *dogam* survives (Kyu 14558). The *uigwe* of the main superintendency is 96 *jang* (Kyu 14546).

4 Han Y., *Joseon wangjo uigwe*, 59–74.

5 Ibid., 85–90.

6 The *uigwe* compiled at this time is *Yeongjeop dogam gunsaek uigwe*. Two copies survive (Kyu 14561 and Kyu 14562); both have 315 sheets but no procession paintings.

7 The *uigwe* compiled at this time is also called *Yeongjeop dogam gunsaek uigwe*. One copy survives (Kyu 14577). It is only forty-seven sheets long and has no illustrations.

8 Han Y., *Joseon wangjo uigwe*, 108–12.

9 *Fengshi tu* (Kr. *Bongsado*) in the Zhongguo minzu tushuguan, a library in Beijing.

10 Jeong E., "Gyeongjin dongji Yeonhaeng gwa Simyanggwan docheop," 97–138; Jeong Eun-ju, *Joseon sidae sahaeng girok hwa* (2012;

repr., Seoul: Sahoe pyeongnon, 2014); Liu, Lihong, "Ethnography and Empire through an Envoy's Eye: The Manchu Official Akedun's (1685–1715) Diplomatic Journeys to Chŏson Korea," *Journal of Early Modern History* 20 (2016): 111–39.

11 This range of dates is based on the fact that the poetic inscriptions on the sixteen leaves of the album coincided with those poems in Akedun's collected poems, *Dongyou ji* (*Journey to the East*), of 1725.

12 Jeong E., "Gyeongjin dongji Yeonhaeng gwa Simyanggwan docheop," 211. Akedun hired a Korean painter and ordered him to paint scenes he had in mind to be included in the album so that the Chinese painter could use them as references.

13 See leaves 15, "Proclamation of Imperial Decree" (*Seon chik-seoui*); 16, "Reception with Tea at Huijeongdang" (*Huijeongdang daryeui*); and 18, "Departure Banquet at the Banquet Hall at Nambyeoljeon" (*Nambyeoljeon yeoncheong jeonyeonui*), in which images of the crown prince (future King Yeongjo), King Suk-jong, and King Yeongjo, respectively, are seen, not frontally, but in nearly profile and back views combined. For color plates of the leaves, see Jeong E., *Joseon sidae sahaeng girok hwa*, 391–95, figs. 5-19, 5-20, and 5-22.

14 Yeoninggun's biological mother is Sukbin Choe ssi (1670–1718), another concubine of King Sukjong.

15 See the eighteenth leaf of the album, in which King Yeongjo is shown along with Akedun.

16 Liu, "Ethnography and Empire through an Envoy's Eye," 122–27 (section titled "The Imperial Ambassador: Subjectivity and Official Role").

17 "*Mallyeok samsippalnyeon samwol chochiril pilseongjeok*" (see glossary). Recorded on the last page of *Yeongjeop dogam docheong uigwe* (1608; repr., Kyujanggak, 1998), 298.

18 Recorded on the first page, ibid., 3.

19 Two copies of this *uigwe* were produced, Kyu 14545 and Kyu 14546, one volume of 192 pages (96 *jang*). Both copies survive in the Kyujanggak Institute for Korean Studies. See the short description in *Gyujanggak sojang uigwe jonghap mongnok* (Seoul: Kyujanggak Institute for Korean Studies, Seoul National University, 2002), 243–44.

20 Kyu 14551, one volume of 102 pages (51 *jang*). The number of copies originally produced is not known, but only this one (from Odaesan History Archive) survives.

21 Kyu 14556 and Kyu 14557. Kyu 14556, one volume of 334 pages (117 *jang*), is in better condition. See also the reduced-size facsimile editions of these three *uigwe* published by the Kyujanggak Institute in 1998 — the first two in one volume and the third one in a separate volume, both volumes with an introduction by Han Myeong-gi.

22 *Yeongjeop dogam docheong uigwe*, 3–6.

23 *Yeongjeop dogam docheong uigwe*, 14 and 40.

24 Ibid., 16.

25 *Yeongjeop dogam sajecheong uigwe* (1608; repr., Kyujanggak, 1998), 145–50.

26 The same procedure can be found in the "Five Rites" section of *Sejong sillok* (*Veritable Records of King Sejong*), 135:26a. See references under *Joseon wangjo sillok* on page 525 of this volume.

27 *Gwak wigwan* refers to Guo Yanguang, the Ming official in charge of safeguarding the imperial seals (*jangingwan*) who came with the Ming retinue at that time. He was one of the chief eunuchs of the Ming court.

28 Reproduced in *Yeongjeop dogam sajecheong uigwe*, 216–24.

29 Ibid., 225–34.

30 Ibid., 167.

31 Ibid., 235–36.

32 They are Kim Eop-su (b. 1543), Yi Eun-bok, Kim Eung-ho, and Kim Sin-ho. *Yeongjeop dogam sajecheong uigwe*, 5.

33 Park J., "*Uigwe* reul tonghaeseo bon Joseon sidae ui hwawon," 203–90.

34 Liu's title is *Saryegam taegam*, chief of the directorate for ceremonials.

35 Han Myeong-gi, "Gwang-haegun ui daeoe jeongchaek jaeron," *Hanguk bulgyosa yeongu* 2 (Fall/Winter 2012): 171–228.

36 *Daily Records of Gwanghaegun*, vol. 17, Gwanghae 1, 1609, second day, sixth month.

37 Han Myeong-gi, "Sipchil segi cho eun ui yutong gwa geu yeonghyang," *Gyujanggak* 15 (1991): 1–36. At this time the Chinese had a "silver standard" currency system.

38 *Docheong uigwe*, of *Yeongjeop dogam docheong uigwe*, 182–85.

39 For an in-depth analysis of Gwanghaegun's policy toward the Ming and the Manchus (Hou Jin), see Kye Seung-beom, "Gwanghaegun ui daeoe jeong-chaek gwa geu nonjaeng ui seonggyeok," *Hanguk bulgyo sa yeongu* 4 (Fall/Winter 2013): 4–39.

CHAPTER FOUR
PAGES 157–168

1 *Five Rites of State*, 2:323–41.

2 The highest national Confucian educational institution in China is called Guozijian.

3 *Gukjo sok oryeui* (1744; Hangul translation by Ministry of Government Legislation, 1982), bk. 4, in *Five Rites of State*, 5:237–51.

4 *Gukjo sok oryeui seorye* (1744; Hangul translation by Ministry of Government Legislation, 1982), bk. 1, in *Five Rites of State*, 4:372–73.

5 Concerning this event, three entries appear in the *Veritable Records of King Yeongjo* (1743, Yeongjo 19), vol. 103: the third, fifth, and eighth day of the second month. See references under *Joseon wangjo sillok* on page 525 of this volume.

6 *Veritable Records of King Taejong*, twenty-seventh day of the first month, 1417. See references under *Joseon wangjo sillok* on page 525 of this volume.

7 Five copies of this *uigwe* were made, one each for royal viewing, History Archives (not specified), the State Council, the Ministry of Rites, and Seonggyungwan. Only the State Council's copy survives, and is now kept in the Kyujanggak Institute for Korean Studies (Kyu 14941). It consists of one volume with ninety-four sheets. A reduced-size facsimile was produced by Kyujanggak in 2001 with an introduction by Sin Byeong-ju.

8 *Daesarye uigwe*, introduction by Sin Byeong-ju (1743; repr., Kyujanggak, 2001), 155–71.

9 See the illustration of the target in color in ibid., 157. It is a very large target compared to a modern-day circular target, with a diameter of 128 centimeters.

10 For an explanation and interpretations of the multiple viewpoints in most other Joseon *uigwe banchado*, see the introduction in this volume.

11 *Daesado (munbanchado)* in *Gukjo sok oryeui seorye*, 37.

12 See chap. 6 of this book for more on the Five Peaks screen.

13 *Five Rites of State*, bk. 6, 2:323.

14 The *bok* stand, made of wood and painted, is constructed of two dragon heads facing each other far apart, with bodies and tails of snakes joined together at the bottom to form an open frame, placed on a wooden board. In the middle of this frame, another piece of wooden board is laid parallel to the one on the bottom. On this middle board, covered with a piece of horsehide, four arrows are laid out. For the illustration and specifications, see *Daesarye uigwe*, 162–64.

15 For the illustration and specifications, see ibid., 168–69.

16 Three additional scrolls of the same theme are in the collections of the National Museum of Korea, Yonsei University Museum, and the Ewha Woman's University Museum.

17 A *bansu* is a narrow, man-made stream that surrounds the National College compound of a vassal state because the college compound is also called a *bangung*.

18 Park Jeong-hye thinks the handscroll versions were commissioned by high officials who participated in the royal archery rites, to be shared with some of the officials, and she therefore dates the scrolls to 1743, the same year as the *uigwe* illustrations; see Park Jeong-hye, *Joseon sidae gungjung girok hwa yeongu* (Seoul: Iljisa, 2000), 252. However, it seems to me that since the painters of the handscroll versions did not appear to understand the technique of constructing the three-dimensional space by placing the targets upside down, as in the *uigwe* illustrations, they could not be the same date as the latter.

19 *Daesarye uigwe*, 171.

20 For other publications on rites and regulations that Yeongjo had published during his reign, see *Yeongjo daewang* (Seongnam: Academy of Korean Studies, 2011), 122–31.

21 Jang Pil-gi, *Yeongjo dae ui musin ran: tangpyeong ui gil eul yeolda* (Seongnam: Academy of Korean Studies, 2014). For notable publications concerning military affairs during Yeongjo's reign, see ibid., 132–39. During much of his reign, political factions and military forces formed alliances to create military revolts at regional centers, which in turn threatened the central royal military power and authority.

22 Sin Byeong ju, "Yeongjo dae ui daesarye silsi wa daesarye *uigwe*," *Hanguk hakbo* 28, no. 1 (2002): 70.

CHAPTER FIVE
PAGES 169–217

1 For a good summary of the entire Joseon state funeral rites, see Yi Uk, "Joseon ui guksang jeolcha wa uimi," in *Orye: Joseon ui gukga uirye*, ed. Ji Du-hwan, Yi Song-mi, et al. (Seoul: National Palace Museum of Korea, 2015), 311–50.

2 The four *yejang* Yeongjo had to take care of were those of his first crown prince, Hyojang (1719–1728); the crown prince's wife, Hyosun Hyeonbin (1715–1751); his second crown prince, Sado (1735–1762); and his crown grandson, Uiso seson (1750–1752).

3 See note 23 in the introduction.

4 The approximate number of the months for the Joseon mourning period is explained on the website of the National Folk Museum of Korea: http://folkency.nfm.go.kr.

5 *Five Rites of State*, 3:20–242.

6 See Han Y., *Joseon wangjo uigwe*, 874, for the list of the *uigwe* currently in the Kyujanggak Library: *Ilbang uigwe* (Kyu 1486-1); *Ibang uigwe* (Kyu 1486-2); and *Sambang uigwe* (Kyu 13511). All contain small, color illustrations of the ritual items that were produced by each of the sub-divisions.

7 Five copies of this royal funeral *uigwe* were produced, one for royal viewing (BNF 2552) and four for the History Archives. One of the History Archives copies is now kept in the Kyujanggak Library (Kyu 13521).

8 See *Five Rites of State*, 5:322, the *seorye* section, for illustrations and dimensions of the tablet, cover, and a small stand for it.

9 In the case of King Injo's funeral, the *Bumyo dogam uigwe* was compiled in 1651, but only *uigwe* of two subdivisions (the first and the second *bang*) are extant today. They were among the *uigwe* that the BNF returned to Korea in 2011.

10 See glossary.

11 *Injo gukjang dogam uigwe*, 1649, 5.

12 *Injo binjeon dogam uigwe*, 1649, 10–17.

13 Notes on this *banchado* by Je Song-heui appear below each page of the digital images provided by the National Museum of Korea, https://www.museum.go.kr/uigwe.

14 Je Song-heui, "Joseon sidae uirye *banchado* yeongu" (PhD diss., Graduate School of the Academy of Korean Studies, 2013), 44.

15 See a late Joseon dynasty *gyoryong gi* preserved in the National Palace Museum of Korea in *Joseon wangsil ui gama* (Seoul: National Palace Museum of Korea, 2005), 33. This particular flag has a blue background, although most of the others have a yellow background.

16 This white drape is called *haengyujang* or the curtain to be used on the road.

17 Park Jeong-hye, "*Uigwe* reul tonghaeseo bon Joseon sidae ui hwawon," *Misulsa yeongu* 9 (1995): 203–90.

18 Mohwagwan is a rest stop for Chinese envoys, where the Joseon king greeted them before they entered Hanyang.

19 For a detailed study of the screens used for funeral rites of the Joseon dynasty, see Sin Han-na, "Joseon wangsil hyungnye ui uijang yong byeongpung ui gineung gwa uimi" (MA thesis, Hongik University, 2008).

20 *Five Rites of State*, 3:64–79.

21 *Orye* (Five Rites), chap. 136. To quote in part, "the heads of the 'four animals' (*sasu*) should reach just below the spacing stone openings" (*gyeokseokchang*).

22 *Injo Jangneung salleung dogam uigwe*, reduced-size facsimile reprint, *Injo Jangneung salleung dogam uigwe* (Seongnam: Academy of Korean Studies, 2007), 122.

23 *Veritable Records of King Yejong*, vol. 1, the second entry dated on the nineteenth day of the ninth month in 1468. See references under *Joseon wangjo sillok* on page 525 of this volume.

24 *Gugyeok Gukjo sangnye bopyeon*, 2008, 170–77.

25 Ji Min-gyeong, "Sip–sipsa segi Dongbuga byeokhwa gobun yesul ui jeongae wa Goryeo byeokhwa gobun ui uiui," *Misulsa yeongu* 25 (2011), 81, fig. 4.

26 *Gugyeok Jeongjo gukjang dogam uigwe*, trans. National Research Institute of Cultural Heritage (Seoul: Minsogwon, 2006), 1:77.

27 For comparative charts of the four animal illustrations from royal tomb construction *uigwe* ranging in date between 1630 and 1926, see Yun Jin-yeong, "Joseon wangjo salleung dogam *uigwe* ui sasudo," in *Injo Jangneung salleung dogam uigwe* (Seongnam: Academy of Korean Studies, 2007), 486–87.

28 Ibid., 487 fig. 12.

29 Yi S., *Searching for Modernity*, 17.

30 Kim Hong-do collaborated with the famous critic and literati painter Gang Se-hwang (1713–1791), who painted the pine tree above the tiger.

31 They are Han Seon-guk (b. 1602), Hong Gyeong-min, and five others whose names do not appear. Their other paintings have not survived, but their names appear in other *uigwe* of the seventeenth century.

32 See the first entry of the thirteenth day of the fifth month in the *Veritable Records of King Yeongjo*, vol. 73 (1751). See references under *Joseon wangjo sillok* on page 525 of this volume.

33 Kim Nam-yun, "Jeongjo ui wangseson chaengnye yeongu," *Gyujanggak* 37 (2010): 217–49. There were other cases: in 1649 (later King Hyeonjong), in 1759 (later King Jeongjo), and in 1830 (later King Heonjong).

34 See the Hangul translation, *Gugyeok Gukjo sangnye bopyeon*, 517–38.

35 For an in-depth analysis of this *banchado*, see Yi Su-gyeong, "Uiso seson barin banchado seonggyeok gwa uiui," in *Hyungnye* I (Funerary Rites of the Oegyujanggak Uigwe) (Seoul: National Museum of Korea, 2015), 212–38.

36 BNF 2511, 391–419.

37 For a list of all the participants in the procession, see Yi S., *Yeongjo dae ui uigwe wa misul munhwa*, 170–71n100.

38 Originally three copies were made, of which two survive (the royal viewing copy, BNF 2517; Kyu 14259). The layout of the buildings of the shrine is included in the *uigwe*. See Kyu 14259, 102a. It shows the main shrine within a walled enclosure that is approached by a series of four gates. It is a handsome illustration with ink and light colors.

39 For a list of Joseon royal tombs with their locations, see Yi Wu-sang, *Joseon wangneung: Jam deulji mothaneun yeoksa*, with photographs by Choe Jin-yeon (Seoul: Dahal Media, 2008), 22–24. For a diagram of the royal tomb precinct with all the objects and their identifications, see ibid., 25–27.

40 There are exceptions to this rule, as when the first tomb was transferred to another location for various reasons, the most important being geomancy, as in the case of King Sejong's tomb Yeongneung in Yeoju, which is about sixty kilometers southeast of Seoul.

41 See https://whc.unesco.org/en/list/1319.

42 http://royaltombs.cha.go.kr

PART TWO INTRODUCTION

PAGE 221

1 Royal banquets, both large and small, sometimes are classified as celebratory rites.

2 There were three such cases: (1) Wonjong (1580–1619), the father of King Injo; (2) Jangjo (Crown Prince Sado), the father of King Jeongjo; and (3) Ikjong (later King Munjo) (1809–1830), Crown Prince Hyomyeong, the father of King Heonjong.

CHAPTER SIX

PAGES 223–258

1 For an English-language article on this subject, see Yi S., "Making of Royal Portraits," 1:363–86. For a more in-depth treatment of the subject in Korean, see Yi Song-mi, *Eojin uigwe wa misulsa* (Seoul: Sowadang, 2012). The first study on Joseon royal portraits based on *uigwe* is Kim Seong-hui, "Joseon sidae eojin e gwanhan yeongu — *uigwe* reul jungsim euro" (MA thesis, Ewha Womans University, 1989), a well-researched thesis that also includes preliminary records called *deungnok* as well as *uigwe*.

2 *Yukjeon jorye* (1867; repr., 4 vols., Hangul translation by Ministry of Government Legislation, 1974), 4:412 (*yejeon, gongjeon*, "Rites" and "Works" sections).

3 [*Gojong hwangtaeja*] *eojin dosa dogam uigwe* (1902). The same passage can be found in the *Veritable Records of Emperor Gojong*, chap. 41, 7 November. See references under *Joseon wangjo sillok* on page 525 of this volume.

4 Entries can be found in the *Diaries of the Royal Secretariat* in which the term *yangseongjo* refers to Kings Sukjong and Yeongjo

(25 January 1874) and Kings Yeongjo and Jeongjo (16 March 1902).

5 Cho Insoo, "Royal Portraits in the Late Joseon Period," *Journal of Korean Art and Archaeology* 5 (2011): 9–23.

6 See a series of entries to this effect in the *Veritable Records of King Jeongjo*, 12 (1781, Jeongjo 5, from the eighth through the ninth month), in Yi Song-mi, "Ideals in Conflict: Changing Concepts of Literati Painting in Korea," in *The History of Painting in East Asia: Essays on Scholarly Method*, eds. Naomi Noble Richard and Donald E. Brix (Taipei: Rock Publishing and NTU, 2008), 288–314. Although Cho Insoo (ibid.) has termed the period spanning the reigns of King Yeongjo and King Jeongjo a "renaissance of royal portraits," no *uigwe* were compiled during those reigns.

7 Originally, five copies were made, of which three survive (Kyu 13978, Kyu 13979, and Kyu 13921).

8 Originally, five copies were made, of which three survive (BNF 2697, Kyu 13995, and Kyu 13996).

9 Originally, six copies were made, of which three survive (BNF 2520, Kyu 14922, and K2-2765).

10 Originally, six copies were made, of which two survive (Kyu 13997 and K2-265).

11 Originally, six copies were made, of which four survive (Kyu 13980, Kyu 13981, K2-2765, and K2-2767).

12 Originally, six copies were made, of which three survive (Kyu 13998, Kyu 13999, and K2-2764).

13 Originally, nine copies were made, all of which survive. Eight are listed here: Kyu 13982; Kyu 13983 royal viewing copy; Kyu 13986; Kyu 13989; Kyu 15069; K2-2766; K2-2767; and in the National Palace Museum of Korea Ku 305-93 (formerly Jo 13987-1 in the Kunaichō Library, Tokyo). The royal viewing copies of the Daehan Empire period *uigwe* are those made for Kyujanggak. They are the equivalents of the royal viewing copies of the earlier period and are bound with gold hardware and yellow silk covers.

14 Kyu 13983. This is the only surviving copy originally made for the Office of Education of Crown Princes, and it is only sixty-eight pages long. The work of repairing the two portraits was conducted concurrently, with the more important work of copying King Taejo's portrait. Therefore, the dates and personnel overlap with the latter. The mounting of King Sunjo's portrait had to be repaired, and the title section for King Munjo's portrait had to be repaired and rewritten. Therefore, in this chapter there will be no more discussion on this *uigwe*.

15 Originally, seven copies were made, of which six survive: Kyu 13990-1-2 royal viewing copy; Kyu 13992; Kyu 13994; K2-2765; K2-2768; and in the National Palace Museum of Korea Ku 305-92 (formerly Jo 13993-1 in the Kunaichō Library, Tokyo]).

16 Originally, six copies were made, all of which survive (Kyu 14000, Kyu 14001, K2-2756, K2-2757 royal viewing copy, K2-2758, and K2-2759).

17 The title of this *uigwe* (K2-2770) seems to have been written in at a later date. On the first page, the following date and title is written: *Ganghui gunyeon yunsamwol il sugae dogam deungnok* (Kangxi 9, second

leap month, preliminary record of repair *dogam*). It is only five pages in all. For the first page, with the title, see Yi S., *Eojin uigwe wa misulsa*, 25, fig. 2-1; for a portrait of King Sejo now kept in the Haeinsa Museum, see ibid., 35, fig. 2-9. Cho Insoo mentions that a portrait of King Sejo was rescued by a Buddhist monk during the Japanese invasion of 1592, and kept in Bongseonsa at Gwangneung. See Cho I., "Royal Portraits in the Late Joseon Period," 9–23.

According to the earlier Korean version of the article (Cho Insoo, "Joseon hubangi eojin ui jejak gwa bongan," in *Dasi boneun uri chosang ui segye* [Daejeon: National Research Institute of Cultural Heritage, 2007], 7–32), this information is from the *Veritable Records of King Seonjo*, chap. 23 (the twentieth day of the second month) and chap. 36 (the sixteenth day of the third month). The portrait was moved from Bongseonsa to several other places until it was installed in Nambyeoljeon in Hanyang in 1637. Ibid., 3ff. It is not known whether this portrait is the same as the one in the Haeinsa Museum. See references under *Joseon wangjo sillok* on page 525 of this volume.

18 Yi Su-mi, "Gyeonggijeon Taejo eojin ui jejak gwa bongan," in *Wang ui chosang* (Jeonju: Jeonju National Museum, 2005), 238, fig. 5.

19 During the Korean War of 1950–53, royal portraits along with other cultural assets were moved for safety to the southern port city of Busan, and stored in a warehouse. In 1954 a fire at the warehouse destroyed or damaged many of them. For a list of forty-six royal portraits kept in the new Seonwonjeon in Changdeok Palace in 1935–36, see *Sinseonwonjeon: Choehu ui jinjeon* (Daejeon: National Research Institute of Cultural Heritage, 2010), 107, chart 3.

20 *Yeongjo daewang*, fig. 24.

21 For the first time, all the existing royal portraits, whether damaged or not, were displayed in an exhibition in the National Palace Museum of Korea in 2015. The catalogue that accompanied the exhibition of the same name is *Joseon wangsil ui eojin gwa jinjeon* (Seoul: National Palace Museum of Korea, 2015).

22 On the subject of royal portrait halls, see Cho Sun-Mie, "Joseon sidae e isseoseo ui jinjeon ui baldal — munheon sang e natanan girok eul jungsim euro," *Gogo misul* 145 (1980): 10–23; Cho I., "Joseon hubangi eojin ui jejak gwa bongan"; and Hwang Jeong-yeon, "Joseon sidae jinjeon ui yeoksa wa Sinseonwonjeon," in *Sinseonwonjeon: choehu ui jinjeon*, 84–111.

23 Now in Unhagidong, Gaeseong, North Hwanghae province, designated as Cultural Heritage #528.

24 For a list of portraits of Joseon queens, see *Joseon wangsil ui eojin gwa jinjeon*, 241–42. Although none of the portraits survives, documentary evidence can be found in the *Veritable Records of the Joseon Dynasty*.

25 For a discussion about the term in 1713 among King Sukjong and his officials, see Yi Song-mi, Gang Sin-hang, and Yu Song-ok, *Joseon sidae eojin gwangye dogam uigwe yeongu* (Seongnam: Academy of Korean Studies, 1997), 29–32, and Yi, *Eojin uigwe wa misulsa*, 19–24. King Sukjong's reign is characterized by the rehabilitation of the Joseon kingdom after the devastating Japanese invasions of Korea in 1592–93 and 1597–98, and the Manchu assaults on the northern part of the peninsula in 1627 and

1636; his coinage of the term *eojin* reflects his "nationalism." On the "reconstruction" of the royal portrait tradition during the reign of King Sukjong because of its collapse after the Japanese and the Manchu invasions, see Cho I., "Royal Portraits in the Late Joseon Period," 12ff.

26 Morohashi Tetsuji, *Dai kanwa jiten*, 13 vols. (Tokyo: Taishūkan Shoten, 1955–1960).

27 For the discussions, see Yi S., *Eojin uigwe wa misulsa*, 21–23; Yi S., "*Uigwe* Royal Documents."

28 After the fall of Ming in 1644, Koreans, out of loyalty to the fallen dynasty, continued to use the Chinese Chongzhen reign dates for more than one hundred years.

29 See the 1688 and 1837 maps in Yi S., *Eojin uigwe wa misulsa*, 46 and 124, respectively. Each of the day and night stops was determined according to the conditions of the terrain, with an average of 70–80 *ri* (approximately 28–32 km) covered in one day. Map 1 in ibid., 46, is based on the *uigwe* records, with marks for day stops and overnight stays. Map 2 in ibid., 47, is today's Google map showing the same travel route. Amazingly, the 1688 map shows nearly the same route, though today it can be traveled by KTX, the fast train, in two hours and ten minutes and by car in about two and a half hours. In 1688 the trip from Seoul to Gyeonggijeon in Jeonju took eight days.

30 [*Sukjong*] *eojin dosa dogam uigwe* (1713), 14 (the page number of the microfilm version).

31 [*Gojong hwangtaeja*] *eojin dosa dogam uigwe* (1902), 4–8.

32 For Western influence on Joseon-period painting, see Yi S., *Searching for Modernity*, 17–80.

33 [*Sukjong*] *eojin dosa dogam uigwe* (1713), 44.

34 For the late Joseon *sinyeon* preserved in Gyeonggijeon, see *Wang ui chosang* (Jeonju: Jeonju National Museum, 2005), figs. 34 and 35.

35 See Yi Song-mi, "The Screen of the Five Peaks of the Joseon Dynasty," *Oriental Art* 42, no. 4 (1996/97): 13–24, as well as the revised version in Yi Song-mi, "Screen of the Five Peaks of the Choson Dynasty," in *Joseon wangsil ui misul munhwa*, ed. Yi Song-mi et al. (Seoul: Daewonsa, 2005), 465–519.

36 For quotations from the 1713 and 1735 *uigwe* that explain the types of screens placed behind and on either side of a royal portrait, see Yi S., *Eojin uigwe wa misulsa*, 285–87.

37 See ibid., 296–97nn243–45, for documentary evidence of 1590, 1637, and 1757 concerning the Five Peaks screens without the sun and moon for which the "sun and moon mirrors" (*irwolgyeong*) were used. Of the three pieces of evidence, the latter two (1637, 1757) are related to funeral rites.

38 Many established families had their illustrious ancestors' portraits in the portrait hall (*yeongdang*) of their own house-compound and paid respect to them, which is why so many scholar-officials' portraits are extant today.

39 Yi S., *Eojin uigwe wa misulsa*, 221–37. However, Confucian principles of ancestral worship were adhered to throughout all the procedures of the rites, such as

transporting the portrait and installing it in the designated portrait hall.

40 This passage is found in a conversation between Confucius and Zengzi in the *Book of Rites* (bk. VII).

41 [*Taejo*] *yeongjeong mosa dogam uigwe* (1688), 12.

42 Yi Ye-seong, *Hyeonjae Sim Sa-jeong yeongu* (Seoul: Iljisa, 2000), 15–16.

43 Kang Gwan-shik, "Gwanajae Jo Yeong-seok hwahak go," pts. 1 and 2, *Misuljaryo* 44 (December 1989): 114–49; 45 (June 1990): 11–70. The portrait, dated 1725, is now in the collection of the Gyeonggi Provincial Museum, Yongin.

44 Ahn Hwi-joon, "Gwanajae go ui hoehwasa jeok uiui," in *Gwanajae go* (Seongnam: Academy of Korean Studies, 1984), 11.

45 Another scholar-painter, Jo Ji-un (b. 1637), was recorded as having served in the 1688 rites as a supervisor.

46 An alternative term for describing a lifelike image would be "naturalistic," but for a portrait, "realistic" seems more appropriate.

47 Yi S., *Searching for Modernity*, fig. 7.

48 Yi S., *Eojin uigwe wa misulsa*, table V-1, 270–73.

49 See Park Jeong-hye, "*Uigwe* reul tonghaeseo bon Joseon sidae eui hwawon." See also Jin Jun-hyeon, "Sukjong dae eojin dosa wa hwaga deul," *Gomunhwa* 46 (June 1995): 89–119; and Jin Jun-hyeon, "Yeongjo · Jeongjo dae eojin dosa wa hwaga deul," *Seoul daehakgyo bangmulgwan yeonbo* 6 (December 1994): 9–72.

50 See Kang Gwan-shik, "Joseon sidae dohwaseo hwawon jedo," in *Hwawon* (Seoul: Leeum, Samsung Museum of Art, 2011), 265. King Sukjong's order appears in *Seungjeongwon ilgi*, 1688 (Sukjong 14, Kangxi 27), thirteenth day, seventh month. More on this subject is discussed in chap. 10.

51 Cho I., "Joseon wangsil eseo hwaryak han hwawon deul."

52 See entries in the *Veritable Records of King Cheoljong*, vol. 4, the third day of the eighth month, 1852, and vol. 13, twenty-second day of the third month, 1861, where Jo was mentioned as the painter. See references under *Joseon wangjo sillok* on page 525 of this volume.

53 Studies on Chae's portrait paintings abound. See Cho Sun-Mie, *Chosanghwa yeongu: Chosang hwa wa chosang hwaron* (Seoul: Munye chulpansa, 2007), 269–323. See also Cho Sun-Mie, *Great Korean Portraits: Immortal Images of the Noble and the Brave* (Seoul: Dolbegae, 2010), 230–48.

54 For An Jung-sik's paintings made for the court, see Park Dong-su, "Wangsil eul wihae geurin An Jung-sik ui geurim deul," in *Joseon wangsil ui misul munhwa*, ed. Yi Song-mi et al. (Seoul: Daewonsa, 2005), 367–94.

55 The whole procession painting is illustrated in Yi S., *Eojin uigwe wa misulsa*, 94–103 and 106–13.

56 *Chiljo yeongjeong mosa dogam uigwe* (1901; Kyu 13990). For a more complete treatment of this *uigwe*, with additional pages of *banchado* illustrations, see Yi S., *Eojin uigwe wa misulsa*, 164–203.

57 A *hongmun daegi* is supposed to be red with two blue dragons. *Hongmun* is a contraction of

hongsal mun, a red gate that stands at the entrance of a royal tomb complex, or any other "sacred" place for the spirits.

58 The crises included the French incursion of 1866, those of the United States in 1871 and 1882, and Japan's in 1876, forcing Korea to sign diplomatic and commercial treaties; the military mutiny (*imo gullan*) of 1882; the Donghak Rebellion of 1893–94; and the assassination by the Japanese of Queen Min, the queen of King Gojong in 1895. See Lee Ki-baik, *A New History of Korea*, 247–99.

59 See *Wang ui Chosang*, 12 for Jogyeongmyo, a shrine for worship of the Yi Clan ancestor Yi Han, and 14 for Jogyeongdan.

1 A reduced-size facsimile was published in three volumes by the Kyujanggak Institute for Korean Studies, Seoul National University, 1994 (hereafter cited as *Jeongni uigwe*).

2 In Korea, even today, one's sixtieth birthday is considered very important. The best account of this trip can be found in Han Young-woo, *Jeongjo ui Hwaseong haengcha, geu 8 il* (Seoul: Hyohyeong chulpansa, 1998). With four scholarly essays and good color plates, the most recent publication on this *uigwe* is the catalogue of the exhibition held in commemoration of the 220th anniversary of King Jeongjo's 1795 trip to Hwaseong: *Jeongjo, parilgan ui Suwon haengcha* (Suwon: Suwon Hwaseong Museum, 2015).

3 Yi S., "Joseon hugi jinjak *jinyeon uigwe* reul tonghae bon gungjung ui misul munhwa," 115–97.

4 *Veritable Records of King Yeongjo*, chap. 99, twenty-first day of the fifth leap month, 1762. See references under *Joseon wangjo sillok* on page 525 of this volume. The negative roles played by the political factions of this time are too complicated to elaborate on here. For the tragic death of Crown Prince Sado and his relationship with his father, King Yeongjo, see JaHyun Kim Haboush, *A Heritage of Kings: One Man's Monarchy in the Confucian World* (New York: Columbia University Press, 1988), esp. chap. 5, "Yŏngjo's Tragedy: The Prince of Mournful Thoughts," 167–233. On the intellectual and cultural background of eighteenth-century Joseon, and a conceptualization of the change that took place at that time, see also JaHyun Kim Haboush,

"Rescoring the Universal in a Korean Mode: Eighteenth-Century Korean Culture," in *Korean Arts of the Eighteenth Century: Splendor and Simplicity*, ed. Hongnam Kim (New York: Asia Society Galleries, 1993), 23–34.

5 Choe Bong-yeong, *Yeongjo wa Sado seja iyagi* (Seongnam: Academy of Korean Studies, 2013).

6 Some scholars call this tomb a "mausoleum." See Hongnam Kim, *Korean Arts of the Eighteenth Century: Splendor and Simplicity* (New York: Asia Society Galleries, 1993), 205; and Jaebin Yoo, "The Politics of Art under King Jeongjo Exemplified by 'Events from King Jeongjo's Visit to Hwaseong in 1795,'" in *In Grand Style: Celebrations in Korean Art during the Joseon Dynasty*, ed. Hyonjeong Kim Han (San Francisco, CA: Asian Art Museum of San Francisco, 2013), 91. But since the tomb is not any different from other Joseon royal tombs, the term *mausoleum* might not be appropriate. In 1899 Emperor Gojong once again elevated his title to Jangjo (King of Solemnness). It was then possible to call the royal tomb Yungneung, not a *won*, a tomb of lesser members of royal family, such as a prince or princess. See chap. 5 for more explanation of the terms.

7 For the architectural characteristics of the Buddhist temple, see Son Sin-yeong, "Joyeong gwajeong gwa johyeong wolli," in the most recent comprehensive report on Yongjusa, *Hwaseong Yongjusa: Joseon ui wondang* 1 (Seoul: National Museum of Korea, 2016), 21–51.

8 See the annotated translation of this book by JaHyun Kim Haboush, *The Memoirs of Lady Hyegyŏng: The Autobiographical*

Writings of a Crown Princess of Eighteenth-Century Korea (Berkeley, CA: University of California Press, 1996). Haboush considers this memoir both a literary masterpiece and an invaluable historical document. See JaHyun Kim Haboush, "Private Memory and Public History: The Memoirs of Lady Hyegyŏng and Testimonial Literature," in Kim-Renaud, *Creative Women of Korea*, 122. In 1899, when Gojong elevated Crown Prince Sado's title to Jangjo, her title was also elevated to Heongyeong wanghu Hongssi.

9 For the description of emotions involved in the situations surrounding the tragic death of Crown Prince Sado, and King Jeongjo's construction project of the Hwaseong Fortress as well as other art works related to it, see Kim Hongnam, *Korean Arts of the Eighteenth Century*, 1993.

10 For a detailed, heavily illustrated examination of the painting techniques of the twenty wedding *uigwe* procession paintings, see Yi S., *Garye dogam uigwe wa misulsa*, 238–79.

11 However, procession paintings of the royal viewing copies were all hand-painted, as is the case with the 1759 wedding procession of King Yeongjo, which is fifty pages long.

12 This book is a compilation of selections from the Buddha's sayings and eminent priests' writings before the author's own time. The title comes from the phrase *jikji insim gyeonseong seongbul*, meaning "if one looks directly into the mind of a sentient being, he will realize that human nature is no different from that of the Buddha."

13 This book is now in the Bibliothèque nationale de France and was made public for the first time at the London Book Fair in 1972. For the Goryeo book's provenance and the bibliographic study of its metal type, see Cheon Hye-bong, *Naryeo inswaesul ui yeongu* (Seoul: Gyeongin munhwasa, 1980), 176–85.

14 The earlier printed works of German engraver, inventor, and printer Johannes Gutenberg (ca. 1398–1468) also predate the world-renowned Gutenberg Bible of 1455.

15 The handwritten first copy was completed in 1454, but the printed copy could not be made until 1473. For a brief history and the process of the compilation of the *Veritable Records*, see *Hanguk minjok munhwa daebaekgwa sajeon*, 20:503–5.

16 One is the *Saengsaeng jabo* (*Catalogue of the Saengsaengja*) and the other, the *Eojeongin seorok* (*Persons of Longevity Invited to the Celebratory Occasion by King Jeongjo*). In the latter are listed the names of 75,145 persons who were invited to the court banquet of 1794 celebrating the fiftieth birthday of Queen Jeongsun (second wife of King Yeongjo), the sixtieth birthday of Lady Hyegyeong, and the nineteenth year of King Jeongjo's ascension to the throne. Listed were the court officials over seventy years of age. Among the general public, those over eighty, both single and married, were listed separately.

17 For a brief history of *saeng-saengja*, see *Hanguk minjok munhwa daebaekgwa sajeon*, 11:645.

18 The Four Branches are *jing* (Classics), *shi* (Histories), *zi* (Masters of Philosophy), and *ji* (Anthologies from Chinese Literature).

19 Yi Eun visited the Qing capital as the chief and Seo Ho-su as the deputy of "an emissary for presenting gratitude" (*jinha gyeom saeun sa*).

20 Seo Ho-su soon compiled the *Gyujang chongmok* (*Complete List of Books in Kyujanggak*) in 1781.

21 Kim's grandfather, Kim Sang-myeong, and father, Kim Sam-bo, were high officials at Qing court, and his sister was the Qianlong emperor's consort (*guifei*).

22 *Hanguk minjok munhwa daebaekgwa sajeon*, 4:578, "Kim Gan." See also the *Veritable Records* of King Jeongjo (the twenty-second day of the third month, 1785; the eighteenth day of the ninth month, 1786; and the twenty-sixth day of the third month, 1790). On the role Kim played in the production of the *Siku quanshu*, see Byeon In-seok, "Sago jeonseo wa hangugin buchongjae Kim Gan e daehayeo," *Dongyang sahak yeongu* 10 (May 1976): 64–95. He pointed out that Joseon and Qing China's development of printing techniques with either wooden or metal movable fonts was through an exchange of these techniques at various stages.

23 Lothar Ledderose, *Ten Thousand Things: Module and Mass Production in Chinese Art* (Princeton, NJ: Princeton University Press, 2000), chap. 6, esp. 142ff., and figs. 6.3–6.7.

24 For the value of the collectanea to Joseon intellectuals, see No Dae-hwan, "Sippal segi Dong Asia ui baekgwa jeonseo *Gogeum doseo jipseong* 18," SNU NOW (blog), Seoul National University, 24 August 2015, https://snu.ac.kr/snunow/snu_story?bm=v&bbsidx=121997&.

25 Appendix vol. 1: Seventh day of the sixth month, 1795. The sixtieth birthday celebration for Hyegyeonggung, Jeongjo's mother. Vol. 2: Tenth day of the first month, 1795. Jeongjo's visit to the Gyeongmogung. This palace was built for Hyegyeong-gung outside the Changdeok Palace, then the main palace of the Joseon royal family. Vol. 3: This volume, titled *Yeongheung Bongung jehyang* (*Sacrificial Rite at Yeonheung Bongung*), records the libation rite performed by officials for Hwanjo, father of King Taejo, at Yeonheung Bongung on the third day of the first month, 1795, by order of King Jeongjo. Vol. 4: This volume, titled *Ongung gijeok* (*Records of the Palace at Onyang*), was compiled to commemorate Crown Prince Sado's trip in 1760 to the hot-springs town Onyang. On the eighteenth day of the fourth month, 1795, Jeongjo ordered that a small palace be built at Onyang along with a stele on the "terrace of divine *goe* tree" (*Yeonggoe daebi*).

26 On her sixtieth birthday (eighteenth day of the sixth month, 1795), a royal banquet was held in honor of Lady Hyegyeong even though she and King Jeongjo had visited Hwaseong in February of that year. See the first of the four appendices.

27 *Jeongni uigwe*, 3:27–30.

28 Ibid., 1:141.

29 For a detailed itinerary of the eight-day trip, see Han Y., *Jeongjo ui Hwaseong haengcha, geu 8 il*.

30 It was customary to provide local applicants with opportunities for state examination whenever a king traveled outside of the capital.

31 This pavilion, built in 1791 on the order of King Jeongjo, was to be used as a stop on the way to Hwaseong.

32 King Jeongjo made two trips in 1797 (in the first and eighth months), so the total number is thirteen. See the chronological list and duration of his trip to Hwaseong in Suwon Hwaseong Museum, *Jeongjo, parilgan ui Suwon haengcha*, 156.

33 Jin Jun-hyeon, *Danwon Kim Hong-do yeongu* (Seoul: Iljisa, 1999), 58–59. Jin's first documentary evidence is the *Ilseongnok*, King Jeongjo's *Daily Reflections*. On the twenty-eighth day of the second leap month, Jeongjo recorded his meeting with high officials on the production of the *Jeongni uigwe*. He ordered several officials into the *dogam* and called Kim Hong-do's name, whereupon Yun Haeng-im (1762–1801) said illustrations were already in the *uigwe*, so it would be best to let him stand by. In volume 2 of the *Jeongni uigwe*, only the last part of that passage appears. See Kumja Paik Kim, "King Jeongjo's Patronage of Kim Hong-do," *Archives of Asian Art* 66, no. 1 (2016): 64, in which she actually names Kim Hong-do as the painter of the illustration of the pontoon bridge in *Jeongni uigwe*.

34 *Jeongni uigwe*, "Award Regulations" (*sangjeon*), 2:406–76.

35 Ibid., 2:294–311.

36 Park J., *Joseon sidae gungjung girok hwa yeongu*, 306–11; Yi S., "Joseon hugi jinjak jinyeon uigwe reul tonghae bon gungjung ui misul munhwa," 2:115–97.

37 *Jeongni uigwe*, 1:62.

38 For a list of screens used in the banquet, see Yi S., "Joseon hugi jinjak *jinyeon uigwe* reul tonghae bon gungjung ui misul munhwa," 172, table 5.

39 For all the items used to decorate the banquet halls, see ibid., 160.

40 The pioneering study of this screen painting was made by Park Jeong-hye, "Suwon neunghaengdo yeongu," *Misul sahak yeongu* 189 (March 1991): 27–68. She has continued to explore this theme in many other publications, which will be cited as appropriate.

41 My English translation of the eulogy (御製華城奉壽堂進饌先唱樂章) in the form of a libretto is based on the Korean translation of the *Jeongni uigwe*, *Wonhaeng eulmyo jeongni uigwe*, an annotated translation into Korean published by the city of Suwon (Suwonsi, 1996), 101.

42 Their tunes are similar to those of the five black keys in the center octave of the piano.

43 This lady was given the title during the reign of Emperor Yao. She wished the emperor longevity, wealth, and many sons. Originally from *Zhuangzi*, quoted in the Korean translation of the *Jeongni uigwe*, 101.

44 Originally a Han palace, this later referred to the residence of a dowager queen. Ibid.

45 *Okjang* and *gyeongaek*, respectively.

46 *Jeongni uigwe*, 2:331.

47 Ibid., 2:394–96.

48 Sa-il was given a *chega* or *chegaja*, and Cheorak a *gaja*. All monks who dwelled there since the completion of the temple in 1790 were given bushels of rice. Ibid., 2:420, 428.

49 Min Gil-hong, "Cheon chilbaek gusibo nyeon Jeongjo ui Hwaseong haengcha wa *Hwaseong wonhaeng dobyeong* 1795," in Suwon Hwaseong Museum, *Jeongjo, parilgan ui Suwon haengcha*, 290–307, esp. 291.

50 Yoo, "Politics of Art," 108–9 (the date 1790 is a mistake). Burglind Jungmann, *Pathway to Korean Culture: Paintings of the Joseon Dynasty, 1392–1910* (London: Reaktion Books, 2014), 216–17, gives the title as "Royal Visit to the City of Hwaseong." She also gives Kim Hong-do as the artist of the screen painting, but it is not easy to assign Kim Hong-do based on the less-than-tight documentary evidence.

51 Park Jeong-hye, "Uhak munhwa jaedan sojang *Suwon neunghaeng dobyeong* ui hoehwa jeok teukjing gwa jejak sigi," in *Hwaseong neunghaeng dobyeong* (Yongin: Yongin University Museum, 2011), 64–99.

52 *Jeongni uigwe*, "Expenses," 2:490–91.

53 For the number of screens and scrolls made at this time and their cost, see Park J., *Joseon sidae gungjung girok hwa yeongu*, 276 (table no. 7).

54 Ibid., 274–76. Since the expenses of paintings were paid for by the court, she considered the original spirit of *gyebyeong* to have become meaningless, and the paintings were given as awards to the participants of the event.

55 Jungmann, "Documentary Record versus Decorative Representation," 95 and 106ff.

56 As is well known, in early Buddhist art, the presence of the Buddha is represented symbolically in the form of a stupa, a bodhi tree, or a footprint. These "aniconic images of the Buddha" are objects that have something to do with the life of the Buddha, and therefore became symbols of the Buddha, who went into nirvana (state of nothingness) upon his death. For this reason, "aniconic image" might not be a proper characterization of the Joseon royal paintings.

57 Yi S., *Searching for Modernity*.

58 *Hongjeonmun* (red arrow gate) is a gateway constructed of two upright wooden posts and two transversal beams on top of which stand small, pointed arrow-like pieces of wood (*sal*, *jeon*), and where sometimes a *taegeuk* (*taiji*, the Great Ultimate, *yin* and *yang*, or origin of the universe) pattern is put in the middle. The whole structure is painted with red lacquer, red being the color to ward off evil spirits. This gateway stands in front of a holy precinct, such as a royal tomb or the Sajik Altar for the spirits of earth and grain. It does not normally stand in front of a palace.

59 Ordinarily the characters 擧動 are pronounced *geodong*, but in the case of royal outing outside the palace, they are pronounced *geodung*.

60 Kim J., "Joseon hugi gugwang haengcha e daehan yeongu: *Uigwe banchado* wa geodong girok eul jungsim euro," 211–34. Kim found the term *gwangwang minin* in *Seungjeongwon ilgi* (Diaries of the Royal Secretariat), bk. 850, eighth day of the sixth month, 1737 (Yeongjo 13).

61 See the album titled *Wonhaeng jeongni uigwedo* that is composed of 102 pages of illustrations, and important labels in the painting written in both Chinese characters and *hangeul*. Some pages of the album are illustrated in Suwon Hwaseong Museum, *Jeongjo, parilgan ui Suwon haengcha*, 26–33.

62 Ibid., 11–123.

63 This scroll of ink and color on paper measures 46.5 × 4,483 cm. The entire scroll is illustrated, with many details, in National Museum of Korea, *Gungnip jungang bangmulgwan seohwa yumul dorok* (Seoul: National Museum of Korea, 2012), 20: cat. no. 1, 10–89.

64 *Jeongni uigwe, gwon su* 1:71–132. For a very detailed analysis of the procession painting, see Je Song-hui, "Jeongjo sidae *banchado* wa Hwaseong wonhaeng," in Suwon Hwaseong Museum, *Jeongjo, parilgan ui Suwon haengcha*, 276–89.

65 *Jeongni uigwe*, "Retinue," 2:342–82. The number of the participants counted by Je Song-hui totaled between 7,200 and 8,430, including possible additional personnel.

66 Je, "Jeongjo sidae *banchado* wa Hwaseong wonhaeng," 284. The number was counted by Je Song-hui.

67 *Jeongni uigwe*, 1:100.

68 For a list of four *banchado* related to this trip, see Je, "Jeongjo sidae *banchado* wa Hwaseong wonhaeng," 286.

69 *Jeongni uigwe*, "Letters to the King" (*gyesa*), 1 February 1795, 2:405–6.

70 His dates are unknown, but he is reputed to have produced good landscape and flower paintings. His *Landscape of Yeongwol* survives in a private collection.

71 *Jeongni uigwe*, 2:476.

72 Ibid.

73 The term *jabi* in this phrase is normally pronounced *chabi*, but in the Joseon linguistic custom of preferring softer consonants, it was pronounced *jabi*.

74 For a list of "painters-in-waiting at Kyujanggak" during the reign of King Jeongjo (1776–1800), see Kang Gwan-shik, *Joseon hugi gungjung hwawon yeongu* (Seoul: Dolbegae, 2001), 1:60. For a discussion of the establishment of the system for this special group of painters, see ibid., 27–40.

75 The most voluminous *uigwe* compiled during the reign of King Jeongjo is *Hwaseong seongyeok uigwe*, published in 1801, with a total of 1,334 pages. This *uigwe* is the subject of chapter 8.

76 Han Y., *Joseon wangjo uigwe*, 432.

77 Yoo, "Politics of Art."

78 *Jeongni uigwe*, vol. 1, "Royal Order," 1797, twenty-fourth day of the third month. Kyujanggak reproduction, 1:206–7.

79 For a list of extant copies of this *uigwe*, see Suwon Hwaseong Museum, *Jeongjo, parilgan ui Suwon haengcha*, 316.

80 One copy is owned by Kim Hak-su, professor of Korean history at the Academy of Korean Studies.

1 See *Hwaseong seongyeok uigwe* (1801; repr., Kyujanggak, 1994), with an introductory essay. See also *Hwaseong seongyeok uigwe gugyeok jeungbopan*, rev. ed. (1801; 1994; Suwon: Gyeonggi munhwa jaedan, 2005), with essays by Han Young-woo and Kim Dong-uk; Yi Dal-ho, "Hwaseong geonseol yeongu" (PhD diss., Sangmyeong University, 2003). For the political and ideological background of the construction of Hwaseong, see Han Young-woo, "Jeongjo wa Hwaseong: Hwaseong geonseol gwa neunghaeng ui uimi," in *Geundae reul hyanghan kkum* (Yongin: Gyeonggi Provincial Museum, 1998), 78–103.

2 The other three were Gaeseong in the north, Ganghwado in the west, and Gwangju in the east. Hwaseong was to defend the capital from the south.

3 For this reason, *suwon galbi* (Suwon beef short ribs) remains popular among Koreans and tourists.

4 *Seongseol* appears in Jeong Yak-yong's collected writings, *Yeoyudang jeonseo* (Seoul: Munheon pyeonjip wiwonhoe, 1962), 208–10. See Bak Cheon-wu and Kim Eun-jin, "Hwaseong chukseong e gwanhan yeongu," *Jangan nonchong* 23 (February 2003): 12. The Korean translation of *seongseol* in *Dasan simun jip*, vol. 5, can be searched online in the database of Korean Classics at http://db.itkc.or.kr.

5 See chap. 7, note 21, in this volume.

6 Bak Ji-won, *Yeolha ilgi*, the twenty-sixth–twenty-eighth days of the sixth month, 1780, "Crossing the [Yalu] River." The Korean translation from the Chinese-language original can be searched online at http://db.itkc.or.kr. See also the English translation by Yang Hi Choe-Wall, *The Jehol Diary: Yŏrha ilgi of Pak Chiwŏn (1737–1805)* (Folkestone, UK: Global Oriental, 2010).

7 See chap. 7 of this volume.

8 *Hwaseong gijeok bi. Hwaseong uigwe*, vol. 2, *bimun*, *Hwaseong uigwe* (1994), 1:509–10.

9 "Won jae Hwasan chwi hwayeohwa sangtong yeogu Hwain chukseongjiui gaebong seonggyojaya" (see glossary). *Hwaseong uigwe*, 1:509–10.

10 *Chuang Tzu*, chap. 12, "Heaven and Earth," in Burton Watson, *The Complete Works of Chuang Tzu* (New York: Columbia University Press, 1968), 130.

11 Han Young-woo, "Jeongjo ui Hwaseong geonseol gwa *Hwaseong seongyeok uigwe*," in *Hwaseong seongyeok uigwe gugyeok jeungbopan*, ed. Gyeonggi munhwa jaedan (Suwon: Gyeonggi munhwa jaedan, 2005), 1:2–21.

12 The manpower for the *Jangyong wi* was supplied by a group of new recruits from the *gyeonggwa* or the "celebratory special military service examination" given in 1784, a year after King Jeongjo elevated his father's title to Sudeok Don-gyeong. At this special examination one thousand military men were recruited.

13 The latter two scholars were initially barred from serving the government because they were illegitimate sons (not born of legal wives of their fathers), but King Jeongjo, for the first time in Korean history, gave them the opportunity to take state examinations and enter government service.

14 It is not possible to discuss the contents of all of the volumes in this chapter, but a summary of their contents can be found in *Hanguk minjok munhwa daebaekgwa sajeon*, 25:258.

15 Ok Young Jung, "*Hwaseong seongyeok uigwe* wa *Dyeongni uigwe* ui seoji jeok bunseok gwa bigyo," *Jindan hakbo* 127 (2016): 167.

16 Ibid., 168–70, tables 1 and 2. In addition, quite a few incomplete sets survive.

17 "Royal Order," *Hwaseong uigwe*, 1:332–33.

18 This information is found in the *Diaries of the Royal Secretariat* (*Seungjeongwon ilgi*), twenty-eighth day of the fifth month, 1800. See Ok, "*Hwaseong seongyeok uigwe* wa *Dyeongni uigwe* ui seoji jeok bunseok gwa bigyo," 166n14 (see note 16 above). In 1797, however, 102 copies of *Jeongni uigwe* were printed.

19 Jeongjo's word for this section is *seongje*, which can be translated as "wall systems."

20 Introduction in *Hwaseong uigwe*, 1:5–6.

21 Jo Seong-u, "Cheon gubaek chilsip nyeondae Suwon Hwaseong bogwon ui baegyeong gwa jeongae gwajeong, 1970," in *Cheon gubaek chilsip nyeondae Suwon Hwaseong bogwon gwa girok 1970*, ed. Suwon Hwaseong Museum (Suwon: Suwon Hwaseong Museum, 2013), 180–83. According to the reconstruction report, it took longer than originally planned due to the process of securing land around the fortress. The reconstruction began in 1974, and was completed in 1979.

22 *Hwaseong uigwe*, 1:57.

23 Additionally, on top of the walls at either side of the gate are high rectangular terraces with battlements called *jeokdae* (enemy-watching terraces) from which one can watch approaching enemies and shoot them through the crenels. From within, soldiers can approach the terrace through a stepped opening.

24 *Hwaseong uigwe*, 1:75. The west gate also has a one-story gatehouse and *ongseong*.

25 Ibid., 1:86, 87.

26 See the illustration of the two views of Namsumun in ibid., 1:90 (from outside), 91 (from within).

27 The structure of the underground sewers is explained in detail in the text that follows the illustrations.

28 *Hwaseong uigwe*, 1:98.

29 Ibid., 1:110.

30 Ibid., 1:112.

31 See *Hwaseong seongyeok uigwe gugyeok jeungbo pan*, 1:82n117.

32 In this connection, it is useful to introduce the scholar-official Seo Ho-su's (1736–1799) *Yeonhaenggi* (*Travel Diary to Yanjing*), vol. 3, fifth day of the eighth month, 1790, in which he recorded that he had seen similarly shaped pavilions in Yuanmingyuan. The entire text in Hangul translation can be searched in the Comprehensive Korean Classics database, available online at http://db.itkc.or.kr.

33 *Hwaseong uigwe*, 1:115.

34 Ibid., 1:116.

35 Ibid., 1:124, 126.

36 The offerings are made on the first days of the spring and autumn months. The first day of the first, fourth, seventh, and tenth months of the lunar calendar are the designated days for offering rites. *Hwaseong uigwe*, 1:138–39.

37 For explanations of the buildings, see the appendix volume 1 of the *Hwaseong uigwe*. See also the explanation of volume 6 later in this chapter.

38 *Hwaseong uigwe*, 1:140, 141.

39 Eighty-nine illustrations in all show small details of battlements, shapes of stones that form walls and arches, corner decorative pieces of roofs, eave structures, and floodgates.

40 "Seongsin jaseong gyuhyeong" (see glossary). *Hwaseong uigwe*, 1:146. Jeongjo stated that the profile was similar to that of a *hol*. A *gyu* is made of blue jade and has a flat pointed top, whereas a *hol* is made of ivory, jade, or wood, and has a rounded top. Both have similar inward-curving profiles. Kings and queens would hold a *gyu*, whereas crown princes and high officials would hold a *hol*. See Im Myeong-mi, "Han Jung Il samguk ui *gyu hol* e gwanhan yeongu," *Boksik* 51, no. 2 (2001): 5–25.

41 Each kiln produced eight hundred to nine hundred bricks every twelve days.

42 *Hwaseong uigwe*, 1:159–60.

43 According to the text, the structure and firing methods were adopted from those detailed in *Tiangong kaiwu* (1637), the comprehensive book of science and technology compiled by Song

Yingxing (1587–1648) of China; these methods had not been tried in Joseon before.

44 For those two drawings, see *Jeongjo Geolleung salleung dogam uigwe* (1800; repr., Kyujanggak, 1999), 322–23.

45 *Hwaseong uigwe*, 1:369–94.

46 *Hwaseong uigwe*, gwon 2, *Hwaseong uigwe* (Kyujanggak, 1994), 1:394–410.

47 Ibid., 1:410–60.

48 The five surrounding regions of Yongin, Jinwi, Ansan, Siheung, and Gwacheon were to strengthen their defenses in order to safeguard Hwaseong.

49 *Hwaseong uigwe*, gwon 2, *Hwaseong uigwe* (Kyujanggak, 1994), 1:454.

50 Ibid., 1:460–510.

51 The tradition of *sangnyangmun* began in China during the Six Dynasties period (221–581). In general, smaller buildings such as private homes would have a short description including the date of the placement of the beam above the center hall (*daecheong*) of the house, and a few other auspicious remarks for the building. The piece is glued to the center of the beam to be clearly visible and legible to those entering the center hall. For larger buildings, however, *sangnyangmun* gradually became the object of a major literary piece written by well-known men of letters of the period. Since the piece can be very long, it was folded or rolled and placed in a boxlike space created for it on the underside of the beam, then the space was permanently sealed.

52 *Hwaseong uigwe*, 2:119–59.

53 For Buddhist art of the Joseon period, see Song Unsok, "Buddhism and Art in the Joseon Royal House: Buddhist Sculpture and Painting," in Woo, *Treasures from Korea*, 53–65, especially 60 for King Jeongjo's role.

54 *Hwaseong uigwe*, gwon 2, *Hwaseong uigwe* (Kyujanggak, 1994), 1:448.

55 See chap. 5 in this volume.

56 *Hwaseong uigwe*, 2:436.

57 The exhibition was held on 5 October–23 November 2016. See the accompanying catalogue, *Misul sok dosi, dosi sok misul* (Seoul: National Museum of Korea, 2016), 90–91, pl. 28.

58 Ibid., 319–20, no. 28.

59 This painting is called *Hwaseongdo* in the National Museum's publication (see note 60 below), but typically the titles of paintings of this type begin with "Complete View of."

60 *Joseon sidae jido wa hoehwa* (Seoul: National Museum of Korea, 2013), 154–73, no. 16.

61 A very interesting, informative blog with wonderful photographic images, details from the screen paintings, and the *uigwe* illustrations on Hwaseong can be found at http://blog.naver.com/keons.

62 *Hwaseong uigwe*, 2:459.

63 Ibid., 2:468–78.

64 Ibid., 2:712–13.

65 Han Y., *Jeongjo ui Hwaseong haengcha, geu 8 il*. For the most recent, succinct analyses of the political and humanistic importance of Jeongjo's 1795 visit to his father's tomb and the publishing of the *Jeongni uigwe*,

see Kim Munsik, "Eulmyo nyeon Suwon haengcha wa geu uiui," in Suwon Hwaseong Museum, *Jeongjo, parilgan ui Suwon haengcha*, 262–75.

66 The *Hwaseong uigwe* was registered as a UNESCO Memory of the World in 2007 along with other Joseon dynasty *uigwe* documents.

CHAPTER NINE
PAGES 339–414

1 See *Kkum gwa sarang: Maehok ui uri minhwa* (Seoul: Hoam Art Museum, 1998).

2 *Gunggwol ui jangsik geurim* (Seoul: National Palace Museum of Korea, 2009). See also Kumja Paik Kim, ed., *Hopes and Aspirations: Decorative Painting of Korea* (San Francisco, CA: Asian Art Museum of San Francisco, 1998), 13–20. Burglind Jungmann's account of the historical development of the interest in the folk art and painting of Yanagi Soetsu (Muneyoshi, 1889–1961) during the Japanese occupation period to Zo Zayong (1926–2000) in late twentieth-century Korea is quite helpful in understanding the issue of court art versus folk art. See Jungmann, *Pathway to Korean Culture*, 268.

3 Park Jeong-hye, Hwang Jeong-yeon, Gang Min-gi, and Yun Jin-yeong, *Joseon gunggwol ui geurim* (Seoul: Dolbegae, 2012).

4 Yi Song-mi, "Joseon sidae gungjung chaesaekhwa," in *Hanguk ui chaesaekhwa* (Seoul: Dahal Media, 2015), 1:366–79.

5 See Kay E. Black and Edward W. Wagner, "Court Style Ch'aekkŏri," in *Hopes and Aspirations: Decorative Painting in Korea*, ed. Kumja Paik Kim (San Francisco, CA: Asian Art Museum of San Francisco, 1998), 23–35, for the use of the term "court style" (*chaekgeori*) for both types of *chaekgado* (trompe l'oeil and isolated) if they are associated with names of court painters. See the section on scholar's paraphernalia below for more discussion and references on this issue.

6 Sin H., "Joseon wangsil hyungnye ui uijang yong byeong-pung ui gineung gwa uimi," for

the Five Peaks screen's use in the Coffin Hall, as well as in the Spirit Tablet Hall.

7 See chap. 6 in this volume.

8 Important essays on the Five Peaks screens include Yi S., "Screen of the Five Peaks of the Joseon Dynasty"; Yi S., "Screen of the Five Peaks of the Choson Dynasty" (rev.); Kim Hongnam, "Irwol obong byeong gwa Jeong Do-jeon," in *Jungguk Hanguk misulsa* (Seoul: Hakgojae, 2009), 458–67; Myeong Se-na, "Joseon sidae obong byeong yeongu" (MA thesis, Ewha Womans University, 2007).

9 Park J., "Joseon sidae Uiryeong Namssi gajeon hwacheop," 28–29.

10 For this reason, in my first article on this topic, I did not accept this album leaf as the earliest evidence of a Five Peaks screen behind the throne. Yi S., "Screen of the Five Peaks of the Joseon Dynasty," 19.

11 Park Jeong-hye, Yi Ye-seong, and Yang Bo-gyeong, *Joseon wangsil ui haengsa geurim gwa yet jido* (Seoul: Minsogwon, 2005), 123; Kang Gwan-shik, "Joseon junghugi ui Seochongdae chinim yeonhoedo" (unpublished seminar paper delivered at the Seminar on Late Joseon Period Painting, Seoul National University, Spring 1992), 4–9.

12 Another version with a similar subject can be found in hanging scroll format, dated to 1564, under the title *Seochongdae chinim sayeondo* (*The Royal Banquet Bestowed at Seochongdae*), now in the National Museum of Korea. But the canopy comes down so low in the painting that the view of the throne is almost blocked, and it is not clear whether there is a Five Peaks screen behind it. Therefore, this painting can

hardly serve as evidence of the use of the Five Peaks screen behind the throne. See Yi S., "Screen of the Five Peaks of the Choson Dynasty," 491, fig. 14.

13 For a detailed analysis of four such paintings, see Yi Song-mi, "Joseon Injo–Yeongjo nyeongan ui gungjung yeonhyang gwa misul," in *Joseon hugi gungjung yeonhyang munhwa* (Seoul: Minsogwon, 2003), 1:104–28.

14 For the documentary evidence of the album painting, see ibid., 101–3. The date of the album, 1706, is the same as the date of the colophon to the album by Choe Seok-jeong (1646–1715), then prime minister.

15 Yeongsugak is the building within the Compound of the Club of the Elders (giroso) that housed royal albums.

16 Yi S., "Joseon hugi jinjak *jinyeon uigwe* reul tonghae bon gungjung ui misul munhwa," 172–75, table 5.

17 There is also a Jagyeongjeon hall in Gyeongbok Palace, but at that time Gyeongbok Palace was still in ruins.

18 Although the title of the poem is just *Tianbao* or "Heaven Protects," it is often cited as *Tianbao jiuru*, literally, "Heaven Protects [Thee] as [Constant as] the Nine [Natural Phenomena Cited in the Poem]." The English translation is quoted from James Legge, *The Chinese Classics*, vol. 4, *The She King* (Taipei: Wenshizhe chubanshe, 1972), 255–58.

19 Jo Yong-jin, *Dongyanghwa ingneun beop* (Seoul: Jimmundang, 1989), 150–53.

20 Reproduced in Julia K. Murray, *Ma Hezhi and the Illustration of the Book of Odes* (Cambridge:

Cambridge University Press, 1993), pl. 30. This painting does not show any of the stylizations that are in evidence in Korean Five Peaks screens but is introduced here as the earliest representation of the *Tianbao* poem.

21 *Chengshi moyuan*, first published in 1605, was compiled by Cheng Dayue, with illustrations by Ding Yunpeng and others, and carving of the blocks by Huang Yingtai and others.

22 See Wang Yuanqi (1642–1715), *Jiuru tu*, dated to 1696, recorded in *Shiqu baoji*, vol. 2, *Sequel* (Taipei: National Palace Museum, 1971), 594. For more examples of the paintings of this theme in China, see Yi S., "Screen of the Five Peaks of the Joseon Dynasty," 19; and Yi S., *Eojin uigwe wa misulsa*, 304.

23 Kim assumed that, according to the overall design of the palace conceived by Jeong Do-jeon (1342–1398), the Five Peaks screen was placed behind the throne. See Yi S., "Screen of the Five Peaks of the Joseon Dynasty," 19 and 24nn32–33. Kim later wrote an article in Korean purportedly to strengthen her earlier arguments (Kim Hongnam, "Irwol obong byeong gwa Jeong Do-jeon"), but did not present any concrete documentary or visual evidence.

24 *Dangga* can also be found in Buddhist temples, placed above large Buddhist sculptural images or paintings.

25 The copying events took place after the portraits of seven past kings — Taejo, Sukjong, Yeongjo, Jeongjo, Sunjo, Ikjong (Munjo), Heonjong — were damaged by a fire in Seonwonjeon, the royal portrait hall of Gyeongbok Palace.

26 *Gwanghaegun ilgi (Daily Records of Gwanghaegun)*, vol. 79, the eighth day of the sixth month, 1614.

27 Yi S., "Screen of the Five Peaks of the Choson Dynasty," 517n40.

28 For the invention of aniline dye and documentary evidence of its importation in Joseon Korea, see ibid., 519nn53–54. The use of aniline dye can be discerned in many of the screen paintings of the late nineteenth century.

29 Sometimes, before sunset, the moon can be seen in the opposite side of the sky, but not as clearly as is depicted in the Five Peaks screen.

30 Park Jeong-hye, "Gungjung jangsik hwa ui segye," in *Joseon gunggwol ui geurim*, ed. Park Jeong-hye et al. (Seoul: Dolbegae, 2012), 79–81.

31 *Jinjak uigwe* (Kyu 14364), 46.

32 Woo Hyunsoo, "A Study of the Pair of the Phoenix and the Peacock Paintings in the Collection of the Philadelphia Museum of Art," in *Gunggwol ui jangsik geurim* (Seoul: National Palace Museum of Korea, 2009), 120–30, figs. 10 and 11. (For a short English abstract, see 60–61.)

33 According to *Nihon shoki*, in Suiko 6 (598), the Silla kingdom sent to Japan a peacock and a pair of magpies. In *Shoku Nihongi*, in Monmu 4 (700), an emissary from Silla presented a peacock among other gifts. At the end of the sixteenth century, Toyotomi Hideyoshi presented through his subordinates a pair of peacocks and several rifles, asking the court to send a Joseon delegation to Japan. See more documentary evidence in Gu Sa-hoe, "Gongjak," in *Joseon sidae daeil oegyo yongeo*

sajeon (Academy of Korean Studies). Search the title at http://waks.aks.ac.kr.

34 Kristina Kleutghen, *Imperial Illusions: Crossing Pictorial Boundaries in the Qing Palaces* (Seattle, WA: University of Washington Press, 2015), chap. 4, figs. 4.1–4.5.

35 Ibid., 143. This is one of a series of sixteen massive paintings (approximately 4 × 8 m) commissioned to commemorate Qianlong's victory in the northwest ethnic pacification campaigns. The pair of magnificent peacocks in the painting was a tribute gift from Central Asia. Qianlong's inscription on the painting, accompanied by a poem about a peahen and a peacock, is translated in ibid., 149–50.

36 Hong Dae-yong, *Damheonseo, oejip*, vol. 10: section called "My observation on various things: birds and animals" (Jugyeon jesa: geumchuk, 1939).

37 Kim Hongnam, "Joseon sidae gungmoran byeong yeongu," in *Jungguk Hanguk misulsa* (Seoul: Hakgojae, 2009), 468–517; Yi Jong-sook, "Joseon hugi gukjang yong moran byeong ui sayong gwa geu uimi," *Gogung munhwa* 1 (2007): 60–91.

38 Illustrated in *Sinseonwonjeon*, 40–41.

39 To the best of my knowledge, this screen has not been illustrated in any publications.

40 This data was taken from Yi S., *Garye dogam uigwe wa misulsa*, 300–303, table 5, which lists all the screens used for Joseon royal weddings.

41 For an in-depth analysis of the Joseon-period palace Peony screens, see Kim Hongnam, "Joseon sidae gungmoran byeong yeongu."

42 For a recent article dealing with the Flowers and Grasses screen, see Go Yeon-hui, "Ichyeojin wangsil byeongpung: hwacho byeong gwa inchu yeongmo byeong," *Misulsa nondan* 43 (2016): 7–30.

43 Ahn Hwi-joon, *Hanguk hoehwasa* (Seoul: Iljisa, 1980, 1986), 123–24. On this list, paintings of bamboo appear first, followed by landscapes and figures. Flowering plants (*hwacho*) occupied the lowest place in the hierarchy of subject matters. But *hwajo*, or "birds-and-flowers," is not included.

44 As for the individual motifs appearing in the screen, Go finds references in the literary works of both China and Korea. See note 42 above.

45 National Palace Museum of Korea, ed., "*Byeongpung e geurin songhak i nara naol ttae kkaji*" (Seoul: National Palace Museum of Korea, 2004). The first major exhibition of Ten Symbols of Longevity screens was held from December 2003 through February 2004 at the National Palace Museum of Korea. Not only were the palace screens included in the exhibition and its accompanying catalogue, but also the smaller size "folk painting" screens.

46 Yi S., "Joseon hugi jinjak jinyeon uigwe reul tonghae bon gungjung ui misul munhwa," 172–75, table 5.

47 Thorough research on the Ten Symbols of Longevity screen can be found in Park Bon-su, "Joseon hugi sipjangsaengdo yeongu" (MA thesis, Hongik University, 2002).

48 Yi Saek, *Mogeun sigo*, in *Mogeun jip*, vol. 12, *Sehwa sipjangsaengdo*, quoted in Park Bon-su, "Joseon hugi sipjangsaeng do yeongu," 251.

49 Park J., "Gungjung jangsik hwa ui segye," 56 and nn51–52.

50 For the first thorough introduction to this screen in English, with color illustrations of the screen and many details, see Charles Lachman, *The Ten Symbols of Longevity: Sipjangsaengdo, An Important Korean Folding Screen in the Collection of the Jordan Schnitzer Museum of Art at the University of Oregon* (Eugene, OR: Jordan Schnitzer Museum of Art, 2006). See also Park Bon-su, "Oregon daehakgyo bangmulgwan sojang sipjangsaeng byeongpung yeongu," *Gogung munhwa* 2 (2008): 10–38.

51 Lachman, *Ten Symbols of Longevity*, 27–47.

52 For their official ranks, see Park Bon-su, "Oregon daehakgyo bangmulgwan sojang sipjang-saeng byeongpung yeongu," 18–19.

53 See the Amorepacific Museum of Art, ed., *Joseon, byeongpung ui nara* (Seoul: Amorepacific Museum of Art, 2018), figs. 15, 66–67, det., 68–69.

54 Other differences are: the Oregon screen has twelve cranes whereas the Amorepacific screen has only eight; the former has eight deer, whereas the latter has nine, etc. Also, there are minor differences in the use of pigments discernible when carefully examined.

55 *Wangseja duhu pyeongbok jinha dobyeong* (Screen Produced to Commemorate the Crown Prince's Recovery from Smallpox), 1880, National Palace Museum of Korea.

56 A recent study revealed the possibility of this screen having been sold in 1942 to the University of Oregon by a trader named Albert Taylor (1875–1948). See Yun Jin-yeong, "Joseon malgi gungjung yangsik jangsikhwa ui yutong gwa hwaksan," in *Joseon gunggwol ui geurim*, ed. Park Jeonghye et al. (Seoul: Dolbegae, 2012).

57 Yi, Gang, and Yu, *Jangseogak sojang garye dogam uigwe*, 87–88. The first in-depth study of the theme was conducted by Jeong Yeong-mi in "Joseon hugi Gwak Bunyang haengnakdo yeongu" (MA thesis, Graduate School of the Academy of Korean Studies, 1999).

58 Another large hanging scroll painting (145.5 × 124.2 cm) is in the National Museum of Korea, and an additional eight-fold screen on this theme is in the Korean Christian Museum at Soongsil University. There are nearly thirty known screens and scrolls of the Guo Fenyang theme.

59 The An Shi Rebellion is widely known as the An Lushan Rebellion.

60 For a detailed account of Guo's life as well as his military and official career based on the biography sections of the *Jiu Tangshu* (juan 120, liezhuan 70) and *Xin Tangshu* (juan 137, liezhuan 62), see Jeong Yeong-mi, "Joseon hugi Gwak Bunyang haengnakdo yeongu," 5–8. The most recent study on the theme of Guo Ziyi can be found in Yoonjung Seo, "Connecting across Boundaries: The Use of Chinese Images in Late Chosŏn Court Art from Transcultural and Interdisciplinary Perspectives" (PhD diss., UCLA, 2014), 212–41; (chap. 3, sec. 3: "From Historical Figure to Manifestation of

Abundant Blessings: The Banquet of Guo Ziyi"). Guo Ziyi's biography can be found on 212–13.

61 *Yeolseong eoje*, vol. 10, quoted in Jeong Yeong-mi, "Joseon hugi Gwak Bunyang haengnakdo yeongu," 27–29.

62 Ibid., 36.

63 Han Jong-cheol and Nam Yu-mi, "Joseon hugi byeongpung ui janghwang hyeongtae mit jejak gibeop yeongu," *Samsung misulgwan yeongu nonmun jip* 1 (2005): 161–85. *Waejang*-style mounting refers to the way the scene of the screen is unbroken from one panel to the next; in other words, no extra silk strips were added on either side of the panels. Here, the screen depicts one theme spread out across all eight or ten panels.

64 Kang, *Joseon hugi gungjung hwawon yeongu*, 2:167–86.

65 Jeong Yeong-mi, "Joseon hugi Gwak Bunyang haengnakdo yeongu," 13–15, and fig. 8.

66 Kim Hongnam, "Jungguk Gwak Jaui chuksu do yeongu: yeonwon gwa baljeon," *Misulsa nondan* 33 (December 2011): 165–202.

67 These types of lacquered screens are called "Coromandel" because they were sold to the West through the East India Company, which was based in the area called Coromandel in the Bay of Bengal. Many of the Coromandel screens are now in museums and private collections in the United States and Europe.

68 Li Bai, "Summer Day," in *Tangshi huapu*, ed. Huang Fengchi (Beijing: Guji chubanshe, 1998), 3:312.

69 Jeong Yeong-mi, "Joseon hugi Gwak Bunyang haengnak do yeongu," 5 and 53. Guo's encounter with the Uyghur army was immortalized by Li Gonglin (1049–1106) in his ink painting *Removing the Helmet* (*Mianzhou tu*, Kr. *Myeonjudo*) currently in the collection of the National Palace Museum, Taipei.

70 Jeong Yeong-mi, "Joseon hugi Gwak Bunyang haengnak do yeongu," 50–51.

71 For an example of the screen of Xiwangmu's Banquet at the Turquoise Pond Garden, see Woo Hyunsoo, ed. *Treasures from Korea: Arts and Culture of the Joseon Dynasty, 1392–1910* (Philadelphia, PA: Philadelphia Museum of Art, 2014), fig. C-6, and 28–29 for more detail on the iconography of the screen.

72 Yi S., *Garye dogam uigwe wa misulsa*, 285–96, table 4. Kim Deuk-sin's name appears on 290.

73 Jin Jun-Hyeon, *Danwon Kim Hong-do yeongu*, 525. For the inscription on the painting with the date 1790 and his name, "painting master Kim Hong-do's preliminary sketch," see also Jeong Yeong-mi, "Joseon hugi Gwak Bunyang haengnak do yeongu," 86–88.

74 Bak Eun-gyeong, "Joseon hugi wangsil garye yong byeong-pung yeongu" (MA thesis, Seoul National University, 2012), 95, table 6.

75 *Dyeongmi garyesi ilgui*, 1847, Jangseogak Archives of the Academy of Korean Studies. See page 80a for screen paintings sent to the bridal detached palace. This record also exists in handscroll format written in Chinese characters, *Heonjong bi Gyeongbin Gim ssi sunhwagung garyesi jeolcha*, 1848, Kyujanggak Institute for Korean Studies, Seoul National University. See also *Jeongmi garye si ilgi*, 1847

76 The bride is the daughter of King Jeongjo and his concubine, Subin Seongssi, therefore, she is not a *gongju*, but an *ongju*.

77 Seo, "Connecting Across Boundaries," 233.

78 *Sukseon ongju garye deungnok*, 1804, Jangseogak Archives of the Academy of Korean Studies; *Bogon gongju garye deungnok*, 1830, Jangseogak Archives of the Academy of Korean Studies.

79 Woo, *Treasures from Korea*, 29.

80 Seo, "Connecting Across Boundaries," 420. For discussion of the practice of *jinibujak* in royal weddings of the Joseon period, see Song H., *Confucian Ritual Music of Korea*, 185 and 207.

81 *Gugong shuhua tulu* (Taipei: National Palace Museum, 1989), 2:67 and 77.

82 For illustrations of the theme, see *Kkum gwa sarang*, pls. 71–73; for an in-depth analysis, see Gang Seon-jeong, "Joseon hugi baekjado yeongu," *Misul sahak* 18 (2004): 7–40.

83 For Crown Prince Sado, see chaps. 7 and 8 of this book.

84 *Naegak illyeok*, 1779–1883; King Jeongjo, *Hongjae jeonseo*, 1814, trans. Korean Classics Research Institute, 1998; Yu Jae-geon's *Ihyang gyeonmullok*, 1862, is a collection of biographies of 308 figures, mostly of the "middle people" class (*jungin*). They are mostly technical officials such as doctors and translators, geomancers, etc., at the court, learned, but not of *yangban* class, which included many professional painters, etc. See Yu Jae-geon, *Ihyang gyeonmullok* (1862; Seoul: Jayu mungo, 1996).

85 See Yi Won-bok, "Chaekgeori sogo," in *Geundae Hanguk misul nonchong* (Seoul: Hakgojae, 1992), 103–26. The pioneering study on this subject in English was conducted by Kay E. Black and Edward W. Wagner, "Ch'aekkŏri Paintings: A Korean Jigsaw Puzzle," *Archives of Asian Art* 46 (1993): 63–75. See also Black and Wagner, "Court Style Ch'aekkŏri," 23–35; Kay E. Black, *Ch'aekkŏri Painting: A Korean Jigsaw Puzzle* (Seoul: Sahoipyoungnon, 2020). For a thorough study of the origin of *chaekgado*, see Bak Sim-eun, "Joseon sidae chaekgado ui giwon yeongu" (MA thesis, Academy of Korean Studies, 2002). See also Pak Youngsook, "Ch'aekkado — A Chosŏn Conundrum," *Art in Translation* 5, no. 2 (2013): 183–218, for an investigation into the iconography and identifications of artists of *chaekgado*.

86 For images of relevant pages of these books, see Gyeonggi Provincial Museum, ed., *Joseon seonbi ui seojae eseo hyeondaein ui seojae ro* (Yongin: Gyeonggi Provincial Museum, 2012), 24–25.

87 Pak, "Ch'aekkado — A Chosŏn Conundrum," 215n19. Yi Hyeong-rok is also known as Yi Eung-rok and Yi Taek-gyun.

88 For the possibility that this screen was painted for the residence of Crown Prince Hyomyeong (*Hyomyeong seja*, 1809–1830), see ibid., 191.

89 Yi Gyu-sang, "Hwaju rok," in *Ilmong go*, vol. 30, *Hansan sego* (1936).

90 For the symbolism of many of the items depicted in the screens, see Pak, "Ch'aekkado — A Chosŏn Conundrum," 190.

91 Hong, *Damheonseo*, *oejip*, vol. 7, Yeon'gi, 1790.

92 Seo Ho-su, *Yeonhaenggi* (1790), vol. 5, "From Rehe to Yuanming-yuan." The ones with three circles were worn by imperial sons, ones with two circles by high officials, and ones with one circle by lower-grade officials.

93 The exhibition held in 2012 at the Gyeonggi Provincial Museum was titled *Joseon seonbi ui seojae eseo hyeondaein ui seojae ro* (*Chaekgeori Screen Paintings: History of Studies from the Joseon Dynasty to Modern Times*).

94 *Chaekgeori: The Power and Pleasure of Possessions in Korean Painted Screens* (Seoul: Dahal Media, 2017), edited by Byungmo Chung and Sunglim Kim, contains an introduction by Byungmo Chung and Sunglim Kim ("Chaekgeori Screens in Material Culture") and the following essays: "From Europe to Korea: The Marvelous Journey of Collectibles in Painting," by Sunglim Kim and Joy Kenseth; "Books as Things in Korean Chaekgeori Screen Paintings," by Kris Imants Ercums; "Pursuing Antiquity: Chinese Bronzes in Chaekgeori Screens," by Ja Won Lee; "Taste of Distinction: Paintings of Scholars' Accoutrements," by Sooa McCormick; "The Mystical Allure of the Chaekgeori, Books and Things," by Byungmo Chung; and "The Evolution of Chaekgeori: Its Inception and Development from the Joseon Period to Today," by Jinyoung Jin. See Pak, "Ch'aekkado — A Chosŏn Conundrum." See also Sunglim Kim, "*Chaekgeori*: Multi-Dimensional Messages in Late Joseon Korea," *Archives of Asian Art* 64, no. 1 (2014): 3–32.

95 For the perspective lines of Yi Hyeong-rok's *Chakkado*, see Yi S., *Searching for Modernity*, 51, fig. 30. Kay Black's perspective drawings (Black and Wagner, "*Ch'aekkŏri* Paintings," 68–71) are not quite effective in conveying how the one-point perspective system is applied.

96 See Yi S., "Joseon hugi jinjak jinyeon uigwe reul tonghae bon gungjung ui misul munhwa," 115–97. This three-year research project, conducted at the Academy of Korean Studies, was an interdisciplinary study of art, music, literature, royal cuisine, and costumes as seen through *uigwe* documents.

97 Currently in the Jangseogak Archives (κ2-2876) and the Kyujanggak Institute for Korean Studies, Seoul National University (Kyu 14405).

98 Called *mango* (looking up to the age of fifty). See Yi S., "Joseon hugi jinjak jinyeon uigwe reul tonghae bon gungjung ui misul munhwa," 137–38, figs. 7-1, 7-2, and 8.

99 Ibid., 118, table 1, and 154, table 2.

100 Lee Ki-baik, *A New History of Korea*, 247. See also entries on Dowager Queen Sinjeong and Regent Heungseon Dawongun Yi Ha-eung (1820–1898) in *Hanguk minjok munhwa daebaekgwa sajeon*, 18:331. Because the political situation during the nineteenth century is too complicated to explain here, I have concentrated on the aspect of Dowager Queen Jo's long rise to power.

101 Sotheby's, *Korean Art*, auction catalogue (New York: Sotheby's, 1996), lot 71.

102 Jeong Do-jeon composed poems to go with the music and developed it into a dance performance.

103 For the performing arts of the palace banquets of the late nineteenth century, see Kim Yeong-un, "Joseon hugi gugyeon ui angmu yeongu," in *Joseon hugi gungjung yeonhyang munhwa*, ed. Academy of Korean Studies (Seoul: Monsikwon, 2005), 2:200–297.

104 See fig. 119 for the same illustration.

105 For the reform movement of the progressive party, see Lee Ki-baik, *A New History of Korea*, 275–78. The coup d'état of 1884 (*Gapsin jeongbyeon*), under which fourteen points of reform were planned, included drastic measures of change in bureaucracy, social structures, land and fiscal reforms, etc., of the Joseon period.

106 See the "Expenses" section in *Jeonghae jinchan uigwe*, 228–29.

107 Illustrated in Jo Pung-yeon, *Sajin euro boneun Joseon sidae saenghwal gwa pungsok* (Seoul: Seomundang, 1986), 144–45.

108 Kim Su-jin, "Joseon hugi byeongpung yeongu" (PhD diss., Seoul National University, 2017).

CHAPTER TEN

PAGES 415–445

1 Yi S., "Ideals in Conflict," 288–314.

2 Ahn, *Hanguk hoehwasa*, 121–24.

3 [*Sukjong Inhyeon wanghu*] *garye dogam docheong uigwe, gongjangjil*, 411–14.

4 Park J., "*Uigwe* reul tonghaeseo bon Joseon sidae ui hwawon," 221–67.

5 For a table listing Prince Anpyeong's collection of Chinese, Korean, and Japanese paintings catalogued by Sin Suk-ju's (1417–1475) "Hwagi" (Painting Records) contained in Sin's collected writings, *Bohanjaejip*, published in 1487, see Ahn, *Hanguk hoehwasa*, 93–96 and 121. Burglind Jungmann was able to single out the cases of Luo Zhichuan (1265–1340), whose Li-Guo manner of painting is by now quite well known, and another painter, Wang Gongyan (active fourteenth century). Wang's twenty-three paintings were recorded by Sin Suk-ju, but both Luo and Wang were forgotten in Chinese painting history. See Jungmann, "Sin Sukju's Record on the Painting Collection of Prince Anpyeong and Early Joseon Antiquarianism," *Archives of Asian Art* 61 (2011): 111–13.

6 For a list of the names of all the artists arranged according to the Korean alphabet, see Yi S., *Garye dogam uigwe wa misulsa*, 319–42, table 6. For a chronological order of the artists, see ibid., table 7.

7 They are, in chronological order: O Se-chang, comp., *Hwasa yangga borok* (1916; Seoul: Jisik saneopsa, 1975); Kim Yeong-yun, comp., *Hanguk seohwaga inmyeong sajeon* (1959; Seoul: Yesul chun-chusa, 1978); and Ahn, *Hanguk hoehwasa*.

8 For a list of 220 painters from the Joseon period and twenty-four twentieth-century painters, see Jeong Yang-mo, *Joseon sidae hwaga chongnam* (Seoul: Sigongsa), 2017. Since this list contains more literati painters than professional painters, only twenty-three painters overlap with those who worked on the wedding *uigwe* from 1627 to 1906.

9 Ahn Hwi-joon, "Donggwoldo," in *Hanguk ui gunggwoldo* (Seoul: Cultural Heritage Administration, 1991), 21–62.

10 For a detailed list of tasks of painters in several categories of *uigwe*, among them royal funerals and royal weddings, see Park J., "*Uigwe* reul tonghaeseo bon Joseon sidae ui hwawon," 208, table 1.

11 For a discussion of three or four different *uigwe* made for a royal funeral, see chap. 5 in this volume.

12 For the responsibility of each *bang* in the twenty royal wedding *uigwe* of the second half of the Joseon period, see Yi S., *Garye dogam uigwe wa misulsa*, 285–98, table 4.

13 Kim Mi-ra, "Joseon hugi okchaek naeham yeongu" (PhD diss., Sookmyung Women's University, 2015). The author was able to identify the dates of about half of the 250 surviving containers now in the National Palace Museum of Korea.

14 For discussion of the change in procedure that took place from the 1759 wedding rites, see chap. 2 in this volume.

15 The *uijangmul* we now have date from the late nineteenth or early twentieth century.

16 [*Sukjong Inhyeon wanghu*] *garye dogam docheong uigwe*, 95.

17 *Jeongui jangmok Inwon wanghu jibo* (see glossary).

18 "Gyomyeong jikjosik," [*Ikjong/ Munjo*] *wangseja garye dogam uigwe* (*Uigwe of the Wedding of the Crown Prince [Hyomyeong, posthumously elevated to King Ikjong/Munjo]*), 1819, Jangseogak Archives of the Academy of Korean Studies.

19 For a pioneering study of this subject, see Robert J. Maeda, "*Chieh-Hua: Ruled-Line Painting in China.*" *Ars Orientalis* 10 (1975): 123–41. Also see Wei Dong, "Xia Yong ji qi jiehua," *Gugong bowuyuan yuankan* 4 (1984): 68–83.

20 Another large-scale view of the Gangnyeongjeon, the queen's quarters of Gyeongbok Palace, appears in the same *uigwe*.

21 At this time an eight-panel screen painting of the banquet was produced, which is now in the Los Angeles County Museum of Art. See Jungmann, "Documentary Record," 95–111.

22 *Seogwoldo* (West Palace) (one copy in the Korea University Museum) and *Donggwoldo* (East Palace) (one copy in the Korea University Museum, another in the Dong-A University Museum in Busan).

23 For a list of palace banquet screens produced between 1795 and 1892, along with the names of painters who were responsible for the paintings, see Yi S., "Joseon hugi jinjak *jinyeon uigwe* reul tonghae bon gungjung ui misul munhwa," 154, table 2.

24 For the subject matter of palace screens and their use, see chap. 9 in this volume.

25 Yi S., *Garye dogam uigwe wa misulsa*, 294–95.

26 Yi S., *Eojin uigwe wa misulsa*, 270–73, table 10.

27 For the role of painters and artisans in decorating the *dangga* as well as providing furnishings with all the ritual items in portrait halls, see Choe Yeong-suk, "Joseon sidae jinjeon ui jangeom gwa uimul yeongu" (PhD diss., Hongik University, 2016).

28 *Yukjeon jorye* (*Applications of the Six Codes*), vol. 3 *yejeon* (Code of the Ministry of Rites) and vol. 4 *gongjeon* (Code of the Ministry of Works) (1867; Hangul translation by Ministry of Government Legislation, 1966).

29 Ibid., 3:412, 416.

30 Ibid., 4:529–49.

31 Kang, "Joseon sidae dohwaseo hwawon jedo," 270–71.

32 Yi S., "Joseon hugi jinjak *jinyeon uigwe* reul tonghae bon gungjung ui misul munhwa," 186–88, table 6. The most comprehensive study of Joseon artisans can be found in Jang Gyeong-hui, "Joseon wangjo wangsil garye yong gongye pum yeongu" (PhD diss., Hongik University, 1999). See also her more comprehensive work, *Uigwe sok Joseon ui jangin*, 2 vols. (Seoul: Solgwahak, 2013).

33 Kang, *Joseon hugi gungjung hwawon yeongu*, 1:516–20; Kang, "Joseon sidae dohwaseo hwawon jedo," 262–69.

34 For salaries given to the painters, scribes, and other artisans, see Yi S., *Eojin uigwe wa misulsa*, 263, table 9.

35 *Hwaseong seongyeok uigwe*, 1:380–94.

36 The Taxation Code (*hojeon*) of the *Sok daejeon*, Beopje jaryoji 19 (1746; Hangul translation by Ministry of Government Legislation, 1979), 95.

37 For an exact quotation of the section, see Yi S., *Eojin uigwe wa misulsa*, 264.

38 For more on *dangsanggwan*, see chap. 6 in this volume.

39 Yi S., *Eojin uigwe wa misulsa*, 174–75, table 7.

40 Ibid., 212, table 8.

41 For an overview of the art of painting by the ruling class of the early Joseon period, see Jeong Yang-mo, "Joseon jeongi ui hwaron," in *Sansu hwa*, ed. Ahn Hwi-joon (Seoul: Jungang Daily, 1980), 1:177–90.

42 Yi S., "Ideals in Conflict."

43 Yi Song-mi, Kang Kyung-sook, and Cho Sun-Mie, *Joseon wangjo sillok misul gisa jaryojip* (Seongnam: Academy of Korean Studies, 2002–2004), 1:330–59. There are more than ten entries on this subject in the *Veritable Records of King Seongjong*, beginning from the twenty-sixth day of the fifth lunar month to the ninth day of the seventh lunar month, 1472.

44 *Veritable Records of King Yeongjo*, fifth day of the fourth lunar month, 1754, in ibid., 2:411. See references under *Joseon wangjo sillok* on page 525 of this volume.

45 For more on Jeong Seon's career, see Kang Gwan-shik, "Gyeomjae Jeong Seon ui sahwan gyeongnyeok gwa aehwan," *Misulsa hakbo* 29 (2007): 137–94.

46 Lee Ki-baik, *A New History of Korea*, 112–13.

47 Even in such cases, public and private lowborns (*gongsacheon*) were given *yangmin* status, and low-ranking civil or provincial workers were given exemptions of statute labor if they so desired. The section on "punishment" (*hyeongjeon/pojeok*) is quoted in Ehwa Womans University, ed., *Joseon sinbunsa yeongu* (Seoul: Beommunsa, 1987), 111–12.

48 On the difficulties of getting into the late Joseon bureaucratic hierarchy, see Kyung Moon Hwang, *Beyond Birth: Social Status in the Emergence of Modern Korea* (Cambridge, MA: Harvard University Asia Center, 2004), 42, especially 50–54.

49 Yi S., "Joseon hugi jinjak *jinyeon uigwe* reul tonghae bon gungjung ui misul munhwa," 191–94.

50 *Hanguk minjok munhwa daebaekgwa sajeon*, s.v. "*jungin*," 21:149–50. The term *jungin* should not be confused with today's "middle class."

51 Jang G., "Joseon wangjo wangsil garye yong gongye pum yeongu," 170–73.

52 For a very detailed description of the status of Joseon women after their marriage, see Deuchler, *Confucian Transformation of Korea*, 263–64. On the architecture of a seventeenth-century *yangban* house arranged to show the separation of the male and female domains (Chunghyodang, Hahoe Village, North Gyeongsang province), see Yi Song-mi, *Fragrance, Elegance, and Virtue: Korean Women in Traditional Arts and Humanities* (Seoul: Daewonsa, 2002), 33–35 and fig. 5.

53 *Jinchan uigwe*, 1848 (Heonjong 14), 2:179.

CONCLUSIONS

1 For its long title, see chap. 2, note 4.

2 *Sinjeung Dongguk yeoji seungnam* (1530; repr., 1906, 1912, 1960; Hangul translation by the Korean Classics Research Institute, 1969); *Dongguk sinsok Samgang haengsildo* (1617; facsimile eds. by National Central Library, 1959; Seoul: Daejegak, 1978); and others. Gwanghaegun was also responsible for the building of the Jeoksangsan History Archive in Muju, North Jeolla province.

3 Yi Uk, Jang Yeong-suk, et al., *Daehan jeguk ui jeollye wa* Daehan Yejeon (Seongnam: Academy of Korean Studies, 2019).

NOTES TO THE CONCLUSION **483**

Glossary

a'ak
雅樂
Joseon court ceremonial
music

aechaek
哀冊
jade book inscribed
with eulogies

Agyangnu
(Ch. Yueyang lou)
岳陽樓
famous pavilion in
Yueyang, Hubei province,
known for its beautiful
view of Lake Dongting

aheollye
亞獻禮
second offering of
libation

Akedun [Ch.]
(Kr. Ageukdon)
阿克敦
(1685–1765)
Qing envoy to Joseon
between 1717 and 1725

akgongcheong
樂工廳
musicians' building
in the Jongmyo shrine
compound

akjang
樂章
eulogies in the form of
a libretto for songs

ammun
暗門
hidden door or secret gate

An Gwi-saeng
安貴生
(d. after 1470)
court painter under King
Sejong who excelled in
figure painting

An Hyang
安珦
(1243–1306)
Neo-Confucian scholar
at the end of the Goryeo
dynasty who worked to
spread the teachings
of Zhu Xi, which he
imported from China

An Jung-sik
安中植
(1861–1919)
one of the last Joseon
court painters; famous for
true-view landscapes

An Shi Rebellion [Ch.]
(Kr. An Sa ui nan)
安史의亂
rebellion of An Lushan
安祿山 and Shi Siming
史思明 during Tang
dynasty Emperor Xuan-
zong's reign

anborye
安寶禮
ceremony of stamping
the royal seal on the royal
letter of appointment

angje
盎齊
wine, brewed two seasons
earlier, offered at a
Jongmyo sacrificial rite

baeansang
排案床
black-lacquered table on
which ceremonial items
are displayed

Baegun
白雲
(1299–1374)
Buddhist monk who
compiled *Jikji simche
yojeol*, selections from
the Buddha's sayings
and eminent priests'
writings

baehyang gongsin
配享功臣
officials whose spirit
tablets are enshrined in
the Hall of Meritorious
Officials in the Jongmyo
shrine compound

baejong
陪從
retinue

baek
魄
yin spirit

Baek Eun-bae
白殷培
(b. 1820)
19th-cent. court painter
who excelled in genre and
landscape paintings

Baek Nak-seon
白樂善
(act. late 19th–early
20th cent.)
painter (but not a royal
portrait painter) of the
Five Peaks screen for the
1900 royal portrait *uigwe*

baekgwan
百官
court official(s), both
civil and military

baekjadongdo
百子童圖
painting of One Hundred
Children, showing
numerous children at
play in a garden; a theme
symbolizing the good life
related to the Happy Life
of Guo Ziyi [Fenyang], who
had many grandchildren
and great-grandchildren

baekse bulcheonjiwi
百世不遷之位
"immovable spirit tablets for hundreds of generations." *See* bulcheonjiwi

baeseol
排設
section of *uigwe* text devoted to screen paintings and other furniture

Bak Chang-su
朴昌洙
(act. late 19th–early 20th cent.)
late Joseon court painter who painted the *banchado* for the 1900 royal portrait *uigwe*

Bak Chi-sun
朴致淳
(act. late 19th–early 20th cent.)
one of seven 1st-grade painters (not royal por-trait painters) comprising the *dancheong* painting masters for the 1901 royal portrait *uigwe*

Bak Hui-seo
朴禧瑞
(act. early 19th cent.)
court painter who worked on screen paintings for the 1819 wedding of Crown Prince Hyomyeong

Bak Jae-in
朴在寅
(act. late 18th cent.)
court scribe under King Jeongjo

Bak Je-ga
朴齊家
(1750–1805)
scholar of the School of Northern Learning; appointed inspector of Kyujanggak Library by King Jeongjo; also known as a painter

Bak Ji-won
朴趾源
(1737–1805)
scholar of the School of Northern Learning and the foremost late Joseon writer; visited Yanjing in 1780 as an emissary sent to congratulate the Qianlong emperor on his seventieth birthday. Bak's travel diary, *Yeolha ilgi* 熱河日記 (*Jehol Diary*), is full of his observations of Qing material culture and is considered one of the best literary pieces of the late Joseon period.

Bak Man-hyeong
朴萬亨
(act. late 19th–early 20th cent.)
one of four painters (not royal portrait painters) of rank 9 who worked on the screen *Sea and Peaches of Immortality* for the 1901 royal portrait *uigwe*

Bak Se-chae
朴世采
(1631–1695)
scholar-official, minister of the left under King Sukjong, author of many books on Neo-Confucianism

Bak ssi (née Bak)
朴氏
(act. mid-18th cent.)
family surname of upper-class lady who was an invitee at a court banquet in 1848

balcha
發車
vehicle or cart construc-ted of two wheels cut from a whole round log and pulled by a bull; used for transporting small pieces of construction stone

banchado
班次圖
illustration(s) in *uigwe* text showing the place-ment of participants by rank/social status and the arrangement of cere-monial objects in court rituals and processions

bang
房
subunits within a superintendency

bangbul
彷佛
faithfulness/likeness to the model

Banghwa suryujeong
訪花隨柳亭
Pavilion of Following Willows and Searching for Flowers, the north-east sentry tower of the Hwaseong Fortress; named after a poem by the Song Neo-Confucian scholar-poet Cheng Hao 程顥 (1032–1085)

bangoe hwasa
方外畫師
painters loosely asso-ciated with provincial government offices

bangsa
雱祀
spirit of snowstorms

bangsangsi
方相氏
demon queller in a royal funeral procession, who wears a mask with four eyes and a bearskin cape, and wields a long spear to chase out evil spirits from the royal burial chamber

bangung
泮宮
national college com-pound in a vassal state

bansa
頒賜
royal bestowal of goods

banseonsaek
飯膳色
unit that prepares side dishes for Chinese envoys

bansu
泮水
a man-made narrow stream that surrounds the national college compound of a vassal state

banu
返虞
bringing the temporary spirit tablet of a king back to the palace from the royal tomb after the funeral

barin
發靷
departure of a coffin for burial

billye
賓禮
rites for receiving foreign (mostly imperial Chinese) envoys

bimanggi
備忘記
special memorandum

bimun
碑文
text inscribed on a stele

bingban
氷槃
wooden structure containing ice placed under the royal coffin in the coffin hall of the palace

bingung
殯宮
coffin hall for the funeral of members of the royal family other than the king or queen

binjeon
殯殿
coffin hall of a palace, often combined with a spirit tablet hall

bo
黼
axe pattern

bo
寶
royal seal

bogaegu
簠盖具
ritual vessel, with a cover, for containing grains at Jongmyo shrine sacrificial rites

bogap
寶匣
chest for royal seal

bogwan yoyeo
服玩腰輿
small palanquin that contains additional clothing and other personal items of the deceased king

bok
復
calling for the spirit of the deceased king to return. A eunuch would stand on the roof of the palace building in which the king just died, shake the king's clothing, and cry loudly for the spirit to come back.

bok
楅
arrow stands used in the royal archery rites

bogwi
復位
restoration of a royal title

boma
寶馬
royal seal horse

bongdon
烽墩
beacon or signal towers of a fortress

bonggeogun
捧炬軍
torch bearers

Bongnaedang
福內堂
Hall of Inner Happiness within the Hwaseong Detached Palace compound

bongsim
奉審
to examine with respect

Bongsudang
奉壽堂
Hall of Revering Longevity within the Hwaseong Detached Palace compound

botaepyeong
保太平
"Preserving Peace," court ritual music and dance consisting of eleven short songs praising former kings for their endeavors in maintaining peace in the nation

bugyejang
浮械匠
artisan who builds scaffoldings for high structures

Bukhakpa
北學派
School of Northern Learning, branch of the School of Practical Learning, which advocated importing advanced science and technology from Qing China

bul
戫
motif created by placing two *hanja* characters for bow (*gung*) back-to-back

bulcheonjiwi
不遷之位
spirit tablets of kings that are to remain forever in the Main Hall of Jongmyo shrine. A king's spirit tablet is normally removed from the Main Hall after four generations to make way for a newly deceased king and placed in the Hall of Eternal Peace. This decision to retain a given spirit tablet permanently in the Main Hall is based on the king's achievements and contributions to the Joseon dynasty.

bulsik
不食
three-day fast of the crown prince and his brothers upon the death of the king

bumul chaeyeo
購物綵轝
black-roofed palanquin with sides covered by plain silk cloth that carries the Chinese emperor's gifts for the Joseon king's memorial rite

bumyo
祔廟
enshrining a royal ancestral tablet in the Jongmyo shrine twenty-seven months after the royal funeral

bumyo dogam
祔廟都監
superintendency set up to oversee the procedure of transporting the king's permanent spirit tablet to Jongmyo shrine

bundo
分圖
drawing of the individual parts of a whole machine

bunmi
粉米
grains

bupyeon
附編
addenda volume

buseokso
浮石所
workshop for making stone items, such as figures of civil and military officials, animals, and so forth, to be placed in the royal tomb precinct

buyeon
副輦
secondary palanquin

byeogyo
甓窯
kiln for firing bricks

byeoldan
別單
separate lists, mostly of names, attached to reports to the king

byeolgam
別監
special guards

byeolganyeok
別看役
inspector of various works

byeolgongjak
別工作
special subunit within a *dogam* (superintendency)

byeolgung
別宮
detached palace where the royal bride-to-be resides until the wedding day and is educated on court life and etiquette

byeollye
變禮
sacrificial rites held at Jongmyo during periods of grave national turmoil, such as foreign invasions

byeolmyo
別廟
sub-shrine of a shrine complex

Byeongin yangyo
丙寅洋擾
"Western disturbance" in the cyclical year *byeongin* (1866), referring to the French invasion and sacking of Ganghwa Island that year; the annex of the Kyujanggak Royal Library was located there.

Byeongja horan
丙子胡亂
"Manchu disorder" of the cyclical year *byeongja* (1636), referring to the Manchu invasion of that year

byeongjo dangsang
兵曹堂上
minister of defense

byeongpungjang
屏風匠
artisan who specializes in constructing screens for paintings

Castiglione, Giuseppe
See Lang Shining

Chae Je-gong
蔡濟恭
(1720–1799)
scholar-official and
prime minister under
King Jeongjo

Chae Yong-sin
蔡龍臣
(1850–1941)
one of the last Joseon
court painters, famous
for portrait painting

chaejeong
綵亭
small, pavilion-shaped
silk palanquins

chaek wangsejaui
冊王世子儀
investiture rite of
a crown prince

chaekbi (chaekbin)
冊妃 (冊嬪)
royal appointment of the
queen (crown princess)

chaekbo
冊寶
royal books and seals

chaekbong gomyeong
冊封誥命
Chinese imperial letter of
approval for investiture
of a Joseon king

chaekgado
冊架圖
bookcase painting
(chaekgeori)

chaekgeori
책거리
vernacular Korean term
for chaekgado

**chaengnip wonja
wi wangseja**
冊立元子爲王世子
"the first-born royal son is
installed as crown prince"

chaesangdan
採桑壇
altar or platform where
royal ladies pick branches
of mulberry leaves to
perform the rites of
sericulture

chaeyeo
彩輿
small painted palanquin

chaeyeo
綵轝
regular-sized silk
palanquins

chagwan
差官
imperial messengers

Changdeokgung
昌德宮
Changdeok Palace, one
of the five Joseon dynasty
palaces in Seoul

Changgeon
創建
section in the Jongmyo
uigwe about King Taejo's
involvement in the
building of the shrine
in 1394

changgyo
槍橋
[pontoon] bridge [dock]
connecting the shore to
King Jeongjo's pontoon
bridge, formed by
anchoring and tying
a row of small boats
together

Changnyongmun
蒼龍門
east gate of Hwaseong
Fortress

changung
欑宮
temporary structure to
house the royal coffin
until burial, after which
it was burned; its inner
walls were painted with
the Four [directional]
Animals.

Chen Chun [Ch.]
陳淳
(1483–1544)
Ming dynasty literati
painter of the Wu School,
famous for mogu 沒骨 or
"boneless style" plants and
flower painting in which
contour lines are not used
in painting objects

Cheng Dayue [Ch.]
程大約
(1541–ca. 1616)
compiler of Chengshi
moyuan (1605)

Cheng Hao [Ch.]
程顥
(1032–1085)
Northern Song Neo-
Confucian scholar-
poet (sobriquet,
Mingdao 明道)

Chengshi moyuan [Ch.]
程氏墨苑
Master Cheng's Ink Garden,
illustrated catalogue of
ink-cake patterns of the
late Ming period, edited
by Cheng Dayue

cheolbyeondu
撤籩豆
removing of utensils
after sacrificial offerings
at Jongmyo shrine

cheolchan
撤饌
removing the foods after
the sacrificial offerings at
Jongmyo shrine

Cheoljong
哲宗
(r. 1849–1863)
25th king of the Joseon
dynasty. When King
Heonjong died without
an heir in 1849, Dowager
Queen Sunwon selected a
nineteen-year-old distant
relative of Heonjong to
ascend the throne as King
Cheoljong. However, it
was the dowager queen's
relatives, the powerful
Andong Kim clan, who
dominated court life
and government during
Cheoljong's reign.

Cheongeum jip
清陰集
collected writings of Kim
Sang-heon, whose sobri-
quet is Cheongeum

cheongi
賤技
the lowly skills of painting
and art, considered mere
craft by scholar-officials

cheongju
清酒
freshly brewed wine

cheongseon
青扇
large blue fan, one of
the items carried in
royal processions

cheongsuanma
青繡鞍馬
white horses with blue
embroidered saddles

cheongyangsan
青陽傘
blue parasol, one of the
items carried in royal
processions

cheonja (Ch. Tianzi)
天子
Son of Heaven, i.e., the
Chinese emperor

cheonje
天祭
sacrifices to heaven

cheonmin
賤民
lowborn class of people
in Joseon society

cheonsa (Ch. tianshi)
天使
Chinese imperial envoys

cheonsa banchado
天使班次圖
painting illustrating the
placement of participants
according to rank and
social class in a proces-
sion of Ming imperial
envoys making their way
to the Joseon court

cheonsin
天神
spirit of heaven

cheonsin
薦新
offering the new harvest
annually at Jongmyo
shrine

cheopji
帖紙
official letter of
appointment

chi
觶
cup made of ox horn

chibyeok
治椑
construction of the
inner royal coffin

chijang
治葬
tomb construction

chilsa
七祀
sacrificial offerings for
seven minor deities

Chilsadang
七祀堂
Hall of Seven Rites for
seven minor spirits
collectively known as the
Seven Deities, situated to
the west of the south gate
of Jongmyo shrine. The
seven spirits represent
samyeong 司命, human
destiny; *jungnyu* 中霤,
interior; *ho* 戶, household;
jo 竈, kitchen and hearth;
gungmun 國門, gates of
the capital's inner walls;
taeryeo 泰厲, awards
and punishments; and
gukhaeng 國行, travel
and roads.

chimseonbi
針線婢
seamstresses called
"needle and thread
servants"

chingyeonghu nojuui
親耕後勞酒儀
rite of celebrating with
wine after the royal rites
of agriculture

chingyeongui
親耕儀
royal rites of agriculture

**Chinim Gwanghwamun
nae Geunjeongjeon
jeongsido**
親臨光化門內勤政殿庭試圖
painting titled *Examination
in Geunjeong Hall inside
Gwanghwa Gate in the
Presence of the King*

**chinim Seojangdae
seongjosik**
親臨西將臺城操式
military exercises
presided over by the
king at the Seojangdae
command post of
Hwaseong Fortress

chinjamui
親蠶儀
royal rite of sericulture

chinje
親祭
sacrifices conducted
by the king himself

chinyeong
親迎
royal groom's visit to the
detached palace to meet
and escort his bride to
the palace

chiseong
雉城
"pheasant wall" turrets
along fortress wall

chobon
草本
draft version (of a
painting)

Choe Deuk-hyeon
崔得賢
(act. late 18th cent.)
court painter under
King Jeongjo

Choe Gyeong
崔涇
(act. second half of
15th cent.)
court painter under
King Sejong, excelled in
figure painting

Choe Hong-seok
崔泓錫
(act. late 19th–early
20th cent.)
court painter (rank 9)
who painted the Peony
screen for the 1901
royal portrait *uigwe*

Choe Ik-hyeon
崔益鉉
(1833–1906)
famous figure of indepen-
dence movement against
Japan

Choe Seok-jeong
崔錫鼎
(1646–1715)
Joseon prime minister and
envoy to the Qing court

Choe Seok-jun
崔錫駿
(act. late 19th–early
20th cent.)
painter (not a royal
portrait painter) of
rank 9; painter of a space
divider screen of Plum
Blossoms, as cited in the
1901 royal portrait *uigwe*

Choe Seong-gu
崔聖九
one of nine *dancheong*
painting masters, as
cited in the 1900 royal
portrait *uigwe*

Choe Won
崔垣
(act. early 19th cent.)
court painter who worked
on screen paintings
for the 1819 wedding of
Crown Prince Hyomyeong

Choe Yeong-su
崔永秀
(act. late 19th–early
20th cent.)
one of six rank 2 painters
(not royal portrait painters)
comprising the *dancheong*
painting masters for the
1901 royal portrait *uigwe*

choheollye
初獻禮
first offering of libation

chubu
追祔
re-enshrinement of a
spirit tablet in Jongmyo
shrine

chuk(mun)
祝(文)
memorial text; prayer
texts (invocations) read at
sacrificial offering rites

chukpye
祝幣
written prayers read at
the sacrificial rites and
the offering of white silk
cloth to the spirits

chuksa
祝史
official who reads
invocations during
ritual sacrifices

Chunchugwan
春秋館
Court History Office

Chunhyang
春香
given name of one of four
seamstresses appearing
on the list of artisans in
the 1759 wedding *uigwe*

chusang jonho (chujon)
追上尊號 (追尊)
posthumous elevation of
titles of kings and queens

chusung
追崇
posthumous elevation
of titles

chwiwi
就位
taking positions at
a ceremony

Chwiyeol
翠烈
given name of one of four
seamstresses appearing
on the list of artisans in
the 1759 wedding *uigwe*

daeeunjang
大銀匠
artisan specializing in
making large silver items

daega
大駕
the king's most formal
and largest palanquin
for the "king's grand
procession"

daega uijang
大駕儀仗
honor guards for the
most formal royal proces-
sions, complete with
ritual weapons and flags
symbolizing the king's
authority

daegeo
大車
large vehicle pulled by forty oxen, used to transport the heaviest stones for constructing the Hwaseong Fortress

Daehan jeguk
大韓帝國
(1897–1910)
Daehan Empire

Daehan yejeon
大韓礼典
Code of the Daehan Imperial Rites

daehogweui
大犒饋儀
rite announcing the king's bestowal of food and wine one day before the actual distribution

daeje
大祭
the great offerings, the most important sacrificial rites at Jongmyo shrine, Yeongnyeongjeon hall, Hwangudan Altar, and Sajikdan Altar

daejehak
大提學
chief academician of the three offices of the government: Hong-mungwan 弘文館 (Office of Special Advisers); Yemungwan 藝文館 (Office of Royal Decrees); and Seonggyungwan 成均館 (National Confucian Academy)

Daejeon hoetong
大典會通
Comprehensive Collection of National Codes (1865)

Daejojeon
大造殿
queen's quarters of Changdeok Palace, also used as the bedchamber of the royal couple

daeri cheongjeong
代理聽政
to take charge of the court affairs in the absence of a king, usually by a dowager queen. Sometimes a king would have the crown prince take charge as training or testing of the heir apparent's ability.

daeryeom
大殮
final wrapping of the royal corpse before it is laid in a coffin

daesa
大祀
the great offerings, the most important sacrificial rites at Jongmyo shrine, Yeongnyeongjeon hall, Hwangudan Altar, and Sajikdan Altar

daesaryeui
大射禮儀
royal archery rites, the only military rites of the Joseon dynasty

daewang
大王
great king

Daewongun
大院君
(1820–1898)
King Gojong's father, also known as Yi Ha-eung 李昰應, who effectively ruled Joseon as regent for ten years (1863–1873) in collaboration with

Dowager Queen Sinjeong. Also known as Heungseon Daewongun (興宣大院君), he was credited with rebuilding the Gyeongbok Palace. Yi is also a well-known painter of orchids in ink monochrome.

daeyeo
大轝
royal coffin palanquin

daeyeorui
大閱儀
military exercise(s) on occasions of royal hunting

Daming jili [Ch.]
大明集禮
Ming Code of Rites, compiled in 1369–70 by Xu Yigui 徐一夔 and others under the order of the Ming emperor Taizu

damje
禫祭
ceremonial offering that occurs twenty-seven months after the state funeral, marking the end of the country's mourning period

damjul
담줄
braided cotton cords held by bearers of a palanquin

dancheong hwasa
丹青畫師
painting masters who decorated the wooden parts of the canopy (*dangga*) of royal portrait niches in bright colors, as listed in the 1901 royal portrait *uigwe*

dang'an [Ch.]
檔案
documents that recorded affairs in the Chinese court

dangga
唐家
decorative canopy resembling the roof and eaves of traditional wooden architecture; constructed over a royal throne, a royal portrait niche, or a main Buddha image

dangjuhong
唐朱紅
red pigment of Chinese origin

dangsanggwan
堂上官
official position of rank 3a, a high enough rank to qualify for seating at the upper level of the throne hall at the morning council with the king

danhwak
丹艧
bright pigments for colorful decoration of traditional wooden architecture

Danjeong
丹情
given name of one of four seamstresses appearing on the list of artisans in the 1759 wedding *uigwe*

Danjong
端宗
(r. 1452–1455)
6th king of Joseon; ascended the throne at age 12, but was forced to

abdicate after three years by his uncle, Grand Prince Sujang (later King Sejo). Exiled to Yeongwol and put to death by poison in 1457.

Daoxue [Ch.]
道學
another name for Zhu Xi's Neo-Confucianism

Deogyudang
德遊堂
Deogyu Hall of the Gyeonghui Palace

Deokheungni byeokhwa gobun
德興里壁畫古墳
Goguryeo painted tomb near Pyongyang datable to 408 CE; has the earliest mural representation of the legend of Gyeonu and Jingnyeo (the herd boy and the weaving maiden)

Deukjungjeong
得中亭
Pavilion of Moderation within the Hwaseong Detached Palace

deungga
登架
court ritual music played on the stone platform in front of the Main Hall of Jongmyo shrine

deungnok
謄錄
preliminary records of court events to be used for the compilation of *uigwe* books

Ding Yunpeng [Ch.]
丁雲鵬
(ca. 1584–1638)
painter and illustrator of the *Chengshi moyuan*

dobyeon

盜變

theft event at Jongmyo shrine

docheong

都廳

main unit within a superintendency (*dogam*)

dogam

都監

superintendency, a temporary office at the royal court set up to carry out important state rites, headed by *dojejo* 都提調, one of the three top officials of the State Council or the Ministry of Rites. The composition of the superintendency varies, but usually consists of the main unit, three subunits (*bang* 房), and a repair unit.

dogam gongjang byeoldan

都監工匠別單

list, within a *uigwe*, of names of painters, scribes, and artisans of all trades who serve for a state event

Dohwaseo

圖畫署

Bureau of Court Painting established in 1470, belonging to the Ministry of Rites, composed of two managerial positions of rank 6b (*byeolje* 別提); twenty painters, one of whom is of rank 6b (*seonhwa* 善畫), one of rank 7b (*seonhoe* 善繪), one of rank 8b (*hwasa* 畫史), and two of rank 9b (*hoesa* 繪史); and fifteen painting students/apprentices (*hwahak saengdo* 畫學生徒)

dojejo

都提調

superintendent, chief officer of a *dogam*

Dojo

度祖

(d. 1342)

King Taejo's grandfather; one of four generations of the founding king's ancestors who were elevated posthumously to kingship and whose spirit tablets are enshrined in the Hall of Eternal Peace at Jongmyo shrine

dok

瀆

spirit of streams

dokchaeksang

讀冊床

black-lacquered table used for reading the royal jade book or bamboo book at a royal rite

dokju

櫝主

container for a spirit tablet

dongban

東班

high-ranking civil officials

dongcha

童車

"children's cart" with four wheels that can be pulled or pushed by men to transport construction materials

dongcham hwasa

同參畫師

one in a pool of painters who participate in painting or copying royal portraits

Donggwoldo

東闕圖

East Palace, a sixteen-panel folding screen in ink and color on silk (datable to ca. 1828–30) that depicts the view of the Changdeok and Changgyeong palaces in one continuous view. One copy is in the collection of the Korea University Museum, Seoul; another in the Dong-A University Museum, Busan.

Dongjangdae

東將臺

East Military Command Post of Hwaseong Fortress

dongnoeyeon

同牢宴

final rite of the six rites of a royal wedding, when the royal couple exchanges a bow and a cup of wine at the banquet

Dongyou ji [Ch.]

(Kr. Dongyujip)

東遊集

Akedun's collected poems *Journey to the East* of 1725

doseol

圖說

illustration

doseungji

都承旨

chief royal secretary

Du Fu [Ch.]

杜甫

(712–777)

famous Tang poet

duk

纛

royal commander's flag

dukje

纛祭

sacrificial offering to the royal commander's flag

dumok

頭目

Chinese traders who accompanied the imperial envoys to the Joseon court

Duobao kejing tu [Ch.]

(Kr. Dabo gyeokgyeongdo)

多寶格景圖

Treasure Cabinet painting, attributed to Lang Shining (Giuseppe Castiglione, 1688–1766), an Italian Jesuit painter who worked at the Qing court

duseokjang

豆錫匠

hardware worker who makes the metal fitting parts in wooden furniture

eoui

御醫

royal physician

Eoje jugyo jinam

御製舟橋指南

"King Jeongjo's Instructions on How to Build a Pontoon Bridge" in the *Wonhaeng eulmyo jeongni uigwe* of 1797

Eoje seonghwa juryak

御製城華籌略

"Imperially Composed Comprehensive Plan of Hwaseong," largely based on the "Fortress Construction Plan" (*Seongseol* 城說) submitted by Jeong Yak-yong in the *Hwaseong seongyeok uigwe* of 1801

Eojeongin seorok

御定人瑞錄

record of persons, including the elderly, invited to the celebratory occasion by King Jeongjo

eojin

御眞

royal portrait

Eom Chi-uk

嚴致郁

(act. late 18th–early 19th cent.)

true-view landscape painter, the only painter recorded in the *Hwaseong seongyeok uigwe* of 1801

eoma

御馬

royal horse

eosa

御射

royal arrow-shooting

eosaryedo

御射禮圖

illustration of a royal archery rite

Eouigung

於義宮

detached palace in Sajik-dong, Seoul, that was the home of King Injo before he assumed the throne in 1623

eoyong

御容

royal visage (referring to royal portrait)

eulhaeja
乙亥字
metal-type font developed
in the *eulhae* cyclical year
(1455), modeled after the
calligraphy of the noted
scholar-official, painter,
and calligrapher Gang
Hui-an 姜希顏 (1417–1464)

eumbongnye
飮福禮
rite of partaking of the
blessings by drinking the
libation wine after the
offering

eungpansaek
應辦色
unit of a *dogam* that
prepares gifts for envoys
and other requested items

eungu
隱溝
hidden underground
sewers of Hwaseong
Fortress on the south side

eunjangdo
銀粧刀
small silver knife carried
by a Joseon woman to
commit suicide if her
chastity was threatened

Fanghu tu [Ch.]
(Kr. Banghodo)
方壺圖
painting dated 1563 of
one of the three moun-
tain abodes of the Daoist
Immortals, Mount
Fangzhang (方丈山), by the
Ming painter Wen Boren
文伯仁 (1502–1573)

Fengshi tu [Ch.]
(Kr. Bongsado)
奉使圖
Diplomatic Paintings,
album of painting and
calligraphy recording the
four visits of the Qing
envoy Akedun 阿克敦
(Kr. Ageukdon, 1685–1765)
to Joseon between 1717
and 1725, now in the
collection of the Ethnic
Library of China, Beijing

gaebokcheong
改服廳
changing or dressing
room

gaegi goyujeui
開基告由祭儀
rite announcing to the
spirits the breaking of
ground for construction

gaeje
改題
changing the titles on
the spirit tablet

gaeju
改主
changing the spirit tablet

gaja
加資
to raise one's rank to 3a,
the level of the upper
ranks of officialdom or
dangsanggwan

gakdaejang
角帶匠
artisan specializing
in making a belt from
pieces of ox horn

gaksil wiho
各室位號
information on kings
and queens in each
tablet hall

gaksil wipan jesik
各室位版題式
method for inscribing
titles on spirit tablets in
each spirit chamber

gallyodeung
肝膋甄
ceramic jar containing
the liver and intestinal
fat of sacrificial animals

gamdong
監董
supervisor

gamgyeol
甘結
documents of orders and
instructions sent to lower-
level offices

gamjogwan
監造官
officer who oversees a
government work unit

gan
間
distance between
two columns, approx.
181.8 cm; also a unit
of space in Korean
architecture, approx.
181.8 × 181.8 cm

Gang Hoebin *also*
Minhoebin *or*
Hoebin Gang ssi
姜懷嬪, 愍懷嬪, 懷嬪 姜氏
(1611–1646)
wife of Crown Prince
Sohyeon, known as
"Princess of Sorrow," as
she was executed for
treason and her children
persecuted because of
association with her late
husband

Gang I-o
姜彝五
(1788–?)
scholar-painter, grandson
of the famous scholar-
painter Gang Se-hwang

Gang Se-hwang
姜世晃
(1713–1791)
celebrated scholar-official,
painter, and critic, who
served as mayor of Seoul
(Hanseong *panyun*)

Gang Seok-gi
姜碩期
(1580–1643)
scholar-official under King
Injo; appointed minister
of the right in 1640, and
father-in-law of Crown
Prince Sohyeon

Gang Tae-hyeong
姜台馨
(act. early 20th cent.)
one of six rank-6 painters
(not royal portrait
painters) of the Sea and
Peaches of Immortality
screen as cited in the 1901
royal portrait *uigwe*

Ganghwa sago
江華史庫
Ganghwa History Archive

gangnu
角樓
corner [sentry] pavilion

Gangnyeongjeon
康寧殿
queen's quarters in
Gyeongbok Palace, the
main royal palace of
the Joseon dynasty

Gangseo daemyo
江西大墓
Goguryeo dynasty Great
Tomb at Gangseo near
Pyongyang, famous for its
early 7th-cent. wall paint-
ings of the Four [direc-
tional] Deities

Gangseowon (seson
gangseowon)
講書院 (世孫講書院)
office in charge of the
crown prince's (crown
grandson's) education

gantaek
揀擇
three-stage selection
process for a royal
bride. The maiden who
is selected in the third
and the final stage of
gantaek becomes the royal
bride-to-be.

gantaek danja
揀擇單子
list of eligible maidens
from which a royal bride
is selected

Gapsul hwanguk
甲戌換局
"Reversal of the Political
Situation in the Cyclical
Year *gapsul* [甲戌]"; victory
of the Western Faction
(Seoin) in 1694

garye
嘉禮
royal weddings and other
celebratory rites

gasang jonsi
加上尊諡
presentation of additional
posthumous title(s) for
kings and queens

geoanja
學案者
holder(s) of the (black) table

geodung
擧動
kings' outings

geojang
車匠
wheelwright

geojunggi
擧重機
machine for lifting heavy loads, used in the construction of the Hwaseong Fortress

Geolleung Yungneung
健陵 隆陵
tomb of King Jeongjo; tomb of Crown Prince Sado, Jeongjo's father; both located in the city of Hwaseong, Gyeonggi province

georim
擧臨
assigning wailing places for royal relatives and officials at a state funeral

geumbeol
禁伐
prohibition against cutting trees

geumbo
金寶
gold royal seal

Geumgang
錦江
river that originates in North Jeolla province and empties into the Yellow Sea

geumgun byeoljang
禁軍別將
chief of the palace guards

geumgwan jobok
金冠朝服
formal court attire for high officials; includes gold-trimmed black silk hat

geumhollyeong
禁婚令
national order of marriage prohibition to all maidens when royal family is about to select a candidate for queen or crown princess

Geumneung jip
金陵集
collected writings of Nam Gong-cheol 南公轍 (1760–1840)

Geunjeongjeon
勤政殿
Throne Hall of Gyeongbok Palace

Geunjeongmun
勤政門
gate in front of the courtyard surrounding the Throne Hall of the Gyeongbok Palace

gigo
祈告
short form of *gido* 祈禱 and *goyu* 告由; prayer and announcement to royal ancestors and to the spirits of earth and grain

gihoe
期會
gathering the boats on time to form into King Jeongjo's pontoon bridge over the Han River

Gil Jae
吉再
(1353–1419)
Neo-Confucian scholar at the end of the Goryeo dynasty and the beginning of the Joseon dynasty

gillye
吉禮
auspicious rites, first of the Five Rites of State, mostly of the sacrificial rites to spirits of heaven, earth, and grain, and to royal ancestors

gimyeong jeolji
器皿折枝
[painting of] antique vessels and cut branches of flowers

giroso
耆老所
Joseon-period "Club of Elders" for retired high officials

giruijang
吉儀仗
auspicious honor guards of a living king's procession

giryugung
吉帷宮
temporary structure composed of bamboo columns and drapes to house the royal coffin while the identity of the deceased is written on the temporary spirit tablet, *uju* 虞主

Gisa gyeonghoecheop
耆社慶會帖
Album of Paintings and Calligraphy Celebrating King Yeongjo's Entry into the Club of Elders, 1744–45

Godongnok
古董錄
"Records of Curios" contained in Bak Ji-won's famous *Jehol Diary*

gogi
告期
announcement of the royal wedding date

Gojong
高宗
(r. 1863–1907)
last king of Joseon; reigned for 34 years from 1863 as king before declaring himself the first emperor of the Daehan (Great Korea) Empire in 1897, but was forced by Japan to abdicate in 1907 in favor of Emperor Sunjong, the last ruler of dynastic Korea

gokgungin
哭宮人
palace ladies who serve as wailers for royal funeral processions, performing unseen inside a draped enclosure behind the royal coffin palanquin

gomyeong (Ch. gaoming)
誥命
Chinese imperial decree conferring the rank of nobility, here on the Joseon kingship

gonghae
公廨
service establishments

gongjakbyeong
孔雀屏
screen of Peacocks

gongjang
工匠
artisan(s)

gongjangjil
工匠秩
list of names recorded in *uigwe* books of all artisans, painters, scribes, and seamstresses in service for particular state rites

Gongjeong (daewang)
恭靖 (大王)
See Jeongjong

gongsimdon
空心墩
observation and arrow-shooting towers with hollow interiors and spiral stairs that guarded the nearby gates at Hwaseong Fortress

Gongsindang
功臣堂
Hall of Meritorious Officials in the Jongmyo shrine compound

gosa
故事
collection of anecdotes

gosamyo
告社廟
announcement rite at the royal ancestral shrine

goyuje
告由祭
announcement rites to ancestral spirits

guhoek
區劃
budget sources

guilsigui
救日食儀
rite of observing the solar eclipse

gujang

九章

nine emblems embroidered on the king's formal attire: on his outer gown, a dragon (*yong* 龍); on the shoulders, mountains (*san* 山); on the back and along the end of the sleeves, fire (*hwa* 火), a pheasant (*hwachung* 華蟲), and two vessels (*jongi* 宗彝). On the front of the skirt are embroidered four additional items: seaweed (*jo* 藻), grain (*bunmi* 粉米), axe (*bo* 黼), and the motif called *bul* (黻), created by two characters for bow (*gung* 弓) placed back-to-back.

gujang myeonbok

九章冕服

ensemble designated as the most formal attire of the Joseon ruler

Gujin tushu jicheng [Ch.] (Kr. Gogeum doseo jipseong)

古今圖書集成

Complete Collection of Illustrations and Writings from the Earliest to Current Times, which was started under the Qing dynasty Kangxi emperor (r. 1661–1721) and finished under the Yongzheng emperor (r. 1722–1735) in 1726

gukhaeng

國行

"travel and roads," one of seven minor spirits (collectively known as the Seven Deities) whose rites took place in the Hall of Seven Rites situated to the west of the south gate of Jongmyo shrine

gukjang

國葬

state funeral, the funeral of kings and queens

Gukjo bogam

國朝寶鑑

Precious Mirror of the Nation, a compilation of achievements of past kings from the reign of King Sejong in the early 15th cent. through the reign of Emperor Sunjong in 1909

gullye

軍禮

military rites, the fourth of the Five Rites of State

gunbuin

郡夫人

honorific title for a wife of a royal relative

gung

弓

bow

gungmo

國母

"mother of the nation" (i.e., queen)

gungmun

國門

"gates of the capital's inner walls," one of seven minor spirits (collectively known as the Seven Deities), whose rites took place in the Hall of Seven Rites situated to the west of the south gate of Jongmyo shrine

Gungnaebu

宮內府

Office of the Affairs of the Inner [Imperial] Court

gunsaek

軍色

military unit

Guo Ziyi [Ch.] (Kr. Gwak Ja-ui)

郭子儀

(697–781)

Tang dynasty general who received the posthumous title King of Fenyang (Kr. Bunyang wang 汾陽王); he led a successful career as a military official and had a prosperous life blessed with successful filial sons, sons-in-law, and numerous grandsons, and thus became a paragon of happiness.

gupan

駒板

"pony board," made of two wooden boards tied together at one end, pulled on round logs placed on the ground parallel to each other

Gwak Bun-yang baekjadongdo

郭汾陽百子童圖

painting of Guo Fenyang and One Hundred Children

Gwak Bun-yang haengnak dobyeong

郭汾陽行樂圖屏

screen painting depicting the Happy Life of Guo Fenyang

Gwak Ja-ui chuksudo (Ch. Guo Ziyi zhu shoutu)

郭子儀祝壽圖

painting of Birthday Celebration of Guo Ziyi (Fenyang)

Gwak wigwan jemul baejin bancha

郭委官祭物陪進班次

placement of participants by rank or social status at the ceremony in which the Ming embassy presented gifts from the Chinese emperor for King Seonjo's memorial service, 1608

gwallye

冠禮

capping, or coming-of-age, ceremony

gwan sau sadanui

觀射于射壇儀

watching the archery rite, part of the military rites

gwanban

館伴

official in charge of taking care of Chinese envoys in the superintendency set up for receiving envoys

Gwanghae(gun)

光海(君)

(r. 1608–1623)

15th king of Joseon; as King Seonjo's crown prince, he contributed greatly to the country's defense during the Japanese invasions of 1592 and 1597. In 1608 he ascended the throne with the support of the Northern Faction officials (*daebuk pa* 對北派). However, he had his stepbrother, Prince Yeongchang 永昌大君 (1606–1614), killed, and demoted him posthumously to a commoner, along with the Dowager Queen Inmok 仁穆大妃 (King Seonjo's second queen). These immoral actions prompted opponents such as Kim Ja-jeom 金自點, Yi Gwal 李适, and other officials of the Western Faction (Seoin 西人) to dethrone him in 1623, whereupon they installed Prince Neungyang 綾陽君, a grandson of Seonjo, as King Injo, the 16th king of Joseon. This incident is known in Korean history as *Injo banjeong* 仁祖反正 (King Injo's Restoration of Rectitude).

Gwangheungchang

廣興倉

bureau in the Ministry of Taxation that oversaw payment of salaries to government workers

Gwangju

廣州

one of the three localities near Hwaseong where kilns for firing bricks were located

gwangwang minin

觀光民人

sightseers

gwangwang sanyeo

觀光士女

men and women sightseers

gweham

櫃函

covered boxes and containers produced for royal wedding ceremonies

gwesik

饋食

presentation of meat and other foods

gwoldalma
闕闥馬
the crown prince's horse, used only within the palace walls

Gwon Dae-un
權大運
(1612–1699)
prime minister (1689) under King Sukjong

Gwon Geun
權近
(1352–1409)
Neo-Confucian scholar-official at the end of the Goryeo dynasty and the beginning of the Joseon dynasty, famous for his insistence on a pro-Ming policy during the Yuan-Ming political transitional period

Gwondong
權洞
mountainous valley area near Hwaseong with a stone vein that could be explored and tapped for the construction of the Hwaseong Fortress

gwonsu
卷首
lead volume or extended preface, which precedes volume one

gyebyeong
契屏
multiple copies of a screen painting to be distributed among important officials who were involved in working at an important court event. Gye 契 means gathering of like-minded people; byeong 屏 means screen painting.

gyedong daenaui
季冬大儺儀
exorcising ritual in the 12th lunar month (part of the military rites)

gyehwa (Ch. jiehua)
界畵
"ruled-line painting," category of painting characterized by a special technique for drawing architecture or large boats with detailed precision

gyeokseokchang
隔石窓
spacing stone openings in Joseon royal tombs

gyeoldae
結隊
forming units and ranks among the boats used to create King Jeongjo's pontoon bridge over the Han River

gyeong
磬
percussion instruments of jade or stone pieces hung on a two-tiered wooden frame to make music at court events

Gyeong i mulhwe
敬而勿毀
To Be Handled with Respect so as Not To Inflict Damage, title of an album of documentary paintings and calligraphy dating from the 15th to the 18th cent., produced in 1767

Gyeongbokgung
景福宮
Gyeongbok Palace, the main palace of the Joseon dynasty, built in 1394, and rebuilt in 1868 after complete destruction at the end of the 16th cent.

Gyeonggijeon
慶基殿
King Taejo's portrait hall in Jeonju, North Jeolla province, the place of origin of the royal Jeonju Yi family

Gyeongguk daejeon
經國大典
Grand Law Code for Managing the Nation, the law code for ruling Joseon; published in 1484 and based on the *Joseon gyeongguk jeon*. Cited as *Joseon Law Code* in this volume

Gyeonghuigung
慶熙宮
Gyeonghui Palace, one of the five royal palaces in Seoul, built in 1617, also known as the West Palace (*Seogwol* 西闕)

gyeongjamgwa
耕蠶科
state examination given during farming and sericulture rites

gyeongjikdo
耕織圖
farming and sericulture painting

Gyeongjong
景宗
(r. 1720–1724)
20th king of Joseon; ascended the throne at age 31 during intense factional struggles at court. In 1724, poor health forced him after only four years on the throne to abdicate in favor of his half-brother, Prince Yeoning, who ruled as King Yeonjo.

Gyeongnyonggwan
景龍館
Hall of the Great Dragon (i.e., king) within the Hwaseong Detached Palace

Gyeonu (Hegu)
牽牛 (河鼓)
herd boy in the legend with the weaving maiden (Jingnyeo); personification of the heavenly body, Dabih. In the legendary love story, the two heavenly bodies are seen coming closer together on the seventh day of the seventh lunar month across the galaxy.

gyeonyeo
肩輿
smaller royal coffin palanquin to be used on narrower and steeper roads on the way to burial at the royal tombs

gyeryeong
戒令
announcement of the rules for the state funeral

gyesa(jil)
啓辭(秩)
(collection of) letters by high officials to the king

gyoja
轎子
sedan chair

gyomyeong
教命
royal order of investiture for a queen, crown prince, crown princess, or royal high-level consorts

gyomyeongham
教命函
box containing the scroll of the royal order of investiture

gyoryonggi
交龍旗
large yellow flag with two dragons and flaming red borders symbolizing the king's authority, carried before the king's honor guards preceding the king's procession

gyoseo banpo
教書頒布
proclamation of royal message

gyu
圭
jade or ivory tablet with a flat top held by kings and queens on ceremonial occasions

Gyujanggak
奎章閣
See Kyujanggak

Gyujanggak jabidaeryeong hwawon
奎章閣差備待令畵員
painters-in-waiting at Kyujanggak

hae
海
sea

haebando dobyeong
海蟠桃圖屏
Sea and Peaches of Immortality screen

haeng (haenghaeng)
幸 (幸行)
kings' outings

haenggak
行閣
covered walkways

haenggung
幸宮
detached palace

haengyujang
行帷帳
white drapery enclosure used to hide the royal women wailing behind the royal coffin in funerary processions

hahyeongung
下玄宮
deposition of the royal coffin

hajeong
下碇
lowering the anchor cables

ham
含
filling a deceased king's mouth with rice and a pearl

hamayeon
下馬宴
banquet for Chinese envoys upon their arrival in Joseon Korea

hamgwe
函櫃
decorated wooden containers for ritual items

Han Hu-bang
韓後邦
(act. late 17th–early 18th cent.)
court painter under King Sukjong

Han Jong-il
韓宗一
(b. 1740)
court painter under King Yeongjo

Han Sa-geun
韓師瑾
(act. mid-18th cent.)
court painter under King Yeongjo

Han Seon-guk
韓善國
(b. 1602)
court painter under King Injo

Han Si-ung
韓時雄
(act. late 17th cent.)
court painter under King Hyeonjong

Hangang
漢江
the Han River, flowing past the capital of Seoul, fourth longest river on the Korean peninsula after the Amnok /Yalu, Tumen, and Nakdong rivers

Hanseong panyun
漢城判尹
mayor of Hanseong

Hanseongbu
漢城府
administrative office of Hanseong

Hanyang
漢陽
Joseon capital and present-day Seoul, also called Hanseong

Heo Dam
許㑦
(act. mid-18th cent.)
court painter under King Yeongjo

Heo Jap
許磼
(act. mid-18th cent.)
court painter under King Yeongjo

Heo Sik
許寔
(act. mid-18th cent.)
court painter under King Jeongjo

Heo Sun
許淳
(act. early 19th cent.)
court painter who worked on screen paintings in the 1819 royal wedding of Crown Prince Hyomyeong

Heo Un
許沄
(act. early 19th cent.)
court painter who worked on screen paintings in the 1819 royal wedding of Crown Prince Hyomyeong

heonga
軒架
wooden frame for hanging percussion instruments; music played by these instruments

Heonjong
憲宗
(r. 1834–1849)
24th king of Joseon; ascended the throne at age seven with his grandmother, Queen Sunwon, of the powerful Andong Kim clan, who served as regent and took orders from her male relatives. The child-king held no political power and died in 1849 at the age of 21.

heunganak
興安樂
"merry and peaceful music," music played while sending off ancestral spirits during the last stage of sacrificial rites at Jongmyo

Heungwang chaekbong uigwe
興王冊封儀軌
Uigwe of the Investiture of Heungwang, the eldest son of the regent Daewongun

ho
戶
(spirit of the) household, one of seven minor spirits (collectively known as the Seven Deities), whose rites took place in the Hall of Seven Rites situated to the west of the south gate of Jongmyo shrine

hoekja
獲者
arrow catcher at the royal archery rite

hoengpan
橫板
planks placed lengthwise on the boats being used for King Jeongjo's pontoon bridge

hojeon
戶典
taxation section of successive *Law Codes* of the Joseon

hojo dangsang
戶曹堂上
minister of revenue

hol
笏
jade scepter held by crown princes and high officials as an insignia of rank

hon
魂
yang spirit of the deceased

honbaek
魂帛
silk or ramie in which the deceased person's spirit is to be wrapped

honbaekgeo
魂帛車
large palanquin that carries the *honbaek* and the temporary mulberry-wood spirit tablet (*uju*) during a royal funeral procession

honbaengnyeon
魂帛輦
small palanquin carrying the cotton-wrapped spirit tablet in a royal funeral procession

Hong Byeong-hui
洪秉禧
(act. late 19th–early 20th cent.)
one of seven rank 6b painters (not royal portrait painters) of the Five Peaks screen, as cited in the 1902 royal portrait *uigwe*

Hong Dae-yong
洪大容
(1731–1783)
scholar of the School of Northern Learning under kings Yeongjo and Jeongjo. His collected writings, *Damheon seo* 湛軒書, include literary

and philosophical essays and his travel diary *Yeongi*, in which he reported the advanced Qing science and technology he saw in Yanjing.

Hong Gye-hui
洪啓禧
(1703–1771)
scholar-official under King Yeongjo; served as minister of defense in 1750, and minister of the interior in 1754

Hong Gyeong-min
洪敬民
(act. mid-17th cent.)
court painter recorded to have served in King Injo's funeral of 1649

Hong ssi (née Hong)
洪氏
a wife of a low-ranking official, invitee at the royal banquet of 1848

Hong Yang-ho
洪良浩
(1724–1802)
chief academician (*daejehak* 大提學) of the three offices of the government

hongcho
紅綃
thin red silk (cf. *hongju*)

Hongjae jeonseo
弘齋全書
Collected Writings of Hongjae (King Jeongjo)

hongjeonmun
紅箭門
"red arrow gate," constructed of two upright wooden posts and two transverse beams on which stand small pointed arrow-like pieces of wood (*sal, jeon*); painted with red lacquer, red being the color of warding off evil spirits. This gateway stands in front of a holy precinct, such as the area surrounding a royal tomb.

Hongjewon
洪濟院
establishment situated in today's Hongje-dong, in the western part of Seoul, for Chinese imperial envoys to change their outfits before going into the Mohwagwan Guesthouse (慕華館)

hongju
紅紬
thick red silk (cf. *hongcho*)

hongmun daegi
紅門大旗
"large flag of the red gate" showing a blue dragon on a red background; filled with cloud patterns of red, blue, and yellow; bordered by red flame shapes; and used only in large-scale royal processions. *Hongmun* is a contraction of *hongsal* and *mun*, a red gate that stands at the entrance of a royal tomb complex or any other sacred precinct.

hongung
魂宮
spirit tablet hall of royal family members other than kings and queens

honjeon
魂殿
spirit tablet hall in a royal palace, used to keep the spirit tablet of a king or queen until it is enshrined in Jongmyo shrine twenty-seven months after the funeral

Hou Jin (Kr. Hu Geum)
後金
Later Jin (1616–1636) dynasty established by the Jurchen leader Nurhaci, who in 1636 was declared emperor of the Qing dynasty

Huang Fengchi [Ch.]
黃鳳池
(act. 17th cent.)
editor of *Tangshi huapu*

Huang Yingtai [Ch.]
黃應泰
(1582–1662)
woodblock carver for the *Chengshi moyuan*

hubu gochwi (hu gochwi)
後部鼓吹 (後鼓吹)
"rear musical band," group of musicians that follows the royal palanquin in a procession

Huijeongdang
熙政堂
king's residential hall in Changdeok Palace

huisaeng chanpum
犧牲饌品
candles, meat, libation liquor, and other foodstuff presented at Jongmyo sacrificial rites

hujik
后稷
spirit of grain

hungseo
薨逝
death of a king

hwacho
花草
flowering plants

hwachobyeong
花草屏
screen of Flowers and Grasses, one of the subjects for screen painting that played an important role in the rites for royal ladies

hwachung
華蟲
pheasant, one of the nine emblems embroidered on the king's formal attire

Hwahongmun
華虹門
Gate of Beautiful Arches, another name for the north floodgate of Hwaseong Fortress, so called because of the seven arch-shaped sluices under the pavilion gate

hwain chukseong (Ch. huaren zhusheng)
華人祝聖
"the dweller of the Hua area congratulated the legendary Emperor Yao," phrase from the *Zhuangzi*, referring to a virtuous ruler

hwajo
花鳥
flowers-and-birds painting subject

Hwajurok
畫廚錄
Records of the Painting Cabinet by Yi Gyu-sang 李圭象 (1727–1799) in his collected writings, *Ilmong go* 一夢稿, Yi's critique on nineteen contemporary painters

hwamunseok
花紋席
woven flower-patterned *wanggol* floor mat

Hwang Ji-gon
黃之坤
(act. late 19th cent.)
rank 2b painter (but not a royal portrait painter) of the Five Peaks screen, as cited in the 1900 royal portrait *uigwe*

Hwang Su-gyeong
黃秀瓊
(act. early 19th cent.)
publisher of *Ijae nango* 頤齋亂稿, written by his grandfather, Hwang Yun-seok 黃胤錫

Hwang Yun-seok
黃胤錫
(1729–1791)
scholar who wrote the collected essays *Ijae yugo* 頤齋遺稿, published posthumously

Hwangudan
圜丘壇
circular mound altar to perform sacrificial rites to heaven

Hwanjo
桓祖
(1315–1361)
King Taejo's father; one of four generations of the founding king's ancestors

who were elevated post-humously to kingship and whose spirit tablets are enshrined in the Hall of Eternal Peace at Jongmyo shrine

Hwanyeongjeon
華寧殿
King Jeongjo's shrine in Hwaseong, built in 1801 near the Hwaseong Detached Palace

hwasa
畫師
painting master

Hwaseomun
華西門
west gate of Hwaseong Fortress

Hwaseong gijeokbi
華城紀蹟碑
stele memorializing the construction of the Hwaseong Fortress

Hwaseong wonhaeng dobyeong
華城園幸圖屛
eight-panel screen depicting King Jeongjo and his mother's 1795 trip to Prince Sado's tomb (Hyeollyungwon) in Hwaseong

Hwaseongdo (Hwaseong jeondo)
華城圖 (華城全圖)
painting titled *Complete View of Hwaseong*

hwawon
畫員
court painter(s)

hwiho
徽號
name of the four-character title of honor that com-pletes the title of a king on his spirit tablet

Hyangdaecheong
香大廳
building in which to prepare incense at Jongmyo shrine

hyangjeongja
香亭子
pavilion-shaped palan-quin carrying an incense burner

hyangnyongjeong
香龍亭
small pavilion-shaped palanquin that contains an incense burner and the king's eulogy

hyangsaui
鄉射儀
archery rite in local administrative centers

Hyegyeonggung Hong ssi
惠慶宮洪氏
(1735–1815)
Lady Hyegyeong (née Hong), wife of Crown Prince Sado and mother of King Jeongjo

Hyeollyungwon
顯隆園
"Brightly Rising Tomb," the tomb of Prince Sado in Hwaseong, relocated there by King Jeongjo

Hyeon Jae-hang
玄載恒
(act. mid-18th cent.)
court painter under King Yeongjo

hyeongjeon/pojeok
刑典/捕賊
section on punishment in the *Daejeon hoetong* (*Comprehensive Collection of National Codes*) of 1865

Hyeonjong
顯宗
(r. 1659–1674)
18th king of Joseon; his reign oversaw Korea's recovery from the Manchu invasions and peace with Qing China, but was marred by political factionalism, particularly over funeral rites. In 1666, the Dutchman Henrick Hamel, who had been shipwrecked off Korea, returned home after 13 years in captivity and introduced the "hermit nation" to Europeans.

hyeonson
玄孫
great-great-grandson

hyeoppok
挾幅
pair of narrow-panel Five Peaks screens placed on either side of a six- or eight-panel folding Five Peaks screen inside the royal portrait niche

Hyohyeon wanghu (née Kim)
孝顯后 (金氏)
(1828–1843)
Queen Hyohyeon, queen of King Heonjong

Hyojang seja
孝章世子
(1719–1728)
Yeongjo's first son (Gyeonguigun 敬義君), also known as Yi Haeng 李緈 and Crown Prince Hyojang; posthumously elevated to King Jinjong 眞宗 when King Jeongjo (son of Crown Prince Sado) assumed the throne. Earlier, the future King Jeongjo, while still a child, was adopted as Hyojang's son to make the Yi family royal succession appear legitimate.

Hyomyeong seja
孝明世子
(1809–1830)
Crown Prince Hyomyeong, first son of King Sunjo, father of King Heonjong; posthumously elevated to King Ikjong/Munjo; talented writer and court music composer and choreographer; died at age 21

hyungnye
凶禮
royal funeral and related rites, the fifth of the Five Rites of State

hyunguijang
凶儀仗
ritual flags and weapons for royal funeral processions

Ibang (uigwe)
二房 (儀軌)
uigwe of the second subunit within a super-intendency (*dogam*)

idu
吏讀
writing system devised during the 7th cent. in which Chinese characters were borrowed to record the sound or meaning of Korean words, e.g., 乙良 (that is), 段 (is), 節 (posi-tion, now, this time)

ieo
移御
moving of a king's residence

igaeng
二羹
two kinds of soup offered at a Jongmyo sacrificial rite

ihwanan
移還安
rites for removing and returning spirit tablets from Jongmyo shrine for various reasons

Ihyang gyeonmullok
里鄉見聞錄
Experiences in the Villages and Countryside (1862) by Yu Jae-geon 劉在建 (1793–1880), a collection of biographies of 308 individuals, mostly of the so-called class of "middle people" who were in the middle stratum of society, below the *yangban* class but above the *yangmin* class; includes many professional painters, doctors, and other skilled technicians

ije
二齊
two kinds of wine brewed with well-measured amounts of water and fire

Ikjo
翼祖
(r. 1300–?)
King Taejo's great-grandfather; one of four generations of the founding king's ancestors who were elevated posthumously to kingship and whose spirit tablets are enshrined in the Hall of Eternal Peace at Jongmyo shrine

Ilbang (uigwe)
一房 (儀軌)
uigwe of the first subunit within a superintendency (*dogam*)

illoin
引路人
ushers

ilmu
佾舞
line dance, a classical Chinese dance that existed as early as the time of Confucius and was performed only at the time of ritual sacrifices to heaven (Ch. *ji tian* 祭天) and at the royal ancestral shrine Jongmyo

Im U-chun
林遇春
(act. ca. late 18th–early 19th cent.)
artisan specializing in constructing screens for paintings (*byeongpungjang*)

imheon chogye
臨軒醮戒
ceremony on the wedding day of a crown prince, performed before he goes to meet the bride. He had to appear before his father, the king, and officials of the court in front of the throne hall of the palace to receive his father's royal order: "Go and meet the bride and order her to inherit the affairs of the royal ancestral shrine and manage the subordinates with authority."

imun
移文
documents sent to and received from local offices of the same governmental level

inchal hwawon
印札畫員
court painters who drew the red margins and vertical lines of the pages of the royal viewing copies of *uigwe* books

ingeogun
引鋸軍
sawyers

ingwi
人鬼
human spirits/ancestral spirits

Injo
仁祖
(r. 1623–1649)
16th king of Joseon; ruled during the Manchu invasions of Korea in 1627 and 1636–1637

Injo banjeong
仁祖反正
King Injo's Restoration of Rectitude, 1623

Injo heonmun yeolmu myeongsuk sunhyo daewang
仁祖憲文烈武明肅純孝大王
King Injo's shrine title (*myoho*) of twelve characters on the first page of the *uigwe* of his funeral

Injong
仁宗
(r. 1544–1545)
12th king of Joseon; ascended the throne at age 29 but ruled for only nine months due to an untimely and somewhat suspicious death

inma
印馬
seal horse, a horse carrying the king's seal in a royal procession

Inpyeong daegun
麟坪大君
(1622–1658)
Prince Inpyeong, third son of King Injo, diplomat, literati painter, and calligrapher

Inwon wanghu (née Kim)
仁元王后 (金氏)
(1687–1757)
Queen Inwon, second queen of King Sukjong

ipo
二脯
two kinds of dried meat

Irae
一愛
given name of one of four seamstresses appearing on the list of artisans in the 1759 wedding *uigwe*

irwol obongbyeong
日月五峯屏
Sun, Moon, and Five Peaks screen(s)

irwolgyeong
日月鏡
sun and moon mirror

jaegye
齋戒
purification and ablution performed before participating in ancestral rites

Jaesil
齋室
building in which to prepare for a ceremony at Jongmyo shrine

jaeyong
財用
finance and expenditure

Jagyeongjeon
慈慶殿
dowager queen's quarters in the Changgyeong Palace; dowager queen's quarters in the Gyeongbok Palace

jakheollye
酌獻禮
libation rite

jammulsaek
雜物色
unit that prepares snacks for Chinese envoys

Jang Byeok-man
張璧萬
(act. mid-18th cent.)
court painter under King Yeongjo; served in his 1759 wedding rite

Jang Deuk-man
張得萬
(1684–1764)
court painter under King Yeongjo

Jang Gyeong-ju
張敬周
(b. 1710)
court painter, son of court painter Jang Deuk-man, who served as the master painter in the copying of King Sukjong's portrait in 1748

Jang Han-jong
張漢宗
(1758–1815)
court painter under King Jeongjo, painter of fish and shellfish *chaekgado* (bookcase painting)

Jang Huibin *or*
Huibin Jang ssi (née Jang)
張禧嬪
consort of King Sukjong

Jang Ja-jing
張子澄
(act. mid-18th cent.)
court painter under King Yeongjo, served in his 1759 wedding rite

Jang Ja-uk
張子旭
(act. mid-17th cent.)
court painter under King Sukjong, participated as assistant painter in the copying of King Taejo's portrait in 1688

Janganmun
長安門
north gate of Hwaseong Fortress

jangchukja
掌畜者
bearer of the live goose at
a royal wedding, who goes
on horseback ahead of the
groom's palanquin and
hands the bird over to the
groom upon his arrival

janggang
長杠
long parallel bars on the
sides of a palanquin

janggye
藏械
to store boat parts such
as the railing posts for
boats used to form King
Jeongjo's pontoon bridge
over the Han River

janggye(jil)
狀啓(秩)
(collection of) written
reports to the king from
officials posted outside
the capital

janghwangin
粧潢人
mounters of scrolls and
screen paintings

jangjong sugyeonui
藏種收繭儀
rites of royal gathering
of seeds and silk cocoons
after the royal rites
of agriculture and
sericulture

Jangnakdang
長樂堂
Hall of Lasting Pleasure
within Hwaseong
Detached Palace

Jangnyeol wanghu (née Jo)
莊烈王后 (趙氏)
(1624–1688)
Queen Jangnyeol, second
queen of King Injo

Jangseogak
藏書閣
library built in 1915 in
Changgyeong Palace
to house the Joseon
dynasty's books and
documents; contents
now housed in a building
of the same name built
in 2011 on the campus of
the Academy of Korean
Studies

Jangyongyeong
壯勇營
military organization
that grew out of the
Jangyongwi (壯勇衛),
established in 1784 by
King Jeongjo as a military
unit for the protection of
the king

japji
雜志
miscellaneous records

jasuanma
紫繡鞍馬
horse with purple
embroidered saddle
in a royal funeral

jehyang
祭享
sacrificial offering

**jehyangsi jingong
gaksa mulmok**
祭享時進供各司物目
list of items required for
a Jongmyo sacrificial rite
and prepared by relevant
government offices

jeju
題主
inscribing titles on
a spirit tablet

jemul chaeyeo
祭物綵轝
plain silk palanquins
carrying offerings at
a memorial service

jemul chaeyeo chilsibobu
祭物彩轝七十五部
seventy-five plain silk
palanquins carrying
offerings to the
memorial service

jemul ipseong gaja yukbu
祭物入盛架子六部
six large wooden
stretchers with handles
to carry food offerings

jeogui
翟依
"pheasant robe," the
queen's most formal
attire; a blue silk gown
embroidered with
pheasants

jeokdae
敵臺
enemy-watching [tower]
platform

jeokjeon
籍田
state-designated field
for performing royal
farming rites

jeon
箭
arrow

jeon
奠
setting up the offering
table for a funeral

jeonak
典樂
conductor of music

jeonallye
奠雁禮
rite of presenting the
goose to the bride

jeonansang
奠雁床
table on which to place
the goose (in the rite of
presenting the goose to
the bride)

**jeonbu gochwi
(jeon gochwi)**
前部鼓吹 (前鼓吹)
"front musical band,"
group of musicians that
precedes the royal palan-
quin in a procession

Jeong Cheok
鄭陟
(1390–1475)
scholar-official under King
Seongjong, one of the
compilers of the *Five Rites
of State*

Jeong Deok-hong
鄭德弘
(act. mid-18th cent.)
court painter under
King Yeongjo, served in
his 1759 wedding rite

Jeong Do-jeon
鄭道傳
(1342–1398)
high official under King
Taejo, compiler of *Joseon
gyeongguk jeon* 朝鮮經國典
(Joseon Law Code for
Managing the Nation)

Jeong Mong-ju
鄭夢周
(1337–1392)
scholar-official and patriot
of the late Goryeo period
who was assassinated by
Yi Bang-won (later King
Taejong)

Jeong Seon
鄭敾
(1676–1759)
famous true-view land-
scape painter of the late
Joseon period

Jeong Yak-yong
丁若鏞
(1762–1836)
famous scholar of the
School of Practical
Learning under King
Jeongjo who submitted
the "Fortress Construction
Plan" (*Seongseol* 城說) for
Hwaseong, and devised
machinery that facilitated
its construction

Jeong Yeop
鄭曄
(1563–1625)
scholar-official, vice-
minister of rites under
Gwanghaegun

Jeongbin Yi *or*
Jeongbin Yi ssi (née Yi)
靖嬪李氏
(1693–1721)
consort of King Yeongjo,
mother of Crown Prince
Hyojang

jeongbuin
貞夫人
honorific title for
spouses of ministerial-
level officials

Jeongdaeeop
定大業
"Establishing the Great Task," ritual music praising the founding and strengthening of the Joseon dynasty by early Joseon kings and their subjects

jeonggyeong buin
貞敬夫人
honorific title for the spouse of a prime minister

Jeonghae jinchan dobyeong
丁亥進饌圖屛
screen painting titled *Palace Banquet of the Jeonghae Year*

jeongjaedo
呈才圖
painting of "presented performances" at a royal banquet

jeongjagak
丁字閣
T-shaped building in front of a royal tomb

jeongjeon
正殿
main shrine at Jongmyo

Jeongjo
正祖
(r. 1776–1800)
22nd king of Joseon; benevolent reformer and champion of new ideas and innovations from Qing China and, via China, the West into Korea; builder of the Hwaseong Fortress, UNESCO World Heritage Site in Suwon, Gyeonggi province

Jeongjong
定宗
(r. 1398–1400)
2nd king of Joseon, who until 1687 was known as Gongjeong daewang 恭靖大王. He was forced by his cunning and ambitious younger brother, Taejong, to abdicate after ruling for only two years. The succession struggle among the many sons of Taejo for the throne is known in Korean history as the "Rebellion of the Princes" (Wangja ui nan 王子의亂).

jeongmyo
精妙
"grasp of fine details" (in royal portrait)

Jeongmyo horan
丁卯胡亂
Manchu invasions of 1627

jeongnija
整理字
movable metal type made of bronze developed in the Jeongniso under the order of King Jeongjo. *Wonhaeng eulmyo jeongni uigwe*, the first printed *uigwe*, used this type in 1797.

Jeongniso
整理所
"Arrangement Office," a temporary office to oversee the preparation and arrangements for the king, such as kings' outings

Jeongseong wanghu (née Seo)
貞聖王后 (徐氏)
(1692–1757)
Queen Jeongseong, first queen of King Yeongjo

Jeongsun wanghu (née Kim)
貞純王后 (金氏)
(1745–1805)
Queen Jeongsun, second queen of King Yeongjo

jeongu
丁憂
period of mourning

Jeongui jangmok Inwon Wanghu jibo
定懿章穆仁元王后之寶
"seal of Queen Inwon, [who was] benevolent, righteous, and virtuous"

jeongyeon
正輦
royal palanquin

jeonnae baeseol
殿內排設
"placement of objects in the interior of the banquet hall," a section of *uigwe* devoted to where ceremonial items and seating for people should be placed in banquet venues

jeonpye
奠幣
presenting gifts to the deceased king during a royal funeral

jeonsacheong
典祀廳
residential quarters in the Jongmyo shrine compound

jeonsin
傳神
successful transmission of the subject's spirit

jeonyeon
餞宴
farewell banquet

jesa
祭祀
generic term for all levels and sizes of sacrificial offerings

jesaek janginjil
諸色匠人秩
section in *uigwe* devoted to "list of artisans of various trades"

Ji
祇
(1598–1623)
first son of Gwanghaegun

Ji Tae-won
池泰元
(act. late 19th–early 20th cent.)
rank-6 painter (not a royal portrait painter) of the *banchado* for the 1900 royal portrait *uigwe*

jigi
地祇
spirit of earth

jik
稷
spirit of grain

jikji insim gyeonseong seongbul
直指人心見性成佛
"If one looks directly into the mind of a sentient being, one will realize that human nature is no different from that of the Buddha."

Jikji simche yojeol
直指心體要節
earliest Korean text printed with movable metal type, printed in 1377 at Heungdeoksa temple 興德寺, Cheongju 清州, North Chungcheong province; two-volume compilation by Baegun 白雲 (1299–1374) of selections from the Buddha's sayings and eminent priests' writings before Baegun's time. The title comes from the phrase "*jikji insim gyeonseong seongbul*" (*Jikji* for short).

Jin Jae-hae
秦再奚
(1691–1769)
court painter under kings Sukjong and Yeongjo; served as the master painter in 1713 for Sukjong portraits; also good at painting landscapes

jin mohyeolban (gallyo deung)
進毛血盤 (肝脅甂)
purifying ritual at a Jongmyo sacrificial rite

jinchan
進饌
"presentation of food" at a court banquet

Jingnyeo
織女
weaving maiden in the legend with the herd boy (Gyeonu); personification of the heavenly body Vega. In the legendary love story, the two heavenly bodies are seen coming closer together on the seventh day of the seventh lunar month across the galaxy

jinha
進賀
congratulatory ceremony

jinibujak
陳而不作
"presented but did not play" custom of Joseon court ritual music at solemn events

jinjeon
眞殿
royal portrait hall

**Jinssi akseo
(Ch. Chenshi yueshu)**
陳氏樂書
book on classical ritual music of China written by Chen Yang 陳暘 (1064–1128) of the Song dynasty

Jinyeon docheop
進宴圖帖
Album of Paintings Celebrating King Sukjong's Thirtieth Anniversary of Ascension to the Throne in 1706

jinyong
眞容
"lifelike image" (referring to royal portrait)

Jipgyeongjeon
集慶殿
royal portrait hall in Gyeongju, the capital of the Silla dynasty, built at the beginning of the Joseon dynasty to enshrine King Taejo's portrait

jipsa
執事
master of ceremony, or officiant at rituals

jirochi
指路赤
soldiers, or ushers, leading the way in a royal procession

jiui
地衣
floor coverings

jo
竈
kitchen and hearth, one of seven minor spirits (collectively known as the Seven Deities), whose rites took place in the Hall of Seven Rites situated to the west of the south gate of Jongmyo shrine

jo
藻
seaweed, one of the nine emblems embroidered on the king's formal attire

Jo Daebi
趙大妃
See Sinjeong

Jo Hak-sin
曺學臣
(act. late 18th cent.) worker who was granted amnesty for crimes committed earlier in lieu of material award after the completion of the Hwaseong Fortress

Jo In-hui
趙仁熙
(act. late 19th–early 20th cent.) one of eight rank-6 court painters who painted a Five Peaks screen mounted on a stand, as cited in the 1901 event of the copying of seven royal portraits

Jo Ja-yong
趙子庸
(1926–2000) founder of the first private museum specializing in Korean folk art, the Emile Museum, in Seoul in 1967. In 1983 the museum moved to Boeun, South Chungcheong province.

Jo Ji-un
趙之耘
(b. 1637) scholar-painter who served as supervisor in the 1688 rites of the copying of King Taejo's portrait

Jo Jung-muk
趙重默
(act. mid- to late 19th cent.) court painter who participated in the copying of royal portraits several times during the 19th cent.

Jo Man-yeong
趙萬永
(1776–1846) powerful official and father of Dowager Queen Sinjeong, member of the Pungyang Jo clan

Jo Myeong-jun
趙命峻
(act. 19th cent.) scribe granted a change of status for service in the court banquet of 1868

Jo Se-geol
趙世傑
(1636–after 1705) court painter under King Sukjong, participated in the copying of royal portraits in 1688 and 1695

Jo Seok-jin
趙錫晋
(1853–1920) one of the last Joseon court painters, famous for figure painting; participated in painting the portraits of Emperor Gojong and Crown Prince Cheok (later Emperor Sunjong) in 1901–2

Jo Seong-myeong
趙成明
(act. 2nd half of 17th cent.) court painter

Jo Sim-tae
趙心泰
(1740–1799) chief of the Yusubu 留守府 office of Suwon during the construction of the Hwaseong Fortress

Jo ssi (née Jo)
趙氏
family surname of the wife of a ministerial-level official

Jo Yeong-bok
趙榮福
(1672–1728) scholar-official and elder brother of Jo Yeong-seok, who painted his portrait

Jo Yeong-seok
趙榮祏
(1686–1761) well-known scholar-painter of landscapes, genre painting, and portraiture

jobi
措備
plan and preparation

jobok
朝服
formal court attire of high officials

jocheon
祧遷
transferring the royal spirit tablet four generations after a king's death from the Main Hall to the Hall of Eternal Peace at Jongmyo shrine

johyeollye
朝見禮
rite of paying respect by the newlywed royal bride(s) to the queen dowager(s) at the end of a royal wedding ceremony

joju
造主
crafting a spirit tablet

jokbo
族譜
Joseon-period family genealogy books

jongheonrye
終獻禮
final offering of libation at the Jongmyo sacrificial rites

jongi
宗彝
two vessels used for ancestral rituals; one of the twelve emblems on a Chinese emperor's robe

Jongmyo

宗廟

royal ancestral shrine of the Joseon dynasty, first built in 1394 on the east side of Gyeongbok Palace. The Jeongjeon (Main Hall) measures 101 meters wide and is one of the largest wooden buildings in the world.

Jongmyo daedeungnok

宗廟大謄錄

Great Records of the Jongmyo Shrine, records on matters of the Jongmyo shrine that existed before the first compilation of *Jongmyo uigwe* in 1706

Jongmyo deungnok

宗廟謄錄

Records of the Jongmyo Shrine, measuring 85.8 cm in height; the largest of all Joseon dynasty books

Jongmyo jerye

宗廟祭禮

sacrificial rites at Jongmyo shrine

Jongmyo jeryeak

宗廟祭禮樂

music played at the Jongmyo sacrificial rites

Jongmyoseo

宗廟署

Jongmyo Office

jongnyang

縱樑

wooden beams placed across boats when creating a pontoon bridge

jongwon myeoncheon

從願免賤

"according to one's wish, be [forever] relieved of lowborn status"

jonhochaek

尊號冊

jade book inscribed with elevated titles

joseo

詔書

Chinese emperor's imperial decree or letter of admonition

Ju Yun-chang

朱潤昌

(act. late 19th–early 20th cent.)
one of eight rank-6 painters (not royal portrait painters), as cited in the *uigwe* report on the 1901 event of the copying of seven kings' portraits

jubu

主簿

rank-6 official who managed documents in various offices of the Joseon government

jucheok

周尺

Zhou dynasty unit of measure (20.8 cm)

juganma

竹鞍馬

horse effigies made of bamboo with saddles and set on four wheels; used in royal funeral processions

jugap

周甲

age of 60, same as *hoegap* 回甲; one complete cycle [of 60 years] on the cyclical calendar used in East Asia

jugwan hwasa

主關畫師

master painter of a royal portrait

jugyo

舟橋

pontoon bridge

jugyoan

舟橋案

list of boats mobilized for forming into a rainbow-shaped pontoon bridge over the Han River

juje

主制

spirit tablet systems

jukchaek

竹冊

bamboo book inscribed with the king's words of appointment

juksanma

竹散馬

horse effigies made of bamboo without saddles and set on four wheels; used in royal funeral processions

junggeon

重建

rebuilding

jungin

中人

"middle people," including painters, scribes, and professionals such as translators, meteorologists, geomancers, medical doctors, etc., who are essential in the running of court affairs (not to be confused with the "middle class" in modern times)

jungnyu

中霤

interior of a house, one of seven minor spirits (collectively known as the Seven Deities), whose rites took place in the Hall of Seven Rites situated to the west of the south gate of Jongmyo shrine

jungnyung

中隆

gradual incline toward the middle and decline toward each end of the rainbow-shaped pontoon bridge over the Han River, created by placing the highest boat in the middle of the formation

jungsa

中祀

secondary sacrifices, mostly to spirits of nature, such as wind, clouds, rain, thunder, and so forth

junhwa

樽花

artificial flowers and birds arranged in a large blue-and-white ceramic jar

Junwonjeon

濬源殿

royal portrait hall built at the beginning of Joseon to enshrine King Taejo's portrait, located in Yeongheung, Hamgyeong province, the birthplace of Taejo

juryeom

珠簾

blinds woven with strings of beads

jwamok

座目

list of personnel serving in a superintendency

jwamyo usa

(Ch. zuomiao youshe)

左廟右社

"Ancestral Shrine to the left, Platforms for the Spirits of Earth and Grain to the right" [of the main palace], from the *Zhouli*

Kim Bo-yeong

金輔榮

(act. late 19th–early 20th cent.)
rank 3b court painter who painted a Five Peaks screen, as cited in the *uigwe* report on the 1901 event of the copying of seven kings' portraits

Kim Cheo-han

金處漢

(act. late 18th cent.)
worker who was granted amnesty for crimes committed earlier in lieu of material award after the completion of the Hwaseong Fortress

Kim Dae-yeong

金大榮

(act. late 19th cent.)
court painter who participated in the painting of the *banchado* of the *uigwe* report on the 1901 event of the copying of seven kings' portraits

Kim Deok-ha
金德夏
(1722–1772)
court painter under
King Yeongjo, son of
Kim Du-ryang; collab-
orated with his father
to paint a set of two
handscrolls depicting
the activities of the
four seasons

Kim Deok-seong
金德成
(1727–1797)
court painter of Buddhist
deities

Kim Deuk-sin
金得臣
(1754–1822)
court painter, well known
for genre painting

Kim Du-ryang
金斗樑
(1696–1763)
King Yeongjo's favorite
court painter who painted
a set of two handscrolls
depicting the activities of
the four seasons

Kim Eop-su
金業守
(b. 1543)
court painter under
Gwanghaegun

Kim Eung-ho
金應豪
(act. early 17th cent.)
court painter under
Gwanghaegun

Kim Eung-hwan
金應煥
(1742–1789)
court painter under kings
Yeongjo and Jeongjo;
famous for true-view
landscape painting

Kim Eung-su
金膺洙
(act. late 19th–early
20th cent.)
court painter who partici-
pated in the painting of
the *banchado* of the *uigwe*
report on the 1901 event
of the copying of seven
kings' portraits

Kim Gan (Ch. Jin Jian)
金簡
(d. 1794)
a man of Korean descent
whose ancestors were
taken to China during
the two Manchu inva-
sions (1627, 1636–1637).
He served as the vice
superintendent in the
special office in charge
of the production of the
Qing collectanea, the *Siku
quanshu* 四庫全書.

Kim Gyeong-sik
金慶植
(act. late 19th–early
20th cent.)
court painter (rank 6) who
painted a space divider
screen of plum blossoms,
as cited in the 1901 *uigwe*
of the copying of seven
royal portraits

Kim Han-gu
金漢耇
(1723–1769)
scholar-official under
King Yeongjo, father of
Yeongjo's second queen,
Jeongsun (1745–1805);
posthumously bestowed
the title of prime minister

Kim Hong-do
金弘道
(1745–1806)
court painter under kings
Yeongjo and Jeongjo;
famous for genre painting
and true-view landscapes,
as well as Buddhist and
Daoist figure paintings

Kim In-mo
金寅模
(act. late 19th–early
20th cent.)
rank-9 painter (but not a
royal portrait painter) of a
Five Peaks screen, as cited
in the 1901 *uigwe* of the
copying of seven kings'
portraits

Kim Je-sun
金濟淳
(act. late 19th–early
20th cent.)
one of the nine rank-6
painters (but not a royal
portrait painter) of a Five
Peaks screen, as cited in
the 1900 royal portrait
uigwe

Kim Jeong-ho
金正浩
(d. 1866)
late Joseon period geog-
rapher and cartographer
famous for the woodblock
map of Seoul, *Suseon
jeondo* (1840), and the map
of the entire peninsula
called *Daedongyeo jido*
大東輿地圖

Kim Jin-gyu
金鎮圭
(1658–1716)
scholar-official under
King Sukjong

Kim Jo-sun
金祖淳
(1765–1832)
father-in-law of King
Sunjo and member of the
powerful Andong Kim
clan

Kim Jong-guk
金鍾國
(act. late 19th–early
20th cent.)
Late Joseon court painter
who painted a Five Peaks
screen in 1900

Kim Jong-su
金鍾秀
(1728–1799)
chief academician and
minister of the right

Kim Myeong-guk
金明國
(b. 1600)
court painter famous for
landscapes and figures,
including Zen figure
painting

Kim Sam-bo
金三保
father of Kim Gan
(Jin Jian; b. 1794)

Kim Sang-myeong
金尙明
grandfather of Kim Gan
(Jin Jian; b. 1794)

Kim Sin-ho
金信豪
(act. early 17th cent.)
court painter under
Gwanghaegun

Kim Su-heung
金壽興
(1626–1690)
high official of the Joseon
period, served as prime
minister under King
Hyeonjong

Kim U-hang
金宇杭
(1649–1723)
scholar-official under
King Sukjong, one of the
compilers of the *Jongmyo
uigwe* 宗廟儀軌

Kim Yak-ro (Kim Yang-ro)
金若魯 (金良老)
(1694–1753)
head of the superinten-
dency; served as both the
minister of the left and
the minister of the privy
council

Kunaichō [Jpn.]
(Kr. Gungnaecheong)
宮內廳
Office of the Imperial
Household Affairs, Tokyo

Kyujanggak (Gyujanggak)
奎章閣
Royal Library in Chang-
deok Palace; office estab-
lished within Changdeok
Palace in 1776 in the
two-story pavilion called
Juhamnu 宙合樓 by King
Jeongjo as a place for
policy studies by young
scholar-officials, and to
store writings and calli-
graphy of successive kings.
Gradually, it also came
to function as the royal
library for storing massive
collections of Chinese
books, *uigwe* books, and
other documents, which
are now kept in the
Kyujanggak Institute for
Korean Studies, Seoul
National University.

Lang Shining [Ch.]
郎世宁
(1688–1766)
Chinese name of the Italian Jesuit painter Giuseppe Castiglione, who worked at the Qing court

Li Bo (Li Bai) [Ch.]
李白
(701–762)
famous Tang dynasty poet

Li Gonglin [Ch.]
李公麟
(1049–1106)
Northern Song literati painter in the circle of Su Shi (蘇軾); excelled in *baimiao* 白描 style figure painting

Liu Yong [Ch.]
劉用
(act. early 17th cent.) eunuch of the late Ming dynasty who came as a Ming imperial envoy to Joseon in 1608 to approve the investiture of Gwanghaegun; had the title *Saryegam taegam* 司禮監太監, chief of the Directorate for Ceremonial

Luo Zhichuan [Ch.]
羅稚川
(1265–1340)
Yuan dynasty painter of landscapes in the Li-Guo style

Ma Hezhi [Ch.]
馬和之
(act. ca. 1130–ca. 1170) Southern Song academy painter under Emperor Gaozong (r. 1127–1162)

mabo
馬步
celestial star of the spirit governing the horse harmer

maedeupjang
每絹匠
artisan specializing in weaving tassels

maehwabyeong
梅花屏
screen of plum blossoms

Maeng Sa-seong
孟思誠
(1360–1438)
high-ranking official under King Sejong; served as minister of rites (1416) and minister of the right (1427)

magyeongjang
磨鏡匠
artisan specializing in polishing bronze mirrors

maje
禡祭
sacrificial rite to spirits of the military

majo
馬祖
celestial star of the spirit governing horses

Mallyeok samsippalnyeon samwol chochiril pilseongjeok
萬曆三十八年三月初七日畢成籍
date that the earliest extant *billye uigwe* was completed (1610)

manggwol haengnye
望闕行禮
one of the rites in the category of *garye* 嘉禮, "paying respect toward the [Chinese imperial] palace," in which Joseon kings, crown princes, and high officials would bow toward the direction of Beijing, the capital city, on New Year's morning, winter solstice, and the birthday of the reigning emperor

mangnyo
望燎
burning (instead of burying) of the offered food (*seojikban* 黍稷飯 cooked millet), the text of the memorial address, and the white silk cloth that was presented to the spirits at Jongmyo sacrificial rites. In 1770, King Yeongjo, having surveyed the Chinese book *Daming jili* 大明集禮, decided to follow this Chinese practice.

mango
望五
"looking up to the age of 50" (i.e., now 41 years old)

mangpal
望八
"looking up to the age of 80" (i.e., now 71 years old)

mangye
望瘞
burying of the offered food (*seojikban* 黍稷飯 [cooked millet]), the text of the memorial address, and the white silk cloth that had been presented to the spirits at Jongmyo sacrificial rites

Mangyeongjeon igil hoejakdo
萬慶殿翌日會酌圖
painting titled *Smaller-Scale Banquet of Presenting Wine Cups on the Second Day at Mangyeongjeon*, produced in 1887

Mangyeongjeon jaeigil hoejakdo
萬慶殿再翌日會酌圖
painting titled *Smaller-Scale Banquet of Presenting Wine Cups on the Third Day at Mangyeongjeon*, produced in 1887

Mangyeongjeon jinchando
萬慶殿進饌圖
painting titled *Banquet at Mangyeongjeon*, produced in 1887 for Dowager Queen Sinjeong

manjang
輓章
funeral eulogies written on white paper or silk streamer and held up in a funeral procession

**Mansanghol
(Ch. Manchuang hu)**
滿床笏
A Table Full of Scepters, title of a Chinese New Year's painting showing Guo [Ziyi] Fenyang and his wife being presented with the scepters (insignias of office) earned by their sons and sons-in-law, a symbol of the happy and well-lived life

Manseokgeo
萬石渠
reservoir for watering a rice field large enough to produce 10,000 *seok* of rice (1 *seok* equals 144 kg), located in Hwaseong

masa
馬社
spirit of the first horse rider, also name of the place for offering sacrifices to it

mihu
麋候
head of a deer, officials' target in a royal archery rite

mimyeonsaek
米麵色
main meal preparation unit for Chinese envoys

Min ssi (née Min)
閔氏
family surname of a female royal relative

minhwa
民畫
folk painting

Mohwagwan
慕華館
"Hall of Revering China," guesthouse for Chinese envoys located in the western section of present-day Seoul

mohyeolban
毛血槃
small tray of the fur and blood of sacrificial animals used at Jongmyo sacrificial rites

Mokcheongjeon
穆清殿
royal portrait hall built in Gaeseong, the capital of the Goryeo dynasty, at the beginning of Joseon to enshrine King Taejo's portrait; now in Unhagi-dong, Gaeseong, North Hwanghae province

Mokjo
穆祖
(d. 1274)
King Taejo's great-great-grandfather; one of four generations of the founding king's ancestors who were elevated post-humously to kingship and whose spirit tablets are enshrined in the Hall of Eternal Peace at Jongmyo shrine

monggeumcheok
夢金尺
dance performance celebrating King Taejo's dream in which he received a golden ruler from a divine spirit who told him to rule the country with it

moranbyeong
牡丹屏
screen of peonies

Mui gugok
武夷九曲
Nine-Bend [Stream] of Wuyi shan 武夷山, Fujian province, China; Zhu Xi's place of retirement

munbanchado
文班次圖
"written" *banchado* or diagram showing the placement of participants in a court event by their official title/rank order written with *hanja* characters, usually inside cartouches

munbang dobyeong
文房圖屏
screen painting of a book-case showing books and scholar's paraphernalia

**Munheon tonggo
(Ch. Wenxian tongkao)**
文獻通考
(preface dated 1317)
Chinese book on political systems and culture compiled by Ma Duanlin [Ch. 馬端臨] of the Yuan dynasty

Munjeongjeon
文政殿
building located in Changgyeong Palace used as the living quarters of crown princes

munjip
文集
collected writings

Munmyo
文廟
Shrine of Confucius, abbreviation of Munseongwangmyo

Munseonwang
文宣王
Confucius

Munseonwangmyo
文宣王廟
Shrine of Confucius in Hwaseong

Munsojeon
文昭殿
royal portrait hall in Gyeongbok Palace that enshrined King Taejo's portrait at the beginning of the Joseon dynasty

museonhyang
舞仙香
court dance performed on an oblong raised podium covered with leopard skin

myeon
冕
king's formal headgear with nine strands of beads in the front and the back

myeongbok
命服
generic term for costumes of officials; formal costumes for royal brides or crown princes

myeonggi
明器
generic term for burial goods

myeongjeong
銘旌
funerary banner of red silk on which is written a detailed identification of the deceased. It is positioned in front of the coffin palanquin in a funeral procession, put on top of the coffin, and buried with it.

myeongjeonggi
銘旌機
stand for the red funeral banner (*myeongjeong*)

Myeongjong
明宗
(r. 1545–1567)
13th king of Joseon. When King Injong died, his third consort, Dowager Queen Munjeong, put her 12-year-old son, Injong's half-brother, on the throne as King Myeongjong. The dowager queen ruled as the power behind the throne during a time of intense factional politics

until her death in 1565. Upon his mother's death, Myeongjong tried to undo the damage caused by the court's warring factions but died two years later.

Myeongju
明珠
name of singer granted a change of social status after serving in the court banquet of 1868

**Myeongmyojo
Seochongdae siyedo**
明廟朝瑞蔥臺試藝圖
"Martial Arts Performance at Seochongdae Terrace," title of an album leaf depicting an archery event at Changdeok Palace in 1560 under King Myeongjong

Myeongnyundang
明倫堂
Hall of Bright Ethics, lecture hall at Seong-gyungwan National College in Hanyang

myeongsan daecheon
名山大川
[spirits of] great mountains and rivers

myoho
廟號
shrine title of a king by which he is known in history, i.e., Taejo, Sejong, etc.

myohyeon
廟見
reporting court events such as a royal wedding to the royal ancestors at Jongmyo shrine

myoje
廟制
Jongmyo shrine systems

naegwan
來關
internal documents from higher or equal-level offices within government

naeip
內入
screen paintings or newly produced *uigwe* books to be presented to the palace

Nakdonggang
洛東江
Nakdong River, the longest river in South Korea, flowing from the Taebaek Mountains in Gangwon province down to the East Sea at Busan

Nakseon(gun)
樂善(君)
(1641–1695)
Prince Nakseon, King Injo's fourth son

Nam Gu-man
南九萬
(1629–1711)
prime minister under King Sukjong, held power through the *Gapsul hwanguk* 甲戌換局 crisis

Nam ssi (née Nam)
南氏
family surname of a wife of a low-ranking official

Nambyeolgung
南別宮
guesthouse for Ming envoys in the early 16th cent., located in present-day Seoul where the Westin Chosun Hotel now stands

Nambyeoljeon
南別殿
royal portrait hall built in 1619 and renamed Yeonghuijeon 永禧殿 in 1690; located in today's Myeong-dong, Seoul

nangcheong
郎廳
third-level officers of a superintendency

Nangnamheon
落南軒
Southern House (from Hanyang) in the Hwaseong Detached Palace

napchae
納采
royal proposal, first of the six rites of a royal wedding

napjing
納徵
gifts sent to bride's home as proof of acceptance of the royal proposal, second of the six rites of a royal wedding

neung (reung)
陵
royal tomb

neungsanggak
陵上閣
"pavilion over a royal tomb," a temporary structure in the shape of a cylinder topped with a conical roof, built of wooden sticks over the royal tomb mound while the tomb chamber is being excavated

Nihon shoki [Jpn.]
日本書紀
History of Japan from the legendary period to 697, compiled in 720

nobu
鹵簿
honor guards accompanying a king's grand procession

nodae
弩臺
high podium from which to shoot arrows [in the Hwaseong Fortress]

noechan gaja yukbu
牢饌架子六部
six food-carrying stretchers

noinseong
老人星
spirit governing longevity

noje
路祭
on-the-road offerings made during funeral processions

nokchwijae
禄取才
quarterly test for higher emolument for painters-in-waiting at Kyujanggak

nokhun gongsin
录勳功臣
meritorious officials registered as such in court documents

Nokju
绿珠
servant for the meal of the crown prince at the court banquet of 1892

nongno
轆轤
device for lifting heavy loads used in the construction of the Hwaseong Fortress

nonsang
论賞
section in *uigwe* on awards from the court for all staff who served in the event

Noraedang
老來堂
Hall of Approaching Old Age in the Hwaseong Detached Palace

Nosan(gun)
魯山(君)
(1441–1457)
Prince Nosan, title given to King Danjong after he was demoted by his uncle, King Sejo

O ssi (née O)
吳氏
family surname of the wife of a ministerial-level official

obongbyeong
五峯屏
screen of the Five Peaks, symbolizing as well as protecting Joseon kings, placed behind the throne, royal portraits, and in the funeral hall of kings

Oegyujanggak
外奎章閣
Outer Kyujanggak, the annex of Kyujanggak Library, known as Gangdo oegak 江島外閣 (Ganghwado Outer Library), built in 1781 in the compound of Ganghwa sago 江華史庫 (Ganghwa History Archive) to house the overflow of books and documents from the main Kyujanggak Library in Changdeok Palace

ogin
玉印
jade seal of the crown prince

Ohyang daejeui
五享大祭儀
rituals of the Five Annual Sacrifices (*Ohyangje*) at Jongmyo shrine

Ohyangje
五享祭
Five Annual Sacrifices at Jongmyo on the auspicious day of each of the four seasons and on the last day of the year

ok
獄
spirits of hell

okbo
玉寶
jade royal seal

okchaek
玉册
jade book inscribed with a king's encomium for a royal bride or a crown prince

okchaek yoyeo
玉册腰輿
palanquin carrying the jade book

okchuk
玉軸
jade roller at the end of a scroll

okjang
玉匠
jade artisan

ondol
溫突
heated floor of a traditional Korean house

onganak
雍安樂
"pleasant and comforting music," played when the food dishes are being removed at Jongmyo sacrificial rites

ongseong
甕城
semicircular dual-protection wall in front of a city or fortress gate

oryun
五倫
five cardinal human relationships: (1) loyalty to the ruler (*chung* 忠); (2) filial piety to the father (*hyo* 孝); (3) respecting the difference between husband and wife (*byeol* 別); (4) love among brothers (*je* 悌); and (5) trust among friends (*sin* 信)

paemun
牌文
official notice

Paldalmun
八達門
south gate of Hwaseong Fortress

Paldalsan
八達山
mountain south of Hwaseong where stone veins were found

Paljunma
八駿馬
Eight Noble Steeds

palsun
八旬
seventy-ninth birthday
or eightieth year

panyun
判尹
mayor

Peiwenzhai gengzhi tu [Ch.]
(Kr. Paemunjae
gyeongjikdo)
佩文齋耕織圖
pictorial album printed
under the order of
the Kangxi emperor
(sobriquet Peiwenzhai),
containing 46 scenes,
23 each of farming and
sericulture, based on the
drawings by Jiao Bingzhen
(act. 1689–1726) [Ch.].
The album was brought
to Joseon in 1697 by the
emissary Choe Seok-jeong
(1646–1715).

Penglai
蓬萊
one of the Three Sacred
Mountains

pip
乏
two small three-fold
screens placed on either
side of the royal target
to shield the guards who
collect arrows that miss
the target during the royal
archery rites

pipjingam
逼眞感
"life likeness" (quality
of portrait)

poje
酺祭
sacrificial rite to protect
farm fields from insects

pojin
鋪陳
floor coverings (at royal
banquets)

poru
砲樓
pavilion tower for firing
guns from secure port-
holes in the wall

posa
鋪舍
house-shaped tower on
fortress wall with secret
gate where soldiers can
watch for enemies, or
simply relax

posa
鋪莎
laying turf on the board-
walk of the pontoon
bridge for royal crossing
over the Han River

pummok
稟目
reports to higher-level
offices; list of goods
bestowed by the
government

pung
豊
footed stand for wine cup
at sacrificial offerings

pung
風
wind; spirit of wind

punganak
豊安樂
"abundant and comforting
music," played at the
beginning of the presen-
tation of food at Jongmyo
sacrificial rites

pyebaek
幣帛
gift of foods presented by
the bride to her in-laws;
gift of white silk cloth to
the deceased

pyeonggeo
平車
smaller vehicle pulled by
a maximum of ten oxen,
used to carry wooden
construction materials

pyeongyeong
編磬
"flat pieces of stone
or jade," percussion
instrument hung on
a two-tiered wooden
frame

pyeonjong
編鍾
"flat bronze bells," percus-
sion instrument hung
on a two-tiered wooden
frame

pyogi
標旗
white flag with black
borders, or the flag of the
Ministry of Defense

pyogolta
豹骨朶
ritual paraphernalia
made of a long pole
displaying a leopard skin
on top held upright at
the most formal of royal
processions

qijuzhu [Ch.]
起居注
records of Qing emperors'
daily words and deeds

roe
雷
thunder

sa
社
earth; spirit of earth

Sado seja
思悼世子
(1735–1762)
"Crown Prince of Mournful
Thought," the posthu-
mous title King Yeongjo
gave to his second son.
Yeongjo considered him
deranged and unfit to rule,
so had him put to death.
As soon as Sado's own son,
King Jeongjo, assumed
the throne in 1776, he
elevated Sado's title to
Crown Prince Jangheon
(莊獻世子). In 1899,
Emperor Gojong elevated
Sado's title once again, to
King Jangjo (莊祖).

saengan
生雁
live goose to be presented
by a groom to his bride at
royal weddings

saenggap
牲匣
covered dishes for
serving sacrificial braised
beef, lamb, and pork at
Jongmyo sacrificial rites

saengsaengja
生生字
wooden printing type
developed under King
Jeongjo's order, modeled
on Qing dynasty font
and metal type used
for printing the *Kangxi
Dictionary*

sago
史庫
history archives of the
Joseon dynasty. The loca-
tions of the late Joseon
history archives are:
Mount Odae 五臺山,
Gangwon province;
Mount Jeongjok 鼎足山,
Ganghwa Island; Mount
Jeoksang 赤裳山, North
Jeolla province; Mount
Taebaek 太白山, North
Gyeongsang province.

sagwan
史官
court historiographer

sagwonhwa
絲圈花
artificial silk flowers
made of fine hemp (絨絲),
silk (禾紬), fish glue , and
silver (銀絲) and bronze
wires (銅絲)

sahae
四醢
four kinds of salted food
offered at Jongmyo sacrifi-
cial rites

sahan
司寒
spirit of the north (alter-
nate name 玄冥), respon-
sible for winter (ice, snow,
etc.). Its tablet would be
placed facing south on the
north-side sacrificial altar.

saheonbu dangsang
司憲府堂上
inspector general

sajagwan
寫字官
court scribes whose rank can go up to rank 4

saje
賜祭
Chinese imperial bestowal of a memorial rite for a Joseon king

sajik
社稷
spirits of earth and grain

Sajikdan
社稷壇
Sajik Altar, platform built to the west of Gyeongbok Palace to perform sacrificial rites to the spirits of earth and grain (*sajik*)

sajin (Ch. xiezhen)
寫眞
image; modern-day photographs

salleung
山陵
royal tomb (construction)

samgang
三綱
three bonds: loyalty to the ruler, filial piety to the father, and chastity to the husband

Samgang haengsildo
三綱行實圖
Illustrated Conduct of the Three Books, book of stories of loyal ministers, filial sons, and the chaste women of Korea and China, compiled by Seol Sun and published with woodblock illustrations in 1434

Samguk sagi
三國史記
History of the Three Kingdoms, compiled by Kim Bu-sik 金富軾 (1075–1151)

samju
三酒
three kinds of wine

sammul
三物
three substances — lime powder, yellow soil, and fine sand — used in a 3:1:1 mixture to coat the walls of the royal coffin chamber and burial or grave goods chamber

samok
事目
rules and regulations pertaining to each office

samsaeng
三牲
three kinds of sacrificial offerings, i.e., braised beef, lamb, and pork, offered at Jongmyo rites

Samsinsan
三神山
the Three Sacred Mountains known in Chinese as Penglai 蓬萊, Yingzhou 瀛州, and Fangzhang 方丈

samyeong
司命
spirit of human destiny, one of seven minor spirits (collectively known as the Seven Deities), whose rites take place in the Hall of Seven Rites situated to the west of the south gate of Jongmyo shrine

sangbae dosik
床排圖式
diagram of the ritual arrangement of food tables at the Jongmyo rites

sangbeol
賞罰
awards and punishments

sangcho
上草
to trace the outline of an image onto silk from oiled draft paper when painting a portrait

sanggung
尚宮
chief of the female palace staff

sangjeon
賞典
award regulations

sangmang sokjeol
朔望俗節
first and the fifteenth days of each month, and other important folk festival days

sangmayeon
上馬宴
banquet for Chinese envoys before their departure from Hanyang

sangnyangmun
上樑文
piece of writing composed for the main crossbeam of a wooden structure. During the construction ceremony, it is placed into position just before the builders hoist the beam into place.

sangnyangmun bongan jeui
上樑文奉安祭儀
placement rite for the *sangnyangmun* on the largest crossbeam of a wooden building

sangsi
上諡
presentation of a posthumous title

sangsi chaekboui
上諡冊寶儀
presentation of a posthumous title and seal to a deceased king

sangtak
床卓
wooden tables of all sizes and heights for serving and displaying

sannoe
山罍
jar decorated with stylized patterns of mountains and clouds for libation offering at Jongmyo sacrificial rites

sapbyeong
插屏
one-panel screen on a stand

sari jangeomgu
舍利裝嚴具
set of *sarira* (Buddhist relics) containers and utensils

saryeong
使令
servants of a government office

sasindo
四神圖
images of the Four [directional] Deities (in the Goguryeo period): blue dragon 靑龍 of the east, white tiger 白虎 of the west, red phoenix 朱雀 of the south, and black warrior 玄武 of the north

sasudo
四獸圖
images of the Four Animals, the Joseon dynasty term for *sasindo*

sasun
四旬
39th birthday or 40th year of human life

satang
私帑
royal family's private funds

sau sadanui
射于射壇儀
archery rite on the shooting range, including the rite of watching (*gwan sau sadanui*)

sawi
嗣位
succession to kingship by the crown prince

Schall, Johann Adam von Bell
(1596–1666)
German Jesuit missionary and astronomer who served at the Qing court. Crown Prince Sohyeon, during his captivity in the Qing capital, met Schall and received from him a globe and an image of Christ along with books on Christianity and Western sciences.

secho
洗草
to wash away the traces of the brush from paper or silk

sedo jeongchi
勢道政治
"in-law government." A typical example in the 19th cent. was ten-year-old King Sunjo's father-in-law, Kim Jo-sun 金祖淳 (1765–1832) of the powerful Andong Kim clan, who fought hard for supremacy at court against Dowager Queen Sinjeong's (mother of the succeeding king, Heonjong) father, Jo Man-yeong 趙萬永 (1776–1846) of the Pungyang Jo clan, who was equally as unyielding.

Seja sigangwon
世子侍講院
Office of Education of the Crown Prince

Sejabin ja byeolgung ye daepyeonggwan si banchado
世子嬪自別宮詣大平館時班次圖
Banchado of the Occasion of the Crown Princess Going from the Detached Palace to Daepyeonggwan

Sejo
世祖
(r. 1455–1468)
7th king of Joseon, an able ruler who strengthened the monarchy and central government by exerting direct control over the official bureaucracy; refined and further developed the administrative system, making advances in civil, military, and economic affairs; laid the foundation for Seongjong's legal publications

Sejong
世宗
(r. 1418–1450)
4th king of Joseon, revered as "Sejong the Great" for his brilliant Neo-Confucian rule that saw great advancements in science, technology, and economic reform. He pacified Japanese pirates, established a national currency, and promoted music, art, and literature, promulgating a phonetic Korean alphabet called *hangeul* to foster universal literacy.

Seo Guk-rin
徐國麟
(act. early 19th cent.) court painter who worked on screen paintings for the 1819 wedding of Crown Prince Hyomyeong

Seo Ho-su
徐浩修
(1736–1799)
scholar-official under King Jeongjo, scholar of the School of Northern Learning; visited Yanjing twice (1776, 1790) and wrote *Travel Diary to Yanjing* (*Yeonhaenggi* 燕行紀, 1790)

seo jik do ryang
黍稷稻梁
four kinds of raw grains offered at Jongmyo sacrificial rites

Seo Mun-jung
徐文重
(1634–1709)
high-ranking official under King Sukjong, appointed prime minister in 1701

seoban
西班
high-ranking officials of the military class

Seobongdong
棲鳳洞
one of the three localities near Hwaseong where brick-firing kilns were located

Seogwoldoan
西闕圖案
preliminary drawing for the painting titled *Plan of the West Palace*, a view of the Gyeonghui Palace drawn in the "ruled-line" technique, using only ink (no color) on 12 sheets of paper glued together to make a large format; datable to ca. 1828–30 (Korea University Museum)

seogye
書啓
reports in writing to the superintendent of a *dogam*

Seoin
西人
Western Faction

Seojangdae
西將臺
West Military Command Post of Hwaseong Fortress

Seokjonui (Ch. Shizunyi)
釋尊儀
Book of Rites at the Shrine of Confucius

Seol Sun
偰循
(d. 1435)
compiler of *Samgang Haengsildo*, a book of stories of loyal ministers, etc.

seolbing
設氷
setting up the *bingban* to ice the royal coffin

seolchae
設彩
applying colors

seolma
雪馬
sledge employed to transport smaller construction materials at Hwaseong

Seomjingang
蟾津江
Seomjin River in South Korea that flows northeasterly through Jeolla province and into South Gyeongsang province before it empties into the East Sea

seongbin
成殯
setting up a coffin hall in the palace

seongbok
成服
donning of mourning robes by the crown prince for a royal funeral

Seonggyungwan
成均館
Seonggyungwan National College compound

Seonggyungwan bansu
成均館泮水
man-made narrow stream that surrounds the Seonggyungwan National College compound

seongje
城制
wall systems

seongjin
聖眞
lifelike image of a ruler (referring to royal portrait)

Seongjong
成宗
(r. 1469–1494)
9th king of Joseon; ascended the throne at age 13 with his mother and grandmother, queens Insu and Jeonhae, who acted as regent until he reached the age of 20. His reign was prosperous, with growth in the national economy and expansion of farmlands. He fostered a resurgent Neo-Confucianism of merit-based rule by law based on the *Grand Law Code for Managing the Nation* (*Gyeongguk daejeon* 經國大典) that had been in the making since the time of King Sejo.

Seonjo
宣祖
(r. 1567–1608)
14th king of Joseon, initially an able ruler who encouraged Neo-Confucianism and political reforms but became

less effective during and after the Japanese invasions of 1592–1598, which brought famine, social unrest, and political disharmony to Korea

seongmaek
石脈
stone vein(s) in a mountain

seongmal
烏襪
shoes and socks for traditional costumes

Seongseol
城說
"Fortress Construction Plan," submitted by Jeong Yak-yong 丁若鏞 (1762–1836) for the construction of the Hwaseong Fortress

Seongsi jeondo
城市全圖
painting titled *Complete View of Hanyang*

Seongsin jaseong gyuhyeong
城身自成圭形
"the mass of the fortress wall is similar to that of a *gyu*," describing the shape of the fortress wall with its inward-curving profile resembling the shape of the *gyu* scepter held by Joseon kings and queens as insignias of their power to rule

Seongsinsa
城神祠
Shrine of the Fortress God (Spirit) at the foot of Paldalsan mountain in Hwaseong

seongsinsa bongan jeui
城神祠奉安祭儀
first sacrificial rite held at the Shrine of the Fortress God (Spirit)

Seonjam
先蠶
First Teacher of Sericulture

seonjang
船匠
artisan specializing in building boats

Seonjeongjeon
宣政殿
living quarters of the king in Changdeok Palace

Seonmok
先牧
First Herdsman, spirit of horse domestication

Seonnong
先農
First Farmer, legendary ancient Chinese emperor who taught farming to mankind

Seonnongdan
先農壇
altar for the offering of rites to the first teacher of agriculture

Seonwon boryak
璿源譜略
shortened title of *Seonwon gyebo giryak* 璿源係譜紀略, *Book of Royal Lineage*

Seonwonjeon
璿源殿
(1) royal portrait hall in Gyeongbok Palace that housed portraits of kings and queens other than King Taejo;

(2) royal portrait hall in Changdeok Palace built in 1656 after a fire destroyed the Seonwonjeon hall in Gyeongbok Palace. *See also* Sin Seonwonjeon.

seopsaui
攝祀儀
sacrifices conducted by the king's deputy rather than by the king

seori
書吏
low-ranking (7b) court scribes

seorye
序例
volume of illustrations

sesil
世室
generational spirit tablet chamber (in Jongmyo or Yeongnyeongjeon)

seson
世孫
crown grandson, term indicating the heir apparent is a grandson, not son, of the reigning king

sesonbin
世孫嬪
princess-consort of the crown grandson

Seungjeongwon
承政院
Royal Secretariat of the Joseon dynasty

Seungjeongwon ilgi
承政院日記
Diaries of the Royal Secretariat (of the Joseon dynasty)

Seungmunwon
承文院
Bureau of Royal/Diplomatic Documents (of the Joseon dynasty)

seungsi
乘矢
set of four arrows, used in royal archery rite

seup
襲
dressing and shrouding of the corpse

Shangshan sihu [Ch.] (Kr. Sangsan saho)
商山四皓
the "Four Old Men of Shangshan" — Dongyuan gong 東園公, Xiahuang gong 夏黃公, Luli Xiansheng 甪里先生, and Qiliji 綺里季 — who led lives of eremitism during the late Qin dynasty, and collectively became teachers of the Han emperor Huidi 惠帝

Shoku Nihongi [Jpn.] (Kr. Sok Ilbongi)
續日本紀
sequel to the *Nihon shoki* covering the history of Japan of the period 697–792

shwiyong
晬容
"outstanding (in Confucian virtue) countenance" (referring to a royal portrait)

sibijangbok
十二章服
Chinese imperial robe embellished with the twelve emblems of the ruler

sibo
謚寶
king's posthumous seal

sichaek
謚冊
jade book on which a king's posthumous titles are engraved

Siku quanshu [Ch.] (Kr. Sago jeonseo)
四庫全書
Comprehensive Library of the Four Treasuries, including: Classics (*jing* 經), Histories (*shi* 史), [Masters] of Philosophy (*zi* 子), and Anthologies [from Chinese Literature] (*ji* 集); completed in 1783

Sim Ik-chang
沈益昌
(1652–1725)
high official, grandfather of Sim Sa-jeong

Sim Sa-jeong
沈師正
(1707–1769)
well-known painter of the late Joseon period, famous for landscapes

Simyanggwando (Ch. Shenyangguan)
瀋陽館圖
Scenes of Shenyang Hall, the title of an album of sixteen leaves depicting Shenyangguan and other nearby sites and monuments; datable to ca. 1760, the date of the official embassy of annual tribute to China led by Hong Gyehui 洪啓禧 (1703–1771) in 1760–1761, and others; probably by the court painter Yi Pil-seong 李必成

Sin Deok-heup
申德洽
(act. mid-18th cent.)
official who served in King
Yeongjo's second wedding
rite in 1759

Sin Han-dong
申漢棟
(act. mid-18th cent.)
court painter who served
in King Yeongjo's second
wedding rite in 1759

Sin Heum
申欽
(1566–1658)
high-ranking official,
son-in-law of King Injo,
appointed minister of
rites in 1604

Sin Jeong
申晸
(1628–1687)
high-ranking official and
calligrapher who wrote
the characters for the jade
book of King Sukjong's
wedding in 1681; later
served as minister of rites
in 1685

Sin Man
申晚
(1703–1765)
prime minister under
King Yeongjo, compiled
the *Addendum to the Sequel
to the Five Rites of State*
(*Gukjo sok oryeui bo*) in 1751

Sin Seonwonjeon
新璿源殿
new Seonwonjeon, the
last royal portrait hall,
built in 1921 in Changdeok
Palace

Sin ssi (née Sin)
辛氏
family surname of a wife
of a low-ranking official

Sin Suk-ju
申叔舟
(1417–1475)
high-ranking official
under kings Sejong and
Sejo; contributed to the
creation of the Korean
writing system *hangeul*;
catalogued Prince
Anpyeong's painting
collection with comments
under the title "Hwagi
畫記," found in his
collected writings,
Bohanjaejip 保閑齋集

**Sindeok wanghu
(née Kang)**
神德王后 (康氏)
(d. 1396)
Queen Sindeok, second
wife but the first queen
of King Taejo

sineojwa
神御座
spirit tablet seat in the
form of a high chair

singnye
式例
regulations for payment

singwallye
晨祼禮
early morning reception
of the spirits by the king
at Jongmyo shrine

Sinjeong wanghu (née Jo)
神貞王后 (趙氏)
(1808–1890)
Queen Sinjeong, mother
of King Heonjong and
wife of King Ikjong; also
known as Jo Daebi 趙大妃
(Queen Dowager Jo)

sinju
神主
spirit tablet(s)

Sinmun
神門
spirit gate at Jongmyo
shrine, reserved for the
spirits of the royal ances-
tors; the center opening of
the south gate (Nammun)
of the walled compound
of the Jeongjeon (Main
Hall) of Jongmyo

Sinnong (Ch. Shennong)
神農
legendary Chinese
emperor who taught
farming to mankind; also
known as Seonnong

Sinpungnu
新豊樓
Pavilion of New
Abundance, the main
gate of the Hwaseong
Detached Palace

sinyeon
神輦
spirit palanquin, or
palanquin carrying royal
portraits of deceased
kings

sipjangsaengbyeong
十長生屏
Ten Symbols of Longevity
screen

sirip
實入
actual expenditure

sisagwan
侍射官
"attending shooters" at
the royal archery rite

sisagwan sangbeoldo
侍射官賞罰圖
painting titled *Awards
and punishments for the
attending officials*

sisaryedo
侍射禮圖
painting titled *Attending
officials' archery rite*

siyong
時用
"used at certain times,"
rites and ritual utensils
in use at the time of King
Seongjong when the *Five
Rites of State* was published
in 1474

Sohyeon seja
昭顯世子
(1612–1645)
Crown Prince Sohyeon,
the first son of King
Injo. After the Manchu
invasion of 1636, he was
sent to Shenyang as a
hostage and remained
there for nine years.
While in Beijing, in 1644
he met Adam Schall,
who gave him books on
Christianity and Western
learning, a globe, and an
image of Christ. In China
he actively served as a
diplomat for Joseon, but
his activities were not
well received back home.
Soon after his return, he
was reportedly killed by
poison on the order of Injo.

Sok daejeon
續大典
*Sequel to the National
Law Code* (1744)

somokjang
小木匠
woodworker specializing
in making small wooden
items

songnok
續錄
continued record

Soraru
所羅樓
Pavilion of the Conch
Shell, nickname for
Dongbuk gongsimdon
sentry tower at Hwaseong
Fortress that has a
hollow interior and
spiral staircase

Soreung
昭陵
tomb of Queen Hyeondeok
(1418–1441)

soryeom
小殮
preliminary shrouding
of the (royal) corpse

sosa
小祀
sacrificial rites for minor
spirits

soyeon
小輦
small royal palanquin

ssanghak hyungbae
雙鶴胸背
insignia embroidered with
twin cranes amid clouds,
attached to the front and
back of a Joseon high-
ranking civil official's robe
beginning from 1734

Su Hanchen [Ch.]
蘇漢臣
(act. 12th cent.)
Northern Song painter
considered to be the
initiator of paintings
of children at play in
a garden setting

subo uijang
修補儀章
repair of the damaged
objects in Jongmyo shrine

subok

守僕

work staff

Subok(bang)

守僕(房)

(residential quarters of)
the keepers and ritual
attendants of Jongmyo
shrine

Sueunmyo

垂恩墓

"Tomb of Bestowing
Grace," the first tomb
of Crown Prince Sado at
Baebongsan, Yangju, in
Gyeonggi province

sujagyeon

受爵宴

banquet of receiving
wine-cup offerings, the
most modest-scale court
banquet

sujik

守直

keeper of office

sujong hwasa

隨從畫師

assistant painter

Sukbin Choe ssi (née Choe)

淑嬪崔氏

(1670–1718)

Lady Choe, King Sukjong's
consort; King Yeongjo's
biological mother

Sukjisan

執知山

mountain near Hwaseong
with stone quarries that
provided stone blocks for
building the Hwaseong
Fortress

Sukjong

肅宗

(r. 1674–1720)

19th king of Joseon; ruled
skillfully for 46 years
despite intense bickering
and purging among court
officials belonging to the
Namin, Seoin, Soron, and
Noron factions. His reign
was prosperous, with new
reforms in the tax and
monetary systems, civil
service, farming, and
publishing.

Sungjeongjeon

崇政殿

Throne Hall of Gyeonghui
Palace

Sungnyemun

崇禮門

"Gate of Respecting
Propriety," one of the four
city gates of Hanyang,
popularly called Nam-
daemun (South Gate)

Sungseongun

崇善君

(1639–1690)

Prince Sungseon, fifth son
of King Injo

Sunjo

純祖

(r. 1800–1834)

23rd king of Joseon. When
Jeongjo died in 1800, his
10-year-old second son
ascended the throne as
King Sunjo, with his step-
great-grandmother Queen
Jeongsun acting as regent.
Sunjo ruled for 34 years
until his death at age 44
during a time of corrup-
tion at court, disorder in
state examinations, and
public unrest — all desta-
bilizing forces which he
tried to change as ruler.

Sunjong

純宗

(r. 1907–1910)

2nd emperor of the
Daehan Empire and
last ruler of the Joseon,
Sunjong was essentially
a puppet of Japan during
its colonization of Korea
(1911–1945). His personal
name was Yi Cheok 李坧
(1874–1926).

Sunwon wanghu (née Kim)

純元王后 (金氏)

(1789–1857)

Queen Sunwon, wife of
King Sunjo

suriso

修理所

repair subunit within a
superintendency (*dogam*)

suryeom cheongjeong

垂簾聽政

to take charge of state
affairs as regent behind
the bamboo curtain,
usually done by queen
dowagers

Suseon jeondo

首善全圖

woodblock-printed map
of Hanyang made by
Kim Jeong-ho, 1840

Suzong [Ch.]

肅宗

(r. 756–762)

Tang dynasty emperor
who ruled during the time
of the Anshi (An Lushan)
Rebellion led by court
eunuchs that was repelled
by general Guo [Ziyi]
Fenyang

swae hyangsu

灑香水

to spray with fragrance at
the final stage of making
a royal portrait

taegeuk (Ch. Taiji)

太極

the Great Ultimate, the
yin and *yang*, the circular
design of blue and red
found in the center of
a Korean flag

taehoseok

太湖石

strangely-shaped porous
rocks from the Taihu lake
district of China, used as
garden rocks

Taejo

太祖

(r. 1392–1398)

revered as the "Great
Ancestor," who overthrew
the Goryeo dynasty to
become the first ruler of
the dynastic house of
Joseon (1392–1911). Taejo
established his new
capital in Hanseong
(present-day Seoul) but
abdicated after ruling for
only six years in favor of
his second son, Jeongjong.
His personal name was
Yi Seong-gye 李成桂.

Taejong

太宗

(r. 1400–1418)

3rd king of Joseon, the
driving force of strength-
ening and consolidating
the dynasty that his
father, Taejo, founded.
An able but ruthless
ruler who secured
power by deposing his
brothers, creating the
Uijeongbu (State Council
of Joseon) to execute his
orders, and installing
the *hopae* system of

identification tablets to
control the movement
of people, particularly
farmers. Personal name
Yi Bang-won 李芳遠; the
third son of King Taejo

taekseon

擇船

selection of boats [for King
Jeongjo's pontoon bridge
over the Han River]

Taemyo

太廟

Main Hall of Jongmyo
shrine, so called because
the spirit tablet of King
Taejo is enshrined in it

Taepyeonggwan

太平館

one of the guesthouses
for Chinese envoys

taeryeo

泰厲

awards and punishments,
one of seven minor spirits
(collectively known as
the Seven Deities), whose
rites took place in the Hall
of Seven Rites situated to
the west of the south gate
of Jongmyo shrine

tangpyeongchaek

蕩平策

policy of impartiality,
implemented by King
Yeongjo to remedy the
factional strife of the
Joseon court

**Tangshi huapu [Ch.]
(Kr. Dangsi hwabo)**

唐詩畫譜

woodblock-printed
illustrated book of Tang
poems edited by Huang
Fengchi 黃鳳池 during the
Wanli era (1572–1620) of
the Ming dynasty

Tianbao jiuru [Ch.]
(Kr. Cheonbo guyeo)
天保九如
"heaven protects [thee]
as [constant as] the nine
[natural phenomena],"
from the "Xiaoya" 小雅
chapter of the *Shijing* 詩經
(*Book of Poetry*)

Tiangong kaiwu [Ch.]
(Kr. Cheongong gaemul)
天工開物
*Compendium of Science
and Technology*, compiled
by Song Yingxing 宋應星
(1587–1648) of the Ming
dynasty

toe
推
plowing motion in the
royal rite of agriculture

tongjeong daebu
通政大夫
"arrived thoroughly at
the executive ranks,"
title given to retired
high officials

Tongmyeongjeon
通明殿
queen's quarters in
Changgyeong Palace

u
雨
rain

ubo
羽葆
pole covered with abun-
dant white feathers, used
to announce the coming
of the king's large funeral
palanquin

uidae
衣襨
formal attire for members
of the Joseon royal family

uigwe
儀軌
books that record state
rites held during the
Joseon dynasty. When the
court decided to carry out
an important event, such
as a royal wedding or a
royal funeral, a tempo-
rary office called *dogam*
(superintendency) was
set up to plan and carry
out the entire process
of the event. While the
work in each division of
the superintendency was
being carried out, all the
details were recorded
in text form known as
deungnok. When the event
was over, based on the
deungnok, a final report
known as a *uigwe* was
created. It was at this
time that the illustrations
called *banchado* were
produced to record the
event in pictorial form, to
be included at the end of
the *uigwe*, particularly if
the event included a royal
procession.

uijangmul (uijiang)
儀仗物 (儀仗)
objects deployed in a royal
procession, including:
ceremonial weapons and
flags of all sizes, shapes,
and colors; blue or red
umbrellas; a royal red
parasol; and fans with
images of a phoenix,
peacock, or dragon, all of
which are carried on foot
by palace honor guards at
the royal procession

Uijeongbu
議政府
State Council

uiju(jil)
儀註(秩)
[collection of] step-by-
step procedures and
protocol for royal rites
in *uigwe* books

Uiryeong Namssi gajeon
hwacheop
宜寧南氏 家傳畫帖
an album of paintings
titled *The Uiryeong Nam
Family Heritage Painting
Album*

Uiso seson
懿昭世孫
(1750–1752)
son of Crown Prince Sado,
grandson of King Yeongjo,
older brother of King
Jeongjo; appointed crown
grandson in 1751, died in
infancy

Uisomyo
懿昭廟
shrine for Crown
Grandson Uiso, built in
Changuigung 彰義宮,
Seoul, under the order
of King Yeongjo

Uisungwan yeongjodo
義順館迎詔圖
Uisungwan Guesthouse,
an album of paintings
recording the reception of
Chinese envoys who came
to announce Emperor
Shenzong's (r. 1573–1620)
ascension to the throne,
showing the Uisungwan
Guesthouse in Uiju, just
across the Amnok/Yalu
River, where the envoys
were greeted by Joseon
officials. The album is
in the collection of the
Kyujanggak Institute for
Korean Studies, Seoul
National University.

Uiyakcheong
醫藥廳
Office of Court Medicine

uju
虞主
temporary spirit tablet of
mulberry wood brought
back from the royal tomb
after the funeral to be
kept for twenty-seven
months before the final
enshrinement of the
permanent spirit tablet
in Jongmyo shrine

ulgeumcho
鬱金草
plant from which the
fragrant liquor *ulchangju*
(鬱鬯酒) is made, to be
poured on the ground
to call for the *yin* and
yang spirits of the royal
ancestors at Jongmyo
sacrificial rites

un
雲
cloud

unggolta
熊骨朶
ritual paraphernalia
made of a long pole
displaying a bearskin on
top and held upright at
the most formal of royal
processions

unghu
熊候
head of a bear, the
king's target in the royal
archery rite

wabyeokjang
瓦甓匠
tile and brick artisan

waejang
倭裝
style of mounting a
screen painting in which
the scenes are unbroken
from one panel to the
next because no extra
silk strips were added to
either side of each panel

Wanchang (daegun)
完昌 (大君)
(b. 1305)
Prince Wanchang, King
Taejo's uncle, also known
as Yi Ja-heung 李子興

wang
王
king

Wang Gongyan [Ch.]
(Kr. Wang Gong-eom)
王公儼
(act. 14th cent.)
Yuan painter who excelled
in flowers and plants,
and birds and animals
paintings

wang seje
王世弟
a king's younger brother
made heir apparent

Wang Zheng [Ch.]
(Kr. Wang Jing)
王徵
(b. 1544)
Chinese mechanical
scientist

wangja
王子
prince

Wangnyun
旺倫
one of the three localities
near Hwaseong where
brick-firing kilns were
located

wangseja chaekbongui
王世子冊封儀
rite for the investiture of
a crown prince

wangseja janae suchaegui
王世子自內受冊儀
rite of the crown prince's
acceptance of the
investiture in person

**Wen Boren [Ch.]
(Kr. Mun Baek-in)**
文伯仁
(1502–1573)
Ming painter of the
Wu School

wipan
位版
permanent spirit tablet
of the king

wipan gwe
位版匱
wooden container for
permanent spirit tablet

wiwigok
為位哭
assignment of wailing
places for the crown
prince and immediate
royal family members

woldae
月臺
high stone terrace on
which important palace
structures such as the
throne hall stand elevated
above other buildings

won
園
tombs of members of the
royal family other than
kings and queens

**Won jae Hwasan chwi
hwayeohwa sangtong
yeogu Hwain chukseong-
jiui gaebong seonggyojaya**
園在花山 取花與華相通 亦
寓華人祝聖之意 皆奉聖
教者也
The name of the city
Hwaseong 華城 is taken
from the name Hwasan
花山 (the town where
Crown Prince Sado's
tomb, Hyeollyungwon,
is located) since the
two characters hwa 花
and hwa 華 can be used
interchangeably.

wonchal
願刹
patron temple for spiritual
protection

**Wongyeong wanghu
(née Min)**
元敬王后 (閔氏)
(1365–1420)
Queen Wongyeong,
King Taejong's queen

wonjeopsa
遠接使
official who meets
Chinese envoys at the
border

wonjip
原輯
original compilation
of 1697 during King
Sukjong's reign [of the
Jongmyo uigwe] in four
volumes

**Xiong Hua [Ch.]
(Kr. Ung Hwa)**
熊化
1576–1649
chief Ming imperial envoy
who came to Joseon
to mourn the death of
King Seonjo and bestow
upon him a posthumous
imperial title in 1608

yabulsu
夜不收
twenty-four-hour
messenger

yajosik
夜操式
nighttime military
exercise

Yanagi Sōetsu also
Yanagi Muneyoshi [Jpn.]
柳宗悅
(1889–1961)
Japanese art historian
famous for exploring the
beauty of Korean folk art

Yang Hui-maeng
梁希孟
painter referred to simply
as "young scholar" (yuhak)
in the Uigwe of Copying
King Sukjong's Portrait, 1748

yangban
兩班
Joseon upper class
consisting of two classes:
literary (dongban 東班) and
military (seoban 西班)

yangcheong
洋青
[Western] aniline blue
pigment, introduced
into Korea via China in
the second half of the
19th cent.

yanghong
洋紅
Western red aniline
dye pigment

yangmin
良民
"good people" or freeborn
commoners, as opposed to
cheonmin, or the lowborn
commoners of Joseon
society

yangseongjo
两聖祖
two sage kings

yechi
禮治
rule by rites

yegi cheok
礼器尺
unit of measure; 1 yegi
cheok is 28 cm long

yegwan
礼關
documents sent from the
Ministry of Rites to other
offices

yejang
礼葬
funerals of members of
the royal family other
than kings and queens

yeje
醴齊
sweet wine(s) offered
as the first libation at
Jongmyo sacrificial rites

yejo dangsang
礼曹堂上
minister of rites

Yejo deungnok
礼曹謄錄
documents of the
Ministry of Rites

yejo geumhollyeong
礼曹禁婚令
order of marriage prohi-
bition to Joseon maidens
issued by the Ministry
of Rites when the royal
family is about to select
a maiden for a queen
or a crown princess

yejo uiju
礼曹儀註
protocol of the Ministry
of Rites

yeo
輿
large palanquin

Yeogisan
如岐山
mountain near Hwaseong
with stone quarries that
provided stone blocks for
the construction of the
Hwaseong Fortress

yeoje
厲祭
sacrifices offered to the
spirit of epidemics

yeokbok
易服
the changing into white
robes and shoes and the
removal of headgear
and hair ornaments by
members of the royal
family upon the death
of the king

yeokgwan
驛館
horse station house

Yeolseong eoje
列聖御製
Collections of Successive
Kings' Compositions

yeom
殮
shrouding of the corpse
after washing

yeomillak
與民樂
orchestral music
composed during the
reign of King Sejong based
on Chinese classical
music (*dangak* 唐樂), but
later gradually evolving
into Korean music
(*hyangak* 鄉樂)

yeon
輦
large royal palanquin

yeon pyeongsang
蓮平床
wide bench decorated
with lotus flowers

yeonbae yeogun
輦陪餘軍
spare or backup bearers
of a palanquin

Yeongbin Yi *or*
Yeongbin Yi ssi (née Yi)
暎嬪李氏
(1696–1764)
consort of King Yeongjo,
biological mother of
Crown Prince Sado

yeongdang
影堂
portrait hall

Yeonghuijeon
永禧殿
royal portrait hall,
located in present-day
Myeongdong, originally
called Sungeunjeon
崇恩殿, later called
Nambyeoljeon 南別殿,
and finally renamed by
King Sukjong as Yeong-
huijeon in 1688

Yeonghwajeong
迎華亭
Pavilion of Welcoming
Beautiful Scenery in
Hwaseong

Yeonghwayeok
迎華驛
Yeonghwa Horse Station
near Janganmun gate,
Hwaseong

Yeongi
燕記
Record of Travel to Yanjing,
Hong Dae-yong's travel
diary of his trip to Yanjing

yeongja
影子
painted image (referring
to a portrait)

yeongje
榮祭
sacrificial rite to the
spirits of mountains and
rivers for clearing of rain

yeongjeong
影幀
(1) portrait; (2) portrait
in hanging scroll format

Yeongjeop dogam
迎接都監
superintendency for
receiving Ming envoys

Yeongjo
英祖
(r. 1724–1776)
21st king of Joseon, father
of Crown Prince Sado
and grandfather of King
Jeongjo. Yeongjo was
deeply Confucian and
ruled by Neo-Confucian
ethics for 52 years,
continuously trying to
reform Korea's taxation
system and minimize
the harmful effects

of political factions at
court by adhering to a
policy of Tangpyeong, or
"Magnificent Harmony"
蕩平, in which the king
would not take sides
among warring factions.

yeongjocheok
營造尺
unit of measure used in
architecture or wood-
working, equivalent to
about 30–30.8 cm

yeongjwa
靈座
spirit seat, a wooden high
seat upon which to place
a spirit tablet

Yeongnyeongjeon
永寧殿
Hall of Eternal Peace, first
built in 1421, the second
building in the Jongmyo
compound to enshrine
royal spirit tablets;
continuously rebuilt to
expand the spirit tablet
halls

Yeongsangang
榮山江
river in South Jeolla
province that flows
southwesterly out of
Byeongpung mountain
in Damyang into the
Yellow Sea in Yeongam

yeongseong
靈星
celestial star worshipped
as the spirit governing
farming

Yeongsugak chinimdo
靈壽閣親臨圖
album leaf titled "King's
Visit to Yeongsugak," from
the album *Gisa Gyeong-
hoecheop* (Celebrating
Gathering at the Club of
Elders) of 1744–45

Yeongsungjeon
永崇殿
royal portrait hall built at
the beginning of Joseon
to enshrine King Taejo's
portrait in Pyongyang, the
capital of the Goguryeo
Kingdom

Yeonguwon
永祐園
"Tomb Forever Protected
by Heaven," Crown Prince
Sado's tomb renamed
(formerly Sueunmyo) by
King Jeongjo in Yangju,
Gyeonggi province

Yeonhaengnok
燕行錄
Records of Travel to Yanjing,
the name given to the
large body of literature
left by Korean emissaries
to the Qing court

yeonhwabyeong
蓮花屛
lotus flower screen

yeonhyangsaek
宴享色
unit responsible for
banquet preparation for
Chinese envoys

yeonyeo
輦輿
large and small
palanquins

yeoryeong
女伶
a group of female enter-
tainers at the Joseon royal
court

yepil
礼畢
"the ritual is finished,"
the close of a royal rite
or ceremony

Yi Bok-gyu
李復圭
(act. mid-18th cent.)
court painter under
King Yeongjo, served in
the 1759 royal wedding

Yi Chi
李珆
(act. late 17th cent.)
painter who participated
in the copying of King
Taejo's portrait in 1688

Yi Choe-in
李最仁
(act. mid-18th cent.)
court painter under
King Yeongjo, served in
the 1759 royal wedding

Yi Deok-ha
李德夏
(act. late 19th–early
20th cent.)
one of two rank-9 painters
(not royal portrait
painters) of the *banchado*
of the 1900 royal portrait
uigwe

Yi Deok-mu
李德懋
(1741–1793)
scholar of the School
of Northern Learning;
appointed inspector of
Kyujanggak Library by
King Jeongjo

Yi Deok-seong
李德星
(act. late 18th cent.)
well-known court translator during the reign of King Jeongjo

Yi Do-min
李道民
(act. mid-18th cent.)
court painter under King Yeongjo, served in the 1759 royal wedding

Yi Eun-bok
李銀福
(late 16th–early 17th cent.)
court painter who served in the superintendency (dogam) set up to receive Chinese envoys in 1608

Yi Gi-yeong
李祺榮
(act. late 19th–early 20th cent.)
rank-2 court painter who participated in the 1901 event of the copying of seven kings' portraits; one of five painters (not royal portrait painters) of the Five Peaks screen mounted on a stand

Yi Gwal's Rebellion (Yi Gwal ui nan)
李适의乱
Yi Gwal (1587–1624) was a general who in 1623 helped dethrone Guanghaegun and install King Injo as king. This incident is known in Korean history as *Injo banjeong* 仁祖反正 (Injo's Restoration of Rectitude). After the Restoration, Yi was posted to the northern border and not rewarded well. In 1624

he and other generals revolted; they marched to the capital and occupied it, causing Injo to flee to the southern city of Gongju. This incident is known in Korean history as Yi Gwal's Rebellion. However, generals loyal to Injo attacked Yi, who then was killed by his own men, and Injo was restored to the throne.

Yi Gwang-pil
李光弼
(act. mid-18th cent.)
court painter under King Yeongjo, served in the 1759 royal wedding

Yi Han-cheol
李漢喆
(b. 1808)
court painter who participated in painting the portrait of kings Heonjong and Cheoljong; he also excelled in landscape and other genres of painting.

Yi Hang-bok
李恒福
(1556–1618)
high-ranking official during the reign of Gwanghaegun and King Seonjo

Yi Heung-ju
李興柱
(act. early 20th cent.)
former magistrate, one of the painters (but not royal portrait painter) of the Five Peaks screen, as cited in the 1900 royal portrait *uigwe*

Yi Ho-jun
李浩駿
(act. early 20th cent.)
one of two grade-3 painters (not royal portrait painters) who were painters of canopies of royal portrait niches in bright colors (*dancheong hwasa*), as cited in the 1901 royal portrait *uigwe*

Yi Hyeong-rok
李亨祿
(1808–after 1863)
also known as Yi Eung-rok 李應祿 and Yi Taek-gyun 李宅均; famous for *munbangdo*, or paintings of scholar's paraphernalia

Yi Hyo-bin
李孝彬
(act. early 19th cent.)
court painter who worked on screen paintings in the 1819 wedding event

Yi I-myeong
李頤命
(1658–1722)
minister of the left under King Sukjong

Yi In-mun
李寅文
(1745–1821)
famous painter of true-view landscape painting; also worked for the 1795 screen painting *Hwaseong wonhaeng dobyeong*

Yi Ja-heung
李子興
(b. 1305)
See Wanchang (daegun)

Yi Jae-gwan
李在寬
(1783–1837)
well-known court painter who excelled in portraiture and landscape

Yi Jeong-gwi
李廷龜
(1564–1635)
minister of defense under Gwanghaegun

Yi Jong-uk
李宗郁
(act. mid-18th cent.)
court painter under King Yeongjo; served at the 1759 royal wedding

Yi Man-eok
李萬億
(act. late 17th cent.)
court painter under King Sukjong; served at the crown prince's (later King Gyeongjong) investiture rite in 1690

Yi Man-su
李晚秀
(1752–1820)
scholar-official of the late Joseon period who oversaw the making of the metal type *jeongnija* 整理字 under King Jeongjo

Yi Myeon-eung
李冕膺
(1746–1812)
governor of Gaeseong

Yi Myeong-gyu
李命奎
(act. late 18th cent.)
court painter who worked on the 1795 screen painting *Hwaseong wonhaeng dobyeong*

Yi Myeong-sik
李命植
(1720–1800)
minister of defense, and head of the Privy Council

Yi Pil-han
李必漢
(act. mid-18th cent.)
court painter under King Yeongjo; served in the 1759 royal wedding

Yi Pil-seong
李必成
(18th cent.)
court painter under King Yeongjo; served at the 1759 royal wedding; most probably the painter of the album *Simyanggwando*

Yi Saek
李穡
(1328–1396)
scholar-official, great Neo-Confucian scholar, man of letters of the last days of the Goryeo dynasty; initiated the three-year mourning period custom which continued throughout the Joseon dynasty

Yi Seong-gye
李成桂
See Taejo

Yi Sin-heum
李信欽
(1570–1631)
court painter of the first half of the 17th cent.

Yi Suk-cheol
李淑喆
(act. late 18th cent.)
court scribe who was
granted the change of
status from lowborn
(*cheonmin*) to freeborn
(*yangmin*) in accordance
with his wish after serv-
ing in the construction of
the Hwaseong Fortress

Yi Tae
李태
(act. 18th cent.)
master painter cited in
the 1735 *uigwe* of the
copying of King Sejo's
portrait

Yi Wan-su
李完秀
(act. mid-18th cent.)
court scribe who
recieved an official letter
of appointment after
the completion of the
Hwaseong Fortress

Yi Yu-gyeong
李儒敬
(b. 1747)
chief of the main office
of the Hwaseong Fortress
construction

Yi Yu-seok
李惟碩
(act. mid-17th cent.)
court painter under
King Injo, served in
Injo's funeral of 1649

Yi Yu-tan
李惟坦
(act. mid-17th cent.)
court painter under
King Injo, served in
Injo's funeral of 1649

yojiyeondo
遙池宴圖
the painting titled *Xiwang-
mu's* (Kr. Seowangmo)
*Banquet at the Turquoise
Pond Garden*

Yongdu
龍頭
Dragon-head, a rocky cliff
overlooking the Dragon
Pond (Yongyeon 龍淵) in
Hwaseong Fortress

yongjeong
龍亭
pavilion-shaped small
palanquin used to carry
royal documents in
a royal procession

yongjun
龍樽
large blue-and-white
ceramic jar decorated
with dragon motif

Yongjusa
龍珠寺
Buddhist temple built in
1790 near Hyeollyungwon
顯隆園 (Crown Prince
Sado's tomb) in Hwaseong
to serve as the tomb's
patron temple (*wonchal*
願刹) and spiritual
protector

Yongle [Ch.]
(Kr. Yeongnak)
永樂
(r. 1402–1424)
reign title of the third
emperor of Ming China

Yongyeon
龍淵
Dragon Pond in the
Hwaseong Fortress

yoyeo
腰輿
small palanquin carried
at waist level that holds
ritual items in state rites

yoyeon
腰輦
small palanquin for a king
or one that carries ritual
items in state rites

Yu Chaosi [Ch.]
(Kr. Eo Jo-sa)
魚朝思
(722–770)
eunuch who accused Guo
Ziyi (Fenyang) of wrong-
doing just before the
Uyghur invasion in 765

Yu Deuk-gong
柳得恭
(1748–1807)
scholar of the School
of Northern Learning;
appointed inspector of
Kyujanggak Library by
King Jeongjo; authored
Barhae go 發海考 (A Study
of the Barhae Kingdom)

Yu Geun
柳根
(1549–1627)
scholar-official who held
many prestigious titles,
including minister of rites

Yu Gong-ryang
柳公亮
(1560–1624)
high-ranking official
under Gwanghaegun;
served as vice minister
of the Ministry of Punish-
ment and governor of
Gyeongsang province

Yu Jae-geon
劉在建
(1793–1880)
author of the *Ihyang
gyeonmullok* 里鄉見聞錄
(Experiences in Villages
and Countryside)

Yu Su
柳綏
(b. 1678)
high-ranking civil official
under King Yeongjo whose
portrait was painted by
Jin Jae-hae 秦再奚

Yu Suk
劉淑
(1827–1873)
court painter who
excelled in genre and
landscape paintings

Yu Sun-jeong
柳順汀
(1459–1512)
meritorious subject under
King Seongjong

Yuanmingyuan [Ch.]
(Kr. Wonmyeongwon)
圓明園
Qing imperial detached
palace situated in north-
west Beijing

**Yuanxi qiqi tushuo luzui
(Qiqi tushuo) [Ch.]**
**(Kr. Wonseo gigi doseol
nokchoe; gigi doseol)**
遠西奇器圖說錄最
(奇器圖說)
illustrated book on
machinery of the West
compiled by the Jesuit
priest Johannes Terrenz
(Deng Yuhan 鄧玉函,
1576–1630)

yuhak
幼學
young scholar

yuhwa
儒畵
scholar-painter, as
opposed to professional
or court painter

yuin
孺人
title for wives of
low-ranking officials
(ranks 9a and 9b)

yukbyeong
六餠
six kinds of rice cake
offered at Jongmyo
sacrificial rites

yukgwa
六果
six kinds of fruit offered
at Jongmyo sacrificial
rites

Yukjeon jorye
六典條例
Applications of the Six Codes,
title of book compiled
in 1867

yumyeong jeungsi
有明贈諡
posthumous title
bestowed by a Ming
emperor

**Yumyeong jeungsi Gang-
heon Taejo Jiin Gyeun
Seongmun sinmu daewang**
有明贈諡康獻太祖至仁啓渾
聖文神武大王
King Taejo's full royal title

Yun Deok-hui
尹德熙
(1685–?)
literati painter of the
late Joseon period, son
of the literati painter
Yun Du-seo

Yun Du-seo
尹斗緒
(1688–1715)
scholar-painter who
painted a famous realistic
self-portrait

Yun Haeng-im
尹行恁
(1762–1801)
high-ranking official of
the late Joseon period

Yun Ja-deok
尹滋悳
(1827–1891)
mayor of Hanseong under
Emperor Gojong

Yun Sang-ik
尹商翊
(act. 1669–1690)
court painter under King
Sukjong; served as the
master painter in 1688
when King Taejo's portrait
was copied

Yun Seok-geun
尹碩根
court painter who
worked on the 1795
screen painting *Hwaseong
wonhaeng dobyeong*

Yun Yong-gu
尹用求
(1853–1959)
late Joseon scholar-official,
painter, and calligrapher;
served as minister of
the Ministry of Rites and
Ministry of Personnel

yungnye
六禮
six rites of a royal
wedding: (1) *napchae* 納采,
the royal proposal;
(2) *napjing* 納徵, sending
gifts to the bride's home
as proof of acceptance of
the royal proposal; (3) *gogi*
告期, announcement of
the date of the wedding;
(4) *chaekbi* 冊妃 (*chaekbin*
冊嬪*)*, royal appointment
of the queen/crown prin-
cess; (5) *chinyeong* 親迎,
royal groom's visit to the
detached palace to meet
and escort the bride to
the palace; (6) *dongnoe yeon*
同牢宴, the wedding rite
proper, in which the royal
couple exchange bows
and wine cups

yusubu
留守府
local administrative
unit responsible for the
defense of the capital city

yuuiching gaja
遺衣稱架子
small structure with a
rack for carrying clothing
worn in life by a deceased
king

Yuyeotaek
維與宅
"House of Togetherness" in
the Hwaseong Detached
Palace

**Zheng Yu [Ch.]
(Kr. Jeong Yeo)**
鄭璵
(act. mid-18th cent.)
Qing painter of Akedun's
album *Fengshi tu* 奉使圖

Zhouli [Ch.] (Kr. Jurye)
周禮
Rites of Zhou, ancient text
from the Zhou dynasty
of China that served
as guide to the Joseon
government when it
created its own ritual
practices at court

Zhu Xi [Ch.] (Kr. Ju Hui)
朱熹
(1130–1200)
Neo-Confucian scholar of
the Southern Song (1126–
1271) who synthesized
earlier Neo-Confucian
scholars' theories of li
(理) and qi (氣). Compiled,
edited, and critiqued the
Four Books (the *Analects* [of
Confucius], *Mencius*, the
Great Learning, and the
Doctrine of the Mean). His
philosophy and writings
had a great influence in
Korea, Japan, and other
Asian countries.

**Zhuzi jiali [Ch.]
(Kr. Juja garye)**
朱子家禮
book compiled by Zhu
Xi on the four principal
rites: (1) coming of age,
(2) marriage, (3) funeral,
and (4) ancestral worship,
to be observed by all
classes of people, from
the royal family down
to the commoners

**Ziguangge [Ch.]
(Kr. Jagwanggak)**
紫光閣
"Purple Light Hall," situ-
ated in the Central and
South Seas (Zhongnanhai)
Imperial Park in Beijing;
contains large paintings

that were commissioned
by the Qianlong emperor
to commemorate the
success of his north-
west ethnic pacification
campaigns

ONLINE RESOURCES

Many *uigwe* have been digitized
and are available on archive
and museum websites in Korea.
For *uigwe* illustrated in this
volume, search the databases
on the appropriate websites by
their collection numbers.

Jangseogak Archives,
The Academy of Korean Studies
jsg.aks.ac.kr

Kyujanggak [Gyujanggak]
Institute for Korean Studies,
Seoul National University
kyu.snu.ac.kr/en

Oegyujanggak Uigwe,
National Museum of Korea
museum.go.kr/uigwe

References

PART I
UIGWE AND
RELATED TEXTS

Uigwe and Deungnok

Bogon gongju garye deungnok
福溫公主嘉禮謄錄
Preliminary Records of the Wedding of Princess Bogon
1830
Jangseogak (K2-2643)

Changdeokgung yeong-geon dogam uigwe
昌德宮營建都監儀軌
Uigwe of the Construction of Changdeok Palace
1834
Kyujanggak (Kyu 14318)

[Cheoljong Cheorin wanghu] garye dogam uigwe
[哲宗哲仁王后] 嘉禮都監儀軌
Uigwe of the Wedding of King Cheoljong and Queen Cheorin
1851
Jangseogak (K2-2598)

Chiljo yeongjeong mosa dogam uigwe
七祖影幀模寫都監儀軌
Uigwe of the Copying of Seven Kings' Portraits
1901
Jangseogak (K2-2768)

Chingyeong uigwe
親耕儀軌
Uigwe of Royal Agriculture
1739, 1767
Jangseogak (K2-2905)
Reduced-size facsimile edition. Seoul: Kyujang-gak Institute for Korean Studies, Seoul National University, 2001.
 Hangul translation of the *Uigwe of Royal Agricul-ture and Sericulture* (*Gugyeok Chingyeong chinjam uigwe* 국역 친경친잠의궤). Trans. Bak So-dong. Seoul: Korean Classics Research Institute, 1999.

Chinjam uigwe
親蠶儀軌
Uigwe of Royal Sericulture
1767
Kyujanggak (Kyu 14543)
Reduced-size facsimile edition. Seoul: Kyujang-gak Institute for Korean Studies, Seoul National University, 2001.
 Hangul translation of the *Uigwe of Royal Agricul-ture and Sericulture* (*Gugyeok Chingyeong chinjam uigwe* 국역 친경친잠의궤). Trans. Bak So-dong. Seoul: Korean Classics Research Institute, 1999.

Daesarye uigwe
大射禮儀軌
Uigwe of the Royal Archery Rites
1743
Kyujanggak (Kyu 14941)
Reduced-size facsimile edition, with an intro-duction by Sin Byeong-ju. Seoul: Kyujanggak Institute for Korean Studies, Seoul National University, 2001.

Dyeongmi garyesi ilgui
명미가례시일긔
丁未嘉禮時日記
Daily Record of the Wedding in the Jeongmi Year
1847
Jangseogak (K2-2708)

Euryu sujak uigwe
乙酉受爵儀軌
Uigwe of Receiving Wine-Cup Offerings in the Euryu Year
1765
Kyujanggak (Kyu 14361)

[Gojong hwangtaeja] eojin dosa dogam uigwe
[高宗皇太子] 御眞圖寫都監儀軌
Uigwe of the Painting of Emperor Gojong's and the Crown Prince's [later Emperor Sunjong] Portraits
1902
Jangseogak (K2-2757)

[Gojong Myeongseong wanghu] garye dogam uigwe
[高宗明成皇后] 嘉禮都監儀軌
Uigwe of the Wedding of King Gojong and Queen Myeongseong
1866
Jangseogak (K2-2599)

[Gyeongjong] wangseja chaengnye dogam uigwe
[景宗] 王世子冊禮都監儀軌
Uigwe of the Investiture of the Crown Prince [later King Gyeongjong]
1690
BNF (2685) / NMK (Ogu 072)

[Gyeongjong] wangseja garye dogam uigwe
[景宗] 王世子嘉禮都監儀軌
Uigwe of the Wedding of the Crown Prince [later King Gyeongjong]
1696
BNF (2528) / NMK (Ogu 077)

Gyeongmogung uigwe
景慕宮儀軌
Uigwe of the Gyeongmo Palace
1784
Jangseogak (K2-2410), royal viewing copy;
Jangseogak (K2-2411), history archive copy

Heonjong bi Gyeongbin
Gim ssi sunhwagung
garyesi jeolcha
憲宗妃慶嬪金氏順和宮
嘉禮時節次
*Proceedings of the Wedding
of Heonjong and Gyeongbin
Gim ssi*
1848
Kyujanggak (Kyu 27008)
Handscroll version of
Dyeongmi garyesi ilgui
(1847).

[Heonjong Hyohyeon
wanghu] garye dogam
uigwe
[憲宗孝顯王后] 嘉禮
都監儀軌
*Uigwe of the Wedding of
King Heonjong and Queen
Hyohyeon*
1837
BNF (2539) / NMK (Ogu 269)

[Heonjong Hyojeong
wanghu] garye dogam
uigwe
[憲宗孝定王后] 嘉禮
都監儀軌
*Uigwe of the Wedding of
King Heonjong and Queen
Hyojeong*
1844
Kyujanggak (Kyu 13142)

[Heonjong] wangseja
garye dogam uigwe
[憲宗] 王世子嘉禮
都監儀軌
*Uigwe of the Wedding of
the Crown Prince [later
King Heonjong]*
1819
Kyujanggak (Kyu 13133)

Hwaseong seongyeok
uigwe
華城城役儀軌
*Uigwe of the Construction
of the Hwaseong Fortress*
1801
Kyujanggak (Garam go
951.2-H992)
Reduced-size facsimile
in 2 vols. Seoul: Kyujang-
gak Institute for Korean
Studies, Seoul National
University, 1994.
 Revised and enlarged
edition of the 1994 facsim-
ile, translated into Hangul
(화성성역의궤 국역증보판).
Suwon: Gyeonggi munhwa
jaedan, 2005.

Hwaseong uigwe
See *Hwaseong seongyeok
uigwe*

[Hyegyeonggung Hongssi]
gisa jinpyori jinchan uigwe
[惠慶宮洪氏] 己巳進表裏
進饌儀軌
*Uigwe of the Presentation
Ceremony and Banquet [for
Hyegyeonggung Hongssi]
in the Gisa Year*
1809
British Library (Or.7458)
Annotated Hangul
translation, *Yeokju gisa
jinpyori jinchan uigwe*
역주 기사 진표리 진찬 의궤.
Seoul: National Institute
of Traditional Korean
Music, 2018.

Hyeollyungwon wonso
dogam uigwe
顯隆園園所都監儀軌
*Uigwe of the Construction of
Crown Prince Sado's Tomb*
1789
Kyujanggak (Kyu 13627)

[Hyeonjong] wangseja
chaengnye dogam uigwe
[顯宗] 王世子冊禮都監儀軌
*Uigwe of the Investiture
of the Crown Prince [later
King Hyeonjong]*
1651
BNF (2681) / NMK (Ogu 015)

[Hyeonjong] wangseja
garye dogam uigwe
[顯宗] 王世子嘉禮都監儀軌
*Uigwe of the Wedding of
the Crown Prince [later
King Hyeonjong]*
1651
Kyujanggak (Kyu 13071)

[Ikjong/Munjo] wangseja
garye dogam uigwe
[翼宗/文祖] 王世子嘉禮
都監儀軌
*Uigwe of the Wedding of the
Crown Prince [Hyomyeong,
posthumously elevated to
King Ikjong/Munjo]*
1819
Jangseogak (K2-2677)

Injeongjeon jungsu uigwe
仁政殿重修儀軌
*Uigwe of the Repair
of the Injeongjeon*
1857
Jangseogak (K2-3577)

Injo binjeon dogam uigwe
仁祖殯殿都監儀軌
*Uigwe of King Injo's
Coffin Hall*
1649
BNF (2596) / NMK (Ogu 010)

[Injo] gukjang
dogam uigwe
[仁祖] 國葬都監儀軌
*Uigwe of the Royal
Funeral of King Injo*
1649
BNF (2552) / NMK (Ogu 011),
royal viewing copy;
Kyujanggak (Kyu 13521),
history archive copy

Injo honjeon dogam uigwe
仁祖魂殿都監儀軌
*Uigwe of King Injo's
Spirit Tablet Hall*
1649
BNF (2596) / NMK (Ogu 010)

[Injo Jangneung] salleung
dogam uigwe
[仁祖長陵] 山陵都監儀軌
*Uigwe of the Construction
of King Injo's Tomb*
1649
Jangseogak (K2-2367)
Reduced-size facsimile
edition. Seongnam:
Academy of Korean
Studies, 2007.

[Injo Jangnyeol wanghu]
garye dogam uigwe
[仁祖莊烈王后] 嘉禮
都監儀軌
*Uigwe of the Wedding
of King Injo and Queen
Jangnyeol*
1638
BNF (2524) / NMK (Ogu 004)

Jagyeongjeon jinjak
jeongnye uigwe
慈慶殿進爵整禮儀軌
*Uigwe of the Royal Banquet
of the Offering of Wine Cups
at Jagyeongjeon*
1827
Jangseogak (K2-2858)

Jangnyeol wanghu gukjang
dogam uigwe
莊烈王后國葬都監儀軌
*Uigwe of the Funeral of
Queen Jangnyeol*
1688
BNF (2561) / NMK (Ogu 070)

[Jeonghae] jangjong
sugyeon uigwe
[丁亥] 藏種受繭儀軌
*Uigwe of the Gathering and
Storing of Seeds and Silk
Cocoons [in the Jeonghae
Year]*
1767
Kyujanggak (Kyu 14544)
Also known as *Yeongjo bi
Jeongsun hu sugyeon uigwe*
英祖妃貞純后受繭儀規
(*Uigwe of Queen Jeongsun's
[second wife of Yeongjo]
Gathering and Storing of
Seeds and Silk Cocoons [in
the Jeonghae Year]*).

Jeonghae jinchan uigwe
丁亥進饌儀軌
*Uigwe of the Palace Banquet
of the Jeonghae Year*
1887
Kyujanggak (Kyu 14405)

Jeonghae jinjak
jeongnye uigwe
丁亥進爵整禮儀軌
*Uigwe of the Royal Banquet
of the Offering of Wine Cups
in the Jeonghae Year*
1827
Kyujanggak (Kyu 14362)

[Jeongjo] Geolleung
salleung dogam uigwe
[正祖] 健陵山陵都監儀軌
*Uigwe of the Construction
of King Jeongjo's Tomb*
1800
Kyujanggak (Kyu 13640)
Reduced-size facsimile
edition. Seoul: Kyujang-
gak Institute for Korean
Studies, Seoul National
University, 1999.

**[Jeongjo] gukjang
dogam uigwe**
[正祖] 國葬都監儀軌
*Uigwe of the Royal Funeral
of King Jeongjo*
1800
Kyujanggak (Kyu 13634)
Hangul translation
(국역 정조국장도감의궤) by
the National Research
Institute of Cultural Her-
itage. Seoul: Minsogwon,
2006.

**[Jeongjo wangseson]
garye dogam uigwe**
[正祖王世孫] 嘉禮都監儀軌
*Uigwe of the Wedding of
the Crown Prince [later
King Jeongjo]*
1762
Kyujanggak (Kyu 13115)
Catalogued as [*Jeongjo
Hyoui hu] garyecheong
docheong uigwe* [正祖孝懿后]
嘉禮廳都廳儀軌

Jeongni uigwe
See *Wonhaeng eulmyo
jeongni uigwe*

Jinjak uigwe
進饌儀軌
*Uigwe of the Royal Banquet
of the Offering of Wine Cups*
1828
Kyujanggak (Kyu 14364)

**[Jinjong] wangseja garye
dogam uigwe**
[眞宗] 王世子嘉禮都監儀軌
*Uigwe of the Wedding of
the Crown Prince [later
King Jinjong]*
1727
BNF (2533) / NMK (Ogu 128)

Jinyeon docheop
進宴圖帖
*Album of the Palace Banquet
That Celebrated the Thirtieth
Anniversary of King Sukjong's
Ascension to the Throne*
1712
National Library of Korea
(Han gwi go jo 51 – na 237)

Jongmyo deungnok
宗廟謄錄
Records of the Jongmyo Shrine
1789
Jangseogak (K2-2174)

**Jongmyo gaesu
dogam uigwe**
宗廟改修都監儀軌
*Uigwe of the Repair of
the Jongmyo Shrine*
1726
Jangseogak (K2-3584)

Jongmyo suri dogam uigwe
宗廟修理都監儀軌
*Uigwe of the Repair of
the Jongmyo Shrine*
1637
BNF (2664) / NMK (Ogu 003)

Jongmyo uigwe
宗廟儀軌
Uigwe of the Jongmyo Shrine
1706
Kyujanggak (Kyu 14220)
The first four volumes,
called *wonjip* 原輯
(original compilation),
were compiled in 1706.
Reduced-size facsimile in
2 vols., with an introduc-
tory essay by Go Yeong-jin
高英津. Seoul: Kyujanggak
Institute for Korean
Studies, Seoul National
University, 1997.

Jongmyo uigwe songnok
宗廟儀軌續錄
Sequel to the Jongmyo Uigwe
Vols. 1–7
1741, 1770, 1785, 1793,
1800, 1820, 1842
Kyujanggak (Kyu 14221)
1741; (Kyu 14223) 1820
Reduced-size facsimile
edition, with introductions
by Yi Uk, Han Hyeong-ju,
and Yi Hyeon-jin. Seong-
nam: Academy of Korean
Studies, 2011–2016.

**Jongmyo Yeongnyeongjeon
jeungsu dogam uigwe**
宗廟永寧殿增修都監儀軌
*Uigwe of the Enlargement and
Repair of the Jongmyo and
Yeongnyeongjeon Shrines*
1836
Jangseogak (K2-3588)

Muja jinjak uigwe
戊子進爵儀軌
*Uigwe of the Royal Banquet
of the Offering of Wine Cups
of the Muja Year*
1828
Kyujanggak (Kyu 14363)

Mujin jinchan uigwe
戊辰進饌儀軌
*Uigwe of the Palace Banquet
of the Mujin Year*
1868
Kyujanggak (Kyu 14374)

Musin jinchan uigwe
戊申進饌儀軌
*Uigwe of the Palace Banquet
of the Musin Year*
1848
Jangseogak (K2-2874)

**[Sado seja] garye
dogam uigwe**
[思悼世子] 嘉禮都監儀軌
*Uigwe of the Wedding
of Crown Prince Sado*
1744
BNF (2682) / NMK (Ogu 157)

Sajecheong uigwe
See *Yeongjeop dogam
sajecheong uigwe*

Sajikseo uigwe
社稷署儀軌
*Uigwe of the Office
of the Sajikdan*
1783
Kyujanggak (Kyu 14229)
Reduced-size facsimile
in 3 vols., with an intro-
duction by Go Yeong-jin
高英津. Seoul: Kyujanggak
Institute for Korean
Studies, Seoul National
University, 1997.

**[Sejo] yeongjeong
mosa dogam uigwe**
[世祖] 影幀模寫都監儀軌
*Uigwe of the Copying
of King Sejo's Portrait*
1735
BNF (2520) / NMK (Ogu 148)

**[Sohyeon seja] garye
dogam uigwe**
[昭顯世子] 嘉禮都監儀軌
*Uigwe of the Wedding of
Crown Prince Sohyeon*
1627
Jangseogak (K2-2592)

**[Sukjong] eojin dosa
dogam uigwe**
[肅宗] 御眞圖寫都監儀軌
*Uigwe of the Painting of
King Sukjong's Portrait*
1713
BNF (2697) / NMK (Ogu 093)

**[Sukjong] garye
dogam uigwe**
[肅宗] 嘉禮都監儀軌
*Uigwe of the Wedding
of King Sukjong*
1718
Kyujanggak (Kyu 13094)

**[Sukjong] gukjang
dogam uigwe**
[肅宗] 國葬都監儀軌
*Uigwe of the Royal Funeral
of King Sukjong*
1720
BNF (2565) / NMK (Ogu 108)

**[Sukjong Inhyeon
wanghu] garye dogam
docheong uigwe**
[肅宗仁顯王后] 嘉禮都監
都廳儀軌
*Uigwe of the Wedding of
King Sukjong and Queen
Inhyeon*
1681
BNF (2527) / NMK (Ogu 054)

**[Sukjong Inwon wanghu]
garye dogam uigwe**
[肅宗仁元王后] 嘉禮都監
儀軌
*Uigwe of the Wedding of
King Sukjong and Queen
Inwon*
1702
BNF (2529) / NMK (Ogu 088)

**[Sukjong] wangseja
chaengnye dogam uigwe**
[肅宗] 王世子冊禮都監儀軌
*Uigwe of the Investiture
of the Crown Prince [later
King Sukjong]*
1667
BNF (2644) / NMK (Ogu 025)

**[Sukjong] wangseja
garye dogam uigwe**
[肅宗] 王世子嘉禮都監儀軌
*Uigwe of the Wedding of
the Crown Prince [later
King Sukjong]*
1671
BNF (2526) / NMK (Ogu 030)
Catalogued as [*Sukjong
Ingyeong wanghu] garye
dogam uigwe* [肅宗仁敬王后]
嘉禮都監儀軌

[Sukjong] yeongjeong
mosa dogam uigwe
[肅宗] 影幀模寫都監儀軌
*Uigwe of the Copying of
King Sukjong's Portrait*
1748
Kyujanggak (Kyu 13997)

Sukseon ongju garye
deungnok
淑善翁主嘉禮謄錄
*Preliminary Records of the
Wedding of Sukseon Ongju*
1804
Jangseogak (K2-2652)

[Sunjo Sunwon wanghu]
garye dogam uigwe
[純祖純元王后] 嘉禮
都監儀軌
*Uigwe of the Wedding
of King Sunjo and Queen
Sunwon*
1802
BNF (2537) / NMK (Ogu 222);
BNF (2536) / NMK (Ogu 223)

[Sunjong] hwangtaeja
garye dogam uigwe
[純宗] 皇太子嘉禮都監儀軌
*Uigwe of the Wedding of the
Crown Prince [later Emperor
Sunjong]*
1906
Kyujanggak (Kyu 13179)

[Sunjong] wangseja
chaengnye dogam uigwe
[純宗] 王世子冊禮都監儀軌
*Uigwe of the Investiture
of the Crown Prince [later
Emperor Sunjong]*
1875
Jangseogak (K2-2691)

[Sunjong] wangseja
garye dogam uigwe
[純宗] 王世子嘉禮都監儀軌
*Uigwe of the Wedding of the
Crown Prince [later Emperor
Sunjong]*
1882
Kyujanggak (Kyu 13174)

[Taejo Wonjong] eojin imo
dogam docheong uigwe
[太祖元宗] 御眞移模都監
都廳儀軌
*Uigwe of the Copying of
King Taejo's and King
Wonjong's Portraits*
1872
Jangseogak (K2-2764)

[Taejo] yeongjeong
mosa dogam uigwe
[太祖] 影幀模寫都監儀軌
*Uigwe of the Copying of
King Taejo's Portrait*
1688
Kyujanggak (Kyu 13978)

[Taejo] yeongjeong
mosa dogam uigwe
[太祖] 影幀模寫都監儀軌
*Uigwe of the Copying of
King Taejo's Portrait*
1838
Kyujanggak (Kyu 13980)

[Taejo] yeongjeong
mosa dogam uigwe
[太祖] 影幀模寫都監儀軌
*Uigwe of the Copying of
King Taejo's Portrait*
1900
Kyujanggak (Kyu 13982)

Uiin wanghu jonho
daebijeon sang jonho
junggungjeon chaengnye,
wangseja chaengnye
gwallyesi chaengnye
dogam uigwe
懿仁王后尊號大妃殿
上尊號中宮殿冊禮王世子
冊禮冠禮時 冊禮都監儀軌
*Uigwe of Elevating the Title of
Queen Uiin, of Elevating the
Title of the Queen Dowager,
the Investiture of the Queen,
and the Investiture and
Coming-of-Age Ceremonies
of the Crown Prince*
1610
Kyujanggak (Kyu 13196)

Uiso seson yejang
dogam uigwe
懿昭世孫睿葬都監儀軌
*Uigwe of the Funeral of
Crown Grandson Uiso*
1752
BNF (2511) / NMK (Ogu 181)

Uisomyo yeonggeon
cheong uigwe
懿昭廟營建廳儀軌
*Uigwe of the Construction
of the Uiso Shrine*
1752
Kyujanggak (Kyu 14259)

Wonhaeng eulmyo
jeongni uigwe
園幸乙卯整理儀軌
*Uigwe of King Jeongjo's
Visit to the Tomb of Crown
Prince Sado in the Eulmyo
Year [printed with
Jeongni metal type]*
1797
Jangseogak (K2-2897)
Reduced-size facsimile
edition. Seoul: Kyujang-
gak Institute for Korean
Studies, Seoul National
University, 1994.
　　Annotated translation
into Hangul, 원행을묘정리
의궤 (역주). Suwon: City of
Suwon, 1996.

Yeongjeop dogam
docheong uigwe
迎接都監都廳儀軌
*Uigwe of the Main Office of
the Superintendency for the
Reception of the Envoys*
1608
Kyujanggak (Kyu 14545,
Kyu 14546)
Reduced-size facsimile
edition. Seoul: Kyujang-
gak Institute for Korean
Studies, Seoul National
University, 1998

Yeongjeop dogam
gunsaek uigwe
迎接都監軍色儀軌
*Uigwe of the Military Sub-
division for the Reception
of the Qing Envoys*
1634
Kyujanggak (Kyu 14561,
Kyu 14562)

Yeongjeop dogam
gunsaek uigwe
迎接都監軍色儀軌
*Uigwe of the Military Sub-
division for the Reception
of the Qing Envoys*
1637
Kyujanggak (Kyu 14577)

Yeongjeop dogam
mimyeonsaek deungnok
迎接都監米麵色謄錄
*Preliminary Records of the
Meal-Preparation Subdivision
for the Reception of the Envoys*
1610
Kyujanggak (Kyu 14558)

Yeongjeop dogam
mimyeonsaek uigwe
迎接都監米麵色儀軌
*Uigwe of the Meal-Preparation
Subdivision for the Reception
of the Envoys*
1610
Kyujanggak (Kyu 14551)

Yeongjeop dogam
sajecheong uigwe
迎接都監賜祭廳儀軌
*Uigwe of the Office in Charge
of the Envoys' Bestowal of
the Imperial Memorial Rite
for King Seonjo*
1608
Kyujanggak (Kyu 14556)
Reduced-size facsimile
edition. Seoul: Kyujang-
gak Institute for Korean
Studies, Seoul National
University, 1998

Yeongjo bi Jeongsun hu
sugyeon uigwe
See [Jeonghae] jangjong
sugyeon uigwe

[Yeongjo Jeongsun
wanghu] garye
dogam uigwe
[英祖貞純王后] 嘉禮
都監儀軌
*Uigwe of the Wedding of
King Yeongjo and Queen
Jeongsun*
1759
BNF (2535) / NMK (Ogu 204),
royal viewing copy;
Jangseogak (K2-2591),
history archive copy
Reduced-size facsimile
edition. Seoul: Kyujang-
gak Institute for Korean
Studies, Seoul National
University, 1994

Yeongnyeongjeon
sugae dogam uigwe
永寧殿修改都監儀軌
*Uigwe of the Repair of
the Yeongnyeongjeon*
1667
Kyujanggak (Kyu 14224)

Five Rites of State

Gukjo oryeui
國朝五禮儀
Five Rites of State
1474
Jangseogak (K2-4761)

Gukjo oryeui seorye
國朝五禮儀序例
*Five Rites of State
with Illustrations*
1474
Jangseogak (K2-2121)

Sequels are listed in
chronological order:

Gukjo sok oryeui
國朝續五禮儀
*Sequel to the
Five Rites of State*
1744
Jangseogak (K2-4759)

Gukjo sok oryeui seorye
國朝續五禮儀序例
*Sequel to the
Five Rites of State
with Illustrations*
1744
Jangseogak (K2-4760)

Gukjo sok oryeui bo
國朝續五禮儀補
*Addendum to the
Sequel to the
Five Rites of State*
1751
Jangseogak (K2-2103)

Hangul translations
(국조오례의, 국조오례의서례,
국조속오례의, 국조속오례의보,
국조속오례의서례). Seoul:
Ministry of Government
Legislation, 1982.

Veritable Records

Joseon wangjo sillok
朝鮮王朝實錄
*Veritable Records of the
Joseon Dynasty*
1413–1865
Modern edition in
48 vols. Seoul: National
Institute of Korean
History, 1955–1965.

Specific volumes and
titles of the *Veritable
Records* are listed in
chronological order:

Taejo sillok
太祖實錄
*Veritable Records
of King Taejo*
15 vols. (*gwon* 卷)
1413

Taejong sillok
太宗實錄
*Veritable Records
of King Taejong*
36 vols. (*gwon* 卷)
1431

Sejong sillok
世宗實錄
*Veritable Records of
King Sejong*
163 vols. (*gwon* 卷)
1454
Kyujanggak (Kyu 12722)

Yejong sillok
睿宗實錄
*Veritable Records
of King Yejong*
8 vols. (*gwon* 卷)
1472

Seongjong sillok
成宗實錄
*Veritable Records
of King Seongjong*
297 vols. (*gwon* 卷)
1499

Jungjong sillok
中宗實錄
*Veritable Records
of King Jungjong*
105 vols. (*gwon* 卷)
1550

Seonjo sillok
宣祖實錄
*Veritable Records
of King Seonjo*
221 vols. (*gwon* 卷)
1616

Gwanghaegun ilgi
光海君日記
*Daily Records of
Gwanghaegun*
187 vols. (*gwon* 卷)
1633

Injo sillok
仁祖實錄
*Veritable Records
of King Injo*
50 vols. (*gwon* 卷)
1653

Sukjong sillok
肅宗實錄
*Veritable Records
of King Sukjong*
65 vols. (*gwon* 卷)
1728

Yeongjo sillok
英祖實錄
*Veritable Records
of King Yeongjo*
127 vols. (*gwon* 卷)
1781

Jeongjo sillok
正祖實錄
*Veritable Records
of King Jeongjo*
56 vols. (*gwon* 卷)
1805

Cheoljong sillok
哲宗實錄
*Veritable Records
of King Cheoljong*
16 vols. (*gwon* 卷),
1 addendum.
1864

Gojong sillok
高宗實錄
*Veritable Records
of Emperor Gojong*
52 vols. (*gwon* 卷)
1935

Joseon Law Codes and Official Diaries

Daehan yejeon
大韓礼典
*Code of the Daehan
Imperial Rites*
1898
Jangseogak (K2-2123)
Hangul edition in 3 vols.
Gugyeok Daehan yejeon
국역 대한예전. Trans.
Im Min-hyeok, Seong
Yeong-jae, et al. Seoul:
Minsogwon, 2018.

Daejeon hoetong
大典會通
*Comprehensive Collection
of National Codes*
1865
Kyujanggak (Kyu 1302)

Gukjo sangnye bopyeon
國朝喪禮補編
*Addendum to the
Funeral Rites of State*
1758
Kyujanggak (Kyu 1010)
Hangul translation
*Gugyeok Gukjo sangnye
bopyeon* 국역국조상례보편.
Compiled by the National
Research Institute of
Cultural Heritage. Seoul:
Minsogwon, 2008.

Gukon jeongnye
國婚定例
*Established Protocol for
a Royal Wedding*
1749
Kyujanggak (Kyu 4)

Gyeongguk daejeon
經國大典
*Grand Law Code for
Managing the Nation*
1484/1485*
NMK (Gu 2647)
Cited as *Joseon Law Code*.
 *Many scholars refer to
the date of publication as

1484 when the bulk of the work was completed. The final version was published and disseminated in January 1485.

Seungjeongwon ilgi
承政院日記
The Diaries of the Royal Secretariat
1623–1894
Reduced-size facsimile edition by the National Institute of Korean History, 1961.

Hangul translation by Korean Classics Research Institute. Seoul: Korean Classics Research Institute, 1994.

Sok daejeon
續大典
Sequel to the Law Code
1746
Kyujanggak (Kyu 1926)
Hangul translation (속대전) by the Ministry of Government Legislation. (Legislation Reference Material no. 19). Seoul: Ministry of Government Legislation, 1965.

Yukjeon jorye
六典條例
Applications of the Six Codes
1867
Kyujanggak (Kyu 5289)
Reprinted in 4 vols. Hangul translation (육전조례) by the Ministry of Government Legislation. Seoul: Ministry of Government Legislation, 1966.

PART II
REFERENCE MATERIALS

Dai kanwa jiten 大漢和辭典 (*Dictionary of Chinese and Japanese Characters*). By Morohashi Tetsuji 諸橋轍次. 13 vols. Tokyo: Taishūkan Shoten 大修館書店, 1955–1960.

Geunyeok seohwa jing 槿域書畫徵 (*Biographical Dictionary of Korean Calligraphers and Painters*). Comp. O Se-chang 吳世昌. 1916; Seoul: Bomun seojeom, 1975.

Go beopjeon yongeojip 古法典用語集 (*Glossary of Old Korean Legal Terminology*). Seoul: Ministry of Government Legislation 法制處, 1979.

Gugong shuhua tulu 故宮書畫圖錄 (*Illustrated Catalogue of Calligraphy and Painting in the National Palace Museum*). Vol. 2. Taipei: National Palace Museum, 1989.

Gyujanggak sojang uigwe haejejip 규장각소장의궤해제집 (*Notes on Uigwe Documents in Kyujanggak*). 3 vols. Seoul: Kyujanggak Institute for Korean Studies, Seoul National University, 2005.

Gyujanggak sojang uigwe jonghap mongnok 규장각 소장 儀軌 종합목록 (*Complete List of Uigwe in the Kyujanggak Institute for Korean Studies*). Seoul: Kyujanggak Institute for Korean Studies, Seoul National University, 2002.

Hanguk hanjaeo sajeon 韓國漢字語辭典 (*Dictionary of Chinese-Character Terms Coined in Korea*). 4 vols. Compiled and published by the Institute of Oriental Studies, Dankook University, 1992.

Hanguk hoehwa sa yongeo jip 한국회화사용어집 (*Dictionary of Names and Terms in the History of Korean Painting*). By Yi Song-mi 李成美 and Kim Junghee 金廷禧. Revised and enlarged edition. Seoul: Dahal Media, 2015.

Hanguk minjok munhwa daebaekgwa sajeon 한국 민족문화대백과사전 (*Encyclopedia of Korean People and Culture*). 28 vols. Seongnam: Academy of Korean Studies, 1995.

Hanguk seohwaga inmyeong sajeon 韓國書畫家人名辭典 (*Biographical Dictionary of Korean Calligraphers and Painters*). By Kim Yeong-yun 金榮胤. 1959; Seoul: Yesul chunchusa, 1978.

Hanyeong uri munhwa yongeojip 한영우리문화용어집 (*Glossary of Korean Culture*). Compiled by Song Ki-joong et al. Seoul: Jimoondang, 2001.

Hwasa yangga borok 畫寫兩家譜錄 (*Records of the Family Lineage of Painters and Calligraphers*). Comp. O Se-chang 吳世昌 1916. Seoul: Jisik saneopsa, 1975.

Idu sajeon 이두사전 (*Dictionary of Idu Writing System*). By Jang Ji-yeong 장지영 and Jang Se-gyeong 장세경. Seoul: Sanho, 1991.

Jangseogak doseo hangukpan chong mongnok 藏書閣圖書韓國版總目錄 (*Comprehensive List of Korean Books in Jangseogak Archives*). Cultural Heritage Administration, 1972; Seongnam: Academy of Korean Studies, 1983.

Jangseogak sojang doseo haeje 藏書閣所藏圖書解題 (*Introduction to Books in Jangseogak Archives I*). Seongnam: Academy of Korean Studies, 1995.

Munhwajae myeong yeongmun pyogi 문화재명 영문표기 (*Transliteration and Translation of Names and Terms of Korean Cultural Heritage*). Compiled by the National Institute of Korean Language and the Cultural Heritage Administration, 2019.

Naegak illyeok 內閣日曆 (*Daily Calendar of Naegak [Kyujanggak]*). 1,245 vols. 1779–1883.

Shiqu baoji 石渠寶笈 (*Treasured Boxes of the Stony Moat [Catalogue of Painting and Calligraphy in the Qianlong Imperial Collection]*). Vol. 2, Xubian 續篇 (*Sequel*). Taipei: National Palace Museum, 1971.

Sinjeung dongguk yeoji seungnam 新增東國輿地勝覽 (*Newly Enlarged Edition of Survey of the Geography of Korea*). 1530. Modern editions printed in 1906, 1912, and 1960. Hangul translation by the Korean Classics Research Institute. Seoul: Korean Classics Research Institute (Minjok munhwa chujinhoe 民族文化推進會), 1969.

Zhongguo gudai shuhua tumu 中國古代書畫圖目 (*Illustrated Catalogue of Selected Works of Ancient Chinese Painting and Calligraphy*). Vol. 11. Beijing: Wenwu chubanshe, 1993.

Zhongguo meishujia renming da cidian 中國美術家人名大辭典 (*Biographical Dictionary of Chinese Painters*). Comp. Yu Jianhua 俞劍華. Shanghai: Shanghai renmin meishu chubanshe, 1981.

Zhongwen da cidian 中文大辭典 (*Comprehensive Dictionary of the Chinese Language*). Eds. Zhang Qiyun 張其昀, Lin Yin 林尹, and Gao Ming 高明. 40 vols. Taipei: Zhonghua shuju, 1962–68.

PART III
WORKS CITED

Ahn Hwi-joon (An Hwi-jun) 安輝濬. "Donggwoldo" 東闕圖 (Painting of the East Palace). In *Hanguk ui gunggwol do* 韓國의 宮闕圖 (*Paintings of Korean Palaces*), 21–62. Seoul: Cultural Heritage Administration, 1991.

———. "*Gwanajae go ui hoehwasa jeok uiui*" 「觀我齋稿」의 繪畫史的 意義 (Art-Historical Significance of Collected Writings of Jo Yeong-seok). In *Gwanajae go* 觀我齋稿 (*Unpublished Writings of Jo Yeong-seok [Gwanajae]*), 3–17. Seongnam: Academy of Korean Studies, 1984.

———. "Gyujanggak sojang hoehwa ui nae-yong gwa seonggyeok" 奎章閣所藏 繪畫의 內容과 性格 (Contents and Characteristics of Paintings in the Kyujanggak Collection). *Hanguk munhwa* 10 (1989): 309–92.

———. *Hanguk hoehwasa* 韓國繪畫史 (*History of Korean Painting*). 2 vols. Seoul: Iljisa, 1980, 1986.

Amorepacific Museum of Art, ed. *Joseon, byeongpung ui nara* 조선, 병풍의 나라 (*Joseon, the Country of Folding Screens/Beyond Folding Screens*). Seoul: Amorepacific Museum of Art, 2018.

Bak Cheon-wu 박천우 and Kim Eun-jin 김은진. "Hwaseong chukseong e gwanhan yeongu" 華城 築城에 關한 硏究: 鄭茶山의 城說을 중심으로 (A Study of the Construction of the Hwaseong Fortress Based on Jeong Dasan's Theory of Fortress Construction). *Jangan nonchong* 長安論叢 23 (February 2003): 5–24.

Bak Eun-gyeong 朴恩慶. "Joseon hugi wangsil garye yong byeongpung yeongu" 朝鮮後期 王室 嘉禮用 屛風硏究 (A Study of the Screen Paintings Used for Royal Weddings of the Late Joseon Period). MA thesis, Seoul National University, 2012.

Bak Sim-eun 朴沁恩. "Joseon sidae chaekgado ui giwon yeongu" 朝鮮時代 冊架圖의 起源 硏究 (A Study on the Origins of Joseon Period *Chaekka-do*). MA thesis, Academy of Korean Studies, 2002.

Baker, Donald L. "Jesuit Science through Korean Eyes." *Journal of Korean Studies* 4 (1982–83): 207–39.

Black, Kay E. *Ch'aekkŏri Painting: A Korean Jigsaw Puzzle*. Seoul: Sahoipyoungnon, 2020.

Black, Kay E., and Edward W. Wagner. "Ch'aekkŏri Paintings: A Korean Jigsaw Puzzle." *Archives of Asian Art* 46 (1993): 63–75.

———. "Court Style Ch'aekkŏri." In *Hopes and Aspirations: Decorative Painting of Korea*, edited by Kumja Paik Kim, 22–35. San Francisco, CA: Asian Art Museum in San Francisco, 1998.

Byeon In-seok 卞麟錫. "Sago jeonseo wa hangugin buchongjae Kim Gan e daehayeo" 四庫全書와 韓國人 副總裁 金簡에 對하여 (*Siku quanshu* and the Korean Vice Superintendent Kim Gan). *Dongyang sahak yeongu* 東洋史學硏究 (*Journal of Asian Historical Studies*) 10 (May 1976): 64–95.

Chengshi moyuan 程氏墨苑 (*Master Cheng's Ink Garden*). Compiled by Cheng Dayue 程大約. Illustrated by Ding Yunpeng 丁雲鵬. 1605.

Cheon Hye-bong 千惠鳳. *Naryeo inswaesul ui yeongu* 羅麗印刷術의 研究 (*A Study of the Silla and Goryeo Printing Techniques*). Seoul: Gyeongin munhwasa, 1980.

Cho Insoo (Jo In-su) 조인수. "Joseon hubangi eojin ui jejak gwa bong-an" 조선후반기 어진의 제작과 봉안 (Making and Installing of the Late Joseon Period Royal Portraits). In *Dasi boneun uri chosang ui segye* 다시 보는 우리 초상의 세계 (*Re-examining the World of Korean Portraiture*), 7–32. Daejeon: National Research Institute of Cultural Heritage, 2007.

———. "Joseon wangsil eseo hwaryak han hwawon deul: Eojin jejak eul jungsim euro" 조선왕실에서 활약한 화원들: 어진 제작을 중심으로 (Joseon Dynasty Court Painters and Royal Portraiture). In *Hwawon* 화원: 朝鮮畫員 大展 (*The Court Painters of the Joseon Dynasty*), 283–95. The English translation appears following the Korean version, 293–95. Exhibition catalogue. Seoul: Leeum, Samsung Museum of Art, 2011.

———. "Royal Portraits in the Late Joseon Period." *Journal of Korean Art and Archaeology* 5 (2011): 9–23.

Cho Sun-Mie (Jo Seon-mi) 조선미. *Chosanghwa yeongu: Chosang hwa wa chosang hwaron* 초상화 연구: 초상화와 초상화론 (*Studies on Portraiture: Portraits and Theories on Portrait*). Seoul: Munye chulpansa, 2007.

———. *Great Korean Portraits: Immortal Images of the Noble and the Brave*. Seoul: Dolbegae, 2010.

———. "Joseon sidae e isseoseo ui jinjeon ui baldal — munheon sang e natanan girok eul jungsim euro" 朝鮮時代에 있어서의 眞殿의 發達 — 文獻上에 나타난 記錄을 中心으로 (The Development of the Joseon Period Royal Portrait Halls — As Seen through Documentary Evidence). *Gogo misul* 考古美術 145 (1980): 10–23.

Choe Bong-yeong 崔鳳永. *Yeongjo wa Sado seja iyagi* 영조와 사도세자 이야기 (*Stories of King Yeongjo and Crown Prince Sado*). Seongnam: Academy of Korean Studies, 2013.

Choe Yeong-suk 崔榮淑. "Joseon sidae jinjeon ui jangeom gwa uimul yeongu" 조선시대 眞殿의 莊嚴과 儀物 연구 (A Study of the Ritual Objects and Solemnly Adorning the Interior of the Portrait Hall of the Joseon Period). PhD diss., Hongik University, 2016.

Choe-Wall Yang Hi. *The Jehol Diary: Yŏrha ilgi of Pak Chiwŏn (1737–1805)*. Folkestone, UK: Global Oriental, 2010.

Chung, Byungmo (Jeong Byeong-mo) and Sunglim Kim (Seong-lim Kim), eds. *Chaekgeori: The Power and Pleasure of Possessions in Korean Painted Screens*. Seoul: Dahal Media, 2017.

Deuchler, Martina. *The Confucian Transformation of Korea: A Study of Society and Ideology*. Cambridge, MA: Council on East Asian Studies, Harvard University, 1992.

———. "Propagating Female Virtues in Chosŏn Korea." In *Women and Confucian Cultures in Premodern China, Korea, and Japan*, edited by Dorothy Ko, 142–69. Berkeley, CA: University of California Press, 2003.

Dongguk sinsok Samgang haengsildo 東國新續三綱行實圖 (*Sequel to the Illustrated Conducts of the Three Bonds of the Eastern Nation*). 1617. Facsimile editions by National Central Library, 1959; Seoul: Daejegak, 1978.

Duncan, John. "The *Naehun* and the Politics of Gender in Fifteenth-Century Korea." In Kim-Renaud, *Creative Women of Korea*, 26–57.

Ewha Womans University, ed. *Joseon sinbunsa yeongu* 朝鮮身分史研究 (*A Study of Joseon Social Status*). Seoul: Beommunsa, 1987.

Gang Seon-jeong 강선정. "Joseon hugi baekjado yeongu" 조선후기 百子圖 연구 (*A Study of Paintings of One Hundred Children of the Late Joseon Period*). *Misul sahak* 18 (2004): 7–40.

Go Yeon-hui (Kho Youen-hee) 고연희. "Ichyeojin wangsil byeongpung: hwacho byeong gwa inchu yeongmo byeong" 잊혀진 왕실 병풍: 화초병과 인추영모병 (Forgotten Royal Screen Paintings: Flowering Plants and Birds and Animals). *Misulsa nondan* 43 (2016): 7–30.

Goryeosa 高麗史 (*History of the Goryeo Dynasty*). Compiled by Jeong In-ji 鄭麟趾 et al. 1452.

Gu Sa-hoe 구사회. "Gongjak" 공작 (Peacock). In *Joseon sidae daeil oegyo yongeo sajeon* 조선시대 대일외교 용어 사전 (*Dictionary of Korea–Japan Diplomacy of the Joseon Period*). Seongnam: Academy of Korean Studies, ca. 2015.

Gugyeok Chingyeong chinjam uigwe 국역 친경 친잠 의궤 (Hangul translation of the *Uigwe of Royal Agriculture and Sericulture*). Translated by Bak So-dong. Seoul: Korean Classics Research Institute (Minjok munhwa chujinhoe 民族 文化推進會), 1999. See also: *Chingyeong uigwe* and *Chinjam uigwe* in References, Part I.

Gugyeok Jeongjo gukjang dogam uigwe 국역 정조국장 도감의궤 (Hangul translation of the *Uigwe of the Royal Funeral of King Jeongjo*). Translated by the National Research Institute of Cultural Heritage. Seoul: Minsogwon, 2006. See also: [*Jeongjo*] *gukjang dogam uigwe* in References, Part I.

Gugyeok Gukjo sangnye bopyeon 국역국조상례보편. (Hangul translation of the *Addendum to the Funeral Rites of State*). Compiled by the National Research Institute of Cultural Heritage. Seoul: Minsogwon, 2008. See also: *Gukjo sangnye bopyeon* in References, Part I.

Gunggwol ui jangsik geurim 궁궐의 장식그림 (*Palace Decorative Paintings*). Exhibition catalogue. Seoul: National Palace Museum of Korea, 2009.

Gyeonggi Provincial Museum, ed. 경기도박물관. *Joseon seonbi ui seojae eseo hyeondaein ui seojae ro* 조선 선비의 서재에서 현대인의 서재로 (*Chaekgeori Screen Paintings: History of Studies from the Joseon Dynasty to Modern Times*). Yongin: Gyeonggi Provincial Museum, 2012.

Haboush, JaHyun Kim (Ja-hyeon Kim). *A Heritage of Kings: One Man's Monarchy in the Confucian World*. New York: Columbia University Press, 1988.

———. *The Memoirs of Lady Hyegyŏng: The Autobiographical Writings of a Crown Princess of Eighteenth-Century Korea*. Berkeley, CA: University of California Press, 1996.

———. "Private Memory and Public History: The Memoirs of Lady Hyegyŏng and Testimonial Literature." In Kim-Renaud, *Creative Women of Korea*, 122–41.

———. "Rescoring the Universal in a Korean Mode: Eighteenth-Century Korean Culture." In Kim, *Korean Arts of the Eighteenth Century*, 23–34.

Han Hyeong-ju 한형주. *Bat ganeun Yeongjo wa nue chineun Jeongsun wanghu* 밭가는 영조와 누에치는 정순왕후 (*Yeongjo Tills the Field While Queen Jeongsun Raises Silkworms*). Seongnam: Academy of Korean Studies, 2013.

Han Hyeong-ju 한형주, **Kim Mun-sik** 김문식, **et al.** *Joseon ui gukga jesa* 조선의 국가제사 (*State Sacrificial Rites of Joseon*). Seongnam: Academy of Korean Studies, 2009.

Han Jong-cheol 한종철 **and Nam Yu-mi** 남유미. "Joseon hugi byeongpung ui janghwang hyeongtae mit jejak gibeop yeongu" 조선후기 병풍의 장황형태 및 제작기법 연구 (*A Study of the Mounting Techniques and the Forms of the Late Joseon Period Screen Paintings*). *Samsung*

misulgwan yeongu nonmun jip 삼성미술관 연구논문집 I (2005): 161–85.

Han Myeong-gi 韓明基. "Gwanghaegun ui daeoe jeongchaek jaeron" 光海君의 對外政策 再論 (Re-examining Gwanghaegun's Foreign Policy). *Hanguk bulgyosa yeongu* 韓國佛敎史研究 (*Studies in Korean Buddhism*) 2 (Fall/Winter 2012): 171–228.

Han Myeong-gi 한명기. "Sipchil segi cho eun ui yutong gwa geu yeonghyang" 一七세기 초 銀의 유통과 그 영향 (The Circulation of Silver at the Beginning of the Seventeenth Century and Its Influence). *Gyujanggak* 규장각 15 (1991): 1–36.

Han Young-woo. *A Unique Banchado: The Documentary Painting of King Jeongjo's Royal Procession to Hwaseong in 1795*. Translated by Chung Eunsun. Amsterdam: Amsterdam University Press, Renaissance Books, 2017.

Han Young-woo (Han Yeong-wu) 韓永愚. "Jeongjo ui Hwaseong geonseol gwa *Hwaseong seongyeok uigwe*" 正祖의 華城건설과 「華城城役儀軌」 (King Jeongjo's Construction of the Hwaseong Fortress and the *Hwaseong seongyeok uigwe*). In *Hwaseong seongyeok uigwe gugyeok jeungbopan* 화성성역의궤 국역 증보판. Suwon: Gyeonggi munhwa jaedan, 2005.

Han Young-woo (Han Yeong-wu) 한영우. *Jeongjo ui Hwaseong haengcha, geu 8 il* 정조의 화성행차 그 8일 (*King Jeongjo's Trip to Hwaseong, the Eight Days*). Seoul: Hyohyeong chulpansa, 1998.

———. "Jeongjo wa Hwaseong: Hwaseong geonseol gwa neunghaeng ui uimi" 정조와 화성: 화성건 설과 능행(陵幸)의 의미 (King Jeongjo and Hwaseong: The Significance of the Construction of Hwaseong and His Visit to the Tomb of His Father). In *Geundae reul hyanghan kkum* 근대를 향한 꿈 (*Dream for the Modernity*), 78–103. Exhibition catalogue. Yongin: Gyeonggi Provincial Museum, 1998.

———. *Joseon sidae shinbunsa yeongu* 朝鮮時代 身分史 研究 (*A Study of the History of Social Status in the Joseon Period*). Seoul: Jimmundang, 1997.

———. *Joseon wangjo uigwe* 조선왕조 의궤 (*Book of State Rites in the Joseon Dynasty*). Seoul: Iljisa, 2005.

Hong Dae-yong 洪大容 (1731–1783). *Damheonseo* 湛軒書 (*Hong's Collected Writings*), *oejip* (outer volumes) 外集, vol. 7: *Yeongi* 燕記 (Record of Travel to Yanjing). 1790.

———. *Damheonseo: naejip sagwon oejip sipgwon* 湛軒書: 內集四卷外集十卷 (*Hong's Collected Writings: Four Inner Volumes and Ten Outer Volumes*). Vol. 10: section called

Jugyeon jesa: geumchuk
主見諸事: 禽畜 ([My] Own
Observations of Things:
Birds and Animals).
Gyeongseong [Seoul]:
Sin Joseonsa, 1939.

Huh, Dong-hwa (Heo
Dong-hwa). *The Wonder
Cloth*. Seoul: Museum of
Korean Embroidery, 1988.

Hwang Jeong-yeon 황정연.
"Joseon sidae jinjeon ui
yeoksa wa Sinseonwonjeon" 조선시대 眞殿의 역사와
신선원전 (A History of
Royal Portrait Halls
of the Joseon Dynasty
and the New Seonwonjeon). In *Sinseonwonjeon:
choehu ui jinjeon* 新璿源殿:
최후의 진전 (*The New Seonwonjeon: The Last Royal
Portrait Hall*), edited by the
National Research Institute of Cultural Heritage,
84–111. Daejeon: National
Research Institute of Cultural Heritage, 2010.

Hwang, Kyung Moon
(Hwang Gyeong-mun).
*Beyond Birth: Social Status
in the Emergence of Modern
Korea*. Cambridge, MA:
Harvard University Asia
Center, 2004.

*Hwaseong seongyeok
uigwe gugyeok jeungbopan*
화성성역의궤 국역증보판
(Revised and enlarged
Hangul translation of
the [1994 reduced-size
facsimile of the] *Uigwe
of the Construction of the
Hwaseong Fortress*). Suwon:
Gyeonggi munhwa jaedan,
2005.
See also: *Hwaseong seongyeok uigwe* in References,
Part I.

Im Min-hyeok 임민혁, Seong
Yeong-jae 성영재, et al.
Gugyeok Daehan yejeon 국역
대한예전 (Hangul translation of the *Code of the
Daehan Imperial Rites*). 3 vols.
Seoul: Minsogwon, 2018.
See also: *Daehan yejeon* in
References, Part I.

Im Myeong-mi 임명미. "Han
Jung Il samguk ui *gyu
hol* e gwanhan yeongu"
한중일 3국의 규홀에 관한 연구
(A Study of *gyu* and *hol* of
Korea, China, and Japan).
Boksik 51, no. 2 (2001): 5–25.

Jang Gyeong-hui 張慶嬉.
"Joseon wangjo wangsil
garye yong gongye pum
yeongu" 朝鮮王朝 王室嘉
禮用 工藝品 研究 (A Study
of Handicraft Items Used
in the Royal Wedding
Rites of the Joseon Period).
PhD diss., Hongik University, 1999.

Jang Gyeong-hui 장경희.
Uigwe sok Joseon ui jangin
의궤 속 조선의 장인 (*Joseon
Artisans Recorded in Uigwe*).
2 vols. Seoul: Solgwahak,
2013.

Jang Pil-gi 장필기. *Yeongjo
dae ui musin ran: tang-
pyeong ui gil eul yeolda*
영조 대의 무신란: 탕평의
길을 열다 (*Military Revolts
during the Reign of King
Yeongjo: Opening the Road
to the Policy of Impartiality*).
Seongnam: Academy of
Korean Studies, 2014.

Je Song-hui 제송희.
"Jeongjo sidae *banchado*
wa Hwaseong won-
haeng" 정조시대 반차도와
화성원행 (Painting of the
Procession by Rank of
King Jeongjo's Era and

His Visit to His Father's
Tomb in Hwaseong).
In *Jeongjo, parilgan ui
Suwon haengcha* 정조,
팔일간의 수원행차, edited
by the Suwon Hwaseong
Museum 수원화성박물관,
276–89. Suwon: Suwon
Hwaseong Museum, 2015.

Je Song-hui 諸松姬. "Joseon
sidae uirye *banchado*
yeongu" 조선시대 儀禮
班次圖 研究 (A Study of the
Paintings of Procession
by Rank in the State Rites
of the Joseon Period). PhD
diss., Graduate School of
the Academy of Korean
Studies, 2013.

Jeong Byeong-mo 鄭炳模.
"Paemunjae gyeongjikdo
ui suyong gwa jeongae"
佩文齋耕織圖의 受容과 展開
(The Process of Reception
of the *Peiwenzhai gengzhi
tu*). MA thesis, Graduate
School of the Academy of
Korean Studies, 1983.

Jeong Eun-ju 鄭恩主.
"Gyeongjin dongji Yeon-
haeng gwa Simyanggwan
docheop" 庚辰冬至燕行과
瀋陽館圖帖 (The Winter
Solstice Emissary to
Yanjing in the *Gyeongjin*
Year and the *Simyanggwan
do* Album). *Myeongcheong
sa yeongu* 明淸史研究 25
(April 2007): 97–138.

———. *Joseon sidae sahaeng
girok hwa* 조선시대 사행기록화
(*Documentary Paintings of
Joseon Emissaries to China*).
2012. Reprint, Seoul:
Sahoe pyeongnon, 2014.

Jeong Yak-yong 丁若鏞.
"*Seongseol*" 城設 (On the
Construction of the
[Hwaseong] Fortress).

In *Simunjip* 詩文集 (*Poetry
and Prose*), vol. 5. Hangul
translation of *Dasan
simunjip* 다산시문집.
10 vols. Institute for the
Translation of Korean
Classics (Hanguk gojeon
beonyeogwon 韓國古典
翻譯院), 1982–1997.

———. *Yeoyudang jeonseo*
與猶堂全書 (*Complete
Writings of Jeong Yak-yong
[Yeoyudang]*). Seoul: Mun-
heon pyeonjip wiwonhoe,
1962.

Jeong Yang-mo 鄭良謨.
"Joseon jeongi ui hwaron"
朝鮮前期의 畫論 (Painting
Theories of the Early
Joseon Period). In *Sansu
hwa* 山水畵 (*Landscape
Painting*), edited by Ahn
Hwi-joon 安輝濬, 177–90.
Hanguk ui mi 韓國의 美
(*Beauty of Korea*) series 11,
vol. 1. Seoul: Jungang
Daily, 1980.

———. *Joseon sidae hwaga
chongnam* 朝鮮時代畵家總覽
(*A Comprehensive Survey of
Joseon Period Painters*). 2 vols.
Seoul: Sigongsa, 2017.

Jeong Yeong-mi 鄭瑛美.
"Joseon hugi Gwak Bun-
yang haengnakdo yeongu"
朝鮮後期 郭汾陽行樂圖 研究
(A Study of the Late Joseon
Period "Happy Life of Guo
Fenyang" Paintings). MA
thesis, Graduate School
of the Academy of Korean
Studies, 1999.

Ji Min-gyeong 지민경.
"Sip–sipsa segi Dongbuga
byeokhwa gobun yesul
ui jeongae wa Goryeo
byeokhwa gobun ui uiui"
10–14세기 동북아 벽화고분
예술의 전개와 고려 벽화고분의

의의 (The Development
of Tomb Mural Paintings
in Northeast Asia of the
Tenth through the Four-
teenth Century and the
Significance of the Goryeo
Mural Tombs). *Misulsa
yeongu* 25 (2011): 67–107.

Jin Jun-hyeon 진준현.
*Danwon Kim Hong-do
yeongu* 단원김홍도 연구
(*A Study of Danwon Kim
Hong-do*). Seoul: Iljisa,
1999.

Jin Jun-hyeon 陳準玄.
"Sukjong dae eojin dosa
wa hwaga deul" 肅宗代
御眞圖寫와 畵家들 (The
Painting of Royal Portraits
and Portrait Painters
during the Reign of King
Sukjong). *Gomunhwa*
古文化 46 (June 1995):
89–119.

———. "Yeongjo · Jeongjo
dae eojin dosa wa hwaga
deul" 英祖 · 正祖代 御眞圖
寫와 畵家들 (The Painting
of Royal Portraits and Por-
trait Painters during the
Reigns of Kings Yeongjo
and Jeongjo). *Seoul daehak-
gyo bangmulgwan yeonbo*
서울 大學校博物館 年報 6
(December 1994): 9–72.

Jo Gye-yeong 조계영.
"Bong-an seochaek gwa
Oegyujanggak *uigwe* ui
janghwang" 봉안 서책과
외규장각 의궤의 장황 (Com-
parative Analysis of the
Bindings of the Oegyu-
janggak *Uigwe* and Other
Joseon Royal Texts). In
*Oegyujanggak uigwe ui jang-
hwang* 외규장각 의궤의 粧
黃 (*Bookbinding of the Oegyu-
janggak Uigwe*), 12–33.
Seoul: National Museum
of Korea, 2014.

Jo Pung-yeon 조풍연. *Sajin euro boneun Joseon sidae saenghwal gwa pungsok* 사진으로 보는 朝鮮時代 생활과 풍속 (*Life and Customs of the Joseon Period Seen through Photographs*). Seoul: Seo-mundang, 1986.

Jo Seung-u 조승우. "Cheon gubaek chilsip nyeon-dae Suwon Hwaseong bogwon ui baegyeong gwa jeongae gwajeong" 1970 년대 수원화성 복원의 배경과 전개과정 (The Background and Process of the Recon-struction in the 1970s of Suwon Hwaseong). In *Cheon gubaek chilsip nyeondae Suwon Hwaseong bogwon gwa girok* 1970 년대 수원화성 복원과 기록 (*The Reconstruction in the 1970s of Suwon Hwaseong and Its Records*), edited by the Suwon Hwaseong Museum 수원화성박물관, 180–83. Suwon: Suwon Hwaseong Museum, 2013.

Jo Yong-jin 趙鏞珍. *Dong-yanghwa ingneun beop* 東洋畵 읽는 법 (*How to Read East Asian Painting*). Seoul: Jimmundang, 1989.

Jongmyo, The Royal Ancestral Shrine 종묘 宗廟. Exhibition catalogue. Seoul: National Palace Museum of Korea, 2014.

Joseon Law Code See *Gyeongguk daejeon* in References, Part I.

Joseon sidae jido wa hoehwa 조선시대 지도와 회화 (*Histor-ical Maps and Topographical Landscape Paintings of Joseon Dynasty*). Catalogue of Korean Painting and Cal-ligraphy in the National Museum of Korea, vol. 21. Seoul: National Museum of Korea, 2013.

Joseon ui wangbi wa hugung 조선의 왕비와 후궁 (*Queens and Concubines of the Joseon Dynasty*). Seoul: National Palace Museum of Korea, 2015.

Joseon wangsil ui eojin gwa jinjeon 조선왕실의 어진과 진전 (*Joseon Dynasty's Royal Portraits and Portrait Halls*). Exhibition catalogue. Seoul: National Palace Museum of Korea, 2015.

Joseon wangsil ui gama 조선왕실의 가마 (*Royal Palan-quins of the Joseon Dynasty*). Exhibition catalogue. Seoul: National Palace Museum of Korea, 2005.

Jungmann, Burglind. "Doc-umentary Record versus Decorative Representa-tion: A Queen's Birthday Celebration at the Korean Court." *Arts Asiatiques* 62 (2007): 95–111.

———. *Pathway to Korean Culture: Paintings of the Joseon Dynasty, 1392–1910*. London: Reaktion Books, 2014.

———. "Sin Sukju's Record on the Painting Collection of Prince Anpyeong and Early Joseon Antiquari-anism." *Archives of Asian Art* 61 (2011): 107–26.

Kang Gwan-shik (Gang Gwan-sik) 姜寬植. "Gwanajae Jo Yeong-seok hwahak go" 觀我齋 趙榮祏 畵學考 (A Study of Jo Yeong-seok's Works and His View on Painting). Pts. 1 and 2. *Misuljaryo* 美術資料 44 (December 1989): 114–49; 45 (June 1990): 11–70.

———. "Gyeomjae Jeong Seon ui sahwan gyeong-nyeok gwa aehwan" 謙齋 鄭敾의 仕宦經歷과 哀歡 (Gyeomjae Jeong Seon's Official Career, and Its Sorrow and Pleasure). *Misulsa hakbo* 美術史學報 29 (2007): 137–94.

———. *Joseon hugi gungjung hwawon yeongu* 朝鮮後期 宮中畵員研究 (*A Study of Court Painters of the Late Joseon Period*). 2 vols. Seoul: Dolbegae, 2001.

———. "Joseon junghugi ui Seochongdae chinim yeonhoedo" 朝鮮 中後期의 瑞蔥臺親臨宴會圖 (Paint-ings of the Royal Banquet at Seochongdae of the Mid- to Late Joseon Period). Unpublished seminar paper of 33 pages, delivered at the Seminar on Late Joseon Period Painting, Seoul National University, Spring 1992.

———. "Joseon sidae dohwaseo hwawon jedo" 朝鮮時代 圖畵署 畵員制度 (The Joseon Period System of the Court Bureau of Painting). In *Hwawon* 화원: 朝鮮畵員大展 (*Court Painters of the Joseon Dynasty*), 261–82. Exhibition catalogue. Seoul: Leeum, Samsung Museum of Art, 2011.

Kim Bu-sik 金富軾. *Samguk sagi* 三國史記 (*History of the Three Kingdoms*). 1145. See also *Yeokju Samguk sagi* 譯註三國史記 (*Annotations on the History of the Three Kingdoms*). Gyeonggi,

Seongnam: Hanguk jeongsin munhwa yeon-guwon, 1996.

Kim Dong-uk. 김동욱. *Jongmyo wa Sajik* 종묘와 사직 (*The Jongmyo Royal Ancestral Shrine and the Sajik Platforms*). Seoul: Daewonsa, 1990.

Kim Hongkyung (Hong-gyeong). "Joseon: A Dynasty Founded on Confucian Classics." In *Treasures from Korea: Arts and Culture of the Joseon Dynasty, 1392–1910*, edited by Hyunsoo Woo (Wu Hyeon-su), 13–23. Exhibition catalogue. Philadelphia, PA: Philadel-phia Museum of Art, 2014.

Kim Hongnam 金紅男. "Irwol obong byeong gwa Jeong Do-jeon" 일월오봉 병과 정도전 (Jeong Do-jeon and the Screen of the Sun and Moon and Five Peaks). In *Jungguk Hanguk misulsa* 중국 한국미술사 (*Chinese and Korean Art History*), 458–67. Seoul: Hakgojae, 2009.

———. "Joseon sidae gungmoran byeong yeongu" 조선시대 궁모란병 연구 (A Study of the Screen of Peony of the Joseon Period). In *Jungguk Hanguk misulsa* 중국한국미술사 (*Chinese and Korean Art History*), 468–517. Seoul: Hakgojae, 2009.

———. "Jungguk Gwak Jaui chuksudo yeongu: yeonwon gwa baljeon" 중국 〈郭子儀祝壽圖〉 연구: 연원과 발전 (A Study of Chinese Painting of the Birthday Celebration of Guo Ziyi). *Misulsa nondan* 美術史 論壇 33 (December 2011): 165–202.

———, ed. *Korean Arts of the Eighteenth Century: Splendor and Simplicity*. New York: Asia Society Galleries, 1993.

Kim Ji-yeong 金芝英. "Joseon hugi gugwang haengcha e daehan yeongu: Uigwe banchado wa geodong girok eul jungsim euro" 朝鮮後期 국왕 行次에 대한 연구: 儀軌班 次圖와 擧動記錄을 중심으로 (A Study of Outings of the Late Joseon Period Kings: Based on the *Uigwe Ban-chado* and Documented Outings). PhD diss., Seoul National University, 2005.

———. "Yeongjo dae chingyeong uisik ui geo-haeng gwa *chingyeong uigwe*" 영조대 친경의식의 거행과 친경의궤 (The Per-formance of the Royal Farming Rites during the Reign of King Yeongjo and the *Uigwe* of Royal Farming Rites). *Hanguk hakbo* 韓國學報 28, no. 2 (2002): 55–86.

Kim, Kichung (Gi-cheong). "Hŏ Nansŏrhŏn and "Shakespeare's Sister." In Kim-Renaud, *Creative Women of Korea*, 78–95.

Kim, Kumja Paik. "King Jeongjo's Patronage of Kim Hong-do." *Archives of Asian Art* 66, no. 1 (2016): 51–80.

———, ed. *Hopes and Aspi-rations: Decorative Painting of Korea*. Exhibition catalogue. San Francisco, CA: Asian Art Museum of San Fran-cisco, 1998.

Kim Mi-ra 金美羅. "Joseon hugi okchaek naeham yeongu" 朝鮮後期 玉冊 內函 研究 (A Study of the Inner Container of a Jade Book of the Late Joseon Period). PhD diss., Sookmyung Women's University, 2015.

Kim Mun-sik 김문식. "Eulmyo nyeon Suwon haengcha wa geu uiui" 을묘년 수원 행차와 그 의의 ([King Jeongjo's] Visit to Suwon in the Eulmyo Cyclical Year, 1795). In Jeongjo, parilgan ui Suwon haengcha 정조, 8일간의 수원행차 (King Jeongjo's Eight-Day Trip to Suwon), edited by the Suwon Hwaseong Museum 수원화성박물관, 262–75. Suwon: Suwon Hwaseong Museum, 2015.

———. "Joseon wangsil ui chinyeongnye yeongu" 조선왕실의 親迎禮 연구 (A Study of the Rite of a Royal Groom's In-Person Escort of His Bride of the Joseon Royal Court). In Joseon wangsil ui garye 조선왕실의 가례 (Royal Wedding Rites of Joseon), vol. 1, edited by Kwon O-yeong, Kim Mun-sik, et al., 99–126. Seongnam: Academy of Korean Studies, 2008.

Kim Nam-yun. "Jeongjo ui wangseson chaengnye yeongu" 정조의 왕세손 책례 연구 (A Study of King Jeongjo's Investiture Rite for his Grandson Heir Apparent). Gyujanggak 규장각 37 (2010): 217–49.

Kim Seong-hui 金成喜. "Joseon sidae eojin e gwanhan yeongu — uigwe reul jungsim euro" 朝鮮時代 御眞에 관한 研究 — 儀軌를 中心으로 (A Study of the Joseon Period Royal Portraits — Based on Uigwe). MA thesis, Ewha Womans University, 1989.

Kim Su-jin 김수진. "Joseon hugi byeongpung yeongu" 조선후기 병풍 연구 (A Study of Screen Paintings of the Late Joseon Period). PhD diss., Seoul National University, 2017.

Kim, Sunglim (Seong-rim). "Chaekgeori: Multi-Dimensional Messages in Late Joseon Korea." Archives of Asian Art 64, no. 1 (2014): 3–32.

Kim Yang-gyun 김양균. "Yeongjo euryu giroyeon · Gyeonghyeondang sujagyeon dobyeong ui jejak baegyeong gwa jakga" 英祖乙酉耆老宴 · 景賢堂受爵宴圖屛의 제작배경과 작가 (The Background and the Authorship of the Screen Yeongjo euryu giroyeon · Gyeonghyeondang sujagyeon dobyeong). Munhwajae bojon yeongu 文化財保存研究 4 (2007): 44–69.

Kim Yeong-un 김영운. "Joseon hugi gugyeon ui angmu yeongu" 조선후기 국연의 악무연구 I (A Study of Performing Arts in the Late Joseon Period State Banquets I). In Joseon hugi gungjung yeonhyang munhwa 조선후기궁중연향문화 (Late Joseon Culture and Palace Banquets), edited by the Academy of Korean Studies, 18–65. Vol. 1. Seoul: Minsogwon, 2003.

———. "Joseon hugi gugyeon ui angmu yeongu" 朝鮮後期 國宴의 樂舞研究 II (A Study of Performing Arts in the Late Joseon Period State Banquets II). In Joseon hugi gungjung yeonhyang munhwa 조선후기궁중연향문화 (Late Joseon Culture and Palace Banquets), edited by the Academy of Korean Studies, 200–297. Vol. 2. Seoul: Minsogwon, 2005.

Kim Yong-suk 김용숙. Joseon jo gungjung pungsok yeongu 조선조 궁중풍속연구 (Customs of the Joseon Royal Palace). Seoul: Iljisa, 1986.

Kim-Renaud, Young-key, ed. Creative Women of Korea: The Fifteenth through the Twentieth Centuries. New York: M.E. Sharpe, 2004.

King Jeongjo 正祖大王. Hongjae jeonseo 弘齋全書 (Complete Writings of King Jeongjo [Hongjae]). 1814. Hangul translation by Korean Classics Research Institute. Seoul: Korean Classics Research Institute (Minjok munhwa chujinhoe 民族文化推進會), 1998.

Kkum gwa sarang: Maehok ui uri minhwa 꿈과 사랑: 매혹의 우리민화 (Auspicious Dreams: Decorative Paintings of Korea). Seoul: Hoam Art Museum, 1998.

Kleutghen, Kristina. Imperial Illusions: Crossing Pictorial Boundaries in the Qing Palaces. Seattle, WA: University of Washington Press, 2015.

Kye Seung-beom 계승범. "Gwanghaegun ui daeoe jeongchaek gwa geu nonjaeng ui seonggyeok" 광해군의 대외정책과 그 논쟁의 성격 (Gwanghaegun's Foreign Policy and the Nature of Debate on It). Hanguk bulgyo sa yeongu 韓國佛教史 研究 (Studies on Korean Buddhism) 4 (Fall/Winter 2013): 4–39.

Lachman, Charles. The Ten Symbols of Longevity: Sipjangsaengdo, an Important Korean Folding Screen in the Collection of the Jordan Schnitzer Museum of Art at the University of Oregon. Eugene, OR: Jordan Schnitzer Museum of Art, 2006.

Ledderose, Lothar. Ten Thousand Things: Module and Mass Production in Chinese Art. Princeton, NJ: Princeton University Press, 2000.

Lee Ki-baik (Yi Gi-baek) 李基白. A New History of Korea. Translated by Edward W. Wagner and Edward J. Shultz. Seoul: Iljogak, 1984.

Lee, Kyeong-hee (Yi, Kyeong-hi). World Heritage in Korea. Seoul: Samsung Foundation of Culture, 1997.

Leeum, Samsung Museum of Art, ed. Jongmyo: chimmuk gwa eunyu 종묘: 침묵과 은유 (Jongmyo: Silence and Metaphor). Photographs by Bae Byeong-u. Seoul: Samsung Foundation of Culture, 2015.

Legge, James. The Chinese Classics. Vol. 4, The She King 詩經. Taipei: Wenshizhe chubanshe, 1972.

Liji 禮記 (Book of Rites). In Saseo 四書 (The Four Books), edited by James Legge. Taipei: Yishi shuju (義士書局), 1949.

Liu, Lihong. "Ethnography and Empire through an Envoy's Eye: The Manchu Official Akedun's (1685–1715) Diplomatic Journeys to Chŏson Korea." Journal of Early Modern History 20 (2016): 111–39.

Maeda, Robert J. "Chieh-Hua: Ruled-Line Painting in China." Ars Orientalis 10 (1975): 123–41.

Min Gil-hong 민길홍. "Cheon chilbaek gusibo nyeon Jeongjo ui Hwaseong haengcha wa Hwaseong wonhaeng dobyeong 1795" 년 정조의 화성행차와 화성원행도병 (King Jeongjo's Visit to Hwaseong in 1795 and the Screen Painting Hwaseong wonhaeong dobyeong). In Jeongjo, parilgan ui Suwon haengcha 정조, 8일간의 수원행차 (King Jeongjo's Eight-Day Trip to Suwon), edited by the Suwon Hwaseong Museum 수원화성박물관, 290–307. Suwon: Hwaseong Museum, 2015.

Misul sok dosi, dosi sok misul 미술 속 도시, 도시 속 미술 (The City in Art, Art in the City). Exhibition catalogue. Seoul: National Museum of Korea, 2016.

Murray, Julia K. *Ma Hezhi and the Illustration of the Book of Odes*. Cambridge: Cambridge University Press, 1993.

Myeong Se-na 명세나. "Joseon sidae obong byeong yeongu" 조선시대 五峯屛 연구 (A Study of the Joseon Period Five Peaks Screen). MA thesis, Ewha Womans University, 2007.

Nam Gong-cheol 南公轍. *Geumneungjip* 金陵集 (*Collected Writings of Nam Gong-cheol [Geumneung]*). 1815. In Korean Literary Collections (*Hanguk munjip chonggan* 韓國文集叢刊) no. 272. Seoul: Korean Classics Research Institute (Minjok munhwa chujinhoe 民族文化推進會), 2001.

National Museum of Korea. *Gungnip jungang bangmulgwan seohwa yumul dorok* 국립중앙박물관 서화유물도록 (*Catalogue of Korean Paintings and Calligraphy in the National Museum of Korea*). Vol. 20. Seoul: National Museum of Korea, 2012.

National Palace Museum of Korea, ed. *Byeongpung e geurin songhak i nara naol ttae kkaji* 병풍에 그린 송학이 날아 나올 때까지 (*Until the Pine and the Cranes Painted on the Screen Fly Out of It*). Exhibition catalogue. Seoul: National Palace Museum of Korea, 2004.

No Dae-hwan 노대환. "Sippal segi Dong Asia ui baekgwa jeonseo *Gogeum doseo jipseong*" 18 세기 동아시아의 백과전서 「고금도
서집성 古今圖書集成」 (The Eighteenth-Century East Asian Encyclopedia, *Gujin tushu jicheng* [Complete Collection of Illustration and Writings from the Earliest to Current Times]). *SNU NOW* (blog). Seoul National University, 24 August 2015. https://snu.ac.kr/snunow/snu_story?bm=v&bbsidx=121997&.

Ok Young Jung (Ok Yeong-jeong) 玉泳晸. "Hwaseong seongyeok uigwe wa Dyeongni uigwe ui seoji jeok bunseok gwa bigyo" 「華城城役儀軌」 와 「뎡니의궤」 의 서지적 분석과 비교 (Bibliographical Analyses and Comparison between the *Hwaseong seongyeok uigwe* and the *Dyeongni uigwe*). *Jindan hakbo* 震檀學報 127 (2016): 159–92.

Pak Youngsook (Bak Yeong-suk). "Ch'aekkado — A Chosŏn Conundrum." *Art in Translation* 5, no. 2 (2013): 183–218.

Park Bon-su (Bak Bon-su) 朴本洙. "Joseon hugi sipjangsaengdo yeongu" 朝鮮後期 十長生圖 研究 (A Study on the Late Joseon Period *Screen of the Ten Symbols of Longevity*). MA thesis, Hongik University, 2002.

———. "Oregon daehakgyo bangmulgwan sojang sipjangsaeng byeongpung yeongu" 오리건대학교 박물관소장 십장생병풍 연구 (A Study on the Ten Symbols of Longevity Folding Screen in the University of
Oregon Museum). *Gogung munhwa* 고궁문화 2 (2008): 10–38.

Park Byeong-seon (Bak Byeong-seon) 朴炳善. *Joseon jo ui uigwe: Pari sojang bon gwa gungnae sojang bon ui seojihak jeok bigyo geomto* 朝鮮朝의 儀軌: 파리 所藏本과 國內所藏本의 書誌學的 比較檢討 (*Joseon Dynasty's Uigwe: Bibliographical Comparative Study of the Uigwe in the BNF Collection and Those in Korea*). Seongnam: Academy of Korean Studies, 1985.

———. *Règles protocolaires de la cour royale de la Corée des Li (1392–1910)*. Seoul: Kyujanggak Archives, Seoul National University, 1992.

Park Dong-su (Bak Dong-su) 朴東洙. "Wangsil eul wihae geurin An Jung-sik ui geurim deul" 왕실을 위해 그린 안중식 (安中植) 의 그림들 (An Jung-sik's Paintings Produced for the Royal Court). In *Joseon wangsil ui misul munhwa* 조선왕실의 미술문화 (*Art and Culture of the Joseon Royal Court*), edited by Yi Song-mi et al., 367–94. Seoul: Daewonsa, 2005.

Park Eun-sun (Bak Eun-sun) 박은순. "Joseon sidae chaengnye uigwe banchado yeongu" 朝鮮時代 冊禮儀軌 班次圖 研究 (A Study of the Procession Paintings by Rank of the Joseon Period *Uigwe* of Investiture Rites). *Hanguk munhwa* 韓國文化 14 (December 1993): 553–612.

Park Jeong-hye (Bak Jeong-hye) 박정혜. "Gungjung jangsik hwa ui segye" 궁중장식화의 세계 (The World of Palace Decorative Paintings). In *Joseon gunggwol ui geurim* 조선 궁궐의 그림 (*Paintings [Produced] in the Joseon Palaces*), edited by Park Jeong-hye et al., 79–81. Seoul: Dolbegae, 2012.

———. "Joseon hugi Jongmyo jehyangnye ui sigak jeok dohae: 'Jongmyo chinje gyuje doseol byeongpung' ui naeyong gwa hoehwa jeok teukjing" 조선 후기 종묘제향례의 시각적 도해: '종묘친제규제도설병풍'의 내용과 회화적 특징 (A Visual Analysis of the Sacrificial Rites at the Jongmyo Shrine: The Contents and the Stylistic Characteristics of the *Screen of the Royal Sacrificial Rites at the Jongmyo Shrine*). In *Jongmyo chinje gyuje doseol byeongpung eul tonghae bon Jongmyo* 종묘친제규제도설병풍 (宗廟親祭規制圖設屛風) 을 통해 본 종묘, 105–48. Seoul: National Palace Museum of Korea, 2012.

———. "Joseon sidae chaengnye dogam *uigwe* ui hoehwasa jeok yeongu" 조선시대 책례도감 의궤의 회화사적 연구 (A Study of the Joseon Period *Uigwe* of Investiture Rites in Art Historical Perspective). *Hanguk munhwa* 韓國文化 14 (December 1993): 521–51.

———. *Joseon sidae gungjung girok hwa yeongu* 조선시대 궁중기록화 연구
(*A Study on the Joseon Period Palace Documentary Paintings*). Seoul: Iljisa, 2000.

———. "Joseon sidae Uiryeong Namssi gajeon hwacheop" 조선시대 의령 남씨 가전화첩 (The Uiryeong Nam Family Heritage Painting Album of the Joseon Period). *Misulsa yeongu* 2 (1988): 23–49.

———. "Suwon neunghaengdo yeongu" 水原陵幸圖 研究 (A Study on the Suwon neunghaeng do). *Misul sahak yeongu* 美術史學研究 189 (March 1991): 27–68.

———. "Uhak munhwa jaedan sojang *Suwon neunghaeng dobyeong* ui hoehwa jeok teukjing gwa jejak sigi" 우학문화재단소장 〈수원능행도병〉 의 회화적 특징과 제작시기 (A Study of the Stylistic Characteristics and the Date of the Screen of the *Royal Visit to the Tomb of Crown Prince Sado in Suwon*). In *Hwaseong neunghaeng dobyeong* 화성능행도병 (*Screen of the Royal Visit to the Tomb of Crown Prince Sado in Hwaseong*), edited by Yun-Jeong Kim and Bo-Hyun Lee, 64–99. Yongin: Yongin University Museum, 2011.

———. "*Uigwe* reul tonghaeseo bon Joseon sidae ui hwawon" 儀軌를 통해서 본 朝鮮時代의 畵員 (Court Painters of the Joseon Period Seen through Uigwe Books). *Misulsa yeongu* 미술사연구 9 (1995): 203–90.

Park Jeong-hye (Bak Jeong-hye) 박정혜, **Hwang Jeong-yeon** 황정연, **Gang Min-gi** 강민기, **and Yun Jin-yeong** 윤진영. *Joseon gunggwol ui geurim* 조선 궁궐의 그림 (*Paintings [Produced] in the Joseon Palaces*). Seoul: Dolbegae, 2012.

Park Jeong-hye (Bak Jeong-hye) 박정혜, **Yi Ye-seong** 이예성, **and Yang Bo-gyeong** 양보경. *Joseon wangsil ui haengsa geurim gwa yet jido* 조선왕실의 행사그림과 옛 지도 (*Documentary Paintings and Old Maps of the Joseon Court*). Seoul: Minsogwon, 2005.

Seo Ho-su 徐浩修 (1736–1799). *Yeonhaenggi* 燕行記 (*Travel Diary to Yanjing*). In vol. 5 of *Gugyeok Yeonhaengnok seonjip* 국역연행록선집 (*Hangul translation of selected Travel Diaries to Yanjing*). Seoul: Korean Classics Research Institute (Minjok munhwa chujinhoe 民族文化推進會), 1976. First published in 1790.

Seo, Yoonjung (Seo Yunjeong). "Connecting across Boundaries: The Use of Chinese Images in Late Chosŏn Court Art from Transcultural and Interdisciplinary Perspectives." PhD diss., UCLA, 2014.

Shin Myungho (Sin Myeong-ho) 申明鎬. "The Contents and the Significance of *Records of the Jongmyo Royal Ancestral Shrine*." Introductory essay in *Jongmyo deungnok* 宗廟謄錄 (*Records of the Royal Shrine*), 3–35. 2 vols. Reduced-size facsimile edition. Seongnam: Jangseogak Archives of the Academy of Korean Studies, 2010.

———. *Joseon Royal Court Culture: Ceremonial and Daily Life*. Translated by Timothy V. Atkinson. Seoul: Dolbegae, 2004.

Sin Byeong-ju 신병주. "Yeongjo dae ui daesarye silsi wa daesarye *uigwe*" 英祖代의 大射禮실시와 大射禮儀軌 (The Performance of the Royal Archery Rites during the Reign of King Yeongjo and the *Uigwe* of the Royal Archery Rites). *Hanguk hakbo* 韓國學報 28, no. 1 (2002): 61–90.

———. *Yuksibyuk se ui Yeongjo, sibo se ui sinbu reul majihada* 66세의 영조 15세의 신부를 맞이하다 (*Sixty-Six-Year-Old Yeongjo Weds the Bride of Age Fifteen*). Seoul: Hyohyeong chulpansa, 2001.

Sin Han-na 신한나. "Joseon wangsil hyungnye ui uijang yong byeongpung ui gineung gwa uimi" 조선왕실 凶禮의 儀仗用 병풍의 기능과 의미 (The Meaning and Function of the Ritual Screens in the Funeral Rites of the Joseon Dynasty). MA thesis, Hongik University, 2008.

Sin Suk-ju 申叔舟 (1417–1475). "Hwagi" (Painting Records), contained in Sin's collected writings, *Bohanjae jip* 保閑齋集, published in 1487. See Ahn Hwi-joon 安輝濬, *Hanguk hoehwasa*, 1980, 93–96 and 121.

Sinseonwonjeon: Choehu ui jinjeon 新璿源殿: 최후의 진전 (*The New Seonwonjeon: The Last Royal Portrait Hall*). Daejeon: National Research Institute of Cultural Heritage, 2010.

Son Sin-yeong 손신영. "Joyeong gwajeong gwa johyeong wolli" 造營 과정과 造形 원리 (The Construction Process and Structural Principles). In *Hwaseong Yongjusa: Joseon ui wondang* 1 華城 龍珠寺: 朝鮮의 願堂 1. (*Yongjusa Temple at Hwaseong: Royal Temples of the Joseon Dynasty 1*), 21–51. Seoul: National Museum of Korea, 2016.

Song Hye-jin 송혜진. *Confucian Ritual Music of Korea: Tribute to Confucius and Royal Ancestors*. Translated by Paek In-ok. Seoul: Korea Foundation, 2008.

———. "Joseon sidae garye ui yongak yuhyeong" 조선시대 嘉禮의 用樂유형 (Types of Music Played in the Wedding Rites of the Joseon Period). In *Joseon wangsil ui garye* 조선왕실의 가례 (*Royal Wedding Rites of Joseon*), vol. 1, edited by Kwon O-yeong, Kim Mun-sik, et al., 71–79. Seongnam: Academy of Korean Studies, 2008.

Song Ji-won 송지원. "Joseon sidae ui nongsa wa yangjam eul wihan gukga jeollye wa eumak" 조선시대의 농사와 양잠을 위한 국가전례와 음악 (The State Rites and Music for Royal Farming and Sericulture of the Joseon Period). *Hanguk eumak yeongu* 45, no. 6 (2009): 149–75.

Song, Unsok (Eun-seok). "Buddhism and Art in the Joseon Royal House: Buddhist Sculpture and Painting." In *Treasures from Korea: Arts and Culture of the Joseon Dynasty, 1392–1910*, edited by Hyunsoo Woo (Hyeon-su Wu), 53–65. Exhibition catalogue. Philadelphia, PA: Philadelphia Museum of Art, 2014.

Sotheby's. *Korean Art*. Auction catalogue. New York: Sotheby's, 1996.

Suwon Hwaseong Museum, ed. 수원화성박물관. *Jeongjo, parilgan ui Suwon haengcha* 정조, 8일간의 수원행차 (*King Jeongjo's Eight-Day Trip to Suwon*). Suwon: Suwon Hwaseong Museum, 2015.

Tangshi huapu 唐詩畫譜 (*Illustrated Book of Tang Poems*), edited by Huang Fengchi 黃鳳池 (active 17th cen.). Vol. 3. Beijing: Guji chubanshe, 1998.

Wang ui chosang 왕의 초상 (*Royal Portrait*). Exhibition catalogue. Jeonju: Jeonju National Museum, 2005.

Watson, Burton. *The Complete Works of Chuang Tzu*. New York. Columbia University Press, 1968.

Wei Dong 魏冬. "Xia Yong ji qi jiehua" 夏永及其界畫 (Xia Yong and His Boundary Painting). *Gugong bowuyuan yuankan* 故宮博物院院刊 4 (1984): 68–83.

Woo Hyunsoo (Wu Hyeon-su) 우현수. "A Study of the Pair of the Phoenix and the Peacock Paintings in the Collection of the Philadelphia Museum of Art." In *Gunggwol ui jangsik geurim* 궁궐의 장식그림 (*Decorative Paintings of the Joseon Palaces*), 120–30. Seoul: National Palace Museum of Korea, 2009.

———, ed. *Treasures from Korea: Arts and Culture of the Joseon Dynasty, 1392–1910*. Exhibition catalogue. Philadelphia, PA: Philadelphia Museum of Art, 2014.

Yeongjo daewang 영조대왕 (*King Yeongjo the Great*). Exhibition catalogue. Seongnam: Academy of Korean Studies, 2011.

Yi Dal-ho 이달호. "Hwaseong geonseol yeongu" 화성건설연구 (A Study on the Construction of the Hwaseong Fortress). PhD diss., Sangmyeong University, 2003.

Yi Gyu-sang 李奎象 (1727–1799). "Hwaju rok" 畵廚錄 (Record of Painting Cabinet). In *Ilmong go* 一夢稿 (*Writings Done in Dream*). Vol. 30 of *Hansan sego* 韓山世稿 (*Collected Writings of the Hansan Yi Family through the Generations*). 1936.

Yi Hye-gu 이혜구. *Gugyeok Akhak gwebeom* 국역 악학궤범. Annotated translation of *Akhak gwebeom* (*Models of Korean Traditional Music*). Seoul: National Institute of Traditional Korean Music, 2000.

Yi Jong-sook (Yi Jong-suk) 이종숙. "Joseon hugi gukjang yong moran byeong ui sayong gwa geu uimi" 조선후기 國葬用 牡丹屛의 사용과 그 의미 (The Use and Meaning of the Late Joseon Period Peony Screens in Royal Funerals). Gogung munhwa 故宮文化 1 (2007): 60–91.

Yi Saek 李穡. Mogeun sigo 牧隱詩稿 (Collected Poems of Mogeun Yi Saek). In Mogeun jip 牧隱集. 1404. Vol. 12, Sehwa sipjangsaengdo 歲畵十長生圖 (New Year's Painting of Ten Longevities). Gugyeok Mogeun jip 국역 목은집 (Hangul translation of Mogeun jip). Seoul: Korean Classics Research Institute (Minjok munhwa chujinhoe 民族文化推進會), 2000–2006.

Yi Song-mi (Yi Seong-mi) 李成美. Eojin uigwe wa misulsa 어진의궤와 미술사 (Joseon Dynasty Uigwe Books of Royal Portraits in Art Historical Perspective). Seoul: Sowadang, 2012.

———. Fragrance, Elegance, and Virtue: Korean Women in Traditional Arts and Humanities. Seoul: Daewonsa, 2002.

———. Garye dogam uigwe wa misulsa 嘉禮都監儀軌와 美術史 (Joseon Dynasty Uigwe Books of Royal Weddings from an Art Historical Perspective). Seoul: Sowadang, 2008.

———. "Ideals in Conflict: Changing Concepts of Literati Painting in Korea." In The History of Painting in East Asia: Essays on Scholarly Method, edited by Naomi Noble Richard and Donald E. Brix, 288–314. Taipei: Rock Publishing International, 2008.

———. "Joseon hugi jinjak jinyeon uigwe reul tonghae bon gungjung ui misul munhwa" 조선후기 進爵, 進饌儀軌를 통해본 宮中의 美術文化 (Art and Culture of the Late Joseon Period Seen through Palace Banquets). In Vol. 2 of Joseon hugi gungjung yeonhyang munhwa 조선후기궁중연향문화 (Late Joseon Culture and Palace Banquets), edited by the Academy of Korean Studies, 115–97. Seoul: Minsogwon, 2005.

———. "Joseon Injo–Yeongjo nyeongan ui gungjung yeonhyang gwa misul" 조선 인조–영조 년간의 궁중연향과 미술 (Art and Palace Banquets of the Joseon during the Reigns of Injo through Yeongjo). In Joseon hugi gungjung yeonhyang munhwa 조선후기궁중연향문화 (Late Joseon Culture and Palace Banquets), 1:66–138. Seoul: Minsogwon, 2003.

———. Joseon sidae geurim sok ui seoyang hwabeop 조선시대 그림 속의 서양화법 (Western Influence on Korean Painting of the Joseon Dynasty). Revised and enlarged edition. Seoul: Sowadang, 2008.

———. "Joseon sidae gungjung chaesaekhwa" 朝鮮時代 宮中 彩色畵 (Polychrome Palace Paintings of the Joseon Period). In Hanguk ui chaesaekhwa 한국의 채색화 (Korean Polychrome Painting), 1:366–79. Seoul: Dahal Media, 2015.

———. Korean Landscape Painting: Continuity and Innovation through the Ages. Seoul: Hollym, 2006.

———. "The Making of Royal Portraits during the Chosŏn Dynasty: What the Uigwe Books Reveal." In Bridges to Heaven: Essays on East Asian Art in Honor of Professor Wen C. Fong, edited by Jerome Silbergeld, Dora C. Y. Ching, Judith G. Smith, and Alfreda Murck, 363–86. Vol. 1. Princeton, NJ: P. Y. and Kinmay W. Tang Center for East Asian Art, Princeton University, 2012.

———. "Screen of the Five Peaks of the Choson Dynasty" (revised). In Joseon wangsil ui misul munhwa 조선왕실의 미술문화 (Art and Culture of the Joseon Royal Court), edited by Yi Song-mi et al., 465–519. Seoul: Daewonsa, 2005.

———. "The Screen of the Five Peaks of the Joseon Dynasty." Oriental Art 42, no. 4 (1996/97): 13–24.

———. Searching for Modernity: Western Influence and True-View Landscape in Korean Painting of the Late Chosŏn Period. Seattle, WA: University of Washington Press, 2015.

———. "Sin Saimdang: The Foremost Woman Painter of the Chosŏn Dynasty." In Kim-Renaud, Creative Women of Korea, 58–77.

———. "Uigwe and the Documentation of Joseon Court Ritual Life." Archives of Asian Art 58 (2008): 113–34.

———. "The Uigwe Royal Documents of the Joseon Dynasty: What It Means to the Better Understanding of Korean Culture." In Baek sasibo nyeon man ui gwihwan: Oegyujanggak uigwe 145 만의 귀환: 외규장각 의궤 (The Return of the Oegyujanggak Uigwe after 145 Years: Records of the State Rites of the Joseon Dynasty), 256–91. Exhibition catalogue. Seoul: National Museum of Korea, 2011.

———. Yeongjo dae ui uigwe wa misul munhwa 영조대의 의궤와 미술 문화 (Art and Uigwe during the Reign of King Yeongjo). Seongnam: Academy of Korean Studies, 2014.

Yi Song-mi 李成美, Choe Jin-ok 崔珍玉, Kim Hyeok 金爀, et al., eds. Jangseogak sojang uigwe haeje 藏書閣 所藏 儀軌解題 (Notes on the Uigwe Books in the Jangseogak Archive). Seongnam: Academy of Korean Studies, 2002.

Yi Song-mi 李成美, Gang Sin-hang 姜信沆, and Yu Song-ok 劉頌玉. Jangseogak sojang garye dogam uigwe 藏書閣 所藏 嘉禮都監儀軌 (Royal Wedding-Related Uigwe in the Jangseogak Archives). Seongnam: Academy of Korean Studies, 1994.

———. Joseon sidae eojin gwangye dogam uigwe yeongu 朝鮮時代御眞關係 都監儀軌 (Royal Portrait-Related Uigwe of the Joseon Period). Seongnam: Academy of Korean Studies, 1997.

Yi Song-mi 李成美, Kang Kyung-sook 姜敬淑, and Cho Sun-Mie 趙善美, eds. Joseon wangjo sillok misul gisa jaryojip 朝鮮王朝實錄美術記事資料集 (Art-Related Articles Culled from the Veritable Records of the Joseon Dynasty). 7 vols. Seongnam: Academy of Korean Studies, 2002–2004.

Yi Su-gyeong 이수경. "Uiso seson barin banchado seonggyeok gwa uiui" 〈의소세손발인반차도〉성격과 의의 (Characteristics and Significance of the Banchado Procession from the Palace to the Tomb of Uiso, the Grandson of King Yeongjo). In Hyungnye 1 (Funerary Rites of the Oegyujanggak Uigwe), 212–38. Seoul: National Museum of Korea, 2015.

Yi Su-mi 이수미. "Gyeonggijeon Taejo eojin ui jejak gwa bongan" 경기전 태조어진의 제작과 봉안 (The Painting and Installation of King Taejo's Portrait in Gyeonggijeon). In Wang ui chosang 왕의 초상 (Royal Portrait), 228–41. Jeonju: Jeonju National Museum, 2005.

Yi Tae-jin 이태진. Wangjo ui yusan: Oegyujanggak uigwe reul chajaseo 왕조의 유산: 외규장각 의궤를 찾아서 (Heritage of a Dynasty: In Search of the Uigwe Books

Once Kept in the Oegyujang-gak Library). New, enlarged edition. Seoul: Jisik sane-opsa, 2010.

Yi Uk 이욱. "Jongmyo jehyang ui jeolcha wa teukjing" 종묘 제향의 절차와 특징 (The Procedure and Characteristics of the Jongmyo Sacrificial Rites). In *Jongmyo, the Royal Ancestral Shrine* 종묘 宗廟, 142–47. Exhibition catalogue. Seoul: National Palace Museum of Korea, 2014.

———. "Joseon ui guksang jeolcha wa uimi" 조선의 국상절차와 의미 (The Procedure of the Joseon State Funeral and Its Meaning). In *Orye: Joseon ui gukga uirye* 오례: 조선의 국가의례 (*The Five Rites: The State Rites of the Joseon Dynasty*), edited by Ji Du-hwan 지두환, Yi Song-mi 이성미, et al., 311–50. Seoul: National Palace Museum of Korea, 2015.

Yi Uk 이욱, **Jang Yeong-suk** 장영숙, **et al.** *Daehan jeguk ui jeollye wa* Daehan Yejeon 대한제국의 전례와 대한예전 (The Rites of the Daehan Empire and the *Code of the Daehan Imperial Rites*). Seongnam: Academy of Korean Studies, 2019.

Yi Won-bok 李源福. "Chaekgeori sogo" 책거리 小考 (A Study on Chaek-geori). In *Geundae Hanguk misul nonchong* 근대한국미술논총 (*Essays on Premodern Korean Art*), 103–26. Seoul: Hakgojae, 1992.

Yi Wu-sang 이우상. *Joseon wangneung: Jam deulji mothaneun yeoksa* 조선 왕릉: 잠들지 못하는 역사 (*Royal Tombs of the Joseon Dynasty: History That Cannot Rest in Peace*). With photographs by Choe Jin-yeon 최진연. Seoul: Dahal Media, 2008.

Yi Ye-seong 李禮成. *Hyeonjae Sim Sa-jeong yeongu* 玄齋 沈師正 研究 (*A Study on Hyeonjae Sim Sa-jeong*). Seoul: Iljisa, 2000.

Yoo, Jaebin (Yu, Jae-bin). "The Politics of Art under King Jeongjo Exemplified by 'Events from King Jeongjo's Visit to Hwa-seong in 1795.'" In *In Grand Style: Celebrations in Korean Art during the Joseon Dynasty*, edited by Hyon-jeong Kim Han, 90–111. Exhibition catalogue. San Francisco, CA: Asian Art Museum of San Francisco, 2013.

Yu Jae-geon 劉在建. *Ihyang gyeonmullok* 里鄕見聞錄 (*Experiences in the Villages and Countryside*). 1862. *Ihyang gyeonmullok* 이향견 문록. Seoul: Jayu mungo, 1996.

Yu Sae-rom 유새롬. "Oegyu-janggak *uigwe* janghwang ui teukjing" 외규장각 의궤 장황의 특징 (Characteristics of Bindings of the Oegyujanggak *Uigwe*). In *Oegyujanggak uigwe ui jang-hwang* 외규장각 의궤의 粧繡 (*Bookbinding of the Oegyu-janggak Uigwe*), 37–63. Seoul: National Museum of Korea, 2014.

Yu Seung-guk 柳承國. Introductory essay. In *Hanguk ui yuhak sasang: Yi Hwang, Yi I.* 韓國의 儒學思想: 李滉, 李珥, translated and edited by Yi Eun-sang 李殷相 and Yi Byeong-do 李丙燾, 11–40. Seoul: Samseong chul-pansa, 1983.

Yu Song-ok 유송옥. "Chinjam *uigwe* e natanan boksik yeongu" 親蠶儀軌에 나타난 복식 연구 (A Study of Costumes Worn in the Royal Sericulture Rites). *Hanbok munhwa* 14, no. 4 (2011): 150–67.

Yun Jin-yeong 윤진영. "Joseon malgi gungjung yangsik jangsikhwa ui yutong gwa hwaksan" 조선말기 궁중양식 장식화의 유통과 확산 (The Spread and Circulation of the Late Joseon Period Palace Decorative Paintings). In *Joseon gunggwol ui geurim* 조선 궁궐의 그림 (*Paintings [Produced] in the Joseon Palaces*), edited by Park Jeong-hye et al., 389–401. Seoul: Dolbegae, 2012.

———. "Joseon wangjo salleung dogam *uigwe* ui sasudo" 조선왕조 산릉도감 의궤의 四獸圖 (The Four Directional Animals Paintings in the Royal Tomb Construction *Uigwe* of the Joseon Dynasty). In *Injo Jangneung salleung dogam uigwe* 仁祖長陵山陵都監儀軌 (*Uigwe of the Construction of King Injo's Tomb*), 476–96. Reduced-size facsimile edition. Seongnam: Academy of Korean Studies, 2007.

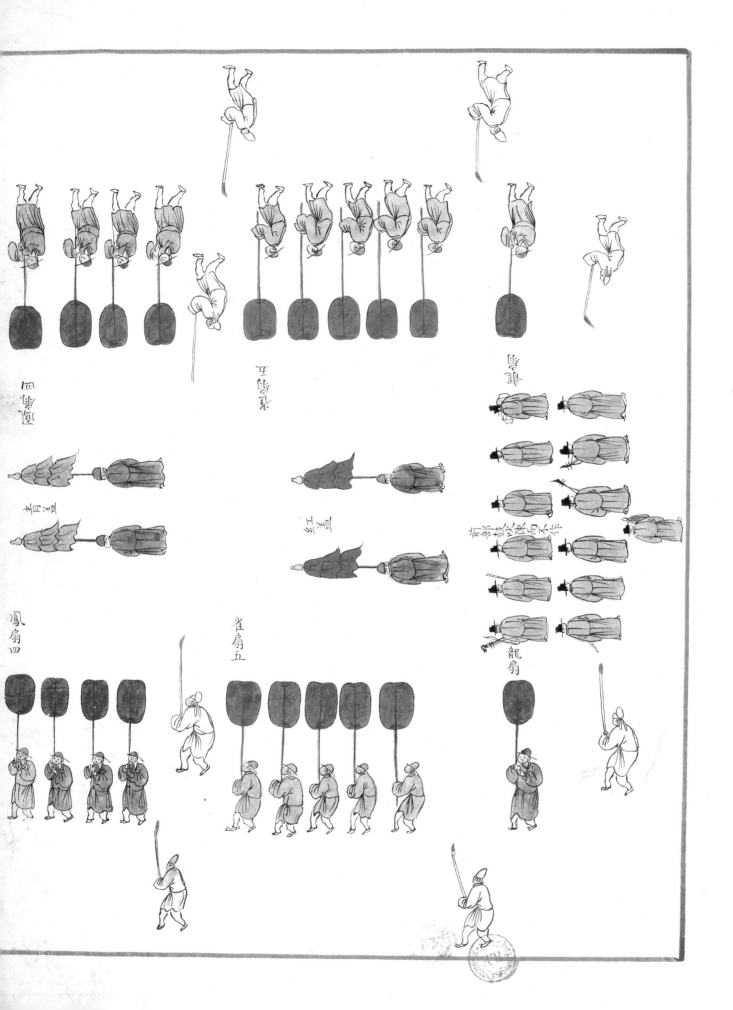

Index

PUBLISHED BY
P. Y. and Kinmay W. Tang
Center for East Asian Art
Department of Art
and Archaeology
Princeton University
Princeton, NJ 08544
tang.princeton.edu
in association with
Princeton University Press

DISTRIBUTED BY
Princeton University Press
41 William Street
Princeton, NJ 08540
press.princeton.edu

ISBN: 978-0-691-97390-6
ISBN: 978-0-691-97391-3 (ebook)

Library of Congress Control
Number: 2023943260

British Library Cataloguing-in-
Publication Data is available

Printed and bound in Italy

Managing Editor:
Dora C. Y. Ching

Copyeditors:
Rose E. Lee, Christopher Moss,
Vanessa Davies, Mary Gladue

Proofreaders:
Christopher Moss, Rose E. Lee,
Hyunjee Nicole Kim

Research Assistants:
Sunkyung Sohn Kim,
Gina J. Choi, Kwi Jeong Lee

Indexer:
Susan Stone

*Book design, composition,
and production:*
Binocular, New York

*Separations, printing,
and binding:*
Trifolio, Verona

This book was typeset in
Caecilia and Caecilia Sans
and printed on 104.7 gsm
Take GA-FS.

Display images:

Cover:
Detail of the *banchado* in the
*Uigwe of the Wedding of King
Yeongjo and Queen Jeongsun*, 1759.
See fig. 43, page 113.

Frontispiece:
Detail of the Cheonsa *banchado*
in the *Sajecheong uigwe*, 1608.
See fig. 56, page 144.

Page 24:
Detail of the *banchado* in the
*Uigwe of the Royal Funeral of
King Sukjong*, 1720. See fig. 195,
page 426.

Page 536:
Detail of the *banchado* in the
*Uigwe of the Royal Funeral of King
Injo*, 1649. See fig. 73, page 181.

Page 555:
Detail of the *banchado* in the
*Uigwe of the Investiture of the
[Crown Princess Yu as] Queen*,
1610. See fig. 30, page 82.

PUBLISHED BY
P. Y. and Kinmay W. Tang
Center for East Asian Art
Department of Art
and Archaeology
Princeton University
Princeton, NJ 08544
tang.princeton.edu
in association with
Princeton University Press

DISTRIBUTED BY
Princeton University Press
41 William Street
Princeton, NJ 08540
press.princeton.edu

ISBN: 978-0-691-97390-6
ISBN: 978-0-691-97391-3 (ebook)

Library of Congress Control
Number: 2023943260

British Library Cataloguing-in-
Publication Data is available

Printed and bound in Italy

Managing Editor:
Dora C. Y. Ching

Copyeditors:
Rose E. Lee, Christopher Moss,
Vanessa Davies, Mary Gladue

Proofreaders:
Christopher Moss, Rose E. Lee,
Hyunjee Nicole Kim

Research Assistants:
Sunkyung Sohn Kim,
Gina J. Choi, Kwi Jeong Lee

Indexer:
Susan Stone

Book design, composition,
and production:
Binocular, New York

Separations, printing,
and binding:
Trifolio, Verona

This book was typeset in
Caecilia and Caecilia Sans
and printed on 104.7 gsm
Take GA-FS.

Display images:

Cover:
Detail of the *banchado* in the
*Uigwe of the Wedding of King
Yeongjo and Queen Jeongsun*, 1759.
See fig. 43, page 113.

Frontispiece:
Detail of the Cheonsa *banchado*
in the *Sajecheong uigwe*, 1608.
See fig. 56, page 144.

Page 24:
Detail of the *banchado* in the
*Uigwe of the Royal Funeral of
King Sukjong*, 1720. See fig. 195,
page 426.

Page 536:
Detail of the *banchado* in the
*Uigwe of the Royal Funeral of King
Injo*, 1649. See fig. 73, page 181.

Page 555:
Detail of the *banchado* in the
*Uigwe of the Investiture of the
[Crown Princess Yu as] Queen*,
1610. See fig. 30, page 82.

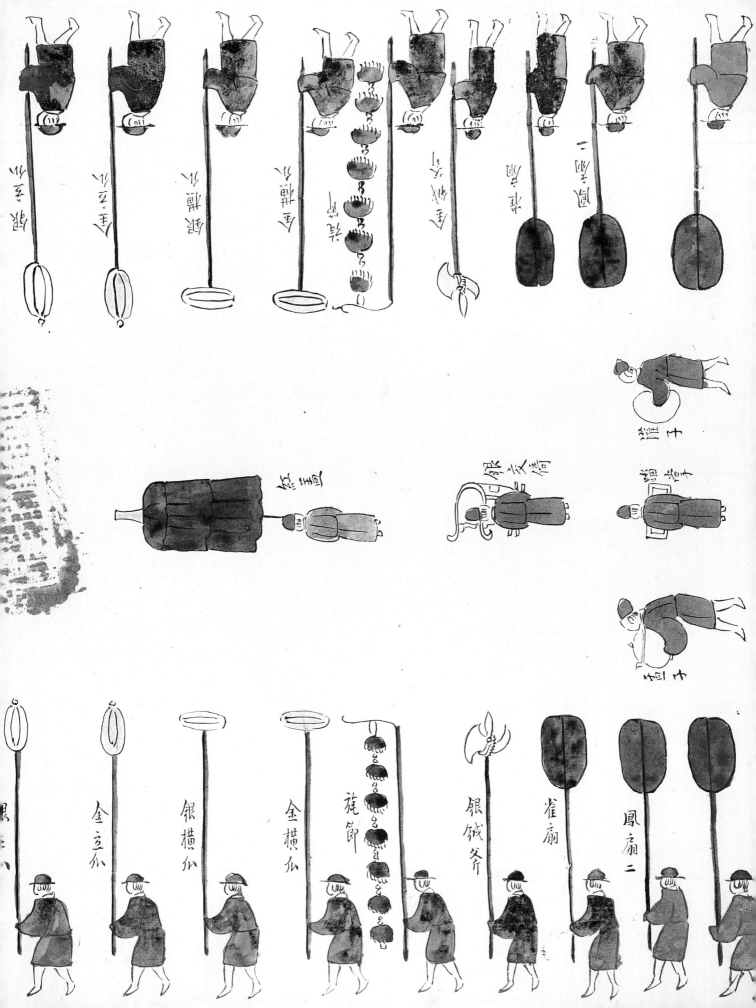

OTHER TANG CENTER PUBLICATIONS

2006
Persistence/Transformation: Text as Image in the Art of Xu Bing
Edited by Jerome Silbergeld and Dora C. Y. Ching

2008
Body in Question: Image and Illusion in Two Chinese Films by Director Jiang Wen
Tang Center Lecture Series
By Jerome Silbergeld

2009
Outside In: Chinese × American × Contemporary Art
By Jerome Silbergeld, Cary Y. Liu, Dora C. Y. Ching, et al.

2010
ARTiculations: Undefining Chinese Contemporary Art
Edited by Jerome Silbergeld and Dora C. Y. Ching

2011
Bridges to Heaven: Essays on East Asian Art in Honor of Professor Wen C. Fong
Edited by Jerome Silbergeld, Dora C. Y. Ching, Judith G. Smith, and Alfreda Murck

2012
Commemorative Landscape Painting in China
Tang Center Lecture Series
By Anne de Coursey Clapp

Crossing the Sea: Essays on East Asian Art in Honor of Professor Yoshiaki Shimizu
Edited by Gregory P. A. Levine, Andrew M. Watsky, and Gennifer Weisenfeld

2013
The Family Model in Chinese Art and Culture
Edited by Jerome Silbergeld and Dora C. Y. Ching

2014
Art and Archaeology of the Erligang Civilization
Edited by Kyle Steinke with Dora C. Y. Ching

Art as History: Calligraphy and Painting as One
By Wen C. Fong

2015
Proceedings from the 2013 College Art Asssociation Distinguished Scholar Session in Honor of Wen C. Fong
Edited by Jerome Silbergeld and Dora C. Y. Ching

Preserving the Dharma: Hōzan Tankai and Japanese Buddhist Art of the Early Modern Era
Tang Center Lecture Series
By John M. Rosenfield

2017
Around Chigusa: Tea and the Arts of Sixteenth-Century Japan
Edited by Dora C. Y. Ching, Louise Allison Cort, and Andrew M. Watsky

2021
Visualizing Dunhuang: The Lo Archive Photographs of the Mogao and Yulin Caves
Edited by Dora C. Y. Ching

Visualizing Dunhuang: Seeing, Studying, and Conserving the Caves
Edited by Dora C. Y. Ching

P. Y. and Kinmay W.
Tang Center for East Asian Art
Princeton University